Critical Acclaim for

JAMES McNEILL WHISTLER:
BEYOND THE MYTH

JAMES McNEILL WHISTLER

BEYOND THE MYTH

RONALD ANDERSON
and ANN KOVAL

CARROLL & GRAF PUBLISHERS
NEW YORK

James McNeill Whistler
Beyond the Myth

Carroll & Graf Publishers
An Imprint of Avalon Publishing Group Incorporated
161 William Street, 16th Floor
New York, NY 10038

Copyright © 1994 by Ronald Anderson and Anne Koval

First Carroll & Graf cloth edition 1995

First Carroll & Graf trade paperback edition 2002

Library of Congress Cataloging-in-Publication Data is available.

ISBN: 0-7867-1032-2

Printed in the United States of America
Distributed by Publishers Group West

To Christine, who perhaps suffered
more than I did. And to Molly, Ellie
and Jack, who had to live through it.

R.A.

To my sister Susie who believed in me.

A.K.

Authors' Note
The introduction, photograph
captions and Parts 1, 2, 4, 5 and 6
plus Chapter 18 were written
by Ronald Anderson, Part 3 and Chapter
27 by Anne Koval. The book as
a whole has benefited from the
research and ideas of both authors.

Contents

JAMES McNEILL
WHISTLER

Acknowledgements

THIS BOOK IS the combined research of over fifteen years. During that
time countless people have aided in the task. At Glasgow University
Library, where most Whistler research begins and ends, the professionalism
and knowledge of Margaret MacDonald and Dr Nigel Thorp, together with
their colleague Martin Hopkinson of the Hunterian Museum and Art
Gallery, were unrivalled and invaluable. At the Library of Congress, Manu-
script Division, in Washington DC the staff during many summer visits
were ever helpful and courteous. The same holds true for the many other
institutions throughout the United States such as the Freer Gallery Archives,
Washington DC, the New York Public Library and the other public
institutions too many to mention individually who patiently and efficiently
answered queries and despatched material. In the United Kingdom we wish
to thank the librarians and archival curators of many institutions including
the British Museum, the Tate Gallery, and the National Gallery, London; the
British Library, the Public Records Office and the Victoria and Albert
Museum. In Ireland we would like to thank the staff of the National Library
of Ireland, the State Papers Office and the Hugh Lane Gallery of Modern
Art. Particular thanks must go to friends and colleagues at the University of
St Andrews in Scotland from whom we have benefited greatly, among them
Dawn Waddell, Patricia de Montfort, and Robin Spencer, the latter
stimulating more than perhaps he realized. Special thanks must also go to
special friends, Dr Tom Normand, his wife Carey and their children, Lewis,
Ewan and Calum, for their warm hospitality on our frequent visits to
Scotland; and also to Barbara Dorf, and likewise Michael Parkin, whose
infectious enthusiasm for all things Whistler left an indelible mark.

Throughout the gestation of this project, Paddy Kitchen has served many roles, most importantly as friend and mentor. Unfailing in her encouragement and incisive in her judgement, she spent many long hours making the unreadable readable. While she is responsible for many improvements, the final product remains the sole responsibility of the authors. Our thanks to her is immeasurable.

Since the late 1960s Whistler scholarship, indeed scholarship in this period in general, has gained enormous momentum in the United Kingdom, the United States and Europe. This book has profited much from the work of many scholars who have researched various aspects of Whistler's oeuvre. Among those who have unwittingly provided much stimulation are Katharine Lochnan, Paul Marks, Ruth Fine, Nesta Spink, Robert H. Getsher, Lynda Merrill and William Vaughan.

Individuals who have displayed remarkable acts of kindness over the years are too numerous to mention. But of those who must be singled out are Richard Prater and Ruth Oliver of Broadmark Services who undertook considerable secretarial responsibilities with a smile, and perhaps more importantly with a care and efficiency far beyond the call of duty. Robin Campbell Cooke and Michael Korner, who undertook to reproduce and enhance many archival photographs in this book, deployed the same skilful professionalism. We are indebted also to Ralfe Whistler, one of the few surviving members of the Whistler family, who not only became a friend, but was also a source of constant support and information. Those who undertook to read the manuscript at various stages of its gestation and added invaluable suggestions include friends Jerrold Northrop Moore and Katherine Assheton. Others who made important contributions include the Comte and Comtesse du Luard, Emilie du Luard, Jayne and Martin Boers, Juliet Carro, Rita Linsley, Mary Dennis, Pat Pearce, John and Lesley Arnold, Elizabeth Chew, Mimi Schmir, Cathryn and Peter Kuhfeld, the Koval family, and especially Joanne Robertson.

Finally a word of special thanks must go to our publisher, John Murray, and our editor, Caroline Knox, and others involved in the editorial process, in particular Gail Pirkis, Roger Hudson and Howard Davies. Their encouragement and skill were invaluable, and their patience was welcomed.

Introduction

ON A HOT afternoon in 1923, almost exactly two decades after Whistler's death, the flamboyant French art dealer, René Gimpel, was introduced to the elderly Edward Kennedy. Once a partner in the New York art dealers Wunderlich and Company, Kennedy had been a close confidant of Whistler for almost twenty years. Gimpel, however, was disappointed when it became clear that his hopes of extracting interesting first-hand recollections were not to be fulfilled. Whether it was the stifling heat that was bothering Kennedy, or the fact that Whistler had characteristically severed relations with him over some trivial dispute, he simply would not be drawn.

As the interview ended, Gimpel suggested that the old dealer might bequeath his extensive collection of Whistler letters to the New York Public Library. Fortunately, the advice was heeded. But as Gimpel rose to leave, Kennedy made one final sally: 'I could write about Whistler, but I leave that to fools.' Exactly what he meant by this remark has haunted anyone embarking on a biography of Whistler ever since.

The name James McNeill Whistler conjures up a confused, contradictory image of an irascible maverick and gregarious dandy – an impression which overshadows his considerable achievement as an artist. Kennedy must have realized even in the 1920s that the myth of the capricious gadfly had become almost indelibly stamped on the popular imagination to the detriment of the complete man.

Much of the blame for this misconception must be laid on Whistler himself. In his lifetime he contributed greatly to his own caricature. He was ready to pounce on those who had the audacity to question him or his art,

and his list of opponents contains some of the most famous and influential names of the nineteenth century. Once his pride was wounded, he never, ever, forgave. Only he could have entitled his sole literary work *The Gentle Art of Making Enemies*.

An inordinately vain man, Whistler was also extremely insecure, and spent most of his life creating a façade behind which he hid. This insecurity, camouflaged by a veil of baleful mistrust, served to deflect any prying enquirers, and at the merest suggestion that he offer himself as a biographical subject he always took fright and bolted.

Twice in the mid-1890s he began an autobiography. In the few fragments that remain in the Glasgow University Library, the wholly inaccurate statements and fabricated half-truths reveal that he had actually begun to believe, in his own words, 'the fiction' of his life. But to sustain such a myth throughout a full-length autobiography would have been an impossible task. Stark, brutal facts terrified Whistler. Fiction he found infinitely easier to cope with.

Biographers colluded with the fiction, and the dozen or so full-length biographies that have appeared at intervals throughout this century have perpetuated the myth – with one notable exception. Over half a century ago, James Laver wrote an incisive study, which remains the most illuminating account of the life ever written. Otherwise Whistler has been singularly, if unwittingly, mistreated by his biographers. Time and time again they have been seduced by the mythology and have separated the colourful and controversial character from the key element of his life, his art. These myopic biographies, though usually well-intentioned, have done little or nothing to set the measure of his achievement, examine the context of his life or to explore the real man behind the façade.

The most famous Whistler biography was published in 1908, five years after his death. Despite their fervent and prolonged claims to the contrary, Elizabeth and Joseph Pennell were never authorized by him to write it. What they did was to distort a mutually agreed idea that they should prepare a catalogue of his work, surreptitiously changing the plan for their own purposes after Whistler's death. When ultimately challenged in a lawsuit brought by Whistler's executrix, Rosalind Birnie Philip, in 1907, they could offer no evidence, save for a typewritten letter purportedly written by the publisher, William Heinemann, in 1900. In this short letter, Heinemann claimed that 'at last' he had managed to secure Whistler's agreement for such an undertaking. Although Whistler lived for another three years after this alleged letter was written, there is not a single scrap of evidence to back up their claim.

In such circumstances it was not surprising that the judge ruled in Miss

Philip's favour and agreed the biography was not 'authorized'; without such sanction the Pennells lacked any claim to documentation that belonged to the estate. While the ruling proved a serious blow, it was not fatal, and the Pennells doggedly persisted in their task. But the book, despite its wealth of valuable contemporary reminiscences, together with their own eyewitness accounts of the later stages of Whistler's life, remains fundamentally flawed. To this eccentric but formidable couple, Whistler was simply a genius and, moreover, an American genius, who had arrived in Europe and almost singlehandedly changed for ever the course of Western art, despite being misunderstood and publicly ridiculed by the English. As a lone genius, he was untouched by those around him, and uninfluenced by the ideas of the day. They had anticipated Kennedy's wise words.

While Whistler would have probably adored the sycophancy, the Pennells' thesis became a burden on his critical reputation. By attempting to isolate his genius, they also isolated him from the genesis of modern European art and, in their desperate effort to singularize his status, they in fact ensured his isolation, confining him to the sidelines of art history.

Unquestionably, James McNeill Whistler was among the most significant artists of the nineteenth century. He did not, however, as the Pennells maintained, either work or live in a void. No artist does. At a singularly critical moment in the development of European art and society, he, together with his friends and colleagues, such as Courbet, Manet, Degas, Fantin-Latour and Monet, were destined to reshape and redefine not only the vision of the modern world, but the role of the artist within it. His libel case against the arbiter of Victorian taste and morals, John Ruskin, had as much to do with the economic rights of the artist to make a living as with any aesthetic proclamation.

Whistler was a complicated and many-faceted character, adored by some and loathed by many. On occasions he could be warm and friendly, thoughtful and generous, while on others, he was often cantankerous and selfish. Although not unduly promiscuous, rare were the times when he did not have a beautiful woman by his side. Ironically, while he spent most of his life pursuing real love, it was only towards the end that he found it. The sheer breadth of his friendships was, by any standards, extraordinary. While he was on intimate terms with members of the aristocracy, politicians and the 'new money' entrepreneurs, one of his most enduring and secretive friendships was with the Irish rebel, John O'Leary, a founding father of modern Irish nationalism. Whistler's life provides a window through which we catch a glimpse of one of the most exciting periods of art and social history. To isolate his personality from his artistic achievement negates the truth.

THE BUTTERFLY

The Butterfly seem'd to the ancients, the soul
As it left its frail cov'ring behind
And spurning the worm and its earthly couture
It soar'd with the freedom of mind.
Apt emblem indeed, is the grovelling worm
Of the sordid pursuits of this earth;
It died and the light, and the rich pencil'd form
Of the Butterfly starts into birth.
Thus Man in his mortal enclosure confin'd
Stoops downward, nor dreams of above;
'Till His Spirit releas'd, on the heav'nward wind
Ascends to the Mansions of Love.'

Unpublished poem by James McNeill Whistler's mother, Anna,
inscribed 'New York, April 1st, 1829'.
Manuscript, private collection, England.

Beginnings

I

Childhood

———————

J AMES ABBOTT WHISTLER, as he was christened, was born into an
extended family. As the first child of his father's second marriage, he
inherited two half-brothers, George William Whistler and Joseph Swift
Whistler, and a half-sister, Deborah. It was hoped that James's arrival, on
11 July 1834, would provide an important link between the new mother,
Anna, and her stepchildren.

Her husband, Lieutenant George Washington Whistler, had known
Anna McNeill for many years, since she had been the closest friend of his
first wife, Mary Swift. The two women had met through Anna's brother,
William, a contemporary of George Whistler's at West Point Military
Academy. From the moment Anna was introduced to the dashing young
cadet, she had secretly adored him. But she was no match in his affections
for Mary Swift, who was beautiful and gay and took the West Point campus
by storm.[1] It must have been a crushing blow for Anna when George
married Mary on 23 January 1821. The friendship survived, however, and
when Mary died in 1827 Anna was devastated. She immediately offered her
assistance to the distraught young husband and his family. According to
one source, on her deathbed Mary was said to have told her husband that if
he ever married again it should only be to her friend, Anna McNeill.[2]

As the months passed after Mary's death, Anna spent a steadily
increasing amount of her time with the Lieutenant and his children. She
was becoming more a surrogate mother than a close family friend. For
nearly four years she acted out this role. When and if she and the young
Lieutenant became lovers is not known. Etiquette, however, demanded a
respectable period of mourning, and perhaps this was the major obstacle to

any early prospect of marriage. During this time, George was seconded by the army to the private sector to build the Baltimore and Ohio Railroad, which meant long periods of separation.

For both the commitment to marriage was a serious proposition. They were devoutly religious, and the ultimate decision had to be absolutely right for them and the children. It was decided that Anna needed to distance herself, to think and ponder her future, and in 1830 she travelled to the United Kingdom for a year. Any doubts she may have had quickly evaporated during her extended vacation abroad. The couple got married quietly on 3 November 1831, and almost immediately moved to the countryside of New Jersey, where Anna set about creating a home for her new family. It was not always easy, and there was often great tension between her and her three stepchildren, particularly Deborah.

As an army officer, Lieutenant Whistler received a salary of just over $1,000 a year. With three young children to clothe, feed and educate, the birth of another would have stretched their already tight budget to the limit. There was only one option open if they wanted to extend their family: George would have to resign his commission and find employment in the private sector. His resignation, however, came sooner than he had planned. He applied for thirty days' leave over the Christmas and New Year period of 1833–4, and was refused. The army instead offered five. After nearly fifteen years of unblemished service, Whistler interpreted the offer as an insult. In an emotional protest, he tendered his resignation, confident that his superior officer would relent. He did not, and within days George Whistler was curtly informed by a letter from the War Department that his offer of resignation had been accepted and would take effect from 31 December 1833.

His periodical secondment from the army to various private companies had prepared him for life as a civilian. He was a first-class engineer, with a considerable reputation in his field. Almost immediately he found work with a firm of mechanical engineers, Shore Line Railway, who were constructing a new line between New London and New Haven. While the salary of some $4,000 a year was more than welcome, the long periods away from his new wife and family, an integral part of the job, soon proved to be too much. After only eight weeks' service, he accepted a new post with the Boston and Lowell Railroad at a lower salary of $3,000. It involved regular hours and little prolonged travel, once the move had been made from the rural beauty of New Jersey to the rapidly growing industrial town of Lowell, Massachusetts, whose skyline was dominated by a score or more of textile mills. Whatever misgivings George Whistler might have had initially, the job gave him the security and status he badly needed.

4

As the family settled down in their rent-free two-storey colonial house on Worthen Street, Anna prepared for the impending birth. It came on 11 July. The baby was christened James Abbott – after his uncle, the husband of his father's sister, Sarah. The older children adored the new addition – 'little Jamie', as he quickly became known in the household. By all accounts he was a beautiful baby, and as one aunt was later to remark, his looks were 'enough to make Sir Joshua Reynolds come out of his grave to paint Jamie asleep'.[3] Just over fourteen months after the birth of James, Anna became pregnant again. She gave birth to her second son on 22 July 1836 and he was christened William McNeill.

George Whistler's steady employment lent an air of relative security to the household. Unfortunately, however, that was about all. The railroad between Boston and Lowell had opened the year before, and was already proving a commercial triumph. But as the demand for locomotive traction engines increased, so too did George's workload. For an engineer anxious to further his career, the prospect of supervising the building of engine after engine seemed a bleak and unfulfilling future. It was time for another change.

Early in 1837 he got an engineering post with the New York, Providence and Boston Railroad, so the family was on the move again, to Stonington, Connecticut, an old town which clambered over the extreme tip of land pointing into Long Island Sound. Significantly, Stonington, along with Baltimore, was one of the two locations that Whistler usually named in later life as the place of his birth. Lowell, that bleak industrial town without any apparent history, was conveniently forgotten.

The three years spent in Stonington were on the whole happy for the Whistler family. Their large timber-framed house, standing on a corner of Main Street, had stunning views of the sea, and with its numerous rooms and huge cellar it made the family seem smaller than it was. Anna's third son, Kirk Booth, was born in July 1838, bringing the family to eight. The older children adored the house. Anna loved it too, and also the town where she made many friends. But it was not all happiness. In 1839 George's second son, Joseph Swift, died from typhoid, causing the family deep sorrow.

George's job provided the boost that his career needed. His brief was to oversee work on the local Stonington line, but his expertise was also in demand for other railway projects in the region. One consultation in particular, where he worked alongside his brother-in-law William Gibbs McNeill on the West Railroad of Massachusetts, resulted in the offer of a new job, a promotion to the rank of Chief Engineer. In 1840 the Whistler family moved to Springfield, Massachusetts.

This move proved to be a terrible upheaval. Anna deeply resented it, as did the older children. But the house in Springfield, with its twenty or so rooms, reflected the new status of Chief Engineer Whistler. The strict order imposed by Anna was soon to be reinforced by a new housekeeper called Mary Brennan, a farmer's daughter from the north of Ireland. She was a welcome arrival, and quickly became one of the family. Over the years she shared the Whistlers' varying fortunes and developed into Anna's most trusted friend and confidante.

In Springfield James's character began to emerge. His mother's diary reveals him often as a mischievous, spirited little boy who, on the point of reprimand, could melt his mother's heart with one innocent glance. He was a fidget, never appearing to stand still for a second, and needed and often demanded constant entertainment. Apart from this incessant activity, which frequently drove the exhausted family to distraction, they all without exception were devoted to him. He easily held his own, with a confidence way beyond his years.

The Whistlers resided in Springfield for only two years. George Whistler's professional reputation was beginning to spread beyond the United States. To compete with the expanding economies of Europe, Russia had to develop a railroad system over its vast tracts of land. Its construction became an important priority for the Tsar, Nicholas I. In 1840, the Tsar personally detailed two senior officers, both Imperial Transport engineers, to visit the major railroad construction sites in the United States. They met and talked at length with Chief Engineer George Whistler, whose knowledge and manner must have made an impression. Eighteen months later he received an official letter from the Russian Ambassador in Washington offering him the post of chief foreign consultant on a major project – the St Petersburg to Moscow Railway.

The railway was to be just over 400 miles long. For most of its length, because of the difficult Russian terrain, the track beds had to be raised by means of embanking. The civil engineering aspect also involved the construction of 200 bridges and nearly 70 viaducts. The scale of the project was unprecedented, as was the misery of the serfs who were forced to build it. George Whistler's specific brief from the Russian authorities was to advise on construction and then provide the rolling stock required. It was an awesome list, consisting of 162 locomotive engines, 5,300 trucks, 2,500 freight cars and 70 passenger cars.

George accepted the offer, including the provision that he would be released from the contract if he failed initially to settle in St Petersburg. For him, it was an attractive and appealing package; the salary of $12,000 was not excessive but the prestige and challenges offered by the huge project

were considerable. Anna, however, was horrified. Not only had she given birth the previous August to another son, Charles Donald, but their three-year-old son, Kirk Booth, had been ill for some time. In such circumstances the last place she wanted to be was in a foreign land thousands of miles from home.

Despite his wife's protestations, George Whistler was determined to go. It was arranged that he would settle in St Petersburg first and find suitable accommodation for the family. They might be able to join him within a year: the time of their departure would be dictated by the frail health of little Kirk.

One of the first letters from 8-year-old James was written only weeks after his father's departure in the early summer of 1842. 'You will remember better than I do', he wrote, 'when I was born on the 4th of July 1832 in Lowell.'[4] American Independence day was not James's birthday, despite his claim. Nor was he born in 1832. He was accurate as to place of birth, and this was perhaps the only occasion during his entire life that he freely admitted to it. Whether the letter was some contrived family joke designed to raise a smile from a lonely father is unclear. In any event it seems to anticipate a major characteristic of Whistler's life: his assumed right to pick and choose and if necessary change his autobiographical details. A few days after the letter had been posted and the day before James's eighth birthday, Kirk died. Even though he had been ill for some time, his death was a crushing blow to Anna and her family.

In the autumn of 1842, Anna began the long and complex preparations for moving the family to St Petersburg. It had been decided that the eldest son George would not go to Russia, but only accompany his stepmother and the rest of the family for part of the journey.

The voyage was planned to start in May 1843, but James delayed the departure by contracting rheumatic fever just days before the scheduled date. Again in the middle of June he became critically ill and very nearly died; but thanks to the skill of his uncle, a doctor, George Palmer, with whom the family were staying in Stonington, he was slowly nursed back to health. The attack was to have a detrimental effect on James's health for the rest of his life. For Anna, the thought of losing her darling Jamie so soon after the death of Kirk was almost too much to bear, and all through this very testing time only her faith in God kept her from totally breaking down.

In August 1843 the Whistler family, together with the indispensable Mary Brennan, boarded the steamship *Acadia* bound for Liverpool, on the first leg of their trip to St Petersburg. The crossing was calm and quick,

taking only ten days instead of the normal twelve. On their arrival in Liverpool on 29 August, they were met at the quayside by Anna's half-sisters Alicia and Eliza, and Eliza's husband, William Winstanley.

The two weeks spent with her older half-sisters in Preston were a tremendous relief for Anna, and a welcome break in the journey. Anna had always enjoyed their engaging company and particularly welcomed their wise counsel. The children too enjoyed the stay, and James himself soon became very attached to Alicia. On 16 September the family left by train to spend a night in London before boarding a steamer for Hamburg. From Hamburg the journey became fraught and arduous. There was an overnight trip of nearly sixty miles in an open carriage to Lübeck. The following day there was an equally hazardous journey by stage-coach to the port of Travemünde, where they were to board a German-registered vessel for the final leg of their journey across the Baltic.

The family arrived at Travemünde utterly exhausted and in a state of inconsolable sadness. This was the point of parting for the eldest son George, who was going no further. As they set sail that same afternoon, Anna's recent fears for the well-being of her youngest son Charles were quickly confirmed. She had suspected for several days that the 2-year-old boy was falling ill, though she had said nothing so as not to delay George's departure. There was no doctor aboard the ship, nor were there adequate medicines for the sickly child. As the hours passed his condition rapidly deteriorated. By the end of the evening he could not eat, drink or sleep. With her youngest child slowing dying before her very eyes, Anna's faith was tested to the limits. Desperately tired and utterly distraught, she sat with the child throughout the night. Throughout the next day he clung tenuously to life. The following morning, a Sunday, he finally died in his mother's arms.

The passengers transferred to a smaller vessel to take them the final fifteen miles up the River Neva to the city of St Petersburg on the morning of 28 September. Corpses were not allowed into the port of St Petersburg, so the body of the baby had to be temporarily held by the customs at Kronstadt. Several days later, after Russian officialdom had been satisfied, the body was sent home to the United States to be buried in the family plot in Stonington. Lieutenant Whistler was shattered by the terrible news and the guilt he felt over the death of his youngest son remained with him for the rest of his life.

The Whistlers' house on the Galernaya, one of the most fashionable and exclusive streets in the city, was huge and luxuriously decorated. Anna had at her beck and call what seemed to be an army of servants. To her relief some of them, and perhaps most importantly the cook, could speak

English. During the Ruskin trial in 1878, Whistler would claim that he had lived in St Petersburg for some twelve to fourteen years.[5] The fact is he lived there for barely half that time. Nevertheless, as his claim implies, his time there was seminal. It was there that his first inclinations towards his future vocation began distinctly to emerge.

As part of an important class of foreigners working for the government of the Tsars, the Whistler family received privileges which the normal Russian citizen could only dream of. The children were all tutored at home. James had a German tutor but, an apt student in many respects, it quickly became clear that he was not an altogether enthusiastic one. One thing always held his attention, and that was drawing. For his mother and Mary Brennan, it came as a welcome relief, when he was in the mood, for them to supply him with a lead pencil and a scrap of paper, which would often occupy him for hours on end. Undoubtedly his yearning to draw stemmed from his father whose work as an engineer involved drawing to a high degree of specification. A lithograph, from a sketch by Lieutenant Whistler, which still survives, shows the hand of a competent and skilled draughtsman.[6] From the time he was able to hold a pencil, James was encouraged by his father to draw, and it was always a great delight to him when a finished article was greeted with approbation by his father.

His father and mother soon gave in to James's request to be given private art lessons. If anything, they reasoned, it might help to discipline him. Since arriving in St Petersburg, he had not settled as well as his younger brother William or his elder half-sister Deborah, who was now 19 and very much enjoying her new social life. James, on the other hand, had become prone to fits of ill temper and displays of blatant insolence to all and sundry. These mood swings were causing concern to both his parents. Anna would chide him for inconsiderate behaviour by telling him that it was 'in his powers to make his mother's heart rejoice'.[7] Playing upon his seemingly incessant ill-health, James usually blithely ignored her reprimands.

His first drawing lessons were held once a week in a room set aside in the house. James enjoyed the one-to-one tuition immensely. He became particularly fond of his teacher, Alexander Karitzky, a senior student at the Imperial Academy of Fine Arts, and eagerly followed his instruction to the letter. This was in stark contrast to his other schoolwork: while he did enjoy reading,[8] it was a constant battle to keep his attention on any subject not connected with art.

By Christmas 1843, Anna and her family had settled in St Petersburg. Although she tried assiduously to avoid the social scene, which centred around the tightly-knit group of American ambassadorial staff and

professional colleagues of the Lieutenant's, Anna was becoming, when required, a congenial hostess. Parties of up to twenty people soon became common occurrences. In keeping with her strict Episcopalian values, she balanced the lavishness of her hospitality by charity work with the old and infirm: she would think nothing of bringing a sick person to her house to nurse, perhaps for weeks on end.

Ten days before James's tenth birthday, on 1 July 1844, the Whistler household was to play host to a very special guest. Anna wrote in her journal: 'While we were at tea, a carriage drove up to the door, and Mr Millar entered, introducing Sir William Allen, the great Scotch artist of whom we had lately heard who has come to St Petersburg to revive in canvas some of the most striking events from the life of Peter the Great.'⁹ Then at the pinnacle of his career, Sir William Allen RA, President of the Scottish Royal Academy, was on his second trip to Russia. As a young man he had travelled there for nearly two years, studying the Cossacks and Circassians. A pioneer in Scotland of history painting, he was, as Anna had rightly noted, in Russia at the request of the Tsar to work on a scene from the life of Peter the Great. The finished painting, massive in scale, *Peter the Great Teaching his Subjects the Art of Shipbuilding*, now in the Winter Palace, was to be his Russian *pièce de résistance*.

As his mother was to recall, the talk of art 'made Jimmie's eyes express so much interest, that his love for Art was discovered, and Sir William must needs see his attempt'.¹⁰ It must have been a wonderful moment for James when he was able to show and explain to Sir William page after page of his drawings. According to Anna, after the boys had finally said goodnight, Sir William turned to her and remarked, 'Your little boy has uncommon genius, but do not urge him beyond his inclination.'¹¹ She duly recorded her reply: 'I told him his gift had been only cultivated as an amusement, and that I was obliged to interfere, or his application would confine him more than we approved.'¹²

Time and time again, Anna made notes in her diary of James's unruly and often anti-social behaviour. Added to her problems with James, she was also constantly concerned about Deborah, whose life, it seemed to her, revolved solely round the social events of the city. The tension this created was beginning to strain their relationship. When dealing with her stepdaughter, Anna had always felt vulnerable. Now, in this strange city, with her husband more often away than at home, the crisis between the two was fast coming to a head.

Throughout the remainder of 1844, James continued with his private art tuition. His progress was good, but he was becoming increasingly bored with the limitations of one-to-one teaching. He was always asking Karitzky

to tell him about the Academy and its teaching, and was fascinated by the stories he was told. He could see the Academy across the River Neva from his new home on the English Quay, and watch the students enter and leave. With Karitzky's help, he was determined to persuade his parents to allow him to enrol. After much argument and cajoling, his parents finally agreed – Anna's latest, difficult pregnancy perhaps the decisive factor – and in April 1845 James was officially enrolled at the Academy for three drawing lessons a week.

The teaching of the Academy was no different from that of any other official art-teaching establishment in the early nineteenth century. The master of the class would set out the day's work – usually plaster casts of ancient classical statues – and the students would simply draw them. The master would walk among the students commenting on their work, suggesting ways of rendering this or that, correcting perspective and generally encouraging their efforts. The Academy, like all others of its type, made no allowance for individual creativity. It was essentially a formulaic training. In spite of the rigidity of the system, James loved the Academy: he loved talking art with the other boys, loved the splendour and history of the place, and, most of all, he loved the idea of himself as a real artist.

To justify his parents' initial consent, James worked hard at his drawing studies, both at the Academy and with Karitzky at home. He was rarely absent, and always handed the prescribed work in to his professors on time. He was awarded a first-class mark and ranked twenty-eighth in his class of more than 100, after an examination held on 2 March 1846:[13] not bad for a boy only 11 years old.

In May 1846, not long after James had excelled himself at the Academy, 'the boys', as Anna constantly referred to them, were taken as a special treat to visit the triennial exhibition of contemporary art at the Academy. Anna noted that 'To James it was the greatest treat we could offer.'[14] Such was his enthusiasm for the show that he visited it more than two dozen times during the six weeks it was on.

His parents had been concerned for some time that James's love for art had taken the place of his 'real' education, so it was finally decided that he, along with William, should be sent to a private boarding school. When the news was broken to the boys they were horrified, and James was heartbroken that he was not to be allowed a second term at the Academy. But on 14 September 1846, dressed smartly in the regulation uniform of their new school, Monsieur Jourdan's just outside the city, the boys reluctantly left home.

After a few weeks and many tears, particularly from the younger William, the boys seemed to settle down fairly well. For the much more

outward-going and gregarious James, the transition from home was easier. There were forty or so boys in his form, and he enjoyed their often rumbustious company.

As autumn drew to a close, the temperature fell alarmingly. The winter months of 1846–7 were especially harsh, even by Russian standards. Repeatedly, James and William contracted colds and related fevers. And they never completely stopped feeling homesick, even though they were allowed home most weekends. On one such visit in mid-October, they witnessed the death of baby John from dysentery.

Their arrival home the week before Christmas was an emotional time for Anna. She had missed them desperately, and in the aftermath of John's death she was very concerned about their health and well-being. At home they seemed content and happy. Among the many treats they had was the use of a magic lantern. James, in particular, was enthralled by this new gadget and it occupied him for hours on end.[15] As the holiday progressed, however, Anna realized the extent of their misery at school. Although the boys undoubtedly exaggerated, Anna was now determined that they should not return. Fortuitously, two unforeseen factors would strengthen her defence when she presented their case to their father.

In the autumn of 1845 Deborah had left for a visit to England. Since her return after a year's absence she had soon become unsettled. The earlier tension between her and Anna had resurfaced, and Deborah needed a focus for her thwarted energies. She suggested that she should become the boys' tutor. Anna was delighted with the idea, which solved two pressing problems at a stroke. Although initially opposed to the plan, the Lieutenant soon relented. Moreover, James's health was now beginning to worry Anna seriously. The bad cold he had caught over Christmas had refused to go away. As the New Year celebrations came and went, the cold damp weather continued. James increasingly complained of headaches and of generally feeling unwell. Anna's alarm heightened as the days passed.

For nearly a week James was desperately ill. Slowly, he began to rally, but the road to recuperation was a long and often painful process, with open blisters on his chest causing great distress.[16] James was a good patient, though he loathed the gruel doled up by Mary Brennan at every meal. Anna and Deborah read to him for hours every day. He adored 'Debs' and loved to listen to her stories. The severity of his illness had also made him a kind of minor celebrity among his friends, and daily, for a period strictly rationed by the ever watchful Anna, one of these boys would troop to the bedroom bearing gifts.

Despite this lavish attention, James sorely missed his drawing and the stimulation it provided. But Anna was adamant; drawing was simply out of

the question. Then the ever-resourceful Deborah hit on an idea. If he could not actually draw, he could surely look. To this end she found an album of Hogarth etchings.

In her journal entry for 27 February 1847,[17] Anna graphically described the patient's initial delight with this unexpected treat:

> We put the immense book on the bed, and draw the great easy chair up, so that he can feast upon it without fatigue. He said, while so engaged yesterday, 'Oh, how I wish I were well, I want so to show these engravings to my drawing master, it is not everyone who has the chance of seeing Hogarth's own engravings of his originals,' and then added, in his own happy way, 'and if I had not been ill, mother, perhaps no one would have thought of showing them to me.'

For James the experience was truly revelatory. For days on end he savoured the contents of the album, entertained by the wit of Hogarth's narrative and intrigued by the technical skill evident in the etched lines before his eyes.

As his recovery progressed throughout March and April, news began circulating in St Petersburg of a widespread flu epidemic. So far it had not reached the city, but the danger alarmed Anna. If James were to catch flu so soon after rheumatic fever, it could quickly kill him. Lieutenant Whistler, too, was concerned. A few weeks later, the epidemic hit the city. Many people died within days of contracting it. To make matters worse, it was simultaneously reported that after many years' absence, cholera was again on the rampage. Anna was now truly fearful for the health of her children: they would have to leave the country.

Deborah was the first to depart. Early in May, she paid a visit to Switzerland where she was to be the guest of the widow of a distinguished English surgeon, Charles Seymour Haden, whom she had met on her previous visit to England. She was glad to be going. The tension between herself and her stepmother had been simmering for some months, and it would be a relief to be free from her wearisome strictures. A month after Deborah's departure Anna and the boys set sail for England. They were going to Preston to stay with Anna's half-sisters, Eliza and Alicia, as they had on the journey out. The boys, particularly James, were delighted at the prospect.

James misbehaved on the voyage, as Anna reported in a letter to her husband. She blamed herself: 'When I examine my own life, dearest,' she wrote, 'I am brought to see how much patience I have towards Jamie, and you who are so forbearing to Annie's failings will not be despairing about those of this noble minded boy, for all his faults he inherits from his

mother. If Jamie and I could take time before we act, or speak, how much mortification we should save both you and ourselves.'[18]

Three days after leaving St Petersburg, their ship docked at Hamburg. Impatient as usual, James could not wait to get ashore. He was desperate to visit an art gallery he had visited before, which was owned by a Mr Flukes, an acquaintance of the Lieutenant. James visited the gallery three times during the same day. Little is known about it, but from various descriptions it seems that Mr Flukes dealt primarily in continental Old Masters. In a letter to his father, James excitedly explained that Mr Flukes had recently bought 'several more paintings for his gallery'.[19] They had been purchased in Lübeck and included 'a very fine head by a Spanish Master which he is prepared to sell'. In the same letter James reported that he had gone to see other paintings of interest in the area, perhaps prompted by Mr Flukes. One visit was to 'the marine church' where he saw a painting 'more curious than pretty' entitled *Death's Dance*. He noted, somewhat nonchalantly, that though 'some think it was painted by Holbein', the dating was wrong for 'he was born long afterward'. The young James, it seems, had become an expert.

The family set sail from Hamburg to Hull the following day. The weather soon turned bad, and they were all seasick. At the end of the second day, a Saturday evening, the ship docked at Hull. The following morning, as James described to his father, the family 'cut to York and were in time for morning service at the Minster, where we heard some most beautiful singing and a very good sermon . . . I think there is no church in all Russia like it.'[20]

After a week in Scarborough for the sea air, Anna, Mary Brennan and the two boys arrived in Preston. Anna was glad to be there. It was a warm-hearted household and she always felt at ease in the company of Eliza and Alicia. Despite earlier misgivings, James too had come to like England. As he declared in a letter to his father, 'I like England and the English people . . . we do sometimes have a fight, so tell Mr Prince [a colleague of his father's] he need not be afraid of me getting too many English notions.'[21]

In mid-August, Deborah returned to England and joined the family in Preston. She had fallen madly in love in Switzerland with one of the widow's sons, Francis Seymour Haden. For a whole day she sought the courage to tell her stepmother the news. Not only was she in love, but she wanted to get engaged and married as soon as possible. Her haste was no doubt partly prompted by her desire to escape the often intolerable tension that had grown between Anna and herself. The calm and agreeable way Anna took the news, when she was told the following day, underlines this view. Anna, relieved at the prospect of losing Deborah, readily gave her

consent to the marriage, and the rather bemused aunts quickly gave Anna and Deborah their support. There was, however, one serious obstacle: the Lieutenant's consent. A letter was sent to St Petersburg.

Anna's earlier plan to take the boys back soon to St Petersburg was abandoned. Both James and William had settled well in Preston, and both loved England. James had conceived his own plan for ensuring they remained; in a letter written early in the holiday, he explained his scheme to his father: 'What do you think of placing us at [Rossall] School? It is so beautifully situated, on the open sea . . . if it was not for the disappointment of not seeing you for such a long time, I should like to go there . . .'[22] The plan had Anna's support, for she still feared for James's health, should he return to Russia. England had done wonders for it, and for the first time he actually wanted to go to school. Lieutenant Whistler gave his agreement: the boys would stay in England, at least for a term.

The news of Deborah, however, took her father completely by surprise; it was the last thing he had expected. The tension between Deborah and Anna had always escaped his notice; his long absences, combined with Anna's skill at hiding the discord, had protected him. The sadness of his response underlines his ignorance on the matter: 'I have never till now felt what it was to contemplate her leaving. She doesn't know how much I shall miss her. Surely she can be spared me these few months.'[23] Anna's reply implied she could not, and the Lieutenant wrote immediately to say he was coming to England. With his tentative approval, the wedding date was set for 16 October.

Francis Seymour Haden was 29 when he met Deborah Whistler, then 21. Coming from a distinguished medical background, it seemed natural that he too should practise medicine. He had trained in obstetric surgery at the Sorbonne in Paris, and had graduated in 1843. He also studied art 'to better train his hand and eye for surgery',[24] and was a talented amateur. To Deborah he seemed a man of the world – well travelled, charming, cultured, with impeccable manners and very romantic. It was perfectly natural that Deborah should see the man she adored in such glowing terms. Unfortunately, to others Seymour Haden had one overriding and irritating fault: old beyond his years, he had an exaggerated pomposity bolstered by his family's wealth and social standing.

It was this unfortunate quality that Lieutenant Whistler immediately perceived when they first met, shortly before the wedding. Haden had a lot to prove; after all, he was about to marry the Lieutenant's only daughter. By all accounts, he failed miserably to impress.[25] For the former West Point officer, used to dealing with hard-talking, no-nonsense railroad workers, Haden seemed to represent the very worst of the English class system. He

was patronizing and opinionated. James, who had also been present at this ill-fated first meeting, had his own reason to complain. As he recalled years later, 'Haden patted me on the shoulder and said it was high time the boy was going to school.'[26] All in all, it boded ill for the future.

Despite his misgivings over her choice of husband, the Lieutenant gritted his teeth and said nothing to Deborah. After the wedding, held at the Old Parish Church in Preston, it was decided that the boys would return to St Petersburg with their mother and father. It had been a very stressful time for the Lieutenant, and he could not face the prospect of another period alone in Russia.

2

Formative Years

THE WHISTLER FAMILY returned to St Petersburg towards the end of October 1847. The massive Russian railway project had now been under way for just over five years. Progress had been good, though there were problems. The rail gauge itself had been the first, and at the outset Lieutenant Whistler had argued strongly for the use of the American-size gauge. He had good reason for this, since he hoped to secure major contracts for several American companies to supply the rolling stock required. The Russian authorities, however, were adamant that they had to have a different gauge. The demand was political, a concession from the Tsar to his bourgeoisie who wanted no rail link with other states for fear they would lose control over the domestic economy. Lieutenant Whistler reluctantly bowed to the demand, though he still managed to secure the American contracts. (A century later the Russians had every reason to be glad of their decision. After the German army's invasion, Hitler faced a major obstacle in that the German gauge, American in size, prevented him from deploying German stock on the Russian rail network.)[1]

As the boys settled down again in St Petersburg, James resumed his drawing lessons with Karitzky. He had sorely missed the stimulation of his art tutorials. As before, Anna insisted that they were given only once a week, and there was no question of him being allowed to return to the Academy. A sketchbook which survives from this period contains numerous figure sketches, some classical, others perhaps from life or memory:[2] these often bold and very competent drawings reveal that James had certainly absorbed the lessons of the Imperial Academy.

The boys, now 13 and 11, were developing very different personalities.

While James, according to Anna, was quick-tempered, often idle, and usually shirked any household chore, William was gentle, determined, always helpful, and usually well-behaved. Where James had still no real interest in anything but drawing and painting, William was diligent and excelled at maths and science.

The long, cold winter months again affected James's health, and he suffered another attack of rheumatic fever. With the first signs of spring came the unwelcome news of another outbreak of cholera in Russia. As the weeks passed, the epidemic worsened, and soon every major town and city was reporting the illness. Its effects were devastating. Within days of appearing in St Petersburg, it had caused many hundreds of deaths. Early in July 1848, Anna, the two boys and Mary Brennan took the now familiar route back to England via Hamburg.

A week later, they arrived in London to stay with Deborah and Haden at the large house Haden had inherited from his late father, 62 Sloane Street. It was a joyful reunion for the boys. Anna was particularly pleased to see how well Deborah had settled into married life, and recorded her initial impressions in her diary: 'The couple are truly one, their tastes the same, perfect harmony and cheerfulness reigns.'³ For nearly a week, the boys had the run of the house. They simply loved London, and every glorious summer day of that week they were taken on tours of various sights. Anna, too, enjoyed the stay. For the first time in many years, she felt at ease with Deborah, who had wonderful news to share with her visitors – she was nearly five months pregnant.

For James in particular, the visit to London had another unexpected bonus – Haden's interest in art. Although he had known of this enthusiasm of his brother-in-law's from their first meeting, he had not understood its true extent. Any misgivings James may have harboured about Haden's personality quickly dissolved as he was taken up to his study to be shown his fine collection of etchings. By 1848, Haden had been collecting prints for nearly three years. He was fascinated in particular by seventeenth-century Dutch etchings, and his collection at the time focused primarily on Rembrandt. But he was also steadily amassing works by Van Dyck, Van Ostade, Hollar and Claude. As he showed his collection to the wide-eyed James, he occasionally paused to explain a rare proof or counter-proof. To James, such enthusiasm, combined with Haden's obviously wide knowledge, was overwhelming. Mr Flukes in Hamburg seemed to pale into insignificance.

Not only was Haden a zealous collector and connoisseur of prints, he was also a talented amateur artist as well. The medium of etching fascinated him; he loved its precision of line and the technical challenge it presented.

For several years now, through meticulous study and observation, he had apprenticed himself to the craft and, completely self-taught, he derived tremendous satisfaction from his work. To Haden, the art of etching was not at all dissimilar to his own profession of medicine. It was a science, empirically based and capable of practical resolutions.

For James, this week in London with the Hadens had been a revelation. When he first set eyes on the Hogarth etchings in St Petersburg, he had marvelled at their narrative beauty, but had no knowledge of the techniques that lay behind them. In Haden he had found someone who could tell him, a soulmate. It was all Anna could do to drag him away from Sloane Street to spend time on a prearranged family holiday in the Isle of Wight. In quieter moments, James painted with his new box of watercolours which Haden had given him. His letters to his father described his progress. None of the pictures, he felt, was as yet quite good enough to send to St Petersburg, despite his father's pleading reply: 'Can't you send me a small one – just a sketch – you know I don't expect anything finished – it will be austere by purpose if it be just a sketch . . .'[4]

It was decided, with Lieutenant Whistler's agreement, that James should stay in England 'if they can find a good school'.[5] They found one – Eldon Villa, near Bristol, run by a friend of Haden's, Mr Phillott. With James settled at the school in early September 1848, Anna and William left for St Petersburg. The day after their arrival there his father wrote to James: 'Although I am certain it is for your own good it was strange to see mother and Willie return without you.'[6] While James may have taken comfort from this kindly sentiment, the remainder of the letter was disconcerting. In it, his father, with a mixture of admonishment and praise, informed him that 'carelessness was wont to be your evil genius – finish your work my boy – with your natural talent, and fondness for drawing, with regularity and perseverance you could have made much greater progress.'[7] The Lieutenant concluded by advising him to choose a career and enter an American college, perhaps to study 'some branch of engineering or architecture'. The contents of the letter perturbed James. It was the first time his father had mooted the notion of a specific career for him, and his own plans were very different. He was bent on becoming an artist, and with Haden's as yet unwitting help, he planned to make the announcement in the very near future.

James returned from Eldon Villa school just before the birth of Deborah's first child, Annie, on 14 December. One of the many things Lieutenant Whistler had done during his brief stay in England in October 1847 was to commission a portrait of James by the noted Academician, William Boxall. His reasons for the commission are not altogether clear,

though one must presume that Haden had a hand in arranging it, since a recently discovered portrait of Deborah, also by Boxall, seems to date from this same period.[8] A highly respected figure, Boxall specialized in painting portraits of established figures in the literary, artistic and ecclesiastical fields. Only days after the birth of Annie, a message arrived that the artist was ready to begin.

After seeing the painting for the first time James wrote to his mother describing it as 'very like me and a very fine picture. Mr Boxall is a beautiful colourist. The background is very fine, and such a warm tone, like one of Gainsborough's. It is a beautiful creamy surface, and looks so rich.'[9] Like most people James came into contact with, Boxall was captivated by the boy's enthusiasm for art. Throughout the sittings James talked incessantly about painting, and afterwards Boxall presented him with a copy of Mrs Jameson's *History of the Early Italian Painters*. This, together with a copy of Reynolds's *Discourses*, a Christmas present from his parents, made a significant addition to his small library of art books. Quietly and carefully he read them over the holiday period.

On 26 January, Boxall took his enthusiastic young sitter on a promised visit to Hampton Court Palace to see the Raphael Cartoons (now in the Victoria and Albert Museum), the finest large-scale works of the Renaissance outside Italy. James wrote to his father: 'Fancy being so near the work of the greatest artist that ever was!'[10] Other news in the letter did not please Lieutenant Whistler, for James defiantly declared his future intention: 'I hope, dear father, you will not object to my choice, viz: a painter, for I wish to be one very much and I don't see why I should not, many others have done so before. I hope you will say "Yes" in your next, and that Dear Mother will not object to it . . .' The Lieutenant's silence was his answer. On the other hand, Anna replied by return:

And now, Jamie, for your future call! It is quite natural that you should think of all others, you prefer the profession of an Artist, your father did so before you. I have often congratulated myself his talents were more usefully applied and I judge that you will experience how much greater your advantage, if fancy sketches, studies, etc., are meant for your hours of leisure. I have hoped you would be guided by your dear father and become either an architect or engineer – but do not be uneasy, my dear boy, and suppose your tender Mother who so desires your happiness means to quench your hopes. Try to enlarge your views by improving your mind first, be governed by the daily direction of dear sis and Seymour till you can be with Father again.[11]

His mother's reply was not as discouraging as he had expected; she had not rejected his wish out of hand. When the Christmas holidays ended, James did not return to Eldon Villa. Instead, he remained at the Haden household where he received private tuition. The news of this decision had not been well received in St Petersburg. Both Anna and the Lieutenant had severe misgivings, and they told him so. They rightly suspected there were motives underlying the move which had nothing to do with James's health. His wish, however, was granted, though with a stern motherly caution, 'I only warn you not to be a butterfly sporting about from one temptation to idleness to another.'[12]

James was in his element. Haden liked having James about, relishing his role as mentor and teacher. During spare moments from his busy medical practice, both he and would James take themselves off to browse among the numerous print shops in and around Charing Cross Road. By 1849 Haden was a well-known figure in print-collecting circles, widely respected as an astute connoisseur.

A highlight of the London scene in the spring of 1849 was a series of lectures given at the Royal Academy Schools by Professor Charles Robert Leslie, one of John Constable's closest friends. As a special treat, Haden allowed James to accompany him. A renowned lecturer and teacher, Leslie drew a packed audience. The main tenet of his first lecture was the absolute need for artists to make a careful study of nature. Only by this method of empirical observation, he argued, could they evolve an original style and contribute to their chosen craft. To illustrate his argument he pointed to Rubens and Rembrandt, who 'by opening new views of nature, [each created] a style of his own, which, in spite of many and great faults, has placed them forever among the most illustrious benefactors of painting'.[13]

One aspect of painting referred to on several occasions which probably intrigued James was the notion of 'finish' – at what point was a painting complete? From his reading of the *Discourses* he knew Reynolds's thoughts on the matter: the great gift of the painter was knowledge of his subject, knowing 'not only what to describe, but what to omit'.[14] Leslie expressed similar thoughts. The whole question of 'finish' would play an important part in James's art in the years to come. By now he was already beginning to experiment.

Shortly after the penultimate lecture, James wrote a long letter to his mother, describing its content. In the same letter James noted that he had begun a sketch of baby Annie, but 'Seymour finished [it]'. He added, 'When I have done a nice likeness all by myself, I shall send it to St Petersburg.'[15] Haden's interference over the drawing of Annie seems to have annoyed James but his reaction is relatively subdued. Over the months at Sloane

Street, he had no doubt grown used to his brother-in-law's somewhat overbearing ways, and continued to admire him and to accept his gifts. One of these, a print by Fuseli entitled *The Lazar House* – 'such a nice present' he later informed his mother – cost nearly 10 shillings.

Less than a week after Anna had received the drawing from London, tragedy again struck the Whistler family. Lieutenant Whistler had fallen ill from cholera. After appearing to recover, he died on 7 April 1849, probably from a heart attack.[16] Anna was totally distraught. So too was William. When the news finally reached London, nearly a week later, it was received with utter disbelief by Deborah. As James walked into the morning room having been summoned by Haden he knew that something was badly amiss. His first reaction was petrified silence. He was dumbstruck. He simply could not conceive of his father's death. That day, and for many days to come, he wept bitterly. Once again, the direction of his life was about to change dramatically. For the moment, however, his London days were over.

In her grief Anna badly needed the comfort and support of her family. As soon as the formalities were settled, she made plans to sail to England with William, collect James, and return to the United States. In one of the many letters she wrote to friends from London while she was staying in Sloane Street, she noted that James and Haden had been discussing the work of William Kilburn, one of the three licensed daguerreotypists in London in this period.[17] This is the first real indication of James's interest in photography, which would continue in various guises for the rest of his life.

The Lieutenant had left no will, and little or no money, beyond a small holding of railroad shares. His income had been quickly swallowed up in St Petersburg through the expenses of day-to-day living. Worse still, his dependants did not qualify for a United States Army pension, nor was any money forthcoming from the Russian government. His death had, in an instant, sent the Whistler family from relative wealth and status into the unknown. Of the very few certainties at that moment, one concerned James. All thoughts regarding his future career as an artist had been blown to the winds.

It was almost six years to the day since they had left the United States that the Whistler family returned – on 9 August 1849. They were met on the quayside by George William Whistler, now aged 27 and a railway engineer like his father. Among the multitude of problems Anna faced, was the question of where the family should reside. Tactfully, George William suggested New Haven – at seventy miles close enough to him in New York, yet far enough away for Anna to maintain her independence. During

the first few weeks back in the United States, Anna seemed content with that plan. Towards the end of the month, however, she suddenly changed her mind, and decided to take the family to a small rural town in the northeast of Connecticut, Pomfret.

What changed Anna's mind so suddenly is unclear. Their rented accommodation in Pomfret was in marked contrast to what William and James had always been used to. The house was small, part of a larger farmhouse 'without a single modern convenience' near the centre of town. It was owned by a friendly woman who quickly made Anna feel at home. But more than ever it was the reassuring presence and practical assistance of the faithful Mary Brennan that kept Anna going during their early days. One of Pomfret's major attractions was its private school, Christchurch Hall. The headmaster, the Reverend Doctor Roswell Park, was a former West Point man who had been warmly recommended to her not only as a good teacher, but more importantly as 'a disciplinarian'.[18] From Anna's point of view it was just what the boys needed at this time – the firm guidance of a male hand.

As his cousin Emma Palmer later described him, when James returned from abroad, aged just over 15 years, he was 'slight, with a pensive, delicate face, shaded by soft brown curls ... he had a somewhat foreign appearance and manner, which, aided by his natural abilities, made him very charming, even at that age.'[19] Emma, who stayed with Anna and attended the new school for the first term with both her cousins, graphically described the impact James was to make at Christchurch Hall:

> he was a great favourite with all the school, for his spirits were perennial, and he charmed alike old and young. No one could withstand the fascination of his manner, even at this early age, or resist the contagion of his mirth, inconsequent and thoughtless as he often was. He was so amiable under the reproofs of his elders, so willing to make amends, that it was impossible to be provoked with him long.

Anna, on the other hand, was growing increasingly alarmed by his wayward behaviour. Her diary[20] recounts on numerous occasions her downright annoyance with him. He frequently stayed away from home after school. In the mornings, he was usually gone long before breakfast, thus missing prayers – an important part of the family ritual. She seemed hardly to see him for days on end. William, on the other hand, was much more reliable. Within months of arriving in Pomfret he had tidied up the garden and helped his mother and Mary Brennan plant vegetables and flowers. With Anna's help, he bought some hens, and within a year he was

fattening up a pig for the family table. James meanwhile was blithely idling around, and was always the first to disappear at any hint of work to be done.

Drawing was still his major preoccupation, and when he was not playing marbles or another game with his friends, he would be found in some secluded place doing what he loved most. As Emma Palmer recalled, 'he was never without sketchbook and pencil'.[21] This quickly elevated him in the eyes of his contemporaries. Away from the strictures of Seymour Haden, he developed one particular forte, caricature. While it was often the cause of much merriment amongst his friends, it was also the cause of trouble at school and elsewhere. When Dr Park discovered James's picture of himself, he sentenced him to 'a few strokes', and that seemed to bring his short career as a caricaturist to an end.

Adjusting to her new life, without the financial security provided by her husband, was hard for Anna. Her stringent economies with her small income of $1,500, all faithfully recorded in her diary, did little to ease her financial burden. The particularly harsh winter of 1850 did not help. So cold was the weather throughout January and February, that on one night a hen belonging to William died when its food froze in its crop.[22] But while the boys caught the usual sniffs and sneezes, they did not, to Anna's relief, suffer from anything more serious. Indeed, Anna seemed determined to toughen them up, and often when the snow was falling, she would send them out to clear pathways and feed the animals.

Since his father's death, James had not mentioned his desire to become an artist; he knew exactly what the answer would be. Few drawings survive from this period in Pomfret.[23] One which does, *Fire in Pomfret*, a watercolour on brown paper, is now in the Freer Gallery of Art, Washington DC, and depicts the scene of a fire at Christchurch Hall which occurred on 21 February 1850. The sense of action conveyed, together with the careful composition deployed in such a small-scale work, while not outstanding, reveals a talented, competent hand.

In early April 1850, during the Easter vacation, James was allowed to visit his uncle in Boston, William Gibbs McNeill, an elder brother of Anna's and one of James's most colourful relations. James, it appears, adored him and looked upon him now very much as a father figure: fascinating, yet formidable. A former West Point cadet, and a contemporary of his father's, William had been an aide-de-camp to a future President of the United States, General Andrew Jackson, during the war in Florida. Like James's father, William became a railway engineer, and for many years worked for the state of Florida. During the Dorr Rebellion in 1842, in Rhode Island, he was recalled to the army and given the rank of

Major-General. A good soldier and an excellent military tactician, he was instrumental in suppressing the uprising. His military success, however, did have its long-term cost. Quite apart from the many personal enemies he made during the bitter rebellion, the election in 1845 of the Democrat President, James Knox Polk, with whom he was politically at odds, effectively spelt the end of his engineering career. Two years before his death in 1853, his engineering feats were officially recognized, not in America but in Britain, where he was elected a member of the Institution of Civil Engineers. It was the first time the Institution had ever elected an American citizen.

Anna's worries about James's future had been a constant cause of concern since the death of his father. Whereas William for the time being presented no problem, having seemingly inherited the McNeill aptitude for science and all things medical, the only course open to James appeared to be a career in the United States Army. Though he knew full well the plan was wrong, he waited with quiet resignation through the remainder of 1850. Perhaps it was a measure of his respect for his mother and her wishes that he offered no argument: he would go through the motions of a military career.

If ever a boy seemed destined by his family history for West Point Military Academy it was James Whistler. His paternal grandfather, John Whistler, had been a soldier. Apart from his father, his uncles William Gibbs McNeill and Joseph Gardner Swift, and several other members of the family, had been cadets. This, added to the influence of his headmaster Dr Park, lent a sense of inevitability to the decision, yet in many ways he brought it upon himself. If he had taken an initiative, Anna might have relented and agreed to some alternative. But he did not, and circumstances forced Anna's hand. She had two sons to educate, and William, with his diligence and obvious academic skills, deserved a college education. James on the other hand had not excelled academically, and was frankly not deserving of the opportunity. The only option was to enter him as a subsidized cadet at West Point. There he could receive a good solid education, and continue the family's military tradition.

Ten years before, in June 1841, Charles Dickens, on a visit to the United States, described the Academy in sympathetic, indeed almost poetic terms:

> along a glittering path of sunlit water with here and there a skiff, whose white sail often bends on some new track as sudden flaws of wind come down upon her from the gullies in the hills: hemmed in, besides, all round with memories of Washington, and the events of the revolutionary war: is the Military School of America. It could not stand on a more appropriate

ground, and any ground more beautiful can hardly be. The course of education is severe, but well devised and manly ... The beauty and freshness of this calm retreat, in the very dawn and greenness of summer – it was then the beginning of June – were exquisite indeed.[24]

Dickens also noted a stark fact about the Academy: 'not more than half the number who begin their studies here ever remain to finish them.'

To gain admission as 'a cadet at large' involved a complicated and fiercely competitive procedure, similar to winning a college scholarship. There were only ten places available, set against thousands of applications. The final choice had to be endorsed by the President. In many ways it was a 'favour' system, designed to embrace sons or relatives of former soldiers who, through various circumstances, could not afford to enter the Academy by the normal route. In that respect it was ideal for James.

Dr Park agreed to act as one of the two referees James required for admission. Anna asked Colonel Joseph Gardner Swift, the brother of Mary Swift, George Whistler's first wife, to be the other. She made a good choice. There was no one better qualified to add influence to the matter than Swift. Not only had he been the first cadet to graduate at West Point after its establishment in 1802, he was also, from 1812, its second Superintendent and for many years the United States Army's chief engineer. Swift was responsible for many changes during West Point's formative years, including the creation of a faculty of engineering and the introduction through Congress of an increase in the number of yearly admissions.[25]

With the formalities completed by February 1851, the family anxiously awaited the outcome. James, even in his mood of passive resignation, was quite excited by the prospect. Over the months, he seemed gradually to warm to the vaguely romantic idea of becoming an army officer. It appealed to his sense of vanity, at least initially. In mid-March, a letter arrived from the office of the President of the United States, Millard Fillmore. James had been successful. This, however, was only the first step towards admission. A notice enclosed from the Secretary of War stated that there was still an entrance examination to pass before he could begin the four-year course. James was both undaunted and jubilant. For the first time since his art examination in Russia, he seemed to have achieved something. Anna, though relieved at the news, was still unsure of his prospects. For the moment she could only hope and pray. As a special treat, and no doubt to secure him a beneficial introduction, James was taken to visit West Point by Joseph Swift later in the month.[26]

James arrived at West Point to begin his preliminary course on 3 June

1851, a month before his seventeenth birthday. Now everything seemed far removed from the gentlemanly scene he had witnessed only months earlier in the company of Joseph Swift. His heart sank, and any romantic notions rapidly began to fade. He was constantly bawled out by senior cadets; his precious hair was cut by someone more suited to grooming animals than humans; the rigid discipline frightened him. And all this was before he had even become a cadet. Along with a class of eighty or so other boys he had first to fulfil a period of probation.

Training of the young cadet soldier at West Point was conducted by means of a ranking system; each cadet was graded every single day of his course on class recitations, discipline, dress and general appearance. For good all-round behaviour the cadet received a quota of points, for bad behaviour he received negative demerits.

What is clear is that James should never have been accepted at West Point in the first place. His weak eyesight and record of bad health would in normal circumstances have automatically excluded him, but his family background had prevailed. Within days of his arrival, he had begun to loathe the Academy. He continued to go through the necessary motions while secretly planning his escape.

During his first month at West Point James, now nicknamed 'Curly' by his peers,[27] passed the requisite examinations in simple arithmetic, fractions, and reading from an assigned selection: failure at this juncture would have meant total humiliation. Shortly afterwards, along with the other successful plebes (first-year cadets), he joined the rest of the Corps of Cadets at summer camp on the plateau above the Academy known as 'The Plain' overlooking the Hudson River. Here they would stay, in tents, until August. During the long daylight hours they practised military tactics and drilled for hours on end in the sweltering heat. In the evenings, as part of their training, they were taught to dance. Summer camp, though hard work, was sometimes fun. The serious work only began when the camp was over and it was at this point that James's problems began.

In mid-September 1851 Anna was sent by the War Department a report of her son's 'progress' which made sorry reading. In nearly every aspect of his training, from drill to dress, he had been reprimanded on dozens of occasions. Anna was horrified, and immediately wrote to him to tell him so. She cajoled him and pleaded with him not to disgrace the family or 'break a widowed mother's heart'.[28] In October she visited him at West Point, the first time she had seen him since June.

Little improved throughout the following year. In September 1852 Anna wrote to the new superintendent of West Point, Colonel Robert E. Lee, to ask permission for James to visit her in New York prior to a trip she was to

make to England. Surprisingly Lee agreed.[29] The main reason for Anna's journey was to see Deborah's new-born son, Harry, whose arrival now brought the number of children in the Haden household to three. Anna enjoyed her stay immensely. Whether she told Haden or Deborah of James's misdemeanours is not clear. They both continued to encourage his artistic aspirations in the letters they exchanged, trying with limited success to induce Anna to understand James's love of art.[30]

During his mother's absence, James's behaviour deteriorated. At Christmas he was refused leave: his excess of demerit points disqualified him from the privilege. In the spring of 1853 he contracted rheumatic fever, and possibly tuberculosis, and during his mother's absence he was looked after by the medical staff at West Point. When Anna returned home in May, Lee wrote to her to explain the situation, apologizing 'for having to forward such bad news'.[31] Soon after James was allowed sick-leave and did not return to the Academy until 28 August. Indeed, on the very day he arrived back at the Academy he gained more demerit points owing to the state of his hair.

Over his three years at West Point, James rarely qualified for leave, except during periods of illness. His conduct patterns did not change throughout his time there. He cleverly played the rules of the Academy to the limit, always careful to do just enough to scrape through, as in January 1852, when he passed a crucial oral examination which enabled him, along with some sixty of his contemporaries, to gain a permanent position. The news delighted Anna. It also delighted James, though for very different reasons. In his second year, he would be allowed access to the drawing class, which was not open to the first-year cadets.

James had continued to draw ever since arriving at West Point whenever it seemed safe to do so, though inevitably that was during periods when he was supposed to be doing something else. Presided over by Professor of Drawing Robert W. Weir, the drawing class was based primarily on the French model of the Ecole Polytechnique, the successor to Louis XV's Ecole Militaire, and despite the thorough and often tedious grounding in map-making, mechanical and reconnaissance drawing, it was certainly James's favourite class. Many years later, in 1898, a former cadet, Thomas Wilson, who had been Chief of Commissariat for the Richmond campaign of 1863–5, recalled and graphically described the routines of Weir's art class and Whistler's participation in it:

The models which cadets are required to copy when they first enter the drawing-class at West Point are what are known as 'topographical convention signs.' They illustrate the mode of depicting, with pen, the

various topographical features of a country, such as water, hills, trees, cultivated ground, etc. In a much shorter time than seemed possible Whistler finished the copy of the model given to him, and his work was most exquisite, far surpassing the model itself in accuracy and beauty of execution . . . Whistler was very near-sighted, and in making a drawing he would first fix his eyes near a portion of the [human] model, and then proceed to copy it upon his drawing board. He never drew any outline of the work he was copying. He seemed to work at random, and in this instance he displayed one of his favourite tricks, which was to draw first, say a face from the model, then a foot, then the body, skipping from one part of the picture to another, apparently without keeping any relation of the parts. But when the picture was completed, all the parts seemed to fit together like a mosaic.[32]

The extant drawings from the West Point period, numbering approximately sixteen, and mostly in pen or coloured chalk, make it possible to form an idea of James's early American work. They are well executed, narrative and realistic – very much in keeping with the style of American nineteenth-century illustration in general.[33] Particular drawings, such as a series of four entitled *On Post in Camp* (now at West Point) completed in 1852, evoke the narrative approach of Hogarth that he was already familiar with, and the imagery of authors he knew, such as Hugo and Dumas. Clearly, during these formative years, James was building upon lessons already learnt from Alexander Karitzky, his tutors at the Imperial Academy in St Petersburg, and of course Seymour Haden.

While the art classes seemed to breathe some sense of enthusiasm back into James – he consistently came top of his class – they were not enough. His examination results in August 1853 reveal an indifferent record. He was placed 37 in mathematics (out of sixty), 13 in French, 32 in general standing and, significantly, 1 in drawing. Such was his demerit rating by the late summer of 1853 that he was effectively disqualified from any of the better cadet appointments on graduation.

Loomis L. Langdon, a year above James, saw him as well-educated, witty and often sarcastic.[34] Their mutual love of drawing drew them together as friends, but, as Langdon's account makes clear, James's heart was never really at West Point. More than ever James immersed himself in literature, perhaps in an attempt to escape the rigours of the military regime. Towards the end of 1853, with the January examinations looming, James was desperate to get away. He wrote to his mother complaining that he was homesick.[35] Anna's response was to promise to send him a new photograph of herself taken a short time earlier while she was in New York, and to

consult with his elder half-brother George. George called on the services of an old family friend, Governor Seymour of Connecticut, in the hope that he might be able to forestall the by now inevitable dismissal of James from the Academy. In a letter to the Governor in December, George wrote:

My brother James A. Whistler is in his third year – his standing in his studies are good – my recollection is that in November he stood in Drawing 1, French about 10 or 12, in Nat. Phil. 32 or 34 – all in a class of 47 or 48 – demerit was 110 about, and for Oct. & Nov. he has not had a report – by the new regulations at West Point 100 demerits between September and January dismisses a Cadet at January Examination – My brother was quite ill in June & July & had a leave until August 28th when he returned, & before he could quiet himself to study and good behaviour he got 115 demerits in Sept. alone!! He is a well-behaved youth – I mean he has no bad habits; his demerits were for inattention – He is a young gentleman of more than common ability & would do credit to the Institution and himself if he could be allowed to pass muster – I think I can promise his good behaviour in future if the President would overlook his past want of attention of the strict discipline at the Point . . .[36]

The letter from George seemed to have worked, at least for the moment. James, oblivious of what was being done on his behalf, got through the January examinations, and his demerits were not held against him. In any event, he did not want to be dismissed by that particularly hazardous route, since he was well aware of the fact that a bad conduct dismissal would have stayed with him for life. In terms of family honour, it was unthinkable. The only other route open was to fail academically. At least that way some measure of honour could be retained. This is exactly what happened. In the summer of 1854 he failed his chemistry examination. After some deliberation on the matter, the US Army finally gave him up. As he would jauntily admit in later life, 'If silicon had been a gas, I would have been a general.' Someone whom James admired throughout his life had also suffered a similar fate at West Point. Edgar Allan Poe, like James a 'cadet at large', only managed some eight months at the Academy before being discharged in 1831 by court-martial for gross neglect of duty and disobedience of orders.

Arriving at the new family house, a cottage owned by Margaret Hill, a close friend of Anna's in Scarsdale, West Chester County, New York, he was neither warmly greeted nor lambasted. His failure happened to coincide with his brother William's early success at Columbia College, to which he had been admitted in October 1853 to study medicine. When

Anna finally vented her anger and frustration on him, he defended himself by claiming he had been unfairly treated by both the disciplinary and examination boards. She seems to have believed him, and at her instigation he wrote on 1 July to the Secretary of War, Jefferson Davis, pleading to be allowed to resit the failed chemistry examination, and to have a reconsideration made of his disciplinary record. The letter was passed to General Totten who, in turn, passed it on to Robert E. Lee at the Academy. In truth James was continuing to act out the same charade he had played throughout his time at West Point. Lee's reply to Totten arrived one week later: 'I can . . . do nothing more on his behalf, nor do I know of anything entitling him to further indulgence – I can only regret that one so capable of doing well should so have neglected himself, and now must suffer the penalty. The application of Cadet Whistler is now returned.'[37] The War Department upheld Lee's decision and with that James's days as a soldier were over.

Whatever was gained or lost by his stay at West Point, it was at least his first taste of independence. The longer he stayed at the Academy, the further he seemed to distance himself from his mother. He rarely wrote to her, nor did he seem interested in what was happening at Pomfret or later at Scarsdale. On many occasions during these periods of silence, Anna wrote to him expressing her concern. She even sent some stamps on one occasion, but it made no difference. Whilst he still needed her comfort from time to time, it now seemed he no longer needed or wished for her maternal guidance. James felt the burden of family tradition lift from his shoulders. In a gesture confirming his new-found independence, he left Scarsdale shortly afterwards to holiday alone. For nearly a month, he travelled around New England. As he pondered his future, nothing had changed. His dreams of becoming an artist had merely been reinforced. There were, however, obstacles still to overcome.

3

Wanderings

JAMES RETURNED FROM his holiday wanderings little wiser than when he left. One thing was definite: it was not yet time to announce his career as an artist. Not long after his return to Scarsdale he went to stay with Ross Winans and his family in Baltimore. The visit, no doubt instigated by Anna, was probably intended to concentrate his mind and even to lure him into a career in engineering.

Ross Winans, an old friend of James's father, was widely known as 'the Baltimore mechanic'. When Lieutenant Whistler had been given the Russian railroad consultancy, their friendship and mutual professional respect had resulted in his securing for Winans the massive contract to supply engines and rolling stock for the project. From being the wealthy inventor of the friction wheel, the Russian contract made Ross Winans a millionaire almost overnight. George Whistler, James's elder half-brother (whose first wife, Mary Ducatel, had died in 1852), had recently married Ross Winans's daughter, Julia.

The splendour of Ross Winans's palatial mansion on Fremont Avenue, Baltimore, proclaimed his status. Aptly named Alexandroffsky, with its army of servants and its spacious gardens it was meant to echo the imperial splendour of St Petersburg. James, not surprisingly, adored the place. Yet all this luxury had its price, and James was offered an apprenticeship by Winans to work in the mechanical drawing office. The apprenticeship brought with it a good salary, tremendous prospects and security. Although to those around him James may have seemed overjoyed, the idea, as it turned out, must have appalled him. Still, in the short-to-medium term it gave him money and a measure of independence. Living with the

and occasionally with George (now a partner in the firm), afforded him a standard of living which, compared with that of his mother's home at Scarsdale, was beyond his wildest dreams.

From the outset, it was clear that James had no intention of becoming an engineer. He treated the workplace simply as an extension to the generous hospitality given him by the Winans family. In later life he never mentioned his short career in Baltimore. Whatever his mother or the Winans may have felt, it was, for him, merely an extended family holiday. Frederick Miles, an apprentice alongside James at the time, would write in his recollections:

> He spent much of his stays . . . in Baltimore loitering in his peculiar bizarre way about the drawing desk in Tom Winans' house. We all had boards with paper, carefully stretched, which Jem would cover with tentative sketches to our great disgust, obliging us to stretch fresh ones, but we loved him all the same! He would also ruin all our best pencils! sketching not only on the paper, but also on the smoothly finished wooden backs of the drawing boards which, I think, he preferred to the paper side. We kept some of the sketches for a long time. I had a beauty – a cavalier in a dungeon cell, with one small window high up – Rembrandt effects and a little bird on the window, à la Silvio Pellico's 'Rondinello Pellegrino'! – perhaps inspired by it? I think he afterwards painted a picture like it, but I could never find it. In all his work at that time he was very Rembrandtesque, but of course only amateurish.[1]

By the autumn of 1854, James's increasingly flippant attitude in Baltimore was beginning to perturb Anna. Reports of his behaviour were probably being filtered to her by George. At the end of October she arrived to see the situation for herself. Shunning the offer of hospitality from the Winanses, Anna installed herself in a small, modestly furnished boarding-house. Confronting James, she berated him for idleness and bad behaviour. She also demanded that he immediately leave Alexandroffsky and stay with her.

With William's unexpected academic problems earlier in the year when he appeared to lose all interest in his studies, and the ongoing battle with James, 1854 was a trying time for Anna. For James, too, this period was a testing one. Until he was 21, when he would be eligible for a small inheritance from his father, he had to play a waiting game. In a last-ditch attempt to set him on the path towards a suitable career, Anna virtually coerced James to visit an old friend of his father and Joseph Swift, Captain Benham, then attached to the United States Survey in Washington DC.

In later years, James told the Pennells a rather different story of how he had come to work for the Coast Survey. Casual to the point of ridiculousness, James recalled that he went to Washington DC, and

There, I called at once on Jefferson Davis, who was Secretary of War – a West Point man like myself. He was most charming and I – well, from my Russian cradle, I had an idea of things, and the interview was in every way correct – conducted on both sides with the utmost dignity and elegance. I explained my unfortunate difference with the Professor of Chemistry at West Point . . . My explanation made, I suggested that I should be reinstated at West Point, in which case, as far as I was concerned, silicon should remain a metal. The Secretary, courteous to the end, promised to consider the matter . . .[2]

Did the Pennells swallow the idea of someone who had been discharged from the most prestigious military academy in the United States walking into the Secretary of War's office to chat casually about his future prospects? Warming to his own invention, James continued:

Before I went back to the Secretary of War, I called on the Secretary of the Navy, also a Southerner, James C. Dobbin, of South Carolina, suggesting I should have an appointment in the Navy. The Secretary objected that I was too young. In the confidence of youth, I said age should not be an objection; I 'could be entered at the Naval Academy, and the three years at West Point would count at Annapolis.' The Secretary was interested, for he too had a sense of things. He regretted, with gravity, the impossibility. But something impressed him; for later, he reserved one of six appointments he had to make in the Marines and offered it to me. In the meantime, I had returned to the Secretary of War, who had decided that it was impossible to meet my wishes in the matter of West Point; West Point discipline had to be observed, and if one cadet were reinstated, a dozen others who had tumbled out after me, would have to be reinstated too. But if I would call on Captain Benham, of the Coast Survey, a post might be waiting for me there.

This account was completely fabricated from beginning to end. But it was just the kind of romantic story James loved to tell in later life. His entry into the Coast Survey Office in Washington had again been engineered by his family. He did not even have to apply for the job. Joseph Swift made the initial enquiries, and Captain Benham quickly agreed the favour for his old friend. Before the end of the first week in November 1854, James was on his way to take up his new post in the capital city.

Arriving in Washington with 10 dollars in his pocket,[3] James found lodgings in a small, modestly furnished room within walking distance of the newly erected Coast Survey offices, on the south side of Capitol Hill. After taking in the sights, he started work the following day. The Coast Survey Office, renamed and enlarged in 1879 as the United States Coast and Geodetic Survey, was constituted by the government in 1807 to carry out the task of mapping the whole of the United States coastline for military and maritime purposes. It was a painstaking and massive undertaking requiring a wide range of technical skills. The Survey had two divisions, Drawing and Engraving. James was assigned to Drawing under Captain Gibson. With an interest in map-making going back to his school days in Pomfret[4] and the classes at West Point, he was well equipped for his duties. James's arrival at the Drawing Division was recalled many years later by a contemporary, John Ross Key:

He was a slender young man of medium height, with dark, curly hair and a small moustache. A Scotch cap was set well forward over his eyes, and he wore a shawl of dark blue and green plaid thrown over his shoulders, as was the fashion of the day . . . We soon became good friends. It was reported about the office that Whistler had been at West Point, and that his disinclination to obey rules, chief of which had been his lack of promptness, had led to his retirement.[5]

His reputation was quickly confirmed. Only days after joining the Drawing Office James began arriving late and leaving early. To those who questioned his punctuality his answer was always the same – he was never late, the fact was, the office opened too early. Within weeks, he was rarely there at all. In January 1855, he reported for work on just seven occasions, and on one of those, he left at noon. This outrageous absenteeism soon became the cause of serious concern amongst his superiors. In an attempt to get him to the office, Captain Benham asked one of the other trainees, Andrew Lindenkohl, to call on James at his lodgings. Lindenkohl later recalled:

Accordingly, one morning I called at Whistler's lodgings at half past eight. No doubt he felt somewhat astonished, but received me with the greatest bonhomie, invited me to make myself at home and promised to make all possible haste to comply with my wishes. Nevertheless, he proceeded with the greatest deliberation to rise from his couch and put himself into shape for the street and prepare his breakfast, which consisted of a cup of strong coffee brewed in a steam-tight French machine, then a novelty; and also

insisted upon treating me with a cup of coffee. We made no extra haste on our way to the office, which we reached about half-past ten – an hour and a half after time. I did not repeat the experiment.[6]

It is not altogether clear how James occupied himself during the day when he was absent from the Survey Office. Most evenings, according to John Ross Key, he played billiards with acquaintances in a room near his lodgings on the corner of Thirteenth Street and Pennsylvania Avenue. As Key recalled, James was a charmer, quiet and sedate, 'had no bad habits' and neither smoked nor showed any interest in young women. Other recollections of his social life in Washington describe him as continuously 'hard-up'. On one occasion, in order to attend a formal social function, he 'pinned back the skirt of a frock-coat to make it pass as a dress-coat'.

Perhaps in another attempt to get him to attend the office, James had been transferred to the Engraving Division in December 1854. His rare appearance was guaranteed on the days when Mr McCoy, a genial Irishman and 'one of the best engravers in the office', gave instruction on the methods of etching. As McCoy went over the rudiments, according to Ross Key, James

> was intensely interested. Always sedate, he was also singularly indifferent, but on this occasion he seemed to realize that a new medium for the expression of his artistic sense was being put within his grasp. He listened attentively to McCoy's somewhat wordy explanations, asked a few questions, and squinted inquisitively through his half-closed eyes at the samples of work placed before him. Having been provided with a copper plate, such as was kept for the use of beginners, and an etching-point, he started off to make his first experiment as an etcher. I watched him with unabated interest from the moment he began his work until he completed it, which took a day or two. At intervals, while doing the topographical view, he paused to sketch on the upper part of the plate, the vignette of Mrs Partington and Ike, a soldier's head, a suggestion of a portrait of himself as a Spanish hidalgo, and other bits, which are the charm of the work.[7]

This plate, known as *The Coast Survey Plate*, was originally printed twice, not long after James had etched it. He subsequently dismembered the images and remounted seven fragments before giving the new arrangement to Thomas Winans.[8] James later sold the actual plate to Ross Key for the price of the copper. Key held on to the plate until 1913 when it was sold to Charles Lang Freer. This and another, *View of the Eastern Extremity of*

Anacapa Island from the Southward, are the sole extant etchings by James from his time at the Survey Office.

Key's claim that McCoy's etching lessons were a revelation to James is not strictly true. He had seen and studied etching long before with Haden, and possibly even earlier at the Imperial Academy in St Petersburg. But McCoy's class broke the tedious monotony of the Drawing Office and rekindled James's interest. His Rembrandtesque doodlings on the *Coast Survey Plate* owed more to his past experiences than his present circumstances.

After attending for a full five days in February, James could take no more. He resigned his post on 12 February 1855. To his colleagues this came as no surprise: they all knew what he wanted to do. He was now determined to go to Europe and become an artist; not to London, but to Paris – that was his dream. He had read Henri Murger's *Scènes de la vie de Bohème*; he had savoured Gavarni's illustrations of student life in the Latin Quarter; he even dressed like a bohemian. The day after his resignation, he received a letter from his mother. Though she had had little contact with him since he arrived in Washington, she was well aware of his intention. Her letter begged him not to resign: 'persevere till your year on the U.S.C.S. is fulfilled. It will be impossible without ruin to our little stock that you go to Europe (as you seem to cherish hopes) and that Willie return to College which he is preparing by daily hard study to do.'[9]

James was now in no mood to compromise. He would wait, but only on his own terms. Besides he had a ready ally in Thomas Winans, Ross Winans's eldest son who, shortly after his resignation, invited James to come and stay at the family home in Baltimore. James gladly accepted the offer. He was bored with Washington and heartily tired of being penniless. Though Tom Winans was nearly fourteen years older than James, they had known and enjoyed each other's company for many years, both in St Petersburg and in America. Tom Winans sympathized with James's dreams. As a creative man himself (for like his father he was an inventor as well as an engineer) he understood James's frustrations. From the moment James arrived at Alexandroffsky, Tom Winans took control of his wants and needs, furnishing him with money, creating for him a studio at the house, and along with George introducing him to their wide circle of friends. One was a man nearly ten years his senior, George A. Lucas. During a friendship which would last nearly thirty-five years, Lucas would be witness to some of James's greatest triumphs and greatest disasters, personal and professional.

Another of the many people James met during his four-month stay with the Winanses was the Baltimore artist, Frank B. Mayer. James freely sought

his advice and, perhaps stimulated by Mayer, began work on two portraits, one of Tom Winans and the other of his cousin, Anna Denny. Sadly, the whereabouts of both portraits has not been known for many years.

The fact that James began painting at Alexandroffsky indicates his state of mind. With his intentions known to all and sundry, a pressure seemed to lift. While his mother's letter in February may have forestalled his departure to Europe, it certainly did not diminish his enthusiasm for the venture. By this stage Anna was resigned; though he rarely wrote to her at Scarsdale, she wrote to him frequently. Her major concern at this time was with William who, in January, had transferred to Trinity College, New York, to prepare for an informal medical apprenticeship. James, to all intents and purposes, was a lost cause.

As James's twenty-first birthday approached, he began to make plans in earnest for his departure. Tom Winans happily assumed the role of his first important patron by buying the portrait of Anna Denny and two other paintings which James finished while at Alexandroffsky: a copy after Turner which he had begun at West Point[10] and *The Fishwife*,[11] a painting which like earlier drawings reiterates the earthy naturalism of Dutch art in general, and Rembrandt in particular.

A week after James's twenty-first birthday on 11 July, he completed what was to be his final work in the United States, and his last recorded lithograph for some twenty-three years. Executed under the watchful eye of Frank Mayer, this pen lithograph, entitled *The Standard Bearer*, again had its source in Dutch seventeenth-century art.[12] It is not a self-portrait, though it could well be a portrait of Frank Mayer. But it does appear to symbolize James's ambitions; he intended to storm the citadel of European art in Paris, under the flag of Rembrandt and the Dutch.[13] James, it seems, was pleased with the result and signed it in the manner of an Old Master print in pencil on the reverse, 'J. Whistler fecit.' As an act of friendship and thanks to his friend Frank Mayer, he dedicated the print to him not once but twice. Only many years later did it come to light, when it was found in a scrapbook of sketches belonging to Mayer.

Within days of completing the lithograph, James wrote to his mother in Scarsdale informing her that his departure for Europe was set for late September.[14] After obtaining a passport and entry visa for France in Washington, James told her that he planned to go and stay with his uncle, Joseph Gardner Swift, in New York. Then with a loan of $450 from Tom Winans, one suitcase full of clothes and another stuffed with painting materials, he boarded a train bound for New York City.

PART TWO

Apprenticeship
Years

4

Arrival

LITTLE IS KNOWN of how James spent his seven weeks in Brooklyn, New York, in the company of his uncle, Joseph Swift and his brother, William Henry Swift. Any worries James may have had about his mother's finances were doubtless eased by William Swift, who had become Mrs Whistler's financial adviser after the death of her husband. Anna's financial situation, though precarious earlier in the year because of the failure of some stock, had now stabilized, and James could leave the United States secure in the knowledge that she would be well looked after by their close network of friends and relations. In late September 1855, he boarded the *Amazon* in New York harbour, bound for England. He would never set foot on his native soil again.

When James arrived in England on 10 October, he went straight to Sloane Street in London, to stay with his half-sister Deborah and her family. It was nearly six years since he had seen them and there were two new nephews to meet, Seymour and Arthur. After three weeks, he set off for Paris. On the Channel steamer to Le Havre, James met two young men – John O'Leary and his companion, James O'Brien. Both were Irish, and they were on their way to Paris to study medicine. All three, it seems, hit it off immediately, particularly James and O'Leary. So much so, in fact, that O'Leary altered his plans to share lodgings with O'Brien, preferring instead the company offered by this somewhat eccentric young American.

As the train pulled into Paris, the two Irishmen said goodbye to one another. James and O'Leary then hailed a cab. According to one source their destination was determined by their cab-driver, who, when asked by the pair, 'Where do students live?' replied, 'At the Hôtel Corneille' – a focal

point for impoverished students wishing to reside in the Latin Quarter of the city.[1] The hotel was a dull six-storey building on the rue Corneille, near the Place de l'Odéon. While the rent of 40 francs a month suited O'Leary perfectly, for James, who could have afforded much better accommodation, the attraction lay in the ambience – scruffy, full of students from all over the world, and like something straight out of Murger's novel of bohemian life.

James had no personal connections when he arrived in Paris, but O'Leary soon made up for that. A network of O'Leary's family and friends was strewn across the city, all without exception 'on the run' from the British authorities in Ireland. After the French Revolution in 1848, and the abortive attempt in Ireland which followed in its wake, France had become a natural refuge for the Irish rebels. Among the many exiles were O'Leary's brother Arthur, his cousin Mary Ann Kelly, and her husband Kevin O'Doherty.[2] As O'Leary's own story unfolded – of his connection with the revolutionary movement through the Tipperary Confederates, and of his brief imprisonment – James, the renegade West Point cadet with his claim to Irish ancestry through his late father's family, must surely have been impressed.

For the first week or so, as they settled in Paris, James spent time in the company of O'Leary and his Irish friends. As they got to know one another and discussed at length each other's plans, O'Leary's wide knowledge of literature, politics and history must have added impetus to their talks. Ironically, though perhaps not surprisingly, while O'Leary had a healthy disdain for Britain and all things British, his great political hero at this time was Thomas Carlyle, whose work he had come to know through his *Latter-Day Pamphlets* published and widely circulated in the late 1840s.[3] Through O'Leary, James quickly became alive to the intricacies of British and Irish politics, and it was the first-hand knowledge gained during these early weeks in Paris that would ultimately colour his view of the British, particularly the English, for the rest of his life.

Aside from the obvious attraction of *la vie de Bohème*, Paris, since the revolution of 1848, had become the art capital of the world. This claim had been reinforced in 1855 by the World Exhibition – the Exposition Universelle – which had opened on 15 May. Until it closed on 16 November, a fortnight after James's arrival, the Exposition Universelle was world news. This enormous undertaking, planned and projected by the government of Louis Napoleon in emulation of the Great Exhibition in London of 1851, was designed to demonstrate to the world a new liberal regime driven by enterprise in every sphere of national life. Unlike its predecessor in England, the Exposition Universelle had a section devoted

to the Fine Arts and this became, according to the *Illustrated London News*, 'the most remarkable collection of painting and sculpture ever brought within the walls of one building'.[4] Over 5,000 paintings were on view, hung from floor to ceiling. Not surprisingly, they were predominantly by French artists, though there were exhibits representing the art of twenty-eight other countries. Amongst the work from Britain was a collection by the Pre-Raphaelite Brotherhood, the first time their work had been seen on mainland Europe, as well as work by popular Victorian painters such as Sir Edwin Landseer, William Mulready and Sir Charles Eastlake.[5]

While reports of the Exposition must have fuelled James's enthusiasm for France, they had not been the original spark that had ignited it. In the period leading up to 1848, and markedly so in the years that followed, Paris in particular, and France in general, had come to represent a combination previously unseen in the Western world: a centre for political refuge as well as a capital of art. Students arrived from all over the world to study, usually at one of the multitude of privately owned ateliers, though sometimes enrolling at intrinsically conservative establishments such as the Ecole des Beaux-Arts.

What had drawn the bilingual, cosmopolitan James to Paris was this very realization that it had become the international crossroads for art education. Of course he could have studied in England: he had, superficially at least, every reason to do so, given the support and professional guidance he would no doubt have had from the Hadens. But in Britain the system of art education seemed set in stone at the Academy schools. This inert conservatism had become the cause of much concern even to certain elements within the art establishment itself. Time after time England compared itself unfavourably to what was happening on mainland Europe. The highly regarded and successful Royal Academician Daniel Maclise lamented as early as 1844: 'My belief is that we in London are the smallest and most wretched set of snivellers that ever took pencil in hand, and I feel that I could not mention a single name with full confidence, were I called upon to name one of our artists in comparison with one of theirs.'[6]

If the situation angered and frustrated men like Maclise, it intrigued outsiders. Hippolyte Taine, a lecturer at the Ecole des Beaux-Arts, believed the source of the problem of English art lay in a trait of the national character: 'Temperament in this country [Britain] is too militant, the will too stern, the mind too utilitarian, man too case-hardened, too absorbed and too overtasked to linger over and revel in the beautiful and delicate graduation of line and colour . . .'[7]

For young men such as James, who could only view English art as they saw it through the strictures of an institution like the Academy schools, and

who were not aware of the subculture of small teaching academies in existence in London, England seemed to lack any sense of an artistic Bohemia. France, on the other hand, seemed to epitomize the spirit of freedom.

The official aspect of French art in mid-century was represented, as it had been since 1795, by the Institut, the home of the five assemblies of the French Academy which, in turn, administered the day-to-day affairs of the Sciences and the Arts. Integral to this were the forty elected members of the Académie des Beaux-Arts, who advised and recommended on policy for the visual arts, as well as music and architecture. In the years running up to the Exposition Universelle, government control of the visual arts was asserted as never before. In contrast to England where the government set up several parliamentary select committees (the most notable in 1835) but with little effect, the influence of the French government was all-pervasive. The famous report on new methods of teaching drawing, written by Félix Ravaisson and published in the *Moniteur* in 1854, is only one of many successful examples of the government in this period directing the subject and substance of the art of the day.[8]

Central to this government control was the official structure of the annual Salon. Here the government officials, or those nominated by the government, not only selected the work to be shown, but also awarded prizes and bestowed the honours. In 1850, the timing of the Salon was changed from an annual to a biennial event.[9] In the first year of the change, the government allowed artists to select the jury. After the plebiscite that acclaimed Napoleon III's coup d'état in 1851, all that changed and the government of the new Second Empire began directly to control the selection procedure. By the time of the Exposition Universelle in 1855, the jury was composed entirely of government appointees. In 1852, it was announced that each artist would be allowed no more three works to be hung at the Salon, and as the government's control of the logistics of the event increased, so its role as arbiter of taste changed in many respects to that of director of taste. Underlining this point, the Comte de Nieuwerkerke, Director-General of Museums, at a speech made at the award ceremony in 1852, informed the gathered artists and officials: 'The exhibitions held as they are, gratuitously in one of the palaces of state . . . confer in themselves a fundamental reward upon those admitted to them . . . [artists] should therefore be represented there by one of their most complete works and not by sketches or *ébauches* unworthy of display in a great competition opened by the state . . .'[10]

Contrary to Nieuwerkerke's observations, the government increased the number of medals and prizes available to the successful artist in the years

after 1852 – fully aware, no doubt, that what amounted to total government control required reward on a large and public scale. By the end of the Exposition Universelle the government had awarded some 240 medals, 222 honourable mentions, and some 40 Légion d'honneur decorations. While the majority of the awards went naturally to French artists, among the outsiders who received awards were John Millais from England and the American artist, William Morris Hunt.

The 1855 Exposition Universelle marked the high point of French government control of the arts: from that point on, the government seemed to loosen its grip. For the newly arrived James, as yet totally ignorant of the intricate politics of French art (he would quickly learn them), the romance and allure of Paris lay initially not in exhibiting at the Salon, nor even in attending the Ecole des Beaux-Arts, but in the labyrinth of private ateliers scattered around the capital which offered good-quality teaching on a less formal and rigid method.

The Exposition Universelle came to represent a summation of French art as it was dominated by two distinct schools, personified in the work of Jean-Dominique Ingres and Eugène Delacroix. Both were well represented at the Exposition: Ingres had forty pictures on view in a gallery especially created for him, and some thirty-five works by Delacroix were hung in the central hall of the building. The separate gallery for Ingres' work underlined his elevated status within the official establishment. By the time of the Exposition, he had been a member of the Academy for nearly thirty years. Indeed, so great was his power and influence in France that he had not bothered to send work to the official Salon for more than twenty years. His usual defence for this omission was to claim that 'the public and the critics had not given him the praise which he expected'. In stark contrast, Delacroix had presented his candidacy to the Academy six times in the past only to be refused admission. The vacancy was usually filled by a lesser talent, often with Ingres' nod of approval.

The debate concerning the dominant classical line of Ingres, perhaps the most famous and gifted pupil of the legendary David, as opposed to the colour of Delacroix was bitter and acrimonious. Both men despised each other and the controversy received wide coverage in the national and international press. Its effect on French art was effectively to polarize it for nearly thirty years. When James arrived in Paris for the final two weeks of the Exposition, he was well aware of the debate, which was raging as fiercely as ever because of the medals and honours bestowed upon Ingres and many of his followers.

Not far from the Fine Arts Pavilion, near the Avenue Montaigne, was another much smaller exhibition of paintings. Though not part of the

official Exposition, it was there as a direct result of it. Gustave Courbet had been invited to submit work to the exhibition, but three of his fourteen submissions were rejected by the committee: these were the huge *L'Atelier du peintre, allégorie réelle, déterminant une phase de sept années de ma vie artistique* ('The Painter's Studio, a true allegory, defining a seven-year phase of my artistic life'), a portrait of his friend and champion, the writer Champfleury, and *Funeral at Ornans*. Courbet was distraught at the committee's decision. Writing to his friend and patron, Alfred Bruyas, he noted: 'I am in an awful state . . . They say it is vital to put a stop to my tendencies which are disastrous to French art . . . People keep urging me to put on a one-man show, and I have agreed.'[11] Courbet did allow the eleven paintings chosen by the committee to be exhibited at the Exposition, in the hope of medals or honours (in the end he received neither), as well as holding his own exhibition in opposition to it.

His one-man show opened six weeks after the official exhibition began. Constructed at his own expense, his Pavillon du Réalisme was emblazoned with a huge sign inscribed: 'REALISM. G. Courbet: Exhibition of forty of his pictures'. Among them were, of course, the three rejected paintings. For the cost of 10 centimes a pamphlet entitled *Exhibition and Sale of 40 Pictures and 4 Drawings by M. Gustave Courbet* could be obtained, containing a brief preface and a listing of works. While the identity of the author of the Preface, though signed 'G.C.', has historically been in doubt, the document nevertheless remains crucial in ascertaining Courbet's own position in this period:

> The title 'realist' has been imposed on me in the same way as the title 'romantic' was imposed on the men of 1830. Titles have never given the right idea of things; if they did works would be unnecessary . . . All I have tried to do is to derive, from a complete knowledge of tradition, a reasoned sense of my own independence and individuality. To achieve skill through knowledge – that has been my purpose . . . to create living art – that is my aim.[12]

Courbet's one-man show was a great disappointment. It had few visitors – though these included Delacroix – and the critics showed as little interest in it as they did in his pictures at the official Exposition. A long essay of defence and praise, which appeared in *L'Artiste* in early September, written by Jules Champfleury, made little difference. Shortly afterwards, Courbet, bitter and disappointed, began looking for an alternative site on the Boulevards to rehouse his pavilion. He did not find one, and consequently his exhibition remained open after the Exposition Universelle had closed.

Did James visit Courbet's exhibition? It seems inconceivable that he would not have done so, if only out of curiosity. In their *Life*, the Pennells imply that he did.[13] In any event, he could not have missed the controversy it evoked, nor the discussion it stimulated. Now, more than ever before, the name of Courbet seemed to be on the lips of every student and professional artist in Paris.

Within days of their arrival, O'Leary had begun studying at the Ecole de Médecine, and occasionally worked at the hospital, La Charité.[14] James followed suit, and within a week had enrolled at the Ecole Impériale et Spéciale de Dessin for day classes. Five days later, he enrolled for evening classes.[15] Although his choice of school might seem revealing when seen against the prevalent line-versus-colour debate, in that the Ecole Impériale was steeped in the tradition of drawing, this was not the determining factor. His decision was simply governed by caution. Since he had been studying drawing for years he could start at the college with some confidence. Also by enrolling at a government-sponsored institution, he would please his family. Finally, he needed time to explore Paris before he selected a suitable atelier. Having come this far, James was in no rush. He was content to give to those back home the appearance of industrious application, while in reality still intoxicated by the freedom of the city.

In January 1856, O'Leary moved out of their shared rooms at the Hôtel Corneille. The claim that he simply wanted to be nearer the hospitals where he was studying does not hold up to scrutiny.[16] Since meeting other senior Irish rebels in Paris, he had other things on his mind than his studies: Ireland and the talk of another revolution. Also James had recently met a French girl called Héloïse, a dressmaker from the Latin Quarter. Not conventionally pretty, but striking with her dark hair and olive skin, she was as fiery as her looks. Together, they must have made an impressive couple, with James dressed in white duck and 'a straw hat of an American shape not yet well known in Europe, very low in the crown and stiff in the brim, bound with black ribbon with long ends hanging down behind'.[17] For O'Leary, reserved at the best of times, James's liaison at such close quarters must have been difficult to bear. During the couple's frequent rows and tantrums, he could only have listened in despair from the neighbouring room. So O'Leary took rooms in an old boarding-house on the rue Lacépède. The parting was made on the best of terms, and during O'Leary's remaining thirteen months in Paris he and James met regularly. It has been assumed that their friendship slowly dwindled, but in fact it endured and had a great effect on James's later life.

If James turned out much work during his first six months in Paris, little of it has survived. Many drawings which he sent home during this early

period in Paris were burnt by his mother on the grounds that they 'caricatured only the depravity of city life'.[18] An unspecified number of others were destroyed sometime later by an enraged Héloïse. However, one drawing did survive these onslaughts. Entitled *Dancing Pierrot*,[19] this pencil drawing undoubtedly owed its reprieve to the fact that on the reverse James had drawn a rather lovely portrait of Héloïse herself.

Although it is dangerous to place too much importance upon a single surviving drawing such as *Dancing Pierrot*, in this instance at least the image and the ideas involved are revealing. It is remarkably similar to a series of lithographs by Gavarni completed during the years 1846–7, particularly *Air; Larifla . . . Nos femm' sont cou-cou!* The series, entitled *Impressions de ménage*, was well known in Paris and had received critical acclaim from a number of progressive French writers. For one writer in particular, Charles Baudelaire, Gavarni's work and his eccentric bohemian life-style seemed to represent his own views as expressed in his highly influential and controversial article 'On the Heroism of Modern Life', published in 1846. James was almost certainly aware of the sentiments set out in the piece, although how much he had absorbed at this time is far from clear. Nevertheless, for young Parisian art students it was certainly one of the most suggestive, controversial and provocative articles written on art for many years. In it Baudelaire demanded that artists, particularly the new generation, should look more searchingly at the source of their subject-matter. The reality and the brutality of modern life in all its colour, nature with all its imperfections, was the challenge for the modern painter, not the didactic idealization of the past. Art and society were at a crossroads, the author argued. Only the new generation could forge the path ahead.

Two other significant pieces of work by James have been dated to around 1856: a self-portrait known as *Whistler Smoking*[20] and a small circular pen drawing entitled *An Artist in His Studio*.[21] However, the dating is only tentative: the self-portrait could well be as late as 1858–9, while the circular drawing, though it may have been started at the Hôtel Corneille, could easily have been completed a year or so later. In terms of style, both reveal very little, serving only to confirm that James was honing what he already knew before he arrived in Paris. The city, as yet, had still to make its mark.

In June 1856, after nearly seven months at the Hôtel Corneille, James moved to a small, though more comfortable studio-bedroom at 35 rue Jacob, just over the river from the Louvre. Shortly after settling into his new residence, James enrolled at the popular atelier of the Swiss painter, Charles Gleyre. A few days after his enrolment, Gleyre applied to the Director-General of Museums, the Comte de Nieuwerkerke, for a student's pass for the Musée du Louvre on James's behalf.[22] This eagerly

sought pass, usually only issued through the Ecole des Beaux-Arts or a select number of independent ateliers, gave unlimited access to the Louvre and allowed a student to set up his or her easel to copy work in the museum. James's pass was issued to him on 17 June.[23]

Great importance has been placed on James's time at Gleyre's atelier, mainly because it is the only place of learning in Paris about which any first-hand accounts of his attendance may be gleaned. (Although he certainly enrolled at the School of Drawing, there are no independent accounts of his ever having been there.) But this importance has been exaggerated. James seemingly never contemplated serious study at Gleyre's. The fact that the atelier, on the rue de Vaugirard, was nearly a two-mile round trip from the rue Jacob (though a shorter distance from the Hôtel Corneille) would seem to imply something amiss. He could have studied at other equally famous and much closer ateliers, such as the Académie Suisse situated on the quai des Orfèvres, or that run by Ary Scheffer. James may have been swayed in the direction of Gleyre's through meeting one of his first real art-student friends, Thomas Armstrong, who was staying at the Hôtel Corneille. The son of a wealthy Manchester cotton mill owner, and two years older than James, Armstrong had arrived in Paris two years earlier, attracted primarily by the romanticism of Delacroix and his followers. He had enrolled at the atelier of Ary Scheffer, before a short break at the Royal Academy in Antwerp. After nearly a year at home in Manchester, Armstrong had returned to Paris to continue his art studies at Gleyre's.

The atelier had an international reputation and attracted a wide variety of students from many countries. James so far had made few real friends in Paris, and he perhaps missed a sense of camaraderie. Unlike many other ateliers, Gleyre's students paid only for the use of the studio – no attendance, no fee. The teaching was organized on a very loose basis: there were no examinations, no set work, only advice once a week from the proprietor. The figure-drawing classes used live models, not just casts. All these too were important advantages.

By 1856, Charles Gleyre had been running his atelier for nearly thirteen years, having taken it over from Paul Delaroche. Of Swiss origin, he had studied in Rome as a young man, but his health had been broken by a trip he undertook to North Africa in the late 1830s where he contracted ophthalmia and later dysentery. He was a curiously sad figure as he shuffled around the studio during his weekly visits.[24] The major attraction of his school to the hundreds of students who attended the atelier over the twenty-seven years of its existence, was that Gleyre preached the teachings of his great idol, Ingres. Uninterested in colour, he believed that drawing

was the foundation of all art. If you could not draw, you could not paint. Claude Monet, who entered the atelier some years after James in 1862, underlined this point in a later interview, when he recalled Gleyre's advice to him: 'I want you to remember, young man, that when one draws a figure, one should always think of the antique. Nature, my friend, is all right as an element of study, but it offers no interest. Style, you see, is everything.'[25]

Gauged by the limited amount of time he spent at Gleyre's, James's choice seems to have been yet another move governed by ulterior motives. Prime amongst these was the student pass. From the outset, it is clear that James did not care for the place. A lack of discipline, and the often riotous behaviour of its incumbents, unnerved him. In consequence, he rarely visited the studio, and when he did, it was usually to socialize. Yet he absorbed two lasting lessons from Gleyre's working methods. So obsessed was Gleyre by the predominance of line over colour, that to enable students to concentrate solely on the image before them, he always insisted that the palette of colours, of secondary importance, should be set out and mixed before a picture was begun. It was Gleyre's belief, too, that the colour black was the only basis of tonal composition.[26] James would deploy both these methods for the rest of his life.

Through Armstrong and his attendance at Gleyre's, James quickly made several more friends, all newly arrived from Britain: George du Maurier, Thomas Lamont and Edward John Poynter. Parisian by birth, Poynter had been brought up in England and had recently completed two years at the Royal Academy schools in London. The circle was soon widened with the arrival of George Boughton from the United States, and another student from England, Joseph Rowley. All were from very different backgrounds, all had very different ideals and aspirations, and all had been drawn to Paris in the wake of the Exposition Universelle.

James enjoyed the company of his new friends, and they too, it seemed, enjoyed his. Before long he had introduced them all to O'Leary.[27] Throughout the summer of 1856, the 'English Group', as his English art student friends became known, met regularly, thrown together by a common language and culture. Armstrong assumed leadership because of his seniority in age but also because he had lived in Paris the longest. After long evenings of eating and drinking, the group would sing and dance throughout the night. James's favourite party trick was singing Negro spirituals. As Armstrong later recalled, he 'would take a stick or umbrella and, holding it in his left hand like a banjo, twiddled on it with the finger and thumb of the right hand while he pattered grotesque rhymes founded on supposed adventures of Scripture characters'.[28]

Everyone had their turn. Lamont would do his Scottish folk-songs, Du Maurier would sing anti-Napoleonic songs such as 'Sieur de Framboisy', while Héloïse would regale the company 'with songs, rather spoken than sung, for she had not much voice or power of musical expression'.[29] So popular did these musical evenings become that within a few months the group had inaugurated their own choral society called Ye Societie of our Ladye in the Fieldes. A drawing of the group by Du Maurier survives from this period. In it, a haggard-looking James is sprawled on a chair with his feet on a mantelpiece. The caption underneath him reads 'Ye Singer of Nigger Melodies'.

Whatever James may have secretly thought of the 'English Group', they certainly in the early days believed him to be one of them. The fact that he turned down an offer made by Armstrong in the late autumn of 1856 to join them in a collective venture of a new studio on the rue Notre Dame des Champs, perhaps indicates his truer feelings on the matter. The studio itself was large, with a huge north-facing window, and smaller windows to the east and west. Before long, Lamont and Armstrong had installed furniture and decorated the room with 'plaster casts, copies of famous paintings, and works of their own'.[30] James at this period was later remembered by one of the group, Joseph Rowley, as being 'most amusing and eccentric . . . He was always smoking cigarettes, which he made himself, and his droll sayings caused us no end of fun . . . He never was a friend of mine, and it was only occasionally he came to see us at the atelier in Notre Dame des Champs.'[31]

By the New Year of 1857, the English Group was joined by Alecco Ionides and his elder brother Luke. Of Greek background, though British subjects, they were not aspiring artists like the rest. Luke was in Paris studying for the Diplomatic Service, while Alecco was there with a personal tutor, though in what precise subjects it appears no one ever really understood, much to the amusement of all concerned. Aside from being good company, the brothers were from an extremely wealthy family which had made its fortune in shipping. In the years that followed, the Ionides family would become important early patrons of James's work.

In stark contrast to James's bohemianism in Paris, his mother's letters always reminded him of her straitened domestic situation and the sacrifices made on his behalf. Writing to him just before Christmas 1856, she noted that she would carefully arrange the day's menu and the order of her day, 'an active routine of mine every morning, that by frugality I may provide hospitality & maintain the respectable caste, bequeathed me'.[32] Although he had the relative security of money sent to him on a regular basis by his half-brother George in Baltimore, James, like most students, possessed

little sense of economy. During his first year in Paris, he had not painted or sold anything of significance, and in consequence he was always in debt.

By a stroke of luck, or perhaps by design, James met up with an old acquaintance from his West Point days, Captain Williams, known also as 'Stonington Bill', who was in Paris with a friend early in 1857. After a tour of the Louvre in the company of James, the Captain apparently not only ordered a portrait of himself, but also commissioned James to make several copies of paintings he had seen in the gallery.

Copying pictures was not new to James; he had painted a copy after Turner while at West Point.[33] The sustained period he spent working in the Louvre suggests that he probably considered this more of an education than anything offered by Gleyre. It was also of course a quick and pleasurable way to make some money. According to James, he charged 'twenty-five dollars a piece'. The copying of works by famous artists has always been a well-established student practice, offering the chance to study closely the ideas and methods of the masters.

The first recorded evidence of James applying to copy at the Louvre is dated 28 February 1857, when he was granted permission to copy Mignard's *La Vierge à la grappe*.[34] But it seems likely that he had already been copying for some weeks at the Luxembourg with a young man he had recently met from Nantes, who was studying at the Ecole des Beaux-Arts – James Tissot. According to the critic and author, Théodore Duret, a close friend of James in later life, they had both copied Ingres' *Roger délivrant Angélique* together there. How James met Tissot is unclear – perhaps at one of the cafés or student haunts in the Latin Quarter. They never became particularly close, rather were thrown together by circumstances of mutual interest. But James admired elements of Tissot's work and remained in touch with him for many years.

As James began his copying, he also hatched another plan to raise money. With his experience in etching, he proposed to Poynter, Lamont, Armstrong and Du Maurier that they should form a group and make some etchings that could be sent to England to form the basis of a published story. Although it has never been discovered who exactly 'the literary bloke' constantly referred to by James was, the joint venture was begun with tremendous enthusiasm. As Armstrong recalled, the publication was to be called PLAWD:

> a word composed of the first letters of our names . . . Three of them were executed, Whistler's represented an interior. I don't remember it well, but I think it was, in composition, something like Tassaert's well-known picture in the Luxembourg [probably *An Unfortunate Family or The Suicide*, of

1850–1], a garret with female figure. Poynter's was in the style of the illustrations to Balzac's *Contes Drolatiques* by Doré, his best work, with which we were all much impressed at the time. It represented a French castle with many turrets dark against the sky, and from the upper part of it a beam or gallow projected with a skeleton dangling from it. I cannot recollect what subjects Lamont and I chose, but I believe the plates were never bitten, certainly mine was not . . .[35]

As Armstrong implied, the venture never reached fruition and the initial enthusiasm seems quickly to have waned. The two surviving works are nevertheless interesting. Poynter's is a rather ghoulish etching,[36] reminiscent of Charles Meryon's *Eaux-fortes sur Paris* completed around this period. James's plate, now known as *Au Sixième,* is a rather romantic image of an artist and his mistress/wife in a garret room, very much in keeping with the Baudelairean ideal. The female depicted may well have been Héloïse, and the male, possibly a French artist friend, Ernest Delannoy.

The first etching completed by James demonstrates that, despite his experience in the medium, he still relied on copying for his inspiration. His particular choice of subject-matter may have been dictated by the fact that he probably knew Tassaert, who lived only doors away from the English Group at 5 rue Notre Dame des Champs.[37] James would almost certainly have seen his work at the Exposition Universelle, where he received a third-class medal.

Tassaert, by then a chronic alcoholic, had one staunch patron and supporter, Alfred Bruyas. Bruyas was a man of substantial wealth, whose considerable collection of art was well known in Paris; respected by many artists, he assumed the role of a father figure to most of those he admired. Tassaert had reason to be grateful to Bruyas, who would call to offer support and advice when he was laid low by severe bouts of drinking. Another artist who had benefited from Bruyas' help was Gustave Courbet: Bruyas was always there to answer his letters and to meet and counsel him, and in time he became one of the major purchasers of Courbet's works. If James did come to know Tassaert, he may well have been closer to the circle of Courbet at this time than is traditionally thought.

By the time James began his etching, he and Héloïse had moved from the rue Jacob to more modest surroundings on the rue Poupée. This was probably due to lack of money, and within weeks they had moved again, this time to the rue de Chabrol. A poor and often dangerous area, where the rent was undoubtedly cheap, it was nevertheless enlivened by a kaleidoscope of riverside activities. From his early days in Stonington and

St Petersburg he seemed to be drawn to and fascinated by rivers and the hustle and bustle they generated.

For the remainder of the summer of 1857 life continued much as before. Occasionally he would visit the English Group, or drop into Gleyre's atelier for a few hours. In August, he said goodbye to O'Leary, who was leaving Paris and returning to Ireland via London. Meanwhile George Lucas, whom James had met through his brother George in Baltimore, had recently arrived to take up residence in Paris. James could not believe his luck: here was yet another financial stream to tap. O'Leary's departure seemed to mark the end of one era; the arrival of Lucas hailed the beginning of another. Now, after nearly twenty months in the French capital, James felt at home, comfortable and confident in his surroundings.

5

First Steps

EXHIBITIONS HAD BEEN on James's mind for most of the summer of 1857, not least because the first official Salon since the Exposition Universelle had opened in May, and it seemed to mark the beginning of a new ideological era in French art. There were institutional changes too, for the government had relaxed the Salon rules and regulations. The limit of three exhibits per artist was abolished, and so was the hegemony of the selection committee. Now it would consist not of government appointees but of artists from the Académie des Beaux-Arts, chosen from amongst themselves. Other changes included a new exemption from jury selection for those artists who were either members of the Institut or had been decorated by the government. Delacroix, who had been so long shunned by the art establishment, was finally elected *membre de l'Institut* in 1857. This allowed him to serve on the Salon jury, but as he said at the time, 'I flatter myself that I can be of use there, because I shall be nearly alone in my opinion.'[1]

When one compares the opening speech of the Minister of State, Achille Fould, at the last official Salon in 1853, with his opening speech in 1857, the shift of attitude is discernible. In 1853, with his focus firmly placed on the forthcoming Exposition Universelle, he had compared the age of the Second Empire with earlier periods of cultural greatness such as the age of Pericles, the centuries of Augustus, of Leo X and Louis XIV. After praising the overall quality and improvement of standards in the exhibition, he expressed regret that the younger generation did not pursue 'le beau idéal' with the same determination that it brought 'to the study of reality'.[2] Fould's gentle reminder to artists in 1853 had obviously become an issue of

real government concern four years later. The new generation of artists had to be applauded, he began, but they also needed to be kept on the right track and not misled:

> Faithful to the traditions of their illustrious masters they will know how to bind themselves perseveringly to those serious studies without which the happiest genius remains sterile or wanders astray . . . Art is very near to losing itself when – abandoning the high and pure regions of the beautiful and traditional paths of the great masters to follow the teachings of the new school of realism – it seeks nothing more than servile imitation of the least poetic and elevated offerings of nature . . .[3]

Although James almost certainly did not attend the grand opening ceremony, he would doubtless have read Fould's address reprinted in the Salon catalogue. More important to James and his student friends were the exhibits on show in this vast public spectacle of art, featuring over 3,000 paintings, together with nearly 100 examples of 'artistic' photography, the first time the medium was admitted. The Salon was the supreme showcase for the young and aspiring artist lucky enough to be selected by the jury; older academic painters also attempted to enhance their reputations at it by winning more medals and decorations. There were few private dealers in Paris at this time, and most of those would not expect to sell paintings by someone who had not been hung at the Salon. With all its faults, it was the benchmark of French art and provided the first rung of the ladder towards success and recognition.

During the six weeks' duration of the Salon James probably visited the show on many occasions, and like most other Parisians followed the substantial coverage it attracted in the French press. With Ingres and Delacroix notably absent from the exhibition, the focus this time was firmly placed on the debate over realism. As an habitué of meeting places such as the Café Taranne and the Café Fleurus, with its panels painted by Corot and others, James was by now well versed in the current arguments. Ever since the Exposition Universelle, there had been a rise in the number of articles defending or denying the merits of realism. One of the most provocative articles was written by the poet Fernand Desnoyers, who proclaimed: 'Let's not write, not paint anything except what is, or at least what we see . . . Any figure, whether beautiful or ugly, can fulfil the ends of art. Realism, without being a defence of the ugly or the evil, has the right to show what exists and what one sees.'

Among a number of news-sheets spawned by the new radicalism was a short-lived, though widely distributed, review written by a young author

named Edmond Duranty. Echoing the sentiments of Desnoyers, he argued passionately that the paintings of past centuries were not created from idealizations of years gone by, but were often brutal realizations of the present. 'Create what you see!' he exhorted his readers.[4]

In such a climate, the Salon of 1857 had been awaited with excitement by the growing number of supporters of the new realism. For two years, they had not seen anything by the one artist whose work had come to epitomize the very essence of the argument, Gustave Courbet. What they now saw did not disappoint. Since the abject failure of his one-man exhibition in 1855, Courbet had spent much of his time away from Paris. Now he submitted six works to the Salon, and they were all accepted by the jury of the Académie des Beaux-Arts.

Of the six, it was *Les Demoiselles des bords de la Seine* ('Young Ladies on the Banks of the Seine'), for which he received a second-class medal, that caused the most controversy. A small painting, begun in Ornans and completed in Paris, it depicted two young females, fully clothed, reclining in the shade of the trees on the banks of the Seine. Although seemingly innocuous, for many of the critics the painting was laden with explicit sexual references. Théophile Gautier, for one, denounced the painting, claiming that 'Courbet is beating the big drum of publicity to attract the attention of an unheeding crowd.'[5] Like many others who took a similar line, Gautier was implying that the picture was meant to shock: the figures were unmistakably women of ill-repute. Whether this was Courbet's intention is not so clear. While his defenders, such as the anarchist, P.J. Proudhon, were at pains to claim it as a moral painting illustrative of the easy virtue of kept women, the silence from the artist himself tended to fan the flames of controversy.[6] The fierce reaction of the press had a deep effect on Courbet and he did not attempt another female pose painting for nearly a decade. Ironically, when he did, this time showing two nudes in a dreamy lesbian embrace accompanied by all manner of allegorical symbolism, rather than women provocatively clothed and posed, one of his fiercest critics would be James himself. His reaction was not based on any aesthetic considerations, but because one of the models was his girlfriend of the time, Joanna Hiffernan.

Despite calls from men like Fould for a return to the masters of a previous age, younger commentators on the Salon hoped for a more radical future. The domination of Ingres and Delacroix seemed to have come to an end, leaving no obvious path forward. Jules Castagnary wrote: 'In the great army of art, I see many soldiers, a general staff, perhaps, but no general. From where will that artist come who will claim the leadership by virtue of his genius, and take the place at the head of the column?'[7]

The lack of any substantial number of surviving works prevents us knowing whether James had absorbed anything of the underlying philosophy and subject-matter of realism into his own work during his early period in Paris. Apart from the known copies he made at the Louvre and the Luxembourg, there are only three paintings which may have come from this period, and two of these contain stylistic inconsistencies which present problems of absolute authentication. The remaining painting, a self-portrait entitled *Portrait of Whistler with Hat*,[8] arguably owes less to realism than to the influence of Rembrandt. As the writer and art critic Théodore Duret was later to remark: 'He had been particularly taken by Rembrandt's head of a young man at the Louvre, with a wide biretta and the long wavy hair, and he amused himself by painting his own portrait in a similar get-up. Here is a heavily loaded canvas, a strong opposition of light and shade, while the wide-brimmed hat and tousled hair complete the analogy.'[9]

Duret's information most likely came from James himself during the many discussions they had in later years. Self-portraits by young unknown artists have a long tradition, involving as they do the cheapest and most patient sitter available. In all probability, the painting was executed as a form of respite from the boredom and drudgery of sustained copying. It serves only to confirm that James's development at this early stage remained tentative and cautious. Although no doubt well aware of Courbet and his work, it seems that even after nearly two years in Paris, he was still looking northwards to Holland for ideas and inspiration. Indeed, Dutch art was much favoured by the supporters of realism in the late 1850s.

Since his arrival James had never left the confines of the city. Now, in the late summer, he began to make plans for his first trip away, to England, to visit the Art Treasures Exhibition in Manchester. There was also another reason to leave Paris for a while. Since the episode in which his drawings had been torn up and destroyed, his relationship with the fiery Héloïse had been growing increasingly troublesome. Her ideas of romantic attachment were different from James's. As the rows and the fights continued, James began to spend more and more time away from her, his prolonged absences only adding to the problem. Frankly, it was time for a break. A study trip to England seemed the most convenient excuse.

He had another reason for wishing to leave Paris for a while. The 'English Gang' had slowly begun to disintegrate over the summer period. Du Maurier had left for Antwerp; Armstrong was spending less time at the studio, and Poynter, with whom James had made the mistake of briefly sharing lodgings, was so innately conservative in every way that his very presence was beginning to annoy him intensely. More and more, James tended to consort with the French; they were more suited to his ideals and

habits. The British students, particularly the English, seemed so caught up in cultural idiosyncrasies, such as boxing and keeping fit, that James could only look on with a mixture of horror and bewilderment, failing to understand how these so-called students of art could be in the remotest way interested in such grotesque pursuits.

Just before he left for England, he called on the gang. In his memoirs, Thomas Armstrong recalled that James

> turned up at our studio one morning to tell us he much wanted to go to Manchester with 'le petit Martin', a fellow student at Gleyre's and a son of Henri Martin, the well-known historian, who was setting off in a few days. There was a little difficulty, however, as to ways and means and he wanted to know if, in our opinion, it would be expedient for him to ask for a loan from M. Bergeron, a sort of connection of his, who was, I think, engineer of the Northern France railway.[10]

M. Bergeron was married to Haden's eldest sister, Emma. James's reluctance to ask for a loan was almost certainly due to the fact that Bergeron had helped him out financially on many previous occasions. In the end, James did request, and receive, 'a loan' and he left Paris with Henri Martin, around 9 September. By the 11th both were staying with his friends, the Potters, at their house near Manchester.[11]

The substantial press coverage given to the Manchester Art Treasures Exhibition, held in a vast arena modelled on the Crystal Palace in London, attracted James like many others. Containing some 2,000 oil paintings and watercolours by Old Masters and living British artists, it was a massive exhibition unprecedented in sheer scale and quality of work. Also included was a large collection of over 1,000 prints chronologically arranged to allow the viewer to see at close range the development of print-making over several centuries. Among these was a group of sixteen Japanese prints never seen in such a context before. Certainly, it was the first time that James had ever had the opportunity to look closely at such work. What his reaction was is not known, but in future years Japanese prints would play an important role in his artistic development.

Another notable feature of the exhibition, clearly echoing developments in France, was the collection of nearly 600 photographs. One photograph in particular, *The Two Ways of Life* by Otto Rejlander, was a source of tremendous interest and must have caught James's fancy, given his abiding interest in photography. Earlier rejected on moral grounds by the Edinburgh Photographic Society because of its semi-nudity, the photograph was later purchased by Queen Victoria for her

husband, the Prince Consort – just the sort of story James loved to hear.[12]

Like many of the photographs, a large number of the paintings and prints were on loan from private collections and the exhibition presented a once-in-a-lifetime chance to see works not normally accessible to the public. Throughout the late summer of 1857, thousands flocked to see it, not only from Britain, but from all over the world.

It has always been assumed that in the Manchester Art Treasures Exhibition it was the Spanish school, particularly the work of Velázquez, which made the most lasting impression on James. However, in view of the work he produced immediately after his visit, it is clear that it was the Dutch school, especially Rembrandt, that caught his attention more than anything else.[13] He was, of course, familiar with Dutch seventeenth-century etchings through Haden, but now, for the first time in his life, he was able to study the paintings of Rembrandt side by side with his etched work.

Once back in Paris, James packed his belongings. One of the many things the break away from Paris had confirmed was that he could no longer continue his relationship with Héloïse on its present basis. He moved to Montparnasse, south of the Latin Quarter, a district far enough from the centre of the city to be exempt from the heavy municipal tax on alcohol, and thus a favourite area for artists – full of cafés, cheap bars and entertainment of every kind. Soon after his arrival, he bought a hand-press.[14] With this cumbersome and antiquated piece of equipment, he began to print a small etching, of which only a limited number of proofs were ever made, inspired by and in homage to the Dutch art he had recently seen in Manchester. Called *The Dutchman Holding a Glass*, this, the second etching which he made in Paris, is crucial for an understanding of James's development. Unlike *Au Sixième*, the title shows its clear affinity with Dutch art and the picture contains imagery not dissimilar to Rembrandt's *Rembrandt and His Wife Saskia* of 1636. James was at this time, as a later writer correctly observed, firmly 'on the road to Holland'.[15]

For the remainder of 1857, James seems to have done little else in terms of work. As the year came to a close, his health deteriorated. It was always at its most precarious during the damp winter months, and since his arrival in Paris he had become a heavy smoker, which played havoc with his weak chest. Added to this he had developed a taste for alcohol which he consumed in greater quantities as time wore on.

Early in the new year of 1858, whether simply drunk or weak through illness, James collapsed in the street. Alarmed at not being able to find him at his studio, his American friend, George Lucas, finally tracked him down to a hospital, the Maison de Santé Municipale. Conveyed at once to England, James for the next nine weeks or so stayed with the Hadens in

Sloane Street. After so much time in damp and often dismal rooms in Paris, the comparative luxury of their household must have come as a welcome relief. As soon as he was well enough, James became engrossed again in Haden's print collection and he set about exploring the medium in detail. During his nine weeks in London, James made six etchings – all portraits. They are *Seymour Standing, Seymour Seated, Little Arthur, Annie,* a *Self-Portrait* and *Annie Haden with Books.* In this last, his niece Annie, now nearly 10 years old, looks out blankly over a hefty pile of books with daunting titles like *Directorium Inquisitorium* and *Swedenborg.* James, it seems likely, was underlining a contentious domestic point.

For the first time in the medium, James chose to work direct from the model, rather than invent, copy or idealize. His bold juxtaposition of dark and light areas and his economy of line, particularly apparent in the image of *Little Arthur,* is a clear refinement on *The Dutchman Holding a Glass,* completed only months earlier. James's enthusiasm, it seems, was infectious: before long Haden was etching alongside him. In comparison to James's work, Haden's first completed plate, after an interval of many years, seems much more laboured. Entitled *Arthur,* it shows a side view of his son's head rather than reproducing the whole face as James had done. When James decided to omit Annie's legs in his full-length portrait of her, Haden quickly 'corrected' his artistic misdemeanour by adding them. For the moment James, as a guest in the household and grateful for the hospitality, held his fire. Year later, he revealed his feelings on the matter when he scathingly inscribed on several later impressions of the print: 'Legs not by me, but a fatuous addition by a general practitioner'.[16] On a less fractious note, James made a little drawing of Haden playing the cello at a family evening recital. While the scale and detail suggest it may have been a preparatory drawing for a future etching, it was never brought to completion.[17]

Anxious about his general welfare, Haden and Deborah, no doubt prompted by his mother, tried to persuade James to stay in London and complete his education at the Royal Academy schools, but as he was to inform his uncle William Swift during a visit by the latter to Paris later in the summer, Paris had everything he desired.[18] He also told Swift that he intended to submit to the next Salon, then only a year away.

In early June, not long after his return to Paris, James applied to the Directeur des Musées, the Comte de Nieuwerkerke, for permission to copy Ziegler's *La Vision de St Luc.*[19] Again, like so many works he copied at this time, it has never been recorded. With the etched portraits of the Haden family under his belt, James also set out to find subjects that not only fulfilled his desire to work in the manner of his idol, Rembrandt, but were

also close to the aspirations of the new realism. In a city as colourful and varied as Paris, such subjects were not hard to find.

Even before the radical and often oppressive rebuilding programme of Baron Haussmann, continued for some seventeen years from the late 1850s, the old Paris was being slowly pushed away to make room for the new. Some 350,000 people had been displaced from central Paris by the 1870s and one-fifth of the streets were Haussmann's creation. How conscious James was of this fundamental reshaping of the city is unclear, but for the first major painting he did in Paris, he chose as his subject someone who might have been a victim of this very displacement.

At the gates of the Luxembourg Gardens was a woman who sold violets and matches. Known to everyone simply as Mère Gérard, old and nearly blind, she was an extraordinary personality. Obviously educated and cultured, she had once written verse and managed her own small lending library, a *cabinet de lecture*, somewhere in the city. Her life in its reduced circumstances seemed to epitomize the essence of change in the capital city. She seemed the personification of the new realism, a victim of the brutality of the modern world, and her worn, yet proud and rugged face represented a challenging combination of a lowlife Rembrandtesque subject and its modern-day equivalent as seen in popular works by Gavarni. By choosing this type of theme, much in vogue since the Salon of 1857, James was tentatively revealing an allegiance to the cause of realism. For English friends such as Armstrong and Poynter, this choice of subject would have been unthinkable.

The work for the portrait began in mid-summer 1858. It seems that James originally promised Mère Gérard the completed portrait in lieu of a modelling fee. Although the Pennells claimed that James painted the portrait on a country outing 'in the course of an afternoon'[20] and later finished it in the studio, that seems unlikely: the work was more probably started by means of sketches *in situ* at the Luxembourg Gardens. Around the same time James also made two etchings of Mère Gérard in different poses, so perhaps the etchings came first and the painting followed.

Since his return from London, James had started to work with an unprecedented vigour. He completed an etching of Héloïse entitled *Fumette*, another entitled *En plein soleil* for which the model may well have been Héloïse under a parasol, and a lowlife subject *La Rétameuse*. *En plein soleil* seems to have been done on a day trip out of Paris. The others (as with *La Mère Gérard*) are direct and uncompromising: visual essays in confrontation.

The inspiration of Rembrandt's work spurred him on to plan a visit to Holland. As with his trip to Manchester, he asked one of his French artist

friends, Ernest Delannoy, to accompany him. Traditionally portrayed as somewhat hapless, better known for his attempts at copying than anything else, Delannoy like so many of James's close friends at this time presents an ambiguous figure, drifting in and out of James's life and leaving little trace. The journey they planned was ambitious, taking them through northern France, Luxembourg and the Rhineland and then on to the main goal of their trip, Amsterdam. On 14 August James obtained the necessary visa for Germany from the legation in Paris. Shortly after, both had themselves kitted out with brown linen suits and broad-brimmed hats. A few days later, their heavy knapsacks bulging with sketch-pads, pencils, copper plates, etching needles and little else save a tourist map, they set out on the first leg of their tour.

Both were essentially poverty-stricken, and the journey soon degenerated into farce. They met a young lady called Gretchen Schmitz at Heidelberg, who had suggested they travel to Cologne and stay at her father's inn. She was a pretty girl, as James's etching of her shows, and no doubt there was a brief attachment. The two artists readily agreed to her proposal. Bidding her farewell, they set off up the Rhine, but by the time they reached Cologne they had no money left. Ernest then gloomily turned to James to ask what was to be done:

'Order breakfast,' I said, which we did. Then I wrote for money to everyone – to a fellow student, a Chilean I had asked to look after my letters in Paris – to Seymour Haden – to Amsterdam where I thought letters had been forwarded by mistake. We waited. Every day we went to the Post Office, and every day the official said, 'Nichts, Nichts' until finally we got to be known, I with my long hair, Ernest with his brown holland suit and straw hat now fearfully out of season. The boys of the town would be in wait to follow us to the Post Office, and hardly would we get to the door before the official would shake his head and cry out 'Nichts!' and all the crowd would yell 'Nichts!' At last, to escape the attention we spent the day sitting on the ramparts outside the town . . .[21]

Having suffered for over a week, James finally revealed their predicament to Gretchen's father, who demanded their copper etching plates and drawings in payment, promising to release them when they returned to Paris and James sent the outstanding money.

Having hopelessly waited for an answer to my letter during ten long days, Ernest and I made up our minds (and our sacs) for the worst. We, or rather I, explained to Mynherr Schmitz, that there was no use putting off any

longer – Mynherr Schmitz suffered severely from doubts as to the value of our property – we nearly wept 'tears of anguish' on being obliged to trust the same in his coarse, unappreciating hands, we sorrowfully took leave of our host and our collection of drawings, the result of so much hearty work – of my series of etchings – my chefs d'oeuvres which I was sure had so bright and so certain a future . . .[22]

Any thoughts of Amsterdam had disappeared. All they really wanted to do was to get back to Paris as soon as possible. With the knapsack in the custody of the landlord, the duo set off on foot for Aix-la-Chapelle, nearly thirty-five miles away, to seek help from the American Consul. Armed only with pencils and sketchbooks, their clothes filthy and worn and their shoes barely holding together, they fell in with a travelling circus, watching the entertainments and hoping for any crumbs of food. To pass the time in the evening, James made drawings of the characters. On one of these, of two figures amid a group of onlookers,[23] James inscribed the words, 'Deux artistes célèbres de Paris! Descendus à la cour profonde, font des portraits à trrrois frranccs!!!' To make some little money to buy food they took to drawing portraits of anyone who would pay. As James explained:

the real honest hard miseries of the pilgrimage would have effaced all poetry and romance from any minds but our own. How we walked until I actually could not take one step more, how the first night I made a portrait in pencil . . . for a plate of soup for Ernest and myself, how we slept in straw and were thankful, how my wretched Parisian shoes got rid of a portion of their soles and a great part of their upper leather . . . how I was unable to move out of the way of a mob of hooting Prussian children such as the prophet Elijah would certainly set all the wolves in his power upon, how we were weary and miserable, how I for a glass of milk had to make the portrait of one of my tormentors, the ugly son of the woman who took our only two groschen for a bed which she made on the floor with an armful of straw.

After almost a week on the cold and wet autumn road accompanying the circus, they reached Aix and went immediately to the American Consul where James sought the cost of a joint train fare to Paris. After completing the requisite formalities, they rested the night. Early the next day, 6 October, the weary pair travelled to Liège; the following day they were on a train bound for Paris. Since they could not afford the price of a stamp, friends in Paris had no idea of their well-being or whereabouts. They had been expected back in late September and as the days passed, concern grew as to their fate. A rumour circulated that they were dead. George Lucas

went to James's rooms to see if he had returned.[24] When they finally arrived, they went straight to their local café, to be warmly greeted by their friends.

Despite all the mishaps, and their failure to reach Amsterdam, the journey had been extremely productive for James. At almost every stop along the route from Liverdun, north-west of Nancy, through to Alsace, Maladrie and Lutzelbourg, during their few days at Saverne near Strasbourg, and finally in Heidelberg where he had had his flirtation with Gretchen, James had etched and made drawings.

Taken as a whole, the work reveals the full extent of James's numerous artistic influences at this time. Despite the fact that many of the locations were in beautiful countryside, the landscape did not seem to interest him at all. He recorded only man-made structures, interiors and exteriors, and figures. Although the Pennells later denied that James ever used preparatory sketches for his etchings at this period,[25] numerous drawings survive, several of them paying homage to Rembrandt. Some of the etchings also reveal his detailed knowledge of the work of Charles Meryon, whilst another influence threading its way through the work comes from the etchings of Charles Jacque, a popular artist whose style and choice of subject-matter became an important bridge between the nineteenth century and the seventeenth-century school of Holland. In the first etching of the tour, *Liverdun*, James followed closely the compositional lessons of Jacque, creating by tonal juxtaposition of light and shade in the farmyard structures a strong, dramatic image.

In *The Unsafe Tenement*, made in Alsace a few days later, James improved upon his earlier work. By bringing the focal point closer, he emphasized the brutal aspect of the image, etching it so skilfully that the whole physical tension of the precarious structure envelops the viewer. The little girl who leans against what appears to be a mirror, central to the composition as a whole, seems like a mirage amid the desolation all around her. There are also elements of the work of another Dutch painter, Pieter de Hooch, especially in the etching *The Kitchen* (which was also the subject of several watercolour and pencil drawings). One of de Hooch's great admirers in the nineteenth century was François Bonvin, a close friend of Courbet's, whose work was certainly well known to James.

As soon as possible, James had sent the money to Gretchen's father in order that the plates might be returned to him. They arrived within a few days, and for the following weeks he was absorbed in completing them and starting new etchings from drawings made on the journey. It was a period of intense activity. *La Mère Gérard*, begun before he left, was set aside. Now, he seemed to be determined to return to the streets of Paris to search out

new subject-matter for his etching. Plates completed at this time such as *The Rag Gatherers* recall the realism of *La Mère Gérard*.

During this busy period, James visited the Louvre and among the artists hard at work was a bearded young man copying Veronese's painting of *The Marriage Feast at Cana*.[26] His name was Henri Fantin-Latour. In all probability James had seen him at the Louvre before, but this time he stopped at his easel. What caught his attention remains a mystery. Fantin later recalled that he quickly noticed this 'personnage étrange, le Whistler en chapeau bizarre'.[27] Quite what struck Fantin as 'strange' is not clear; perhaps merely James's extraordinary hat, as Elizabeth Pennell suggested.[28] In any event his appearance amused and intrigued this somewhat intense young man, and before long they were engrossed in conversation.

Fantin's family had been in Paris since moving from Grenoble in 1841. He had always wanted to be an artist and at the age of 15 was allowed to enter the atelier of Horace Lecoq de Boisbaudran, one of the most popular teachers in the city. After nearly two years of study there, he enrolled at the Ecole des Beaux-Arts. As the young man talked it became clear to James that he had met, perhaps for the first time since his arrival in Paris, a true kindred spirit. They arranged to meet again that same evening, and Fantin took him to the favourite haunt of his friends, the Café Voltaire. Amongst other young artists James met that night were Alphonse Legros (who had studied with Fantin at Boisbaudran's atelier) and the brilliant, yet moody portrait painter, Carolus Duran. Also at the café table was Zacharie Astruc, sculptor, painter, poet and critic, supporter of the new realism and a close friend of Courbet.

The talk during his first evening at the Café Voltaire may well have centred on realism and its relationship to their own work and experiences. It probably became clear to James that Fantin in particular was not greatly impressed by Courbet, preferring instead to look to artists such at Delacroix and Géricault;[29] but simply listening to him and his friends converse, James quickly realized that these young artists could provide a deeper understanding of art than anything he had so far experienced in Paris. In November 1855, just as James had arrived in Paris, Fantin had recorded a statement of his beliefs and aspirations. Now three years later, it could have been written by James himself.

> Painting is my only pleasure, my only goal. In art, and modern art ... nature around us is the only subject matter for the artist: one's era, the wonderful things happening in it, its varied characters and passions; the beauty of nature, including both the countryside around us and the least things that catch our eye – all are of great interest. The man of Genius, like the artist

with lesser abilities, can find what he is looking for in nature's rich variety. We are living . . . in a great age and we are following a true path: nature. Not working at all from ideas, we will have only form as our sublime guide . . . Ah, the future will be beautiful, because everyone will find his place, his way of expressing what he feels.[30]

James met regularly with his new friends who introduced him to many more of their circle. Among those he met during this early period were the German artist, Otto Scholderer, another etcher, Félix Bracquemond, Louis Marc Solon, Leo Ottin and Charles Cuisin. Another friend of Fantin's almost certainly interested James. Edouard Manet seemed different from the rest: quiet to the point of shyness, yet generating an air of indifference bordering on hostility. Nearly two years older than James, Manet came from a relatively wealthy Parisian background and, like James, had met Fantin while copying in the Louvre. Manet's story had a familiar ring about it. Intended for a naval career, Manet had failed the entrance exams (whether he did this on purpose has never been ascertained). In the event, he was obliged to opt for the merchant marine. In 1848, as a cadet sailor, Manet put to sea on a training vessel bound for Brazil. The six months away from Paris did not stifle his aspirations to become a painter. For most of the time he drew caricatures of his senior officers, and was often involved in pranks against fellow cadets. In the summer of 1849, he returned to France. Again he failed the examinations for entry to the navy. At this point, his attorney father relented and permitted him to enter the studio of Thomas Couture. While the sense of shared experience may have made James sympathetic to Manet, as an acknowledged *caractère difficile*[31] Manet himself rarely throughout his life warmed to anyone.

James learnt that Fantin and Legros were keen practitioners of etching and it was probably Legros who suggested he should contact one of the most respected printers in Paris, Auguste Delâtre. From the etchings he had made so far, James had decided to create a set for publication not dissimilar in principle to Charles Meryon's celebrated collection of 1851, *Eaux-fortes sur Paris*. Through the publication of these etchings, James planned to launch his career. The portfolio would mark the end of his apprenticeship and signal to all his future intentions.

James had, of course, been familiar for years with the process of printing etchings, though he had never seen it handled by such a skilled master-printer. Watching Delâtre at work was a revelation. He demonstrated the technique of creating colour tone, and explained in detail the chemical and aesthetic reasons for preferring old paper, as well as other important considerations such as different paper weights and textures. In quieter

moments, James almost certainly examined other portfolios of etchings strewn round the busy shop, containing work by Millet and Charles Jacque.

Towards the end of October 1858, as James was completing a final selection of etchings for publication with Delâtre, Haden arrived unannounced in Paris. Ostensibly there on business, he had no doubt also been deputed to see James, in order to report back to the family on his well-being. According to Mrs Whistler, Haden was 'pained to see him not taking care of his health, and coaxed him into consenting to spend the winter in their home'.[32] But before James would leave Paris, he was determined to see the first few sets of his etchings printed.

After hearing James speak of Delâtre, Haden was very keen to meet him. James arranged an introduction, and Haden was fascinated by Delâtre's handling of the etching process. Having watched James's proofs being pulled, Haden was 'surprised by the beauty of his work'.[33] Years later, when he and Haden were estranged, James characteristically claimed Haden learnt much at this time, observing that it was from Delâtre that he developed 'his strong sense of good printing . . . while watching the proofs of the French Set as they were proved by me and printed by Delâtre to whom I introduced him . . .'[34]

As James was making his final arrangements to leave Paris for London, the first twenty sets of the etchings were published. Officially entitled *Douze eaux-fortes d'après Nature*, the twelve etchings, plus an etched title page dedicated to 'my old friend Seymour Haden', are better known today as the French Set. As Lochnan has pointed out, the collection of etchings is neither 'French' nor a 'Set'. Broken down into groups, it contains two of the five etchings of the Haden children, *Little Arthur* and *Annie*; five of the seven plates inspired by Paris, including *La Mère Gérard*; and five of ten plates either sketched or etched during his recent journey with Ernest Delannoy. The fact that James always referred to this group as the French Set underlines one important point: he now considered himself an integral part of the new artistic and intellectual movement in Paris.

6

Between London and Paris

IN NOVEMBER 1858, several days after James had settled down in London to begin his holiday with the Hadens, August Delâtre arrived from Paris with the newly printed English edition of the French Set. As planned with Haden several weeks before in Paris, this edition was to be published from his address at 62 Sloane Street and he would underwrite the purchase of half of the fifty sets. Although there was a minor difference between the two editions, in that the title page of the English edition was printed directly on the protective folder, rather than being a separate sheet as in the French edition, the format deployed was exactly the same. Within days of their arrival, Haden began the process of marketing the sets, priced at 2 guineas each. After a few weeks he enlisted the help of Anna, who enthusiastically agreed to publicize the twenty-five remaining in the United States. In one of the many letters she wrote to potential subscribers, in this instance a close family friend, she could hardly contain her mixed emotions of joy and trepidation at her son's achievement:

> His sister and brother write me they are exerting all their energies to make him prefer London for his work to Paris. I shall try to interest all friends to become subscribers to a set of etching views of France and Germany . . . You may imagine my trembling anxiety, my earnest prayers that God may bless the endeavours of my pious daughter and her good husband to settle Jamie's versatile genius at this crisis . . . Praise God and bless his Holy name for all His tender mercies towards the widow and the fatherless![1]

On 17 November, Haden invited Delâtre and James to a meeting of the Etching Club which he had recently joined. As a guest of honour, Delâtre spoke to the members on the techniques of printing and offered advice. As a gesture of goodwill, he promised to print several of the members' etched plates and bring them back with him when he returned to London in the New Year.[2] James took an active part in the meeting and was introduced to many of the members including James Clarke Hook, a renowned marine painter, whose work he had first seen at the Exposition Universelle where it was well received.[3] He was particularly interested to hear that Hook, like him, intended to submit to the next Paris Salon. The introduction proved important. Apart from his endearing wit and sense of humour Hook was the first major painter, aside from Boxall, James had met in London. A friend of many of the Pre-Raphaelite painters, and shortly to be promoted from Associate of the Royal Academy to a full Academician, with all his contacts he was a useful person to know. The fact that James genuinely admired his work was an added bonus.

Shortly before Delâtre left London, James asked him to pose for an etching. As a token of gratitude and a measure of his admiration he inscribed it, 'Hommage à M. Delâtre'. The visit, coupled with the appearance of James's first published work, rekindled Haden's interest in the practice of etching as never before. Within days of Delâtre's departure, and undoubtedly as a result of their many conversations, Haden began to purchase the necessary equipment to print his own etchings. No expense was spared and later, during a visit to London, Fantin could only stare in amazement at the array before him in Haden's 'atelier'. With the new equipment installed in a small room at the top of the house, Haden and James worked closely together on a variety of subjects over the next few weeks. In completed plates by James, such as *The Wine Glass*,[4] the subject, the use of chiaroscuro and the diminutive scale clearly reveal that he was still absorbed in the work of Rembrandt. There can be no doubt that the proximity of Haden's rich collection was the source of much of his inspiration.

As Christmas approached, James began working on an etching entitled *The Music Room*. The several proof states in the collection of the British Museum reveal that he was intrigued by the chiaroscuro effects created by people reading and working by lamplight, and was also consciously reiterating in his own work the ideas of interior genre he had picked up from Fantin in Paris just weeks before. In *The Music Room*, the three subjects – Haden, Deborah and Haden's medical partner, James Reeves Traer – are compositionally grouped around a table lit by a lamp. Haden and Traer are reading, while Deborah appears to be engaged in sewing. The sheer

number of proofs which survive, and the various additions and subtractions made, underline its compositional complexity, and reveal James's determination to create a domestic interior more sophisticated than anything he had ever attempted before. It was during this short period of intense experimentation, shortly before the Christmas festivities, that James conceived the idea of his first major interior painting, *At the Piano*.[5]

This was conceived and begun in the same room as the etching; unlike the etching, however, it was painted in daylight. The composition is no longer focused on the circular table but on the main focal point of the room, the grand piano, with its luxurious backdrop of two heavily gilt-framed paintings. Underneath the piano lie two instrument cases, casually placed and probably intended to give an aura of spontaneity to the picture.

Excluding the possibility of larger pictures copied at the Louvre and now lost, *At the Piano*, measuring 67 × 90.5 cm, was the largest picture James had so far attempted. X-ray examinations have revealed that, during the initial stages of its execution, he had planned to include only the figure of Deborah sitting playing the piano.[6] The addition of her daughter Annie, who stands at the waist of the piano listening intently to her mother's recital, was made later, probably in an effort to ease the compositional awkwardness. The painting is dominated by bold and dramatic cut-off areas: at the top, where the two pictures behind the piano are sliced horizontally across their centres; vertically at both sides, where the circular table on the right is barely visible; and at the extremity of the piano itself, where the third leg is completely omitted.

James's choice of subject-matter is revealing. While it was strictly within the bounds of realism, being unidealized imagery from the present, the middle-class surroundings seem a far cry from the human and material dereliction which had recently dominated his work in France. The ease with which he could move between abject poverty and middle-class comfort would be reflected in his work for more than a decade, demonstrating as much as anything else the contradictions of his own situation.

As with so many early paintings, *At the Piano* unwittingly set an artistic agenda. Major elements presented here for the first time, such as the carefully planned composition, the cut-off effects, the contrasts of black and white in the clothing, and the bold use of paint, were refined and used again and again in the coming years.

On 12 January 1859, after nearly two months in London, James returned to Paris, via Dieppe, taking with him the unfinished painting. As he informed Deborah several days later, his break in London had done him wonders.[7] He had especially valued his long talks with Haden and Traer

discussing the rudiments of optical science and photography. Both men were keenly interested in these subjects, and Traer had published an important article in the *Journal of the Photographic Society*, entitled 'On the Photographic Delineation of Microscopic Objects', on the day that James had arrived in London. One of Traer's observations had been that cameras could not cope with objects immediately before them: it caused distortion. To counteract this mechanical difficulty, he recommended the photographer 'to take portraits at greater distances, and to omit the immediate foreground of landscapes altogether'.

The work of both Haden and Traer had been influenced by the pioneering research of the German scientist, Hermann Ludwig von Helmholtz. One of the central arguments of his thesis *Physiological Optics* was that it 'was impossible for the human eye to focus on near and distant objects simultaneously'. Instead the eye worked very much like a picture 'minutely and elaborately finished in the centre, but only roughly sketched in at the border'. His work reaffirmed the belief of many artists. James, who had been taught optical theory as part of his course at West Point, was well aware of the implications, and his work in London reveals his tentative experiments in eliminating peripheral detail. There was another reason why James was particularly interested in optical science. Like his mother, he had suffered from chronic near-sightedness since an early age, and it became worse as time went on. Far too vain to wear glasses in public, he relied instead upon a monocle, which became his trademark. James rarely discussed the extent of his myopia, and the implications it had for his work were something of a mystery to his friends. In 1906, Thomas Armstrong informed Joseph Pennell:

> In early life Whistler was so short-sighted that he had to put up his eyeglass to see if his shoes were clean. I have seen him do it many a time. This accounts for something in his painting, but it is puzzling to make out how he saw all the details there are in some of his Thames etchings.[8]

To others, like Walter Sickert and his brother Bernhard, James's solution to his problem was apparent – he used optical magnification. While Walter suggested he used a microscope in the studio 'lying handy on the etcher's table',[9] Bernhard remembered James wearing 'enormous goggles'.[10]

Fired by the work he had done in London, James returned to the task of completing *La Mère Gérard*. Within days of his return it was finished. Almost to the letter, he followed the optical theories discussed in London and consequently *La Mère Gérard* is stripped bare of all peripheral detail and the thick impastoed paint, applied with a palette knife, adds an intensity so

far unseen in his work. He was pleased with the result and proudly informed Deborah, 'it is likely to be the best thing I have yet done.'[11] Shortly after its completion he made another portrait of Mère Gérard.[12] Although slightly smaller than the first, and less impastoed, he chose this time to paint his old hawker friend in a full-length sitting pose, reminiscent of his earlier etching of Héloïse. Again the peripheral detail is omitted. For reasons known only to himself, James kept the second portrait of Mère Gérard for the rest of his life: its existence only became known when it surfaced two years after his death in 1905.

Work on portraits occupied James for most of January, though not all were successfully completed. A lithograph of his father, sent to him from Baltimore by George, set him to work, but no portrait resembling the lithograph has ever been seen. The same is true of another begun around the same time. The sitter, an American friend from his schooldays in St Petersburg, Henry Harrison, was on a visit to Europe. Other work documented during this busy period included the preparatory stages of a painting which he later gave to his friend, the sculptor Charles Drouet. As he proudly informed Deborah, the picture, entitled *Head of an Old Man Smoking*,[13] was done 'all from Nature, tell Seymour'. The subject was a seller of *pots de chambre* whom, according to the Pennells and in contradiction to what he had told Deborah, he chanced upon in 'the Halles, brought to his studio and painted, a full face with a large brown hat'.[14] Larger than *La Mère Gérard*, the treatment was similar, bold and impastoed.

The main topic of conversation with Fantin, Legros and the rest of his new friends was assuredly the forthcoming Salon and their proposed exhibits, which had to be submitted for selection before the end of March. Fantin had decided to send his recently completed painting, *Les Deux Soeurs ou les brodeuses* ('The Two Sisters or The Embroiderers'), along with *Self-Portrait, Standing Holding a Paintbrush*, while Legros planned to submit *The Angelus* (a church interior) and a portrait of his father. Almost certainly through Fantin, James learned that another of their friends, Edouard Manet, planned to make his debut at the Salon with a large picture entitled *The Absinthe Drinker*. Manet's picture, of an old ragpicker called Colardet who frequented the galleries of the Louvre, underlines at this early stage the similarity of his subject-matter to James's, particularly in the latter's *La Mère Gérard* and the Paris etchings.

Fantin's picture, *Les Deux Soeurs*, also shares similarities of subject-matter and style with *At the Piano* and etched work done by both James and Haden over the Christmas period, such as *A Lady Reading* (Haden) and *Reading by Lamplight* (James) which Fantin would have known. Both paintings use similar compositional devices, the severe cut-off areas, and muted

colouring and brushwork, so reminiscent of Courbet. They represent the highpoint of the two young artists' stylistic interplay.

James, it seems, quickly settled on submitting two paintings, *La Mère Gérard* and *At the Piano*, which he would still have to touch up and complete. Not surprisingly, in view of the recent publication of the French Set, he had also decided to submit two etchings for the Gravure section of the Salon, *La Marchande de moutarde* and his earlier portrait of Héloïse which he simply called *Portrait de femme*. Haden also submitted an etching. James's reasons for the anonymity of Héloïse were probably to do with placating the new lady of his life, Finette, whom he had recently met.

James's relationship with Finette was in marked contrast to that with Héloïse. She was much more independent and evidently demanded less of him. Since she worked as a cancan dancer, usually at the Bal Bullier, he rarely saw her in the evenings, which left him free to meet his friends and generally do what he liked. Although James unquestionably adored Finette, the relationship was essentially physical, and seemed simply to involve their sleeping together. There is little or no evidence of anything more.

During one of his evenings in the company of Fantin and Legros, James was asked if he would join them in creating a Société des Trois, a successor to the recently disbanded Société des Vrais Bons of which Fantin and Legros had both been members. Flattered by the invitation, he immediately agreed; the idea of belonging to such a club was the sort of thing he adored. The new society was closely modelled on its predecessor, which had been unflatteringly described by a cynical contemporary as a group who

> in their enthusiasm, in their love of art, had founded and inaugurated the painting of the future. They had set themselves apart, erected a scaffolding built of artistic theories while demolishing everything around them . . . No sooner had these gentlemen set out on their explorations than they believed they had arrived: they imagined they had captured success; they paraded their future glories and from on high on the pedestal which they erected over the ruins of modern art, they watched the poor devils like ourselves, who had not had our share of their sunshine, floundering below.[15]

In reality the Société des Trois was a loose affiliation whose direction, if any, was determined more by youthful aspiration than any profound philosophy or stylistic coherence. The only major shared interest was in etching. Nevertheless, from the moment of its inauguration, the members of the Société des Trois took the business of the group very seriously. One of the first major public excursions they planned was their collective appearance at the forthcoming Salon.

Horace Lecoq de Boisbaudran, one of the most influential, if unorthodox, teachers in Paris, had taught both Fantin and Legros at the Ecole Impériale et Spéciale de Dessin et de Mathématique.[16] As a pamphlet written by him in 1848, and entitled *L'Education de la mémoire pittoresque*, underlined, Boisbaudran's belief lay in a teaching philosophy far removed from the normal academic method. It was rooted in the principle that visual memory could be, and should be, trained.

The first exercise started with the simplest models, straight lines. It then progressed to studying in depth an anatomical detail, perhaps a human foot. After a lecture on the anatomical construction of the foot, together with another lecture on its most salient characteristics, the students were ordered to learn the model by heart by either simply drawing it over and over again, or by the preferred method of minute mental notation. This process was continued relentlessly, and after each successful completion the student moved on to the next stage. By the end of the course, which could last for a year, Boisbaudran hoped that his students would be able to observe a scene, however obscure or difficult, and later record it with seemingly effortless accuracy, through their highly tuned powers of observation.

Boisbaudran's methods were by no means new. Leonardo da Vinci had given similar advice, as had Sir Joshua Reynolds. James taught himself the rudiments of the system as explained by Fantin and Legros, and in later life he would deploy the method on some of the most controversial paintings of his career.

The grand entrance of the Société des Trois at the Salon was thwarted in March by the jury's rejecting the work of both James and Fantin, while accepting Legros' *The Angelus*. In comparison to the last Salon, which had over 6,000 exhibits, the selection this time contained barely half that number. Manet's *The Absinthe Drinker* was also rejected, though Delacroix had voted in its favour.[17] The jury's tough line was underlined when they rejected a painting by as respected a figure as Millet. As the sheer number of rejections became known, a crowd of disenchanted artists gathered outside the Institut de France to protest at the office of the Director-General of Museums, the Comte de Nieuwerkerke, and had to be dispersed by the police. France had never witnessed such a spontaneous reaction from artists, and it seemed to mark a new era of assertiveness in their relations with the establishment. Both James and Fantin were devastated at the jury's decision. James, however, had some consolation; his two etchings were accepted, as was Haden's single submission.

As James was licking his wounded ego, John O'Leary unexpectedly arrived in Paris accompanied by two of the most senior figures in the Irish

Republican Brotherhood, James Stephens and Thomas Clarke Luby. They had come, laden with nearly £600 of illegal gold, to set up the Paris headquarters of the Irish Republican Brotherhood whose aim was to overthrow British rule in Ireland by force, if necessary.

Shortly after O'Leary's arrival, Fantin informed James that his friend, the realist painter François Bonvin, a close friend of Courbet's, had, in disgust at the jury's decision, decided to hold an exhibition of some of the rejected pictures at his studio – the 'Atelier flamand' as it was known, more in reference to the source of his inspiration than for any reasons of aesthetic principle. Bonvin's exhibition was a generous act of defiance, since his own work had been accepted by the jury. Nonetheless, affirming his solidarity with his fellow artists, his show opened in May to coincide with the official Salon. James, like Fantin, readily agreed to show his two pictures. There was only one glaring omission from Bonvin's list of exhibitors: Manet. Although asked by Fantin to submit *The Absinthe Drinker*, he refused.

Bonvin's show received little attention from the Parisian press. The same cannot be said, however, of the city's artists. As the word spread, they flocked to Bonvin's to view the pictures. One of the most important visitors was Gustave Courbet. Courbet had intended to submit some work to the Salon of 1859, but in the end had not: there was no ulterior reason for this; he had simply not prepared any work in time for the prescribed submission date[18] – since his last appearance at the Salon, Courbet had spent much of his time working in Belgium and Frankfurt. Fantin was yet to be convinced of Courbet's greatness; he was still firmly of the opinion that artists such as Delacroix, Millet and Corot were more important. His view, however, was a minority one.

When Courbet went to visit the exhibition James and Fantin were there. Fantin recalled years later that Courbet was 'très frappé' when he first set eyes on James's picture *At the Piano*.[19] James, in turn, was enchanted by Courbet. To be in the presence of the great realist painter was an honour for him. Courbet did not suffer fools and his attitude, often coarse and dismissive, had wounded many in the past. He perhaps had seen something of himself in the painting before him. The meeting in Bonvin's studio marked the beginning of a friendship that would affect them both profoundly. Several days later, Fantin and James joined a group of other artists at Bonvin's studio and worked from a live model 'under the direction of Courbet'.[20] After the session, James could only repeat to Fantin: 'He is a great man! A great man!'[21]

James left Paris for London on 6 May, presumably to be there for the opening of the Royal Academy exhibition on the 9th. In it he had two etchings, whose submission had been arranged by Haden (who himself had

one etching accepted). As a professional doctor, Haden chose to make his Academy debut under the pseudonym 'H. Dean', a precaution against his fear of ridicule. While the Royal Academy was a convenient reason for leaving Paris, it was not James's only one. The exertions of the past four months, the rejection by the Salon, and a dead-end situation with Finette all made it time for another break. He needed a breathing space and a change of scenery.

For his first few weeks in London, James, as usual, stayed with Deborah and Haden. Taking advantage of fine summer weather, he and Haden took their etching kits to the nearby Kensington Gardens and among the work James completed there was *Seymour Standing Under a Tree* – a portrait of Seymour junior. His close working relationship with Haden is underlined by the joint effort *Trees in a Park*.[22] James paid a visit to the Ionides family at their palatial house in Tulse Hill, then a relatively small village in south London. Not only did he meet the beautiful Ionides girls, Aglaia and Helen, or 'Nellie' as she was known within the family, but he was also shown the superb pictures and fascinating collection of Tanagra figurines which Alexander Ionides, the father, had been amassing for many years. The day was splendidly concluded when Alexander Ionides commissioned James to paint a picture.

The subject chosen by James for the commission was *Old Battersea Bridge*.[23] It was not very far from the Hadens' house, and had been the only bridge between Westminster and Putney until the opening of the Chelsea Bridge in the previous year, 1858. Completed in 1771 to replace a ferry, Old Battersea Bridge transformed the neighbouring area of Chelsea from the status of village to that of a fully fledged town. When it was first opened to traffic, the population of Chelsea could be counted in hundreds; several years later, it had risen to nearly 20,000. What immediately struck James about the bridge was its structure. Made entirely from wood, it consisted of nineteen spans bolted together along its 720-foot length, while its width of 24 feet allowed the hundreds of laden wagons which crossed back and forth daily to pass each other with ease.

The spot he chose to work from was on the Chelsea side of the bridge opposite a terrace of houses set back from the road known as Lindsey Row. Before the construction of the embankment in 1871, the area to the right of the bridge was the only part of the Thames frontage at Chelsea that had a retaining river wall, which rose some 4½ feet above the road surface. From the downward viewpoint of the painting, it seems that James took up his position sitting on the wall. In many respects the composition,

particularly the three tied-up boats at the bottom right, is disconcerting. The middle boat seems to be suspended on a plane of its own and in this respect the picture has some of the contrived compositional naïvety of Legros' *The Angelus*.

Old Battersea Bridge marks a critical turning point in James's art in another important respect. Apart from its attraction in terms of realist subject-matter, the subject also allowed him, certainly for the first time in his painting, to explore the visual potential offered by Japanese art, particularly through the work of artists such as Hokusai and Hiroshige.

James's exposure to Japanese art, particularly woodcuts, was almost certainly initiated by his association with Félix Bracquemond who is credited with having discovered Hokusai's *Manga* at the shop of their mutual friend, Auguste Delâtre, in 1856.[24] By the late 1850s Bracquemond had already begun amassing his collection of Japanese albums, and there is no doubt that James, among many other artists and friends, was shown them. What intrigued James, and no doubt others, were several compositional features which characterized this art form: perhaps most importantly the schematized motif, the flattening of form, the emphasis upon asymmetry and the idea of opening up space within the picture. *Old Battersea Bridge* presented James with the ideal subject, but significantly – and this was to be characteristic of James's work in the future – he assimilated the ideas of Japanese art, in varying degrees, to a Western perspective. Unlike many contemporaries such as Bracquemond, he never contemplated wholesale imitation.

Yet *Old Battersea Bridge* reveals just how close James was to the art of Japan in 1859. When it is compared to Plate 39 from the *Fifty-three Views of the Tokaido* by Hiroshige, both images bear an uncanny resemblance, with the long sweep of the bridge and the rumbling traffic, the foreshore space and the use of balancing devices – James choosing people, Hiroshige plants.

Whether James actually painted it on the spot is not altogether clear. Thick, bold and apparently spontaneous brush-strokes of brown and blue suggest that he did. Courbet would have approved wholeheartedly of his choice of subject-matter, with its rivermen and wagon drivers. Interestingly an X-ray of the painting reveals that James had originally begun a self-portrait underneath. In it, for the first time (and the last), he appears to be sporting a goatee beard, not dissimilar to Fantin's. Alexander Ionides was pleased with *Old Battersea Bridge* and paid James £30 for it.[25] James too was pleased with the picture, as well as his fee. It was, after all, the very first 'original' picture he had sold.

This, together with steady sales of the French Set which had raised nearly

£200 and the sale of the plates which raised another £100, enabled James to become independent of his brother-in-law. Although the seemingly endless and lavish hospitality offered by Deborah and Haden was tempting, their domestic arrangements did not coincide with his own. The main problem, apart from Haden's overbearing personality, was their piety and the personal prohibitions it involved. There could be no women under their roof, no heavy liquor, and he always felt confined to the hours they kept. In some ways their home had come to resemble his mother's house. The solution was a place of his own, and he found exactly what he was looking for in Newman Street, just off Oxford Street and close to the British Museum.

By the late 1850s Newman Street had become a miniature Latin Quarter in the heart of London. James fitted into the area perfectly. Thomas Armstrong who visited the flat, or studio as James preferred to call it, described it as 'long and narrow, with a window at one end looking out to the back, and about the middle of it a string was fixed across from wall to wall. Over this hung a piece of silk drapery about the size of two pocket handkerchiefs. This was supposed to separate the parlour from the bed-room.'[26] For the price of sixpence a week, the friendly landlady delivered a cooked breakfast every day.

Fantin wrote to James in June that his etchings at the Salon had been greatly admired by a gentleman who had seen the French Set some time earlier at Delâtre's. He also noted that he had gone again to see Haden's etchings at the Salon and that they had looked 'devilishly handsome'.[27] The letter revealed the extent of Fantin's continuing misery over his rejection by the Salon which had been compounded by family problems and his dire financial predicament. James knew exactly how Fantin was feeling. Several days later he showed Haden Fantin's letter and pointed out the glowing compliment. His reaction was just what James had surmised, and within days Haden had issued an invitation to Fantin to come to London as his guest. James begged Fantin to join him:

> Come, come, come, Just come to me at once! Here you will find all you need to continue in the vein and with the abundance that has begun for you. No idea, theory or any other nonsense must prevent you from coming here immediately . . . Let my lucky star influence you just a little bit. You know I have always told you that something would come your way. Well, it is England, my dear fellow, that greets young artists with open arms.[28]

Fantin lost no time in accepting and arrived on 10 July.

One of the most interesting developments in Paris during James's

absence, so Fantin reported, was Baudelaire's article in the *Revue française* which had singled out Legros' Salon submission *The Angelus*. A little after its publication, Fantin explained, both he and Legros had met the critic and had found him 'so charming'.[29] Although Baudelaire's notice was short, the critic had admired the work and particularly praised its naïvety.[30] As their first critical review, and despite such underlying jealousy as it may have caused, particularly on Fantin's part, it was an important advance for the Société des Trois.

By 1859 Baudelaire, after having been a public champion of Courbet for many years, had moved decisively away from him personally, and the cause of realism in general. Like George Sand, he distrusted the wider political significance of realism, in particular its democratic implications. Instead, he favoured the political and aesthetic notion of aristocracy in which a higher class revealed itself as society's intellectual and creative force. Baudelaire moved in social circles where Courbet was patently unwelcome; by one particular group, the habitués of rue Frochot, a private salon which included painters and writers such as Meissonier and Gautier, he had been relegated to the category stigmatized as 'Pignoufs' (Socialist louts).[31] Since 1855, Baudelaire's writing had revealed the increasing distance between his own changing beliefs and realism. In some essays, such as the unpublished 'Si Réalisme il y a', he was openly hostile to its ideals and aspirations. By 1859, his stance had become uncompromising. In an attack directed squarely at the supporters of realism, he rounded on them, noting:

> Our public . . . wants to be astonished by means alien to art, and the obeying artists conform themselves to its taste; they endeavour to astonish, to surprise, to stupefy it through unworthy tricks since they know the public to be incapable of being carried away by the natural tactics of true art . . . From day to day art diminishes its self-respect, prostrates itself before exterior reality, and the artist becomes more and more inclined to paint not what he dreams but what he sees.[32]

Fantin fully concurred with these sentiments, since he, like Baudelaire, was a fervent admirer of Delacroix, the great romantic, and also Corot, in whose paintings Baudelaire could see 'an infallible strictness of harmony'.[33] For James, on the other hand, exposure to Baudelaire's ideas, at least initially, would have presented a fundamental dilemma: the poet's outright condemnation of realism must have been unsettling. Though opposed to James's hero of the moment, Courbet, Baudelaire's writings not only showed a deep understanding of painting but proffered sound advice, as when he urged the new generation of artists to view nature simply as a

visual 'dictionary'. The act of creation, Baudelaire believed, was in picking and choosing from the 'dictionary', and not simply through slavish imitation; it could come only through the imagination, 'queen of the faculties'.[34]

Fantin's first trip abroad was an exhilarating experience. Haden's generous hospitality appeared to lift the burden of his depression, and his outings with James were stimulating. After going together to the National Gallery, Fantin informed his parents that Velázquez's *Philip IV Hunting Wild Boar* was 'the most beautiful and the most true thing that I have ever seen'.[35] On a visit to the Royal Academy to see James's two submissions, Fantin had a chance to see a representative selection of contemporary English art. Apart from the work of John Everett Millais, who had been appointed Chevalier of the Légion d'honneur during the Exposition Universelle of 1855, he found the exhibition somewhat predictable. Even the work of Frederic Leighton, whom Fantin had met in the Louvre some years before, failed to impress him: 'Here everything is done conscientiously from Nature; it is very good, but not outstanding.'[36]

The painting by Millais which especially caught their attention was *The Vale of Rest*, a painting of two nuns digging a grave. This large and extraordinary picture, which Millais himself considered to be one of his best paintings,[37] seemed to be spatially constructed on planes not dissimilar to a photograph, as one critic pointed out in the *Art Journal*.[38] Although there is no evidence to suggest that Millais had used photographs during the painting of the picture, it was almost certainly this aspect of the picture which fascinated both James and Fantin. It was a new development, and James began within weeks to introduce it into his own work.

Fantin wrote to his parents, 'Realism has existed here for some time . . . I seem to find here a sensibleness in everything – no French nonsense – right down to this very steady table on which I am writing . . . in my room I have shelves and a small cabinet in which some implements are hung; the way everything fits together so precisely is marvellous.'[39] He also revelled in Haden's habit of offering 'chilled champagne to drink all the time', and as an added bonus, Haden bought two small portraits, and commissioned him to make a copy of Giovanni Calcar's *Melchior von Brauweiler*, from the original in the Louvre. 'You wouldn't believe how much good this trip is doing me. I'm seeing the world . . . I understand life. I am quite the rogue. I think I'm learning what it takes to get along with people.'[40]

James was becoming increasingly preoccupied with other matters. As future events unfolded it is clear that he had minutely dissected the series of Baudelaire's articles provoked by the Salon. The more he read, the more he realized that Baudelaire was indeed a kindred spirit. The thoughts conveyed

through the pages of the *Revue française* seemed to cover the whole gamut of art, with the choice of subject-matter a critical priority. One passage almost certainly caught his attention; in it Baudelaire questioned the absence of

> a genre which I can only call the landscape of the great cities, by which I mean that collection of grandeurs and beauties which results from a powerful agglomeration of men and monuments – the profound and complex charm of a capital city which has grown old and aged in the glories and tribulations of life.[41]

In Baudelaire's view, there was one great exponent of the genre, Charles Meryon, by then mentally ill and a patient at the asylum at Charenton. Although Baudelaire had not met Meryon and would only do so later in the year, he nevertheless regarded his work as unparalleled in France:

> I have never seen the natural solemnity of an immense city more poetically reproduced. Those majestic accumulations of stone; those spires 'whose fingers point to heaven', those obelisks of industry, spewing forth their conglomerations of smoke against the firmament; those prodigies of scaffolding round buildings under repair, applying their openwork architecture, so paradoxically beautiful, upon architecture's solid body; that tumultuous sky, charged with anger and spite, those limitless perspectives, only increased by the thought of all the drama they contain . . .[42]

For James, it seemed that Baudelaire was throwing down a gauntlet. In a combination of romanticism and realism Baudelaire was defining his own beliefs as to the future direction of art. Paris was out of the question. Who could begin to compete with the great Meryon? London, however, was a different matter. The genre of cityscape in London had a long tradition – Hollar in the seventeenth century, and William Hogarth, whose work James knew intimately, in the eighteenth century. He was also aware through Haden of the engraved work of J.M.W. Turner, particularly sets such as *Picturesque Views in England and Wales* (1827–38), and the unfinished *Ports of England* (1826–8). The time had now come for London to have a practitioner in the second half of nineteenth century. James volunteered himself for the task.

Stimulated by Baudelaire's article, James conceived the idea of creating a set of etchings similar to Meryon's *Eaux-fortes sur Paris*. The area he chose was the Thames, not in the higher reaches of Chelsea, but in the lower reaches around the docks. This was one of the most important economic junctions of the Empire, as well as the biggest slum in western Europe.

Like Meryon, James was fascinated by such unsavoury districts. There was, of course, poverty to be seen in wealthy districts such as Belgravia near Haden's house, but this seemed a different type of poverty and, more importantly, a poverty which could be hidden from general view. The docks area of the lower Thames was demonstrably a different world: the London Diocesan Building Society reported that the vast area of the 'East End', as it was coming to be known, was 'as unexplored as Timbuctoo'.[43]

After a day of searching he found what he was looking for, a small room down a litter-strewn alleyway close to Great Hermitage Street in Wapping, the central area of the docks district. Not long before Fantin left London in August, James took him for a walk around the area as though to sound him out. Fantin, however, did not share his friend's fascination. It was an incredibly dangerous place for someone like James who would have stood out as an easy target for the many gangs which roamed, and indeed ruled, the area. Like an intrepid explorer, James set out to begin his project unperturbed.

For nearly two months in the docks area, he lived on his wits, and worked like a devil. The eleven etchings he produced underlined the fundamental changes that had taken place in his work since the publication of the French Set only months before. One of the most important developments was the clear break he had made from the influence of Rembrandt and Jacque. In many ways it was a return to the early skills learnt at West Point as a cartographer, these rudimentary lessons skilfully combined with the ideas he had long known in the work of Hogarth, Hollar and, in more recent years, Meryon.

There were other important changes taking place. In works such as *Black Lion Wharf*, the third etching he worked on, there are clear references to photography: the work seems to resonate with ideas expressed in Millais' painting *The Vale of Rest* and perhaps more importantly in Meryon's work such as *La Morgue* (1854) when the etcher's knowledge of the medium is revealed in the spatial construction. While it is known that Meryon did work from a photograph in at least one of his etchings, *San Francisco*,[44] there is no evidence to suggest that James was doing likewise. He emulated the medium's spatial effects, but was not interested in slavish photographic reproduction. Indeed, any thoughts he may have entertained in this respect would have been thwarted by knowledge of Baudelaire's views on the matter which had been thoroughly aired in his Salon reviews. James continued to employ the optical theory that had influenced the final version of *La Mère Gérard*; detail in the periphery is eliminated, and, as Lochnan has noted, he focused 'on the foreground, middle or background, and allowed those areas which the eye was incapable of seeing clearly to fall

into abeyance. Foregrounds were summarized in a few lines, and background details melted together.'[45]

As the weather became colder, James decided to leave the docks area and return to France, although his project was not yet finished. He departed for Paris on 6 October, promising to return to spend Christmas with the Hadens. The past two months had been engrossing, but he also missed the camaraderie of his French artist friends and needed to be back amongst them. There was also another reason. He had heard on the grapevine that John O'Leary had arrived back in Paris from a trip as Republican envoy to the United States. It seemed as good an excuse as any for a short holiday.

On the evening of his return to Paris, James visited Fantin at his studio on the rue Ferou and saw a small self-portrait in black chalk which Fantin had just finished that day.[46] In it, the artist peers out nonchalantly at the viewer from beneath a top hat. In all probability, it was done for James's benefit and perhaps designed to show him the effects of Fantin's visit to London in the summer. It was, however, a façade hiding a more depressing tale. As the story unfolded, it became clear that Fantin's life over the past few months had been agonizing. His youngest sister, Nathalie, whom he adored, and who with his other sister Marie had posed for his rejected Salon submission, had been mentally ill for some time. In the past few months, her condition had worsened. For Fantin and his family it had created a terrible strain and as a result he had done little work. Ten days after James arrived, Nathalie was committed to the Maison Nationale de Charenton, diagnosed as suffering from schizophrenia 'démence précoce'. She remained there until her death in 1903, nearly forty-four years later. By a strange irony, Meryon, after nearly fifteen months of treatment, had been released some six weeks before from the same institution.

The whole episode seems to have had a depressing effect on James. Instead of experiencing a feeling of well-being now that he was back amongst his friends, he was agitated and unsettled and immediately flung himself into work. Within days he had completed a small drypoint etching entitled *Soupe à trois sous*. It was the first time he had ever used this particular technique, which does not require the plate to be coated with a ground. His reason for adopting it was probably simple convenience. The subject-matter was a sleazy, all-night cáfe full of men in various states of inebriation. This paralleled his recent experiences in the East End of London, and employs many of his new compositional elements. As Lochnan has pointed out,[47] a rather sinister element is introduced by the black bottles on the tables, which recalls a similar device used by Manet in his rejected Salon painting *The Absinthe Drinker*. Its inclusion underlines James's close working knowledge of Manet's work.

This restless, agitated mood was eased when James was reunited with John O'Leary, who regaled him with the story of his so-called secret mission to the United States where he had been greeted at the quayside by a forty-piece brass band and a crowd of hundreds. In all probability it was James who now suggested that O'Leary should have a break and come to London. Certainly his departure coincided with James's.

In terms of work, let alone his social life, James's ten-week period in Paris had been hectic. One of the most interesting and intriguing of his new etchings completed there was simply entitled *Venus*, a nude woman sprawled on a bed. The model was undoubtedly James's lady of the moment, Finette. The image reveals his passion – a fiery sexual passion that had been absent from his life for many months. Although he had portrayed her several weeks earlier, named and clothed and eminently respectable, this later image seems to sum up the essence of their sporadic relationship, physical and sexual. It was the last time they would be together, as James had made the decision to break the relationship before he returned to London.

While some, notably Lochnan, see a possible source for *Venus* in Rembrandt's *Jupiter and Antiope*, of 1647, its truer source was perhaps more recent. One half of Courbet's scandalous picture for the Salon of 1857, *Les Demoiselles des bords de la Seine*, if one reverses the images and removes the clothing, has strong similarities. With *Venus*, James, it seems, was preparing to match Courbet. The year before, Courbet had painted the first of his many erotic pictures, *Femme couchée*,[48] a recumbent woman, naked and implicitly post-coital. Although it was never exhibited in Courbet's lifetime, James, it seems likely, was aware of the picture. *Venus* was, if anything, only a gesture of general intent, a nod in Courbet's direction, and James would not repeat a similar explicitness again. In future, he would concentrate on a different type of image – a suggestive eroticism.

While James had been in London through the summer and early autumn he had missed the many colourful soirees hosted by Courbet at his studio in Paris. Fantin wrote to James to tell him they were a 'waste of talent'.[49] The final event had been the 'grande fête du Réalisme' held on 1 October just days before James had returned. As the printed programme solemnly declared, 'This is the last party of the summer. The artist Courbet will not be receiving guests this winter.'[50] Courbet left Paris to spend the winter in Ornans on the day that James arrived. Any disappointment caused by Courbet's absence was compensated for when he was introduced by Fantin and Legros to Baudelaire. During their meeting Baudelaire told James and his friends that he had seen Meryon and was discussing with him the possibility of a new edition of the *Eaux-fortes sur Paris*. This seemed to fire

again James's enthusiasm for Meryon, and shortly afterwards he engraved his *Isle de la Cité*, an image with direct and obvious indebtedness to the great etcher.

After collecting *At the Piano* from Bonvin, James made arrangements to return to London. Although his ten weeks in Paris had been productive he was keen to get back and seek out the company of a young Irish girl he had recently met who lived opposite him in Newman Street. Strikingly beautiful with long copper-coloured hair, she and her family had fled Ireland, like thousands of others, in the aftermath of the Great Famine of 1845. Her name was Joanna Hiffernan and with her easy-going nature, her sense of fun so reminiscent of Mary Brennan, James was deeply smitten.

On the freezing cold morning of 20 December, James called at Fantin's studio to bid him farewell. After several knocks and no reply, he let himself in to find Fantin sketching in bed, fully clothed and wearing his top hat, a picture of abject misery. It was a far cry from the image in the self-portrait that Fantin had produced on his arrival in the autumn. James could not resist the temptation to capture the hilarious scene and made a small drawing which he inscribed 'Fantin abed, pursuing his studies with difficulty $-14°$ [C] cold'.[51] Fantin had to smile at his situation. With that, James handed him the drawing and was off.

7

A Little Public Recognition

JAMES INTENDED TO make his debut as a painter at the Royal Academy exhibition in 1860 with *At the Piano*. In the meantime, as he later explained to the Pennells, he gave the painting 'in a way' to Haden: 'Well you know, it was hanging there, but I had no particular satisfaction in that Haden just then was playing the authority on art, and he could never look at it without pointing out its faults and telling me it never would get into the Royal Academy – that was certain.'[1]

One of the first people he must have visited during this stay was Joanna in Newman Street. Their relationship was conducted on a very discreet basis. James knew that Haden and Deborah would not have approved of it – Joanna's social class being the main stumbling-block – but he had the convenient excuse that he was going to his studio. For the first time in his life, he seemed to be truly in love. In all likelihood he also had O'Leary in tow since the latter spent the Christmas period in London.[2]

Despite James's double life, he did do some work during the holiday period. He continued to experiment with the drypoint technique and produced four new etchings: *Arthur Haden, Annie Haden, Portrait of a Lady* (Deborah) and *Mr Davis*, an amateur photographer and family friend. He was pleased with these portraits, especially the one of Annie, of which in later life he said 'that if he was to be remembered by only one plate, he would like it to be this one'.[3]

James returned to Paris early in 1860 and stayed for several months. Apart from the usual social round, he seems to have done little, save for two further portraits of friends in drypoint, *Axenfeld* and *Riault, the Engraver*. The absence of any substantial work from this period seems to underline

the fact that James had other things on his mind. For some time, he had been mulling over the idea of making London his permanent base. Much as he loved Paris, his failure at the Salon had caused him a lot of anguish. Moreover, the patronage he had so far received, apart from the sale of the French Set, had not come from any French source, but either from American relatives and friends, or from friends in England such as the Ionides family. He had given away more work in France than he had actually managed to sell. Paris may have been the ideal place for the eager student to serve his apprenticeship, but for the young and relatively unknown professional artist, it was an exceedingly difficult forum in which to perform. Unless you gained success at the Salon, only a minor miracle could save you. And there was to be no Salon in 1860, the next one being planned for 1861. It seemed a good time to test the water in London. Friends such as Fantin and Legros would only be a boat trip away. But such a move would depend on the reception of his work at the Academy.

He returned to London in the early spring. As planned, and despite any misgivings Haden had on the matter, he submitted *At the Piano* to the Royal Academy show, together with five etchings. The latter consisted of two drypoints, *Monsieur Astruc, rédacteur du journal 'L'Artiste'* and an unidentified portrait; and three etchings from his stay at Wapping, *Thames, Black Lion Wharf, W. Jones, Limeburner, Thames Street* and *The Thames from Tunnel Pier*. His choice was revealing. *At the Piano* represented his painterly talents; the etching of Astruc underlined his worldly and cosmopolitan outlook, and the three etchings of the Thames provided a showcase selection for future reference.

Two weeks later the news arrived: everything had been accepted. It was a marvellous breakthrough made undoubtedly all the more satisfactory, at least in private, by the news that his friend Poynter's first submission to the Academy, *Heaven's Messenger*, a scene from Dante, had been rejected by the jury.[4] Haden's reaction to James's success has gone unrecorded. Perhaps any reservations were tempered by the fact that, like last year, he had submitted two etchings under the pseudonym of H. Dean, and again his work had been accepted.

Before the Royal Academy show opened in May, James, buoyed by his success, had thrown himself confidently into the London social scene. He quickly renewed many of his London contacts, among them James Clarke Hook with whom he got on extremely well. Hook, with his snow-white beard and usual attire of homespun jacket, tweed knickerbockers and stout shoes,[5] and James in his customary black suit and patent shoes, must have turned a few heads as they strolled together arm in arm down Oxford Street. James also shared some evenings with old English friends from

Paris, now settled in London, such as Willie O'Connor and Mat Ridley. And among his most enjoyable moments were those spent with the Ionides family. On most Sundays he would walk the four miles to their house at Tulse Hill, where inevitably there would be a large gathering of family and friends engaged in musical recitals, dancing, singing and story-telling.

During a visit to the National Gallery he came across a young man with a high forehead, a shock of dark hair and a beard, who introduced himself as George Price Boyce – like James, also an artist. Boyce later recalled the event in his diary, noting he had met 'a gallicized Yankee, Whistler by name, who was very amusing, and with whom I walked part of the way home'. Boyce, six years James's senior and a gregarious and amiable man, was a close associate of Dante Gabriel Rossetti. This was perhaps the first person James had met in London who was part of the Pre-Raphaelite group and knew intimately their great critical champion, John Ruskin. It soon became clear that, like James, Boyce was fascinated by the Thames and for several years now he had lived in Buckingham Street, just off the Strand, overlooking the river and within sight of Hungerford Bridge.

After a seemingly interminable wait the opening day of the Royal Academy finally arrived. By the end of the first week, the press notices had begun to appear. On 17 May, *The Times* art critic, probably Tom Taylor, singled out James's painting for special praise:

> The name of Mr Whistler is quite new to us. It is attached to a large sketch rather than a picture called *At the Piano*. This work is of the broadest and simplest character. A lady in black is playing at the piano, while a girl in white listens attentively. In colour and handling this picture reminds one irresistibly of Velázquez. There is the same powerful effect obtained by the simplest and sombrest colours – nothing but the dark wood of the piano, the black and white dresses, and under the instruments a green violin and violoncello case, relieved against a greenish wall, ornamented with two prints in plain frames. Simpler materials could not well be taken in hand; but the painter has known what to do with them. With these means he has produced one is inclined to think, on the whole, the most interesting piece of colouring in the year's exhibition . . . if this work be the fair result of Mr Whistler's own labour from nature, and not the transcript of some Spanish picture the gentleman has a future before him, and his next performance will be eagerly watched.

The critic of the *Daily Telegraph*, on the other hand, was scathing, noting that it was 'an eccentric, uncouth, smudgy, phantom-like picture of a lady at a pianoforte, with a ghostly-looking child in a white frock looking on'.[6] The

periodicals and weeklies, as expected, were more reasoned. The *Athenaeum* was on the whole very impressed with the picture: despite

> a recklessly bold manner and sketchiness of the wildest and roughest kind, [it has] a genuine feeling for colour and a splendid power of composition and design, which evince a just appreciation of nature very rare amongst artists. If the observer will look for a little while at this singular production, he will perceive that it 'opens out' just as a stereoscopic view will – an excellent quality due to the artist's feeling for atmosphere and judicious graduation of light.[7]

In all likelihood this piece was written by Frederick George Stephens, one of the original seven members of the Pre-Raphaelite Brotherhood, who had recently given up art after little success to follow a career as a critic. Described by contemporaries as 'a man of firm and settled opinions and a character far from supple',[8] Stephens was introduced to James shortly after the review was written, most likely by George Price Boyce. While initially James seems to have admired the strikingly good-looking Stephens, it was not the easiest of friendships, and the critic's often scathing reviews of James's work in the years that followed not surprisingly created an air of mistrust. Unusually for him, James persevered with Stephens for several years and he was one of the privileged few to whom he introduced O'Leary.[9]

Shortly after the opening James received a letter from John Phillip, a Scottish artist who had been made a full Academician the previous year. Phillip, or 'Spanish' Phillip as he was often known after his visits to Spain in 1851 and 1856 when he began to paint lush Spanish genre scenes, came straight to the point. He wanted to buy *At the Piano*. Years later, James recounted his version of the story to the Pennells:

> Phillip looked up my address in the Catalogue and wrote to me at once to say he would like to buy it, and what was its price? I answered in a letter which I am sure must have been very beautiful. I said that in my youth and inexperience I did not know about these things and would leave to him the question of price. Phillip sent me thirty pounds.[10]

When Phillip died in 1867 Haden somehow 're-acquired' it, possibly at the studio sale. Years later, in 1897, Haden sold it to Alexander Reid, the Scottish dealer.

James's exposure at the Royal Academy had other beneficial effects. It is very likely that the publicity, together with particular praise from the likes

of the novelist Thackeray, who 'admired it beyond words', and George Frederick Watts who remarked that the picture was 'the most perfect thing I have ever seen',[11] prompted Alexander Ionides to commission James to paint a portrait of his son, Luke. While 'pet of the set' he might have been,[12] James took the commission very seriously, and the amount of time he spent on it underlines his anxiety to get it right. In all, the small, half-length portrait, measuring 40.6 × 30.4 cm, took twelve sittings spread over nearly six months. Although worked with a palette knife, it is less impastoed than earlier work such as *La Mère Gérard* and *Head of an Old Man Smoking*. The portrait is one of the clearest indications of just how much James had absorbed from the teachings of Charles Gleyre. Black tonal graduations predominate in the clothing of the sitter, and, as Luke Ionides recalled many years later, James had an intriguing working method:

[he] would compose his colour on the palette, and put on some touch; then he would stand off, and re-compose his colour. It was almost like working in mosaic . . . He never, to my knowledge, made any studies of the sitter before beginning a portrait.[13]

The day after the opening of the Royal Academy exhibition, on 2 May, James made his debut as a member of the Junior Etching Club.[14] He was probably accompanied to his first meeting by James Clarke Hook, and introduced to several members, the most important being the illustrator, Charles Keene. James probably already knew Keene's work, through the various publications issued by the Junior Etching Club, such as *Passages from the Poems of Thomas Hood* (1858) in which Keene had made his first contribution. Despite Keene being nearly eleven years James's senior, they immediately became good friends. Of all the people James had met, with the possible exception of Hook, Keene was the most congenial: he seemed not to have an enemy, or a care, in the world. From the beginning, James was in awe of Keene's skill as a draughtsman. And Keene proved a valuable contact in the London art world since he too knew most of the Pre-Raphaelite circle and their affiliates. Through him James was to meet Millais and possibly Henry Stacy Marks, another artist and notorious practical joker, whom Ruskin often chastised for 'allowing that faculty to interfere with his artistic progress'.

On 26 May, George du Maurier arrived in London. James had not seen him for nearly three years, but he had heard through the grapevine of the terrible tragedy which had befallen his friend. During a drawing class at the Antwerp Academy just months after he had left Paris, Du Maurier had suddenly and inexplicably lost the sight of his left eye. James quickly

arranged a small welcome party at Newman Street, consisting of himself and Willie O'Connor. The next day he took him on a guided tour of the Royal Academy exhibition and proudly showed him his work. In a letter to his mother a short time later Du Maurier described the events:

> You've no idea of the kind of welcome from O'Connor and Whistler . . . I have seen his picture, out and out the finest thing in the Academy. I have seen his etchings, which are the finest I ever saw. The other day at a party where there were swells of all sorts he was introduced to Millais, who said 'What! Mr Whistler! I am very happy to know you. I never flatter, but I will say that your picture is the finest piece of colour that has been on the walls of the Royal Academy for years.' What do you think of that, old lady? And Sir Charles Eastlake took the Duchess of Sutherland up to it and said 'There Ma'am, that's the finest piece of painting in the Royal Academy.'
>
> But to hear Jemmy tell all about it beats anything I ever heard. A more enchanting vagabond cannot be conceived. He will introduce me to his brother-in-law etc and I shall not lack nice houses to go to.[15]

Within days of Du Maurier's arrival, James offered to introduce him to Charles Keene, who immediately befriended the young artist. During the next few weeks, Du Maurier introduced James to several of his own friends. It was a hectic time, and throughout the early summer there was a steady stream of visitors to Newman Street, all of them suitably impressed with James's achievement. Thomas Armstrong perhaps best summed up the collective response when he noted, 'We were amazed at Whistler's sudden and unexpected success.'[16]

Amid the lavish praise there was one conspicuous voice absent, Fantin's. During this period, there seems to have been little or no communication between the two friends. Fantin's only continuing link with London was through Haden, who after receiving his previously commissioned painting from Fantin in early June, was so pleased with the result that he commissioned two further copies.

Around this time in early June, James had again begun to visit the docks area. The critical reception of *At the Piano* had convinced him that it was now time to find another substantial subject for the Salon or the Academy, or both. With a body of work based on the area, which he now knew intimately, it seemed natural that he should look here for his next painting.

In an act of friendship James suggested to Du Maurier that he should move into the lodgings in Newman Street for a rent of 10 shillings a week. This was expensive, but Du Maurier readily agreed, and after settling him in the studio, James quickly moved to the docks area. The place he chose to

stay was The Angel, an inn at Cherry Gardens on the south side of the river, looking across to Wapping on the north side and linked to it through the Thames Tunnel. Almost immediately, he started on a major etching which would form a basis for the eventual painting, *Wapping*.[17] After such intensive work in the etching medium, it seems logical that he should have chosen to begin to explore the painterly possibilities of the Thames in this way. After all, he had not painted in earnest for over a year. The finished etching, entitled *Rotherhithe*, is a view from the balcony of The Angel looking in a north-westerly direction towards the City of London. In the foreground there are two seated male figures, while the background is a view of ships' rigging, moored boats and the waterside buildings sweeping round the river bend.

How long James took to complete the etching is not known; nor is it known when he actually began the painting. But throughout the summer of 1860, the idea, if not the work, was certainly occupying his mind. At regular intervals he returned to Newman Street, primarily to see Joanna, and sometimes to see Du Maurier and his other friends and companions. On several evenings the whole group – James, Hook, Mat Ridley, O'Connor, Poynter, Lionel Charles Henley, Thomas Jeckyll, Stacy Marks and Keene – descended on Pamphilon's in Argyle Street, a restaurant where for the price of less than 2 shillings, they could eat, drink and chatter boisterously for the whole evening.

During one of these balmy summer evenings, James was introduced by Mat Ridley to Edwin Edwards, a well-known and highly respected lawyer who had recently begun to study art with the intention of becoming a professional artist. From the moment they met, Edwards fascinated James, as he did nearly everybody else. It seemed incredible, if not downright crazy, for a well-paid lawyer to abandon his career at its zenith in order to become an artist. Edwards, with the full support of his wife, was determined to fulfil his ambition. He had always loved art and was an avid and discerning collector. Most important of all he did have talent – and he was extremely wealthy and generous to boot.

Throughout the remainder of the summer, James continued working down in Wapping. Apart from *Rotherhithe*, he did only one further etching that year, entitled *The Penny Boat*. Later in the summer Legros arrived in London so poverty-stricken that James later recalled, 'it needed God, or a lesser person, to pull him out of it'.[18] While Haden, as usual, offered lavish hospitality, which was accepted by Legros with characteristic gratitude, James offered him, with Du Maurier's permission, the daily use of his studio in Newman Street and introduced him to useful contacts such as Edwin Edwards.

On several occasions throughout the late summer James persuaded his somewhat reluctant friends to abandon Pamphilon's for one evening and visit him at his lodgings at Wapping. When they did agree all, without exception, were surprised at the joviality of the company. Luke Ionides remembered being invited to a dinner-party at The Angel hosted by James: 'Jimmie proposed the landlord's health – he felt flattered, but we were in fits of laughter. The landlord was very jealous of his wife, who was rather inclined to flirt with Jimmie, and the whole speech was a chaff of a soothing kind that he never suspected.'[19]

By September, James had begun to work seriously on the painting *Wapping*. As X-ray examinations have revealed,[20] although certain details of the composition were to change during painting, the fundamental structure remained the same. The picture, like the etching *Rotherhithe*, was a view from the balcony of the Angel Inn. From that point the similarities end. The etching is vertical, while the painting is horizontal. Furthermore, as Lochnan has pointed out, 'the division of space and structure of the composition are quite different'.[21] In the painting James brought the focal point of the picture downwards and the sky, which dominates the etching, is relegated to a slim punctuated strip across the top. This change redirects the attention to the three figures, one of whom is Joanna, all seated around the table. The backdrop is the marine activity on the river. In effect he swung his view from off-centre to the right. In compositional terms he again called upon aspects of Japanese design, visible in the asymmetric structure of the balcony and the overall clarity of the composition. The way in which he summarized the peripheral background with rapid horizontal brush-strokes is visual evidence that James was still experimenting with the theories of optical science.

Wapping was the most complex and challenging picture he had undertaken to date. By October it had become an obsession. Fearful that anyone should steal his idea, he vowed his London friends to silence on the matter. As Du Maurier told his mother: 'he is working hard and in secret down at Rotherhithe, among a beastly set of cads and every possible annoyance and misery, doing one of the greatest chefs d'oeuvres – no difficulty discourages him.'[22]

A short time later James wrote to Fantin in Paris. As he explained:

I have succeeded in getting an expression! . . . a real expression . . . an air of her saying to her sailor: 'All that's very fine, my fellow, but I have seen others of your sort!' You know, she winks and she makes fun of him. Now all this against the light and consequently in a half-tint/tone that is atrociously difficult . . . Ssh! not a word to Courbet.[23]

This last dramatic plea was certainly more for show than anything else. Given Fantin's reservations about the artist, he would have been the last person to tell Courbet.

The difficulties posed by *Wapping* were unresolved as winter approached. The key problem appeared to lie with what James had earlier described to Fantin as 'expression': establishing properly some sort of narrative relationship between the two males and the figure of Joanna.[24] It was the sort of earthy effect of which Courbet would have approved. But the fact that it eluded him some months later underlined his ongoing dilemma with realism. James, it seems, was having serious doubts and left off the painting. He would not return to it for nearly two years.

In early November James was paid a visit by a lawyer-cum-print dealer, Serjeant Edmund Thomas, who played patron to many young artists over the years, including Millais. He was a shrewd businessman with an eye for marketable prints. Thomas proposed to James that together they should re-issue the French Set. He would also become his agent for all other prints, and in the spring an exhibition of James's etchings would be held at Thomas's gallery in Old Bond Street. At the time it seemed a good offer, and James immediately entered into a contractual agreement with him to halve the proceeds.

Joanna had begun living with James at The Angel with, it seems, her family's approval. Now that he wanted to return to Newman Street, James diplomatically explained the situation to Du Maurier, who received the news graciously and within days had moved out. He soon returned to Newman Street taking lodgings with another of their artist friends, Bill Henley, five doors up from James's studio. Over the next few months, although they still continued to see each other, Du Maurier's earlier enthusiasm for James markedly diminished. James did, however, appear in Du Maurier's first-ever drawing for *Punch* in the issue of 6 October 1860.[25]

As Christmas Day 1860 dawned on one of the coldest spells ever recorded in London, James began another painting entitled *The Thames in Ice*.[26] It is not certain where he painted it, but the size of the two ships depicted suggest that it was on the lower Thames, probably from the Angel Inn, as taller masted ships could not venture much further up the river because of the bridges. The rare sight of the Thames almost freezing over intrigued him immensely, and in spite of the cold he completed the picture in three days, according to the Pennells.[27] While his technique is similar to that in the then unfinished *Wapping*, there is a certain unease about the painting as a whole. The spontaneous approach, something he was not used to, seems to have made his hand unsure. On first sight Haden loved the picture and immediately offered James £10 for it. He agreed, not so

much for the money (which was more than welcome) but because as he later recalled, 'my sister was in the house, and women have their ideas about things, and I did what she wanted, to please her!'[28]

This, no doubt, was the reason why Joanna never came to Sloane Street. Her exclusion did not end with the Hadens: she was never introduced officially to the Ionides or anyone else of social standing. Her humble

James as he appeared in George du Maurier's first *Punch* cartoon on 6 October 1860. The caption read:

Photographer: 'No smoking here, Sir!'

Dick Tinto: 'Oh! A thousand pardons! I was not aware that –'

Photographer (interrupting, with dignified severity): 'Please to remember gentlemen, that this is not a *common Hartist's studio!*'

status was not the only reason for keeping her apart from the Ionides family. James had become infatuated with their eldest daughter, Aglaia. At gatherings he flirted with her blatantly and outrageously, and according to Du Maurier, professed his love for her on at least one occasion.[29] Aglaia, however, was one woman he could not seduce.

Before the seasonal festivities ended, James began another interior painting. Originally entitled 'The Morning Call', and subsequently retitled *Harmony in Green and Rose: The Music Room*, the picture was again painted in the music room of Haden's house. This time, however, the scene is set at the end of the room, towards the back of the house. *The Music Room* was certainly the most ambiguous 'narrative' picture James would ever paint, and perhaps should be seen in the context of the unresolved *Wapping*. Here, it seems, James was experimenting again with the three-figure composition, albeit in a different context. This time, perhaps learning from the problems of *Wapping*, he totally excluded the possibility of an 'expression', in spite of the narrative implications of the painting's first literary title.

The central figure, a woman dressed in a long black riding-habit, with white gloves and trimmings, dominates the picture. Behind her, seated, and dressed entirely in white, is Annie Haden, James's niece. Reflected in a mirror on the right of the picture is Deborah Haden. It is a curious painting, in many ways similar to Fantin's picture *The Two Sisters*, which James knew well. Although the three figures occupy a relatively small area of the room, they all seem very much detached from one another. Annie, deeply engrossed in her book and sitting in the light from a hidden window, is apparently oblivious to all around her. And while Deborah appears from her reflection to be looking at the central figure, Isabella Boott, this central figure is possibly taking her leave of the room – the spatial ambiguities suggest an element of doubt. If, as some contemporaries certainly presumed, *At the Piano* owed much to the art of Spain, particularly Velázquez, then *The Music Room* represents a fundamental change of tack. Its aspects, such as his innovatory use of interior space, owes more to Dutch art, especially the work of Vermeer. Many years later, after not having seen the painting for nearly two decades, James appeared to confirm the debt when he described it as 'quite primitive – but what sunshine! none of the Dutchmen to compare with it – and such colour!'[30]

Despite his intentions, the painting took longer than planned, a characteristic of James's work for the rest of his life. Once a painting was started, it could take him years to complete it to his own fastidious measure of satisfaction. His pattern of work commonly consisted of an initial burst, a period of change, quite frequently major, followed by a period of neglect, then a final flurry to completion. After the initial burst and probably before

the addition of the compositional element of Deborah's reflection, he left *The Music Room* for several months. According to Du Maurier, James showed the picture to Frederick Leighton who 'told him [the head of Annie] was out of harmony, and the last time I saw him he was in complete despair, couldn't put it in again – hope it's alright now.'[31]

Over forty years later, Annie Haden, by then nearly 60, recalled for the Pennells some of the trauma (and pleasurable moments) she endured during the sittings for Uncle Jemmie:

> It was a distinctly amusing time for me. He was always so delightful and enjoyed the 'no lessons' as much as I did. One day in The Morning Call picture, I did get tired without knowing it, and suddenly dissolved into tears, whereupon he was full of the most tender remorse, and rushed out and bought me a lovely Russian leather writing set.[32]

The first of the Ionides' major parties that year was held on 14 January 1861. As the main attraction of the evening, Du Maurier and James, along with John Cavafy and members of the Ionides family, took part in a short play entitled *The Thumping Legacy* for which Du Maurier designed the programme. The event was attended by over 200 people, including many important painters such as Lawrence Alma-Tadema. Before the play began, Du Maurier and James – especially James – got very drunk. Togged out in Greek costume, they fell into helpless fits of laughter much to the amusement of the audience. At one point in the dialogue, when Du Maurier was meant to say 'I would arrest you', it came out as 'I would eat you'. As quick as a flash, James retorted, 'Are you quite sure you wouldn't throw me up?'[33] There was, however, a serious side to the evening. It was here, before the play began, that John Cavafy informed James that he was keen to buy his pictures, and over the next few years he did indeed become an important collector and patron for James.

James returned to work at the Angel Inn. His forthcoming etching exhibition was looming, and the unfinished Wapping picture was left untouched as he began another series of etchings based on the Thames. During the early months of 1861 he made three etchings on the theme of bridges: *Vauxhall Bridge*, *Westminster Bridge in Progress* and *Old Hungerford Bridge*. His interest in these structures, as with his earlier painting *Old Battersea Bridge*, was twofold. First, he marvelled at their technological achievement: with his engineering background, James understood this better than most. Secondly, he was stimulated by an ever-growing interest in Japanese art in which the bridge is a recurring motif. In these etchings, notably *Westminster Bridge in Progress*, his positioning of the bridge structure

high in the composition is an overtly Japanese pictorial device. So, too, is the emphasis he placed upon asymmetry. Other work completed in this period includes *Ratcliffe Highway*, which develops the idea of groups of people used in the earlier etching, *Soupe à trois sous*, and a drypoint, *Early Morning, Battersea*, describing a hazy view, evocatively Japanese, across the Thames below the bridge.

Throughout the early months of 1861, Serjeant Thomas and his son Ralph were regular visitors to the Angel Inn. In one etching, *The Little Pool*, James is shown working on an etching with Serjeant Thomas standing behind looking over his shoulder. The scene sums up the relationship: the print-dealer was always on hand to offer advice and encouragement. After a day's work, James would often make the trip to Thomas's premises in Old Bond Street to use the printing press installed in one of the rooms at the top of the building. Percy Thomas, another son, later recounted how

> Whistler would come . . . and try and bite his plates. Sometimes he would not get to work until half-past ten or eleven. In those days, he always put his plate in a bath of acid, still keeping to the technical methods of the Coast Survey. Serjeant Thomas . . . 'was great for port wine', and he would fill a glass for Whistler, and Whistler would put the glass by the bath, and then work a little on the plate and then stop to sip the port, and he would say: 'Excellent! very good indeed!' and they would never know whether he meant the wine or the work. And always, the charm of his manner and his courtesy made it delightful to do anything for him.[34]

As the printing of the plates progressed, the services of Delâtre were requested. The printer readily agreed to help and came over from Paris as the guest of Haden, to lend his technical support. His expenses, paid by Thomas, were worth every penny.

The show opened in the early spring to a mixed reception, especially from the potential buyers. Whereas the complete French Set cost 2 guineas, the cost now for a single etching was between 1 and 2 guineas: this was the penalty for a dealer's intervention. Sales were not helped by the fact that the press took little or no notice, which was not unusual for an exhibition of this nature. James made great efforts to ensure all and sundry were aware of the exhibition. He even apparently sent an etching to the influential Academician William Powell Frith, as an enticement, though whether Frith attended the exhibition is not clear.[35]

His continuing problems with *Wapping* unresolved, James chose instead to submit to the Royal Academy *La Mère Gérard* and three etchings: *Thames from New Crane Wharf*, *Monsieur Axenfeld*, *Littérateur*, *Paris* and *The Thames*,

near Limehouse. All were accepted, but this time the response from the critics was mixed. While his new friend Stephens, now a staff writer for the *Athenaeum*, saw the painting as 'a fine, powerful-toned and eminently characteristic study', the *Daily Telegraph* again took issue with his methods. Despite this, the underlying sentiment was encouraging, though the description was harsh. The picture, the reviewer, wrote, was

> far fitter hung over the stove in the studio than exhibited at the Royal Academy, though it is replete with evidence of genius and study. If Mr Whistler would leave off using mud and clay on his palette and paint cleanly, like a gentleman, we should be happy to bestow any amount of praise on him, for he has all the elements of a great artist in his composition. But we must protest against his soiled and miry ways.[36]

As James pondered the reviews, he was aware from his friends in Paris of events surrounding the Salon. Unlike that of 1859, the 1861 Salon had provided more scope for those, especially the younger artists, who were still seeking recognition. As the success of his friends became apparent, James must have rued his decision not to submit any work. While one of the old guard, Jean-Léon Gérôme, appeared to steal the show with his picture *Phryne*, the contribution of Courbet and the general inclusion of realism were to prove significant.

For the first time in many years, Courbet created little controversy. Instead, critics normally hostile to his work, such as Théophile Gautier and Hector de Callas, wrote reasoned, even laudatory reviews. Such was the apparent mood of reconciliation that it was even suggested he might be decorated, but his nomination was blocked by the Emperor.[37] Instead the jury gave Courbet the nominal award of second *rappel de médaille* for his work *Fighting Stags: Spring Rutting*. Characteristically, Courbet celebrated the event with 'a realist banquet with plenty of cheap wine'.

Of James's contemporaries, it was the shy and reticent Manet whose work prompted the strongest reactions. The numerous reviews that singled out his paintings, especially the *Spanish Singer*, ranged from tentative acclaim to total incomprehension. One of the more favourable reviews, which appeared in the government-sponsored paper, the *Moniteur universel*, was written by the influential pen of Théophile Gautier, who instantly drew attention to what he considered to be Manet's major influences – Velázquez and Goya: 'There is a great deal of talent in this life-sized figure, broadly painted in true colour and with a bold brush.'[38]

In the more scathing reviews the term realism became a focal point for derision. Hector de Callas, writing in the influential *L'Artiste*, singled out

the *Spanish Singer*. Apart from taking Manet to task for his method – the criticism levelled at James's work by the *Daily Telegraph* – the picture recalled, so the critic believed,

> the palmy days of Courbet. What poetry in the idiotic figure of the mule-driver, in this blank wall, in the onion and cigarette, whose combined odours have just perfumed the room! The fine brush strokes, each separately visible, caked and plastered on, are like mortar on top of mortar.

Artists such as Fantin and Legros could only stand and view the picture in amazement. That Manet could produce such painting and, moreover, produce it so secretly and in such an unassuming manner, seemed beyond comprehension. It acted as a catalyst because, as the author Fernand Desnoyers recalled several years later, it was painted

> in a certain new way, of which the astonished young painters thought they alone had the secret, a kind of painting midway between that called realistic and that called romantic . . . It was decided there and then by this group of young artists to go in a body to Manet's . . . Manet received the deputation very graciously and replied to the spokesman that he was no less touched than flattered by this proof of sympathy . . .[39]

When the Paris news began to filter through to London during the latter part of May, James's precarious health, which had not given any cause for concern for some time, took a turn for the worse. During a visit to the Edwards' beautiful riverside house at Sunbury in early June, he and Mat Ridley and Edwin Edwards went on a camping trip on a boat to Mapledurham in appalling wet weather. It proved the final straw. James contracted a severe bout of rheumatic fever and within days was seriously ill. Under the care of Haden and his partner Traer, James was carefully nursed back to health at Sloane Street.[40]

Fantin, meanwhile, had arrived in London. He had hoped to stay with James before going to Sunbury as a guest of the Edwards but found James too ill to put him up. Instead it was arranged that he should stay with James Hook at his home in Surrey and after a pleasurable week and a half there, Fantin arrived at Sunbury on 20 July. James began to recover slowly in August, and he and Haden visited Fantin. They found him in great spirits, working on a portrait of Mrs Edwards. Edwards, Haden and James, together with Fantin, spent a glorious afternoon etching in the open air. James made four etchings, *Sketching No. 1* and *Sketching No. 2*, *Landscape with Fisherman* (probably Haden) and *The Punt*. Edwards, in turn, recorded the

event with three etchings, two of which include his house-guest Fantin: *Between the Poplars, Sunbury* and *Fantin at St George's Hill.* As the title implies James can be seen in *Whistler Sketching at Moulsey Lock.*

During his illness, and throughout his recuperation at Sloane Street, James had seen little of Joanna. Not long after the visit to Sunbury he planned for them both a visit to France. Although the trip was 'officially' to aid in his recuperation, in reality it was much more than that. In the first place he wanted to be alone with Jo, away from prying relatives and inquisitive friends. In the second place the struggle with *Wapping* had worn him out, and he badly needed to recharge his batteries and find stimulation elsewhere. Also, after hearing more news of the Salon from Fantin, he was keen to see for himself what was happening. With the blessing of Joanna's father, an affable Irishman who had taken to referring to James as 'me son-in-law', to James's extreme discomfort, he and Joanna left for Paris at the end of the first week in August.

8

The White Girl

JOANNA, WHO HAD never been to France before, was taken on a whistle-stop tour of the city. One place they certainly visited, possibly prompted by Fantin, was the Chapelle des Anges in the church of St Sulpice where Delacroix had just completed two murals, *Jacob Wrestling with the Angel* and *The Expulsion of Heliodorus from the Temple*, the last great works of his career.

One person James was particularly keen to see was Manet. Whether he visited him at his new studio at 81 rue Guyot is unclear, but he certainly went to Louis Martinet's gallery on the Boulevard des Italiens where Manet was exhibiting a picture entitled *Reading*. Although the two painters barely knew one another, they had much in common. Probably accompanied by Félix Bracquemond and perhaps Legros, they spent an evening together discussing their work. What James thought of Manet's painting at this time is not known, but he would have been intrigued to learn that Manet was again exploring a Spanish theme, having been stimulated by the presence of a troupe of Spanish dancers and singers at the Paris Hippodrome. Likewise Manet's opinion of James's work is unrecorded, but the assumption can be made, based on future events, that at this stage at least there was a strong mutual respect. Among other topics of conversation were certainly the plans for a Société des Aquafortistes (Etchers). One piece of news that probably surprised James more than anything else, was that Manet planned to send a picture entitled *The Surprised Nymph* to an exhibition at James's old alma mater, the Imperial Academy in St Petersburg. Perhaps during this meeting, or if not then, certainly during his first few days back in Paris, James was introduced by Manet to his friend, the Belgian painter, Alfred Stevens.

During this short stay in Paris James did no work; it was a holiday, a time to relax with Joanna and catch up with the art news and gossip. On 23 August, Courbet returned from an exhibition of work including his own in Antwerp,[1] and although it is not known for certain, it seems likely that James would have seized the chance to meet him. It was two years since he had seen Courbet, whose reputation had been spreading rapidly. This popularity was the result of public acclaim, not of official recognition, as the conduct of the Salon underlined. At the congress which accompanied the Antwerp exhibition, an address was delivered by Courbet which then appeared in numerous Dutch and French newspapers and periodicals. The speech showed a more reasoned, though still characteristically determined, Courbet, keen to explain his position carefully:

> Realism is based on negation of the ideal . . . [his famous painting] *Funeral at Ornans* was really the funeral of the romantic school of painting except for that part of it which was an assertion of the human spirit and therefore had the right to exist, that is to say the works of Delacroix and Rousseau . . . Romantic art, like classical, meant art for art's sake . . . In all things man must be ruled by reason . . . Deducing from this the negation of the ideal with all its consequences, I arrive at the emancipation of the individual and, finally, democracy. Realistic art is essentially democratic.[2]

Such words did much to allay the fears of his detractors. Several months later when Courbet opened his short-lived teaching studio in Paris at the behest of his friend and admirer, the art critic Jules Castagnary, one of the first 'students' to enrol was Fantin, so long suspicious of Courbet's motives and personality. Courbet's recent placatory tones almost certainly governed Fantin's decision. James did not follow his example: in fact whether James ever fully understood the political ramifications of Courbet's work and writings is doubtful. Certainly, as far as a theoretical basis for painting was concerned, he was, if anything, more aligned now to the spirit of Baudelaire than Courbet. At the moment, however, to be associated, like Manet, with the master of realism was no bad thing and James was content so to be seen, considering himself very much part of the 'movement'.

At the beginning of September, James and Joanna left Paris and travelled to the small seaside town of Péron-Guirec in Brittany. Here, in the clean, warm autumnal air of the coast they planned to stay for two months. While the main objective was for James to recuperate from his illness, he also completed a drypoint etching and an oil painting. The etching was probably done first. Entitled *The Forge*, the scene depicts a blacksmith working with several assistants in the background. What attracted James to such a scene

was not the image of the working, sweating man – the realism – but the dramatic effect of light and shade. As Lochnan has pointed out, it recalls Bonvin's painting *Les Forgerons: souvenir du Tréport* which had been exhibited at the Salon of 1857.[3]

The painting, known today as *The Coast of Brittany*,[4] is the first recorded seascape James had done. The figure of the single reclining girl, Joanna, amongst the seashore rocks seems far away from the continuing struggle with *Wapping*. Yet given the company he had been keeping in England, the subject should come as no surprise. By now, he knew very well the work of his friend, the British marine painter James Clarke Hook, and on the purely commercial level he must have realized that the British public had a particular penchant for seascape paintings. William Dyce's *Pegwell Bay*, for example, had recently been a critical success at the Royal Academy.

How long he actually took to paint *The Coast of Brittany* is unclear. As one of the largest canvases he had ever worked on (87.3 × 115.8 cm) it presumably occupied him for some time. George du Maurier recorded that James told him the following year, 'The sand was not laid on with a palette knife. And there is not one part of the picture with which he is not thoroughly satisfied he says, and its open air freshness nothing can stand against.'[5] The implication of Du Maurier's recollection, that it was painted on the spot, is undoubtedly correct and consistent with James's work at the time. Some writers see evidence in the painting of the art of Japan, particularly in the 'expanse of sand stretching before the incisively drawn rocks'.[6] While James was certainly employing Japanese spatial effects, the 'incisively drawn rocks' are arguably no more than an idea he had picked up from Dyce's *Pegwell Bay*, which is dominated by the artist's geological interests. Such rocks only momentarily arrested James's attention, and in the seascapes he painted in the years that followed are notably absent.

At the end of the first week of November, as the weather on the coast worsened, James and Joanna returned to Paris where they planned to spend Christmas together. They found somewhere to live on the spacious Boulevard des Batignolles. They met up with Fantin, who had returned from England in September, at his studio in the nearby rue Saint-Lazare. They found him gloomy and depressed. His sister Nathalie was showing no signs of improvement at Charenton, and his other sister, Marie, was now unwell, owing to the strain of the whole situation. Money, too, was a besetting problem, and the portrait of Mrs Edwards he had recently completed had caused him tremendous anxiety.

For many months now, James had been pondering the subjects of his next submissions to the Royal Academy. The satisfactory completion of

The Coast of Brittany had eased the pressure, and he certainly had the picture earmarked for the show, as he had *The Thames in Ice*. The problem now was what the third submission should be. The still unfinished *Wapping*, though a possibility, was not a serious contender. It did not seem a good idea to submit three marine paintings to the same exhibition; moreover, James had always implied that he intended it for the Paris Salon. He found the answer early in December when he began to paint *The White Girl*, later renamed *Symphony in White, No. 1: The White Girl*.[7]

Of all the 500 or more recorded paintings done by James throughout his long career, *The White Girl* has always been the most puzzling. Today the painting seems simple enough. It is a near life-size, full-length portrait of Joanna measuring 214.6 × 108 cm. She is dressed completely in white and holding a lily in her left hand. Behind her is a white curtain, and she stands on a wolfskin rug which has been laid over a patterned carpet. This straightforward description is more or less what James wrote several months after he had completed the painting. Fervently disclaiming any outside literary source, he sent a letter to the *Athenaeum* claiming that the painting 'simply represents a girl dressed in white standing in front of a white curtain'.[8] While there is no reason to doubt the literal truth of this claim, the painting did not spring from nowhere; like every other picture it has an ancestry. What makes the painting unique, is the way James reassembled his sources.

He had, of course, painted a 'white girl' before: twice, in fact, though in a very different context. The model in both cases was Annie Haden, and the two pictures concerned were *At the Piano* and *The Music Room*. Annie Haden's presence in these pictures, however ambiguous, was always eminently respectable. *The White Girl*, however, poses different problems.

One of several theories as to the painting's source, and that favoured by most of James's biographers despite his refutation of it in the *Athenaeum*, was that it lay in Wilkie Collins's novel, *The Woman in White*. This supposition seems reasonable. Collins was one of the most popular novelists in England[9] and *The Woman in White* had been serialized with immense success in Charles Dickens's weekly journal *All the Year Round* from November 1859 for nearly a year. James must have been aware of the novel though he claimed never to have read it.[10]

He might also have heard the rumours as to the incident claimed to have given rise to the novel, apparently witnessed by none other than Millais, a close friend of Collins. According to Millais' son and biographer, John Guille Millais, his father had been having dinner with Collins, who then decided to accompany the painter and another friend back to his studio in

Gower Street. Reaching the Finchley Road, they heard a piercing scream from the garden of a nearby villa:

> the iron gate leading to the garden was dashed open, and from it came the figure of a young and very beautiful woman dressed in flowing white robes that shone in the moonlight. She seemed to float rather than to run in their direction and, on coming up to the three young men, she paused for a moment in an attitude of supplication and terror.[11]

Millais ended his account of the story by noting that Collins followed her, and did not come back that evening. 'Her story is not for these pages,' he gravely told his son.[12] The woman in question, Caroline Graves, later became one of Collins's mistresses. The incident may have influenced Millais' own work, as a girl in a white dress appears in at least two of his major paintings of this period: *The Black Brunswicker* of 1859–60, and, perhaps more pertinently, *The Eve of St Agnes* of 1862–3 when one of the major themes of the painting was the effect of the moonlight 'falling correctly on the figure'.[13]

It has also been suggested that French literary sources may have influenced *The White Girl*.[14] In 1857, Baudelaire published one of his most important works, *Les Fleurs du mal*, to a mixed reception from the French press. Dedicated to Théophile Gautier, one of the poems in the book was written to 'Une Fille blanche aux cheveux roux'.[15] That James would have known of the work is unquestionable – that he was picking up on these particular themes is debatable.

What has never been explored as a possible source for *The White Girl* is the German Romantic literature that was very much in vogue in England during these years. A work such as Wilhelm Meinhold's *Sidonia von Bork, die Losterhexe*, later translated by Lady Wilde (Oscar's mother) in 1849 as *Sidonia the Sorceress*, was the sort of dark romantic novel that the English reading public adored. In it, a bewitching beauty, who is powerfully manipulative, captivates all who set eyes on her. She is the ultimate *femme fatale*. The most direct and certainly one of the most successful interpretations derived from the book was Edward Burne-Jones's small watercolour painting of 1860, entitled *Sidonia von Bork*.[16] James, while arguably unaware of this particular picture and its companion piece *Clara von Bork*,[17] nevertheless knew of the general thematic content of work by artists such as Boyce and Millais. Though not yet close to any of the Pre-Raphaelite circle, James was conversant with their latest developments and had watched their work carefully.

Millais, we know, was of special interest to him, and he absorbed ideas

from works such as *The Vale of Rest* which he had seen with Fantin in the summer of 1859. Possibly, he had also reacted to the implicit sexual symbolism both in *Autumn Leaves*, which had been exhibited at the Royal Academy in 1856, and in *Spring*, shown in 1859. But the spark that may have ignited the idea to paint a single female figure perhaps came from a painting entitled *Thoughts of the Past*, by John Roddam Spencer Stanhope, one of the lesser known Pre-Raphaelite artists, which had been exhibited at the Royal Academy in 1859.[18] Although this painting has never been cited before in this context, there are several reasons to suggest it as the critical primary source.

Stanhope's picture, his very first submission to the Royal Academy, is less than half the size of *The White Girl*. Packed with detail and symbolism, it bears several uncanny resemblances to James's picture. Like *The White Girl*, it depicts a young red-headed girl standing alone in a room. Although her outer garment is a blue dressing-gown, underneath her clothing is white. Beside her, on the right, is a window overlooking the Thames at Blackfriars Bridge that throws a light down her right side and across the room. Although not immediately apparent, in James's painting there is also a light source from a window. Early in 1862, James described the figure in the painting to Du Maurier as 'standing against a window which filters the light through a transparent white muslin curtain – but the figure receives a strong light from the right and therefore the figure bearing the red hair is one gorgeous mass of brilliant white'.[19] Even the detail of the way the hair of the two girls is represented – the right-hand locks are brought over the cleavage, while the left-hand locks flow down behind the shoulder – shows a remarkable similarity.

The notion that *Thoughts of the Past* was a primary source is given added credence by the existence of a small, quickly sketched portrait of Joanna dating from this period. Entitled *A White Note*,[20] the portrait is three-quarter length and depicts Joanna standing side-on to a window in almost the same pose as Stanhope's model. One view from James's apartment on the Boulevard des Batignolles was of the main railway-line into the Gare Saint-Lazare, and in order perhaps to add a sense of realism he included in *A White Note* one of the many steam engines that passed his studio window every day, like the glimpse of the shipping on the Thames in Stanhope's picture. In *The White Girl*, he stripped away the outside view. There are only two major differences in the pose of the two pictures: Joanna's arms are folded across her stomach and her head is more inclined towards the window.

One person who knew Stanhope's painting well, and had watched its progress, was James's friend, George Boyce. It is not inconceivable that

they discussed this picture. On several occasions during 1858 Boyce went to Stanhope's studio, and after one particular visit, he described in his diary the picture of an 'unfortunate' in 'two crises of her life'.[21] The symbolism of the painting, together with Boyce's description, leaves no doubt as to the narrative content: the girl is a prostitute, 'gripped in remorse as she thinks of the past'.[22] Such explicit symbolism is not to be found in *The White Girl*. Unlike Joanna's depiction in *Wapping* where James freely admitted that he saw the subject as a prostitute, she is now represented simply as an ambiguous, beautiful girl, timeless and placeless. The only clues to anything overtly sexual are implicit: the lily she holds in her left hand, the wolfskin rug and the wilted flowers at her feet.

James concentrated hard on the painting, working on it, as he later told Du Maurier, 'all the winter from eight in the morning'.[23] Not surprisingly, he regarded it as his most important submission for the next Royal Academy exhibition. In the context of works such as Millais' *Autumn Leaves* and Rossetti's *Ecce Ancilla Domini*, *The White Girl* can be seen as a quintessentially Pre-Raphaelite subject, painted for an English audience. It brings James closer to the circle of the Pre-Raphaelites than is traditionally assumed.

While James worked on through December and into January, Courbet's teaching studio opened in a blaze of publicity at the rue Notre Dame des Champs. Fantin attended only briefly, put off before long, like several others, by its slovenliness and degeneration into a 'club for pointless political arguments'.[24] The studio closed on 2 February after the owner of the premises 'complained of damage caused by Courbet's pupils and gave them notice to leave'.[25] Early in January, James exhibited a selection of his Thames etchings at Martinet's gallery on the Boulevard des Italiens. Louis Martinet, who was also the director of *Le Courrier artistique*, ran one of the few galleries in Paris that were willing to show work of the more progressive artists. Manet had exhibited there the previous summer, and so had Courbet. Accompanying the Thames etchings was one of Fantin's still lifes, a type of picture he had begun to paint while staying with the Edwards family at Sunbury. For them both, the exposure of their work in such a pleasant and well-respected gallery was useful, and provided the chance of some badly needed income.

In February, after his small show at Martinet's had ended, James made a flying visit to London to see Serjeant Thomas about his work. Following the relative failure of his show of etchings the previous year, he felt the dealer was not doing enough to market his prints, and in the light of the proposed formation of a Société des Aquafortistes in Paris, he was bitterly regretting his seven-year contract. However, his predicament was solved

decisively a few weeks after he had returned to Paris, when Serjeant Thomas died. As James cold-heartedly recounted shortly afterwards to Du Maurier, 'I wrote to the old scoundrel, and he died in answer by return post – the very best thing he could do!'[26]

While *The White Girl* may have occupied James's daylight hours, the evenings were spent with Joanna at cafés in the company of friends such as Fantin, Bracquemond, Manet, Courbet, Astruc, Henri Martin, Alfred Stevens and Tissot. The most important of the numerous new introductions, probably made by Tissot, was to a young artist the same age as himself called Edgar Degas who, like Manet, represented a curious figure to the extrovert James. Quiet, pensive and altogether not the bohemian type, Degas was of Parisian birth and came from a wealthy banking family. He began his career as an artist in 1854 when he studied under Louis Lamothe, a pupil of Ingres. These studies were punctuated by trips abroad, and in 1856 he travelled to Italy for three years.

From early in his career Degas, like James, had been keenly interested in etching and spent many hours exploring the print-room of the Bibliothèque Nationale. Amongst the discernible influences in his early work is Rembrandt. While it was his interest in etching that brought Degas into the group, he had already been marked down as a painter of considerable note. Though still mainly occupied with copying Old Masters, he had also completed several individual and group portraits of family and friends – chief among these a group portrait of his aunt, Baroness Bellelli, and her family in Florence which Degas had completed in 1860. Despite the fact that they had not known of each other's work, Degas' group portrait, together with James's *The Music Room* and Fantin's *Two Sisters*, show remarkable similarities. As Reff has rightly noted, all are 'indebted, among other things to Dutch genre scenes . . . in their depiction of a serenely ordered middle-class existence and their harmonious pictorial style'.[27]

By April Fool's day 1862, James had finished *The White Girl* and began to make preparations to take the painting to London for submission to the Royal Academy.[28] He was also going to submit *The Coast of Brittany*, *The Thames in Ice* and the etching *Rotherhithe*.

A week later, he and Joanna arrived in London with the painting. Shortly afterwards he apparently showed it to 'several painters who did not understand it at all', although Millais thought it 'was splendid, more like Titian and those of old Seville than anything he has seen'.[29] As a favour to Fantin, he arranged for one of his recent still lifes to be submitted to the Academy, and soon after his arrival in London wrote to the Edwards at Sunbury requesting that they should select the 'most important' in their keeping and make the necessary arrangements.[30]

While he was waiting for the Academy's deliberations, James looked up his old friend John O'Leary who had been back in London for some time since the death of his brother Arthur the previous year.[31] O'Leary had become the focal point of his family's anxiety on account of his wandering ways and seeming inability to settle to anything remotely resembling a career. O'Leary, however, had other things on his mind than a career. Throughout 1861, the Irish Republican Brotherhood had grown in numbers in Ireland and abroad. Six months earlier, in November, some 50,000 volunteers marched in military formation through Dublin to attend the funeral of T.B. McManus, senior member of the movement. O'Leary claimed later that he was only a spectator watching events at home from a distance. Other evidence suggests, however, that he was firmly back within the structure of the movement and at that time recruiting English sympathizers. The IRB could count on the support of many thousands of Englishmen with Irish nationalist sympathies, as well as on 15,000 British Army soldiers who had secretly sworn the oath of allegiance to the movement. Considering that O'Leary was close to the leadership of the IRB at this time and that there is no evidence that any other member was in England for such prolonged periods as he, one must strongly suspect, despite his denials, that O'Leary was a central part of this recruitment drive.[32]

How much James knew of O'Leary's activities is always difficult to ascertain. What one may assume is that he too had politics on his mind, though American rather than British. Since the summer of 1860, he had been following the events in his homeland with trepidation as the Republican, Abraham Lincoln, was elected President. Reading the newspaper reports, the implications seemed clear. The Southern states would secede from the Union and the country would be plunged into war. These fears were realized early in 1861 when seven Southern states formed themselves into the Confederate States of America and set up a provisional government. Despite a period of uneasy calm in the early spring, any real hope of peace was shattered when the Confederates shelled Fort Sumter, in Charleston Harbour, South Carolina.

In addition to the newspaper accounts, James was kept fully abreast of events by his mother. True to her Christian faith, Anna, at least at the outset of hostilities, took a neutral stance. 'Truly I know no North, I know no South,' she wrote to James shortly after hostilities began.[33] As the conflict turned into a full-blown war, such neutrality did not last. Despite the fact that Anna now lived in Philadelphia, a strong Union city, her North Carolina upbringing ensured that her views on the role of slavery in American society were not influenced by her present geographical location.

In 1853, she had explained to a friend:

> I can witness to the humanity of the [slave] owner of Southern Atlantic
> states, and testify that such are benefactors to the race of Ham believing as
> I have been often led to by my mother's opinions, that the blacks of the
> South are cared for by Christian owners, being taught from the Gospel and
> all their religious indulgences provided for. I take the view that God has
> permitted this.[34]

If she had any lingering doubts when the conflict began, they were
dispelled when James's younger brother, William, who had graduated in
medicine from the University of Philadelphia in 1860, joined the
Confederate regiment, Orr's Rifles, at the behest of his Virginia-born wife,
Florida King.

The Civil War was a painful period for the Whistler family. Like so many
other American families, the various branches found their loyalties divided.
James's cousin Donald McNeill Fairfax, son of Anna's elder sister Isabella,
saw active service during the war on the side of the Union and later became
a Rear-Admiral in the United States Navy. Among his non-combatant
relatives was the family of his great-uncle, Zephaniah Kingsley, plantation
owners from Florida, who took the side of the Confederacy. The Swifts,
who were related to James through his father's first marriage, not
surprisingly took the side of the Union, as did the wealthy Winans family
from Baltimore.

James never had any doubts as to where his loyalties lay. His derogatory
view of blacks as an inferior race had long been a prominent feature of his
personality and ensured his support for the Confederate South. Time and
time again, his feelings on the matter crop up in his correspondence. He
wrote with apparent relish of 'a little healthy American lynching'.[35] It has
been argued that James's bigotry was deep-rooted, stemming from the fact
that in the King branch of his family there was a 'sizeable number of
mulatto first and second cousins'.[36] James was aware and privately ashamed
of this family secret, and so reacted bitterly.

Interestingly, James's sympathies were very much at odds with O'Leary's
for many of the key Irish Republican Brotherhood members were fighting
in the Civil War on the side of the Union. There were Irish Brigades such
as the Phoenix Zouaves, and one of the most important American
members of the Republican Brotherhood, Thomas Meagher, was
commissioned a General by Lincoln as part of his policy of rewarding
ethnic leaders. O'Leary was horrified at the human cost of the war,
particularly in relation to the Irish Volunteers, and writing much later in

1898, he noted, 'Irish blood was shed like water in a cause which was not Ireland's.'[37]

However, despite their ideological differences, the two friends did not fall out, and O'Leary seems to have acted as a foil to James's uncertainties as the horrific events in America unfolded. He was familiar with the political background, and a good analyst of military affairs, so was in a position to explain and rationalize episodes to James as they occurred. It seems certain that they met frequently during this period, and O'Leary's biographer has suggested that James's presence was one of the main reasons for O'Leary preferring London to anywhere else.[38]

On Varnishing Day early in May, a week before the official opening, James arrived at the Royal Academy to see if his pictures had been hung. He later described what happened to Harper Pennington:

> I went . . . to see where they had put her. She was not in the first room, nor the second, nor the third – I felt a little anxious – but I wandered on, and on, and on, through room after room, and when I came to the last of them I knew she was rejected. Still, I might have missed her, somewhere in the crowd of pictures, so I went all over them again, growing positively sick. And then I went downstairs and poked about until I found her leaning on a wall . . . and I knew that she was beautiful and was consoled.[39]

His two other paintings and the etching *Rotherhithe* had been accepted, but the rejection of *The White Girl* was a bitter blow. It seemed that all the hard work of the winter had been in vain.

The press reacted favourably, however, to the remaining work, and again his friend, the critic Frederick Stephens, rallied to the cause and compared his etching to the work of Rembrandt. Fantin's still-life entry had been hung, but this success did little to cheer the gloomy artist, who shortly afterwards wrote to Edwin Edwards deploring his need to paint such pictures: 'Never have I had more ideas about Art in my head, and yet I am forced to do flowers . . . This cannot go on.'[40]

Characteristically, James's reaction was different and almost immediately he flung himself back into his work. Around this time, perhaps in an effort to take his mind off other matters and to earn some badly needed money, James began a series of magazine illustrations – four for *Good Words* and two for *Once a Week*. How he came to do the work is not altogether clear, though the Pennells were later told by the editor of *Once a Week* that the commissions 'were arranged' by Edward Dalziel.[41] This statement is hard to explain since James appears not to have known Dalziel; it is more likely that it had something to do with his circle of illustrator friends such as

Keene and Du Maurier. As James jokingly related to Edwin Edwards a short time later, 'I've been guilty of something in *Once a Week*!!!!'[42] He never again repeated the exercise.

During the spring and early summer, he continued to attend meetings of the Junior Etching Club and took an active part in many of the proceedings. At a meeting on 4 June, James proposed a publishing scheme similar to that contemplated by his friends of the Société des Aquafortistes, formed several days earlier on 31 May in Paris. According to the minutes: 'Whistler raised the possibility of starting a periodical which should contain illustrations by the Etching Club. It was proposed that members should ascertain whether any publisher would undertake such a thing.'[43] When shortly afterwards it became apparent that his proposal was not going to get any further, he made up his mind to quit the club and he never returned. Several weeks later, he offered his Thames plates to the dealers Colnaghi, but they found his terms unacceptable.

Although he had grown accustomed to the depressions suffered by Fantin, it came as a shock when he heard from Haden that Du Maurier had suffered a nervous breakdown while on a visit to Sloane Street. It seems Du Maurier had been ill for some time, almost certainly through the stress of his relationship with Emma Wrightwick whom he was desperate to marry. James visited Du Maurier at his studio shortly after hearing the news, accompanied by Joanna. Du Maurier resented their arrival and he particularly disliked Joanna, scathingly noting later that she was 'got up like a duchess, without crinoline – the mere making up of her bonnet by Madame somebody or other in Paris had cost 50*fr*.'[44]

A month of so after *The White Girl* had been rejected at the Academy, a new gallery opened in Berners Street around the corner from Newman Street. What attracted James to it was the owner, an enterprising young man called Matthew Morgan, who invited him to show *The White Girl*. His earlier picture, *At the Piano*, was also loaned to the gallery by its new owner, John Phillip RA.[45]

Shortly after the exhibition opened in June, James wrote proudly to George Lucas:

> She looks grandly in her frame and creates an excitement in the artistic world here which the Academy did not prevent or foresee – after turning it out I mean. In the catalogue of this exhibition it is marked 'Rejected at the Academy'. What do you say to that? Isn't that the way to fight 'em! Besides which it is affiched all over the town as

> Whistler's
> Extraordinary
> picture
> The
> Woman in
> White

That was done of course by the directors but certainly it is waging an open war with the Academy. Eh![46]

Two days later, James's excitement turned to ruffled indignation. An article which appeared in the 'Fine Arts Gossip' of the *Athenaeum* singled out the painting, noting:

> Able as this bizarre production shows Mr Whistler to be, we are certain that in a few years he will recognize the reasonableness of its rejection by the Academy. It is one of the most incomplete paintings we have ever met with . . . But for the rich vigour of the textures, one might conceive this to be some old portrait by Zucchero, or a pupil of his practising in a provincial town. The face is well done, but it is not that of Mr Wilkie Collins's 'Woman in White'. Those who remember the promise of the artist's 'Lady at the Piano', seen at the Academy, will gladly see it here.[47]

On 1 July James sought to set the record straight:

> The Proprietors of the Berners Street Gallery have, without my sanction, called my picture 'The Woman in White'. I had no intention whatsoever of illustrating Mr Wilkie Collins's novel; it so happens, indeed, that I have never read it. My painting simply represents a girl dressed in white standing in front of a curtain.[48]

In the light of James's earlier letter to Lucas, his protestations at this juncture seem curious, if not a little weak. The fact that he might object to the literary association with Wilkie Collins is understandable, but his refutation of the actual title was taking a liberty. Not surprisingly, his letter annoyed the manager of the gallery, Mr Buckstone, who without James's knowledge wrote to the journal and explained his side of the story:

> Mr Whistler was well aware of his picture being advertised as 'The Woman

in White', and was pleased with the name. There was no intention to mislead the public by the supposition that it referred to the heroine of Mr Wilkie Collins's novel.[49]

Buckstone's letter brought the matter to a close. James's first impetuous letter to the press had backfired, and, if anything, had made him look a little silly among his friends. But it had got him noticed again, which was always important. The fact that an artist had written to the press at all was unusual, particularly one so relatively new on the scene, and it is possible that James had been influenced by the example of the highly publicized Antwerp address by Courbet when he used the media to defend his position. In doing so, James had given his answer to the time-honoured dilemma: who criticizes the critic? For James the answer was obvious – the artist, the only person qualified to do so. The reaction to his first letter to the press had, however, hurt, and it was another five years before he had the courage to repeat the performance. When he did, he made sure that he had all the ammunition.

Eight days after Buckstone's rebuttal had appeared in the *Athenaeum*, James spent an evening at the lodgings of a young poet, Algernon Charles Swinburne, who had recently moved to Newman Street. George Boyce, who had almost certainly arranged James's invitation, later noted an outline of the evening in his diary:

> at Swinburne's, taking with me as a contribution to his housekeeping 2 old blue and white Wedgwood dishes and a very fine Chinese plate or dish. Present: D.G. Rossetti, Whistler, Val Prinsep, Ned Jones and Sandys. Whistler gave humorous vent to a lot of comic stories. Walked away with Jones and Rossetti. Chat about Ruskin.[50]

This meeting is the first recorded between James and Rossetti. For the first time since his arrival in London James was now at the heart of the later Pre-Raphaelite circle. While the company may have found his stories amusing, he must have found them, especially Rossetti and Swinburne, remarkable. As related by his brother Michael, Rossetti's typical evening had its own peculiar routines wherever he happened to be. Dinner was always late, while

> He lolled on the sofa, chatting as the humour came or sometimes dozing . . . My brother, though radically good-natured, was not of what one calls an accommodating turn. His own convenience dictated his habits, and persons in his company had to adapt themselves as best they could . . . he did

nothing in the evening, beyond talking and lounging . . . We usually sat up late.[51]

In contrast to Rossetti's benevolent indifference, Swinburne's behaviour must have seemed like outright lunacy. Three years younger than James, Swinburne had met Rossetti at Oxford when he was 20. He was of small build, like James himself; his head, topped with a mop of undisciplined red hair, seemed out of proportion with the tiny body below, and his personality could be overwhelming. N. John Hall, one of his biographers, writes that Swinburne was

subject to nervous trembling that his contemporaries likened to St Vitus's dance. He was a raging alcoholic and sexual exotic, who, naked, would indulge in frenzied dances, slide down staircase handrails, and generally create scenes. Drunk or sober, he loved to recite poetry.[52]

The others present that night, Val Prinsep, Edward Burne-Jones and Frederick Sandys, were, in their entirely different ways, more moderate characters. James had already come across the huge jovial frame of Prinsep in Paris, at Gleyre's studio. Prinsep, like Burne-Jones, had assisted Rossetti in the decoration of the Union Debating Society's premises at Oxford. By this time, James may also have met Burne-Jones through the Ionides and Sandys through Du Maurier.[53] Both were interesting personalities: Burne-Jones was witty and considered by Rossetti as 'the greatest of living draughtsmen'.[54] Sandys' easy-going manner ensured that he had few enemies, and from that evening he and James became lifelong friends.

By this time, the Pre-Raphaelite Brotherhood had all but abandoned its original intentions. Of the founder members, only Holman Hunt continued to work with the same biblical and moralizing subject-matter. Created on the wave of revolution which had swept Europe in 1848, the Brotherhood had challenged what they perceived as the moral emptiness of current work. 'They hated the lack of ideas in art,' wrote Michael Rossetti, as spokesman for the group. They also hated, he continued,

those forms of execution which are merely smooth and prettyish, and those which, pretending to mastery, are nothing better than slovenly and slapdash . . . Still more did they hate the notion that each artist should not obey his own individual impulse, act upon his own perception and study of Nature.[55]

The study of nature was to be the key characteristic of their work. Such objectives were not new, and as early as 1843 a young writer (and sometime

painter) called John Ruskin had published a book, *Modern Painters*, which he intended to be 'a complete treatise on landscape art'.[56] Although he would not meet any members of the group until many years later, his work was of seminal importance during the formative years of their existence. In the first volume, one passage seemed both to epitomize and endorse the Brotherhood's objectives. Ruskin exhorted young artists

> to go to Nature in all singleness of heart and walk with nature laboriously and trustingly, having no other thoughts but how best to penetrate her meaning and remember her instruction; rejecting nothing, selecting nothing and scorning nothing; believing all things to be right and good, and rejoicing always in truth.

They placed scrupulously recreated biblical and literary scenes in backgrounds full of meticulous detail and, by using a wet white ground, achieved a luminosity probably unique in British art.

In 1850, with the appearance at the Royal Academy of Millais' picture *Christ in the Carpenter's Shop*, the Brotherhood was ferociously attacked, particularly in the infamous review by Charles Dickens which appeared in *Household Words*: describing the Christ figure as a 'blubbering, red-haired boy in a nightgown' and the Virgin as a woman 'horrible in her ugliness'. But the movement was not without support. In May the following year, Ruskin threw his popular critical weight behind the Brotherhood, and concluded by noting that with it 'lay in our England the foundations of a school of art nobler than the world has seen for three hundred years'.[57] For nearly a decade, particularly through his widely read *Academy Notes*, Ruskin's support for the Brotherhood never wavered, and time and again he reiterated his oft-quoted opinion that since the death of Turner, 'I consider that an average work from the hand of any of the four leaders of Pre-Raphaelitism [Rossetti, Millais, Holman Hunt and John Lewis] is, singly, worth at least three of any other pictures whatever by any living artist.'[58]

Although James had known Millais for some time, as well as more peripheral members of the circle such as Keene and Boyce, his introduction to Rossetti was almost certainly the result of the public appearance of *The White Girl* in Berners Street, which indicated a certain aesthetic compatibility. Since the mid-1850s some of the Pre-Raphaelites, particularly Millais and Rossetti, had begun to move away from the stern strictures of Ruskin's philosophy based on historicism and realism. The appearance of Millais' picture *Autumn Leaves* at the Royal Academy in 1856 was arguably the first signal of future intent. As his wife Effie noted in her

ournal, her husband 'wished to paint a picture full of beauty and without subject'.[59] A recent commentator, Malcolm Warner, expanding upon this intention, has described *Autumn Leaves* as 'metaphorical, self-contained and strangely static, with no implication of events or action leading up to the moment depicted or continuing afterwards'.[60] Such a description fits *The White Girl* perfectly.

By 1862, James was no stranger to the debate whether art should serve beauty or morality and was familiar with the Baudelairean belief that the socio-political philosophy behind Courbet's realism was the complete negation of the creative spirit. For James, the argument still posed a dilemma, and while *The White Girl* may have been seen in England as essentially a Pre-Raphaelite painting, it could (and later would) be perceived as a reaction against realism.

Of the younger circle of Pre-Raphaelite followers, it was Swinburne more than anyone else who, in his writing, embraced and popularized the emerging belief in the supremacy of form over subject-matter. It may be no accident that shortly after his first meeting with James, Swinburne began writing a review of Baudelaire's *Fleurs du mal*, which had been published five years before in France. The review appeared on 6 September in the *Spectator*, and its opening paragraph gives the gist of Swinburne's argument:

> The poet's business is to write good verses, not to redeem the age and remould society. The courage and sense of a man who professes and acts as if the art of poetry has absolutely nothing to do with didactic matters are proof enough of the wise and serious manner in which he is likely to handle the materials of his art.

This was the clearest exposition of Aestheticism, or art for art's sake, which had so far appeared from the Pre-Raphaelite camp. It was, as Swinburne implied, as much a way of life as an aesthetic theory. Although some authors have justifiably argued that Baudelaire's beliefs transcended the concept of art for art's sake, nevertheless at its first appearance in England his work was seen as personifying that creed.[61] For Swinburne, the *Spectator* review was only his first tentative step towards Aestheticism. During the years that followed, in works such as *Poems and Ballads* (1866) and *William Blake* (1868), he honed and refined his thinking and created some of the finest aesthetic writing in Victorian England.

The appearance of *The White Girl* in 1862 turned out to be timely. The painting was, as Malcolm Warner has pointed out, 'a key picture . . . placing the beautiful above all other considerations . . . an impassively beautiful female face that became the chief icon of aestheticism'.[62]

During the summer, James had been working intermittently on a river painting entitled *The Last of Old Westminster*.[63] This did not, as the title suggests, depict the demolition of old Westminster Bridge, but the building of the new replacement bridge then nearing completion. His choice of subject-matter was not surprising. *Wapping* was still unfinished, but the relative success of other river paintings had convinced him of their popularity. During the initial stages of the painting, he and Joanna were still living at Newman Street, but not long after his meeting with Rossetti they had moved to Queens Road, Chelsea (the street now known as Royal Hospital Road) not far from the river.[64] In June, Joanna's mother had died suddenly and James, who seems to have taken to her, was, according to Du Maurier, 'quite sentimental' when he attended the funeral.[65] While the move may well have been in part prompted by this, it was also probably determined by the proximity of both Rossetti, who had moved some months before to Tudor House in Cheyne Walk, and O'Leary, who was a short distance away in Pimlico Terrace.

According to Arthur Severn, an artist and fringe associate of the Pre-Raphaelites and a friend of John Ruskin, *The Last of Old Westminster* was painted from the window of his lodgings in Manchester Buildings which he shared with his elder brother, Walter. In an interview given to the *Morning Post* several months after James's death in 1903, Arthur Severn described James's working methods.

> I had an idea that he would do the picture very quickly, but he took weeks over it . . . most of the stone work had been removed and many piles were being driven into the deep mud. To my uneducated eye these piles looked all about the same grey, and the shirts of the little figures working looked to me all the same white, but Whistler spent much time getting various tones out of the heaps of colours on his large palette. After securing the exact shade of grey or white which he wanted he did his pile or shirt with a few dexterous dabs, screwing up his eyes and expressing satisfaction if successful.[66]

In subject-matter and style, *The Last of Old Westminster* is much freer than the earlier painting *Old Battersea Bridge* of 1859. It is also evident that James was still preoccupied with realism. His earlier etching of the same subject, *Westminster Bridge in Progress*, was never completed satisfactorily, a fact confirmed by its rarity.[67] Now, it seems, he was determined to resolve the compositional dilemma posed by the structure. In the etching, he had deployed a Japanese device, using a long horizontal format which visually exaggerates the scale of the bridge. In the painting he had moved away

from the horizontal shape to a squarer format, virtually the same size as *Old Battersea Bridge*.

The picture was probably completed sometime in August. James was pleased with it, and later in the year decided to send it to the second exhibition of the Société Nationale des Beaux-Arts at Martinet's gallery.[68] It was the last work he did in London during 1862. Between then and the end of September he continued to meet almost daily with Rossetti and Swinburne. Occasionally they would visit the Hogarth Club, an important meeting point for artists, where James would encounter other artists such as Ford Madox Brown, Arthur Hughes and John William Inchbold.

In late September, after nearly five months in London James decided to make a return trip to France which he had planned for some time.[69] The place he chose this time was Guéthary in the Basses-Pyrénées. By the beginning of the first week of October, he and Joanna were on their way.

9

The Salon des Refusés

JAMES AND JOANNA booked into a small hotel, the Maison de la Croix, at
Guéthary, four miles south of Biarritz, in October 1862. Although the
trip was primarily a holiday, James intended to do some work and also
planned to travel down to Madrid to see the work of Velázquez in the
Prado. He had hoped that Fantin would join them in Spain, but Fantin
declined, and instead asked that James should 'report his impressions' and
possibly 'bring back reproductions – of the master's pictures'.[1] Full of
enthusiasm James agreed:

> If there are any photographs to be had, I will bring some back. As for
> sketches, I hardly dare attempt it, but if I have the nerve, I may try. You
> know, that glorious painting cannot be copied. Oh, mon cher, how he must
> have worked.[2]

Shortly afterwards, Fantin sent James a review by Baudelaire which had
appeared in the *Boulevard* on 14 September of the first portfolio published
by the Société des Aquafortistes. Although James had been included in the
list of artists sent to the Minister of State, Count Walewski, by Léon Cadart
the managing director and editor of the new society, he had still not
officially joined it or submitted a plate for publication.[3] In his wide-ranging
review, Baudelaire commented generally on the etching revival, and
recalled seeing some of James's Thames etchings at Martinet's gallery in
January:

a set of etchings, subtle, lively as to their improvisation and inspiration, representing the banks of the Thames; wonderful tangles of rigging, yard-arms and ropes, a hotchpotch of fog, furnaces and corkscrews of smoke; the profound and intricate poetry of a vast capital.[4]

James's adverse reaction to these remarks seems surprising. Replying to Fantin he wrote that Baudelaire 'said many poetic things about the Thames and nothing about the etchings themselves'.[5] In the same letter, he enquired about the running of the new society and stated his intention to join when he returned to Paris. In reply, Fantin merely dismissed Baudelaire's comments as nonsense, and warned James about 'the stupid politics' of the new society.[6] Apparently Cadart and Delâtre intended 'to reject those who are doing things, and to have only what pleased the public – finished works, as they call them'.[7] In view of this, Fantin believed that Manet, Legros and Bracquemond were planning a coup in order to wrest control from Cadart, and he said that he too would 'quit the society with arrogance and disdain' if they rejected, as he believed they would, his first etching, *The Two Sisters*.[8]

James's odd reaction to Baudelaire's article, together with Fantin's dismissive attitude, must be seen in terms of the review as a whole. By this time Baudelaire had toned down his scathing attacks on Courbet, arguing that he had played an important role in repudiating the prevalent academicism, re-establishing 'a taste for simplicity, for freeedom and for an absolute, disinterested love of painting'. While James undoubtedly read this part of the review with interest, it was what followed that caused his annoyance. Here, Baudelaire singled out the work of Manet and Legros for special mention:

Manet is the painter of the *Guitarero* which caused such a lively stir at the recent Salon. At the next we shall see several of his paintings, touched with the strongest Spanish savour, which leads us to believe that Spanish genius has taken refuge in France. Manet and Legros join to a pronounced taste for reality, for modern reality – which is indeed a healthy symptom – that active and spacious imagination, both sensitive and bold, without which it must be said even the best talents are only servants without a master, agents without authority.[9]

Baudelaire's anticipation of 'Spanish savour' in Manet's painting perhaps spurred James on to search for a Spanish subject which he too could submit to the next Salon. It was not long before he and Joanna crossed the border into Spain and visited the small town of Fuenterrabia. Here they

quickly came across the artist Gustav Collins whose work James had seen in the Société Nationale des Beaux-Arts exhibition at Martinet's gallery in Paris. Collins explained to James that in order to be successful with Spanish subjects it was necessary to 'persevere for several years'.[10] The most likely reason for Collins's discouragement, James remarked, was that he wanted 'to keep his hard-won territory to himself'.[11] Circumstances enabled him to do so: 'no one understands a single word of French,' James told Fantin; models were difficult to find and even more difficult to train'. Faced with these frustrations, James returned to Guéthary.

Fantin was going through another personal and professional crisis, and wrote of lonely evenings spent looking at his photographs of 'many Old Master pictures', thus engaging in 'charming conversations with the finest minds in the world'.[12] In the same letter, he confessed: 'I am in such a troubled state, searching for myself . . . I, more than others, am caught in the struggle between Life and Art.'[13] Perhaps in an effort to lighten Fantin's burden, James wrote divertingly from Guéthary about his own problems. He found the sea 'so flat you want to spit in it',[14] and the amount of time wasted waiting for the right painting conditions was exasperating:

My picture drags. I do not work fast enough! Moreover painting from nature can only be large sketches. It does not work. A wave or cloud is there for one minute and then is gone. You must catch it in flight as you kill a bird in the air – and then the public asks for something finished.[15]

There was only one possible conclusion: 'painting from nature should be done at home!'[16] This sentiment was underlined when, later in the holiday, the flat sea erupted while James was painting on some rocks, and he was swept off and very nearly drowned.

The sea here is terrible. I was carried away by a strong current which dragged me towards those breakers . . . and if it had not been for my model in the red shirt I should have left my canvas unfinished. Because I should have been stone dead. The sea was enormous. The sun was setting, all lent itself to the occasion, and I saw the land getting further and further away. A wave fifteen feet high engulfed me, I drank a ton of salt water, passed through it, to be swallowed up in a second twenty feet high, in which I turned round like a catherine-wheel and was overwhelmed by a third. I swam and swam, and the more I swam the less I approached. Ah my dear Fantin, to feel one's useless efforts and lookers-on to be saying, 'But this gentleman is amusing himself; he must be jolly strong.' I cried, I howled in despair, I disappeared three, four times. At last they understood. A brave

railway contractor ran and was twice rolled over on the beach. The bathing attendant, my model, heard the call and arrived at a gallop, jumped into the sea like a Newfoundland, succeeded in catching my hand and the two pulled me out.[17]

The only painting which was finished and survives from the holiday is *Blue Wave, Biarritz*[18] which James clearly intended for the Royal Academy, following the acceptance of *The Coast of Brittany* and *The Thames in Ice*. In the end the painting was never exhibited there, but was sold to Gerald Potter for £50. It was the first time he had attempted a picture that does not include the prop of a human figure, being wholly concerned with capturing the moment and the effect when the huge waves crash against the break-water.

Compared to his other work of this period, *Blue Wave, Biarritz* was very much an experimental picture. Although painted in a bold realist manner, it has arguably as much to do with the recent formal concerns of *The White Girl* as with anything else. Alone, on a beautiful stretch of beach overlooking the Bay of Biscay, James had created a timeless, placeless picture. Moreover, in spite of the uneven weather, he had done it *en plein air*.

Joanna's health, which had not been good for some time, had not improved by early November, so they decided to forgo the visit to Madrid. Explaining their decision to the still thoroughly depressed Fantin, James wrote: 'I am postponing my trip until next year, and then you will come with me . . . It will be a sacred pilgrimage, and nothing must stop us.'[19]

Before returning to London, James and Joanna paid a brief visit to Paris to see Martinet about exhibiting *The Last of Old Westminster* at his gallery, and to find out what his friends would be submitting to the Salon the following spring. When James visited Fantin, he found him melancholy and withdrawn; he had not yet completed any work for the Salon. From Fantin, James also heard the rumour that Martinet was planning a one-man show of Manet's work to take place in March, a month before the Salon.

James arrived back in London in mid-December convinced that he should submit *The White Girl* to the Paris Salon.[20] His half-brother George, who had been working for the Winans railway project in St Petersburg, arrived and there was a joyful reunion at Deborah's house in Sloane Street, but everyone was shocked by George's appearance. He looked haggard and ill; the climate in Russia had played havoc with his health. One topic dominated the family reunion – the American Civil War. William was still safe and unharmed, based with his regiment in Virginia. During the Yankee naval blockade Anna had managed to travel through the Union lines to visit him. For Confederate supporters like James, the increasing public support

for their cause in Britain was encouraging. By the end of 1862 they genuinely believed that victory was around the corner.

Throughout that winter, James did no work. In the evenings he often visited Rossetti and Swinburne at Tudor House where, surrounded by a menagerie of exotic animals and birds, including a pet raccoon, a wombat, peacocks and two kangaroos, they talked and drank until the early hours. In the first months of 1863 James met the architect, Edward Godwin, and J. Anderson Rose, Rossetti's solicitor, who was soon to act for him. Both men would play important roles in his future. One person he had not yet met through Rossetti was the author and art critic, John Ruskin. One thing, however, is certain: through Rossetti and his circle Ruskin was well aware of James's art.

The early months of 1863 were essentially concerned with matters other than work. In the aftermath of adverse publicity which had followed the publication of the Société des Aquafortistes' first portfolio, Fantin's belief that Cadart was anxious to revamp the publication with more 'picturesque' plates proved correct. To this end, Cadart had visited London during James's absence in France expressly to see Haden and acquire an etching for the fourth portfolio, which was scheduled to appear in December 1862.[21] Haden's inclusion certainly infuriated James, and throughout the Christmas period his anger simmered. In February, a review by Philippe Burty appeared in the *Gazette des Beaux-Arts* which, after criticizing the more progressive work of Legros and Bracquemond, heaped lavish praise on Haden, calling him one of the most brilliant etchers in England.[22] For James it came as a severe shock to read such praise for his 'amateur' brother-in-law: he was stealing the limelight from right under his nose. When he visited Du Maurier to congratulate him on his marriage, the blow to his ego had cut deep and Du Maurier observed a difference in his attitude. It is, he wrote, 'rather changed lately – he is more modest about his own performances . . . and was peculiarly modest about his etchings.'[23]

James's first practical reaction to Haden's success was to ensure as far as possible that he was well represented by etchings at both the Royal Academy and the Paris Salon – where he was confident he would at last make his debut appearance. By the end of February, he had decided on his submissions to the Royal Academy: he would send only one painting, *The Last of Old Westminster*, and six etchings, the largest number he had ever submitted.

Apart from *Weary*, the etchings were not recent – one, *Monsieur Becquet*, was nearly four years old and part of a series of portraits of Parisian friends done in 1859. But they were carefully selected in order to re-establish his credentials in the face of Haden's recent critical acclaim. *Weary* is a sensitive

portrait of Joanna reclining in a chair, executed between late December and March, and indicative of how James was now blatantly adopting Pre-Raphaelite themes; it seems to relate directly to a particular drawing by Rossetti of his new mistress Fanny Cornforth.[24] But the flow of influence was by no means one-way. There is strong evidence in a picture such as Rossetti's *Fazio's Mistress*,[25] begun late in 1863, to suggest otherwise. Rossetti described it as 'chiefly a piece of colour',[26] a clear echo of the rebuke James had delivered in the *Athenaeum* in regard to the alleged literary overtones of *The White Girl*. White predominates in this sensuous half-length portrait of the beautiful, red-headed Fanny Cornforth, and whether consciously or not, Rossetti was certainly affected by James's *The White Girl*.

Millais' contribution to the 1863 Royal Academy exhibition also shows intriguing similarities to *The White Girl*. Entitled *The Eve of St Agnes*,[27] it illustrates Keats's poem, and shows Madeline undressing in the moonlight, while being secretly watched from a distance by her lover, Porphyro. It was a subject that Millais had experimented with for many years but left unresolved. The fact that he now approached the theme again suggests that something had rekindled his interest, and *The White Girl* seems a convincing spur. Unlike the cluttered and highly literal interpretation by Holman Hunt in 1848, Millais rids the scene of all detailed props and shows instead a single female figure, bathed in light, standing in a spacious room. The timeless quality of the painting, the implicit sexuality of the subject, the use of falling light, all point to the same source.

While creative influences may be a matter for speculation, James and Rossetti had one definite area of mutual interest – a taste for old blue and white porcelain from the Far East. Rossetti adored the china and had been feverishly collecting for some time. James, of course, had been well aware of Japanese art for several years, though when exactly he began collecting china is not clear. He certainly knew of shops in Paris such as La Porte Chinoise on the rue Vivienne and Mme Desoye's on the rue de Rivoli, which had opened the previous year and was a regular haunt of several friends including Manet and Astruc. When he was last in Paris, he had bought several Far Eastern *objets d'art* and taken them back to London. Rossetti was impressed, if not a little jealous. By the end of 1863 Du Maurier could write, after a rare dinner with James, that his china was very fine, 'about sixty pounds worth, and his anxiety about it during dinner was great fun'.[28] The collecting craze continued for several years and became increasingly competitive. In an effort to upstage James, Rossetti was at one point keen to visit Holland to buy more 'blue china' and wrote to Anderson Rose, 'do not hint a word to Whistler'.[29] On another occasion so excited did James become over a 'particularly choice Japanese fan' that he

had to be physically restrained from coming to blows in Paris with his friend Zacharie Astruc.[30]

Despite his growing links with Rossetti's circle James still felt a strong kinship with Paris and kept in touch with his French friends, particularly Fantin. When Fantin needed advice, it was usually to James that he turned. In early February 1863, when Stavros Dilberoglou, a Greek merchant and friend of the Ionides living in England, bought three paintings from Fantin and commissioned three others, it was James, at Fantin's request, who acted as his agent. He collected the finished paintings from the railway station, arranged delivery and took the payment which he sent to Fantin in Paris;[31] he even formulated a new pricing framework to ensure that Fantin got the best prices for his work.[32] It was a measure of their friendship that James neither asked nor received a penny for his efforts.

In March, James decided to move with Joanna to a new residence, 7 Lindsey Row, directly overlooking the Thames at Battersea Bridge, and only yards from Tudor House. He took a lease for three years at an annual rent of £50, thus signalling his intent to settle in London. Shortly after moving in, he heard that his brother William's wife, Florida, had died suddenly from illness in Virginia. The news certainly saddened him tremendously. He always felt close to his brother, and this tragedy in the midst of the Civil War was particularly poignant.

One of the first visitors to Lindsey Row was Haden. There was still an uneasy calm between the two, and James must have decided that it was time that Haden should be introduced to Joanna and his domestic situation made clear. From later events it can be assumed Haden took offence, but for the moment held his fire. Indeed, on his first visit he made an etching from the window looking down-river.[33]

Not long after Haden's visit, James came across two young boys who were painting on the tidal foreshore outside his house. Intrigued at the sight, he introduced himself and invited them to come and see his new studio. It transpired that they were brothers and that their names were Henry and Walter Greaves, sons of Charles Greaves, the nearby boatyard owner.

After seeing the studio, Walter, who was 17, and Henry, who was 19, took James to meet the rest of their family two doors along the Row. There were six children in the Greaves family – three girls: Eliza, Emily and Alice, always known as 'Tinnie', and another older brother, Charles. Their parents, Charles Snr and Elizabeth, always Mrs Greaves to James, warmly welcomed him to their modest household, and were as curious about this 'Yankee' neighbour as were their sons. A proud man, Charles Greaves sat the 'Yankee' down and explained the family business. They had always

been involved with the river and they built the pulling boats and skiffs for Thames watermen, and also maintained the structure and paintwork of the ceremonial barges belonging to the Corporation of the City of London which were berthed at Chelsea. In the summer months, they transported people and goods under contract up and down the river and across to Battersea. The river was in their blood. James was fascinated; Walter and Henry were captivated.

So began a relationship that would last for nearly twenty years. James became an integral part of the Greaves' family life. That, at any rate, was how the family viewed the relationship. For James, however, nothing was so clear-cut. He did for many years enjoy their warm and welcoming company and liked their down-to-earth honesty and unsophisticated ways; and on occasions when he was in a financial predicament, he was not averse to borrowing money from Mrs Greaves to pay off pressing debts.[34] But as with so many of James's friendships, it was often his convenience as much as anything else which determined its course. For the moment, however, he was flattered by the family's appreciation and readily assumed the role of teacher and mentor to the two boys. In the early stages, he kept them away from his circle since Walter never mentions Rossetti or anyone else from further up the riverside. The brothers, particularly Walter, seem to have worshipped James and they quickly became his self-appointed unpaid studio-assistants. No task was too great: to be in James's company was their only demand.

On 16 March, James despatched *The White Girl*, together with three Thames etchings, *The Pool*, *Limehouse* and *Rotherhithe*, to George Lucas in Paris for submission to the Salon. It was his first major entry and its importance to him is revealed in the letter which accompanied them: 'I have set my heart upon this succeeding, and it would be a crusher for the Royal Academy here, if what they refused were received at the Salon in Paris and thought well of –'[35]

Not long after the pictures had been despatched, James decided to make a quick visit to Paris himself with Swinburne. The fact that he offered to bring the wildly exhibitionist poet to Paris to meet his friends Manet and Fantin is indicative of how close Swinburne and he had become during the six months of their friendship, and shows that James could be totally unselfish when he was genuinely interested in a fellow artist's well-being. It was around this time that he gave Swinburne the first version of *La Mère Gérard* which he kept for the rest of his life. Swinburne was then working on his 'epic of flagellation', *The Flogging Block* (unpublished), being deeply into the practice himself, and had a reputation for becoming 'screaming drunk' most nights. Perhaps James thought an introduction to Fantin and,

in turn, Manet might somehow calm him down: he had found that he could sometimes talk Swinburne out of excessive drinking if he could provide something to occupy his mind.[36] For James himself a visit to Paris at this time would enable him to see Manet's one-man show, which had opened at Martinet's gallery on 1 March.

Leaving Joanna in London, James and Swinburne arrived in Paris sometime towards the end of March. They were both convinced Francophiles, and after attending to the serious business of framing *The White Girl*, which was done in Fantin's studio shortly after they arrived, they presumably spent the remainder of their time in Paris visiting James's old haunts, and drinking under James's supervision. The trip was to prove memorable for Swinburne, particularly his introduction to Manet. Many years later he wrote in a letter to Stéphane Mallarmé: 'He [Manet] doubtless does not remember it, but for me, then very young and completely unknown . . . you may well believe it is a memory which will not easily be forgotten.'[37]

Displayed around Martinet's gallery were fourteen of Manet's recent paintings including *Street Singer*, *Old Musician* and *Music in the Tuileries*. The hope that the exhibition would incite the critics to write sympathetic reviews and thus favourably influence the Salon jury, turned out to be a bad miscalculation. The show did attract much attention, but nearly all of it adverse. When the Salon jury began its mammoth task on 2 April, James and Swinburne had returned to London. By the third day of the selection procedure, rumours had begun to circulate that the jury was engaged on a 'veritable massacre'. Such fears were confirmed when the official list was published on 12 April. Nearly 4,000 paintings had been rejected, some three-fifths of the total submitted. Manet's three paintings were among them, as was *The White Girl*, though James's etchings were accepted. His disappointment was certainly not helped, no matter how he reacted outwardly, by the fact that Legros, Fantin and Courbet all had paintings accepted. His decision to make London his base had been correct, and this was underlined a week or so later when he was informed that the jury of the Royal Academy had accepted all his submissions.

As he pondered his next move, reaction to the mass of refusals was gaining momentum in Paris. On 15 April, Martinet in his own publication, the *Courrier artistique*, stated his views on the subject:

Numerous artists, having learned that the jury had refused their works, have come to ask whether they might exhibit them in our galleries. Here is our reply: 'We shall try to receive well all those proscribed; the only excess which must be fought and against which one has to be severe is that of

mediocrity. Every work of art submitted to us which is free of blemish shall be welcome.'

James was informed of this alternative plan by Fantin[38] but no sooner had Martinet's proposal been aired than a shock announcement was made in the government-sponsored newspaper, the *Moniteur*, on 24 April, a week before the Salon was due to open. Undoubtedly the authorities feared a repetition of the ugly scenes which had marred the Salon in 1859, and the announcement read:

Numerous complaints have reached the Emperor on the subject of the works of art which have been refused by the jury of the exhibition. His majesty, wishing to let the public judge the legitimacy of these complaints, has decided that the rejected works of art are to be exhibited in another part of the Palace of Industry. This exhibition will be voluntary, and artists who may not wish to participate need only inform the administration, which will hasten to return their works to them. This exhibition will open on 15 May. Artists have until 7 May to withdraw their works. After this date their pictures will be considered not withdrawn and will be placed in the galleries.

The move by the Emperor was unprecedented, and many of the artists whose work had been refused, further refused to have anything to do with the new proposal, bewildered at the implications. For others, the decree from the Emperor resolved the problem. The critic Jules Castagnary understood the dilemma, and when the furore had calmed down, wrote: 'Not to exhibit means to condemn oneself, to admit one's lack of ability or weakness; it means also, from another point of view, to accomplish a glorification of the jury.'[39]

As soon as James heard of this new development from Fantin, he readily agreed to allow his painting to be exhibited and cancelled his earlier agreement with Martinet to show the painting at the Société Nationale des Beaux-Arts. His positive response must have been rapid since his name appeared in the catalogue which was hastily and incompletely put together without any help from the 'official' administration. He wrote to Fantin: 'It's marvellous for us, this business . . . Certainly my picture must be left there and yours too. It would be folly to withdraw them . . .'[40] Fantin heeded James's advice and allowed his rejected painting *Fantasy* to be exhibited. Of his other friends, Manet contributed his three rejected pictures which included *Le Bain* (better known today as *Le Déjeuner sur l'herbe*), Legros was a willing participant, and Bracquemond submitted several etchings. The major absentee was Courbet, who had two paintings and one sculpture

accepted by the Salon and was not allowed to exhibit his 'refused' painting, *Return from the Conference*, at the alternative show, despite public protests from friends and admirers such as Proudhon. Fuming at the prohibition, Courbet wrote to the *Figaro* later in May proclaiming, 'I intend to show it in the other big European cities. Meanwhile it is on view at my own studio, where honest critics can come and see it where there is a crowd every day.'[41]

While Paris eagerly awaited the opening of the Salon des Refusés, as it came to be known, the first reviews of the official Salon began to appear. Courbet, not surprisingly in view of his public outbursts, was treated harshly. Fantin's painting, *Reading*, a pensive portrait of his sister Marie, was singled out by the critic Théophile Thoré as the best female portrait in the exhibition.[42] Legros too had a favourable press. James's etchings were not mentioned at any length during the course of the Salon, and when they were noticed in July by Philippe Burty in the *Gazette des Beaux-Arts* his review turned out to be a two-edged weapon. After a laudatory introduction, in which James was described 'as a fine colourist and intelligent draftsman', Burty launched into a severe critique. He singled out what he called 'the theory of foregrounds' which he said was to be 'bitterly regretted'. It was the major flaw in work which is 'so remarkably fitted in all other aspects'.[43] Burty's criticism cut deep with James. Coming from a critic who had lavished praise on Haden, James saw it as something more than impartial: he began to believe that Haden and Burty were conspiring against him.

In comparison to events in Paris, the Royal Academy exhibition at the National Gallery followed a more predictable course. Among James's friends exhibiting were Millais with *The Eve of St Agnes*, together with Ridley and Poynter. Absentees included Rossetti, Boyce and Sandby. Neither Fantin nor Legros elected to show, though Hook was there in force with three major oils of various nautical subjects which were well received. According to Du Maurier, *The Last of Old Westminster* was badly hung, 'down to the ground'.[44] Despite their differences, he still admired James, describing him to their mutual friend Tom Armstrong as 'almost the greatest genius of the day'.[45] The press were not so whole-hearted. To most reviewers the painting was merely a 'sketch', it lacked the 'finish' expected at the Royal Academy. The *Illustrated London News* took James severely to task: 'Since the painter would have us believe he can do so well with so little pains, we think he should show more respect to himself, his art, and the public by trying to do better.'[46] This adverse criticism did not put off John Cavafy, an old acquaintance from the Ionides circle, who bought the painting a short time later for 30 guineas.

The Salon des Refusés opened on 15 May. From the moment the doors

were unlocked at the Palais de l'Industrie, crowds flocked in their thousands to see the show. According to contemporary accounts, some 1,500 artists whose work had been rejected by the Salon refused to take part, thereby, in effect, condoning the original decision of the jury.[47] The critic, Philip Hamerton, a friend of Haden's, described in detail the effect of *The White Girl* on the Parisian audience:

> The hangers must have thought her particularly ugly, for they have given her a sort of place of honour, before an opening through which all pass so that nobody misses her. I watched several parties, to see the impression *The Woman in White* made on them. They all stopped instantly, struck with amazement. This for two or three seconds, then they always looked at each other and laughed. Here, for once I have the happiness to be quite of the popular way of thinking.

Hamerton's description is confirmed by Emile Zola who viewed the exhibition in the company of Cézanne and later wrote, 'Folk nudged each other and almost went into hysterics; there was always a grinning group in front of it.'[48] The *Revue des Deux Mondes* saw the exhibition as 'at once sad and grotesque' and 'even cruel'. The *Moniteur*, which had initially announced the Emperor's decree, totally ignored it, even though its chief critic Théophile Gautier had devoted twelve lengthy articles to the 'official' Salon. Despite the popular myth that has grown up around the Salon des Refusés, the exhibition was largely an exhibition of nonentities, who would never have been accepted by any jury; but scattered amongst these were James and other artists such as Manet, Bracquemond, Fantin, Pissarro, Jongkind and a young Cézanne – a group of artists Fantin would later describe as 'la jeune école'.[49]

Notwithstanding the critics' hostility, the exhibition received considerable coverage. Fantin's *Fantasy*, which showed just how far he had moved away from anything remotely resembling realism, sharply divided the critics. As promised, Fantin sent an anxious James a full account of the opening day. After describing where *The White Girl* was hung, he relayed the reactions of his Parisian friends:

> Your picture is very well hung. You have won great success. We find the whites excellent; they are really superb, and at a distance (that's the real test) they look first class. Courbet calls your picture an apparition, with a spiritual content (this annoys him); he says it's good . . . Baudelaire finds it charming, charming, of an exquisite delicacy, as he says. Legros, Manet, Bracquemond, de Balleroy and myself; we all think it's admirable.[50]

Despite Courbet's reservations, such praise from Baudelaire touched James deeply. Conveniently forgetting his previous dismissal of Baudelaire's review of his etchings, he wrote to Fantin asking him to thank Baudelaire personally, saying he would like to 'have the pleasure of finally meeting him, at which time I hope he will accept a few of the best proofs of the etchings of which he once spoke so well'.[51]

The admiration of his friends was echoed by sections of the press. Paul Mantz, writing in the *Gazette des Beaux-Arts*, had slight reservations about his technique, 'the head ... is painted with too rough a brush', but conceded that the painting was firmly within the French tradition and 'is the principal piece in the heretics' Salon'. It was Mantz who christened the painting a 'Symphony in White': a title later used by James who, by adding 'No. 1', wished to emphasize the formal rather than the narrative quality of the painting. Louis Etienne, who had praised Fantin, also singled out James's painting – 'this austere young woman' – for special praise, while others who had found fault with Fantin, such as Chesneau, Alexander Pothey and Fernand Desnoyers, described *The White Girl* as 'superior' and 'one of the most original paintings in the exhibition'. On the whole the painting found favour with the critics, but Manet's *Le Bain* incensed many of them. According to one source, the Emperor himself considered it morally offensive.[52] Some critics such as Etienne, who had sung the praises of both Fantin and James, rounded on Manet and lambasted this 'schoolboy prank'.

The Salon des Refusés turned out to be very important for James, as for Manet. The discussions his picture provoked among artists and critics ensured that in future, even when his work was considered unacceptable by certain elements of the press, it could not be ignored. Their notoriety had been achieved by very different paintings: Manet's was a direct and uncompromising challenge to traditional values, whilst James's was a somewhat wistful and ephemeral vision. Yet the pictures had a common, and crucial, underlying bond – their technique. This is the key to understanding their rejection in the first place, and their subsequent reputation at the Salon des Refusés. Neither made any pretence of achieving an academic finish: both were broadly and decisively painted. This style, combined with their modernity of subject and ambiguity of context, set the two pictures apart from the rest. James and Manet had challenged others to follow them down a path described by the art critic Théophile Thoré as the attempt to 'create an effect in its striking unity, without bothering about correct lines or minute details'.[53]

James revelled in the Parisian press coverage *The White Girl* received, and his elation was increased when he heard that the art critic, Arsène

Houssaye, editor of *L'Artiste*, wished to purchase it (although, in the event, the purchase never took place).[54]

Towards the end of May James made a visit to Holland to see his etchings on show at The Hague, where he received a gold medal; accompanying him was Legros who had been staying at Lindsey Row. Before returning to England he travelled to Paris and visited the Salon des Refusés. Once back in London one of the first people James contacted was O'Leary:

> I have just come from another runaway journey into Holland and have ruined myself in old Japonise China!! – Come and see it and also my large picture of the Thames that I have nearly finished and forgive my truant conduct – I am tired of travelling and shan't bolt for any very distant parts again in a hurry.[55]

The painting James referred to was clearly *Wapping*, and at Lindsey Row O'Leary would also have seen two other smaller Thames paintings recently completed. The first, *Battersea Reach*,[56] shows the view across the river slightly east of James's house, while the second, *Old Battersea Reach*,[57] is the view from his window at Lindsey Row overlooking Lindsey Jetty. Both paintings were broadly painted and follow the technique used in his successful submission to the Royal Academy, *The Last of Old Westminster*. The criticisms levelled at him earlier in the summer in regard to his 'sketches' had clearly not affected him. *Battersea Reach* was sold almost immediately to John Cavafy for the same amount he paid for *The Last of Old Westminster* and the speed of execution suggests that James may well have been doing an informal commission for Cavafy, with *Old Battersea Reach* providing a second option. This supposition is borne out by the fact that James had the latter picture in his possession for many years afterwards.[58]

If O'Leary accepted James's invitation to visit that afternoon, it was undoubtedly to talk on private matters as well as to look at pictures. O'Leary was planning within the next month to leave London to become nominal proprietor and permanent writer for the newly created newspaper of the Irish Republican Brotherhood, the *Irish People* in Dublin. As the brainchild of James Stephens, the movement's leader in Ireland, the paper was conceived with two main objectives in mind: as an important propaganda tool, and to help raise more money for the movement which had seen its funds dwindle dangerously, particularly in America. Unquestionably James at some time discussed the planned newspaper with O'Leary, though whether he was fully aware of its subversive implications

is not clear. It was a busy time for O'Leary and occasionally, so absorbed was he in IRB business, he would forget to turn up at prearranged meetings. James's exasperation at his absences is revealed in another letter written just days before O'Leary left:

> Why do you stay away like this – I have been expecting you to walk in every evening – and have expected you in vain. I have many things to tell you – Do come on Friday evening – when you will meet Poynter and Du Maurier and perhaps Keene – Or if you would rather have a quiet [meeting] come tomorrow to tea, when there will only be Stephens of the *Athenaeum* here.[59]

As James, along with many other Confederate supporters in London, watched the diplomatic efforts to achieve Parliamentary recognition for their side, one of the most critical battles of the Civil War was about to begin. At the end of June, brigades of both Union soldiers and Confederates converged on the small town of Gettysburg, north of Baltimore. After three days of ferocious fighting, the Union army was victorious. The human cost, particularly for the Confederates, was horrendous. Nearly 28,000 men were reported killed, wounded or missing. Despite the fact that the Confederate commander, General Lee, had escaped, the battle profoundly altered the course of the war. Although it continued for two further bloody years, for many its outcome now seemed inevitable. Anna Whistler was one of these. Shocked by the death and destruction she had witnessed, she had made up her mind to leave America. Unknown to James, she was planning to come to live with him in London.

10

Domestic Upheavals and Professional Uncertainties

A LTHOUGH JAMES ENJOYED the company of his guest Legros at Lindsey Row, Joanna it appears did not. Writing to Fantin not long after Legros' arrival, James described how the other member of the Société des Trois was settling down in the London scene:

> Legros has become so debonair you just wouldn't recognize him. His sole preoccupation seems to be what shade of gloves to wear. I shall get him to have his photograph taken so you can see him in all his glory. He is the darling of the beau-monde here; all the young English misses are enamoured of him, and even the married women are showing signs of abandoning their duty on his account. Indeed Alphonse has developed such social talents that one just wouldn't know him, and his ease and aplomb in company beggar description.[1]

As James began attempting to resolve the compositional problems and narrative dilemma of *Wapping*, he heard the news from Paris of the death of Delacroix on 13 August. At his burial a week later Fantin, together with Manet and Baudelaire, walked in the funeral procession. Delacroix's passing represented the end of an era. Over the next few weeks, the French press analysed his work and life, one of the most important reviews being Baudelaire's three-part article which appeared in the form of a letter to the editor of the widely read *Opinion nationale*. In this brilliant summation of the art of Delacroix,[2] Baudelaire described him as not a realist, 'not one of that herd of vulgar artists and scribblers',[3] but rather one who chose and selected elements from nature and infused them with the faculty of

imagination. For Baudelaire, as for many others, Delacroix was the first truly great modern painter. These sentiments found absolute agreement with Fantin, who conceived the idea of immortalizing Delacroix in a painting. Completed nearly six months later, *Homage to Eugène Delacroix*[4] is one of the finest achievements of his career, if not the most important. Aside from a desire to redress the fact that Delacroix's death had been treated with total indifference in government circles, Fantin was keen to advance Baudelaire's conviction that Delacroix was indeed the first 'modern' artist. He wanted to place the artist and his legacy at the forefront of modern art. One of the first people he decided to include in the picture was James.

Towards the end of January the following year, 1864, he sent James a letter containing a detailed drawing of the work.[5] James's response to the proposed *Homage* was favourable: 'Your picture will be superb! The composition is very fine, and I foresee the heads having magnificent colour. The bust will perhaps be difficult to arrange, but I have every confidence in you . . . it is a picture that is bound to draw attention to you.'[6] James's warning proved accurate: for the final form of the picture, Fantin used a painted portrait, not a bust.

In the roll-call of names to be included in *Homage*, James also had his say. He agreed with all the suggested names, which included Manet, Legros, Bracquemond, Duranty, Champfleury, Baudelaire, Louis Cordier and Albert de Balleroy – save one, Théodule Ribot. Instead, James suggested Rossetti. He had, he wrote, a 'fine head' and a 'great talent'. It seems that Fantin, who had never met Rossetti, demurred and Rossetti was not included. Nor was Courbet ever mentioned as a possible candidate: Fantin's passing interest in the master of realism began and finished with his brief attendance at his short-lived teaching studio. That James never suggested Courbet was probably more to do with knowing Fantin's feelings than an indication of his own.

James had other plans to unify progressive artists from either side of the Channel, and as Du Maurier reported in October:

> Jimmy . . . Legros, Fantin and Rossetti are going to open an exhibition together. Jimmy and the Rossetti lot, i.e. Swinburne, George Meredith, & Sandys, are as thick as thieves . . . Their noble contempt for everybody but themselves envelops me I know. Je ne dis pas qu'ils ont tort, but I think they are best left to themselves like all Societies for mutual admiration of which one is not a member.[7]

The planned exhibition unfortunately never took place.

Du Maurier's letter reveals the distance that had come between the former friends. Now settled in to work and domesticity, he found the atmosphere of Tudor House distasteful. For example, James and Rossetti were obsessed with spiritualism, and one of the ritual events of the evening was a seance. So interested did James become that he and Joanna began to practise seances at home. On one occasion, according to the Pennells, he heard the voice of a cousin 'long since dead'.[8] So clear was the content of the message that it obviously shocked him into giving up the craze soon after.

When not at Rossetti's or entertaining at home, James enjoyed visiting some of the numerous local inns, especially during the long summer evenings. One particular favourite was the Adam and Eve on the riverside below the city side of Old Battersea Bridge: the inn, like so many others along the river, was later demolished to make way for the new embankment. Rough and ready, the Thames watermen would tie up their boats beneath its wall and enter the premises by a series of rickety steps which led from the river. Apart from having to step over, or climb around, the piled-up bodies of drunken rivermen, the unwary visitor had the added hazard of having to avoid a profusion of stuffed fowl which seemed to be placed on every available space around the three levels of the inn.[9] It was not a place to bring respectable women, and the inn often served as James's retreat when Joanna was angry or irritable. Here, in the company of Rossetti and Swinburne, and occasionally with Walter and Henry Greaves, he would stand with a glass of Bass ale and enthral the company for hours on end.

Towards the end of 1863, he had several projects in gestation which indicated that his work was now entering a new phase. His interest in Japanese art had previously been focused almost exclusively on spatial effects, but he now preferred to allude to the art of the Orient through its cultural artefacts. To understand why he should do this at this particular time, one has to look no further than the work of his friends, Rossetti and Manet especially. Manet suggested simply and effectively the Spanishness of his subjects through appropriate costume and the objects beside them. From Rossetti – and Swinburne in relation to literature – he had imbibed at first hand the belief that sheer beauty can be a justifiable end in itself. The combination of beautiful *objets d'art* and beautiful women, therefore, seemed the natural path to pursue.

The first of these paintings, begun in late 1863, was entitled *Die Lange Lijzen of the Six Marks*[10] (later entitled *Purple and Rose: The Lange Lijzen of the Six Marks*). *Lange Lijzen* is Dutch for long Eliza, the Delft name for the blue and white Chinese porcelain decorated with 'long ladies'; the 'Six Marks'

was the potter's identification mark, indicating his name and the date on which any particular piece was made. For this picture, and others which included porcelain, James drew on his own extensive collection.

The other major picture of the period is *La Princesse du Pays de la Porcelaine*.[11] The sitter for *La Princesse* was Christine Spartali, the daughter of Michael Spartali, a friend of the Ionides circle who later became the Greek Consul in London. Christine and her sister Marie, who always accompanied her to the sittings, were both beauties, particularly Christine who was considered 'one of the most beautiful women of her generation'.[12] All were smitten in her presence, and Swinburne, after seeing her in February 1864, turned to Thomas Armstrong and exclaimed, 'She is so beautiful I feel as if I could sit down and cry.'[13]

James had known the sisters for some time and, according to the Pennells, asked Christine to sit for him in late 1863. Many years later, Marie explained how, when they first arrived, James had everything ready, 'The Japanese robe . . . the rug and the screen were in place, and he gave the pose at once.'[14] Characteristically, the work at first proceeded well. Twice a week, the sisters were announced at Lindsey Row and during the long hours James worked silently and intently, engaging in conversation only during lunch. Inevitably, the sittings 'began to drag', and when Christine became ill, he used another model to stand for the robes. The painting was finished sometime in the spring of 1864, after she recovered. Rossetti tried to sell it to 'a collector', but the deal was unsuccessful because James apparently refused to erase his large signature from across the top of the painting. Soon after, Rossetti managed to sell it to another collector, who then died, so it was bought by the London dealer Gambart early in December for £100. It was later acquired by F.R. Leyland.

As Christmas 1863 approached, there were other problems preoccupying James besides *La Princesse*. His already precarious relationship with Haden was steadily deteriorating for he still had not resolved his jealousy at the critical acclaim accorded to Haden's etched work in France and could not bring himself to resume his own etching. In early December he found a way to taunt his brother-in-law to the point of distraction.

During a rare social visit to Sloane Street with Legros, they discovered that Haden had taken it upon himself to alter the deliberately naïve perspective of Legros' painting *The Angelus*, which he had bought shortly after the Salon of 1859. When Haden made the changes is unclear, but they deeply offended Legros and James. For James, this was the worst example yet of Haden's pomposity in matters of art. There and then, they decided to take the painting to Lindsey Row and remove Haden's disfiguring

alterations. After restoration, they secretly returned the picture to Sloane Street and awaited Haden's reaction. Feigning ignorance of the deed, they visited Sloane Street almost daily throughout the Christmas period. As James reported to Fantin, 'the feeling of hostility grew from day to day between Haden and his devoted brother-in-law'.[15] Haden, it seems, had spotted the restoration almost immediately but had refused initially to be drawn into any conflict. But as the days passed the behaviour of James and Legros weakened his resolve and he finally exploded, snapping at Legros, 'Oh! you have removed all that! Very well! Do it better!'[16] Haden's fury then turned on James. He forbade James to visit Sloane Street with Joanna, and Deborah was banned from visiting Lindsey Row. Haden decreed that in future if they wanted to meet, they could do so only at the homes of mutual friends.

Domestic friction in another quarter was coming to a head, thanks to Joanna's increasingly stormy relationship with Legros, who had outstayed his welcome at Lindsey Row. The situation was not at all helped by his sloppy manner and apparent indifference to his hostess. One problem may have been that Legros' English was virtually non-existent and Joanna did not speak a word of French. Despite that, they managed to bicker constantly, particularly during James's absences. When James confronted his friend on the matter, angry words were exchanged. Reporting the incident to Thomas Armstrong, Du Maurier explained – perhaps not without a hint of glee – that 'Jimmy and Legros are going to part company, on account (I believe) of the exceeding hatred with which the latter has managed to inspire the fiery Jo: one never sees anything of Jimmy now.'[17]

James then received a bombshell from America: his mother Anna would be arriving to take up residence in just over a week's time. At a stroke, his world was turned upside down. James explained the perilous situation in a letter to Fantin: 'General upheaval!! I had to empty my house and purify it from cellar to eaves, look for a *buen retiro* for Jo, an apartment for Legros, and to Portsmouth to meet my mother. If only you could see the state of affairs! Affairs! Up to my neck in affairs!'[18]

The arrival of Anna in early January 1864 put an end to James's bohemian existence with Joanna. Anna could have easily stayed in the comfort and luxury of Sloane Street but, no matter how much she had come to care for Deborah over the years, she was, after all, only a stepdaughter. What Anna did not know, but soon learned, was the extent of the strained relationship between Haden and James. No longer was he James's helpful guardian and brother-in-law, but simply a pompous, overbearing bore.

Anna arrived in London looking ill and frail, and her eye trouble, which

appeared to have symptoms similar to conjunctivitis, was worse than ever. Her appearance must have shocked James, who had not seen her for nearly eight years. With James in attendance, she attempted a reconciliation at Sloane Street. It turned out to be a disaster. An argument quickly erupted between James and Haden which resulted in James being shown the door. Again, it is Du Maurier who describes the scene:

> Jimmy and Haden *à couteaux tirés*, quarrel about Jo, in which Haden seems to have behaved with even unusual inconsistency and violence; for he turned Jimmy out of doors *vi et armis*, literally, without his hat; Jimmy came in again, got his hat and went and said goodbye to his mother and sister. It appears he had told Haden that he was no better than him.[19]

The Pennells tell a more humorous version of the episode. After being lectured by Haden in a room at the top of the house on the subject of Joanna, James could take no more and left the room to climb down the four flights of stairs to the front door. Following behind was the outraged Haden, still lecturing. When James finally reached the door, he discovered to his horror that he had forgotten his hat. Turning to Haden he said, 'I've left my hat upstairs, and now we have to go through all this again!'[20] The confrontation, however, left James in no doubt where he now stood with Haden. As Du Maurier further explained, the major inconsistency in Haden's argument was the fact that, prior to Anna's arrival, Haden had not only dined at Lindsey Row, but worked there and appeared to treat Joanna as 'an equal'.

After the confrontation at Sloane Street, family meetings became rare, and it was usually Deborah and the children who visited Lindsey Row rather than the other way round. Another sad consequence of the rupture was the abandonment of an earlier plan for Haden and James to make a series of etchings on the theme 'The Thames from its Source to the Sea'.[21] Despite the fact that Anna concurred with Haden's apparently flawless moral argument, she recognized that there was more behind his outburst than offended moral propriety, and her loyalty to her son proved in the end the stronger bond. In her eyes, 'Jemmie' had simply and momentarily erred; now that she was with him, he would quickly see the error of his ways. James, of course, did not and never would. But in the meantime, as so often in the past, he appeared to dance to her tune, at least for the moment.

Despite the uneasy atmosphere, Anna quickly settled at Lindsey Row and before long James had introduced her to the Greaves family, Rossetti, Swinburne and the rest of his circle of friends. Of them all, it was

Swinburne she warmed to instantly, perhaps sensing his vulnerability. Reciprocating her affection, Swinburne became in a sense another son, and when he occasionally failed to keep a social appointment with her she chastised him mercilessly. She also lectured him endlessly on the sins of alcohol, and though Swinburne paid little heed he took great pleasure in her concern. One person she did not 'formally' meet was Joanna, who was kept at a safe distance several streets away. When occasionally she came to visit Lindsey Row it was in the guise of a model, particularly when James resumed work on the long-running *Wapping*. It was unquestionably a trying time for them both.

For Anna, after years of financial struggle in America, and constant moving from one area to another during the horrors of the Civil War, it must have seemed like another world to be living in the relative calm of London, safe in the company of her eldest son. In a long letter written shortly after her arrival, she described in glowing terms the decor, several of James's pictures in progress and the general ambience of 7 Lindsey Row:

> Are you an admirer of old China? This artistic abode of my son is ornamented by a very large collection of Japanese and Chinese. He considers the painting upon them the finest specimens of Art and his companions (Artists) who resort here for an evening relaxation occasionally get enthusiastic as they handle and examine the curious objects . . . some of the pieces more than two centuries old. He has also a Japanese book of painting unique in their estimation . . . He is finishing in his Studio . . . a very beautiful picture for which he is to be paid one hundred guineas without the frame which is always separate. I'll try to describe this inspiration to you. A girl seated as if intent upon painting a beautiful jar which she rests on her lap, a quiet and easy attitude, she sits beside a shelf which is covered in with Chinese matting a buff colour, upon which several pieces of china and a pretty fan are arranged as if for purchasers. A Scind rug carpets the floor . . . there is a table covered with crimson cloth, on which there is a cup (Japanese) scarlet in hue, a sofa covered with buff matting, too, but each so distinctly separate, even the shadow of the handle of the fan, no wonder Jamie is not a rapid painter, for his conceptions are so nice, he takes out and puts in over and oft until his genius is satisfied.
>
> And yet during a very sharp frost of only a very few days, I think for two days ice was passing as we look out upon the Thames, he could not resist painting while I was shivering – at the open window – two sketches and all say are most effective, one takes in the bridge. Of course they are not finished, he could not leave his oriental paintings which are ordered and he has several in progress: One portrays a group in oriental costume on a

balcony, a tea equipage of the old China, they look out upon a river, with a town in the distance. I think the finest painting he has yet done is the one hanging in this room, which three years ago took him so much away from me. It is called *Wapping*. The Thames and so much of its life, shipping, buildings, steamers, coal heavers, passengers going ashore, all so true to the peculiar tone of London and its river scenes it is so improved by his perseverance to perfect it. A group on the Inn balcony has yet to have the finishing touches. He intends exhibiting it at Paris in May with some of his etchings . . . While his genius soars upon the Wings of ambition the every day realities are being regulated by his mother, for with all the bright hopes he is ever buoyed up by, as yet his income is very precarious. I am thankful to observe I can and do influence him. The Artistic circle in which he is only too popular, is visionary and unreal tho so fascinating.[22]

Anna was quick to make her mark on the household, and soon began censoring James's extravagant lifestyle, apparently with his free acquiescence. One of the first events to be sacrificed were his Sunday lunches. Now the Sabbath was given over entirely to Anna, whom James would proudly escort to Chelsea Old Church, a short walk from Lindsey Row, leaving her at the door to hear a sermon. An hour later he would arrive back to take her home. She always enjoyed this weekly spiritual excursion, informing a friend in America, 'I think in the small Churches there is a more Evangelic spirit.'[23] No doubt Anna prayed hard for her son as she had always done. As she wrote to her friend:

God answered my prayers for his welfare, by leading me here. All those most truly interested in him remark upon the improvement in his home and health. The dear fellow studies as far as he can my comforts, as I do all his interests, practically – it is so much better for him generally to spend his evenings tête-à-tête with me, tho I do not interfere with hospitality in a rational way.[24]

James was determined that *Wapping* should be finished in time for the Salon and become his first successful painting submission. He wrote to Count Nieuwerkerke on 3 February asking leave to delay his submissions, which included etchings, but apparently no dispensation was given.[25]

What had started out as an essay in realism had, by early 1864, moved in a direction that reflected the changes in both James's own development and those around him. From the initial risqué subject – Joanna portrayed as a prostitute conversing with potential clients at the Angel Inn, and the 'expressions' James was so anxious to achieve – the painting had

undergone a fundamental and profound transformation. He was now no longer interested in the 'expression', the narrative relationship between the members of the group. In the final version the three figures remain, but Legros now takes the place of the old man in the white shirt, and although Joanna sits physically close to him as she did to the old man, there is now an aloof, psychological distance between them. Coincidence or not, this reflected the uncomfortable real-life situation between Joanna and Legros. Since the final form was completed in the studio at Lindsey Row, James had, perhaps unwittingly, portrayed the tension implicit in his own house-hold. In a letter to Fantin written in early February 1864, he described the new composition:

> For the Paris Salon I intend to send my picture of the Thames which you saw one day with Edwards – it's completely changed . . . and I know it will be better received in Paris – you will love it I am sure. There is a portrait of Legros and a head of Jo which are among my best.[26]

Wapping and *The Balcony* (mentioned in Anna's long letter) were concerned with the technical problems of composition – form and design over subject-matter. As in *The White Girl*, both these pictures have more to do with aestheticism than with the dictates of realism. While *The Balcony* is certainly less complicated than *Wapping*, it is nevertheless carefully planned and painted to an exacting design.[27] Problems of composition were by no means unique to James: Fantin was experiencing them in *Homage*, as had Manet in *Déjeuner sur l'herbe*. How far James was influenced by Manet's work is difficult to ascertain, but he knew the painting well and regarded it highly. Despite his outward appearance of insouciance, James found the work hard and exacting. In another letter in February, he confided to Fantin:

> I am horribly depressed at the moment. It's always the same – work that's so hard and uncertain. I am so slow. When will I achieve a more rapid way of painting and when I say that, I mean to say something different; you will understand what I'm driving at. I produce so little, because I rub out so much. Oh! Fantin, I know so little. Things don't go much. Oh! I know so little. Things don't go so quickly.[28]

James's struggle to complete *Wapping* in time for the Paris Salon was being echoed in Paris by Fantin's problems with *Homage*. He had no alternative but to use photographs before James arrived with Joanna in mid-March. By then James had changed his mind about submitting *Wapping* to the Salon. Whether he simply took fright at the prospect of yet

another rejection is not clear; instead he chose to submit it, along with *Lange Lijzen*, to the Royal Academy exhibition. This decision seems all the more puzzling when set against the new regulations which had been instituted by the Emperor after the débâcle of the previous year, and of which James was well aware. Now, only a quarter of the jury would be nominated by the official arts administration and the remainder would be drawn from exhibiting artists. While the new system still favoured the more conservative artists in that a nominee, to be eligible, had to be a previous medal recipient, nevertheless it was theoretically more favourable to the younger and so far unrewarded artists. Even James's old teacher Gleyre had become a member of the jury.

There was, however, another possible reason why James declined to submit: the appearance of Fantin's *Homage*, which had all the makings of a sensational picture. Indeed, so important did Baudelaire consider it that he had personally written to the Marquis de Chennevières, the chief curator of the exhibition, to ensure that it, along with Manet's work, was 'hung advantageously'.²⁹ *Wapping*, despite all the years of endeavour, was simply no match for it, nor had it the same critical potential as *The White Girl* of the previous year. In such circumstances, James seems to have made the decision to withdraw gracefully from the arena, happy in the knowledge that his name, and its associations, would still be one of the major talking points of the show thanks to the presence of *Homage*, in which he and Manet were placed in the most prominent positions, flanking the portrait of Delacroix.

Courbet had been working hard on a group portrait, possibly parodying *Homage*. Entitled *The Fount of Hippocrene*, the painting was a cynical look at the state of modern poetry, and featured in a far less flattering light than Fantin's artists such prominent writers as Lamartine, Baudelaire and Théophile Gautier. Unfortunately the painting was damaged before completion and subsequently abandoned. Courbet began another painting on a classical theme, but it was rejected, a decision, so it was rumoured, influenced by the Empress on the grounds that its two voluptuous nudes offended the standards of good taste. The rejection made Courbet the only major casualty in the otherwise liberal Salon of 1864.

Manet had two submissions, *Incident in the Bull Ring* and *The Dead Christ with Angels*. He appeared to have two objectives in mind: on the one hand, the choice of the latter's subject-matter was perhaps intended as a conciliatory gesture to the inherently conservative jury; and on the other, he seemed to be challenging Courbet, who had once bitterly rebuked another artist for painting a religious scene, snapping that he 'could not paint an angel because he had never seen one'.³⁰ Both pictures were accepted.

Manet was, and always remained, his own master. James would soon assert a similar nonconformity, but for the moment there was still a sense of uncertainty. James and Joanna returned to London in time for the opening of the Royal Academy in early May. Before he left Paris, he had solicited from Fantin a promise to visit London later that summer.

11

'A Most Inexplicable Adventure'

A S THE WINTER of 1864 approached, James's mother Anna decided to leave London to spend some time with friends on the south coast. With her departure James soon re-established a more vigorous social life. One of his greatest pleasures was to spend the evening with his friends in Cremorne Gardens some three hundred yards west of his house along the river. Originally the grounds of one of the last great country houses to be built in the Chelsea area nearly a hundred years before, Cremorne Gardens was by the 1860s one of the best-known (and notorious) places of pleasure in London. It covered a beautifully landscaped twelve-acre site with river frontage, and for an entrance fee of one shilling the visitor could participate in a multitude of activities. There were aeronautical spectaculars which featured captive balloons raised to a height of 2,000 feet and then lowered by means of a 200-horsepower steam engine; shooting galleries, fortune-tellers, band-stands, theatres, hurdy-gurdy men, curiosities and freak shows of every shape and form. The evening was traditionally concluded with a huge firework display which could be seen for miles around. Food and drink were plentiful, and for those wanting a more intimate setting there were supper boxes, discreetly partitioned and candle-lit. James adored the place and spent many long hours there with Joanna, usually accompanied by the Greaves brothers. Rossetti too was a frequent visitor, and according to one story he bought a humped ox, a zebu, at the Gardens for £20 which he then proceeded to keep in the back garden of Tudor House secured to a stake. Christened by James the 'Bull of Bashan' because of its ferocious temper, after several escapes and rampages the beast disappeared, never to be heard of again.

For nearly fifteen years Cremorne Gardens was an important part of James's life. Although in the mid-1860s the place had not yet become a subject for his painting, it did in time and one particular work, *Nocturne in Black and Gold – The Falling Rocket*,[1] would become one of the most controversial paintings of the nineteenth century. Years later Walter Greaves recalled the nights spent with James at Cremorne, 'the whole place ablaze with thousands of lamps, and the crowds of dancers, with their multi-coloured dresses all moving around the brilliantly lighted bandstand to the strains of the "Derby Gallop" and the noted waltzes of the day'.[2]

The forthcoming 1865 exhibitions at both the Royal Academy and the Paris Salon placed James in a quandary. After the reception of *The White Girl* at the Salon des Refusés, that picture seemed the obvious choice for submission to the Salon proper. Again, however, he wavered and in the end sent nothing. He was to be seen in the Salon only in another group portrait by Fantin – *The Toast! Homage to Truth* (since destroyed). It was Fantin's retort to the generally indifferent response evoked by his earlier *Homage*, and again James was posed in a prominent position, this time dressed in Japanese robes. As Fantin explained to Edwin Edwards, 'They are drinking to Truth, their idea, and by one of those licences granted to painting, which constitutes one of its charms, their ideal, the object of their toast, is made visible to the viewer. It is pure fantasy, mixed with reality.'

James chose instead to send *The Little White Girl*, together with *The Golden Screen*, *Old Battersea Bridge* and *The Scarf*, to the Royal Academy. Around the same time he heard the news that his brother William had escaped through Union lines by a tortuous route and, using a false identity, had managed to board a ship in New York, bound for England. He arrived in London in April 1865 carrying important Confederate despatches. With his wife's tragic death, and the South all but defeated, he no longer felt any reason to return to the United States. His remaining family were in London and within days he had made the decision to stay there with them.

William's arrival in London has been perceived by past biographers as an acutely uneasy time for James, accounting for seemingly irrational actions in the future. It has been assumed that this stemmed from the 'guilt' James harboured for not participating in the war.[3] There is not, however, a scrap of evidence to support this theory. There is perhaps some faint reason to suppose that as a former West Point cadet James might have volunteered his services during the conflict. But that ignores the fact that he had always loathed the idea of being a soldier: he had never wanted to be in the army, considering himself an artist, first and always. Of course, like many expatriates, he had been deeply worried about the war, but this concern did not extend to thinking he ought to enlist. William's arrival in England, if

anything, made James's life easier. The constant care required by his mother could now be divided. Who better to divide it with than a brother who was a qualified doctor? William, as far as can be ascertained, never questioned his brother's avoidance of the war.

With William now ensconced in Lindsey Row, James could spend more time with Joanna and more trips abroad could be planned. In early April, James learnt that all his submissions had been accepted by the Royal Academy. If there was any uneasiness to be detected in his behaviour it was assuredly more to do with awaiting the critical response to his pictures than with his brother's arrival. Though as usual tempering his notice with reservations about 'finish' – or rather lack of it – Tom Taylor, writing in *The Times*, expressed the general feeling of the leading newspapers when he said of *The Little White Girl*:

> Written around its frame are some very beautiful verses by Mr Swinburne, addressed to the picture, which is a woman clad in white and very truthfully painted muslin ... There may seem to some an uncouthness in the monotony of colour and in the attitude, but nevertheless the picture is one ... which perhaps means more than it says though not so much perhaps as the poet has said of it. Thought and passion are under the surface of the plain features, giving the undefinable attraction.[4]

One of the most laudatory reviews appeared in *Fraser's Magazine* in June and perhaps not surprisingly it was written by a friend, Michael Rossetti. He singled out *The Little White Girl* as 'exquisite ... retorting delicious harmony for daring force', while *Old Battersea Bridge* was 'perfection' and 'precious'. Such sentiments, despite their source, were important for James. Exposure in widely read magazines like *Fraser's* was all-important to keep his name on the lips of the influential. As to sales, the Royal Academy was not particularly fruitful for him that year. *The Little White Girl* was bought by Gerald Potter, whose wife had sat for Fantin, for £150; *Old Battersea Bridge* already belonged to Ionides, and *The Golden Screen* and *The Scarf*, both Japanese-inspired paintings, found no buyers.

Of all the other paintings in the exhibition, there was one which particularly caught his attention by its sheer elegance and design. Entitled *The Marble Seat* (now lost) it was by a 24-year-old artist called Albert Joseph Moore, the younger brother of Henry Moore, a renowned marine painter often unfairly seen as a slavish imitator of Hook. Undoubtedly James had seen Albert's work before as he had been exhibiting at the Academy as early as 1859. His earlier work had been a mixture of landscape and biblical scenes much influenced by the work of the Pre-Raphaelites, but *The Marble*

Seat represented a dramatic departure. Intrigued, James sought out Moore at his studios in Russell Place not far from the British Museum.

In many ways Moore was similar in character to several of James's French friends such as Fantin and Manet. Shy to the point of embarrassment and utterly devoted to his work, he seemed oblivious to everything around him. Years later one of the few people who ever got to know him at all well, W. Graham Robertson, said of him: 'He seldom took the trouble to make friends. Yet he was a most gentle and affectionate man. His splendid Christ-like head with its broad brows and great visionary brown eyes was set upon an odd awkward little body that seemed to have no connection with it.'[5]

The fundamental transition in Moore's art had occurred after a trip to Italy during 1863–4 when he had studied in detail the line and form of classical sculpture. On his return he had begun to experiment, refining his linear design and combining it with subtle colouring. As at his first meeting with Fantin, James immediately believed he had found someone special, a soulmate in his experimentation with form over subject-matter. Sidney Colvin later wrote that in Moore's art there was no quest for subject-matter, 'Whatever subject is chosen is merely a mechanism for getting beautiful people into beautiful situations.'[6] In W. Graham Robertson's words, 'The technical perfection of his pictures fascinated me; the rather uninteresting Graeco-West Kensington young women who invariably appeared in them did not appeal very strongly.'

Moore seemed to represent to James a positive step forward from the semi-formal tendencies of friends such as Rossetti and Millais. It was Swinburne who confirmed James's view, noting that Moore's work was to painters 'what the verse of Théophile Gautier is to the poets: the faultless and secure expression of an exclusive worship of things beautiful'.[7] Moore's work made a deep impression on James and seemed to be the spur he needed. Within weeks he had written to Fantin in Paris suggesting that Moore was the ideal candidate to replace Legros, who was out of favour with both, in the Société des Trois. This was more a gesture than anything else, since the society had for years existed in nothing but name. James also began work on two major projects. In the first he planned an atelier scene which would include himself, Fantin and Moore and two female figures. It would be, he wrote, 'an apotheosis of everything that can scandalize the Academicians'.[8] Only two oil sketches remain for this:[9] in both James stands with palette and brushes in hand, painting at an unseen easel looking out to the viewer; behind him are two female figures, Joanna and perhaps Milly Jones, the wife of an actor acquaintance, who was modelling for him around this time. The reclining figure of Joanna, and the emphasis put on

the drapery of both models, recalls Moore's work. It is, however, in his other major project at this time that a clearer statement of James's shifting perspective emerges.

Entitled *Symphony in White, No. 3*[10] – and possibly earlier *The Two Little White Girls*[11] – James had begun work on the picture perhaps as early as July 1865. By mid-August he was able to send Fantin a detailed sketch and description of the two girls – Joanna sitting on the white sofa propped on her right elbow, while Milly Jones sits on the floor, arms outstretched, leaning against the sofa. As James indicated to Fantin, he was pleased with the work so far, particularly the composition and the figure of Joanna – 'tout ce que j'ai fait de plus pur', he wrote.[12] The treatment in the preparatory drawing sent to Fantin is very close to Moore's composition of the two female figures in his painting *A Musician*. There was obviously a mutual understanding of their respective aims, but it soon becomes difficult to ascertain exactly who was influencing whom: they often used the same subjects, deployed similar techniques, used the same titles, and even adopted a similar method of monographic signature. For the moment James enjoyed the interaction and had a deep and genuine fondness for Moore, but in time the resemblance would become an issue of concern.

James worked on *Symphony in White, No. 3* throughout the remainder of August and the beginning of September at Lindsey Row.[13] The work proved difficult in the stifling summer heat, and the tension was probably heightened by the strain felt by Anna at Joanna's frequent appearances at the house. But there were more important problems. For over a year Anna's eyesight had been deteriorating and causing her much distress; all treatments had failed and Anna herself had resorted to faith. As she had earlier informed a friend, 'I have just risen from praying to our Lord to enable me to use my eyes so painfully weak.'[14] On 12 September, William escorted Anna on a trip to visit friends in the spa town of Malvern in Worcestershire where they stayed for a 'week to ten days'.[15]

Several days after their departure James would have read of the dramatic events which had occurred in Ireland over the previous weekend. After months of public displays of drilling and parading in towns up and down the country by members of the Irish Republican Brotherhood, the authorities had decided to quell what was clearly a menacing revolutionary threat. On the evening of 12 September, in a carefully planned operation directed by high-ranking government officials at Dublin Castle, the security forces arrested scores of IRB members: among these James's long-time friend, John O'Leary, who had become not only editor of the *Irish People*, but had also assumed the role of financial manager of the IRB.

Early in the evening of the planned arrests, O'Leary shut up the offices

of the paper to attend the theatre with his sister, Eva. Not able to find him during the initial round of arrests, the police feared he had been tipped off and had escaped, so they set up a surveillance operation around his lodgings at Palmerston Place. In fact, O'Leary, unaware of events, arrived home shortly after midnight to be arrested by 'G'-man Robert King, a member of a specialist detective unit formed to deal with political subversion. O'Leary characteristically refused to do anything until he was allowed to smoke his pipe, which he later recalled he had 'flavoured with a glass of whiskey and water'. After this, he was taken to police headquarters to be questioned, and was found to have hidden in his clothing several American banker's drafts destined for the movement. For several hours after O'Leary's departure, King and his companion methodically searched his house. Amongst the material found were three letters to O'Leary from James, which were initialled and dated by King.

After being interrogated all night by detectives, a bedraggled O'Leary, along with twenty-six other high-ranking IRB officers, was formally charged the following afternoon at Dublin Castle with 'feloniously and treasonably conspiring with other evil disposed persons belonging to a secret society called the Fenian Brotherhood [*sic*] having for their objective the levying of war in Ireland against the Queen and separating it from the United Kingdom'.

There is no evidence of James's reaction to the news from Ireland. He apparently said nothing to friends, nor mentioned it in any correspondence, at least not in any that survives. An uncanny cloud of silence begins to descend over James's life at this time and remains there for over three months. Throughout the rest of the week, press coverage continued unabated: speculation was rife, and there was one bizarre report of an imminent retaliatory attack from a Fenian battle-cruiser sailing in the Irish Sea.

Anna and William at Malvern decided that in a final attempt to cure her eye ailment Anna should be taken to consult a famous oculist in Coblenz.[16] On hearing of their plans, James, it seems, quickly decided to leave London and join them. After settling his mother in Coblenz with William, James departed and apparently retraced the route of his earlier Rhineland trip, before arriving at Trouville where he met up with Joanna. Also there, by coincidence or design, was Gustave Courbet.

For several weeks both James and Courbet painted and socialized together. James worked hard in Trouville, and that Courbet admired him is beyond doubt. In one letter to his father, Courbet noted that he was in the company of a 'pupil' called Whistler; James, one can be sure, did not see himself in that light. Significantly for James's painting it was here for the

first time that he attempted a painting at dusk. Later entitled *Crepuscule in Opal: Trouville*, the subject conceivably could have been suggested by Courbet, who had himself attempted similar works some years before. But it is more likely that James's interest in night effects came primarily through the occasional efforts of his friend, George Price Boyce.

Since at least 1862, Boyce had been experimenting with depicting the evening light on the River Thames.[17] In the earliest of these extant paintings, *Night Sketch of the Thames near Hungerford Bridge*,[18] which is circumstantially dated around 1860–2, Boyce creates an extraordinarily murky, silhouetted view across the river at dusk. That James was aware of these experiments there is no doubt. For him, the fascination lay in the painterly possibilities of the subject. Painting at dusk obliterated the peripheral detail of the day. Night, when the eye is confronted only with shapes, offered a logical progression for one pursuing the criterion of form over subject-matter.

The other six seascapes which James completed in Trouville show further refinement in the flattening of form and economy of paint. In four of them, ships are represented by scant sweeps of the brush. In another, later entitled *Harmony in Blue and Silver: Trouville*,[19] Courbet stands alone on the shore looking out to sea, and it recalls his own work *Le Bord de la mer à Palavas* of 1854. Symbolically or not, Courbet's position, with his back towards James, reveals perhaps the true situation. James had now nothing to learn from Courbet; his sympathy with the sources of realism was probably still intact, but he had moved to the Baudelairean position where form was of critical importance and subject-matter only provided the means to the end. In Trouville, Courbet, if anything, was learning from James: in most, if not all of his work done there, any sense of narrative or social comment, so characteristic of his earlier work, is totally absent. In the engaging company of James, he seemed concerned only with variations of colour imposed by the time of day or the weather conditions. For the master of realism it was a fundamental, albeit momentary, change of tack.

Courbet was particularly captivated by Joanna, and she quickly agreed to pose for him. Apparently from a single sitting he produced *Portrait de Jo, la belle irlandaise*.[20] A beautiful, sensitive portrait, it shows Joanna looking at herself in a hand-held mirror while running her fingers through her long red hair. The painting could well have been done by Rossetti, and reinforces the suggestion that Courbet had been listening carefully to James and tentatively exploring the possibilities presented by aestheticism. According to one source, the portrait became one of his favourites and he kept it for the remainder of his life. At one point he apparently turned

down an offer of 5,000 francs for it, preferring instead to sell something else.[21]

On 26 October, James wrote again from Trouville to Ionides in London: 'I am finishing some important pictures which will keep me here until about the 10th of Nov . . . The sea is splendid at the moment but I am anxious to get back.'[22] A possible reason for his anxiety was that O'Leary's trial was due to begin on Friday 1 December, at the Supreme Court in Dublin.

As the trial progressed, it can reasonably be assumed that James became very concerned, particularly at the evidence given by the arresting officer of finding 'personal' letters received from 'Americans' both in the United States and England, amongst which, he probably guessed, were some of his own. It was through the 'American link' that the prosecution had built its case against O'Leary as the 'financial manager' of the movement, responsible for raising and receiving funds from sympathizers in the United States.

When on 7 December the jury returned a verdict of guilty, the presiding judge ordered O'Leary to stand. He refused with a shake of his head. The judge continued: 'You knew that insurrection or revolution meant a war of extermination.' O'Leary: 'It meant no such thing.' Judge: 'You have lost.' O'Leary: 'For the present.' After this exchange the judge sentenced O'Leary to twenty years' penal servitude.

Shocked perhaps by the brutal reality of the situation and the horrendous punishment served on his friend, James apparently did nothing throughout December and wrote no letters. Was he approached by the police in London and asked to explain the friendship? This is almost impossible to answer, but something certainly happened around this time. Any fears he may have harboured were dramatically heightened in early January when Lord Wodehouse, the Lord Lieutenant of Ireland, applied to the government for greater powers of arrest.

Arguing that 'American emissaries' were still arriving daily in England and Ireland and were enticing loyal men to join their scheme of insurrection, he called for the Liberal government to suspend the Act of Habeas Corpus and introduce a Bill which would allow the security forces in both Ireland and England sweeping powers of arrest. With unprecedented speed, the Coercion Bill was passed in a single sitting and received the Royal Assent the following day.

In practical terms the Bill allowed anyone suspected of involvement with the Irish Republican Brotherhood to be detained without trial for up to six months. Given such wide-ranging powers, the Bill had a swift and decisive effect; within days there were hundreds of arrests in both Ireland and

England. Among those detained was Thomas Haynes, a friend of O'Leary's and reputed leader of the Brotherhood in London. In mid-January 1866, during all the arrests and confusion, James decided to leave London. Of all the places he could have gone, he chose Valparaiso in Chile as his bolt-hole.

For the doggedly loyal Pennells along with every other biographer, James's abrupt disappearance to Valparaiso has remained one of the most inexplicable events of his life. According to the Pennells, who asked him outright to explain his actions, James told them he had gone to Chile to help fight against the Spaniards with defeated Confederate soldiers, 'who were knocking about London, hunting for something to do'. James was partly truthful: Confederates were for the most part in England and Ireland to help the Irish Republican Brotherhood. Unaware of the true implications, the Pennells were justifiably suspicious and, in turn, they allotted barely two pages in their 600-page biography to his ten-month disappearance. When he further explained that the decision and arrangements were 'made in an afternoon' he was again misleading them. It is perhaps the only time during their long association with him when the Pennells did not believe a word he said. They knew there must have been another reason for his journey but James was not forthcoming, nor would he ever be. Only two people probably knew the whole truth – Joanna and his brother William.

As soon as he had made up his mind to leave early in the New Year, James wrote to his mother, still in Coblenz and unwell. Sparing her any details, he merely noted that he intended to 'travel and do some painting'. Anna's reply was practical and positive. If he must travel he must shut up the house at Lindsey Row. She told him 'to spend the money made from picture sales and the legacy from aunt Alicia to carry out his promise to enable his model to return to a more virtuous life'.[23]

It must have been with a tremendous feeling of relief that James boarded a ship bound for Panama. On 23 February he crossed the Panama isthmus by land and picked up a second ship, the *Solent*, which then steamed south towards Peru and Chile. He finally arrived at Valparaiso on 12 March, after travelling for nearly six weeks.

As they approached, James would have seen a sprawling town stacked haphazardly on the side of a steep hill. He was enchanted by it, and years later remembered 'the beautiful bay with the curving shores'.[24] Completely surrounded by hill and cliffs, the long sweeping bay is a natural deep-water harbour; but its climate is volatile, and when warm air from the Pacific is

blown eastward towards the Andes, the coastline can be enveloped in minutes by dense, rolling sea mist. This may continue for days, then suddenly a change in the wind direction transforms the cold, damp town into a subtropical paradise once again. As the most important commercial and military port in Chile, Valparaiso played host to thousands of foreigners in the nineteenth century. There was a thriving British community, mostly involved in shipping and commerce, with a sprinkling of diplomatic personnel.

None of James's letters from Chile has survived. One of the people who certainly wrote to him on several occasions was Gabriel Rossetti, who seems to have been assigned the role of keeper of James's business affairs and minder of Joanna. Only days after James left, Anderson Rose attempted to sell some etching plates in his possession to the dealers, Colnaghi's. After mulling the proposition over, they declined the offer.[25] By May the situation was no better, and Joanna was forced to write what must have been an acutely humiliating letter to Anderson Rose begging for money.

> Being at present rather in want in the way of money owing to the fact that none of Mr Whistler's pictures have yet been sold I take the liberty of asking you if you would be willing to lend me £10 for which I will give you as security anyone of Mr Whistler's Sea Views that are now at Mr Rossetti's. Would you kindly drop me a line to let me know if you could oblige me in this.[26]

There was further bad news in June when the Bank of London, in which James had deposited £43 1s 11d, went into liquidation.[27] As his creditor, Joanna received just five shillings in the pound.

While no letters of instruction, or indeed comfort, remain from this period, one piece of written evidence does: a small, 32-page taffeta-covered journal.[28] The 'Valparaiso Journal' – the only journal James ever kept during his life – is a fascinating though often cryptic record. The early entries indicate his concern with expenses, and various sums of money are added, subtracted and divided. The journal also indicates that he was not on his own for very long after he left London. During the journey by train to Southampton, he apparently met two women – a Mrs Doty and a Lizzy Purdy – also travelling to South America. But while Mrs Doty remained in Valparaiso, Lizzy Purdy quickly disappeared from the scene – though not before James had noted her London address. At a later point, Mrs Doty's husband arrived and towards the end of his stay James used him as a banking facility and borrowed from him large sums of money.

The journal shows that he spent a lot of time with naval officers whom he presumably met during the voyage or when their ships were in port. The hospitality was certainly reciprocated and James noted that he dined on board HMS *Leander*. One man named Scott, who was not obviously associated with any ship, seems to have been a constant companion and they ate together, while consuming large quantities of wine, port, cognac and pale ale.

The journal also reveals that James was quite ill in April; that he was involved in a fight with an unidentified man whom he slapped in the face with a letter, and that he frequently travelled around the immediate area on horseback, particularly to the neighbouring town of Limache. One subject, however, dominates the journal – James's observations on Chile's war with Spain. The Peruvian War of Independence had ended in 1826, with Spain still claiming control, and the conflict erupted again in 1864 after the Spanish fleet seized the Chincha guano islands and claimed from the Peruvian government an indemnity of $3,000,000. Chile immediately came to the aid of Peru. On 24 September 1865, after ultimatums were issued against it, the Chilean government declared a state of war. The Spanish response was to blockade the whole of the Chilean coastline. After intense diplomatic negotiation, the Spanish agreed to reduce the blockade to four ports: of these, Valparaiso was the most significant.

Early in March 1866, the Spanish commander, Admiral Nuñez, moved his fleet into battle position just outside Valparaiso harbour. In his journal James described the events which followed:

Saturday 24th [March]: Spanish Admiral's ultimatum. If by the 28th their flag will not be saluted, they will take extreme measures (bombard). Evening – news of attempted communication with and delivery of despatch to Spanish fleet. Individual captured – supposed Englishman.
Sunday 25th: Mistake about the Spanish spy – a Scotch chap drunk and on a lark.
Wednesday 28th: Went to Limache [?] Lunch [?].
Thursday 29th: Returned to Valparaiso.
Saturday 31st: Bombardment of Valparaiso.

Despite his leaving Valparaiso on diplomatic advice before the threatened bombardment like most other foreign nationals, the last entry shows James to have witnessed it when it actually occurred three days later. The cannon fire from the Spanish frigates positioned in the harbour continued for more than three and a half hours. Nothing within range was spared. According to one source, nearly ten million dollars' worth of damage was inflicted on the

city – nine million of which was to property owned by foreigners.[29] For the next two weeks the Spanish continued the blockade. On 14 April, as James noted in his journal, 'the Spanish left'. In fact, the Spanish fleet sailed north to Callao. Here, on 2 May, after meeting with fierce resistance from the Chilean land artillery, Admiral Nuñez, who later died of wounds, ordered his fleet to retreat. With that, the war with Spain was effectively over.

James's journal contains not one scrap of information about what he painted, or why he painted as he did. Yet years later, when he recalled the Valparaiso period to the Pennells, he told them: 'I made good use of my time, painted the three Valparaiso pictures that are known and two others that have disappeared.'[30] The two, he told the Pennells, were given to a ship's purser, to take home to England and look after for him. The purser, however, decided to keep them. According to James, they were later seen at the purser's house in London. Their loss occurred, he went on, when they were being taken back to South America by the purser, whose ship met a tidal wave, which swept off purser, cabin, Whistlers and all. Like many of James's stories, it is difficult to ascertain whether this one is true: poetic justice, whether real or imagined, characteristically delighted him.

Today, it is generally accepted that there are six extant oil paintings from the Valparaiso period: *Nocturne: The Solent, Symphony in Grey and Green: The Ocean, Crepuscule in Flesh Colour and Green: Valparaiso, Oil sketch for Nocturne in Blue and Gold: Valparaiso Bay, Nocturne in Blue and Gold: Valparaiso Bay* and *The Morning after the Revolution: Valparaiso.* There is also evidence suggesting the existence of at least one watercolour and a drawing.

The Valparaiso paintings reveal fundamental and decisive changes, compared to the work completed at Trouville. His earlier tentative experiments in evening painting are moved a step forward and James for the first time takes up the challenge of painting not just twilight, but the stillness and colour of the night itself. His breakthrough is perhaps best summed up by Donald Holden:

> spatial relationships become ambiguous. Detail is suppressed and only the general outline of things – the big shapes – remain. Ships cease to be ships, but become flat forms, blurred by the night. In the all-pervading darkness, the distinction between near and far is minimized. Ships, water, wharf, and coastline melt into the blue haze and become patches of colour lying on the surface of the canvas . . . Thus, Whistler's new vision was not an arbitrary attempt to redesign nature, but a fresh look at the visible world.[31]

To achieve this end, James's use of colour became much more subtle, and the application of paint thinner and more fluid. Gone are the impasto

paint-strokes seen in his Trouville work; the evocation of light and atmosphere is everything, and is achieved through fluent sweeps and flicks of colour. The recording of contemporary events, as in *The Morning after the Revolution* which shows the battleships at anchor in the bay, was not a new idea within James's circle of friends. Two years before, in 1864, his friend Edouard Manet had explored a similar theme when painting a naval battle between Confederate and Union ships that had occurred off the French coast near Cherbourg. Whether Manet's own naval background had added to his fascination with this highly publicized incident is not clear, but James was certainly aware of the series of paintings by Manet which followed in its wake. Such similarity of subject-matter underlines the overlapping, interchanging flow of ideas between James and his circle of artist friends at this time.

The same holds true in regard to other aspects of his subject-matter. As Manet had incorporated Spanish elements into his work, James had followed a similar line with the art and culture of Japan. Now, however, in Valparaiso, there is a discernible change of tack. Before, James's fascination with the art and artefacts of Japan had been indicated by their inclusion as mere props in a Western composition. In Valparaiso, however, his work began tentatively to incorporate more fully the fundamentals of Oriental spatial construction – high horizontal lines and asymmetrical arrangements creating intricate balance and rhythm with economy.

James's self-imposed isolation from England and France allowed him the space to break decisively with his earlier working methods and technique and to lay the basis for the future. In particular, this period anticipates the Nocturnes of the 1870s. What is also intriguing about the Valparaiso work is what is missing: James was, it seems, solely interested in the harbour. There are no recorded portraits, which one might have expected from someone so obviously in financial straits, nor are there any townscapes, landscapes or etchings. James himself seems to have been unaware of his radical achievement. Away from the day-to-day company of his friends and relatives and the problems of London, it appears he suffered no anxieties and no crises of confidence. He simply got on with his work, slowly and methodically.

In September James set sail for England. Towards the end of the voyage, a day and half from Southampton, he was involved in a fracas. A year later he described what happened to his friend William Boxall, who had painted his portrait as a child. The man he assaulted, according to James,

was simply a negro, among several forced on our company aboard. The degree to which he offended my prejudices as a Southerner who for the first

time found Negroes at the same table, led finally to a collision. His afterwards rushing out with a drawn sword led to the Captain's courteously, for safety's sake, requesting me to remain in my cabin, which I at once acceded to.[32]

Telling the same story to the Pennells in 1900, he named the recipient of his violence as the Marquis de Marmalade, 'a black man from Haiti who made himself – well – obnoxious to me by nothing in particular except his swagger and his colour'.[33]

As James was sailing home to England, Joanna had left London for France. Her destination was Paris and the purpose of her trip was to pose for Courbet. While the exact circumstances of the trip remain uncertain, Joanna arrived at Courbet's studio at the rue Hautefeuille sometime after mid-October. It seems likely that, in James's absence, she had been in contact with Courbet, in the hope of doing some modelling work for him. This she was now preparing to undertake.

After hearing lavish praise of Courbet's *Venus and Psyche* which had been rejected at the Salon of 1864, Khalil Bey, the former Turkish ambassador in St Petersburg, had asked the painter to do another version. Courbet refused and instead suggested he should do something else on a similar theme. The new painting was *Le Sommeil* (The Sleepers) – in the opinion of one writer, 'the most carnal, if not the most sensitive ever painted by Courbet'.[34] The painting allowed Courbet to experiment further with his fascination with lesbian love, which had surfaced periodically in his work since the years 1841–2. One of the models was Joanna, while the other was a model used by Courbet in several other paintings including *La Femme au perroquet*, which he had exhibited earlier at the Salon and which became the cause of a bitter quarrel between himself and the Superintendent of Fine Arts, Count Nieuwerkerke. *Le Sommeil* is sensuous and revealing, and shows an easily recognizable Joanna in a lesbian embrace. Both she and the other figure are nude. How long the picture took to complete, and how long Joanna remained in Paris is uncertain. What is certain, however, is that such a painting was not of a type to please James, nor were its implications. The whole episode certainly contributed to the breakdown of his relationship with Joanna, whether or not James saw the painting, which was never exhibited in Courbet's lifetime.

As Joanna was in Paris when James returned, she missed the final bizarre incident, which occurred when James stepped off the train in London. Although all of his friends knew about it, it was something that he omitted to tell the Pennells, perhaps out of embarrassment rather than forgetfulness. As they later recounted:

James never told us, but everybody else says that when he got out of the train at Euston or Waterloo, someone, besides his friends, was waiting: whether the captain of the ship, or relations of the Marquis de Marmalade or an old enemy really made little difference. Someone got a thrashing . . .[35]

The person who got the thrashing was James, and the person who delivered it was not one of the Pennells' suspects. It was, in fact, none other than Mr Doty, who was waiting to exact revenge for James's seduction of his wife on the outward journey and during their time in Valparaiso.[36] Characteristically, James denied the story and later gave his own version of events to William Boxall, claiming that Doty's suggestion of 'seductions' was made with 'astounding impudence'. With a 'sudden outburst of passion', James continued, 'I struck him then and there'.[37] What he omitted to mention was that Doty retaliated and beat him. James's 'blooding' was a suitable sign that his years of apprenticeship were over.

PART THREE

'Art is upon the Town'

12

Search for an Aesthetic

There's a combative artist named Whistler,
Who is, like his own hog's-hair, a bristler;
A tube of white lead
And a punch on the head
Offer varied attractions to Whistler.[1]

THIS AMUSING LIMERICK written by Gabriel Rossetti aptly described the
pugnacious James, just returned from Chile in the early winter of 1866.
Within less than a year, he was to have initiated four brawls. His moods
were marked by an increasing restlessness, as he moved back and forth
between London and Paris. Coupled with the constant movement was a
frustration and indecisiveness that began to fracture both his personal
relationships and his artistic life, and caused him sometimes to settle
arguments with his fists and not his tongue.

On first arriving back in London James soon took up temporary
abode with Joanna, recently returned from Paris, in a house in Fulham.
George Price Boyce recorded in his diary an evening gathering at this
address:

Went to Whistler's at his new house, 14 Walham Grove. Besides him and
'Joe' [Joanna] there was Gabriel Rossetti and Fanny [Cornforth] . . . He has
brought back but 2 oil sea-sketches with shipping, both are near Valparaiso,

both slight but effective, artistic and true in tone. He has also begun a portrait of himself.[2]

James told his friends of the fight, or 'shindy' as Boyce described it, with the Haitian, and the subsequent row with the 'mail agent', Mr Doty, who gave James a black eye. The highlight of the evening for Boyce, however, was the refreshment on offer from Whistler, who 'made us some wonderful brandy and whiskey milk punch'.[3]

Within a month of his return, James was in Paris re-establishing contact with his French friends. James brought with him *Symphony in White, No. 3* which was admired by Fantin, Alfred Stevens, Tissot and Degas; indeed Degas made a pencil sketch after the composition.[4] Yet, for all this praise, James chose to exhibit the work at the Royal Academy in London and not in Paris. It was back in James's studio in London by the end of March, as W.M. Rossetti recorded in his diary: 'Called to see Whistler's pictures for the R.A. etc. To the R.A. he means to send *Symphony in White, No. 3* (heretofore named *The Two Little White Girls*) . . . '[5] The change from a descriptive to a musical title marked the beginning of James's use of the analogy of music to capture the colour harmonies in his work. This concept was not new, as Baudelaire and his theory of the corresponding arts was already familiar in artistic circles: it would become an important influence on James's work in the next two decades.

On the domestic scene James, early in 1867, had arranged to lease no. 2 Lindsey Row, located at the east end of the row, just a few doors down from his previous home at no. 7. This elegant three-storey house overlooked the Thames and its proximity to the river was soon to have significance in his more experimental work, the Nocturnes of the seventies.

The new living arrangement suggests that James and Joanna had parted. The details of their separation are vague, and when Joanna's name does arise in the 1870s, it is in connection with Charles Hanson, James's illegitimate son by a parlourmaid. Born in June 1870, the boy appears, after a period, to have been taken in by Joanna, who was later referred to as 'Aunty Jo'. To the Pennells James described his son as 'my infidelity to Jo', which suggests that there might have been some sort of brief reconciliation between her and James in 1869.[6]

By March James was briefly back in Paris, to deliver his paintings for exhibition at the Salon and the Exposition Universelle; he then travelled on to Dieppe. Returning to London early in April James was back in Paris later that month.[7] In fact, much of James's time, on his return from Chile, was spent placing work into exhibitions for that coming spring, as though to compensate for his lengthy absence from the art circles of Paris and

London. In the selection of paintings on display in the spring and summer of 1867, James exhibited only two completed within the last year. The remainder were previously exhibited paintings, recycled by James to keep his name afloat on the art scene.

At the Royal Academy summer show James exhibited alongside his *Symphony in White, No. 3* two works completed before his trip to Chile. One, a seascape painted at Trouville in 1865, was given the title *Sea and Rain*, and the other was an earlier painting of the Thames, *Grey and Silver: Old Battersea Reach.*

At the Paris Salon James exhibited his earlier painting, *At the Piano*, which had been rejected by the 1859 jury, and a painting of 1861, *The Thames in Ice*. He was fortunate in having them both accepted, as the 1867 jury was particularly stringent: out of 3,000 applicants, only 1,000 were included.[8] The group of artists who were later to be known as the Impressionists, and included Monet, Renoir, Pissarro, Sisley, Bazille and Cézanne, were all rejected from the Salon that year. A petition was organized by these artists that a Salon des Refusés be permitted, but this was refused.

Some of the rejected artists placed their hopes in the Fine Art section of the Exposition Universelle which was being held in the Champs de Mars. Opening in April, in competition with the Salon, the Exposition Universelle continued until October. Again the jury selection was a conservative and limited affair and few of the hopeful young French artists were accepted. Fortunately for James, the entries were divided by countries and he submitted under the American section, exhibiting his early painting *Old Battersea Bridge*, as well as *Wapping, The White Girl*, previously exhibited at the Salon des Refusés in 1863, and a seascape from Valparaiso, entitled *Twilight at Sea*.[9]

Two artists who decided to take the initiative and exhibit on their own were Gustave Courbet and Edouard Manet, each erecting a pavilion to house their work on the Place de l'Alma, en route from the Salon to the Exposition Universelle. It would have been hard for the curious James to resist visiting either pavilion, especially as he knew both artists and took an interest in the direction realism, as a movement, was taking. It is possible that, on viewing Courbet's more retrospective exhibition, James began seriously to reassess the movement. Such a visit could have prompted a later letter to Fantin when James renounced his own artistic allegiance to realism.[10] Was this just another target for the combative James to fight against, or were there other factors motivating James's heartfelt rejection of the movement and more particularly of Courbet?

During this period James seems to have been at his most irritable. One provocation for a fight came from familiar quarters, namely James's

brother-in-law, Seymour Haden. The fight began over Haden's ill-treatment of his medical partner Traer, who had died recently in Paris. It was later disclosed that Traer had died whilst frequenting a brothel. Perhaps because of these embarrassing circumstances, Haden had given him a rather hasty burial in Paris, without contacting Traer's family. James was outraged by what he regarded as Haden's disrespectful conduct and ended up knocking him through a plate glass window. James, his brother William and Haden were taken to the local magistrate, on a charge of disorderly conduct, but the case was dismissed. However, it resulted in a permanent rift in the family and, thereafter, meetings between the Whistlers and Deborah Haden had to be arranged away from the Haden household.

Perhaps another motive lay behind James's anger with Haden, a sense of both professional and personal rivalry with another artist: Courbet. With his pavilion of over 100 paintings he could have aroused James's jealousy; such a display of Courbet's productivity would be hard to swallow for an artist like James who had produced only a handful of paintings in the past year. Add to this the fact that during James's absence his mistress Joanna had modelled for Courbet as one of two lesbians asleep after lovemaking, and jealousy seems a natural reaction. That Courbet had persuaded Joanna to pose nude, and in such a composition, suggests that he was equally persuasive at other levels.

On returning to London in the early summer of 1867 James was soon engaged in another row. The incident occurred in the office of his friend Luke Ionides, where he accidentally came upon Alphonse Legros. According to Ionides a fist fight soon developed, with Legros calling James a liar. It is difficult to ascertain exactly why the fight began. Antagonism between James and Legros had been growing over the years. One rumour had it that Legros had challenged James over a commission, which had been promised to Legros, but which James suggested be given to Fantin. Another possible motive, however, is offered by W.M. Rossetti, who later told the Pennells that the cause was women and that the details were unfit for publication, the Pennells adding in their *Journal*, 'and he was right'.[11] Could Legros have known of the Courbet nude of Joanna? Certainly animosity between Joanna and Legros was strong at this period. In a letter James wrote that August to Fantin, he mentions Legros:

He's no longer welcome at the Ionides' – I'm not going to attack him any more for gossiping about me in Paris because he's so pathetic – no wonder that after having been beaten he should be on the look-out! while for my part it's only natural that I should have nothing to do with him.[12]

Thus ended James's relationship with Legros.

The same lengthy letter to Fantin marks a crucial stage in the development of James's art. James begins it by admitting difficulties with his present work, describing it as 'the pain of giving birth!' He declared, 'Ah my dear Fantin what a frightful education I've given myself – or rather what a terrible lack of education I feel I have had!' On his early years spent in Paris, James wrote:

> You see the time was not good for me! Courbet and his influence was disgusting! The regret I feel and the rage, hate, even, that I have for that now will perhaps astonish you but perhaps there is an explanation. It's not poor Courbet whom I find repugnant, any more than his work – As always I recognize its qualities – I'm not at all complaining about the influence of his painting on mine – there is none, and you will not find it in my canvases – it couldn't be; because I'm too personal and know I've always been rich in qualities he doesn't have but which suit me well – But there's perhaps a reason why all this has been pernicious for me. It's that damned realism which made an *immediate* appeal to my vanity as a painter! and mocking tradition cried out loud, with all the confidence of ignorance, 'Long live Nature!!' Nature! My dear chap that cry has been a big mistake for me!

Interestingly, James then rejects the work he so recently exhibited in Paris. *At the Piano, The White Girl*, his Thames paintings, and even the seascapes, are derided as 'canvases produced by a nobody puffed up with pride at showing off his splendid gifts to other painters'. Continuing in this vein, James then made the curious claim, 'Ah! how I wish I had been a pupil of Ingres!', qualifying this statement with a confession that he had only a moderate liking for Ingres' work; but as a master, 'What a master he would have been'.

Ingres, who had died that year, was being celebrated in a retrospective exhibition of almost 600 works held to coincide with the Exposition Universelle.[13] James presumably had attended this exhibition on one of his numerous visits to Paris at this time. The well-known debate in French circles between colour and line lay behind much of what James admired in Ingres' work; Ingres as the master of draughtsmanship appeared to be winning over the seductive lure of colour.[14] Only a few years earlier James had posed for Fantin's group portrait, *Homage to Delacroix*, the nineteenth-century master of colour. He was now claiming:

> My God! Colour – it's truly a vice! Certainly it's probably got the right to be

one of the most beautiful of virtues – if directed by a strong hand – well guided by its master drawing – colour is then a splendid bride with a spouse worthy of her, her lover but also her master – the most magnificent mistress possible! – But coupled with uncertainty – drawing – feeble – timid – defective and easily satisfied – colour becomes a cocky bastard! making fun of 'her little fellow', it's true! and abusing him as she pleases – treating things lightly so long as it pleases her! treating her unfortunate companion like a duffer who bores her! the rest is also true! and the result manifests itself in a chaos of intoxication, of trickery, or regrets – incomplete things!

Could James have been extending the debate between colour and line into his own personal life? The strong language he employed, colour personified as a 'magnificent mistress' on the one hand and a 'cocky bastard' on the other, suggests that James's feelings went much deeper. At one point his pen seems to carry him away and his hand-writing becomes illegible. He ends the passage, admitting to Fantin:

In the end this explains the enormous amount of work that I am now making myself do – Well old chap I've been undergoing this education for more than a year now – for a *long time*, and I'm sure I will make up for the time I've wasted – but what a punishment!'[5]

Having bid adieu to realism, to Courbet and to Joanna, James was ready, at the age of 33, to undergo three years of intensive searching for a new style that would unite his artistic practice to a theoretical framework. After a decade as a practising professional James was determined to re-educate himself. For the next three years he kept a relatively low profile, choosing not to exhibit, whilst remaining largely in London. It is during this dormant period, regarded by both his contemporaries and by subsequent historians as unproductive, that James sought and developed an aesthetic system that he was to adhere to for the remainder of his artistic career.

James's decision to remain in London was not an immediate one; he toyed also with the idea of quietly returning to Paris where he could continue his studies undisturbed – a rather different picture from his early Paris years. Writing to his old friend, the collector George Lucas, in November 1867, James asked whether he might know of any suitable studio to rent.

I should I think like much to come over and stay in Paris – I wonder if you were accidentally to know of a decent studio – nothing but a bare studio

with a little room to sleep in? Perhaps for about 800 fr. or 1,000 – such might be met with – Large you know if possible, but not at all necessary to be *swell*, as I intend to be very quiet and scarcely 'receive' any one so I should want the money to go for *size* only, and warmth in its construction.[16]

As James went on to explain, 'I have a great deal of very hard work to do, and must be more quiet than I can be here – Also care but little to meet the old Café set just now, as I have no time for talk.'[17]

James's intention to avoid the old café crowd suggests that he had no wish to cross paths with the likes of Courbet. Yet, despite the serious tone of his request, James was to change his mind within a month and choose to remain in London instead. Writing to Lucas, who had found a suitable studio, James gave the reason for his change of heart as the sudden arrival of his mother from America, and told of his plans for making his home more habitable for her.[18] Anna, who had long since returned to London from Germany, had decided to visit America during the autumn of 1867. For whatever reason, Anna took James by surprise and that December had decided to settle at no. 2 Lindsey Row. By the new year James had taken temporary lodgings with the young architect Frederick Jameson, in Bloomsbury. Jameson later recalled:

It is impossible to conceive of a more unfailingly courteous, considerate and delightful companion than Whistler, as I found him. We lived in great intimacy, and the studio was always open to me, whatever he was doing. We had all our meals together except when elsewhere engaged, and I never heard of a complaint of anything in our simple household arrangements from him.[19]

This more compliant James seems to show a dramatic shift from the cantankerous artist of the previous year. A calmness and purpose have replaced the anger and frustration that marked his return from Valparaiso. Perhaps by moving to Bloomsbury, James was able to leave Chelsea and his troubles behind. The location of his studio, overlooking the entrance to the British Museum, is not without significance. Albert Moore also lived in Bloomsbury and frequented the British Museum. James's admiration for the artist continued to grow as Moore, eschewing narrative, developed a system of carefully controlled colour harmonies in his paintings of beautiful women, lightly draped and reminiscent of Greco-Roman sculpture.

Into this cult of the beautiful James settled himself, admiring not only the subject-matter of Moore's paintings but also his technical approach. The lusty, impastoed technique of Courbet was hereafter abandoned by James

and replaced by an economical thinness of paint which came to characterize his work. The purpose of the palette knife, if used at all, was no longer to load the paint on to the canvas in thick slabs, but to scrape away any excess paint.

James's use of colour also came under close scrutiny, and his earlier freedom with the palette was replaced by a precise and careful rendering of tones within a few colours. In his developing sensitivity to the subtleties of colour, he found himself allied again with Albert Moore: Moore's system of using a limited palette and repeating the colour throughout the canvas was a method that appealed to James. In another letter to his friend Fantin-Latour, written in 1868, he expressed his increasing fascination with colour:

> It seems to me, that colour ought to be, as it were, embroidered on the canvas, that is to say, the same colour ought to appear here and there, in the same way a thread appears in an embroidery, and so should the others, more or less according to their importance; in this way the whole will form a harmony. Look how well the Japanese understood this. They never look for the contrast, on the contrary, they're after repetition.[20]

James's interest in the Japanese print, a passion since his early years in Paris, was reaching a deeper level of understanding. Prior to this, he had used Japanese props, fans and figures dressed in kimonos, to add a touch of the Orient to his pictures. Now he began to assimilate the lessons of Japanese prints at a much more profound level.

The first manifestation of these lessons from Japan was to be found in James's 'Six Projects', a series of decorative pictures he was planning for his new patron Frederick Leyland. As a serious collector of Pre-Raphaelite paintings Leyland was first introduced to James through Dante Gabriel Rossetti. Leyland belonged to a new class of collectors who, earning their vast wealth in business or industry, had turned to what had hitherto been largely regarded as an aristocratic hobby. Leyland had come from a poor family in Liverpool where he worked his way up from being an apprentice clerk until he owned his own shipping company. He was self-educated and had a natural gift for the piano. As a patron of the arts Leyland dealt directly with the artists rather than through the intermediary of the emerging dealer system. In many of his dealings with Rossetti and James, Leyland proved himself an unusually patient man, often waiting many years for a commissioned work to be completed. James was fortunate to have met such a promising patron and Leyland would continue to commission the artist for the next decade.

The decorative scheme of the 'Six Projects' was intended for Leyland's London home at 23 Queen's Gate. Although James never completed the commission the six small oil sketches of the decorative scheme still exist. These paintings of figures dressed in loose-fitting draperies have an affinity with the Greek terracotta Tanagra figurines that James and Moore had seen at the British Museum. James also had a photograph album of Tanagra statuettes in a collection owned by his Greek friends the Ionides. Throughout his 'Six Projects' sketches keynotes of colour are picked up here and there as in a Japanese print.

James was at work on these sketches in the early summer of 1868, when Swinburne visited his studio. Swinburne was preparing his review for the Royal Academy Summer Exhibition, and despite the fact that James was not exhibiting that year, the critic included a long entry on the work he saw in his friend's studio. Much of Swinburne's review was a reflection of his increasing interest in 'art for art's sake', and the synthesis of music to art. Of James's 'Six Projects' Swinburne wrote:

> Of three slighter works lately painted, I may set down a few rapid notes; but no task is harder than this of translation from colour into speech, when the speech must be so hoarse and feeble, when the colour is so subtle and sublime. Music or verse might strike some string accordant in sound to such painting, but a mere version, such as this, is as a psalm of Tate's to a psalm of David's. In all of these the main strings touched are certain varying chords of blue and white, not without interludes of the bright and tender tones of floral purple or red.[21]

As is evident from Swinburne's review, James had found, in an English writer and critic, a sensibility compatible with his own. Interestingly, it was through the writings of Baudelaire that Swinburne became familiar with the literary work of the American, Edgar Allan Poe. It is during this period too that James, familiar with Poe's tales and poetry, began a painting entitled *Annabelle Lee*.[22] But it is Poe's essay 'The Philosophy of Composition' which bears the closest resemblance to James's aesthetic evolution; James later referred to the essay as 'one of the most fascinating things in literature'.[23] First published in 1846, for *Graham's Magazine*, Poe's analysis of his poem 'The Raven' would have appealed to James for its systematic rather than anecdotal approach. In Poe's description of the poem's refrain, he stressed that 'The pleasure is deduced solely from the sense of identity – of repetition', with effects being produced 'by the variation of the application of the refrain'. James was arriving at the same sense of repetition through the use of colour.

Continuing his review, Swinburne discovered in the work of Albert Moore a visual equivalent to poetry, and compared his painting to the verse of Théophile Gautier in its worship of the beautiful.[24] In his book on William Blake, an extended essay begun in 1863 and published in the late summer of 1868, Swinburne's belief in art for art's sake can be seen at its strongest. Removing morality from art was one of his chief tenets:

> Once let art humble herself, plead excuses, try at any compromise with the Puritan principle of doing good, and she is worse than dead . . . The one fact for her which is worth taking account of is simply mere excellence of verse or colour, which involves all manner of truth and loyalty necessary to her well-being.[25]

James's friendship with both Swinburne and Albert Moore can be seen as significant in developing the aesthetic sensibility that was to shape his art. Through Swinburne, James was able to renew his link with avant-garde French theory, and through Moore, he was able to find a visual equivalent to practise upon. James tried to emulate Moore's system of working his pictures up by an elaborate series of steps, but his temperament was such that he would grow impatient before success.[26] He was, however, prepared to spend time on improving his drawing and it is no accident that he sought out an artist like Moore, whose emphasis on draughtsmanship related to his renewed interest in this area. James's flatmate, Frederick Jameson, recalled:

> His talk about his own work revealed a very different man to me from the self-satisfied man he is usually believed to have been. He knew his powers, of course, but he was painfully aware of his defects – in drawing, for instance. I can remember with verbal accuracy some very striking talks we had on the subject. To my judgement, he was the most absolutely truthful man about himself that I ever met. I never knew him to hide an opinion or a thought – nor to try to excuse an action.[27]

With a view to improving his drawing skills during this period, James attended an evening life-class held by a Monsieur Victor Barthe in Limerston Street, Chelsea. Accompanied by the ever-faithful Greaves brothers he would often arrive late, interrupting the quiet atmosphere of the life room. While Walter Greaves would ceremoniously sweep aside the outside curtain for James's entrance, the other brother Henry would carefully hang the master's hat and coat on a nearby peg. Once seated, with James taking a central position flanked by the two brothers, they began the serious work of drawing after the model. While James drew chalk studies of

the nude, the Greaves brothers, whether from their shy nature or reverence for their master, often worked directly from James's sketch.[28]

When James returned from Bloomsbury to his studio in Chelsea in the spring of 1869, the Greaves brothers were close at hand, ready to do the work of apprentices in the studio, preparing the master's canvases, paints and brushes. James attempted to enlarge his 'Six Projects' series on to canvas, but his relentless need for perfection began to defeat him. Frustrated by the state of the work, in March 1869 he attempted to pay Leyland back the advance for the pictures and in his anxiety James turned to his mother, who wrote to Leyland concerning this delicate matter. Anna in her letter spoke of her son's disappointed hopes, mentioning his frustrated plans to complete the work for the Royal Academy that year. She confided that 'He is a poor fellow more to be pitied than blamed', surmising that his failing was that 'he has only tried too hard to make it the perfection of Art, preying upon his mind unceasingly it has become more and more impossible to satisfy him.'[29] In the letter, Anna asked Leyland to be patient, and ended with the hope that her son could obtain a loan of £400 from his half-brother George in order to return the advance to Leyland.

James also wrote at this time a letter to their old family friend Thomas Winans asking for a loan which was possibly intended as repayment to Leyland. The letter is a revealing document in that it admits to the several years of experimentation James had been undergoing.

> But for the last two years I have been absorbed in study, a most expensive proceeding for one who has no capital to go on, first because study and experiment prevent time for saleable production, and secondly because the study is made at the daily cost of materials – models who must be paid and who come to an awful lot and rent for a studio I was obliged to take during the winter. In short a continued outgoing and nothing coming in.
>
> All this study has doubtless astonished many who wonder what I *can* be about and how it is that I have shown nothing for so long in the Academy or even in my studio. I am sure you will sympathize in my anxiety in my work which will not admit of my being contented with what merely 'would sell'.[30]

James's next step was to attempt to reassess his work alongside his friend Albert Moore. Fearing the consequences of too close an affinity in subject-matter and style, James wrote to Moore, suggesting that a mutual friend, the architect and collector Billy Nesfield, act as an arbitrator.[31] This unnecessary request was handled with great tact by Nesfield who judged

that while both artists had learned from each other and often painted similar subject-matter, in their effect and treatment they stood far apart.

Despite Nesfield's verdict James chose to move away from the classicism of Moore and to turn his attention back to landscape and portraiture. His friendship with Moore continued through the next two decades, although the intensity they had once shared in their work had begun to fade. With commissions from Leyland to paint portraits of his family, James was set to embark on a new phase of his artistic career. The period of intense study was at an end and James was to reap the benefits of his search for an aesthetic style in the next productive decade.

13

The Butterfly Emerges

IF THE LATE SIXTIES were the chrysalis stage in James's development as an artist then the seventies witnessed the emergence of the butterfly. The lack of confidence he expressed in the late sixties was replaced by a new-found voracity for his work and his life. He painted such remarkable portraits as the *Carlyle*, the *Cicely Alexander* and the better-known *The Painter's Mother*, and created his most original series of pictures, the Nocturnes. These poetical paintings, largely depictions of the Thames, helped to bring about a new way of seeing the city. The 'Peacock Room', his greatest contribution to interior decoration and a key part of the Aesthetic Movement, helped to set a precedent for Art Nouveau. Furthermore, it is during this period that James's ability to promote his work is most evident, from his first one-man exhibition in 1874, held in London, to his well-publicized trial of 1878.

By the 1870s the status of the artist had changed in both England and France. In England artists were receiving knighthoods, building palatial houses, earning large incomes, and challenging the rigid class structures of society. Artists were often regarded as celebrities, with the latest news of them appearing in the gossip columns of the day. Events such as the private view at the Royal Academy were duly reported in all the major papers. The equivalent of today's film or pop stars, artists such as James Whistler provided continual entertainment for a news-hungry public. James, well aware of the potential of the press, used it to his own advantage, inviting reporters to his studio, to his openings, and later to record the events of the trial against Ruskin.

The situation in France, however, was quite different at the start of the

decade. On 19 July 1870 France declared war on Prussia. The Prussian army was both superior in numbers and in equipment, and within two months, after a series of defeats, Napoleon III surrendered. Two days later the Third Republic was proclaimed and fought on against the Prussians. Many artists took refuge in London at this time, including Tissot, Daubigny, Pissarro and Monet. Manet and Degas chose to stay on and fight in Paris.[1] Fantin, too, chose to remain in Paris, but rather than participate in the resistance against the Prussians, he shut himself off from the world.

By 28 January 1871, Paris was forced to surrender and Prussian troops occupied the city. France had lost the war and at the cost of many lives, including that of the painter Frédéric Bazille. Pissarro's house and studio in Louveciennes was ransacked by Prussian soldiers and many years' work was destroyed.[2]

By March, a Commune was proclaimed in the capital; in this revolutionary mood, Courbet was designated Curator of Fine Arts. He became involved in the event that led to the symbolic destruction of the Vendôme Column, an act which after the fall of the Commune was to lead to his trial and subsequent exile to Switzerland. This short-lived revolution was brought to a bloody end in May when government troops were sent in from Versailles to Paris. Manet, though not a partisan of the Commune, was nonetheless horrified by the actions of the troops and drew two lithographs showing scenes of the soldiers shooting the communards and fighters perishing on the barricades.[3]

Despite this gloomy scenario, the Third Republic rapidly recovered. The huge debt owed to Prussia for reparations was paid back within a short time. Zola wrote of this period optimistically as an opportunity to rebuild, not only France, but its artistic movements. Writing in December 1872, he proclaimed:

> All great literary and artistic blossomings have taken place in periods of complete maturity or else after violent upheavals . . . And those pariahs of late, those whose talents were denied, that group of naturalists of recent times will now come to the fore and will continue [in art] the scientific movement of the century.[4]

Zola's prophecy was fulfilled by the group of artists who came to be known as the Impressionists.[5]

The Parisian dealer, Paul Durand-Ruel, also sought refuge in London in 1870. Always the businessman, Durand-Ruel did not leave Paris empty-handed. He brought to London a large collection of contemporary French

paintings, including the work of Millet and his fellow Barbizon painters and the future Impressionists, and on arrival rented a gallery in New Bond Street, and set up the Society of French Artists. Here Durand-Ruel also displayed paintings by artists in exile, including Daubigny, Pissarro and Monet. James was invited to exhibit with these French artists, and he submitted paintings from 1872 until 1875 when the gallery was closed.

During the latter years of the 1860s James had remained largely in London and had little contact with Paris but, having seen the work of his French colleagues in the gallery, he would have felt a kinship in the choice of subject-matter. Both Pissarro and Monet during their exile in London had painted views of the city. Pissarro focused his vision largely on the suburbs whilst Monet selected the famous parks and views of the Thames. Despite the hardships of living in a foreign city these artists sought, nonetheless, to discover its secret beauties.[6] It is this attitude which James shared with these French painters, and which continued to inform his work of the seventies.

James's Nocturnes can be argued to be the most distinct and original of all his work. Already in 1866, when visiting Chile, he had experimented with painting a site at different times of the day, as seen in *The Morning after the Revolution: Valparaiso* and *Nocturne in Blue and Gold: Valparaiso Bay*. The latter painting comes closest to his Nocturnes of the 1870s, with its combination of a water subject and evening light.

Living at Lindsey Row with its view overlooking the Thames, James was to take the river as a constant theme in his work. Although he had been etching and painting the river since the late 1850s, he now looked anew at it as potential subject-matter: this may have stemmed from the recent success of his etchings *A Series of Sixteen Etchings of Scenes on the Thames and Other Subjects*, completed by 1863, but not published until 1871.[7] By May the Thames Set was on sale at Thomas Agnew in Old Bond Street at 2 guineas a set. To James's delight the etchings were the subject of a *Punch* review entitled 'A Whistle for Whistler', which included the pleasing comment that 'before Seymour Haden was Whistler, his brother-in-law and etching master'.[8] Previous painters, particularly those within the Pre-Raphaelite circle such as George Price Boyce and William Holman Hunt, had depicted scenes of the Thames at night; but their approach was sporadic and lacked the atmospheric quality that James brought to the subject. By the summer of 1871 James had begun his first 'moonlights', a subject that would evolve into his series of Nocturnes.

James was also engaged on what came to be one of his most famous paintings, the portrait of his mother. With this painting he had at last struck a formula which could bring the crucial portrait commissions he so

desperately needed for success. The story of how the portrait came about can be related from Anna Whistler's letters to her sister Kate Palmer. One day when James had been let down by a model's absence, he turned to his mother and asked her to sit for a portrait. At first James had his mother stand, a pose he preferred all his models to take. As she was weak, however, James then allowed her to sit, and the remarkable profile pose was adopted. She wrote to her sister in November 1871:

> Jemie had no nervous fears in painting his Mother's portrait for it was to please himself and not to be paid for in other coin, only at one or two difficult points when I heard him ejaculate 'No! I can't get it right! it is impossible to do it as it ought to be done perfectly!' I silently lifted my heart, that it might be as the Net cast down in the Lake at the Lord's will, as I observed his trying again, and oh my grateful rejoicing in spirit as suddenly my dear Son would exclaim, 'Oh Mother, it is mastered, it is beautiful!' and he would kiss me for it!⁹

Anna's words come alive when looking at the portrait of this remarkably patient and pious woman.

The portrait, which came to be known as *Arrangement in Grey and Black: Portrait of the Painter's Mother*, is incredibly restrained in its near monochromatic colouring and controlled composition. By using the device of the framed etchings of the Thames and the patterned curtain, James has both achieved a sense of depth and succeeded in breaking up the monotony of the background. In place of the usual Victorian sentimentality, James was able to render his sitter's facial features with great sensitivity: Swinburne, a favourite of Anna Whistler's, was later to point to the portrait's 'intense pathos . . . and tender depth of expression'.¹⁰

Anna not only modelled for James at this time, but also served as house-keeper, sharing his home at no. 2 Lindsey Row. She organized the household, saw to the servants, arranged his meals on a regular basis, and insisted that he adhere to the rule of not working on the Sabbath. James's friends in Chelsea, such as Swinburne and the Greaves family, both adored and respected Anna. What she was able to give to James was a look of respectability that both patrons and neighbours responded to. The Leylands were to invite Anna down to Speke Hall near Liverpool, and she was often the recipient of gifts, such as a basket of hot-house fruit, from other admiring patrons of James.

Anna also provided James with much needed stability, although at times her son found her presence a little irksome. Anna, however, saw her influence on her wayward son as being beneficial. An incident which bears

her out took place soon after James had begun to paint her portrait. One day she had been too feeble to sit for him, and James, concerned about her health, suggested that they take a boat-ride down the Thames. When they returned in the late afternoon, James was moved to paint the scene before them, described by Anna as 'the river in a glow of rare transparency an hour before sunset'.[11] Rushing to his studio James sought out a canvas, easel, brushes and tubes of paint, and began to paint the scene with Anna watching transfixed at her son's progress. As the sun set and the moon began to appear Anna exclaimed, 'Oh Jemie dear it is yet light enough for you to see to make this a moonlight picture of the Thames', and James proceeded to do so. It appears that in fact he painted two scenes, one of the sunset and one of a moonlit scene.[12] That winter James exhibited both these paintings at the Dudley Gallery, located at the Egyptian Hall in Piccadilly. One was entitled *Variations in Violet and Green* and the other *Harmony in Blue-Green – Moonlight.* The latter picture is now known as *Nocturne: Blue and Silver – Chelsea* and hangs in the Tate Gallery, London.

Two favourable reviews, from the *Athenaeum* and *The Times,* singled out these works by James. The latter reviewer, possibly Tom Taylor who later took the role of James's adversary, wrote a sensitive appreciation of the artist's work. It is likely that he had taken James aside to ask him to explain his output and his theories thus far, as the words echo many of the artist's. This review is important as unequivocal proof that, despite the Pennells' view to the contrary, James had indeed gained acceptance in certain circles, including more conservative papers such as *The Times.* Speaking of the two paintings in the Dudley exhibition the reviewer wrote:

> They are illustrative of the theory, not confined to this painter, but most conspicuously and ably worked out by him that painting is so closely akin to music that the colours of the one may and should be used, like the ordered sounds of the other, as means and influences of vague emotion; that painting should not aim at expressing dramatic emotions, depicting incidents of history, or recording facts of nature, but should be content with moulding our moods and stirring our imaginations, by subtle combinations of colour through which all that painting has to say to us can be said, and beyond which painting has no valuable or true speech whatever. These pictures are illustrations of this theory.[13]

The review continues in this fashion commending Whistler's frames, where the colour is carried over in a consistent manner, with delicate patterns of diapering and ripples of 'faint green and moony blues on their gold'.

Encouraged by this review and by the purchase of one of the paintings for £210 by William C. Alexander, a Quaker banker working in the City of London, James must have been stimulated to continue his painting of 'moonlight' scenes. He received *The Times* review in the post from his pupil Greaves, while staying with the Leylands at Speke Hall that November.[14] He had spent a few days away at the seaside, where he had hoped to paint some seascapes, but found the weather disappointing; he wrote to Walter Greaves, 'The sky – I never saw it so stupid – and as to the sea, it was nowhere at all! It had simply gone off altogether – really I went to the seaside and I found no sea!'[15]

In an earlier letter to his pupil, James admitted to missing his early morning row with the brothers, and thanked him for safely packing and sending a picture to Speke Hall.[16] This was the portrait of his mother and it is likely that James wanted it on hand to convince Frederick Leyland of his ability to paint a portrait. In this same letter to Greaves, James mentioned the work he was engaged on at Speke Hall, with 'two large canvases underway'.[17] The two pictures James spoke of were the full-length portraits of his patron Frederick Leyland and his wife Frances. These life-size paintings were his first attempt to paint commissioned portraits of the full figure set within the frame. James was in good company, as he told Walter Greaves of the 'Grand Velázquez' which presided over his pictures.[18] This painting, now untraced, went by the title *El Corregidor de Madrid*, and can only doubtfully be attributed to Velázquez.[19] There are certain similarities between Velázquez's *Portrait of Philip IV* (Prado, Madrid), of which James had a photograph, and his own portrait of Leyland.[20] Both subjects appear in dark contemporary dress and are shown in a similar stance. Like Velázquez James has found the solution to spatial ambiguity by setting Leyland in a darkened background, thus allowing the figure to emerge from the shadows.

With James's portrait of Frances Leyland another solution was sought. James positioned Frances with her back turned to the viewer, her head turned to her left in profile. Frances's elegant figure and auburn hair appealed to James's sensibility and he sought to bring out these attributes in his picture. A series of chalk drawings exist where James was attempting to find both a pose and a dress suitable for his sitter. At last an artistic dress of pink chiffon with rosettes was decided on, which set the colour scheme for the composition. The resulting portrait, which took innumerable sittings through to 1874, can be seen as the feminine counterpart to Leyland's darker portrait.

James spent much of the festive season of 1871/2 with the Leyland family, and grew to be on intimate terms with both Frances and the

children. He did several drypoint etchings of the family and the house. One is simply entitled *Speke Hall* and shows Frances Leyland, again with her back turned, in the foreground, while set into the receding background is the half-timbered house of the title.[21] The other etchings are more intimate portraits of Frances, her husband and the children. It is during this time that James became briefly engaged to Frances Leyland's sister Lizzie Dawson.[22] This engagement was short-lived and without recriminations on either side, and James continued to remain on good terms with the family.

In spring 1872 James chose to submit to the Royal Academy his painting of his mother. It had just narrowly escaped being burnt in a fire on its return journey by freight train from Liverpool and narrowly escaped being burnt again, metaphorically, by the Royal Academy selection committee. Fortunately James's connection with the Royal Academician Sir William Boxall, who in 1849 had painted him as a boy, saved the day. The jury of Royal Academicians had decided against hanging the portrait. Boxall intervened on James's behalf, and threatened to resign unless the painting was accepted. Unfortunately the picture was poorly hung above an entranceway – yet another slight to James's sensitive ego. Its reception by the press was cool, with one paper commenting on the severity of the picture and suggesting that the artist could have 'thrown in a few details of interest without offence'. On later recounting this criticism to his pupil, Walter Sickert, Whistler added that suitable details such as 'a glass of sherry and the Bible!' would be appropriate.[23] The near rejection of the painting, poor hanging and the lukewarm response of the press combined to convince James never again to exhibit with that most conservative of institutions, the Royal Academy.

Despite its poor reception the picture was to attract the attention of several patrons and lead to the commissioning of at least two portraits. One such commission came from the wealthy collector Louis Huth, to paint a portrait of his wife Helen. Huth, who was introduced to James through Rossetti, was the first purchaser of his *Symphony in White, No. 3*.[24] James chose to paint Helen Huth in a black velvet dress with a lace collar, standing in profile. The velvet train of her dress spills into the foreground of this full-length painting. As Helen Huth was delicate in health, she could not stand for long and the painting took two years to complete. There are similarities to James's portrait of Frederick Leyland, where he chose to depict the sitter in dark clothing against a dark background. Again the connection to Velázquez's full-length portraits is evident: the Huth family owned three works attributed to the Spanish master. For James to paint Mrs Huth in such a manner would serve to complement the collection.[25]

The painting came to be known by the title *Arrangement in Black, No. 2: Portrait of Mrs Louis Huth* and was exhibited at James's first one-man show in 1874.

James was also hard at work at this time on another portrait, again inspired by the portrait of his mother. During the late summmer of 1872 Thomas Carlyle, living at no. 5 (now 24) Cheyne Row in Chelsea, had visited James's studio with a mutual friend, Madame Emilie Venturi, a neighbour and collector; there they had seen the portrait of his mother, recently returned from the Royal Academy summer show. The presence of Anna Whistler, herself from the McNeill clan, might have induced the Scottish sage to sit for her son soon after that initial visit, but much persuasion is not likely to have been necessary, since numerous paintings and photographs of Carlyle serve as a testament to his vanity. Soon he was being painted in the studio at Lindsey Row, having assumed a similar pose to that of *The Painter's Mother*. Gradually the two or three sittings that James had requested of Carlyle grew, with Carlyle complying until he had simply had enough. James then completed the portrait using another model to sit in Carlyle's coat.

What came to be known as *Arrangement in Grey and Black, No. 2: Thomas Carlyle* became, like *The Painter's Mother*, one of James's most exhibited paintings. It was shown eighteen times between James's inaugural 1874 one-man show and the memorial exhibition of 1905. Both paintings can be seen as his most aesthetically designed works to date, and that he came to regard the portraits as important to his oeuvre can be deduced from the fact that he eventually sold them to public collections.

Why James chose to paint the philosopher-historian in the first place is not quite clear. Possibly he hoped to attract commissions by using the portrait of such a notable contemporary figure as bait. Carlyle for his part liked the fact that James managed to paint his linen collar white, a point where other portrait painters such as G.F. Watts had failed. Carlyle's niece, Mary Carlyle Aitken, wrote to James of her uncle's impressions of the portrait: 'he remarked to me when he returned from his last sitting "that he really *couldn't help* observing that it was going to be like him, and that there was a certain *massive originality* about the whole thing, which was rather impressive!"'[26]

The strange conjunction of the elderly Carlyle sitting for the dandified James Whistler caught the imagination of one later writer, Max Beerbohm. He drew a caricature of the two, entitled *Blue China*, which depicts the diminutive James showing Carlyle an Oriental pot, and went on to use the incident in his unfinished novel, *The Mirror of the Past*. Finally, paying homage to both Whistler and Carlyle, Beerbohm, the perpetual dandy,

dressed down to pose for a photograph which exactly replicated the original *Carlyle* portrait.[27]

One winter day after yet another morning session posing for James, Carlyle, as he was escorted to the front door by the maid, turned to her and asked to whom the little girl who had passed him in the hall belonged. He was informed that the fair child was Miss Cicely Alexander and that she was to begin sittings with Mr Whistler for her portrait. Carlyle shook his head and under his breath exclaimed 'Pur lassie, pur lassie', as he placed his hat on his head and took his leave. Young Cicely made her way up the stairs to James's studio, escorted by her father, William Alexander, to become the next victim of the artist's perfectionism.

Alexander, who was already the owner of one of James's Nocturnes, had visited the Royal Academy exhibition and been impressed by the portrait of the artist's mother. He soon contacted James and commissioned him to paint his six daughters. Although James began paintings of three of them, he was only to complete the one portrait of Cicely. Originally starting a portrait of the eldest girl, Agnes Mary – better known as May – he soon tired of the picture and suggested to Alexander that he begin with the youngest daughter, Cicely, who was 8 at the time.[28]

Cicely's fair colouring immediately appealed to James's artistic eye, and he soon had specific designs drawn up for the white muslin dress he envisaged the girl wearing.[29] The resulting portrait, which was entitled *Harmony in Grey and Green*, was a modern-day equivalent to the Spanish princesses painted by Velázquez: Cicely stands as proud and impudent as the Infanta Margarita.[30] Where so many portrait-painters of children had failed, James succeeded by avoiding the sentimentality usually associated with the subject. In comparison to Millais' portraits of little girls, such as his Royal Academy diploma picture, *Souvenir of Velázquez* (1868), James's portrait achieves a much greater restraint. Refusing to cater to the Victorian 'cult of childhood' it has an objectivity arrived at by a careful aestheticism, achieved largely through James's method of 'sacrificing' his sitter to the decorative whole. True to his developing aesthetic principles, James kept the colour to a minimum: greys, black and white, with hints of yellow in her hair ribbon, her dress, the bows on her dancing shoes, the daisies at her side and the butterflies flitting above.

The painting took over seventy sittings and later in life Cicely told James's biographers, the Pennells, of her trials with the painter:

So I was the first victim, and I'm afraid I rather considered that I was a victim all through the sittings, or rather standings, for he never let me change my position, and I believe I sometimes used to stand for hours at a

time. I know I used to get very tired and cross, and often finished the day in tears. This was especially when he had promised to release me at a given time to go to a dancing class, but when the time came I was still standing, and the minutes slipped away, and he was quite absorbed and had forgotten all about his promise, and never noticed the tears; he used to stand a good way from his canvas, and then dart at it, and then dart back, and he often turned round to look in a looking-glass that hung over the mantelpiece at his back – I suppose to see the reflection of his painting.[31]

James did give the child the run of the studio, allowing her to put charcoal eyes to some of his sketches done in coloured chalks, and made her promises, such as painting her doll, which he never kept. Fortunately for Cicely, Anna ensured that the habit of luncheon was more closely adhered to.

This portrait of Cicely shows James at his best, having captured the essence of childhood. James was later to sum up the spirit of what he sought in a portrait in these words: 'If you paint a young girl, youth should scent the room: a thinker, thoughts should be in the air; an aroma of the personality.'[32] Such an achievement can be claimed by James for both the *Cicely Alexander* and the *Carlyle* portraits.

Although James spent much of 1872 engaged on portraiture he was also busily painting his series of views of the Thames. That winter he exhibited at both the Society of French Artists and at the Dudley Gallery. At the latter gallery James submitted two moonlights for the first time under the musical title of 'Nocturnes': *Nocturne in Grey and Gold – Southampton Water* and *Nocturne in Blue and Silver*. He wrote excitedly to Frederick Leyland, thanking him for thinking up the inspired title:

> I say I can't thank you too much for the name 'Nocturne' as a title for my moonlights! You have no idea what an irritation it proves to the critics and consequent pleasure to me – besides it is really so charming and does so poetically say all that I want to say and *no more* than I wish! The pictures at the Dudley are a great success.[33]

Leyland, an amateur musician who often shut himself up for hours to practise the piano, was particularly fond of Chopin's music. By naming and renaming all his paintings with musical titles, James sought to remove the subject from setting or narrative. He also included within the title the key colours used in the painting. Such a method of naming contributed to James's aim to focus on the painting itself and to encourage an abstraction of the work from its more material origins.

James's debt to Japanese prints by Hiroshige and others is at its most apparent in his Nocturnes. Unlike some of the earlier paintings which had merely used Japonaiserie props such as fans and kimonos, James now had assimilated the concepts of design such as asymmetrical balance (the golden section), and sought a harmony of colour and form within the picture and beyond to the frame. One particularly successful painting, *Nocturne in Blue and Gold: Old Battersea Bridge*, of 1872, shows James at his best and most indebted to the Japanese. When compared to his earlier realist version of the same subject, painted in 1859, *Old Battersea Bridge*, James's later version is notably different. The heavy wooden supports of the bridge are elongated and the bridge itself is curved in a way reminiscent of several prints by Hiroshige. The figures on the bridge are only suggested, with abbreviated strokes of paint. The figure on the barge passing below the bridge is a type seen frequently in Japanese prints. Yet, on the whole, James's Nocturne is Western not Oriental. It may have been influenced by Japanese concepts of design, but the final work is a Whistler original, a point strongly maintained by James himself.[34]

There were also certain technical changes in James's approach to landscape painting during the seventies which echoed the methods of Chinese and Japanese landscape painters. In their search for the essential in a scene, parallels do exist, both being concerned with capturing a certain mood or atmosphere based on their observations from nature. Whether James was aware that Oriental painters worked from memory is uncertain, but he no longer needed to observe the subject first-hand as he had done in paintings of the previous decades. Instead he employed a method of carefully observing the scene, occasionally sketching little chalk notes, then returning home to paint the picture from memory the next day. This method was derived from earlier discussions with his friends Fantin-Latour and Legros over the mnemonic teachings of Lecoq de Boisbaudran.

One young follower, Thomas Way Jnr, son of James's lithographic printer, later recounted an incident when he was witness to James's unusual method. On stopping with James outside a group of buildings at twilight, the older artist paused and exclaimed 'Look', as if mesmerized by the scene. Way, offering James his sketchbook, was interrupted with 'No, no, be quiet'. After a long pause James turned to Way and said, 'Now, see if I have learned it', and repeated a full description of the scene he had just observed. Way characterized James's method as similar to the way 'one might repeat a poem one had learned by heart'.[35] Such a memory-method discarded unnecessary detail, leaving only the essential to be grasped.

The technical difference between James's approach to landscape

painting and that of his French contemporaries, such as Monet and Pissarro, is at its most revealing during this period. At a time when the Impressionists were exploring the advantages of working out of doors, *en plein air*, James's method of memorizing the scene, and later returning to the studio to paint the picture, seemed far removed from their aim of spontaneity.[36] Yet, despite these differences, both approaches sought to record the artist's impression of a scene.

What James held in common with the Impressionists was his interest in depicting the urban centre and scenes from modern life. In his choice of subject-matter, James transformed what had been previously regarded as an industrial river, full of noise and pollution, to a vision of rare beauty. This ability to find potential beauty in ugliness was an attitude which had its precursors in writers such as Baudelaire.[37] James later described this vision in his famous 'Ten O'Clock' lecture:

> And when the evening mist clothes the riverside with poetry, as with a veil, and the poor buildings lose themselves in the dim sky, and the tall chimneys become campanili, and the warehouses are palaces in the night, and the whole city hangs in the heavens, and fairy-land is before us – then the wayfarer hastens home; the working man and the cultured one, the wise man and the one of pleasure, cease to understand, as they have ceased to see, and Nature, who, for once, has sung in tune, sings her exquisite song to the artist alone, her son and her master –[38]

The Cremorne Pleasure Gardens along the Thames, a notorious meeting-place for late-night revellers and favourite haunt of James's, now became a source of inspiration to him. Every night a grand display of fireworks would light up the gardens and river. It was such a sight that prompted James to paint several Nocturnes: fireworks providing yet another challenge to his night painting. He would stroll to Cremorne, accompanied by his faithful pupils Henry and Walter Greaves. Dressed in the dandified attire of wide-brimmed hats, with coloured silk ties worn loosely at the neck, he and his pupils had all the airs of romantic bohemians. James himself was very much in the mould of the French *flâneur*, as Baudelaire described the figure in his 1863 essay 'The Painter of Modern Life':

> For the perfect *flâneur*, for the passionate spectator, it is an immense joy to set up house in the heart of the multitude, amid the ebb and flow of movement, in the midst of the fugitive and the infinite . . . to be at the centre of the world, and yet to remain hidden from the world – Such are a few of

the slightest pleasures of those independent, passionate, impartial natures which the tongue can but clumsily define.[39]

What James saw in Cremorne Gardens was the nearest equivalent in London to the outdoor cafés and cabarets of Paris where his contemporaries, Manet, Monet, Degas and others, were beginning to depict scenes from modern life. Yet the emphasis on colour and movement, so much a part of the work of Renoir or Degas, was not to be found in James's interpretation of similar subjects. James does not engage the viewer in the gaiety of scenes such as Renoir's *Le Moulin de la Galette*. Instead he distances himself as observer and removes the garish mood of Cremorne from the setting so as to give a timeless floating quality to the subject.

At the first exhibition of the Society of French Artists at 168 New Bond Street, organized largely by Paul Durand-Ruel and Charles Deschamps, Pissarro's *A Snow Effect* and *Upper Norwood* and Monet's *Entrance to Trouville Harbour* were included in the display. By 1872 the future Impressionist clique had enlarged to include paintings by Manet, Pissarro, Monet, Sisley and Renoir. In that year James was invited to exhibit and submitted two paintings to the society, one entitled *Harmony in Grey*, which was an early-morning scene of the Thames, and *Arrangement in Grey and Black, No. 2*, which was a self-portrait of the artist.[40]

The German artist Otto Scholderer, who had recently settled in London and regularly corresponded with Fantin-Latour, visited the exhibition and wrote of his impressions to the French artist: 'I like Whistler's landscapes more than before, also his portrait he calls "harmony in black and gray" it's very fine, with a magnificent background, and it's true he has more nicety than Manet, but I still like the latter much more, I don't know where Whistler's paintings will end up.'[41] Scholderer's confusion about the titles was not surprising considering the novelty of James's labelling.

James's decision to exhibit a self-portrait is interesting in the context of his friend Fantin's recent entry of a self-portrait in the 1871 London International Exhibition in South Kensington.[42] Unlike Fantin's portrait, which shows no indication of his profession, James portrays himself as indubitably the painter, brushes held almost defiantly in hand. The portrait harks back to Rembrandt and Velázquez and can be read as an attempt by James to establish himself as a serious artist amongst his French colleagues exhibiting with Durand-Ruel. This supposition is all the more convincing when examined against the poor reception of his mother's portrait at the Royal Academy earlier that year. Could James's alignment with these French artists be interpreted as a deliberate rebuke to the Academy? The

answer seems to be bound up in James's decision to exhibit in the following spring of 1873 with Durand-Ruel in Paris and, more importantly, to mount his own independent show in 1874 in direct defiance of the summer exhibition at the Royal Academy.

With the return of the French dealer Durand-Ruel to Paris after the Franco-Prussian War, the art scene there began to regenerate itself. By 1872 Durand-Ruel was holding exhibitions on a regular basis. Having already established a relationship with James in London, the art dealer was willing to include his work in his Paris shows. Well aware of the importance of his re-initiation into the Paris art world James sought to make an impact in the 1873 exhibition at Durand-Ruel's, and showed several Nocturnes and possibly a portrait or two. Writing to his friend, the collector George Lucas, James spoke of his work in the exhibition and explained his artistic intentions:

> They are not merely canvases having interest in themselves alone, but are intended to indicate slightly to 'those whom it may concern' something of my theory in art. The science of colour and 'picture pattern' as I have worked it out for myself during these years.[43]

In his reference to 'those whom it may concern' James was alluding to other artists and critics of the avant-garde. His wording is carefully constructed to indicate the seriousness of his intentions.

The critic Edmund Duranty, in a pamphlet written three years after the exhibition, noted:

> Three years ago, in these same Durand-Ruel galleries, another painter, an American [Whistler], exhibited remarkable portraits and paintings with colour variations of infinite delicacy – dusky, diffused, and vaporous tints that belonged to neither night nor day.[44]

Although this article post-dates the exhibition, Duranty's inclusion of James in his article, which mentioned the work of Manet, Monet, Degas and other avant-garde artists, is nonetheless significant. James, after his years of retreat in London, was back on the scene.

In his letter to George Lucas, quoted earlier, James goes on to explain the theory behind his decorated frames:

> You will notice and perhaps meet with opposition that my frames I have designed as carefully as my pictures – and thus they form as important a part as any of the rest of the work – carrying on the particular harmony

throughout. This is of course entirely original with me and has never been done.

This was an overstatement and James was disregarding the very real influence of the Pre-Raphaelites' use of decorative frames, despite his qualification: 'Though many have painted on their frames but never with real purpose or knowledge – in short never in this way or anything at all like it.' Continuing in this vein, James stressed his originality to Lucas:

> ... and I wish this to be also clearly stated in Paris that I am the inventor of all this kind of decoration in colour in the frames; that I may not have a lot of clever little Frenchmen trespassing on my ground.

He also mentioned to Lucas his novel use of titles which he explained as his 'theory of painting' and in a postscript added that the mark on the pictures and frames was a butterfly which stood as a monogram for 'J.W.' This butterfly monogram was adapted by James to add a further decorative element to the final composition. Great care was taken to find the appropriate place for his signature both within the picture and on the frame, thereby creating a completely balanced work of art.

Thus James, in a letter to an influential collector in Paris, made clear his artistic theories to date. Having developed an aesthetic code which carried the physicality of the paint surface on to the frame, and beyond, James was introducing an important decorative element into his work. He was soon to take this concept further, and adapt the hanging scheme in the gallery or room to harmonize with the picture.

Concluding his letter to his friend, James emphatically stated that 'This exhibition of mine you will see clearly is especially intended to assert myself to the painters, in short, in a manner to register among them in Paris as I have done here my work.'[45] Essentially James saw the exhibition as a means to patenting his work. For the first time in his career he felt the need, as Courbet had done in his one-man show of 1855 entitled 'Realism', to expound his theories of art. Confident that he was producing something new and original, he was preparing the theoretical groundwork to back up his visual statements.

James's need to explain his work to Lucas suggests that he was worried about the reception of his paintings by his Parisian colleagues: 'those whom it may concern'. One long-time friend, Fantin-Latour, took the opportunity to see James's work on view at the Durand-Ruel gallery and was surprised, if not shocked, by what he saw. In a letter to Otto Scholderer in London, Fantin expressed his disbelief:

I've seen the pictures he has just sent at Durand-Ruel's. It was a big surprise for me, I don't understand anything there; it's bizarre how one changes. I don't recognize him any more. I'd like to see him to hear him explain what he's trying to do, but I need to see it again, and then I will write frankly to him the effect it has on me.[46]

As promised, Fantin revisited the exhibition, but remained unchanged in his opinion. He regretted the change in direction that James's work had taken, a trait he had seen in a number of his colleagues' work. Writing again to Scholderer, Fantin admitted to being

left with my first impression, and to understand me you would have to have seen Whistler's first pictures, but the reason is everyone follows his own path; one no longer understands another, it's a law of Art. Every day I am troubled by that; I no longer understand, I almost no longer like what I see by my old comrades, for which I reproach myself, I can't do otherwise. However I make a big effort.[47]

During and following the upset of the Franco-Prussian War Fantin had become increasingly reactionary in his views towards art; the Old Masters and the time-honoured traditions of painting increasingly occupied his interest, both stylistically and technically.[48]

By June James had visited Paris and seen his old friend. Fantin later wrote to Scholderer of this reunion with James:

I've seen Whistler here, and I felt on seeing him how much less interested I am in all these things today; we discussed amicably what I didn't understand about what he wanted to do in his canvases. I think that he has too much feeling to be vexed with me, but in spite of all there was a coolness between us; what would you think? Each goes his own way, he appeared enchanted with himself, persuaded that he is moving forward while we others stick with the old painting.[49]

In reality their relationship had been cooling since the late 1860s and their correspondence had dramatically fallen off.

Back in London in the summer of 1873, James continued working on his various portrait commissions and paintings of the Thames. On visiting the Society of French Artists' summer exhibition, James saw the work of his French contemporaries, including Claude Monet, who had since returned to France. Monet's entry was a picture he had painted in 1871 during his exile in London, entitled *The Thames at Westminster*. While Monet brought

his own fresh interpretation to the river scene, the influence of James's work is arguably present. In Monet's depiction of the misty Thames, there are echoes of James's Nocturnes, not only in subject-matter, but in the broad sweeps of liquid paint on to the canvas.[50]

In a later letter to the English art critic, Wynford Dewhurst, Pissarro listed some of the artists both he and Monet had found interesting during their stay in London, a list including Turner, Constable and Crome, and wrote: 'but we were struck chiefly by the landscape painters, who shared more in our aim with regard to *plein air*, light and fugitive effects.'[51] Although Pissarro omits any mention of James Whistler, it is difficult to imagine that they would not have come into contact with his work. Certainly by 1873, when James was exhibiting in Paris with Durand-Ruel, both Pissarro and Monet would have seen the Nocturnes he exhibited there. What James himself thought of the work by Monet was later revealed in the eighties when, as President of the Society of British Artists, he asked the French artist to join him in exhibiting with the Society.[52]

In the winter of 1873 James again exhibited at both the Dudley Gallery and the Society of French Artists in London. To the Dudley James sent a view of the recently built Thames embankment, entitled *Variations in Pink and Grey*. This painting has elegant figures of women strolling in the foreground set against the river as it recedes into the background. To the society James sent two earlier paintings, one erroneously entitled *Yacht Race – A Symphony in B sharp*, now known as *Trouville*, and the other given the title *The Golden Screen – Harmony in Purple and Gold*. On 8 November, the *Athenaeum* mentioned the 'whimsical title' assigned to the first painting, and James after a delay of almost two weeks wrote to the paper correcting the error of the 'B sharp' of the title and claimed that it had been a misunderstanding between the dealer and himself.[53]

James concluded his letter to the *Athenaeum* by excusing his tardy response: 'I have been prevented writing to you before by illness.' The artist George Boyce, who had visited James on the 11th, recorded in his diary: 'Called on Whistler who has been very ill with rheumatic fever. Saw him in his bedroom. He is getting better. His mother there; she has been much troubled with her eyes, poor old lady.'[54]

By the middle of November it appears that James's health had returned. On visiting the Bond Street galleries that winter and inspecting his own paintings, James would also have seen works by Degas, Manet, Monet, Pissarro and Sisley. Monet's pictures, in particular, with the titles *A Factory* and *The Old Bridge*, would have drawn an interested nod of approval from James, whose paintings of the Thames reflected similar themes.

These same artists were now meeting in Paris to discuss an alternative exhibiting group, and by December it had been officially constituted. Originally known as the 'Société anonyme coopérative d'artistes-peintres, sculpteurs, etc.' the group, largely instigated by Camille Pissarro and Monet, was to have a lasting effect on the history of modern art. There were several factors at play which came to influence James's decision not to take part in this important formation, when he was invited by Degas.[55] Finding it already under discussion when he visited Paris that June, he would have been dissuaded from joining it by Fantin-Latour, who had taken an avowed dislike to the group and refused to join. Fantin had also been responsible for influencing Manet in his decision not to exhibit with the radical group. When visiting the first exhibition held at the photographer Nadar's old studio on the Boulevard des Capucines in May 1874, Fantin again denounced it. Writing to Otto Scholderer in London he blamed Monet, Pissarro, Sisley and Renoir for making 'a caricature out of what we others are devoting ourselves to, to no little trouble'.[56]

This first exhibition of the Société Anonyme marked the emergence of the group soon to be known as the 'Impressionists' and included work by Claude Monet, Berthe Morisot and Edgar Degas. Organized primarily by Pissarro and Monet, this first exhibition opened on 15 April 1874. It is unlikely that James visited this inaugural exhibition as he was busy in London making preparations for his own artistic statement.

14

The Artistic Seventies

IN JUNE 1874, taking his cue from Courbet's and Manet's previous one-man exhibitions, James decided to go it alone and stage his first one-man show. James, who came to manipulate the role of outsider, here made his first major appearance in that part. By opening his exhibition that summer he was making a direct challenge to the Royal Academy where he had not exhibited since 1872.

Although James had alternative venues to exhibit in, it was nonetheless important for him to make a larger statement of his own independence. Artists in both France and Britain were becoming increasingly disgruntled at the often conservative selections for the annual shows at the Salon and the Royal Academy. To compensate for this, a number of dealer galleries were springing up to serve the needs of artist and buyer. During the seventies group shows or exhibitions of single pictures by popular artists were frequent. However, it was not until the eighties that commercial galleries held one-man shows on a regular basis.

Therefore, when James made the decision to exhibit alone, he had to finance the venture out of his own pocket. He took a lease of what had formerly been known as the Flemish Gallery, in Pall Mall, where he was able to tailor the exhibition to his every whim, spending over £30 redecorating the rooms to his own taste.[1] Gabriel Rossetti wrote to Ford Madox Brown guessing, in a jealous manner, at James's apparent motive:

I see Whistler is getting up an exhibition! I think I twig the motive power. He must have finished the Leyland portraits, and persuaded Leyland that they were sure to be hung badly if sent to the R.A. – whereupon Leyland,

rather than see himself hoisted, paid bang out for an independent show of them. I have no doubt at this juncture it will send Whistler sky-high, and Leyland will probably buy no one else anymore! I believe Leyland's picture will set the fashion in frills and buckles.[2]

Rossetti's suspicion about Leyland funding the exhibition is unfounded, but it is conceivable that James sought to flatter his patron by holding an exhibition where the two Leyland portraits had pride of place. He also listed the portraits of Leyland and his wife as numbers one and two in the accompanying catalogue. Such gestures would not have gone unnoticed by Leyland, who attended the opening of the exhibition with his wife.

James's private view was held on 4–6 June, and the invitations were adorned with handsome silk butterflies. James's pupil, Walter Greaves, later spoke of the last-minute urgency as he and his family, along with Mrs Whistler and her son, made these butterflies.[3] On entering the gallery the viewer must have been struck, not only by the complementary decoration of the galleries, but by the fascinating juxtaposition of several dominating full-length, life-size portraits of the Leylands, Carlyle and Whistler's mother, with the flesh-and-blood originals. Carlyle would have cut a curious figure in his dowdy black coat, amongst the fashionably dressed men and women attending the opening.

Although James's exhibition received some notice from the press, it did not attract the interest of the major papers such as *The Times*. However, such notices as James received were generally favourable. The reasons behind James's decision to boycott the Royal Academy and hold his own show were set out by Sidney Colvin in the *Academy*:

> But the excuse for private exhibition is that our great annual shows, in the present state of public taste, do not really provide a genial element for works of art . . . If there is any case in which an artist is justified in opening a gallery of his own, it is when he is conscious of a distinct vocation for certain kinds of artistic combinations which it takes delicate organs to appreciate, and when experience has taught him that this kind of combination receives scanty welcome at the hands of art's official censors. And this is Mr Whistler's case.[4]

Addressing James's principles, the critic went on:

> That Mr Whistler is an artist having a distinct vocation stands acknowledged. To produce a peculiar order of delicate arrangements and harmonious pattern of colour, in the representation whether of individual

sitters or fancy groups or landscape; to carry out the pattern-making part of his intention to as subtle and complete a point as possible, and to stop very short with the representing or realizing part . . . these may be set down as the heads of the mission, which Mr Whistler feels himself inspired to fulfil. And as of all harmonious and spirited pattern-makers the Japanese race stands infinitely the foremost, so it is in the art of Japan that Mr Whistler finds his closest precedent.[5]

What intrigued most of the gallery-goers was the decoration of the galleries rather than the display of pictures. James employed a colour scheme of grey and pink distemper for the surrounding walls with a subdued overhead lighting which softened the features of the gallery. The floor was covered in yellow matting and the seating was upholstered in a light maroon cloth. Plants and flowers stood around in pots artistically placed to give the mood of a light and airy artist's studio. When compared to the overcrowded displays at the Royal Academy, James's gallery must have seemed radical and modern. As the reviewer for the *Pictorial World*, Henry Blackburn, wrote:

> The visitor is struck, on entering the Gallery, with a curious sense of harmony and fitness pervading it, and is more interested, perhaps, in the general effect than in any one work. The Gallery and its contents are altogether in harmony – a *symphony in colour*, carried out, in every detail, even in the colour of the matted floor, the blue pots and flowering plants, and, above all, in the juxtaposition of the pictures . . . If anyone wishes to realize what is meant by true feeling for colour and harmony – born of the Japanese – let him sit down here some morning, within a few yards of, but in secure shelter from, the glare of the guardsman's scarlet tunic in the bay window of the club opposite, just out of hearing of Christie's hammer, and just out of sight of the conglomeration of a thousand pictures at the Royal Academy.[6]

As well as the portraits already mentioned, the show included the portrait of Mrs Huth, *Arrangement in Black, No. 2*, and finally his most recently completed portrait, that of Cicely Alexander, *Harmony in Grey and Green*. Such a selection of life-size, full-length portraits, amounting to over half the paintings on exhibition, suggests that one of James's prime motives in holding the show was to advertise himself as a fashionable portrait-painter. Had he just submitted one or two portraits to the Royal Academy, the subtlety of his work would have been lost in the sea of portraits exhibited there annually. In his own show, however, James could compete

with himself, and such carefully selected juxtapositions of his own work only served to bring out the best qualities in each.

Commissioned portraits could promise a steady income provided that the painter remained in fashion. However, as competition was fierce, it is possible that James's aim in holding his 'artistic' show was to set himself up not only as a likely portraitist, but as one who could satisfy the aesthetic sensibilities of his prospective patrons. James was offering not only a portrait, but a 'work of art' as well, and the packaging of the exhibition helped to promote such a concept.

The portraits on exhibition did receive some notice from the press, with the *Art Journal* writing that

> The portraits alone stand out as exceptional examples of the intellectual qualities that enter into this branch of art, joined with a quick and subtle executive power of the most valuable kind. Rapidity of vision and the apparent ease of technical expression are the two prominent facts in Mr Whistler's portraiture.[7]

Fortunately for James, this reviewer was unaware of the laborious methods employed by James when painting portraits. Another paper, the *Hour*, mistakenly reported that the portraits, which were compared favourably to Velázquez, were not in fact of recent date:

> This exhibition causes one to form a high estimate of Mr Whistler's artistic knowledge and power; but it gives rise to the melancholy reflection that the best works are not of recent production, and that the latest are the least satisfactory.[8]

James quickly responded to the *Hour*'s erroneous statement in a letter which was published the following day:

> the paintings he speaks of in glowing terms – notably 'the full-length portrait of a young girl' which he overwhelms me by comparing to Velázquez, as well as two life-size portraits in black, 'in which there is an almost entire negation of colour' (though I, who am he says, a colourist, did not know it) – are my latest works, and but just completed.[9]

This comparison to the work of Velázquez was frequent in the criticism of James's work. His sarcastic retort belies his admiration for the Spanish artist: James, Manet and a number of other artists, who were seeking something more than a simple photographic likeness of their sitters, turned

to Velázquez for inspiration. This fashion of turning to the Old Masters for solutions in portraiture reached its apex with the American artist, John Singer Sargent, who in the eighties and nineties offered his English patrons a whole repertoire of styles to choose from. Sargent's skill in painting in the manner of previous masters such as Van Dyck made him especially popular amongst the aristocracy and *nouveau riche*.

This practice of recalling the work of Old Masters can be seen as an attempt to re-establish portrait painting as an art and not simply a means of reproduction. The liberation of the medium from its task of mere reproduction is interesting when examined against the advent of photography. With the popularity of the small *carte de visite* photographic portrait as well as the increasing number of photographic portrait studios, the genre of portrait-painting was to shift to higher aesthetic ground.[10] James was well aware of this challenge and his aim was to subject the sitter to the decorative whole, rather than attain a photographic likeness.[11]

In 1878 James expanded his views on portraiture in a letter published in the *World*, and later reproduced in his *The Gentle Art of Making Enemies*.

The imitator is a poor kind of creature. If the man who paints only the tree, or flower, or other surface he sees before him were an artist, the king of artists would be the photographer. It is for the artist to do something beyond this in portrait painting, to put on canvas something more than the face the model wears for that one day; to paint the man, in short, as well as his features; in arrangement of colours to treat a flower as his key, not his model.[12]

With such beliefs James could not help setting himself up for disappointment. The role of the portrait-painter, expected to flatter and cater to the whims of his wealthy clients, was not exactly suited to his temperament. Oscar Wilde would later encapsulate the problem in *The Picture of Dorian Gray*, a novel likely to have been inspired by the hours the writer spent in Whistler's studio: 'every portrait that is painted with feeling is a portrait of the artist, not of the sitter. The sitter is merely the accident, the occasion. It is not he who is revealed by the painter; it is rather the painter who, on the coloured canvas, reveals himself.'[13]

James's big gamble in holding his 1874 one-man show, in the end, did not pay off. The costs of renting and decorating the gallery, when balanced against the poor sales and lack of resulting commissions, placed him in deficit.[14] By the eighties the public was less wary and more willing to take risks with the, by then, notorious James; by the nineties his name had become fashionable. However, the tragedy was that in the twenty years that

intervened, James had aged and he was no longer capable of taking up the challenge with the energy of his earlier days.

Walter Sickert, James's pupil in the eighties, aptly summed up his master's predicament:

> Whistler, like Manet, aspired for years to the social and financial triumphs of Carolus Duran [a fashionable French portraitist]. They both hoped to make their fortunes by portraits for which the models themselves were to pay. Both misjudged their public, and while Manet fell back on portraits of non-paying characters for the collector, Whistler's instinct pushed him to landscape panels, nine inches by four, which were to become his masterpieces.[15]

As an intimate of the studio Sickert saw James's technique as ill-fated from the start:

> Whistler's large full-lengths against plain backgrounds, generally black, suffered from the fact that he pitted his physical rapidity and endurance, not only against the unsleeping mobility of life, even in a northern light, but against the laws of the very paint he knew and loved so well. He accepted, why I have never understood, the very limited and subaltern position of a *prima* painter . . . These paintings suffer from, firstly, the necessary simplification of their backgrounds; secondly, from the fatigue of the sitters, and of their very clothes; thirdly, from the fact that sittings approaching the rule of *de die in diem* [from day to day] necessitated the use of too tenuous a medium.[16]

James's technique, described by Sickert as that of the *prima* painter, who painted directly on to the canvas without any preliminary studies, echoed such masters as Velázquez. Yet, with James, as he rarely achieved the effect he wished for in the first 'go', the method evolved into one in which he constantly rubbed down the work after painting in an unrelenting search for perfection. Such a method was often more successful when working on a non-commissioned painting such as his portraits of his mother and Carlyle, but it was technically unsuited to a busy patron who could not afford the time for the numerous sittings that James could request.

James's technique as a portrait-painter was unique. Before beginning to paint a portrait he would spend fifteen minutes or more arranging the colours of the palette, which to him was as important as the fine-tuning of a musical instrument before a concert.[17] To paint a full-length portrait he would place the large canvas near his table palette, and his sitter about four

feet to the other side of the easel. He would then stand back about twelve feet to observe the scene, taking a good look at both the sitter and canvas, then step forward quickly. With long brushes that enabled him to stand as far from the canvas as possible, he would begin rapidly to sketch in the figure, with long firm strokes. By standing away from the canvas he could sketch directly from his sitter. With the figure thus sketched in, James then discarded these long-handled brushes for normal-length ones and set about working up the painting. His need to maintain the whole visual picture was achieved by his stepping back to assess and memorize, then returning to the easel, often with a run and a slide, to fix the image on to the canvas.[18] Such an athletic approach to portraiture would have tired both the painter and the sitter.

With the aid of his table palette James would dilute his paint with turpentine and oils, creating a thin paint, which could be applied then rubbed down on numerous occasions to create a suitably thin 'skin' on the surface of the canvas. A sense of depth was thus created by these innumerable layers of liquid paint. James's object was to cover the whole canvas at each sitting, with the ghostly figure of the sitter emerging, despite the constant rubbing down and repainting. One sitter later compared James's method with the process of developing a photograph: 'And so the portrait would really grow, really develop as an entirety, very much as a negative under the action of the chemicals comes out gradually – lights, shadows, and all the first faint indications to their full values.'[19]

Interestingly, James's obsessional method of continually rubbing down a canvas was reversed in Oscar Wilde's haunting novel, *The Picture of Dorian Gray*, where the painting takes on a life of its own and literally 'grows' its own 'skin'. Such inversions were commonplace for a writer like Wilde, and it is conceivable that in his observations of James in the studio, the seeds of his story were already being sown. Richard Ellmann in his excellent biography of Wilde reveals that James Whistler was in fact the original model for the painter in that book, but owing to fears of libel the character was altered to erase any resemblance to James.[20]

Frederick Leyland described his sittings to James as 'my own martyrdom'.[21] James was often unaware of the weariness of his sitter or of the coldness of the studio, caring only for the task at hand. Even the fading of the light was not of concern to him:

As the light fades and the shadows deepen all petty and exacting details vanish, everything trivial disappears, and I see things as they are in great strong masses: the buttons are lost, but the garment remains; the garment is

lost, but the sitter remains; the sitter is lost, but the picture remains. And that night cannot efface from the painter's imagination.[22]

Such poetical attitudes were lost on many of James's sitters.

After the 1874 exhibition, one rare commission did, however, come – from the rather dubious character, Charles Augustus Howell. James described Howell to the Pennells as 'the wonderful man, the genius, the Gil Blas-Robinson Crusoe hero out of his proper time, the creature of top-boots and plumes, splendidly flamboyant, the real hero of the Picaresque novel, forced by modern conditions into other adventures, and along other roads.'[23] Born in Portugal, Howell first came to light as secretary to John Ruskin. Having gradually drifted into Chelsea and set up as a collector and dealer, a shifty 'jack-of-all-trades', he was untiring in his search for the 'blue pots' which obsessed Rossetti and his friends. It appears that James first came across Howell through the Rossetti brothers and his amusing antics appealed to James's sense of bravado. After his death, James summed him up: 'Criminally speaking, the Portugee was an artist.' However, in times of need, Howell could be very practical and, especially during James's bankruptcy in 1879, helped the artist immeasurably.

Howell's commission was for James to paint Rosa Corder, his mistress and an artist in her own right. She was described by the actress Ellen Terry as 'one of those plain-beautiful women who are far more attractive than some of the pretty ones'.[24] James's portrait was included in the 1879 Grosvenor Gallery exhibition, as *Arrangement in Brown and Black: Portrait of Miss Rosa Corder*, and was favourably reviewed. Most portraits that James painted during the mid to late seventies were non-commissioned works, which included 'artistic' portraits of his mistress, Maud Franklin, one of the actor Henry Irving, and one of the music hall performer, Connie Gilchrist. The last two portraits reveal his increasing interest in the stage at this period.

While prospective patrons did not materialize, according to the Pennells, 'Lindsey Row was lined with the carriages of Mayfair and Belgravia. Whistler was the fashion, if his pictures were not, and he could say nothing, he could do nothing, that did not go the rounds of drawing-rooms and dinner-tables.'[25] By now, James was free to entertain after his old fashion. In 1875, his mother, whose health had been precarious for years, had been advised to move to the coast, to aid her recovery. At her doctor's suggestion she took up residence in Hastings, boarding with an amiable landlady in a house which could accommodate her family when they visited

her. James, still at Lindsey Row, was thus able to invite his new model, the young Maud Franklin, to move in with him.

Maud was around 18 when she began to model for James's paintings.[26] Her father was a cabinet-maker and upholsterer in London, and came to be connected with artists through frame-making. Maud's profession as an artist's model possibly pre-dated her involvement with James. Once she was James's main model and mistress, Maud appears to have turned to painting herself, and by the eighties was exhibiting under the pseudonym of Clifton Lin.[27] Her elegant figure, pale skin and auburn-coloured hair conformed to the type of woman James was particularly attracted to. At one point James had Maud pose for Frances Leyland's portrait, when the sitter was not available. Their similarity in appearance was not overlooked by James, whose fondness for Frances Leyland was perhaps given a vicarious physical dimension through his sexual relationship with Maud.[28]

With Maud as his regular and, in all likelihood, unpaid model, James was able to explore further his interest in portraiture. Her ability to endure the long hours of modelling for the exacting James is a tribute to her professionalism. That James was inspired by Maud, as a model, is attested by the numerous pictures he painted of her, among them *Arrangement in Black and Brown: The Fur Jacket* and *Arrangement in White and Black*, which were painted during the mid-seventies and later shown by James at the newly opened Grosvenor Gallery in 1877 and 1878, respectively.

It is during this period that James emerged fully as a social butterfly. His novel Sunday breakfasts soon gained him the sort of notoriety that he relished. Although he invited his guests for twelve, they would often have to wait hours for their host, who could be heard beyond the drawing-room, splashing about in his bath.[29] By two o'clock, freshly bathed and dressed in white linen, James would emerge, armed with such irresistible charm and chatter that his waiting guests would soon forgive his bad manners. Amongst his guests would be the Rossetti brothers, Alan Cole, C.A. Howell, and any prospective patrons. The fare was typically American, with buckwheat cakes, green corn, eggs, bacon, biscuits and plenty of hot coffee. A fellow artist, Louise Jopling, who was fond of James, gave a description of those breakfasts:

One met all the best in Society there – the people with brains, and those who had enough to appreciate them. Whistler was an inimitable host. He loved to be the Sun round whom we lesser lights revolved. He ignored no one. All came under his influence, and in consequence no one was bored, no one was dull. Indeed, who could be when anywhere near that brilliant personality?[30]

One aspect of James's personality which was not agreeable to all guests was his voice. According to various accounts it was high-pitched and his famous 'Ha! ha!' which marked him out to his enemies would often be heard resounding through a room. Mrs Leyland recalled that his voice was unattractive to some people and recounted an evening reception where a guest complained 'that even genius could not excuse such a voice'.[31] James's accent and expression was unique: an American Southern drawl sprinkled with English and French idioms. The Symbolist poet, Arthur Symons, wrote of James's idiosyncratic means of expression:

> And his voice, with its strange accents, part tuned to the key of his wit, was not less personal or significant. He had a whole language of pauses, in the middle of a word or of a sentence, with all kinds of whimsical quotation marks, setting a mocking emphasis on solemn follies.[32]

Such was the originality of James's speech that even when being interviewed, his manner was noted:

> In a second you discover that he is not conversing – he is sketching in words, giving impressions in sound and sense to be interpreted by the hearer ... A half-finished sentence, a detached phrase, a gesture, a laugh, a wayward argument not carried to its expected conclusion, an interrupted anecdote; so the monologue runs easily, with here and there a gay note of colour, a word, a twinkle, an unfamiliar idiom. The meaning of what he says is flashed hither and thither, bewildering, charming, provoking, and yet at the end you have understood what he intended to convey in a curiously vivid way ... and you feel you cannot hope to report the syncopated rhythm of his sentences, the pizzicato of the accent.[33]

A much later acquaintance, Max Beerbohm, wrote of James's peculiar style both in writing and speech: 'The voice drawls slowly, quickening to a kind of snap at the end of every sentence, and sometimes rising to a sudden screech of laughter; and, all the while, the fine fierce eyes of the talker are flashing out at you, and his long, nervous fingers are tracing quick arabesques in the air.'[34]

At another of James's Sunday breakfasts a guest once expressed a desire to see him paint. Much amused, James turned to Louise Jopling and said, 'If Mrs Louise will sit, I should like to paint her.'[35] She quickly agreed and off they all went up to the studio to see the master at work. In front of such an audience, James was compelled to succeed and within a few hours he had painted a full-length portrait in oils. One of the guests, the architect

Edward Godwin, recorded the event in his diary: 'saw Whistler paint full length of Mrs Jopling in an hour and a half; an almost awful exhibit of nervous power and concentration.'[36]

Other accounts exist of preparations for dinner parties, with the Greaves brothers running to neighbours to borrow pots and pans, and James borrowing Mrs Leyland's butler for the evening. Not untypically, when James first gave a dinner party at no. 2 Lindsey Row, he decided on the day of the party to paint the drawing-room, with the assistance of the Greaves brothers. To their exclamations of 'It will never be dry in time!', James responded, 'What matter? It will be beautiful!'[37] The three worked incessantly, covering the walls with a flesh-coloured paint complemented by a pale yellow and white on the doors and woodwork. Before the evening was over James's guests were part of the decoration with touches of flesh colour and yellow on their dresses and coats. The dining-room was painted in shades of blue, with purple Japanese fans tacked on to the walls and ceiling.

Another story, of James's ability to scrape together a dinner party from pennies, is told by Luke Ionides:

> Jimmy was busy putting things straight – he asked me if I had any money. I told him I had twelve shillings. He said that was enough. We went out together, and he bought three chairs at two and sixpence each, and three bottles of claret at eighteenpence each. On our return he sealed the top of each bottle with a different coloured wax. He then told me he expected a possible buyer to dinner, and two other friends. When we had taken our seats at the table, he very solemnly told the maid to go down and bring up a bottle of wine, one of those with the red seal. The maid could hardly suppress a grin, but I alone saw it. Then, after the meat, he told her to fetch a bottle with the blue seal; and with the dessert the one with the yellow seal was brought, and all were drunk in perfect innocence and delight. He sold his picture, and he said he was sure the sealing wax had done it.[38]

James's interest in the arts extended to the culinary, and he would spend time each day writing and arranging the menu. Each menu is a work of art in itself and James's ability to create a harmony of taste, texture and visual appeal echoed his painterly skills. No detail was too slight to miss his touch, from the choice of centrepiece on the dining-room table to the selection of guests for the evening. On one such evening, 7 December 1875, James invited the American artist G.A. Storey, Cyril Flower (later Lord Battersea), Alan Cole and the French artist, James Tissot. The menu was as follows:

Potage au homard – Harengs – sauce au vin rouge – Côtelettes de Mouton, purée Champignons – Poulet à la Baltimore – Homony, Bécassines – Agourtzies – Mince pies – Compôte de Poires – Café – Brie – Salade[39]

James loved to indulge his guests and luxuries such as lobster soup were his speciality. Other recipes were borrowed from his mother's 'Bible', a cook book which, as a family heirloom, had passed from Anna Whistler to her son and his descendants. The recipe for the above mince pies would have been followed by James's cook, Mrs Cossins, with perhaps a few flourishes of her own. James later described Mrs Cossins' cooking as very good and her nature as 'good tempered enough – and willing – and honest – if not always strictly sober', keeping to his belief that 'All good cooks drink!'[40]

The Pennells tell of James's inimitable way of playing the host: 'At his own table, he had a delightful way of waiting upon his guests. He would go round the table with a bottle of some special Burgundy in its cradle, talking all the while, emphasizing every point in his talk with a dramatic pause just before or just after filling a glass.'[41] When James could afford it, he would spend lavishly on wine, buying a particular favourite, sparkling Moselle Muscatelle, by the crate.[42]

With such extravagances in wine, food and entertainment, James was much relieved when, in 1876, he was given a commission to help decorate the mansion which his patron, F.R. Leyland, had bought at 49 Prince's Gate. The interior was redesigned by Richard Norman Shaw and his assistant Thomas Jeckyll, as well as Murray Marks, a dealer in Chinese porcelain. It was Leyland's wish to create an ornate interior reminiscent of a Venetian palace, to house his collection of paintings, fine furniture, porcelain and *objets d'art*.

In these early stages of redecoration, James was assigned the task of painting panels for the main staircase. Always one to delight in decorative tasks, James rendered the panels in imitation lacquer, painted with an Oriental flower motif in cream, rose, and gold leaf. Leyland was apparently happy with the design and soon sought the artist's advice on the decoration of the dining-room.

What began as an initial consultation on colour schemes grew to be James's only remaining decorated room, the Peacock Room. To his biographers the Pennells, James characteristically exaggerated his methods, stating that: '[I] just painted it as I went on, without design or sketch – it grew as I painted.'[43] In fact James made a series of sketches, which he later enlarged to full-scale cartoons, employing the method of fresco painters in pricking through these large drawings to the surface below, to outline his design. What is significant, however, was James's

transformation of the room, from Jeckyll's rather dark and sombre design, to one of resplendent blues and golds, decorated throughout with the motif of the peacock.

The room took up much of James's and the Greaves brothers' time from the summer of 1876 to the spring of 1877. With such a huge investment of time, James could not agree about his fee with his patron Leyland. The resulting argument over payment, and over James's blatant use of the house for self-advertisement, was vehement enough to end their artist–patron relationship of ten years.

James began by touching up the red flowers on the Spanish leather wall-hanging with yellow and gold paint and trimming off the red border of a rug, both of which, he insisted, clashed with his painting, *The Princess from the Land of Porcelain*, hanging above the mantelpiece. On examining his paintwork on the leather, James felt that the overwhelming effect was too yellow, and wrote to Leyland telling him that he had removed the paint he had added and that he would make further changes by way of adding a wave motif of blue on a gold ground, which would serve as a decorative border for the leather hangings.

It appears that James soon abandoned the wave motif for another, that of peacocks and peacock feathers. He had earlier suggested this peacock motif to another patron, William Alexander, for his new home at Aubrey House on Campden Hill near Holland Park in London, but Alexander had dismissed the idea. The peacock motif was adapted by a number of decorators at this time, including Albert Moore, who decorated a frieze in the house of F. Lehmann in Berkeley Square, in 1872, with a peacock design. Furthermore, James's friend, Edward Godwin, had designed a wallpaper with the peacock as a repeating decorative motif in 1873.

According to Charles Hanson, James's son, they made visits to the zoo to study the peacocks. Little 'Charlie' must have been about 6 when he accompanied his father on these excursions.[44] Gradually the peacock motif spread in blue and gold over the walls, along the shelving, behind the shutters, and on to the ceiling. James used the motif as an abstract design, repeated again and again throughout the room without wearying the eye, thanks to his ability to create variations on a theme. As the design grew, James invited friends and acquaintances to view his work. Alan Cole, son of the director of the South Kensington Museum, Henry Cole, went often, on one occasion taking the Prince of Teck. Other important visitors included Queen Victoria's daughter Princess Louise, and the Marquis of Westminster. By February, James had called in the press, and provided a leaflet, entitled 'Harmony in Blue and Gold – The Peacock Room'.[45] The

response was generally enthusiastic, with society papers such as the *Pall Mall Gazette* extolling the virtues of James's decorations.[46]

Leyland had become aware of the extensive work that James had executed, but felt that it went far beyond his original agreement, and he refused to pay the full £2,000 that James requested. Instead he agreed to pay half that amount and stated, 'I do not think you should have involved me in such a large expenditure without previously telling me.'[47] He further suggested that James remove the shutters to reduce the expenses the artist had incurred. Leyland ended the note apologizing for such an unpleasant correspondence but reiterating:

> I do think you are to blame for not letting me know before developing into an elaborate scheme of decoration what was intended to be a very slight affair and the work of comparatively few days.[48]

James's first response was surprisingly moderate, expressing agreement to accept 1,000 guineas for payment which, he noted, he was awaiting. Another more angry letter followed, in which James noted the payment by cheque for £600 not guineas. This point was a sensitive one with James, who reckoned workmen were paid in pounds, whilst a gentleman was paid in guineas. Leyland had already paid James an advance of £400. Payment in pounds rather than guineas meant that James was £50 out of pocket by his estimate. James concluded his letter to Leyland with typical bravado:

> The work just created *alone remains* the fact – and that it happened in the house of this one or that one is merely the anecdote – so that in some future dull Vasari you also may go down to posterity, like the man who paid Correggio in pennies![49]

To ensure that posterity be made aware of Leyland's niggling over money, James immortalized the dispute on the far wall of the dining-room, where he had painted a scene of two peacocks fighting. At some point after this correspondence, James had added touches of white paint to the breast of the more aggressive peacock, to resemble the ruffled shirt that Leyland liked to wear, and at its feet the golden guineas that had been withheld from the artist. James got the last word by writing to Frances Leyland, asking her to note the painting of the two peacocks: 'I refer you to the Cartoon opposite you at dinner, known to all London, as L'Art et l'Argent or the Story of the Room.'[50] Such bitterness was the result of a further fight which had ensued between James and Leyland when the latter literally kicked the

artist out of his house. Banned from his 'Peacock Room', Whistler could only provoke from afar.

There may have been more to the story than a simple dispute between angry patron and artist. James had, through the seventies, been very close to Leyland's wife, Frances. When she was in London she would often stay at the Alexandra Hotel and have James escort her to her box at the opera, to the theatre, and to dinner parties. In several of James's letters to her, there is a fondness that suggests there may have been more to the relationship than that of patron and escort. In one letter, written after Frances Leyland had returned to Liverpool, James wrote: 'What shall I tell you of this dreary waste they call London – You seem to have carried away with you not only the life and joy of the place but even the sun too – and why shouldn't you – it is your right!'[51]

In another letter, written after a visit to Speke Hall, James's flirtatious mood is undeniable: 'Of course I am up to my elbows in paint and only venture to think very little at a time of Speke Hall – or at once the brush would be dropped for the dreamy cigarette – and you can fancy the ready ease with which I yield to pleasant temptations.'[52] In that same letter he mentions her picture, which he was still attempting to complete:

Meanwhile I am painting on Leyland's big picture – having at last found a beautiful creature to replace the 'perfect woman' – though I fear I shall never absolutely believe any other (model of course 'common people') her equal.[53]

It appears that James was speaking of his mistress Maud Franklin, who stood in for Frances Leyland to complete the portrait.

The Pennells wrote later in their *Journal* of a visit to the elderly Frances Leyland, who spoke of such possibilities as mere gossip: 'People talked about her and Whistler, went so far as to say she was going to elope with him, which was absurd, as if she would!'[54] Yet, when later reminiscing to the Pennells, she allowed herself to admit that she 'regretted that he could not have married her – it would have been much better for him, she thinks.' The Leylands' marriage did not last, for whatever reason, and by 1879 they were living separately.[55] To Leyland's credit, he kept James's 'Peacock Room' intact, although his contact with artists thereafter became minimal, as if the whole incident had left a bitter taste in his mouth.

James continued to prod at Leyland from afar, painting various caricatures of his former patron. When Leyland became one of James's creditors during his bankruptcy, the artist deliberately left a painting behind, which was intended to reveal to the world Leyland's apparent part

in James's downfall.[56] It was sold at James's bankruptcy sale as 'A Satirical Painting of a Gentleman styled "The Creditor"' and was bought by the dealer Charles Dowdeswell for 12 guineas. Later the picture became known as *The Gold Scab*. Leyland, in his ruffled shirt, is represented as a scaly peacock, sitting astride a model of James's Chelsea home, the White House, whilst playing the piano. James always claimed that Leyland had been the major factor in his bankruptcy.

The 'White House' had been James's next manoeuvre to keep himself in the public eye. The fashion for artists building their own homes was now in vogue, with Frederic Leighton, Luke Fildes and Francis Holl all settling near Holland Park, whilst St John's Wood became the mecca for artists such as Alma-Tadema, W.P. Frith and others. The art historian and critic, A.L. Baldry, later wrote of this period:

Housebuilding became a fashion that scarcely any rising artist with a balance at the bank could resist. He felt that he must surround himself with visible evidences of the appreciation in which he was held or there would be a danger that the public, always too ready to judge by externals, would pass him by as a failure, and prefer to him some of his more demonstrative competitors.[57]

James and his friend, the architect and furniture designer E.W. Godwin, visited the recently built home of Luke Fildes, in Melbury Road, Kensington.[58] Godwin, a tall, slender, bearded man, was James's senior by a year, and had much in common, in the way of taste, with the artist. They shared an interest in the art of Japan, and Max Beerbohm went so far as to call Godwin 'the greatest aesthete of them all'. Godwin designed for James what came to be known as the 'White House', because of its white brick façade. The simplicity of the design, the asymmetrical placing of the windows, and the avoidance of any extraneous detail made it, in Victorian terms, an unconventionally modern house. Located on Tite Street, Chelsea, the house's exterior decoration had to be altered to conform to the Metropolitan Board of Works' stipulations, but the final design remained close to the original intentions of artist and architect. It is presumed that James worked closely with Godwin on the design of the interior and exterior, which reflected James's predilection for spaciousness and light.

The dealer Charles Dowdeswell, in a later unpublished 'Reminiscence', gave a description of the interior:

The house was a very strange one – The front door opened on to the pavement, and on entering one found oneself at once midway upon a flight of stairs – I was directed to descend, and found myself in a large Terra cotta coloured room with white woodwork very plainly furnished – and very unusual. There were two long windows about 16 ft. high on one side of the room, looking upon a little bit of garden. They had small square panes of almost a foot square. The furniture consisted of a table and some large low chairs and a couch, covered to the ground in terra cotta serge.[59]

After ascending a narrow staircase, Dowdeswell reached the studio on the top floor of the house, which he described as running the whole length of the house and which was large enough to accommodate the serious students when James, in due course, hoped to attract.

Both as a matter of aesthetic principle as well as economic constraint, James kept to a simple decor: the odd etching, a small painting, flowers and goldfish swimming around in huge porcelain bowls. The dining-room was painted in shades of yellow. James decorated the interior with paint alone, never succumbing to the Victorian fondness for wallpaper. Such minimalism was novel in a period when clutter was all the rage.

The 'White House' and James's interest in interior decorating were all part of the broader movement which by the eighties was referred to as the 'Aesthetic Movement'.[60] This movement came to embody what was beautiful in art, architecture and design. In architecture the revival of the Queen Anne style was very much in vogue, with its emphasis on red brick and white-trimmed façades. In painting, the Victorian emphasis on narrative and moral meanings lost over the cult of Japan and a vague classicism. Art could exist purely for its own sake and be enjoyed on this level alone. One effect of the movement was to break down the division between 'high art', that is painting, and decoration, encouraging co-operation between architects and artists. James went on to collaborate with Godwin on several pieces of furniture, including what came to be known as *Harmony in Yellow and Gold: The Butterfly Cabinet*. Designed by Godwin and painted by James between 1877 and 1878, the cabinet was originally a fire-place surround and shows the strong Oriental influence on both men at this time. It was exhibited in a room designed by Godwin for the Paris Exposition Universelle of 1878.

During the decoration of this cabinet in 1877, James was invited, along with other aesthetes, to join in the inaugural exhibition of the Grosvenor Gallery. Viewed by the owner Sir Coutts Lindsay as a 'palace of art', the gallery was intended to show a select coterie of contemporary artists, such as G.F. Watts, Burne-Jones and Albert Moore. The gallery was situated in

New Bond Street, and had a Renaissance façade and a luxurious interior with richly coloured walls, velvet couches and Persian carpets. Resembling an aristocratic drawing-room, the gallery catered for the fashionable patron. The opening of the Grosvenor was the event of the season, attended by the Prince and Princess of Wales. James was in his element. Amongst the glittering crowd, James's eight paintings were on view, including the portraits of his mother and Carlyle, and his Nocturnes. Unfortunately the richly covered walls clashed with his paintings which needed a quieter colouring. Nonetheless James felt at home with the Grosvenor and exhibited there annually until 1884.

During his preparations for the inaugural exhibition, James was also engaged in family matters. That April he attended the wedding of his brother William to Helen Ionides, held at St George's in Hanover Square. Helen was related to James's old friends, Alecco and Luke Ionides. This union of the two families would have been much celebrated by James, who was particularly fond of Helen, or 'Nellie' as he called her. With William and Nellie now settled in Wimpole Street, where he carried out his medical practice, James once more had a family to visit, as he had once done at the Hadens. Frances Leyland, who knew both brothers, observed that while James was 'quick and alert, the Doctor was slow and deliberate – he would take half an hour almost to write out the simplest prescription'.[61] She further described James as slight and William as short and heavy. Yet despite their differences of temperament the brothers were very close. Often when James was ill or hard-up he would settle into William and Nellie's home for a few months until he had pulled himself together. With Anna living away in Hastings, the role of nursemaid or comforter now fell inevitably to Nellie or Maud Franklin.

When not visiting his brother and his wife for dinner, James might spend the evening with Maud at Tite Street, or go to a club or theatre. One of James's passions was the popular theatre. Whilst Shakespeare could put him to sleep, a music hall number had him singing along in the stalls. Through his friendship with Godwin, he met numerous actors and actresses, including Godwin's former lover, Ellen Terry. James would be seen frequently at the theatre, and it is during this decade that he painted his portrait of the actor, Henry Irving. He also painted his 'Gold Girl', Connie Gilchrist, the child music hall actress.

In 1877/8 James himself was caricatured on stage in the comedy, *The Grasshopper*, which was performed at the Gaiety Theatre. In the original French version, *La Cigalle*, by Meilhac and Halévy, the character of the painter is modelled on Degas. John Hollingshead, who produced the English version, used James as a model for the character Pygmalion Flippit,

an artist of the future, but took him one remove from the artist, by calling him a pupil of Whistler's. In the course of the play there is a discussion between another character, the Earl, and Pygmalion Flippit on art:

Earl What are you?
Flip. A Harmonist!
Earl I beg your pardon.
Flip. Harmonist in colours – in black and white, for example.
Earl Oh! I understand now! – what they call a *Christy Minstrel*!
Flip. No! no! my lord! you mistake me! I am an artist. We used to call ourselves painters, and our work painting, but feeling that we were often confounded with house decorators and workmen even of a lower stamp, we now call ourselves harmonists, and our work harmonies or symphonies, according to colour.
Earl Ah! I begin to see now.
Flip. Like my great master, Whistler, I see things in a peculiar way, and I paint them as I see them. For instance, I see you a violet colour, and if I painted your portrait now I should paint it violet. Shall I paint your portrait?[62]

In Act III, a further discussion of this movement of 'Harmonists' ensues, between the characters of Flippit, the Earl and his son, Morass:

Flip. (*returning with a picture*) Here, gentlemen, here is the newest thing that we 'Harmonists' can show you. We have simple harmonies in black and blue.
Mor. (*chuckling*) A black eye, for example?
Flip. No, sir, that we call a discord in black and blue. (*Addressing the Earl*) But here I show you, my lord, a dual harmony in red and blue (*holding up picture*).
Earl I don't think I quite comprehend the idea of a dual harmony.
Flip. Nothing easier! Look at this work from this point of (*he holds the work up*) view. You observe before you the ocean – the boundless ocean – lighted up by one of those gorgeous sunsets which rests like a bank of cloud upon the waters. Reverse the harmony thus, (*he turns it the other way up*) and you have the equally boundless desert – the burning sands of the Sahara – slumbering peacefully beneath an azure sky!
Earl Admirable!
Flip. It is original, and I hope your lordship does not object to its originality.[63]

In the final scene, Pygmalion Flippit asks the 'Grasshopper' of the play, a star acrobat in a travelling circus who, in the course of the play, discovers her true identity as a member of a noble family, to marry him. Yet he worries whether their two professions, as artist and acrobat, will go well together. Grasshopper finds the solution, suggesting that once Flippit has finished painting a picture, it will be held up, like a hoop, for her to jump through. The play then ends with Grasshopper jumping through the picture into Flippit's arms.

James gave his consent for the use of his name in the play, and attended both rehearsals and performances. He also permitted the use of a caricature of himself by the popular cartoonist Carlo Pellegrini, which was actually wheeled on stage in Act III.[64] The play was popular and added to James's notoriety when performing his next role in the *Whistler* v. *Ruskin* trial.

15

Whistler v. *Ruskin*

ONE WARM EVENING in July 1877 James sat with his friend, the American artist George Boughton, in the smoking-room of the Arts Club in Hanover Square. Both were immersed in their papers when Boughton came across an article mentioning James.[1] The review had been extracted from another journal entitled *Fors Clavigera* published by the art critic John Ruskin. Having established himself as the champion of J.M.W. Turner and then as defender of the Pre-Raphaelite artists, Ruskin had become a formidable authority on art in the Victorian period. He published and lectured widely, and although he maintained that *Fors Clavigera* was written for the working classes, his audience was composed largely of the middle classes. The original article, published that month, was a review of the work on display at the newly opened Grosvenor Gallery. Because of the vehemence of the criticism Boughton hesitated before drawing James's attention to it.

Boughton observed a strange expression cross James's face as he read the following:

> For Mr Whistler's own sake, no less than for the protection of the purchaser, Sir Coutts Lindsay ought not to have admitted works into the gallery in which the ill-educated conceit of the artist so nearly approached the aspect of wilful imposture. I have seen, and heard, much of cockney impudence before now; but never expected to hear a coxcomb ask two hundred guineas for flinging a pot of paint in the public's face.[2]

Having read the criticism James silently handed the paper back to Boughton. After a few moments of thought James turned to his companion and quietly said, 'It is the most debased style of criticism I have had thrown at me yet.'[3]

'Sounds rather like libel,' was Boughton's reply.

'Well – that I shall try to find out,' said James as he lit his cigarette and departed, leaving his friend to finish the evening papers.

Soon after this incident, James saw his solicitor, Anderson Rose. Rose had been acquainted with James since 1866, when he had been involved with drawing up his will before his departure for Valparaiso, and had proved to be a sensitive and understanding solicitor. A writ for libel was served on Ruskin at his home, Brantwood on Lake Coniston, on 8 August.[4] By 21 November, James had published his statement of claim which made a demand for general damages of £1,000 plus the costs of the action. The amount claimed for damages equalled the amount James felt that he had lost over the Peacock Room, completed earlier that year. Never one for thrift, James's spending at this period was remarkably free, and that autumn he had commissioned the building of the White House. In placing his hopes on a quick and easy victory over Ruskin, James played one of the biggest gambles of his career.

Ruskin, for his part, responded to James's challenge with apparent relish, writing to his friend, the artist Edward Burne-Jones:

> It's mere nuts and nectar to me, the notion of having to answer for myself in court, and the whole thing will enable me to assert some principles of art economy which I've never got into the public's head, by writing, but may get sent over all the world vividly in a newspaper report or two.[5]

Despite his initial enthusiasm, Ruskin was never to assert himself in court. He had been subject to bouts of mental instability which would recur until his death in January 1900. In fact, when Ruskin wrote his review of the Grosvenor Gallery exhibition in the summer of 1877, he had been prone to light-headedness and dizziness since returning from Venice, where he had overworked himself to the point of exhaustion.[6] Under such stress his malicious criticism of James's work begins to make more sense.

Although the date of 2 February 1878 was set for the trial, by late January Ruskin's counsel was seeking postponement on account of the mental instability of his client. In late February Ruskin suffered a severe attack of mania, again delaying the trial. When the final date of 25 November 1878 was proposed, his counsel again used the excuse of mental illness to keep Ruskin at a distance from the proceedings.[7]

James and Rose had originally counted on an early victory but the case took over a year to come to court. As time passed, James's financial situation became more pressing, with rising costs on the White House added to a variety of bills that had been accumulating over the years.[8] James kept back the truth from his elderly mother in Hastings; writing to Anna on her seventy-fourth birthday he conveyed a somewhat different picture of his impending financial situation: 'I am making careful economies . . . soon I hope to be in comparatively smooth water.'[9] His friend Alan Cole recorded a more accurate version of the situation that October, writing in his diary: 'Poor J. turned up depressed – very hard up, and fearful of getting old.'[10] At the age of 44, with debts piling up, James was very dependent on a successful verdict.

As well as offering the chance of financial reward James saw the trial as an opportunity for publicly pronouncing his views on art. A week before the trial began in November 1878 he wrote to Rose, asking about the chief witness: 'How about Ruskin himself after all? Are you not going to subpoena him – had you not better subpoena him instantly or have you already done so?'[11] Ruskin's defence, however, was able to provide doctor's certificates claiming his unfitness to stand trial. Nonetheless, plans for the trial were already in full swing, with Rose making preparations for the day. In another letter to Rose James outlined how he wished the barrister to present him in court:

> First I am known and always have been known to hold an independent position in Art and to have had the Academy opposed to me – That is my position and this would explain away the appearance of Academicians against me . . . Again I don't stand in the position of the popular picture maker with herds of admirers – my art is quite apart from the usual stuff furnished in the mass – and *therefore* I necessarily have *not* the *large number* of *witnesses*! In defending me it would be bad policy to try and make me out a different person than the well-known Whistler – besides I think more is to be gained by sticking to this character –[12]

Rose indeed found that acquiring witnesses for James was a problem. One potential witness, W.M. Rossetti, when subpoenaed to appear, wrote to Rose expressing his reluctance as an 'old and valued friend' of Ruskin. Rossetti concluded his letter agreeing that, if otherwise unavoidable, he would appear for James and 'give my sincerely felt witness to the excellences of that picture'.[13] Rossetti did eventually stand as one of three witnesses for James along with the normally reticent Albert Moore, and the Irish playwright and artist William Gorman Wills.

Burne-Jones was Ruskin's chief witness, together with the art critic Tom Taylor and the popular genre painter, W.P. Frith. All three had some link with Ruskin, either through their shared beliefs in highly finished narrative painting or for personal reasons. Burne-Jones was particularly indebted to Ruskin for his defence of the artist's work and his helpful patronage: indeed, Ruskin had praised the work of Burne-Jones in the same review in which he had lambasted James. Although Burne-Jones later claimed to have been reluctant to appear at the trial, his involvement was far from passive, as Linda Merrill in her comprehensive book on the subject has shown.[14] In a statement given to Ruskin's defence counsel, Burne-Jones was adamant that 'scarcely anybody regards Whistler as a serious person.' He continued: 'For years past he has so worked the art of brag that he has succeeded in a measure amongst the semi-artistic part of the public, but amongst artists his vanities and eccentricities have been a matter of joke of long standing.'[15] That Burne-Jones's statement had some effect on the strategy of the defence is borne out by the jocular questioning put to James by Ruskin's counsel.

On the morning of the trial London could have been described as Whistlerian in its fog-bound condition. The crowded courtroom was excited and talkative. Given such an audience, James's sense of show-manship did not fail him and, as the examination proceeded, any initial nervousness was replaced by the mask of that 'well-known Whistler'. Under oath James claimed his birthplace to be St Petersburg rather than the more accurate, though provincial, town of Lowell, Massachusetts: evidently he was intent on promoting an image of himself as a sophisticated man of the world. The examination by his own counsel, Sergeant Parry, had a rehearsed quality to it with James well prepared and answering questions with an easy urbanity. On the term 'nocturne', James took the opportunity to set down for posterity his theory of art:

> By using the word 'nocturne' I wished to indicate an artistic interest alone, divesting the picture of any outside anecdotal interest which might have otherwise attached to it. A nocturne is an arrangement of line, form, and colour first. I make use of any means, any incident or object in nature, that will bring about a symmetrical result.[16]

This answer became a key statement in the movement of art towards abstraction. Yet, to an English audience grounded in the belief that a

picture is meant to tell a story, James's words must have sounded alien if not blasphemous. That a painting was to be autonomous, to stand alone without a narrative, was indeed a foreign idea, originating from the French concept of 'art for art's sake'. When questioned further James expanded: 'Among my works are some night pieces, and I have chosen the word "nocturne" because it generalizes and simplifies the whole set of them; it is an accident that I happened upon terms used in music.'

When cross-examined by Sir John Holker, the Attorney-General, appearing for Ruskin, James was asked to define the subject of the picture that had given rise to the critic's comments – *Nocturne in Black and Gold: The Falling Rocket.*

'It is a nightpiece and represents the fireworks at Cremorne Gardens,' was James's reply.

'Not a view of Cremorne?' persisted Holker.

'If I called it a "View of Cremorne" it would certainly bring about nothing but disappointment on the part of the beholders,' replied James to the amusement of the court. Continuing his definition: 'It is an artistic arrangement. That is why I call it a "nocturne".'

Holker asked: 'I suppose you are willing to admit that your pictures exhibit some eccentricities. You have been told that over and over again.'

'Yes, very often,' James responded amidst much laughter.

'You sent your pictures to the Grosvenor Gallery to invite the admiration of the public?' Holker continued.

'That would have been such a vast absurdity on my part that I don't think I could have,' answered James to more laughter.

Holker then turned the proceedings to the question of value for money, asking, 'Did it take you much time to paint *Nocturne in Black and Gold*? How soon did you knock it off?' Such familiar language caused some giggles.

'I beg your pardon?' James asked in gentlemanly fashion.

'I was using an expression which is rather more applicable to my own profession,' Holker explained.

'Thank you for the compliment,' James replied.

Reiterating his question, Holker asked, 'How long did you take to knock off one of your pictures?'

'Oh, I "knock one off" possibly in a couple of days,' replied James amidst laughter, adding, 'one day to do the work and another to finish it.'

'The labour of two days is that for which you ask two hundred guineas?' queried Holker.

'No, I ask it for a knowledge I have gained in the work of a lifetime,' retorted James to great applause. The judge, Baron Huddleston, inter-

rupted with, 'This is not an arena for applause. If this manifestation of feeling is repeated, I shall have to clear the court.'

Deciding to change tactics, Holker stated to James, 'You know that many critics entirely disagree with your views as to these pictures?'

'It would be beyond me to agree with the critics,' was James's retort, again much appreciated by the court. Pushing his point further, Holker asked, 'You don't approve of criticism?' James, as though prepared for such a question, replied in a serious tone:

It is not for me to criticize the critics. I should not disapprove in any way of technical criticism by a man whose life is passed in the practice of the science that he criticizes; but for the opinion of a man whose life is not so passed I would have as little respect as you would have if he expressed an opinion on the law. I hold that none but an artist can be a competent critic. It is not only when a criticism is unjust that I object to it, but when it is incompetent.

Playing directly into James's hand, Holker asked, 'You expect to be criticized?'

'Yes, certainly; and I do not expect to be affected by it until it comes to a case of this kind,' said James, driving his point home.

The questioning then proceeded with a presentation to the jury of James's *Nocturne in Blue and Gold: Old Battersea Bridge*. The judge, intrigued by the painting asked, 'Which part of the picture is the bridge?' – a comment which brought muffled laughter from the court.

James obligingly answered,

Your lordship is too close at present to the picture to perceive the effect I intended to produce at a distance. The spectator is supposed to be looking down the river toward London. I did not intend to paint a portrait of the bridge, but only a painting of a moonlight scene. As to what the picture represents, that depends upon who looks at it. To some persons it may represent all that I intend; to others it may represent nothing.

During the lunch hour the jury visited the nearby Westminster Palace Hotel where James's paintings were on display. It was important to James that his work be seen in a sympathetic setting and the hotel provided better lighting for his pictures than the dark courtroom. After lunch the next witness for James, the art critic W.M. Rossetti, was called to the stand. James's barrister, Sergeant Parry, approached the witness stand and after a

series of questions which received monosyllabic, non-committal answers, he was able to extract from Rossetti a more favourable response to the work of Whistler. On the Nocturnes, Parry asked, 'Do you, or do you not, consider them works of a conscientious artist desirous of working well in his profession?'

'I do decidedly. I consider Mr Whistler a sincere and good artist,' acquiesced Rossetti.

When cross-examined by Sir John Holker, a more specific line of questioning was used, applied to the painting, *Nocturne in Black and Gold: The Falling Rocket*, the work Ruskin had openly criticized. Holker asked Rossetti whether *The Falling Rocket* was a 'gem', much to the hilarity of the court. Rossetti, again resorting to one-word answers, denied this claim. When asked whether it was 'exquisite' or 'beautiful' he refused to acknowledge these attributes. However, when Holker asked, 'Is it eccentric?' Rossetti confirmed, 'It is unlike the work of most other painters.'

Changing direction, Holker then asked whether it was a work of art and if so, why.

'Because it represents what was intended. It is a picture painted with a considerable sense of the general effect of such a scene and finished with considerable artistic skill,' admitted Rossetti.

When Holker asked Rossetti about the price of the painting Rossetti deferred to the judge who insisted, however, that the question be answered. Holker repeated the question, 'Is two hundred guineas a stiffish price for a picture like this?'

'I would rather not express an opinion as to the value of a picture, but if I am pressed I should say two hundred guineas is the full value of it (*laughter*), not a "stiffish" price,' replied Rossetti.

Holker pressed the question again, 'Do you think it worth that money?'

'Yes,' Rossetti affirmed, and when asked the hypothetical question whether he would purchase the picture, he concluded, 'I am too poor a man to give two hundred guineas for any picture.'

Rossetti then stepped down, and Albert Moore took the stand. The normally reticent Moore proved himself much more eloquent than Rossetti, answering:

The pictures produced, in common with all Mr Whistler's works, have a large aim not often followed. People abroad charge us with finishing our pictures too much. In the qualities aimed at, I say Mr Whistler has succeeded, and no living painter, I believe, could succeed in the same way, in the same qualities. I consider the pictures beautiful works of art; I wish I

could paint as well. There is one extraordinary thing about them, and that is that he has painted the air, which very few artists have attempted.

When cross-examined by Sir John Holker, Moore, as composed as ever, replied to the question whether James Whistler's pictures were eccentric, 'I should call it "originality",' and further turned the tables by asking Holker, 'What would you call "eccentricity" in a picture?', thereby bringing laughter back into the courtroom. Moore was then followed by the final witness for Whistler, W.G. Wills, whose testimony added little to the proceedings.

Ruskin's defence then presented its case with an opening statement from Sir John Holker, which was at length interrupted by the judge who announced, 'The condition in which the court is now might be called "nocturne". As it is four o'clock, this court will adjourn until tomorrow morning at half-past ten.'

The following morning the courtroom was full to overflowing, the crowd excited and prepared for another amusing day. Sir John Holker resumed his address and asked the jury to remove themselves imaginatively to the Grosvenor Gallery where James Whistler's pictures had originally been on display. Recreating the scene Holker condescendingly referred to a group of aesthetically dressed ladies who, not knowing better, were deep in admiration of Whistler's paintings. Playing the part of one of these ladies Holker gushed theatrically, 'How beautiful! It is a "Nocturne in blue and silver".' Adding, 'Do you know what a Nocturne means?'

Continuing in this patronizing tone he said: 'Passing to the Cremorne Nocturne, I do not know what the ladies would say to that, because it has a subject they would not understand – I hope they have never been to Cremorne – (*laughter*) – but men will know more about it.' Cremorne Gardens had recently been closed down owing to its bad reputation and was not considered to be patronized by respectable women.[17] Holker then gave the court a definition of the term 'coxcomb' as used by Ruskin: 'a licensed jester who wore a cap with bells and a cock's comb on his head and went about making jests for the amusement of his master and family'. Holker asked why the artist should complain of the use of such a description when he had performed such a part with his pictures: 'I do not know when so much amusement has been afforded to the British public as by Mr Whistler's pictures.'

Edward Burne-Jones then took the stand as chief witness for Ruskin. Under direct examination by the junior defence counsel, Charles Bowen, Burne-Jones's answers were steeped in the Ruskinian belief in high finish as a vital attribute for a painting, with the degree of labour involved being

reflected in the cost. In Burne-Jones's own work, Ruskin's notion of highly detailed, finished pictures with a narrative meaning reached its culmination: in fact, the article which first caused the libel to come to court was written to champion this latter-day Pre-Raphaelite. Nonetheless, despite his affinities to Ruskin, Burne-Jones had hesitated before appearing in court. Once on the stand, however, he was able to describe Whistler's work as 'incomplete' and 'a sketch in short', while admiring his use of colour.

The second witness for Ruskin was the popular Royal Academician, W.P. Frith, well known for his large, detailed group paintings such as *Derby Day* and *The Railway Station*. Describing himself as the 'author' of these two works, Frith gave the court some estimation of his narrative approach to painting which at times rivalled Dickens for anecdotal detail. Frith had been subpoenaed by Ruskin's counsel, knowing full well that the artist held finish and high detail as integral to a work of art, factors which did not concern James. When asked by Bowen whether composition and detail were important elements in a picture, Frith responded: 'Very. Without them a picture cannot be called a work of art.'

Under cross-examination by Whistler's lawyer, Sergeant Parry, Frith was questioned on Ruskin's admiration for the work of Turner. Frith obliged with the statement: 'I think Turner should be an idol of all painters.' Parry then cited Turner's painting, *The Snow Storm*, and asked Frith whether he knew that a critic had once referred to the painting as 'a mass of soapsuds and whitewash'. He then went on to ask him whether he would regard the picture in such a light and Frith answered in the affirmative, again to the amusement of the court. Qualifying his earlier statement, Frith then added, 'When I say that Turner should be the idol of painters, I refer to his earlier works and not to the period when he was half crazy and produced works about as insane as the people who admire them.' Again laughter filled the court.

The third witness for Ruskin was Tom Taylor, art critic of *The Times*, who followed his predecessors in endorsing the views of Ruskin on finish and labour. When cross-examined by Parry, Taylor drew from his pocket a newspaper clipping which he proceeded to read: 'Mr Whistler's full-length arrangements suggest to us a choice between materialized spirits and figures in a London fog.' When pressed further to describe James's work, Taylor admitted that, whilst he possessed high artistic merit, it was still incomplete; his paintings were 'the unfinished beginnings of pictures'.

In his summing-up Sergeant Parry alluded to Holker's rather patronizing manner, reminding him that

When the honourable and learned gentleman sneeringly conjured up an

imaginary group of young ladies admiring Mr Whistler's paintings, he must have forgotten that there are women's names in art that are entitled to the greatest consideration and respect.

On Ruskin's absence from court, Parry remarked: 'Mr Ruskin cared not whether his decree injuriously affected others and loftily declined to discuss his judgement or to justify himself before a jury.' Parry then cited a number of insults Ruskin had directed towards others besides James, and concluded:

> he is a man who exceeds the fair limits of criticism and allows personal feeling to carry him too far . . . This is the language of a libellous mind, utterly indifferent to others' feelings but gratifying to its own vanity. Mr Ruskin might delight in the reflection that he is a smart, a pungent, and a telling, writer; but he must not be allowed to trade in libel. The works of Mr Whistler are open to fair and honest criticism. He has not shrunk from any public investigation; but his detractor has.

Winding up, Parry made a plea for James Whistler as a serious and genuine artist, hard-working, industrious and dependent on his profession for his livelihood. Putting the question to the jury, Parry asked, 'Is he to be expelled from the realm of art by the man who sits there as a despot? I hope the jury will say by its verdict that Mr Ruskin has no right to drive Mr Whistler out by defamatory and libellous accusations.'

After almost two hours' deliberation, a verdict for the plaintiff, James Whistler, was given by the jury, with the award of one farthing in damages. On further consideration, the judge ruled that the verdict was 'without costs', meaning that both sides had to pay their own. The gamble that James had taken with the trial had not paid off.

James had not yet finished with Ruskin. Always one to get in the last word, he quickly assembled his first pamphlet, '*Whistler* v. *Ruskin*: Art and Art Critics', which was issued on Christmas Eve. The pamphlet, bound in brown paper and published by Chatto & Windus, sold for a shilling. Its popularity was such that by January 1879 it had undergone its sixth edition, allowing James to remain in the public eye well beyond the actual trial.

The novelist Henry James wrote in his regular contribution to the American paper, the *Nation*:

It is very characteristic of the painter, and highly entertaining; but I am not sure that it will have rendered appreciable service to the cause which he has at heart. The cause that Mr Whistler has at heart is the absolute suppression and extinction of the art-critic and his function. According to Mr Whistler the art-critic is an impertinence, a nuisance, a monstrosity – and usually, into the bargain, an arrant fool. Mr Whistler writes in an off-hand, colloquial

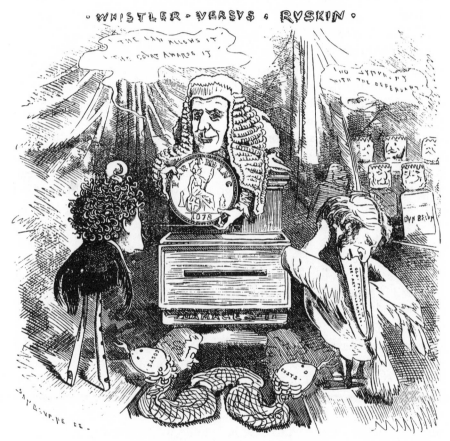

AN APPEAL TO THE LAW.
Naughty Critic, to use bad Language! Silly Painter, to go to Law about it!

Edward Linley Sambourne, 'An Appeal to the Law', *Punch*, 7 December 1878. Judge Baron Huddleston awards a farthing in damages to Whistler (shown with penny-whistle legs). Ruskin is represented as a pelican and the jury (*far right*) are depicted as tubes of paint.

style, much besprinkled with French – a style which might be called familiar if one often encountered anything like it.[18]

Twelve years later, when James published *The Gentle Art of Making Enemies*, the trial again featured, taking primary position at the beginning of the book. Always the manipulator, James tacked on, as marginalia, condemnatory extracts from Ruskin's writings which served to expose the extremity of his views.

Ruskin, for his part, used the outcome of the trial as an excuse to retreat further from public scrutiny. He resigned his chair as Slade Professor of Fine Art at Oxford claiming: 'I cannot hold a chair from which I have no power of expressing judgement without being taxed for it by British law', though he would later resume the post briefly.[19] Ruskin, in fact, suffered no great loss financially since the Fine Art Society organized a subscription to pay for his trial costs. However, his position as the arbiter of high art was no longer so impregnable.

As to his financial situation James sought to take evasive rather than offensive action. By January he was no longer opening his post but forwarding all letters to his solicitor. Writing to Rose in the New Year, James pleaded: 'Do see if you can keep them off my back –'[20] In an effort to make some money James was doing a series of etchings of Chelsea and the Thames. His old friend, the dealer C.A. Howell, had come to his assistance, helping to print them in Tite Street and then market them.[21] Despite this the creditors were fast encroaching.

James's inability to face the reality of an impending bankruptcy was mirrored in his unfortunate behaviour at this time towards Maud Franklin, his mistress. Maud, who was eight months pregnant, had been confined to a London hotel by James, who then tricked her into thinking he was in Paris.[22] In a series of letters to George Lucas in Paris, James wrote from the White House asking him to return any letters addressed to him from Maud Franklin.[23] The dutiful Lucas received Maud's letters and forwarded them to James. He also received James's letters to Maud and posted them back to her with the necessary Paris postmark. Such an involved piece of duplicity suggests that James wished to have little to do with Maud's pregnancy. On 13 February 1879, Maud gave birth to a baby girl, whom she named Maud McNeill Whistler Franklin. Little is known about the child and according to family tradition she may have died young; prior to that she may have been discreetly sent away to be adopted or fostered.[24]

That May, Maud wrote to Lucas from the White House of the precarious state of affairs: 'The place is full of men in possession and the sale is fixed for the 13th. You had better come over and buy.'[25] On 9 May James had

officially been declared bankrupt, with debts of £4,500. At the age of 44, all that James had accumulated, his beloved White House, his Chinese porcelain, his pictures, had to be sold. The harm to his reputation was considerable too. And to make matters worse, James's old patron and recent enemy, F.R. Leyland, was assigned chief creditor for having bought up his debts – an action the artist claimed was intended to ruin him.[26]

Characteristically James put on a brave, even defiant front, entertaining until the last moment with those famous Sunday breakfasts. His guests were surprised by his ability to maintain, despite the circumstances, a number of servants to wait at table, until James revealed that they were, in fact, the ever-present bailiffs.

Ironically it was the Fine Art Society, the same gallery which had helped to organize the subscription to pay Ruskin's costs, which provided James with the means to recoup his losses. The managing director, Marcus Huish, gave James a commission to etch twelve plates of Venice and advanced him £200. James arranged to winter in Venice and in the autumn of 1879 set off, with Maud to follow from Paris. This could be interpreted as yet another challenge to the authority of Ruskin who, as many believed, had said the last word on the city in his book, *The Stones of Venice*. James would tell another story.

16

A Venetian Exile

A WAY FROM THE DISTRACTIONS of London James's exile in Venice proved to be one of his most productive periods. Set up in New Bond Street in 1876, the Fine Art Society, known largely for its exhibitions of engraved reproductions of popular paintings, was a commercial venue that took few risks. It is therefore to the credit of the manager Marcus Huish and one of the trustees, Ernest Brown, that James was offered the Venetian commission. It came at a time when his reputation was low, following the trial with Ruskin and his subsequent bankruptcy, when he was seen as something of a laughing-stock by the press and public at large. In print-making circles, however, James was still taken seriously.

The visual splendours of Venice meant that the three months that Huish had originally offered to James were stretched to fourteen. During this time James produced a rich collection of work that far exceeded the original commission for twelve etchings, comprising in total over fifty etchings, several Nocturnes, a few watercolours and over 100 pastels. Not only was this period incredibly productive for James, but it also marked a new stylistic development for the artist in his etchings and pastels. Linked to a more spontaneous, impressionist style, James found 'a Venice in Venice' that no one else had yet discovered.

James and Maud first took rooms at the Palazzo Rezzonico on the Grand Canal, near the Accademia. This immense and dilapidated palace was shared by a number of artists working in Venice and came to include amongst its denizens John Singer Sargent, who visited the city that September.[1] James would have been charmed by the ceiling frescos by Tiepolo, featuring stories of Pulcinello, and the wall frescos by Canaletto.

To an artist as sensitive as James, time was necessary for assessing and discovering his own particular vision of Venice: hence the period of adjustment that followed, whilst he adapted to his new environment and settled into the city's tranquil pace. He was homesick too. In a letter to his sister-in-law Helen Whistler he wrote of the Italian weather and wished himself back in London:

and now that it has taken to snowing I begin rather to wish myself back in my own lovely London fogs! – They are lovely those fogs – and I am their painter! – Of course you know Venice is superb and if I hadn't dined horribly today – and yesterday too – and the day before for the matter of that, nothing could induce me to speak the truth and acknowledge that I am bored to death after a certain time away from Piccadilly! – I pine for Pall Mall and I long for a hansom![2]

This letter points to the urbanity of James's character: outside London James, the dandy, went to waste. Exile for a man like him or Oscar Wilde – a later example – was the greatest punishment. When removed from the setting of London, both James and Wilde lost something of their identity.

In another letter home, to his half-sister Deborah on New Year's Day 1880, James again expressed his longing for London and his discontent with Venice:

Of course if things were as they ought to be all would fit in well and I should be *resting* happily in the only city in the world fit to live in, instead of struggling on in a sort of Opéra Comique country when the audience are absent and the season is over![3]

Had James been content to be an artist alone Venice might have provided him with enough stimulus, but being the social creature he was, he could not help feeling that he was in the wrong place at the wrong time.

Nonetheless, during his stay in Venice, James was not exactly the outcast exile. A large and wealthy American expatriate society existed there and quickly embraced him. Katherine de Kay Bronson, a distant relative of Thomas de Kay Winans who was one of James's early patrons, had settled in Venice in 1876, purchasing a small palazzo, the Ca' Alvisi, on the Grand Canal opposite the church of Santa Maria della Salute.[4] A fellow American artist, Ralph Curtis, wrote of this society hostess:

During happy years, from lunch till long past bed-time her house was the open rendezvous for the rich and poor – the famous and the famished –

les rois en exil and the heirs-presumptive to the thrones of fame. Whistler there had his seat from the first, but to the delight of all he generally held the floor.[5]

James was also a regular guest at the American Consulate where he entertained the company with his typically droll remarks. Writing to Deborah, James recounted an early visit in which he deliberately set out to shock the other guests by voicing his peculiar views on art. On one such occasion James expressed his opinion that the artist's only positive virtue is idleness, adding, with a typically Whistlerian flourish, 'and there are so few who are gifted with it'.[6]

Another artist, Henry Woods, writing to his brother-in-law Luke Fildes, reported on James's shining performances at various parties, adding: 'I believe if the papers were to take no notice of him for a time he would collapse altogether.'[7] Woods, as part of the established 'artists' colony' in Venice, was a painter of Venetian genre scenes which he sent annually to the Royal Academy. Despite their artistic differences James found some companionship with Woods, whose words had some validity, as James's need for an audience became all the more evident whilst in Venice.

Writing again to his sister-in-law Helen, James repeatedly asked for the latest gossip and for any news clippings mentioning his name: 'Now it is for all of you in your turn to write me lots of news and if you can find no scandal you must invent some.'[8] In the same letter James wrote, with typical bravado, of a Christmas mass he had attended at St Mark's:

> I went to a grand high mass in St Marc's and very swell it all was – but do you know I couldn't help feeling that the Peacock Room is more beautiful in its effect – and certainly the glory and delicacy of the ceiling is far more complete than the decorations of the golden domes make them – That was a pleasant frame of mind to be in you will acknowledge – and I am sure you are not surprised at it![9]

In the new year James's dealer, Marcus Huish, wrote from the Fine Art Society asking why he had not yet returned. Huish also voiced his concern at a rumour he had heard of James producing large plates, possibly for another commission. James responded immediately, defending himself against such accusations and explaining the reasons for his delay in a colourful description that would have charmed rather than angered the patient Huish:

> The 'Venice' my dear Huish will be superb – and you may double your bets

all round – only I can't fight against the Gods – with whom I am generally a favourite – and not come to grief – so that now – at this very moment – I am an invalid & a prisoner – because I rashly thought I might hasten matters by standing in the snow with a plate [etching] in my hand and an icicle at the end of my nose – I was ridiculous – the Gods saw it and sent me to my room in disgrace . . . I have not written to you for I hate writing – and couldn't tell you anything that you didn't already well know – Have you not read how the people in Monte Carlo fled before the snow – shrieking with fear at the unknown miracle? How Mount Vesuvius is frozen inside – and nothing but icicles come out? How here in Venice there has been a steady hardening of every faculty belonging to the painter for the last two months and a half at least . . . I am frozen – and have been for months – and you can't hold a needle with numbed fingers – and beautiful work cannot be finished in bodily agony – Also I am starving – or shall be soon – for it must be amazing even to you that I should have made my money last this long – [10]

Concluding the letter James asked for a further £50, a sum Huish advanced early in February. Despite the advance James was financially stretched to his limits. There are other begging letters to friends and dealers and it seems he survived largely by borrowing from various acquaintances in Venice.

At this time James shared a studio with another artist, William Jobbins, which James went on to commandeer without paying a penny in rent. Jobbins was part of the British artists' colony and one day the discussion among the artists turned to James's domestic situation. Jobbins, taking a moral stance, argued that James was living far too provocatively with his mistress Maud and suggested that they snub him. A few weeks later Jobbins found himself near James's lodgings and, having forgotten his earlier sentiments, decided to call. James looked over the balcony to see who the visitor could be. Noting it was Jobbins, James called out loudly, 'Maud, Maud. Come here and look! It's little Jobbins. It isn't *true*, Maud; he *isn't* going to cut us!'[11] Even so Maud, whilst included in the more intimate circles of their painting friends, would not have accompanied James to the soirees he attended at prominent houses. There were certain social circles where conventions had to be followed and James in accepting invitations to such gatherings would have understood the unwritten etiquette of such occasions.

With the impending sale at Sotheby's of the contents from the White House due to take place in London on 12 February 1880, James must have been in particularly low spirits. It is probably no coincidence that he was still to be found in Venice, far removed from the public humiliation of such an event. The extent of James's impoverishment during this period in

Venice is told in an amusing story by Woods in which he claims that James was reduced to stealing paint from the palette of other artists:

> He uses all the colours he could lay his hands upon; he uses a large flat brush which he calls 'Matthew', and this brush is the terror of about a dozen young Americans he is with now. Matthew takes up a whole tube of cobalt at a lick; of course the colour is somebody else's property.[12]

Woods no doubt exaggerated the story but, given the state of James's financial affairs, it is evident that he was living largely by his charm and wit.

The dozen young Americans mentioned by Woods were, in fact, a group of artists who had trained with Frank Duveneck in Florence during the winter, arriving in Venice for the spring weather. Always one for companionship James soon moved with Maud to the lodgings of the 'Duveneck Boys' on the Riva degli Schiavoni. At the Casa Jankovitz James's room had two windows, one which looked towards the Doge's Palace and another that looked out towards the Salute. Woods' nephew recounts one particular incident involving the Duveneck Boys:

> A band of young American art-students used to follow Whistler about wherever he went, and this was sometimes a cause of annoyance to the older members of the artist colony, agreeable young fellows though the students may have been. My uncle, thinking he would drop Whistler a hint about it, looked in on him in his studio one day. He found him hard at work at his easel, and he stood by his side for a time, watching him paint, being interested in how Whistler got his effects. Eventually he broached the subject of his visit. Whistler heard him through without pausing in his work or offering any comment, then remarked, 'Waal, Arry, I needn't tell the boys. They've heard what you said, *there they are!*' and with a sweep of his arm he pointed to four or five of the acolytes sitting on a bench which a screen had prevented my uncle noting on his entering the room.[13]

It is very likely that James's contact with these enthusiastic young artists helped to motivate him. One, Otto Bacher, was particularly interested in etching and had brought to Venice a small printing press which James made use of. Bacher later wrote of James in Venice: 'He rose early, worked strenuously, and retired late. He seemed to forget the ordinary hours for meals and would often have to be called over and over again, unfinished work frequently being taken in hand at this time.'[14]

In a letter to his 10-year-old son, Charles Hanson, James described himself as 'a slave to my work' and explained, 'I get up Charlie every

morning at six and labour away until dark.'[15] This letter is an interesting document and was obviously treasured by Charles as a memento of great value. James's affection for his son is evident in the tone of the letter which he signs from 'Your fond papa'. In it James mentions the sights of Venice, and the gondolas, and promises that someday he will bring Charlie there. He speaks also of 'your kind Auntie Jo' who at this time appears to have looked after Charles. This mention of Joanna, and James's promise to write to her the following day, suggests that they were still friends and shared an interest in the boy. Unfortunately any letters to Joanna remain untraced.[16]

In writing to his mother that spring James spoke of Venice's beauty:

> this evening the weather softened slightly & perhaps to-morrow may be fine – and then Venice will be simply glorious, as now and then I have seen it – after the wet, the colours upon the walls and their reflections in the canals are more gorgeous than ever – and the sun shining upon the polished marble mingled with the rich toned brick and plaster, amazing city of palaces become really a fairy-land! – created one would think especially for the painter. The people with their gay gowns and handkerchiefs – and the many tinted buildings for them to lounge against or pose before, seem to exist especially for one's pictures and to have no other reason for being! – One could certainly spend years here and never lose the freshness that pervades the place –[17]

The variation in texture of marble, brick and plaster, and the enticingly decorative quality of the old palaces and entranceways, were now captured very successfully by James in his etchings. Although echoing Ruskin's interests in his book *The Stones of Venice*, James did not try to recreate the detail of the buildings but rather to suggest a decayed elegance. Equally, the 'gorgeous colours' of Venice came alive in James's delicate pastel sketches of picturesque views. He became fascinated with obscure side-streets, hidden doorways and the old palaces along the canals. The local landmarks of St Mark's, the Salute and other grand buildings were bypassed for the unfamiliar, the picturesque.

James was so fascinated by these particular 'discoveries' of Venice that he felt it unnecessary to reverse his etched plates, suggesting that he had no interest in making them recognizable landmarks of the city. Instead he was preoccupied with depicting his own personal Venice. In an earlier letter to Huish, James wrote of this particular vision:

> I have learned to know a Venice in Venice that the others never seem to have perceived, and which, if I bring back with me as I propose, will far

more than compensate for all annoyances delays & vexations of spirit . . . the etchings themselves are far more delicate in execution, more beautiful in subject and more important in interest than any of the old set [i.e. his earlier French and Thames etchings] –[18]

James had found a naturally decorative motif in the geometrical shapes of the windows, arches and balustrades, provided by the endless façades of Venice. Composition, often a difficult problem for artists new to their environment, was solved by James with his method of focusing, a 'secret of drawing', which he later passed on to his pupils Walter Sickert and Mortimer Menpes. James described his approach:

I began first of all by seizing upon the chief point of interest. Perhaps it might have been the extreme distance, – and the little palaces and the shipping beneath the bridge. If so, I would begin drawing that distance in elaborately, and then would expand from it until I came to the bridge, which I would draw in one broad sweep. If by chance I did not see the whole of the bridge, I would not put it in. In this way the picture must necessarily be a perfect thing from start to finish. Even if one were to be arrested in the middle of it, it would still be a fine and complete picture.[19]

This method of vignetting helped James to avoid extraneous detail and grasp the essential in what he was trying to depict. Unlike the studio method used in his Nocturnes James worked directly from the motif.

When the weather was too cold to work with an etching needle and copper plate James would turn to his pastels. Previously he had used pastels largely for figure studies in emulation of Albert Moore; however, in Venice, he discovered new possibilities with the medium. To his friend Howell, James wrote:

I wish I could show you some of the lovely pastels I have done! I told you I should discover something new and of course you may be sure that a fresh condition of things have I stirred up . . . I tell you old chap that I am bound to turn everything I touch now into gold – I can't help it – The work I do is lovely and these other fellows here have no idea! no distant idea! of what I can see with certainty . . . The whole thing with me will be just a continuation of my own art work, some portion of which complete themselves in Venice.[20]

James's abbreviated use of line and colour resulted in a set of over 100 gem-like pastels. Using a gondola or *barca* (a more sturdy version of the

gondola) as an open-air studio, James would load the boat with copper etching plates, etching needles, his pastels and paper, and set off with his gondolier. According to Otto Bacher, James's gondolier was a handsome man named Cavaldoro, who 'came to know by his Italian intuition just where James most desired to go'.[21] Bacher described James's pastel method:

> He always carried two boxes of pastels, an older one for instant use, filled with little bits of strange, broken colours of which he was very fond, and a newer box with which he did his principal work. He had quantities of vari-coloured papers, browns, reds, grays, uniform in size.
>
> In beginning a pastel he drew his subject crisply and carefully in outline with black crayon upon one of these sheets of tinted paper which fitted the general colour of the motive. A few touches with sky-tinted pastels, corresponding to nature, produced remarkable effect, with touches of reds, grays, and yellows for the buildings here and there. The reflections of the sky and houses upon the water finished the work. At all times he placed the pastels between leaves of silver-coated paper. Even the slightest notes and sketches were treated with the greatest care and respect . . . Taken as a whole, the pastels are as complete a collection of pictures of Venice and its life as can be found.[22]

The facility with which James drew his obscure alleyways, doorways and bridges was greatly admired by the other artists within James's ever-enlarging circle. One young artist, a Russian named Alexander Roussoff (Wolkoff), set out deliberately to imitate James's pastels, claiming that he could do as well. A competition was held with a jury of six who were to determine whether they could distinguish the Russian's work from the master's. By all accounts there was no contest and James's reputation remained unscathed.[23]

James also executed several watercolours of Venice, which in treatment suggest a close affinity with Turner's work.[24] Both artists have a brevity and lightness in their execution, which in a glance summarized a particular view. Although James refuted any connection with Turner in his own work, a view in all likelihood distorted by the artist's association with Ruskin, the similarities are apparent in both mediums of watercolour and pastel.

But James's stay in Venice was not all work and no play. On hot days during the summer, James and the Duveneck Boys would hire a gondola and row some way out to practise their diving. Despite the difference in age James had no qualms about being 'one of the boys' and splashed and frolicked like a youngster.[25] In the evenings, with the Boys in tow, James

would often stroll, in his scrupulous dress of a sack coat with white duck trousers topped off by a soft brown hat, to the famous Café Florian in the Piazza San Marco, where delicious but expensive ice-cream and coffee could be enjoyed.[26] Numerous newspapers were available and James, despite his apparent poverty, used Florian's as a substitute sitting-room. Ralph Curtis, one of the wealthier Americans, later recounted these evenings:

> Very late, on hot sirocco nights, long after the concert crowd had dispersed, one little knot of men might often be seen in the deserted Piazza, sipping refreshments in front of Florian's. You might be sure that was Whistler in white duck, praising France, abusing England, and thoroughly enjoying Italy.[27]

Yet James still craved the excitement of London. Otto Bacher described James's restlessness in Venice and his impatience to get back to town:

> He did plan, arranging and rearranging his methods of action, designing to meet all obstacles that he could then foresee. He laboured incessantly, gathering more and more material for his future triumph. To Whistler, London was the world, for he said on another occasion: 'Whistler must get back to the world again. You know Whistler can't remain out of it so long.'[28]

By August there was serious talk of James's return to London. A farewell fête was organized by the 'Boys' in a large open barge, festooned with flowers and grasses, the tables covered with fruit, salads and flasks of Chianti. Yet this farewell party was to be premature as James was still in Venice late into the autumn months.

Before finally leaving Venice James decided to hold a little informal reception in his rooms. Ralph Curtis later wrote of this party:

> Shortly before his return to England with portfolios of the famous etchings and delicious pastels, he gave his friends a tea-dinner. As seeing the best of his Venetian work was the real feast, the hour for the hors d'oeuvres, consisting of sardines, hard-boiled eggs, fruit, cigarettes, and excellent coffee prepared by the ever-admirable Maud, was arranged for six o'clock.[29]

James's productivity was at its greatest during this period. Without the distractions of London he could focus on his art. Yet work alone could not sustain him. James, not content to be an artist without an audience, sought out London to re-establish his reputation both artistically and financially.

Marcus Huish wrote to James asking him to return in time for a group exhibition of etchers at the Fine Art Society. James, however, was unable to finance his return to London and wrote to the now frustrated Huish asking for £100 to settle his debts and pay for his return trip. Huish was able to obtain £50 for James and wrote asking him to return as soon as possible. In a lengthy letter James angrily pointed out that he had asked for £100 and that he was still in need of that sum.[30] By November Huish had agreed to send another £50 and James was able to pay his debts and leave Venice.

In true Whistlerian fashion there was a conspiratorial nature to his return, as he wrote to his brother and sister-in-law: 'I think I shall turn up in about a couple of weeks! – Only keep it dark and on the strict Q.T. [quiet] – for I don't want anybody to know until I am in full blaze.'[31] Yet, on arriving back in London, the strain of remaining incognito was too great for James and he quickly ordered a hansom cab to drive to the Fine Art Society's show of 'Twelve Great Etchers', from which he was excluded as a result of his delayed return. James later told his biographers, the Pennells, of his grand entrance:

> Nobody expected me. In one hand, I held my long cane; with the other, I led by a ribbon a beautiful little white pomeranian dog – it too, had turned up suddenly. As I walked in, I spoke to no one, but putting up my glass, I looked at the prints on the wall. 'Dear me! dear me!' I said, 'still the same old sad work! Dear me!'[32]

Such bravado was in keeping with James's new-found confidence brought about by the work he had produced in Venice. That confidence would be sorely tested in the next few months of his 'triumphant' return.

17

A Triumphant Return

J AMES'S RETURN TO LONDON marked a new phase of his artistic career
when, more determined than ever, he set out to turn his art into gold. The
King Midas touch, however, proved elusive. From 1880 to 1886 he held six
one-man shows: three exhibitions at the Fine Art Society, two at the
Dowdeswells' gallery, and a display of his work at the Sketching Club in
Dublin.

On his return from Venice in the late autumn of 1880, James stayed with
his brother William at Wimpole Street, walking the short distance each day
to the Fine Art Society where he was engaged on the printing up of his
Venetian plates. Working above the galleries was not an ideal arrangement
for James, and he soon moved to a nearby house in Air Street, where he
could print his work in complete privacy and under his own conditions.
From this time forward, James insisted on printing his own plates rather
than send them to a commercial printer. He had begun to recognize that
there was an art in the printing method itself and, in taking such care, he
insisted that every proof was unique.[1] By late November James was able to
hang the set of twelve etchings in a room at the Fine Art Society. It appears
to have been a rather rushed affair with the prints pinned on maroon-
coloured cloth and identified by chalk numbers roughly drawn by James.
His friend E.W. Godwin was disappointed and let him know that such
an impromptu hanging did little justice to the work.[2] It was perhaps this
makeshift effect which resulted in the poor press coverage. But many
of the reviews were also highly critical of James's method of artistic
printing. This process involved printing both from the surface of the plate
as well as from the etched line. The resulting proofs were variable in

treatment, which suited James, who argued that each impression should be unique.

Some of the criticisms were directed towards James's choice of subject-matter. Harry Quilter, who had bought James's White House in the bankruptcy sale, reviewed the exhibition in the *Spectator*. Quilter, a critic of the Ruskinian school, lamented that James had not looked to the past glory of Venice in his representations of the city. He compared James's vision to that of the two-day tourist; yet all was not negative:

> What has been done, and done with cleverness so great as to be almost genius, is to sketch the passing, every day aspect of canal, lagoon, and quay; to give, in fact, to those who have not seen the city some notion of that outside aspect, in which wealth and poverty, grandeur and squalor, life and death, are so strangely mingled.[3]

Other criticism focused, not surprisingly, on the etchings' lack of finish. Some papers actually went so far as to say, applying the Ruskinian notion of time equalling money, that the price of 50 guineas for the set was too high. In the end only eight sets were sold but this did not discourage James from persuading the Fine Art Society to hold another exhibition of his work within a month's time.[4]

While preparing for the second show, James was also busy socially, holding his famous Sunday breakfasts for the likes of Oscar Wilde and Lillie Langtry. At one particular breakfast, James asked the famous actress whether she would pose for a portrait and she obliged.[5] James chose to paint her in a yellow robe and she apparently came for numerous sittings for the portrait, but the work remains untraced. It was during one of these sittings that James told another party, possibly Oscar Wilde, that 'Her beauty is simply exquisite, but her manner is more exquisite still.'[6]

Oscar had become a regular visitor to James's studio and the two were frequently seen together. All the best parties or social events were guaranteed success with the appearance of James Whistler and Oscar Wilde, who together could set the town talking. The actress Ellen Terry wrote in her memoirs that 'The most remarkable men I have ever known were Whistler and Wilde.'[7] Arthur Symons, the poet, wrote of the subtle differences between the wit of the two men:

> Whistler, whom I knew for many years, was a great wit, and his wit was a personal expression . . . [It] was not, as with Wilde, a brilliant sudden gymnastic, with words in which the phrase itself was always worth more than what was said: it was a wit of ideas, in which the thing said was at least

on the level of the way of saying it. And, with him, it was really a weapon used as any rapier in an eternal duel with an eternal enemy.[8]

Another contemporary, Frank Harris, the editor of the *Fortnightly Review*, was witness to the moulding of Wilde in James's studio: 'Oscar sat at his feet and assimilated as much as he could of the new aesthetic gospel. He even ventured to annex some of the master's theories and telling stories, and thus came into conflict with his teacher.'[9] Harris further claimed that among the influences which went into the shaping of Wilde's talent, it was James who taught him the value of wit and that 'singularity of appearance counts doubly in a democracy of clothes.'[10] This importance of presentation was further noted by Harris who described James during this period as:

> an alert, wiry little person of five feet four or five; using a single eyeglass and very neatly dressed, though always with something singular in his attire – the artist's self-conscious protest which gave him a certain exotic flavour and individuality . . . The second or third time I met him I noticed that his features were well shaped: both chin and forehead broad; the eyes remarkable, piercing, and aggressive; a greying black moustache, inclined to curl tightly, added a note of defiance.[11]

With James and Wilde dressing the part, the 'Cult of the Dandy' was now in full swing.

James's second exhibition with the Fine Art Society, at the end of January 1881, included over fifty pastels of Venice as well as his set of twelve etchings. To avoid the problems that the previous exhibition had encountered, James arranged with Huish to decorate the galleries to complement the collection. Great care was taken to create an elegant setting, with a low skirting of yellow gold, above which hung a dado of dull green cloth. The ceiling and frieze were painted a reddish brown. Each pastel was set in a gold mount, with deep yellow-gold frames. This suggests that both James and Huish were well aware that pastel was still regarded by many as a medium for sketching and such a presentation was necessary to elevate the pastels to a high art form.

Their efforts paid off and the exhibition proved to be a great success, both from a critical and a financial standpoint. Maud Franklin wrote of the success to her friend from Venice, Otto Bacher:

> As to the pastels, well – they are the *fashion* – there has never been such a success known – Whistler has decorated a room for them – an arrangement

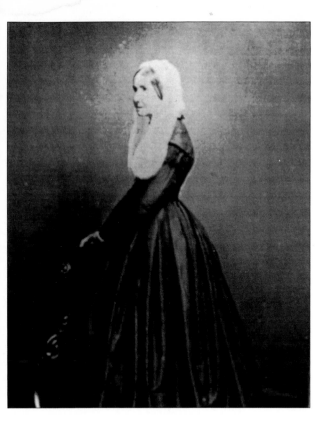

A recently discovered photograph of Anna McNeill Whistler, private collection, England.

Lieutenant George Washington Whistler, *c.* 1820, Pennell Collection, Library of Congress, Washington DC.

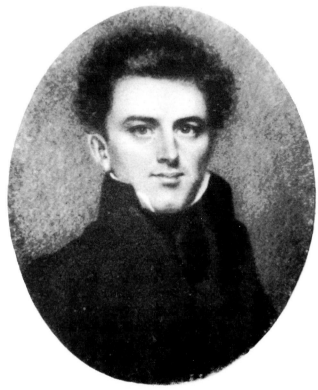

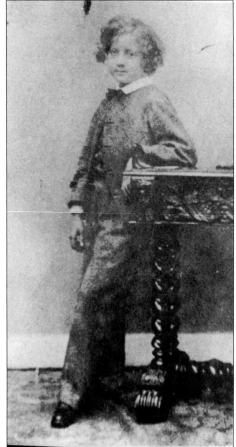

James aged about 10, Glasgow University Library, Rosalind Birnie Philip Bequest.

Aunt Alicia, c. 1844, pencil, Cooper-Hewitt Museum, Smithsonian Institution, Washington DC.

This drawing by James of his favourite aunt was probably executed as a memento of Alicia's visit to St Petersburg in 1844.

FRENCH FRIENDS

Gustave Courbet

Edouard Manet

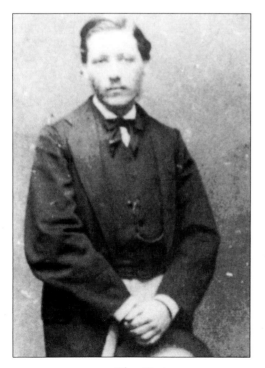

Edgar Degas

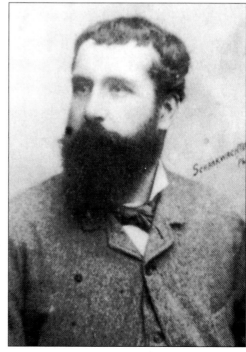

Claude Monet

The official prison photograph of Whistler's friend, the Irish Fenian leader, John O'Leary, taken minutes after he was convicted of treason in December 1865. O'Leary was sentenced to twenty years' penal servitude.

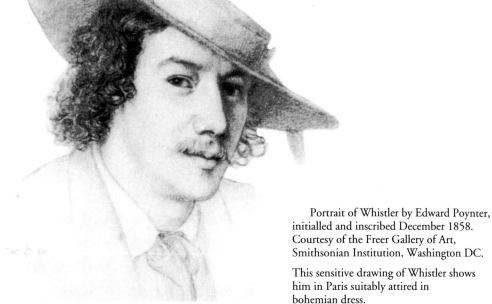

Portrait of Whistler by Edward Poynter, initialled and inscribed December 1858. Courtesy of the Freer Gallery of Art, Smithsonian Institution, Washington DC.

This sensitive drawing of Whistler shows him in Paris suitably attired in bohemian dress.

ENGLISH FRIENDS

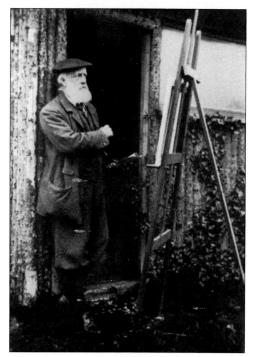

James Clarke Hook

George Price Boyce

Albert Moore

Charles Augustus Howell

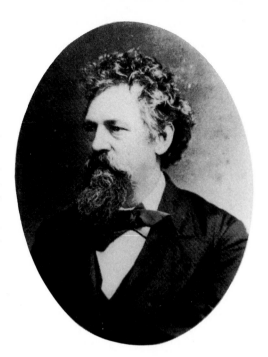

Thomas de Kay Winans, Glasgow University Library, Special Collections.

Related to Whistler through his sister Julia's marriage to Whistler's half-brother George, Tom Winans was one of Whistler's first important patrons. Not only did he buy work from Whistler but his loan of $450 enabled Whistler to travel to Paris in 1855.

Charles Lang Freer, photograph by Alvin Langdon Coburn, c. 1909. Freer Gallery of Art, Smithsonian Institution, Washington DC.

Although Freer did not meet Whistler until March 1890, he was to become his greatest collector. During the later stages of Whistler's life Freer began to collect his work in earnest, often with Whistler's direct help. After Whistler's death his help and guidance were always on hand to aid Whistler's executrix, Rosalind Birnie Philip. One of his greatest purchases was *Harmony in Blue and Gold: The Peacock Room* which he bought through the London art-dealers Obach and Company in 1904.

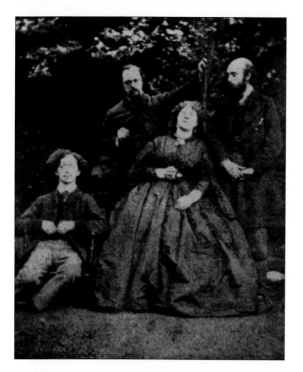

Algernon Swinburne, Dante Gabriel Rossetti, Fanny Cornforth and Michael Rossetti in the garden of Tudor House, Cheyne Walk, London.

In the early 1860s Whistler was a frequent visitor to Tudor House. Although he was friendly with all of the group, it was undoubtedly Swinburne whom he was closest to. Nevertheless, during the early 1860s Whistler came under the influence of Rossetti's work. Such was his admiration of him that he suggested to Fantin-Latour that Rossetti should be considered for inclusion in Fantin's *Homage to Delacroix*.

The White House, Tite Street, Chelsea (now demolished).

Whistler commissioned the architect E.W. Godwin to design and build the house in September 1877. Whistler not only planned to live in the house but also to open an atelier there. In May the following year he moved in. He only resided in the house for just over a year, the Ruskin trial, in the interim, having forced him into bankruptcy. The house was sold to the art critic Harry Quilter, an arch-enemy of Whistler's, for £2,700.

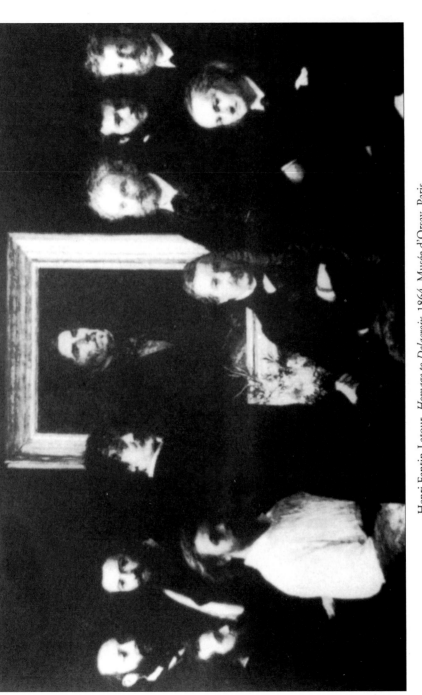

Henri Fantin-Latour, *Homage to Delacroix*, 1864, Musée d'Orsay, Paris.

Painted as a tribute to the great Romantic artist, Eugène Delacroix, it shows Whistler standing at the front (*left*) flanking the portrait of Delacroix with Manet. Immediately behind Whistler sitting in the white shirt is Fantin. Others included are Alphonse Legros (*back row, second left*) and Charles Baudelaire (*seated front, extreme right*). In all probability Whistler did not pose for the painting but gave Fantin a photograph to work from.

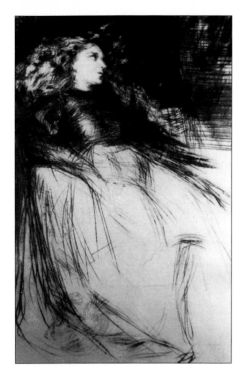

Weary, 1863, drypoint, private collection, England.

This beautiful portrait is of Joanna Hiffernan, Whistler's girlfriend. Executed in the style of the Pre-Raphaelites, it shows the extent of Whistler's assimilation of ideas, particularly from Rossetti, in the early 1860s.

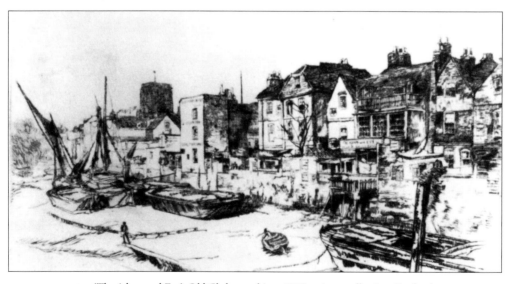

'The Adam and Eve', Old Chelsea, etching, 1879, private collection, England.

Whistler often frequented the Adam and Eve, one of the most notorious taverns along the riverside at Chelsea. By the time he began this etching in 1879 the tavern had been demolished as part of the Thames Embankment project. Almost certainly he used a photograph by James Hedderly, *Duke Street House Backing on the River,* as an aid. Although the topography of the scene is of great interest, that was not the primary aim. Rather, with its use of Japanese spatial construction in the deployment of detail and shadow, the eye is drawn along the scene and not focused on any one particular area. This etching, together with several others made around this time, set the basis for Whistler's mature style of etching.

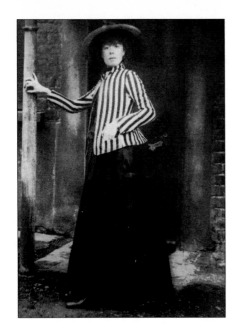

Maud Franklin photographed outside The Vale. Library of Congress, Prints and Photographs Division, Washington DC.

As one of the most enduring of Whistler's girlfriends, Maud Franklin was witness to some of the most tumultuous years of his life. Only months after the Ruskin trial in February 1879, she gave birth to another of his illegitimate children, Maud McNeill Whistler Franklin. She posed for several important portraits such as *The Fur Jacket* and *Effie Deans*. Even though Whistler treated her badly in the final period of their relationship, she resolutely refused to talk to any of his future biographers.

Whistler in his Fulham Road studio in 1886. Glasgow University Library, Rosalind Birnie Philip Bequest.

The full-length portrait behind Whistler is of Maud Franklin. The portrait is now lost, probably destroyed.

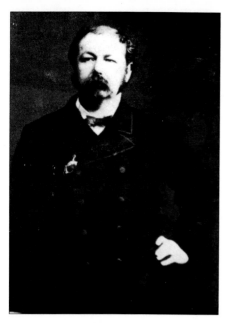

Dr William Whistler, Whistler's brother. Glasgow University Library, Rosalind Birnie Philip Bequest.

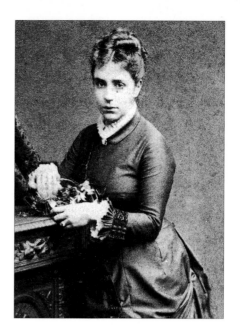

Helen Whistler, William's second wife. Glasgow University Library, Special Collections.

Known to all as 'Nellie', Helen was a member of the wealthy Ionides family. She and William were married on 17 April 1877.

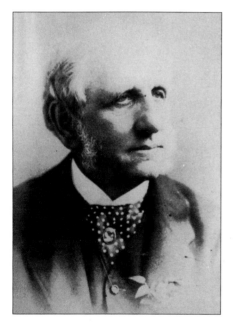

Francis Seymour Haden, Whistler's brother-in-law. Glasgow University Library, Special Collections.

Haden married Whistler's half-sister Deborah in 1847. Both Whistler and Haden were keen etchers and although initially Whistler seems to have enjoyed his brother-in-law's company, he soon tired of his pompous and overbearing ways. After a fight in Paris in 1867, they never spoke to one another again.

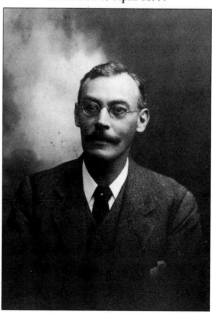

Charles James Whistler Hanson. Glasgow University Library, Rosalind Birnie Philip Bequest.

Charles Hanson is the most documented of Whistler's illegitimate children. The son of a parlourmaid, Louisa Hanson, Charles was brought up by Joanna Hiffernan. He re-entered Whistler's life again in the 1880s. Hanson died in 1935.

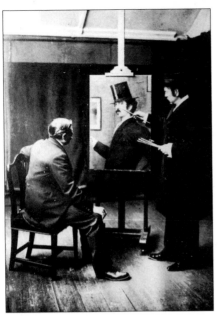

Walter Greaves (*standing right*), a long-time 'pupil' of Whistler, who was 'dropped' after Whistler's marriage to Beatrice in 1888.

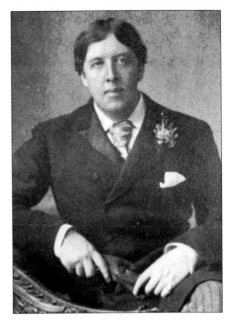

Oscar Wilde, a friend, then foe.

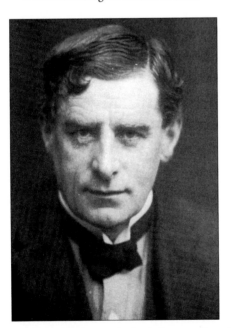

Walter Sickert. One of Whistler's most talented 'pupils', Sickert not only painted well but was also a useful ally, defending Whistler's art through his numerous articles in the press. However, Sickert was too independent-minded to remain a mere stooge. After a courtroom battle with Joseph Pennell over the methods of lithography in 1897, in which Whistler eventually sided with Pennell, Sickert shortly left London for France.

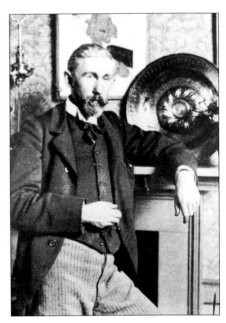

Joseph Pennell in his house in Buckingham Street, London. Pennell and his wife Elizabeth became Whistler's most famous biographers. Highly opinionated, arrogant and self-important, Pennell made many enemies. Although Beatrice disliked him, Whistler persevered with the friendship probably because he recognized Pennell's usefulness as an unquestioning defender. The Pennells bequeathed their vast and invaluable collection of Whistler material to the Library of Congress.

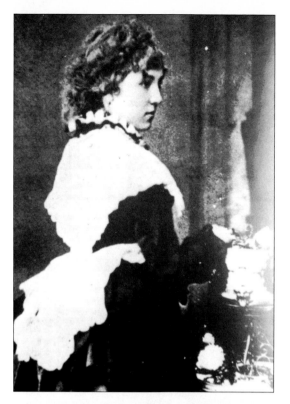

Beatrice Whistler, probably photographed in the late 1880s around the time of her marriage to Whistler. Glasgow University Library, Rosalind Birnie Philip Bequest.

Daughter of the Scottish sculptor, John Birnie Philip, Beatrice married the architect E.W. Godwin in 1876. She posed for Whistler in the 1880s and there is some evidence to suggest that she and Whistler were having an affair before the death of Godwin in 1886. Their marriage in 1888 marked one of the happiest periods in Whistler's life, but by the same token her long illness, and eventual death through cancer, was for him the most miserable.

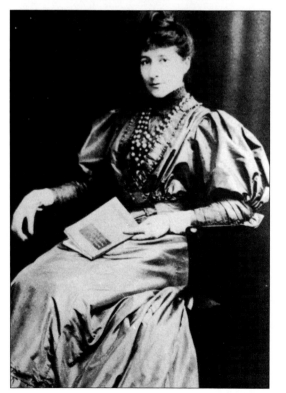

Rosalind Birnie Philip, 1903. Glasgow University Library, Rosalind Birnie Philip Bequest.

As Whistler's heir and executrix, Rosalind, the youngest sister of Beatrice, inherited Whistler's entire estate. For the rest of her long life she devoted herself to protecting his name and arranging affairs connected with him. In her later years, in 1935 and 1954, she made two substantial gifts to Glasgow University comprising letters, paintings, etchings, lithographs and other material. On her death in 1958 she bequeathed to the university the remaining contents of her estate.

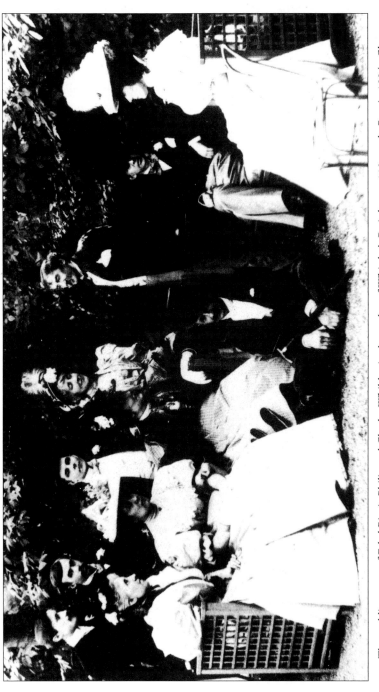

The wedding party of Ethel Birnie Philip and Charles Whibley in the garden of Whistler's Paris home, 110 rue du Bac, in 1894. Glasgow University Library, Rosalind Birnie Philip Bequest. Whistler is standing in the centre, while Beatrice in the dark hat sits on the right of the garden seat.

Ethel was a favourite of Whistler's. For several years before her marriage to the journalist Charles Whibley, or 'Wobbles' as Whistler called him, Ethel acted as Whistler's secretary. On numerous occasions throughout the 1890s he used her as a model. One of his most successful portraits of her is *Red and Black: The Fan, c.* 1891–4, Hunterian Museum and Art Gallery, Glasgow University, Rosalind Birnie Philip Bequest.

Portrait of Stéphane Mallarmé, lithograph, 1893, private collection, Ireland.

In the 1890s Mallarmé, the great Symbolist writer and poet, became a close friend of Whistler. He adored his work and translated the 'Ten O'Clock' lecture into French. He was also instrumental in the arrangements for the purchase by the French government of Whistler's *Arrangement in Grey and Black: Portrait of the Painter's Mother*. Although Whistler considered Mallarmé one of his closest friends, it is probable that he did not always understand Mallarmé's work. When Mallarmé died in 1898 Whistler was devastated.

The Siesta, 1896, lithograph, private collection, London.

This image of Beatrice in the final stages of her illness is one of the most moving Whistler ever made. By then, almost completely addicted to morphine, she lay in a comatose state for hours on end, with Whistler sitting beside her. From her death in May 1896, Whistler never fully recovered.

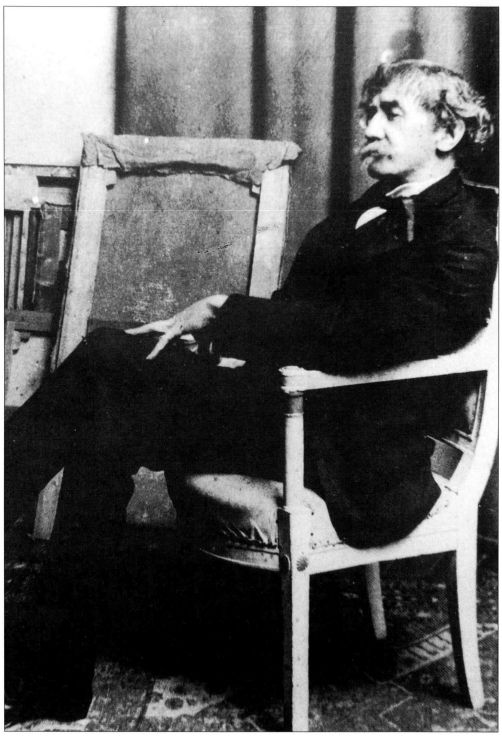

Whistler in his Paris studio at 186 rue Notre Dame des Champs in 1892, by Dornac. Glasgow University Library, Rosalind Birnie Philip Bequest.

Taken just after the retrospective exhibition at Goupil's in London. Whistler began, if he did not always complete, many of his later major works in his Paris studio.

in brown gold and Benedictine red which is very lovely – out in it they look perfectly fine. All the London world was at the private view – princesses, painters, beauties, actors – everybody – in fact at one moment of the day it was impossible to move – for the room was crammed –[12]

Maud added that James had bought her a new dress for the private view, and attached a scrap of the material to her letter. She also mentioned that there had been over £400 in sales of the Venetian pastels on the first day.

The reviews were generally encouraging, in part because several were obviously a collaboration between dealer, artist and writer. Such collusion was not an uncommon practice. For example Huish, who was also the editor of the *Art Journal*, arranged for the printer of Whistler's pamphlets and lithographs, Thomas Way Jnr, to write an article on the exhibition.[13] James's ringing tone is clear in one statement that was later to form part of his 'Ten O'Clock' lecture: 'Nature does not unfold her chiefest beauties but to her closest observers, and the power of reproducing them is given only to him who combines with the rarest gifts of form and colour that aptitude for tireless labour which alone makes the hand a helpmate for the brain.'[14] By contrast E.W. Godwin's review for the *British Architect* was unprompted. It was glowing in its admiration of James's choice of subject-matter: 'Of Venice as it is, in the dethroned, neglected, sad passing away of it, Whistler tells us with the hand of a master, who has sympathized with the noble city's suffering and loss.'[15]

The positive reception of the exhibition was marred by news that Anna Whistler was seriously ill in Hastings. Hurrying to her bedside in late January, James was filled with remorse for not being a better son to his mother. Having been away for almost two years, then busily engaged mounting his two exhibitions on his return, James had had little time to spend with her. Despite the infirmities of her later years, Anna had been a source of comfort to James, living with him for a number of years in Lindsey Row, attending to his needs and ambitions and watching over the progress he made in the art world. James, for his part, had always acted protectively towards her, shielding her where he could from the more embarrassing aspects of his life.

On the last day of January 1881, Anna died. James received some comfort from his brother William and his sister-in-law Helen, but guilt at his long absence made him despair. Helen Whistler later recalled one windy and wet afternoon when they had walked out to the cliffs together, 'Jimmie was taking himself to task for not having been kind and considerate enough – he had not written as often as he should from Venice – he fairly cried with remorse.'[16] As though to compensate for the loss of his mother James, who

had already adopted Anna's maiden name in his youth, was from this period known publicly as James McNeill Whistler.

By the end of February James had decided to travel to Guernsey and Jersey to do some seascapes for an exhibition of sea pieces at the Fine Art Society. He invited Oscar Wilde to accompany him, writing, 'Now Oscar you have simply to get on your disguise again and come off with me *tomorrow* to Jersey. I shall be down at the studio tomorrow – and shall send for you at about 12 – we can make our final arrangements and probably leave by the five o'clock train.'[17] But it is not known whether Wilde joined James and no mention is made of the younger man in the artist's letters home.

One letter that James wrote to Helen Whistler on this trip tells of the frustration he experienced when attempting to paint the sea:

> After being whisked about on the tops of very grand rocks and nearly blown into the sea, canvas and all, and dragging myself each evening back to the inn a dishevelled wreck of fright and disappointment, I ceased a career only fit for an acrobat and came over to Jersey, remembering that you had said it was comparatively flatter! –[18]

He admitted that he had not yet painted a picture although he had 'discovered a little game in watercolours that may possibly be worked into a pound or so'. Unfortunately, James was unable to produce anything for the exhibition of seascapes at the Fine Art Society; but this trip perhaps whetted his appetite for another journey to Cornwall in late 1883.

On his return to London James was provoked into yet another confrontation with his brother-in-law, Seymour Haden, over Haden's mistaking a group of Venice etchings by Frank Duveneck as James's.[19] They were part of an exhibition of the work of the Society of Painter-Etchers, due to open that April at the Hanover Gallery. Haden, as president of the newly-founded society, thought that James was purposely deceiving him by using a pseudonym. Angered by this supposed deception, Haden, accompanied by Legros, made his way to the Fine Art Society to see James's plates of Venice. James soon heard of this and demanded that Huish write to challenge Haden. Haden's reply was simply to state that he had been mistaken. This was not enough of an apology for the bitter James, who sought revenge in the form of a pamphlet, 'The Piker Papers', which included the correspondence between Haden and Huish over the incident, as well as press accounts. This pamphlet reveals the pettiness of James's character at times, a trait that seemed to emerge when he was particularly vulnerable, under the effects of distress or bereavement.[20] Again, in March,

James arrived at the Fine Art Society, where his successful exhibition of pastels was still open, and demanded that the directors pay him the money he was owed. Huish wrote out a cheque for £300, but James's impudent behaviour was noted by the Society, whose future dealings with him would be less accommodating.[21]

With a sudden supply of cash, James decided to visit Paris that April where he stayed with his old friend, George Lucas. They went around the galleries together and saw the sixth Impressionist exhibition, including the work of Degas, Mary Cassatt, Pissarro, Berthe Morisot and others.[22] One work, in particular, caught James's attention: Degas' wax figurine of the *Little Dancer of Fourteen Years*. James was observed 'wielding a painter's bamboo mahlstick instead of a walking stick; emitting piercing cries; gesticulating before the glass case that contained the wax figurine'.[23]

James's relationship with Degas at this time was one of mutual respect. When visiting Paris, James would attempt to contact him, often with little success, as he wrote in one letter to the French artist, 'It is rare these days that I have the pleasure of seeing you, although I never pass through Paris without many efforts to find you.'[24] The fact that it was James who sought out Degas is telling of their friendship. The English artist, William Rothenstein, once wrote that 'Degas was the only man of whom Whistler was a little afraid.'[25] Only Degas had the courage to reproach James, once saying to him, 'You behave as though you have no talent', a comment that left the artist uncharacteristically speechless.

James's interest in the work of Degas and the other Impressionist painters was more than mere curiosity. Later James would deride the work of his contemporaries, but in the seventies and eighties he kept well abreast of their work. Although he had toyed with the idea of showing with them in the days of their inaugural exhibitions, he had hesitated.[26] While there were similarities in his choice of subject-matter, in his paintings of the Thames and Cremorne Gardens, James's technique of memory painting differed radically from the Impressionist practice of *plein air* painting. However, by 1881, James had largely abandoned his memory method and his painting of Nocturnes, and after working in the open air in Venice for both his etchings and pastels, had again come to appreciate the immediacy of working directly from the subject. Having seen the numerous small landscape paintings on show at the Impressionist exhibition in 1881, it is no wonder that from this time forward, James began earnest work on his *plein air* panel paintings and watercolours, which were to feature in his exhibitions of the eighties.

Despite the fact that James was technically moving in new directions, he

was still busy promoting his earlier accomplishments. While still in Paris, the *Gazette des Beaux-Arts* published a lengthy article on James by the art critic Théodore Duret. Written that March while he was on a visit to James's London studio, Duret's article is careful to include much of the important work to date, with a long discussion on *The Painter's Mother* and *Carlyle*, the 'Peacock Room' and the Nocturnes. Duret wrote:

> In his Nocturnes, by drawing the extreme consequences from the harmonic combinations of colours which had appeared instinctively in his first works, Mr Whistler has thus arrived at the outermost margins of formalized painting. One step more and there would be nothing on canvas except a formless blob, incapable of imparting anything to the eye and mind.[27]

One step further and Duret would have stumbled into the abstract art of the twentieth century. Yet his description of James's Nocturnes as 'formalized painting' does serve as a precursor to the formalist art criticism of the next century.

On his return from Paris, James moved from his brother's home in Wimpole Street to no. 13 Tite Street, where he took lodgings and a studio. His old friend Alan Cole recorded that May in his diary: 'Jimmie . . . is going to paint all the fashionables – views of crowds competing for sittings – carriages along the streets.'[28] Despite James's wish, the fashionables did not come in droves to his studio door, but rather dribbled in. One of his first major commissions of this period was to paint a series of portraits of Mrs Meux. Her husband, Henry Meux the London brewer, agreed to pay James 500 guineas for each portrait, a sum that was later reduced when one of the three paintings was left unfinished. This commission must have been timely since James, as always, was in serious financial straits. Valerie Meux, soon to be Lady Meux, sat successfully for two of James's portraits, which came to be known as *Arrangement in Black* and *Harmony in Pink and Grey*. In the first she stands out as an elegantly dressed woman, wearing a long black evening gown, with fur cloak and jewels. Duret, who saw James painting the portrait, wrote later that

> Mrs Meux was enchanted with the portrait. It was a rare event that this woman should have been capable of appreciating the art of Whistler when great judges and famous critics only discovered in it material for depreciation. In her satisfaction at being placed on canvas in so distinguished a manner Mrs Meux immediately wished to possess a second portrait.[29]

The second depicted Valerie Meux in a rose-coloured hat and gown, and again followed the familiar formula of the full-length. When the painting was later exhibited at the Grosvenor Gallery, Henry James was to write that 'her hat doesn't fit'.[30]

Mrs Julian Hawthorne was present for the completion of the first portrait in black and later described the picture for the October issue of *Harper's Bazaar*.[31] James's exposure in such a magazine suggests that he was looking to a wider audience of wealthy patrons, in particular rich Americans. In a later account of the visit, Mrs Hawthorne wrote more fully of James's technique:

> Whistler held in his left hand a sheaf of brushes, with monstrous long handles; in his right the brush he was at the moment using. His movements were those of a duellist fencing actively and cautiously with the small sword . . . He advanced and retreated; he crouched, peering; he lifted himself, catching a swift impression; in a moment he had touched the canvas with his weapon and taken his distance once more.[32]

One such patron who came calling at this time was Lady Archibald Campbell. Known as Lady Archie, she was a beautiful and cultured woman who had a passion for the theatre, and in particular, pastoral plays, which she produced on her estate at Combe in Surrey. Duret described her as 'a tall woman of great distinction, slim, fair and, in addition, intelligent and of independent spirit'.[33] In 1886 she privately published an eccentric pamphlet entitled *Rainbow Music*, with the Whistlerian sub-title 'or, the Philosophy of Harmony in Colour-Grouping'. James's influence on this work can be seen from the introduction in which she refers to Poe's essay 'The Philosophy of Composition', and in later passages when she makes reference to Velázquez and the 'Peacock Room'.[34]

She sat happily to James for three portraits from 1882 to 1883, but refused to continue because of a friend's opinions on the suitability of the poses, and insisted that James repaint the pictures.[35] Not armed with the easy urbanity of a painter like John Singer Sargent, prepared to alter a portrait at his patron's whim, James was left utterly discouraged. However, with the help of Duret, who was starting to pose for his own portrait, he persuaded Lady Archie to continue with the sittings. Although James ended up destroying two of the three portraits, one survived as *Arrangement in Black: La Dame au brodequin jaune*. It departs from James's portraits of Mrs Meux in its theatrical manner, reminiscent of his earlier portraits of Maud Franklin. Lady Archie is posed as if departing for a secret rendezvous. Despite Duret's intervention, the portrait was eventually rejected by the

family who considered that it 'represented a street-walker encouraging a shy follower with a backward glance'.[36]

James's compatriot, Sargent, was still living in Paris at this time, embarking on his career as a society portraitist. Having trained with the fashionable portrait-painter, Carolus Duran, Sargent, unlike James, was adept at arriving at a likeness within a few sittings. Like James, and more importantly Velázquez, Sargent worked *alla prima*, covering the canvas all at once with a bravado of brushwork. The ease with which he could complete the more difficult commissions, such as group portraits, is apparent in his soon to be completed portrait *The Daughters of Edward Boit*. Sargent sought a solution to the spatial problem by reinterpreting Velázquez's *Las Meninas*, thereby creating an atmospheric mood which goes beyond a simple portrayal of the sitters. Soon after, he was to embark on painting a portrait of the society beauty, Virginie Gautreau. The picture, which later came to be known as *Portrait of 'Madame X'*, was – uncharacteristically for Sargent – fraught with problems from the start. Madame Gautreau was a temperamental and difficult sitter and when the completed portrait was exhibited at the 1884 Salon, it was fiercely criticized.[37] Such a poor reception was damaging, not only to Madame Gautreau's already insecure reputation, but to Sargent's burgeoning career as a successful portrait painter.[38] In time, Sargent was to transfer his studio and ambitions to London, where by the end of the eighties he was establishing himself as a successful society portraitist. Later he moved to 31 Tite Street, where, as James had once predicted for himself, fashionable society flocked to have their portraits painted.[39]

Tite Street was a mecca of the artistic, and during the early eighties James was frequently in contact with Oscar Wilde, who was now a neighbour, living in a house designed by E.W. Godwin, which he shared with the artist Frank Miles. It was at this time that both James and Oscar Wilde were parodied in Gilbert and Sullivan's comic opera, *Patience*, produced by Richard D'Oyly Carte at the newly built Savoy Theatre on 10 October 1881.[40] Written as a satire on contemporary aestheticism, it had in its protagonist, Reginald Bunthorne, the fleshy poet, a combination of Oscar Wilde and James. The actor George Grossmith played Bunthorne largely as Whistler, wearing his hair in black curls with the famous white lock, an eye-glass and dancing shoes, and included James's deadly 'Ha-ha' as part of the script.[41] The comic opera was popular and attended by both James and Wilde.

Punch was capitalizing on this satire of the Aesthetic Movement with a series of caricatures by James's old friend, George du Maurier. Well aware of James's prickly character, Du Maurier largely parodied Wilde, who was a

softer target, portraying him as the poet Maudle and Whistler as the painter Jellaby Postlewaite. The series ran through the early eighties and gave much notoriety to the good-humoured Wilde, who recognized the advantage of any publicity. Such collaboration prompted James to approach Du Maurier and Wilde, standing together at one of James's private views, and ask, 'Which of you two discovered the other?'[42]

In the first half of the eighties, Wilde took it as his appointed role to promote the cult of the Aesthetic Movement and its exponents. In his 1882 introduction to a collection of poems by James Rennell Rodd entitled *Rose Leaf and Apple Leaf*, he stated:

> The ultimate expression of our artistic movement in painting has been, not in the spiritual visions of the Pre-Raphaelites, for all their marvel of Greek legend and their mystery of the Italian song, but in the work of such men as Whistler and Albert Moore, who have raised design and colour to the ideal level of poetry and music.[43]

When lecturing on his tour of America in 1882, Wilde was to diversify his views and include the Pre-Raphaelites in his pantheon of artists.

Wilde set out on his tour the day before Christmas. Designed to promote the opera *Patience*, Wilde's task was to give flesh to the Aesthetic Movement, without which the parody would have fallen flat. He was also to promote James's art, according to the latter. Wilde's tour took him across America and into Canada. At one stop in the Rockies, he lectured to a group of miners, and wrote later to a friend: 'I spoke to them of the early Florentines, and they slept as though no crime had ever stained the ravines of their mountain home.' He then decided to describe to them one of Whistler's Nocturnes in blue and gold. 'Then they leaped to their feet and in their grand simple style swore that such things should not be. Some of the younger ones pulled their revolvers out and left hurriedly to see if Jimmy was "prowling about the saloons".'[44] During his tour Wilde corresponded with James by letter or telegram. The tone in some of his letters is that of an exasperated lover: 'You dear good-for-nothing old Drypoint! Why do you not write to me? Even an insult would be pleasant, and here I am lecturing on you, see penny rag enclosed, and rousing the rage of all the American artists by so doing.'[45]

As Wilde toured America, James exhibited his portrait of Mrs Meux, *Arrangement in Black*, at the Paris Salon of 1882. It was the first painting James had shown at the Salon since 1867, when he exhibited *At the Piano* and *The Thames in Ice*. Part of James's decision to show again at the Salon had to do with the fact that by the eighties the jury was accepting over 7,000

works, a huge increase from the late sixties.[46] In 1882 the French government officially handed over all responsibility for the exhibitions to the artists. After more than two hundred years of state control over the arts, this new-found freedom was celebrated by many artists who believed that the Salons could only improve once artists were in charge.[47] James would have been kept informed of these important changes through his contact with Duret. It may have been Duret indeed who encouraged James to submit to the Salon again. Writing to him that spring, James asked Duret to check on the painting at Goupil's gallery, where it had been shipped. Fearful of the painting having 'bloomed' because of the recent varnish, he advised Duret to rub it softly with a silk handkerchief, before submission to the Salon. Degas saw the work on display in May, and was impressed enough to write to a friend, 'An astonishing Whistler, over-refined, but of a quality!'[48]

At the Grosvenor Gallery that May, James exhibited seven works including several early Nocturnes. Of James's contribution Henry James wrote for the *Atlantic Monthly*: 'Mr Whistler, of course, is extremely peculiar; he is supposed to be the buffoon of the Grosvenor, the laughing stock of the critics. He does the comic business once a year; he turns the somersault in the ring.'[49] Such a narrow vision of James as a sort of licensed clown was not limited to the criticism of Henry James. Fortunately, the artist had an ally in Duret, who again wrote a laudatory review of James's work for the *Gazette des Beaux-Arts*.[50]

That April Chelsea was in mourning for Dante Gabriel Rossetti, who died one month short of his fifty-fourth birthday. Since the early seventies Rossetti had lived largely as a recluse, writing poetry and painting pictures of William Morris's wife Jane. Although James's contact with Rossetti had become sporadic, he would have felt the artist's absence every time he passed by Tudor House on Cheyne Walk.

It was around this time that Charles Augustus Howell re-entered James's life and then left it for good. The incident concerned a Japanese cabinet that James had arranged to sell through Howell during his bankruptcy. Howell sold the cabinet for cash to a collector, Mr Morse, then induced a pawnbroker to advance him money on the piece, leaving with him the top half of the cabinet. When the collector then sent for his purchase, Howell claimed that the top had been broken and was being repaired at the cabinet-makers. A similar story was told to the pawnbroker, concerning the lower half. Howell's amazing juggling of the top and bottom halves of the cabinet between the pawnbroker and collector finally resulted in his duplicity being discovered, when the two angry men approached James on his return from Venice. Once the incident was resolved, James decided to

put Howell in his place, and published another pamphlet entitled 'The Paddon Papers: or, The Owl and the Cabinet', in which he retold the story with relish, and included other accounts of Howell's double-dealings. Howell felt that James had taken the joke too far and distanced himself from the artist thereafter.

In January 1883 Wilde, recently returned from his American tour, was a constant visitor to James's studio. There he was witness to the mad scramble to print up another series of James's Venice etchings for a forthcoming exhibition at the Fine Art Society. Opening in February 1883, the exhibition was entitled 'Arrangement in Yellow' and displayed the remaining Venetian etchings along with several recent plates of London street scenes. Having already learned his lesson from the success of the pastel exhibition, James set out to make the gallery's decoration a major element in the display. Futhermore it was important to focus attention on the setting and away from the fact that James was mounting yet another largely Venetian exhibition. The theme of yellow and white ran through the gallery: from the yellow socks of the attendant on the door to the white frames of the etchings, all was orchestrated. The walls were simply covered in white felt with the skirting board, mouldings, fireplace and carpet in yellow. James insisted that the catalogue be handed out by a 'yellow man' who wore the canary and white livery specially ordered for the occasion. The poor man soon gained the nickname of 'the poached egg', much to James's amusement.

James wrote in anticipation of the opening to his friend, the sculptor Waldo Story:

> A servant in yellow livery! handing catalogues in brown paper cover same size as Ruskin pamphlet!!! And such a catalogue! The last inspiration – sublime simply – never such a thing thought of. I take, my dear Waldo, all that I have collected of the silly drivel of the wise fools who write, and I pepper and salt it about the catalogue . . . in short I put their nose to the grindstone and turn the wheel with a whirr! . . . The whole thing is a joy – and indeed, a masterpiece of mischief.[51]

The 'silly drivel' was a compilation of the adverse criticism that he had received, largely from his first show of Venetian etchings in 1880. James delighted in selecting the most vehement of reviews and juxtaposing them alongside the entries in the catalogue: he cut and snipped away at the press cuttings in his collection, often quoting the criticisms completely out of their original context. Writing again to Story, James, with characteristic bravado, saw the results as a complete success:

It has been the most brilliant campaign! Never such a social Hurrah brought about by art means in London before! –

The critics simply slumped and lying about in masses! The people divided into opposite bodies, for and against – but all violent! and the Gallery Full! and above all the catalogue selling like mad! – The papers have been full of the affair – and in short it is amazing![52]

James's scheme for notoriety had paid off and large crowds were attracted to the exhibition, including the Prince and Princess of Wales, for whose visit the galleries had to be closed. One particularly gossipy paper, the *Lady's Pictorial*, reported on the royal couple's arrival at the private view:

There was a goodly mustering of ticket-holders about the doors and wandering about Bond Street, catalogue in hand, when the Prince and Princess of Wales drove up, and Mr Whistler went forth to meet them. The Prince shook hands with him, the Princess smiled upon him; it was evident that, if critics growled at him, Mr Whistler basked in royal favour.[53]

On the departure of the royal couple, James's invited guests were permitted to return to the galleries. The critics gave the show ample coverage although, to distance themselves from James's attack, a number chose to portray him as an artistic jester and treated his catalogue as a joke. But James, as so often, got the last laugh: the catalogue sold so well that it had to be reprinted six times.

With orders for his etchings on the increase, James desperately needed some assistance in the printing of his plates. To his aid came Mortimer Menpes and Walter Sickert, who acted as studio assistants, following in the footsteps of their predecessors, the Greaves brothers. On his return from Venice James appears to have kept his distance from his earlier pupils, presumably wishing to shed his bohemian ties and be seen as a more sophisticated version of the established artist. Compared to the worldliness of the Duveneck Boys, with whom James had recently spent much of his time, the Greaves must have struck James as old-fashioned and naïve.

The erudite Sickert would have appealed immediately to James when he first met the young man in 1879. Sickert wrote to his friend Alfred Pollard describing the encounter:

I went to see Whistler the other day. He showed me some glorious work of his and it was of course a great pleasure to me to talk with him about painting. Such a man! The only painter alive who has first immense genius,

then conscientious persistent work striving after his ideal, he knowing exactly what he is about and turned aside by no indifference or ridicule.[54]

After the initial meeting Sickert continued to tour the provinces as an actor with the stage name of 'Mr Nemo', but by 1881 he had enrolled at the Slade School of Art to study under James's erstwhile friend, now adversary, Legros. When he met up again with James, Sickert was advised, 'You've wasted your money, Walter. There's no use wasting your time too!' and the young man defected to the Whistler camp.[55]

The Australian artist, Mortimer Menpes, who had been trained under Poynter at the South Kensington Schools, was only too eager to leave behind his academic background and submit to James's spell: he appears to have begun helping as an assistant printer by 1881. As Menpes had his own printing press installed in his house in Fulham, James took full advantage of the opportunity to print up his Venetian etchings.

As apprentices to James, they were given little formal instruction, as Menpes later wrote:

We were allowed the intimacy of his studio; we watched him paint day after day; we studied his methods, witnessed his failures and successes. He never placed us down as pupils and told us to paint such-and-such an object, nor did he ever see our work when it was finished; but we felt his influence, nevertheless, and strongly.[56]

Both Menpes and Sickert were permitted, under James's strict guidance, to print up a number of the Venice etchings. Menpes later recalled James's statement on the master–pupil relationship: 'I have educated and trained you, and have created an atmosphere which enables you to carry out my intentions exactly as I myself should. You are but the medium translating the ideas of the Master.'[57] Such a vicarious relationship between pupil and master enabled James to insist that this system of printing was direct from the hand of the master etcher.

Sickert was later trusted to deliver James's *The Painter's Mother* to the 1883 Salon. That spring, armed with letters of introduction from Whistler to Manet and Degas, Sickert arrived in Paris, where he stayed at the Hôtel du Quai Voltaire, as a guest of Oscar Wilde's. James had written to Wilde in Paris, entrusting his disciple to his care:

No, Oscar! – I can spare him longer if needs must – behave well to him – and attempt not to palm off wine of inferior quality upon my ambassador!
Remember, he travels no longer as Walter Sickert – of course, he is

amazing – for does he not represent the Amazing One – and his tastes are for the nonce necessarily of the most refined – even the Louvre holds for him no secrets . . .

What more shall I say? – He can explain to you the Amazing Catalogue – and for the rest has he not my blessing and his return ticket?'[58]

The tone of the letter is one of pride, as James shows off his pupil to Wilde. The catalogue that Sickert delivered to Wilde was from James's recent exhibition of etchings shown at the Fine Art Society.

Sickert soon set out to visit Manet but, the older artist being mortally ill, was unable to see him, though he was given the opportunity to peer into Manet's studio. He had more success with Degas, when visiting his apartment in the rue Pigalle in Montmartre. Introducing himself as a student of Whistler's, he was soon invited by Degas to visit his studio, where he carefully examined the paintings, and the wax and plaster statuettes. This meeting with Degas was to have a lasting effect on Sickert, and his work would soon begin to show influences of this other master.

Unfortunately for James, who had arrived in Paris later that May, the reviews of *The Painter's Mother* were not as favourable as he had hoped for and he only received a third-class medal. He had also missed Manet's funeral by four days. Manet's death on 30 April was a great loss and undoubtedly a shock to James. Pissarro had written earlier to his son Lucien of Manet's illness, and could not keep from saying, 'We are losing a great painter and a man of charm.'[59]

Théodore Duret had been Manet's champion through the years of most adverse criticism. On a visit to James in London late that spring, the talk had turned to Manet and to modern portraiture. Both James and Duret had been displeased by a portrait they had seen that day of a man in the ceremonial robes of his office rather than in modern-day clothing.[60] They reached the conclusion that the sitter should wear ordinary clothes, and James then leapt at the idea that he portray Duret in evening dress; so the critic, who had been painted fifteen years previously by Manet, was again to be painted by James.[61] The portraits differ considerably in size, with James's full-length of Duret being over twice as large as Manet's canvas. James posed Duret standing full-length in his black evening clothes, holding in one hand his top hat and in the other a lady's pink domino and fan. As with his portrait of Lady Archibald Campbell, there was an element of theatricality in the pose. James's use of a pale grey background, however, is something of a departure from his previous portraits. This background device had been used in both Manet's portrait of Duret and in a Courbet

Portrait of a Man of 1865.[62] James's painting evolved gradually over numerous sittings in 1883 and 1884.

In the spring and summer of 1883, James would have been well aware of an interesting exhibition being held at the recently opened Dowdeswells' Gallery at no. 133 New Bond Street. Organized through the intermediary of Durand-Ruel, the exhibition consisted of members of 'La Société des Impressionistes' and included over sixty-five works by Monet, Pissarro, Renoir, Manet, Degas, Mary Cassatt, Berthe Morisot, and others.[63] As Kate Flint observes in her book *Impressionists in England,* the critical reception for this exhibition at Dowdeswells' 'veered from the laudatory to the violently condemnatory'.[64] She notes, however, a turning point 'not just in the reception of the Impressionists in England, but in the development of English art criticism'.[65] One critic for the *Artist* wrote that the work on display needed a specialized audience: 'Truth is always unpalatable, and the public eye demoralized and prevented may fail to see wherein consists the attractions of Impressionist art; but to the connoisseur, the artist, the student, and to the thinker about art Messrs Dowdeswell's gallery will be for some time a centre of interest.'[66] The exhibition certainly attracted the attention of James, who the following year exhibited for the first time at the same venue.

Oscar Wilde, now returned from Paris, decided to give a series of lectures to London audiences starting in the summer of 1883. One was to the students at the Royal Academy, and for this he sought the advice of James, who jumped at the opportunity to indoctrinate the students of the oldest art establishment in Britain with some of his more advanced ideas. Wilde repeated his performance in an updated lecture given at Prince's Hall, on 11 July, which also happened to be James's birthday. James naturally attended and was reported by the *World* to be 'jumping about like a cricket'.[67] Seeing Oscar on stage, doing what James claimed he could do, only better, must have suddenly made him aware that he was in danger of losing his place at the forefront of the aesthetic avant-garde. Wary of Wilde's ability to steal his thunder, James must have conceived the idea for his own lecture that would take place two years later at the same venue.

That autumn James and Wilde featured again in *Punch*, which mentioned the two as being recently engaged in a conversation about some actresses. Wilde's subsequent telegram to James ran: '*Punch* too ridiculous. When you and I are together we never talk about anything except ourselves.' James's response was: 'No, no, Oscar, you forget. When you and I are together, we never talk about anything except me.'[68] It was not enough to leave the witty

correspondence at that. They published their telegrams, by mutual consent, in the *World* on 14 November 1883. For the moment their double-act continued for the public's enjoyment, but James's view of his disciple Wilde was already beginning to cloud.

His attentions were being diverted to his other disciples, most notably Walter Sickert. When not printing up etchings for James, Sickert or Menpes would accompany him on sketching trips around the streets of Chelsea. Using either oil on panel or watercolour, James sought subject-matter which would allow him to continue his Venetian preoccupation with the façades of buildings. Such subjects allowed for the focus to centre on the decorative details of the building, in the windows, doors and supports. In one of these panels, *Blue and Orange: Sweet Shop*, the geometrical design of horizontals and verticals creates a natural pattern of colour, texture and line, a formula James would return to again and again in the next two decades. As Menpes later recorded:

> Nowhere in England could you find better material for pictures than in Chelsea, more especially Chelsea as it appeared four or five years ago; but it was then practically owned by James McNeill Whistler. There were his little shops, his rag shops, his green-grocer shops, and his sweet shops; in fact, so nearly was it all his, that after a time he sternly forbade other painters to work there at all.[69]

Menpes in his own work at this time closely emulated his master. James often had Sickert or Menpes accompany him when sketching the little shop fronts, as the latter duly recorded: 'Whistler would get his little pochade box, and together we would drift out into the open, – on to the Embankment, or down a side street in Chelsea, – and he would make a little sketch, sometimes in water, sometimes in oil.'[70] One of the pochade boxes used by James that facilitated sketching from nature has been preserved in the Hunterian Gallery at Glasgow. It was designed to hold one or two small panels which slid into a fitting, with the lid doubling as a palette. James preferred to use panels prepared with a grey undercoat, a practice adopted by many of his followers.

In the winter of 1883–4 Menpes and Sickert travelled with James to St Ives in Cornwall. Although Menpes later recounts the trip in his book, *Whistler as I Knew Him*, he chose not to name Sickert as the other follower. Sickert for his part seems to have asserted an individuality that distanced him from the more sycophantic devotion of Menpes. A good example of the difference between the two pupils' attitudes towards their master is amply illustrated by Menpes:

The 'fish follower' [Sickert] almost invariably went off by himself painting pictures, sometimes five and six a day, talking to the fishermen as he worked, for he really loved them. The Master and I generally found ourselves alone, and I used to watch him for hours as he worked. Sometimes he allowed me to sketch the same subject.[71]

Nevertheless a few panels of Sickert's survive from this period and reveal that his style was then at its closest to his master. Years later Sickert was to write glowingly of James's panel paintings, which he regarded as the master's greatest achievement.

I imagine that, with time, it will be seen that Whistler expressed the essence of his talent in these little panels – pochades, it is true in measurement, but masterpieces of classic painting in importance . . . He will give you in a space nine inches by four an angry sea, piled up, and running in, as no painter ever did before. The extraordinary beauty and truth of the relative colours, and the exquisite precision of the spaces, have compelled infinity and movement into an architectural formula of external beauty. Never was instrument better understood and more fully exploited than Whistler has understood and exploited oil paint in these panels. He has solved in them a problem that has hitherto seemed insoluble: to give a result of deliberateness to work done in a few hours from nature.[72]

This later tribute to James is significant, and Sickert's description of the panels as an 'architectural formula of external beauty' reveals a recognition of the geometrical design inherent in James's panels. It is notable that James had abandoned his earlier memory method of the Nocturnes, and was responding directly to the subject.

The practice of painting in the open air was not exclusive to this little trio. Another artist, Albert Ludovici, soon to be a follower of James's at the Society of British Artists, recalled a visit to St Ives around this time, when 'Like many young men of that time, I was studying the *plein air* and working on the spot, instead of in a studio.'[73] Menpes also records the presence of other artists:

We used often to meet when sketching what we called 'outside' artists, to whom Whistler was a continual source of wonder, and I often overheard their remarks. They could not understand him at all. 'The man must be idling,' they said. 'How can one work in earnest sitting on a borrowed chair and with nothing but a small pochade and grey-tinted panel? Real hard work necessitates a great canvas and easel, large brushes, and at least a sketching umbrella.'[74]

Many of the artists who came to work in the open air during the eighties
and nineties derived their style and approach from a strain of realism
adapted from Courbet, and found in the work of his follower,
Bastien-Lepage.[75] Artists such as Clausen, La Thangue, Stanhope Forbes
and the 'Glasgow Boys' were simultaneously discovering the advantages of
working in the open air. However, their depictions of rural life tended to
focus on figures rather than the landscape. James's interest lay essentially in
pure landscape, and his work followed more the manner of the French
Impressionists working on a small scale *en plein air*.

That James was desperately in need of money at this time can be
ascertained from a letter to his sister-in-law Helen, in which he described
himself as 'on the verge of destitution again'.[76] In the letter James returned
a cheque for a sum of money previously borrowed from his brother
William, but asked whether he might know of another source to borrow
from. James must have hoped that the forthcoming 1884 exhibition at
Dowdeswells' would be a money-maker and the small works, painted in a
few hours from nature, were produced with this object in mind. This is not
to say that all James's thoughts were of making money; as the letter reveals,
James was formulating some new theories on nature.

Well – for dulness, this place is simply amazing! – nothing but Nature about
– and Nature is a poor creature after all – as I have often told you – poor
company certainly – and artistically, often offensive –

 Upon this subject I shall be quite eloquent when you see me again –
Indeed it must be made much of in my next brown paper pamphlet – When
shall I write that masterpiece! –

 I wish enough, I could run up to town again at once – but I don't know –
The work I am doing may make this exile worth while – I have such
inspirations too! in the way of 'games' for the other shows – indeed I am
sometimes quite bewildered with my own sparkling invention –[77]

In the 'Ten O'Clock' lecture given the following year he reiterated the
notion that 'Nature is very rarely right' and must be improved upon by the
artist.[78]

James wrote to Ernest Brown at the Fine Art Society: 'I am staying here
longer than expected to – the sea to me, is, and always was, most
fascinating! Perhaps you will think that there is a novelty about the little
things I bring back – I shall show them to you with pleasure –'[79] Working
from nature on panels was not a new practice in itself, as many earlier
painters had used this method to make preparatory sketches; the novelty

was that James regarded these small studies from nature as finished work, ready to be framed and exhibited.

In fact it was not at the Fine Art Society that the novelties were shown, but at his exhibition at Dowdeswells' held that May under the title '"Notes" – "Harmonies" – "Nocturnes"'. Many reviewers remarked on the decoration of the rooms, which James himself had referred to as an 'Arrangement in Flesh Colour and Grey'. The subtlety of the small water-colours and oils was not lost in this delicate combination of grey, pink and white. E.W. Godwin, writing in the *British Architect*, found the gallery particularly pleasing, a work of art in itself:

> When, however, Mr Whistler's 'notes, harmonies, nocturnes' – his moon and his stars – have departed to their several purchasers, there will remain to Messrs Dowdeswell a gallery specially prepared for this collection in grey, white and flesh colour, which might be in itself an exhibition if people could enjoy colour. On a July afternoon, when the blind is drawn across the sky-light, there is no place I know of more grateful, more satisfying to the eye.[80]

One gossip and fashion magazine, *Queen*, went so far as to suggest that the reader could adapt Whistler's colour arrangement to the decoration of one's house: 'Altogether the effect is very refined, harmonious, and pleasant, and to be commended to ladies wishing to decorate a boudoir in an inexpensive and elegant manner.'[81]

In the preface to the exhibition catalogue, James included a list of propositions entitled 'L'Envoie'. One proposition read: 'A picture is finished when all trace of the means to bring about the end has disappeared.' Why James harped on this point is significant in view of the sketch-like qualities of the paintings in the exhibition, many of which were small informal pictures, watercolours, pastels and oils on panel. Another proposition stated:

> Industry in Art is a necessity – not a virtue – and any evidence of the same, in the production, is a blemish, not a quality; a proof, not of achievement, but of absolutely insufficient work, for work alone will not efface the foot-steps of work.[82]

This statement attempted to invert a Ruskinian principle by admitting that whilst art required industry, industry alone was not sufficient.[83] James took this confrontation with Ruskin further in his concluding proposition, where all traces of a moral context are removed:

The masterpiece should appear as the flower to the painter, – perfect in its bud as in its bloom, – with no reason to explain its presence, – no mission to fulfil, – a joy to the artist, – a delusion to the philanthropist, a puzzle to the botanist, an accident of sentiment and alliteration to the literary man.[84]

Press reaction to James's catalogue saw it largely as a defence of his own work. But opinion was generally responsive to James's display and the coverage of the exhibition was good. Again the collaboration between reviewer and dealer was close, with one article for the *Artist* being, in fact, written by Walter Dowdeswell. Under the pseudonym of 'An Enthusiast', Dowdeswell cast James in the role of the 'talented outsider'.[85] Dowdeswell would again assume the role of 'the Butterfly's Boswell' in 1887, when he wrote a lengthy article on James for the *Art Journal*. Oscar Wilde would later criticize him for this, describing Dowdeswell as 'the most ardent of admirers, indeed, we might say the most sympathetic of secretaries'.[86]

The exhibition was a financial failure and James, writing to Charles Dowdeswell, admitted, 'I am grieved to hear that you say the Exhibition was an absolute loss to you, and that you could have done better with the works of some one else –'[87] James was soon to have another solution: some of the works would travel. That December they would reappear at the Dublin Sketching Club.

18

Performance Art

IN EARLY NOVEMBER 1884, James received a letter from the Honourable Secretary of the Dublin Sketching Club, Alexander Williams: he invited James to contribute one or two works for the club's tenth anniversary exhibition, to be held in December, and suggested that James might also consent to give a lecture about his art. Williams concluded his letter by noting that the club had also invited three other 'Americans' to exhibit – John Singer Sargent, Julian Story and Ralph Curtis.[1] The 'London link' with the Dublin Sketching Club was the Hon. Frederick Lawless, an Irish sculptor, who had until recently been working in London and had been part of the Whistler coterie.[2]

Before the day was out James had replied accepting the invitation to exhibit, confirming the proposal of a lecture and suggested sending more pictures than were originally requested. As James later confirmed to one of the organizers, William Booth Pearsall, a Dublin dental surgeon, the twenty-six paintings he sent to Dublin represented 'the largest collection I have sent to any gallery in the United Kingdom, out of London'.[3] The scale of James's loan presented a pressing problem for the club's organizing committee, for a major collection of James McNeill Whistler's work was bound to give rise to objections among the club's more conservative membership. The committee, which consisted of Pearsall, Lawless, Nathaniel Hone and John Butler Yeats (father of William and Jack), decided to press ahead regardless: it was too good an opportunity to miss. It was to prove a courageous, if not foolhardy, decision.

Of the twenty-six paintings which left London for Dublin on 17 November, eight were unsold watercolours left over from James's one-

man show at Dowdeswells' gallery earlier that year and the remaining eighteen consisted of the portraits of Carlyle, the painter's mother, and Lady Meux, together with Nocturnes and seascapes. Interestingly, James insisted that the Carlyle portrait was insured for the sum of £1,000, while that of his mother he insured for only £300. One reason for this discrepancy may well have been the fact that Carlyle's book, *Reminiscences of My Irish Journey*, published posthumously in Dublin the previous year, was in essence a scathing attack on the Irish ruling classes, and had incurred the wrath of Irish politicians and press. James, it seems, was taking no chances with the picture's safety.

Uncharacteristically, the normally fastidious James left the arrangement of his exhibits in the hands of the organizers. By the early evening of 25 November the Whistler paintings, together with three sent by Sargent, Curtis and Story, had been hung along one complete wall – a wall normally reserved for a section of the members' work, adjudged by the hanging committee as 'especially meritorious'. The work of the members was hung on the remaining walls. At around seven-thirty the club members began arriving at the hall with family and friends for a private view of the exhibition. By the end of the evening the membership of the Dublin Sketching Club was split for the first time in its ten-year history. On one side irate members, such as Dr John Todhunter of Trinity College, Dublin, a founder-member of the club, demanded that Whistler's pictures should be taken down, or at least that 'the eccentricities should be hung in a less conspicuous area'.[4] On the other side, Pearsall, Lawless, Yeats and Nathaniel Hone, together with other members, declared that as duly appointed organizers (and supporters) their decision as stipulated by the club rules was final.

During the week leading up to the official opening on 1 December the row continued unabated. The Dublin press, having got wind of the furore, put in the largest attendance ever witnessed by the club on press day, and throughout the day critics, writers and whoever else could get their hands on a presscard thronged the exhibition at Leinster Hall. One of the first broadsides fired against the organizers, and one which would dominate Dublin society for the next three weeks, appeared in the widely read *Irish Times*:

> It looks rather bad for the impressions of the vitality and usefulness of the club which its annual exhibition is intended to convey to the public . . . The loan is inappropriate, if not ludicrous . . . the exhibition ought to be a loan collection pure and simple, or an exhibition of the year's club work, and it is

not an encouraging sign to discover a tendency to merge the usefulness of the latter in the attractiveness of the former.[5]

Wholehearted support, however, came from the *Dublin Daily Express*, who wrote of James's work on display:

The freshness and originality was as startling as it was novel. On the small drawings – caprices, nocturnes, notes in pink and red – the critical wrath of the uneducated and inexperienced waxed hot, and such complimentary remarks as 'rubbish', 'daubs', 'unfinished', 'has to be looked at from a long way off' were as plentiful as blackberries, but as time passed on and the real skill and genius of the painter were pointed out the ferocity of the expletives abated and a more generous and rational estimate taken. The fact is Mr Whistler sees nature his own way . . . from the vaporous stillness of quiet Dutch canals and the Thames at Chelsea, to the gas-illuminated, smokey atmosphere of Piccadilly bustling with omnibuses, hansom cabs and hurrying figures.[6]

The following day, in a long letter to the *Irish Times*, Pearsall strenuously defended the decision to allow the Whistler paintings to come to Dublin. 'No other club or society,' he wrote, 'except the Dublin Sketching Club, takes any trouble to show their members and the public any of the current art of the day . . . I have received many letters of thanks and congratulations from artists, literary men, musicians, and others in Dublin . . . '[7]

The same day Pearsall wrote to James and enclosed the press-cuttings. James replied with a word of caution: 'I fear Mr Pearsall that if you once take up the cudgels for Whistler, you will spend the rest of your days in STRIFE! – I like FIGHTING – but do not wish to involve all my friends, among whom I may count you – in all my battles.'[8]

The furore continued unabated. There was much support for Pearsall and the committee in other newspapers and periodicals. The *Dublin Evening Mail* said that Whistler

has struck a path for himself wider and broader than that which convention allows without resentment . . . His pictures came at the beginning of the aesthetic craze and augmented it. As Edison and Fulton experimented in the sciences, so Whistler does in painting. His method is strange and new . . . His effects are consequently striking . . . [9]

On Thursday 4 December, another letter appeared in the *Irish Times*,

signed simply 'A Member of the Club'. It went straight to the heart of the matter, regarding the manner

> by which the members' work has been sacrificed to make room for Mr Whistler's unintelligible productions . . . Any visitor to the exhibition can see the contrast between the wall on which Mr Whistler's eccentricities are so prominently displayed and the opposite wall, into a corner of which the work of the members has been crowded, each sketch overlapping the other regardless of margin, and some have been placed so high that it would have been more kind to exclude them altogether.[10]

The anger expressed in the letter set the tone for a confrontation which took place in Leinster Hall on the evening of Monday 8 December. On that evening a group of dissident members, led by Todhunter (who was in all likelihood the author of the letter), gathered together and drew up a resolution calling for the resignation of Pearsall, Lawless and Yeats. As part of their evidence they attempted to photograph the hanging of Whistler's paintings *in situ*, presumably to highlight the discrepancy of the overall hang. At this point it appears that several members, including Pearsall and Lawless, intervened and attempted to remove the opposition by force. As Pearsall later told the Pennells, 'Suddenly a terrible convulsion took place.'[11] The ungentlemanly behaviour in Leinster Hall resulted in an emergency meeting being called for the following Wednesday when Todhunter and his supporters put forward a 'no confidence' motion. The motion was defeated by fourteen votes to eleven. Then, as though to rub salt into the wound Pearsall rose and put forward his own motion that 'Mr Whistler should be made an Honorary Member of the Dublin Sketching Club'.[12] The motion was eventually carried despite intense resistance from Todhunter. Upon hearing the news from Dublin several days later, James informed Pearsall that he was 'greatly pleased with my elevation in the club'.[13]

Not surprisingly, in popular terms the exhibition was a tremendous success and throughout its duration the crowds flocked to Leinster Hall. However, in spite of the tremendous interest shown in James's work he made little financial gain. Only one serious collector came forward. A club member, the Rt Hon. Jonathon Hogg, was keen to buy the portrait of the artist's mother. When word of this was sent by Pearsall, James, perhaps remembering that he in theory did not own the portrait as it was pledged as security with Graves the printseller, refused to sell, reminding Pearsall that it was 'never other than lent'.[14] In the end Hogg settled for the purchase of two watercolours, *Yellow and Grey* and *Piccadilly in Fog* –

both eventually bequeathed by Hogg in 1930 to the National Gallery of Ireland.

By the time the exhibition ended on 20 December, James had still not confirmed the dates of his proposed lecture in Dublin – perhaps for good reason. Since tentatively agreeing to the proposal, he had read almost daily in the papers of Oscar Wilde's lecturing escapades up and down the country. From Liverpool to Bristol, Southport to Glasgow, Wilde had been lecturing on 'Dress', sometimes subtitled 'Beauty, Taste and Ugliness in Dress', and on 'The Value of Art in Modern Life'. It was the delivery and content of the latter address which James was beginning to loathe with a vehemence bordering on paranoia. There would be no point, he could have reasoned, in taking Wilde to task in Dublin.[15] A much better and more effective way would be to do it in London in front of a specially invited audience of press and friends with, of course, Wilde in attendance. Then, and only then, would James have his prey on the rack, with the kill a mere formality. So Dublin was not to be the venue of Oscar's public 'wake and burial'.

Oscar Wilde's audiences in his lectures in Edinburgh and Dublin over Christmas and the New Year of 1884/5 were not in fact very big. This pattern was repeated for his remaining nineteen lectures; they had, it seems, simply lost their popular appeal. After another short break at Tite Street in mid-January, Wilde embarked on the second leg of his UK tour. By the time he arrived at his first venue, Sheffield, on 21 January, James's plans were already in motion.

The first person James turned to for advice was the journalist and lecturer, Archibald Forbes. The choice of Forbes was not without significance: Wilde despised Forbes, and the feeling was mutual. The row had begun when both men had been on the same lecture circuit in the United States during 1882. Forbes had been affronted by Wilde's dress and general demeanour, while Wilde saw Forbes as a boring old war journalist. The clash continued for weeks, and at one stage became so vicious, spilling over into the press, that the remainder of the tour was nearly cancelled.

How James met Forbes is unclear, but by the end of the first week in January Forbes had contacted his former tour managers, Richard and Helen D'Oyly Carte, on James's behalf. Helen replied on 8 January:

I have booked the hall [Prince's Hall, Piccadilly] for Friday 20th February with an option for the 27th at 12gns for the evening. It has 500 seats in the stalls and 80 at the side plus a small balcony.

The stalls could sell at 10/6d and make a reasonable profit. Whistler has not yet sent a draft of advert. Mrs Forbes said Whistler suggested that if Mr

Carte and he managed to arrange the affair, Mr Carte should take 10% of the profit and Whistler accept the risk.[16]

The option of a second lecture at the same venue the following week was quickly dropped. The reason was simple – James was a firm believer in the importance of the 'moment'.

The title James gave to the event was the 'Ten O'Clock'. The reasoning behind this was twofold. First, it had novelty value: the occasion was never publicized as a lecture – simply as the 'Ten O'Clock' – thereby creating an air of mystery and intrigue. Secondly, timing of the event was crucial, as James explained:

> Every dull bat and beetle spouts at eight o'clock, just as we are about to sit down to dinner. So we never go to see Bat and Beetle . . . I shall lecture at Ten, in order to dine myself, and let my victims get through with their dinner.[17]

The D'Oyly Cartes were also given charge of the publicity, and almost immediately they booked advertising notices in all the major papers and insertions in selected periodicals.[18] This massive publicity campaign was indicative of James's own feelings of insecurity. Despite the popular mythology, he was not a natural showman like Oscar Wilde; in fact he was petrified at the prospect of public failure and humiliation. To make absolutely sure of an audience, James wrote, and then posted tickets, to those he wished to attend. Some, like the Wildes, bought their tickets promptly. Others like Albert Moore, short of money and time, had to be coerced and cajoled by James. In a letter to Waldo Story, James demonstrated his persuasive technique:

> Waldino! Where shall I begin – Here is the game in full swing! Amazing!! – You must come over – Feb. 20th Ten O'Clock in the evening – Do my dear Waldino come – Two seats shall be kept for you *'among* 'em' – It will be amazing! Write one line and say that you and Mrs Waldo, to whom my devoted kind regards, will be *thar*! Just remember the last time when we were at the Prince's Hall together! [when Wilde lectured in 1883] . . . Write at once to D'Oyly Carte and say you want two stalls – This will cost you a cheque for one *guinea*! Tant pis! it must be done – even poor Walter [Sickert] is obliged to pawn something and pay. Harper [Pennington] also – everyone – even I myself pay for one stall – Shocking but amazing – *Everybody* is coming – the place is filling up every moment – and 'the rest don't matter'![19]

As James was working hard mustering support among his friends, so too was his long-suffering printer, Thomas Way Snr. Under James's strict supervision, Way worked on and continually revised the printing of specially designed application forms, some 200 tickets (mostly doubles), and some twenty posters which were to be strategically placed around Mayfair, St James, Piccadilly and Chelsea.

The press began speculating on the event. The *World* warned:

> Mr James McNeill Whistler . . . has lately issued huge cards, couched in most dubious terms, inviting people to be present at what he terms his 'Ten O'Clock' . . . Bitter will be their disappointment, however, on finding that they cannot obtain admission without payment. I should strongly advise them, however, not to let their chagrin get the better of them, but manfully, or womanfully, as the case may be, to plank down the pieces and go in . . . [20]

Repeated press requests for information were met with stony silence: James was revelling in the mystification of it all. No one, apart from his closest confidants, knew what the event was to entail; all were sworn to the utmost secrecy.

James began earnest work on the lecture shortly after Christmas. Writing, whether a simple letter of rebuttal to the press, or a stinging letter to an enemy, had never been an easy task for him. The 'Ten O'Clock', the most adventurous literary project he had so far undertaken, proved to be no exception. The numerous revisions and notes still extant bear witness to the anguish of the whole ordeal. Indeed it seems possible that James did not write the 'Ten O'Clock' unaided and was helped a great deal by Walter Sickert. The exact role of Sickert is difficult to unravel. Certainly his autograph hand reveals itself throughout the working drafts of the lectures.[21] The key questions which arise are: to what extent was he simply following James's dictation, and how much was he adding of his own? The evidence seems to suggest a combined authorship. It can be safely assumed that Sickert was not working in the capacity of mere secretary. As another artist, G.P. Jacomb-Hood, would later recall, James already had the services of a secretary: 'I recall his literary devotion in writing his spirited "Ten O'Clock" lecture, with his secretary hard at work in the room below, while at intervals he was busily printing his "Venice" plates on his press upstairs . . . '[22] Sickert must have played a more pivotal role. With his literary talent and lively mind, he apparently became James's philosophical sounding-board, working out ideas with him, rehashing and rewriting. Sickert's help was never mentioned by James, nor indeed by the Pennells, who devoted a

whole chapter of their biography to the lecture. But even if they had known of the part Sickert played, they would never have referred to him, such was the hatred engendered between them by later events.

James and Sickert finished writing the lecture towards the end of the second week in February. Between then and 20 February, it was honed and rehearsed. On the night before, James held a dress-rehearsal, and in the dimly lit hall read and reread the lecture to Helen D'Oyly Carte, carefully following her instructions and advice.

On the evening of 20 February, James's 350 invited guests were carefully and strategically placed within the hall, with the remaining 100 or so members of the public occupying the six rows at the rear. The first six rows contained the most important people, critics, favoured fellow artists, distinguished members of the public and patrons. Duret was allotted a seat in the front row. Lady Randolph Churchill and friends occupied four seats on the second row alongside two American artists, George Boughton and Harper Pennington, together with the rather reluctant Albert Moore. The third row contained Lord Dunraven, George Lewis (James's new solicitor), Archibald Forbes and Edward Poynter. Alongside them was James's brother William, his wife and two other guests. The remainder of the first six rows contained such people as the Mitfords, Sir Arthur Sullivan, the artist Herbert Herkomer, and the sculptor J.E. Boehm.

In seats on the left of the centre block of row six, were the Godwins: Edward and his wife Beatrice, and a guest. Maud Franklin, together with a friend, was seated discreetly as 'Mrs Abbott' at the end of the far right aisle of row nine. Wilde, who travelled back from his lecture tour in Scotland, was seated with his wife Constance in the centre block of row six, placed strategically for the impending assault. Among the other guests were Sickert and Menpes; art dealers such as the Dowdeswells and representatives from the Fine Art Society; the critic, George Moore, and James's old friend, Thomas Armstrong; Sir Leslie Ward – 'Spy' from *Vanity Fair*. The press, who were there in force, were firmly relegated to seating at the rear of the hall along with other ordinary members of the public.[23]

By ten o'clock everyone had arrived and taken their seats. As the chatter began to lessen, an air of expectation swept the hall. Five minutes passed. There was no sign of James. Ten minutes, still no appearance. Then, at precisely a quarter past ten, James emerged from the wings. The *Age* described the scene:

> Mr Whistler appeared in evening dress – supported by a 'crush-hat', an eye-glass, a rickety table, a bottle of water, and a tumbler, a roll of manuscript, a thousand eyes, and about five hundred pairs of ears . . . He did not say, 'You

are entirely welcome, ladies and gentlemen, to my little picture shop'. But, like a modest maiden, he simpered a note of abnegation, and made an apology for his appearance on the platform.[24]

In the first five minutes or so, James set out in no uncertain terms the gist of his speech: art, and the self-proclaimed role of those who purported to explain its existence and purpose to the masses:

Art is upon the Town! – to be chucked under the chin by the passing gallant – to be enticed within the gates of the householder – to be coaxed into company, as proof of culture and refinement.

If familiarity can breed contempt, certainly Art – or what is currently taken for it – has been brought to its lowest stage of intimacy.

The people have been harassed with Art in every guise, and vexed with many methods as to its endurance. They have been told how they shall love Art, and live with it. Their homes have been invaded, their walls covered with paper, their very dress taken to task – until, roused at last, bewildered and filled with doubts and discomforts of senseless suggestion, they resent such intrusion, and cast forth the false prophets, who have brought the very name of the beautiful into disrepute, and derision upon themselves . . .[25]

By the end of the initial onslaught, Wilde must have realized with some discomfort that he was the main target of attack. Wilde's popularization of the Aesthetic Movement was held in contempt by James and much of the lecture returns to this point. By now well into his stride, James continued for nearly an hour, covering numerous aspects of his subject – from dress, to the *a priori* nature and necessity of art's internationalism and the role of art in society. James dismissed out of hand the prevalent Victorian notion that art had a moral, or indeed a social function:

Beauty is confounded with virtue, and, before a work of Art, it is asked: – 'What good shall it do?'

Hence it is that nobility of action, in this life, is hopelessly linked with the merit of the work that portrays it: and thus the people have acquired the habit of looking, as who should say, not at a picture, but through it, at some human fact, that shall, or shall not, from a social point of view, better their mental or moral state . . .[26]

At several points in his lecture James renewed his old rivalry with John Ruskin, referring to him as the 'Sage of the Universities – learned in many

matters, and of much experience in all, save his subject. Exhorting – denouncing – directing. Filled with wrath and earnestness.'[27]

In reality, there was nothing new in the lecture. As many commentators at the time were to note, 'they had heard it all before' – if not from James, then from Wilde. Indeed, to understand the 'Ten O'Clock' and the motives behind it one must look at James's own position at the time. He was desperate to be taken seriously by press, public and patrons alike. The lecture was an attempt to distance himself from the theatrical aestheticism of Oscar Wilde, and to counteract the comic association of the pair in the pages of *Punch* and the mind of the public. Jealousy of Wilde's lecturing success was also a motive, but at the heart of the matter lay James's concern that the prevalent image was failing to impress patrons and collectors. It certainly did not help to sell paintings. Combined with his recent election to the Society of British Artists, discussed in the next chapter, it was a bid to re-establish himself as a serious artist.

Ominously, there was no standing ovation at the end of the lecture as one might have expected from an audience of friends. Instead, there was what can only be described as polite applause. Indeed, as several papers reported, perhaps as many as a third of those attending probably did not even hear it, simply because James's voice was not strong enough to carry throughout the hall. As he went backstage James was congratulated by close friends and admirers and he must have been considerably heartened when Sidney Colvin asked if he would repeat the lecture for the Fine Art Society at Cambridge University that March.[28] The following morning, as he read his post, his spirits must again have been lifted. There were over a dozen letters of congratulation from friends and admirers. Some of the correspondents, such as J.E. Boehm, were short and to the point: 'The lecture was better than I had expected.'[29] Alan Cole, one of the friends who had nursed him through the whole ordeal, wrote: 'Wilde's face was a picture when you talked of aesthetic costumes.'[30] There was also a characteristically flattering letter from his pupil, Mortimer Menpes: 'It was an undoubted success, far far beyond anything I could have imagined . . . You did indeed look a swell and so dignified and strange to say you appeared to be much taller than you really are . . . '[31] This last remark was brave, if not a little foolish, in view of James's sensitivity on the subject of his height.

James's mood must have changed dramatically as he began reading the first of the press reports. The *Daily Telegraph* was scathing of his performance and the lecture's content.

From Mr Whistler anything might have been expected – a burlesque, a

breakdown or a comic song. But surely his eccentricity would not carry him so far as to deliver with malicious pretence a serious dissertation on art. Alas! it was only too true, and when the various factions, Philistines and philanderers, had settled down to smile or scowl, as the spirit moved them, a jaunty, unabashed, composed, and self-satisfied gentleman, armed with an opera hat and an eye-glass plunged into the history of art in confidence and cold blood. When the matter of Mr Whistler's lecture is fairly printed on Dutch hand-made paper, with a 'river of margin', and the latest eccentricity in type, signed, of course, with the immortal butterfly, it will be time to criticize what appears at the outset to be an undigested mass of pretentious platitudes and formulated fallacies . . . on the whole we are inclined to think that when the entertainment is well slept over and carefully digested it will be forgotten as a serious counterblast against folly and philistinism, and remembered only as the eccentric freak of an amiable, humorous, and accomplished gentleman.[32]

The Times report was altogether more approving, the reviewer simply restating in his own words the gist of the lecture; it was the sort of report that James adored. The same, however, could not be said of the article which appeared on the same day in the *Pall Mall Gazette*, by Oscar Wilde himself. Considering the speed with which it appeared it has been suggested that Wilde had prior knowledge of the lecture's content: this was most certainly not the case.[33] Indeed, the whole point of the exercise was the element of surprise and Wilde, of all people, would have been the last to know. What Wilde had almost certainly done was to request the space beforehand from the editor, make the notes during the lecture, and then flesh out the article late into the night so that it could be delivered to the typesetters very early in the morning.

Wilde's review was a brilliant piece of writing under pressure. What must have irked James most as he read over the piece, was that the lecture, despite its obvious and sustained attack on Wilde, had failed to ignite the reaction he so badly wanted. Instead, Wilde had turned the tables completely by combining lavish praise for James's presentation with incisive critical rebuke of what he perceived as a fundamentally flawed argument. After describing James as 'a miniature Mephistopheles mocking the majority!', Wilde set out his central objection to James's thesis:

Of course, with regard to the value of beautiful surroundings I *differ* entirely from Mr Whistler. An artist is not an isolated fact, he is the resultant of a certain milieu and a certain entourage, and can no more be born of a nation that is devoid of any sense of beauty than a fig can grow from a thorn or a

rose blossom from a thistle. That an artist will find beauty in ugliness, *le beau dans l'horrible*, is now a commonplace of the schools, the argot of the atelier, but I strongly deny that charming people should be condemned to live with magenta ottomans and Albert blue curtains in their rooms in order that some painter may observe the side lights on the one and the values of the other. Nor do I accept the dictum that only a painter is a judge of painting. I say that only an artist is a judge of art; there is a wide difference. As long as a painter is a painter merely, he should not be allowed to talk of anything but mediums and meglip . . . But the poet is the supreme artist, for he is the master of colour and of form, and the real musician besides, and is lord over all life and all arts; and so to the poet beyond all others are these mysteries known; to Edgar Allan Poe and to Baudelaire, not to Benjamin West and Paul Delaroche.[34]

Wilde's insistence on poetry as the highest form of art followed the old debate on the hierarchy of the arts. By placing the poet above the painter Wilde was, in essence, claiming superiority over James. Nonetheless, he concluded his review magnanimously:

However, I would not enjoy anyone else's [lecture] unless in a few points I disagreed with them, and Mr Whistler's lecture last night was, like everything that he does, a masterpiece. Not merely for its clever satire and amusing jests will it be remembered, but for the pure and perfect beauty of many of its passages – passages delivered with an earnestness which seemed to amaze those who had looked on Mr Whistler as a master of persiflage merely, and had not known him, as we do, as a master of painting also. For that he is indeed one of the very greatest masters of painting, is my opinion. And may I add that in this opinion Mr Whistler himself entirely concurs.[35]

In spite of the generous tribute in this last passage, James must have been shocked and aghast at the article. Wilde should have been licking his wounds after such a public whipping, and certainly not writing this. Even the savage criticism of the *Telegraph* was forgotten; James could hardly contain his anger towards Wilde. All day he simmered, pondering his next move. Work was cast aside. He tried to write a response. Again and again, the result ended up in the waste-paper basket. In his frustration he turned once more to Walter Sickert. No doubt Sickert did his best to prevent James taking on Wilde again in the press: James was simply no match for Wilde when it came to witty literary repartee. After all, the whole idea of the lecture was to get the public to accept James as a serious artist, and to shake off the view of him as one half of a comedy duo. Indeed, to all intents and

purposes it had succeeded in that respect. But despite any wise counsel Sickert might have given, James was determined to continue: the end result was barely five lines long. Each word, however, had been carefully weighed for maximum effect. One copy was sent immediately to Wilde in Tite Street with a note to say that another copy had been sent for publication to the *World*. Wilde must have expected something of the sort, but that it was to be publicly printed was an unexpected bonus. It gave him the chance of another public reply.

James's letter, together with Wilde's, duly appeared in the *World* on 25 February, under the banner headline 'Tenderness in Tite Street':

> I have read your exquisite article in the *Pall Mall*. Nothing is more delicate, in the flattery of 'the Poet' to 'the Painter', than the *naïveté* of 'the poet', in choice of his Painters – Benjamin West and Paul Delaroche!
>
> You have pointed out that 'the Painter's' mission is to find 'le beau dans l'horrible', and have left to 'the Poet' the discovery of 'l'horrible' dans 'le beau'!

Wilde's reply was characteristically sabre-sharp:

> By the aid of a biographical dictionary I discovered that there were once two painters, called Benjamin West and Paul Delaroche, who recklessly took to lecturing on Art.
>
> As of their work nothing at all remains, I conclude that they explained themselves away. Be warned in time, James; and remain, as I do, incomprehensible: to be great is to be misunderstood.
>
> *Tout à vous,*
> Oscar Wilde[36]

For Wilde it was an immensely enjoyable game of wits, played for the benefit of London society. The young Irishman saw no harm in it, not yet at any rate. Besides it kept his public profile high, and more importantly, served as a distraction from the altogether more serious conflicts now beginning to torment him. For James it was very different. He was out to destroy a rival. So far he had failed; the lecture, the letters, had been to no avail. Tragically, within a few years Wilde would destroy himself.

19

Vive le Président

AT THE SAME TIME that James was preparing the 'Ten O'Clock', he was taking another step to correct his image as something of a buffoon and eccentric. Choosing not to exhibit at the Grosvenor Gallery after 1884 he joined the artist-controlled body, the Society of British Artists (SBA). James had attempted to exhibit his portrait of Théodore Duret at the Grosvenor in the 1884 spring exhibition, when Sir Coutts Lindsay rejected it with the words: 'I trust that you will withdraw your portrait of Monsieur Duret, the work is so incomplete and slightly made out that I cannot accept it at the Grosvenor.'[1] Such an affront was reason enough for James not to exhibit again with the gallery. With his venues now excluding the Royal Academy and the Grosvenor it is no wonder that James turned to the Society of British Artists.

This conservative society, formed in 1823, functioned as a stepping-stone to the Royal Academy, its bi-annual exhibition providing Academicians with the best space to hang their often secondary work. When the society opened its doors in the winter of 1884 to James the artist-renegade, the move was greeted with incredulity by the public and press, *The Times* of 3 December reporting: 'Artistic society was startled a week ago, by the news that the most wayward, most unEnglish of painters has found a home among the men of Suffolk Street – of all people in the world.'[2] Yet, when this most unusual of unions is examined more closely, it is clear that both James and the society had much to gain by it.

In the previous year, John Burr, the society's president, had begun a subscription drive intended to recuperate the club's straitened finances.

The conventional nature of the society is apparent from a circular used to promote membership:

> The great services that this Society has rendered in the interests of Art will be best shewn by the fact that a large number of the most distinguished members of the Royal Academy availed themselves of its advantages while working for the higher honours they afterwards attained.[3]

One of the younger members, Albert Ludovici Jnr, spurred on by Walter Sickert at James's prompting, now approached the council of the society to propose James as a suitable candidate.[4] Always the diplomat, Sickert had been able to convince Ludovici of the serious intentions of his master, and Ludovici proposed that James be made a member. Ludovici, a painter of fashionable London life, later wrote of the initial hesitancy amongst the older members:

> They seemed especially concerned with what the Royal Academy might think; however, in the end, a special meeting was called, and Mr Whistler was elected a member – the majority of voters, I am sure, thinking only of the advertisement it might be to the Winter Exhibition, and confident that he would not take much part in the workings of the Society.[5]

Electing James for his notoriety did in the end pay off, attracting the much-needed publicity for the winter exhibition of 1884. Yet, the society sorely underestimated the interest James would take in the club. On his resignation in 1888, James made a parting speech, recorded by Mortimer Menpes, which reveals that James was fully aware of the original motivation behind his election to the society:

> But then you talk about my eccentricities. Now, you members invited me into your midst as President because of these same so-called eccentricities which you now condemn. You elected me because I was much talked about and because you imagined I would bring notoriety to your gallery. Did you then also imagine that when I entered your building I should leave my individuality on the door-mat? If so, you are mistaken. No, British Artists: I am still the same eccentric Whistler whom you invited into your midst.[6]

Joining the society at the age of 50, James had been practising as an artist for thirty years. His contemporaries, such as Sir Edward Poynter or Sir Frederic Leighton, were comfortably established with official honours, the

latter as president of the Royal Academy. James wanted to rival them and chose the society as a means to that end. He can be seen as a prospective buyer, who, coming across a rather run-down property, decides to buy it and 'do it up': he would shape the Society of British Artists to his own needs. To effect these 'renovations', James employed the services of a number of young artists who were beginning to be drawn into the seductive circle of the 'master' builder. Menpes wrote of this group:

> We were a little clique of the art world, attracted together in the first instance by artistic sympathies. At the most we never numbered a dozen. We were painters of the purely modern school – impressionists, I suppose we might have been called.[7]

This group included Menpes, Walter and Bernhard Sickert, Albert Ludovici, Sidney Starr, William Stott of Oldham and Theodore Roussel. Though loosely calling themselves 'Impressionists', these artists were more 'Whistlerian' in mode, concentrating on painting a scene broadly in terms of atmosphere and tone, rather than engaging in a more complex analysis of colour in shadow.[8] Their proclamations on art echo the master: '"Nature", we said, "for the painter should be divested of all human and spiritual attributes; sentiment, philosophy, poetry, romance – these things belong to the literary art, and not in the painter's palette."'[9] Shifting the focus from artists in search of a subject, to painters denying the importance of subject, was central to their thinking. In his book Menpes tells an amusing anecdote which illustrates the danger of taking James's concepts too literally:

> Whistler talked of breadth and simplicity, and broader and emptier sketches than the Followers produced you could not possibly imagine. At that period I was painting little children on the sands – some clad only in sunbonnets, and others without the bonnets. I began to paint so broadly and so simply that the flesh tone of the child and the sand were so much alike that the picture, when it was finished, resembled a clean sheet of paper.[10]

A number of James's followers listed themselves as 'Pupil of Whistler' in the exhibition catalogues, a mannerism which raised a comment from the *Pall Mall Gazette*: 'Mr Whistler has also caused his pupils to insert in the catalogue, *à la française*, the fact of his tutorship, thus laying the foundation of a "school".'[11] Through James his followers gained the attention of the press, especially when hung sympathetically alongside the work of the master.

One member of the Whistler clan, G.P. Jacomb-Hood, later wrote of the penetration and take-over of the society:

> Meetings, pledged to secrecy (of the younger and Whistlerian faction), were held in my studio, and at these meetings it was arranged to vote solidly for Whistler as President, and for certain men as Treasurer and Secretary – in view of the approaching annual election of officers. The solid vote was entirely successful, as the rest of the members were divided in their choice, and the Whistler regime began.[12]

When James resigned in 1888 as many as twenty-five members resigned with him, causing James to comment: 'the "Artists" have come out and the "British" remain.'[13]

At the 1885 spring–summer exhibition of the Society of British Artists, James contributed his recently completed portrait of the violinist, Pablo de Sarasate y Navascues. Exhibited under the title, *Arrangement in Black*, the work shows Sarasate standing full-length holding his violin. The work was given a positive reception by the press, and James chose to show the portrait the following year at the Paris Salon.

The American artist, William Merritt Chase, who was visiting London, undoubtedly saw the work on exhibition at the SBA. Already a great admirer of James's work, when he was at last introduced to him that summer he was surprised to find another side to him:

> There were two distinct sides to Whistler, each one of which made him famous . . . One was Whistler in public – the fop, the cynic, the brilliant, flippant, vain, and careless idler; the other was Whistler of the studio – the earnest, tireless, somber worker.[14]

James persuaded Chase to pose for him, and Chase in turn painted a portrait of the master in the Fulham Road studio James had recently acquired. This exchange grew to be a trying experience for Chase, who confessed, 'He proved to be a veritable tyrant, painting every day into the twilight, while my limbs ached with weariness and my head swam dizzily. "Don't move! Don't move!" he would scream whenever I started to rest.'[15] In turn, James felt cheated when Chase exhibited his portrait of Whistler in America the following year without his permission, and he wrote in the *World* that while he had made Chase 'beautiful on canvas – the Masher of the Avenues', Chase had only created a 'monstrous lampoon' of himself.[16]

At the 1885 winter exhibition of the SBA the press showed itself fully aware of the division James was creating between the older, more

conservative 'British Artists' and the Whistler contingent. The *Spectator* remarked:

> There is now no gallery in London, probably none in the world, where can be so clearly seen as in this exhibition at Suffolk Street, the most conventional, and commonplace of old-fashioned work, side by side with the most eccentric and daring examples of modern Impressionism. They made a bold bid for popularity by choosing as a member one of the most well-known and eccentric of modern artists, Mr McNeill Whistler. And the influence of this painter has already become, if not paramount, at all events a very marked characteristic of the Suffolk Street Galleries; for he has brought in his train a number of fellow-workers, pupils and imitators, till now one could almost say that the chief feature of this exhibition is this art of shadowy impression, which Mr Whistler was practically the first to introduce to Britain.[17]

The juxtaposition of narrative paintings, with titles such as *Don't Tease the Baby,* beside the more advanced work of James, such as *Arrangement in Black, No. 8: Portrait of Mrs Cassatt,* illustrates these two schools of painting. James's portrait was a commissioned work of the sister-in-law of the American painter, Mary Cassatt, who lived in Paris and exhibited with the French Impressionists. James's contributions to Parisian galleries such as those of Durand-Ruel and Georges Petit were interpreted by the press as an affiliation with the Impressionist movement.[18] Furthermore, when President of the SBA, James invited Claude Monet and Alfred Stevens to exhibit in the galleries, an unprecedented action which caused much growling amongst the 'British Artists' who were suspicious of this foreign infiltration.

When James was voted President in the spring elections of 1886, one of his first acts was to loan the society £500 to meet financial debts incurred for rental and insurance of the gallery in Suffolk Street. The loan was undoubtedly an investment on James's behalf and indicates the extent of his involvement with the society at this time. To raise the money he had to 'mortgage' the portraits of his mother and of Lady Archibald Campbell to D'Oyly Carte.[19] But despite his generosity, not all members were pleased with his actions within the society. During the 1886 winter exhibition opposition was raised over the showing of James's unfinished portrait of Lady Colin Campbell, with one member proposing that the picture be removed from its conspicuous position.[20] The proposal was lost and the painting remained in the galleries. Many of the objections, both by society members and by the press, had to do with the fact that Lady Colin

Campbell, sister-in-law to Lady Archibald Campbell, was currently undergoing a well-publicized divorce. The public scandal of a divorce among the aristocracy was newsworthy and James's decision as president to give her portrait pride of place in the exhibition was considered offensive by the more reactionary members.

One of the reforming measures which James and his followers introduced to the society was the vast reduction of pictures, resulting in a two-tiered hang, which allowed ample space around each one. This was in direct contrast to previous hanging procedures in the Royal Academy and other societies, which sought to cover every available inch, from floor to ceiling. One astute critic, R.A.M. Stevenson, noted in the *Saturday Review*:

> He introduced a system of hanging which set an example to every show in London. He so arranged common pictures that, forming part of a decorative scheme and approached under the spell of other work, you could scarcely believe the evidence of your eyes as to their worthlessness. He gave, in fact, an artistic air to the place, which he made the talk of London.[21]

That the second-rate work of the followers shone in the reflected glory of the master was often true. In turn, James was to make use of the followers as pawns in the political structure of the society. To succeed with his reforms in hanging, he was careful to co-opt his supporters on to the hanging committee – a tactic which Mortimer Menpes described:

> Myself and a few others, all friends of his, Whistler gathered together and formed an inner circle, whose sacred duty it was to fight for the Master and protect him. On the night before one of the exhibitions we met at his studio, where he explained his plan for cleansing the Society. I, as a member of the Hanging Committee, was instructed to be ruthless in rejecting pictures. He impressed upon me the necessity of saying, 'Out, damned spot!' 'Never weary, Menpes, of saying "Out". If you are uncertain for a moment, say "Out". You need never be afraid of rejecting a masterpiece. We want clean spaces round our pictures. We want them to be seen. The British Artists' must cease to be a shop.' And out they went, one after the other, until very few and select were the pictures reserved for the exhibition. But these few were hung faultlessly, and in a decorative pattern, with plenty of wall space round each of them. Undoubtedly the pictures were shown at their best advantage.[22]

The decorative aspect of the galleries was taken further by adopting a neutral colour scheme and making use of James's patent for a velarium

(awning) which, when hung suspended above the galleries, softened and diffused the overhead light. In the spring exhibition of 1887, James chose to decorate the galleries in hues of pale brown, yellow and gold. All this made him more than a few enemies, most noticeably amongst the 'British Artists' who had benefited financially from the 'shop' effect that James was attempting to efface. Not only were sales suffering because of the vast reduction in pictures, but the crowds were thinning. Unused to such sparse surroundings, they felt cheated, with less to look at for their shilling entrance fee. At one committee meeting, a member actually calculated in pounds, shillings and pence the loss of revenue due to the sparsity of James's hang.[23] According to one entertaining anecdote, James, taking the chair at another such meeting, and challenged with the emptiness of the galleries, opened a mysterious book. Written twenty years earlier, it referred to the Suffolk Street galleries as an ideal place for young lovers to find a quiet and comfortable retreat for courtship, with only paintings as witnesses of their amorous embraces. Closing the book, James reflected: 'So you see, gentlemen, that history repeats itself', much to the amusement of the younger members.[24]

Writing of the days before the Whistler reforms, Ludovici claimed that 'Even the catalogue in those days looked more like a tradesman's book of advertisements than an artistic compilation of pictures.'[25] James redesigned it from the insignia of the lion on the front cover to the typeface within, and reduced the number of advertisements, which were relegated to the back pages. James also chose to have the prices listed at the back of the catalogue, rather than alongside the entries, thus removing the commercial taint that he so despised.

James's attempt to distance the Society of British Artists from commercial concerns was designed to set it apart not only from the methods of the dealers but, more importantly, from the overt marketing of the Royal Academy, which he referred to as 'that Bazaar'.[26] In joining the SBA, James set out to shape the club as a serious rival to the Academy, which had formerly been regarded as its sister institute. One partisan critic, Malcolm Salaman, writing for a clubland paper, the *Court and Society Review*, summed this up in an article entitled 'Hail President Whistler':

> One thing is certain, that unless some very radical reforms take place at Burlington House, all the rising young painters to whom we must look for the future of British art will flock to the standard of Mr – why not Sir James? – Whistler, rather than to that of Sir Frederic Leighton. The Society of British Artists should now receive a Royal Charter.[27]

James did, indeed, set out to acquire the 'Royal' prefix in 1887, the year of Queen Victoria's Silver Jubilee. His invitation to the Prince and Princess of Wales to visit the spring exhibition of 1887 was accepted. A story is told of the Prince of Wales turning to the president and saying: 'I had not heard of this society until you brought it to my notice, Mr Whistler, what is its history?' To which James responded: 'It has none, Your Highness, its history dates from today.'[28] By August 1887, after months of negotiation, James was able to affix the title 'Royal' to the Society of British Artists. Not uncharacteristically, James regarded this as a personal triumph, and hints were in the air of a possible knighthood.[29]

James was also courting Claude Monet who had stayed with him that summer at The Vale, his house off the King's Road.[30] Monet was present for the private view and would have seen James's portrait of Sickert's wife Ellen on display. James persuaded Monet of the merits of showing with the society and the French artist contributed four works to the winter exhibition: the paintings *Coast of Belle Isle, Bretagne, Meadow of Limetz, Village of Bennecourt* and *Cliff near Dieppe*. James also invited the Belgian artist, Alfred Stevens, who had been elected a member of the society that year, to contribute work. These foreign contributions were noted by the press, drawing a favourable response from R.A.M. Stevenson who wrote in the *Saturday Review*:

> In past years we have chiefly admired in these shows the work of young men of our own country whose practice of art has been modified in varying degrees by foreign influences. On this occasion two of those very influences are shown to us. Mr Alfred Stevens, the well-known Belgian painter, author of the little book *Impressions sur la peinture*, sends five charming little canvases; and Mr Claude Monet, one of the early heroes of 'Impressionism' in Paris, is represented by four brilliant studies of sunshine and open air. It is very curious to see, hanging in the gallery of an English society, the work of one painter, famous for the last thirty years in Paris, and that of another who may almost be said to have initiated one of the latest and most interesting developments in art.[31]

Despite the fact that Monet and Stevens contributed only a handful of paintings, many of the members of the society felt their galleries were being infiltrated by foreign artists and would later use their inclusion as a mark against James.

James, however, was unconcerned with the opinions of the diehards, and following his acquisition of the 'Royal' title, his reign became even more autocratic as he steered the society in direct opposition to the Royal

Academy. One of his first and most dramatic moves was to issue an agenda for the meeting of 1 November 1887, which proposed

> That this Society having been recognized and constituted by the personal Act and Will of Her Most Gracious Majesty as Her Royal Society of British Artists, it is obviously unbecoming and improper that any person being, or desiring to become a member of this Royal Society, should affiliate himself, or remain affiliated, with any other association of Artists established in London.[32]

According to the minutes of the meeting, the ruling on this proposal was postponed for six months, in which time the 'British Artists' began to form ranks against the Whistler contingent. However, the anti-Academy sentiments of the proposal were not lost to the papers, who duly recorded the event. The *Pall Mall Gazette* was the most explicit, printing Whistler's agenda for the meeting with the following commentary:

> The excitement caused by this proposal brought down a large concourse of members, and some lively scenes followed. That President Whistler should seek to adopt a suicidal policy – which was even appreciated as unjust and fatal to the interests of the institute by the Royal Academy itself some years ago, and duly reversed – seemed to attract less attention than the obnoxious wording of the resolution; however, 'this Royal Society' was anxious to point out in what particular direction the 'impropriety and unbecomingness' lay, and to record their resentment of the intrusion upon their personal privileges. In any case, the presidential party was routed and the resolution driven off the field. But was this resolution of Mr Whistler's an illustration of the fable of tailless fox, or is there knighthood in the air?[33]

The satirical slant of the article, with the suggestion that the president was using the society as a social ladder, was too much for the combative James to bear. He sent a letter to the editor:

> Mr Whistler begs with his compliments to assure the Editor of the *Pall Mall Gazette* that the linen of the Royal Society of British Artists is officially washed at home – notwithstanding evidence to the contrary in this evening's issue of that admirably managed paper.[34]

The winter exhibition of 1887/8 again featured the decorative Whistlerian galleries, with the added touch of 'Sunday teas' for fashionable

London society to attend. Opening on the Sabbath was a matter still in strong contention during the eighties, and the Whistler faction again faced opposition from the 'British Artists' over this. However, James got his way and the Suffolk Street galleries became the place to be 'seen' on Sunday afternoons. It was in these galleries that Wilde remarked of a particularly good witticism heard the night before, that he wished he had said it, only to be met with James's retort: 'Oh, but you will Oscar, you will!'[35]

For these events James's lady friends had dresses specially made, to be admired by the distinguished guests. One particular woman arrived one Sunday with a dress fresh from the Parisian designer, Worth. On entering the galleries she was dismayed to find that Oscar Wilde took no notice of the gown. She quickly found James, whom she took aside: 'Well, Jimmy, what do you think of it?' James adjusted his eye-glass and, with a serious glance, replied: 'There is only one thing.' To which she responded: 'Oh Jimmy, what is it? Tell me where it is wrong?' 'Only that it covers you, madam,' said James. 'Ah, you will always be the same', was her happy response.[36]

These fashionable teas gave the society a gentrified air, which not all the 'British Artists' were pleased with. This, coupled with James's habit of often arriving late at council meetings with his retinue in tow, all wearing evening dress, grated on the older members' notions of etiquette. Leading the opposition was Wyke Bayliss, a painter of church interiors. At these monthly meetings James would poke fun at Bayliss, referring to him as 'Mr Bailey', much to the latter's annoyance. This joke lasted until Bayliss at one meeting addressed the president as 'Mr Whistle', explaining that if the president chose to leave out the last part of his name, he would do the same. 'Touché!' was James's appreciative reply and he thereafter referred to Bayliss by his proper name.[37]

When James did take the chair as president, his methods were idiosyncratic. Mortimer Menpes commented:

> Never has there been, and probably there never will be again, such a president as Whistler. He was unique. As to the duties of his position, he was not quite clear; but he had in his mind certain things of which he wished to speak. The result was disastrous. The President at a meeting is supposed to encourage the members to talk, and give their opinions; but that was not Whistler's idea. He sat in the President's chair and talked himself. He talked for hour upon hour. He was brilliant, flowing, caustic. Was this the same man whom they had elected as President? the members whispered one to another – this epigrammatic person who talked not to them but at them?[38]

The whispers of members began to increase in volume, until finally matters came to a head at the meeting of 7 May 1888. The more conservative faction of the society, which had been growing in strength as a result of the hasty recruitment of like-minded artists, called for James's immediate resignation. James appears to have been unprepared for this onslaught, but agreed to call a special meeting to discuss the matter further. The meeting took place five days later, and the issue of James's resignation was put to the vote. By the narrow margin of one vote, James was able to remain president, but not for long.

At the General Meeting on 4 June, when the annual elections took place, James was defeated by Wyke Bayliss, and immediately tendered his resignation. Examining the roll-call for that specific meeting, the unusually large number of members in attendance suggests that the conservative faction of the society had been called on specifically for this vote. As Ludovici recounted:

> Our surprise was great however, when we saw how they had whipped up the oldest members to the meeting, some we had never seen before – old and decrepit people residing in the country, one or two of whom, I heard, had been so affected by the long railway journey and the night air, that they died shortly after that memorable evening.[39]

James's account, given in an interview with the *Pall Mall Gazette*, is a similar, albeit more exaggerated version: 'My dear sir, they brought up the maimed, the halt, the lame, and the blind – literally – like Hogarth's "Election"; they brought up everything but corpses, don't you know!'[40]

The conservative papers celebrated the return of the 'British Artists', whilst the liberal papers lamented the loss of the Whistler faction with the resignation of over twenty members – a loss reflected in the poor quality of work on display at the exhibitions. Rumours abounded concerning a secessionalist or alternative gallery, to be set up with James McNeill Whistler as the head. But James did not involve himself with another artistic society until 1898, when asked to be President of the International Society of Sculptors, Painters and Gravers.

Although James's bid to establish himself in London society had backfired, it was not to be his last attempt to climb the social ladder, as his 1892 retrospective exhibition attests. However, it is significant that by 1901, aged and ill, when drafting his entry for *Who's Who*, James omitted any mention of his tumultuous two-year presidency at the Royal Society of British Artists.[41]

Return to Europe

20

The Butterfly Chained

B ETWEEN THE YEARS 1884 and 1888, during his membership and
subsequent presidency of the Royal Society of British Artists, James
exhibited little on the continent. He did, however, occasionally submit
work, usually portraits, to the annual Paris Salon, and his reputation on the
continent was still potent. After the débâcle of the RBA, James set his
sights once again on Europe. Over a year before, on 14 March 1887, he had
received an invitation to exhibit from the committee of the Exposition
Internationale Annuelle held at the Galérie Georges Petit on the rue de
Sèze.[1] Obviously delighted, James immediately agreed to send a
considerable body of work – some fifty small oils, watercolours, pastels
and etchings. It was his first appearance at Petit for nearly four years and
his work was well received by critics and artists alike. Writing to his son
Lucien, Camille Pissarro observed:

> Whistler has some very fine bits of sketches in paint, forty-two!! He was
> honoured with the best places, he also has a large portrait of a lady, the
> painting is completely black. Nor is there any luminosity either. Whistler, by
> the way, does not care for luminosity. His little sketches show fine
> draughtsmanship. In the corridor he has some very good, in fact, quite
> superior etchings, they are even luminous, which is strange for an artist who
> does not aim at this in his colour.[2]

Monet, now firmly established with Petit in preference to Durand-Ruel,
had been a member of the exhibition committee at the former, along with
Besnard, Cazin, Raffaelli, Renoir and Rodin, and it was almost certainly at

his instigation that James, along with new exhibitors such as Sisley, Pissarro and Berthe Morisot, had been invited to show.

As the troubles of the RBA began brewing early in 1888, James received a letter from Octave Maus, the secretary of Les XX, the Secessionist break-away art forum in Belgium, inviting him to exhibit with the group. James had first exhibited with Les XX at their inaugural exhibition in 1884 and again in 1886. His absence in 1887, when Sickert had shown,[3] with James's approval, was by way of a rebuff for his failure to be elected to the society. At the time, Maus tried to explain diplomatically his decision not to vote for James: 'I admire you and your work, but I opposed your election, like that of Rodin and Raffaelli, because you live and work in another country . . . the two vacant places should go to encourage young local artists.'[4]

After speaking to Maus on a visit to Brussels the previous autumn with his brother William, things seemed to have been smoothed over enough for James to consent to exhibit with the group once more. Also he knew there were five vacancies in the society by then and hoped that this time he might be elected. What Maus had failed to tell James was just how much bitterness and controversy his proposed candidacy had provoked within the society the year before. James Ensor, one of James's fiercest opponents, argued that he was already an established painter with a not inconsiderable reputation. He also added, somewhat disparagingly, that his work was old-fashioned, that there was nothing new he could bring to the society. Ensor's stated objections covered up his truer feelings on the matter. Very likely he was deeply suspicious of James's motives, and cared little for him personally. Knowing of the well-publicized feud within the RBA, Ensor probably feared that James would repeat the performance at Les XX by surrounding himself with younger members who admired his work and eventually making a bid to take over the society. While Ensor could be forgiven his fears, James's motives were not altogether underhand. He had long recognized the value of Les XX and admired its Secessionist stance. It was the sort of anti-establishment society to which he desperately wished to belong.

For the exhibition in Brussels, James chose two oils: *Nocturne: Black and Gold – the Fire Wheel* and a portrait, *Arrangement in Black and Brown: The Fur Jacket*. The former represented his anti-academic stance at its best, while *The Fur Jacket* was calculated to appeal to the more conservative members of the society. Together with two pastels and four etchings, the selection provided an accurate summary of James's work.

As usual with Les XX exhibitions, the show attracted a tremendous amount of press coverage. As well as being a major artistic event, it was

also of great social importance and crowds flocked to see the exhibits. It was perhaps as well James did not go, since it was the developments by French Neo-Impressionists like Signac and Dubois-Pillet and their experiments with colour and technique that caught the critical imagination there. In fact by 1888, even Willie Finch, one of James's greatest champions in Belgium, had begun to throw off his influence and was now clearly reflecting the methods and techniques of the altogether more fashionable Neo-Impressionists.

Another feature of the exhibition reviews was the clear identification of a group emerging within the society whose subject-matter was concerned not with light and colour, but with 'un état d'âme', a state of mind or mood. Known loosely as the Symbolists, they were a relatively new movement in Belgium and followed closely the example of the longer established Symbolists in France who could trace their literary roots back to Baudelaire in the 1850s with *Les Fleurs du mal*; the art of Puvis de Chavannes since the early 1860s, and the writings of Mallarmé and Verlaine in the 1870s and 1880s. The most apt description of the movement was that it was based on the complete negation of realism. Courbet's remark that 'painting is an essentially concrete art and can only consist of the representation of things both real and existing' was in complete contrast to the Symbolist belief that sought to express the visual language of the mystical and occult. As in France, the Belgian Symbolists, artists such as Khnopff, Rops, Picard and Toorop, reflected a diversity of style which at the same time underlined the eclecticism of their sources. While its followers looked to England for inspiration they did not get it from James; rather they found it in the work of artists such as Ford Madox Brown and Edward Burne-Jones, both of whom were invited to show with Les XX. In 1893, by which time the group was disintegrating, Madox Brown eventually agreed to show, but Burne-Jones never did.

The 1888 exhibition of Les XX was not a success for James, and only served to underline how remote his work was from that of the other exhibitors. He was not happy with his treatment at the hands of the society and complained by letter to Maus in March that he had heard nothing, received no catalogue and, moreover, that the frame of the portrait had been smashed 'because of bad packing or neglect'.[5]

That autumn, the five vacant places for membership of Les XX were put to the vote. Apart from James, there were eleven other candidates, including Henry Signac, Georges Seurat, Louis-Henry Devillez, William Degouve de Nuncques, Paul-Albert Besnard and Jean-François Raffaelli. Since the ballot had to be transacted by post, the process of election took nearly a month. By the beginning of November the selection was agreed,

and the members decided to fill only three places and keep the two vacant for the future. James was not elected. Instead, membership was offered to Van de Velde, Rodin and Georges Lemmen. All accepted with enthusiasm. James's support with Les XX had waned to such an extent that he was never really in the running. There was no support from Maus, who, despite having said earlier that he would back only young local artists, had this time been active in getting Rodin elected. It was a humiliating blow for James and terminated his relationship with Les XX. He never exhibited with them again, nor did he ever mention his failure to anyone. For him, Les XX had ceased to exist.

In early January 1888, he had received a letter from his old friend, the diplomat Rennell Rodd, now attached to the British Embassy in Berlin. Rodd chided him for sending work to Berlin in preference to a major exhibition scheduled for Munich in the summer. As Rodd explained: 'Whereas Berlin is a city of politics and finance, Munich is entirely consecrated to the Muses. They are very anxious to get a good English room, and there are lots of gold medals going about.'[6]

James had planned to send his portrait of Carlyle and 'another painting'[7] to Berlin in the course of 1886, but in the end had sent nothing: it was this plan Rodd was referring to. Now with a major show planned in Munich, Rodd was determined that James should participate. In January 1888, Rodd wrote again, imploring James to exhibit in Munich, and enclosing a letter of introduction to 'Herr Pafferitz, who is in London arranging an exhibition'.[8] By March he had agreed to send a considerable body of work to the exhibition, the third international Kunst-Ausstellung in Munich.

Since it was to be an international exhibition, James first had the problem of deciding with which country to exhibit – England or the United States. It was a problem which would recur time and again in the future, but on this occasion his position as president of the RBA quickly settled the question. The scale and quality of his loan to the exhibition – 15 major oils, including *The Painter's Mother, Cicely Alexander* and *The Fire Wheel*, 20 watercolours, 7 pastels and 30 etchings – demonstrates the importance James attached to this critically important debut in Germany.

As he was pondering his selection for the Munich exhibition James was playing host to Claude Monet who had been in London over Christmas and New Year.[9] With Monet's close friend John Singer Sargent away in America it had been an ideal moment for James to spend some time with one of the few French artists he really admired, both personally and professionally. The visit gave James the opportunity to talk with Monet at length, and it is evident that many long evenings were spent together in the company of friends such as Ralph Curtis and Walter Sickert. One issue

which may have intrigued James was Monet's refusal of the highly coveted award of the cross of a Chevalier of the Légion d'honneur offered to him only weeks before. Monet no doubt explained, as he always did when asked, that his refusal was a protest against the corruption within the official art world of France, with which he wanted no part. Whether James was aware that Courbet, both his and Monet's mentor years before, had done the same, is unclear, although from James's point of view, the refusal was simply another example of Monet's stubbornness.

Other likely topics of conversation were James's new friendship with Stéphane Mallarmé, who had been approached to translate Whistler's 'Ten O'Clock', and the struggles at the RBA. Over the years Monet had become a trusted friend and James even proposed him for membership of the Beefsteak Club, one of London's famous gentlemen's clubs. It was a rare privilege indeed. However, and in spite of some enthusiastic support, the club decided to delay his election for six months, 'so that he might become better known', and in the meantime granted him temporary membership for one month.[10] Aside from James who proposed him, Monet was also supported by Leslie Ward (the caricaturist 'Spy'), Ralph Curtis, Edwin Abbey and latterly, John Singer Sargent.

Monet was renowned for his astute handling of Parisian art dealers. He took regular delight in playing one dealer off against the other, informing each of them of a rival's success with his pictures.[11] James could only listen and learn in amazement. Monet had become his eyes and ears, so far as Parisian exhibitions were concerned, and his trust in his judgement was implicit. After his return to France at the end of February 1888, Monet wrote to remind James of the next Petit exhibition. As he explained, and it was a point which appealed, there were to be few other exhibitors.[12] Monet also mentioned that he had recently heard from Mallarmé, who had again expressed great admiration for James, although he added that Mallarmé had said nothing about his intended translation of the 'Ten O'Clock' lecture.

Exactly when James first met Mallarmé is unclear. It has always been assumed that it was not until May–June 1888, when James visited Paris to see the Exposition Internationale, although they are known to have been in contact through mutual friends before that date. Almost certainly it was Monet who made the introduction and helped sustain the relationship in its early days. Mallarmé's association with artists is legendary, and he had known and written about Parisian friends of James's such as Manet and Degas, as early as 1876.[13] James must surely have known about him then, though his return to London perhaps prevented a meeting.

The idea of Mallarmé translating the 'Ten O'Clock' into French can be

traced back to November 1886, when the young Symbolist writer, Edouard Dujardin, founded the *Revue indépendante*, an avant-garde journal which strongly supported the Symbolist movement. For the first edition, Dujardin invited James, who agreed, to allow three of his pastels to be illustrated. It was almost certainly at Dujardin's instigation that Mallarmé, another contributor to the review, was approached about the 'Ten O'Clock'.[14] The proposed translation was timely since James was preparing to republish the lecture in England, while at the same time trying to get it published in the United States.[15] Mallarmé seems to have started work on the translation early in March 1888. By the middle of the month, he was able to write to James, promising its completion by Easter. In this letter, the first of many between the two men, Mallarmé explained that Dujardin would print it privately as a leaflet and publish it in the *Revue indépendante*. The only thing James would now have to do, he added, was to supply the brown paper covers he favoured.[16]

Just over a month later, Mallarmé forwarded the completed translation to James and asked for his comments. He explained that he had tried for overall meaning rather than a literal word-for-word version. He had experienced great trouble working with James's idiosyncratic style, and in the end had invoked the help of the poet, Francis Viele-Griffin. Concluding his letter, Mallarmé noted that according to Renoir to whom he had recently spoken the planned Exposition Internationale would probably open on 16 May at Durand-Ruel, rather than on the 6th at Petit's. Ominously, Mallarmé added that Monet had shown no interest in it.[17]

James returned the translation a week later. All in all, he felt it was good, though he had reservations about 'the ambiguity of certain passages I would now like to alter'.[18] He also agreed with Dujardin's suggestion that they should print around 400 copies and sell them at one franc each. Mallarmé replied shortly afterwards thanking James for his appreciation, and noting that he did not now think the planned Paris exhibition 'will come off'.[19] To his relief, James received a letter the following day from Durand-Ruel inviting him to contribute some pictures and explaining that the show would consist of some 150 works by artists such as Monet, Renoir, Sisley and Rodin. With Monet now apparently agreeing to exhibit, James quickly accepted. Durand-Ruel was delighted, and so too was Renoir, who wrote several days later thanking James for participating.[20]

The early summer of 1888 was proving to be a hectic time for James, both personally and professionally. Seething with anger at the way he had been treated by some of the members of the RBA, he allowed an early work, *A White Note*, to be exhibited at the inaugural exhibition of the New

English Art Club, together with an etching. Underlining his initial refusal to bow out of the RBA gracefully, he shortly afterwards wrote to the organizing committee of the International Exhibition planned in Munich for July, to remind them to be sure and 'see that "President of the Royal Society of British Artists" is entered after my name in the catalogue, as it will be expected'.[21]

As he prepared his work for Paris, he received a bombshell from Monet, who had decided against exhibiting with Durand-Ruel: 'I refuse to have any more to do with him,' he wrote. Instead, he went on to explain, Petit had offered his gallery for a joint exhibition in October or November. This was Monet at his manipulative best. Despite the offer of a show with Monet at Petit in the autumn, and a pledge from him to show with James in London 'the following season', Monet's decision left James in a dilemma. Should he now pull out of the Durand-Ruel show? After some thought, he decided not to. He simply could not renege on his agreement, however confusing the circumstances. And even if Monet appeared to have secured gallery space at Petit for the autumn, there was always a chance he would have fallen out with Petit too by then. Finally James selected only fourteen works for the show – he had sent fifty to Petit the previous year – thereby perhaps indicating a desire to appease Monet. At any rate, the exhibition gave him an excuse to go abroad and put the squabbles of the RBA behind him. He needed a break and, moreover, he needed to be among friends.

James arrived in Paris around 20 May, taking rooms in the Hôtel Tibre. One of the first things he did was to meet Mallarmé, and together they visited the studio of Berthe Morisot, who was also exhibiting at Durand-Ruel.[22] A fervent admirer of James's work, Morisot was later to tell Monet that, had it not been for James and Renoir, the show would have been a total disaster.[23] The exhibition opened on 27 May to a mixed press. Even the Parisian journal normally supportive of James's work, *Gil Blas*, complained that his exhibits showed no new developments. The same critic pointed out that the show lacked cohesion and Monet's absence was lamentable. Nevertheless, despite these reservations the critic announced: 'their exhibition is superb.'[24] Any further substantial coverage of the exhibition was effectively curtailed with the news of the death of the German Emperor Frederick III on 17 June, which left a dark and uncertain cloud over the city of Paris for the remainder of James's visit.

During their many discussions there was one piece of news from Monet which took James completely by surprise. Monet and Rodin were to be given a joint retrospective the following year by Georges Petit, carefully

timed to coincide with the mammoth Exposition Universelle, which was to be the main attraction of the centennial celebration of the French Revolution. As Monet stressed, the plan was still secret. He was to show about sixty paintings covering most of his career to date, while Rodin would show some three dozen sculptures. There would also be a substantial catalogue, with Mirbeau writing an essay on Monet, and Geffroy one on Rodin. The timing, let alone the combination, was just the sort of thing that James found irresistible and undoubtedly for the remainder of his visit the idea of a similar exhibition was never far from his mind. He was also able to see at first hand the sheer scale of the 1889 Exposition Universelle as the buildings, including the Eiffel Tower, began to take shape.

James did no work in Paris. He met Mallarmé several times; on one occasion towards the end of his visit, he dined with him and the sculptor Jean Carriés, whom he greatly admired. Many years later, Henri de Régnier attempted to explain the spontaneous rapport that had developed between Mallarmé and James:

> Mallarmé instantly succumbed to Whistler's magic and was touched, as though by a conjuror's wand, by the ebony cane which this great dandy of painting wielded so elegantly. Everything in Whistler justified the curiosity and affection Mallarmé felt for him: his mysterious and ponderous art, full of subjective practices and complicated formulae, the singularity of his person, the intelligent tension in his face, the lock of white hair amid the black, the diabolical monocle restraining his frowning brows, his prompt wit in the face of scathing retorts and cruel ripostes, that ready and incisive wit which was the weapon of defence and attack.[25]

James left Paris in mid-June and returned to London, where Chatto & Windus had just republished the 'Ten O'Clock'. The lecture's reappearance would probably have gone unremarked by most, save for a notice which appeared in the first June issue of the *Fortnightly Review*. Written by Algernon Swinburne, the 2,000-word article was a clever and calculated attack on the content, argument and substance of James's lecture. What galled James most was that Swinburne cast him in the role of an amateur, dabbling in areas where he had no expertise.

James read the review with incredulity. He had, after all, asked Swinburne to write it in the first place, in the mistaken belief that a well-written appreciation would help boost sales, even though he had known for some time that Swinburne's mental health was being severely undermined by alcoholism. Another straw in the wind was Swinburne's

recent denunciation of Parnell and the Irish Home Rule movement, when it was Swinburne who had sympathized with James over the O'Leary affair in the 1860s. Indeed, James had always remembered his bravery (or, to some, stupidity) for publicly appealing for clemency for the Fenians sentenced to death in 1867.

The reasoning behind Swinburne's literary lashing is difficult to pinpoint. Both men had always agreed on the general issues of aestheticism. Swinburne had written two pamphlets, 'Notes on Poems and Reviews' in 1866, and 'Under the Microscope' in 1872, defending the basic tenets of the philosophy of 'art for art's sake'. Unquestionably there was an element of jealousy involved. As the great champion of French cultural liberalism, Swinburne may have felt that James's relatively new association with Mallarmé and his associates somehow undermined his own literary position. Swinburne was well aware of Dujardin's and Mallarmé's intention to reprint the 'Ten O'Clock' lecture in the *Revue indépéndante*, since a translation by Francis Viele-Griffin of Swinburne's 'Laus Veneris' was scheduled to appear in the same edition. Viele-Griffin, it will be remembered, was also closely involved in James's translation. It may have been no coincidence that one of the first people James informed of Swinburne's 'treachery' was Mallarmé.[26] Throughout the controversy, however, one may safely assume that Swinburne's action, if not influenced directly by Theodore Watts-Dunton, a one-time solicitor and Swinburne's self-appointed guardian, who privately disliked James, certainly had his full support.[27]

James's response to the article was swift. In a long vitriolic letter, whose biblical cadences, as well as direct quotations, are very evident, he cast Swinburne in the role of traitor:

> Why, O brother! did you not consult me before printing, in the face of a ribald world, *that you also misunderstand* ... Cannot the man who wrote *Atalanta* – and the *Ballads* beautiful – can he not be content to spend his life with *his* work, which should be his love, – and has for him no misleading doubt and darkness – that he should stray so blindly in his brother's flowerbeds and bruise himself! ... Do we not talk the same language? Are we strangers, then, or, in our Father's house are there so many mansions that you can lose your way, my brother and not recognise your kin?[28]

Swinburne did not reply. According to the Pennells, when he read the letter from James he grew 'pale with rage',[29] and swore he would never speak to him again. He was true to his word: it marked the end of a relationship that had lasted over twenty years.

In France, the translation of the 'Ten O'Clock' was published as planned in the *Revue indépendante*, before its general release in the familiar brown paper covers. Towards the end of June, Mallarmé wrote to James informing him that, despite earlier optimism, the translation had not been mentioned in the press.[30] It seemed the same old story all over again.

To compound James's misfortunes at this time, his personal life had become complicated. His relationship with Maud was in tatters, and had been so for many months, if not years. While she still looked after James's affairs and managed the household, another woman had become the object of his devotion: Beatrice Godwin. James had known Beatrice for many years, at least since her marriage to the architect E.W. Godwin in 1876. Twenty-one years James's junior, Beatrice was the second daughter of the popular Scottish sculptor, John Birnie Philip. From a distance James had long admired her, captivated by her personality and charm. Beatrice had style, she was well educated and cultured – in this respect outshining all his other female friends, Maud in particular. James's feelings towards her seem to have been surreptitiously reciprocated. In an almost confessional letter, written years later when she was already fatally ill, she said: 'I think I've loved you always even from the Peacock room days.'[31] From 1885 she had exhibited frequently at the RBA, at James's invitation, under the pseudonym 'Rix Birnie'. And on one occasion, in 1886, both she and Maud exhibited as 'Pupils of Whistler'.[32]

Over the years their meetings had become more frequent, and perhaps even intimate, particularly after James began to paint her portrait, *Harmony in Red: Lamplight*,[33] probably sometime in 1884. The full-length portrait took nearly two years to complete and the result is a flattering, even risqué image of Beatrice standing with hands on hips, head slightly cocked and face vibrant, looking out confidently to her expected audience. As Margaret MacDonald has already observed, the pose is almost aggressive, reflecting perhaps the domestic circumstances in which she found herself. But if Maud suspected anything during the early stages of the portrait, she said nothing. The showdown was yet to come.

In 1885, Beatrice and Godwin separated; she had had enough of his wayward, raffish behaviour. The parting was amicable, and Beatrice went to stay with friends in Oxfordshire.[34] On her occasional visits to London, James began to act as her escort. It was during a stay in Paris in 1886, where she had resumed her study of art, that she heard the news from London that Godwin had been taken seriously ill. He died shortly afterwards. Several weeks later in a letter to George Lucas Maud innocently noted, obviously not appreciating the full implications, that 'Mrs Godwin is now a widow. He died two week ago.'[35]

James was genuinely upset by the death of Godwin and immediately took control of the arrangements, ensuring that appropriate notices appeared in the press. Following Godwin's wishes to be buried at Northleigh, in Oxfordshire, with no religious ceremony, James, along with Beatrice and Lady Archibald Campbell, accompanied the coffin by train from London, then by open wagon to the graveside. During the journey, according to Godwin's biographer, a cloth was laid over the coffin on which the trio consumed a picnic lunch.[36]

Within weeks of her husband's death, Beatrice had moved into the Chelsea area, presumably to be closer to James. He continued his work on her portrait, which he intended to exhibit at the RBA winter exhibition, and she was a frequent visitor at his house, The Vale, off King's Road. Maud, feeling her position threatened, finally exploded with anger and resentment. James ordered the two from the house to settle their dispute outside. Beatrice apparently burst a blood vessel and had to be treated by James's brother, William.

By now it was clear that James had made up his mind to rid himself of Maud. Although for some time after the incident she continued to live at The Vale, he spent more and more time at his studio on the Fulham Road. Increasingly isolated, Maud resumed modelling and during 1887 she posed for William Stott of Oldham who was married to her sister. Stott, some twenty-three years James's junior, first became acquainted with James sometime after he returned from studying in Paris in 1881. Stott was a great admirer of James's work and wrote at least one laudatory defence of it in the *Court and Society Review* in 1886. James, in turn, supported Stott's work by proposing him for membership of the RBA in November 1885.

The painting Maud posed for was entitled *Venus born of the Sea Foam*.[37] In it she is shown completely nude with her long auburn hair cascading down her sides. Stott submitted the work to the RBA winter show in 1887 where it received considerable notice in the national and provincial press. The *Sportsman*, a popular London newspaper, described what it perceived as the implicit eroticism: 'the fiery hue of her looks glows with a heated ardour which seems to raise the temperature of the picture whenever the eye rests on it.'[38] Other reports followed a similar line. The *Manchester Examiner* noted: 'Venus is a fine figure . . . The head is cocked coquettishly on one side, and the eyes, which are evidently meant to be somewhat roguish, positively leer at the beholder. Mr Wm Stott, in fact, instead of a goddess, has given us a red-headed Topsy.'[39]

The fact that Stott had dared publicly to present Maud in this way unquestionably infuriated James. While he could, in his position as President, have engineered a veto of the submission, in the end he chose

not to. To compound his undoubted embarrassment and anger, *The Times* failed to give the expected full critique of his own six submissions – which included a recent portrait of Walter Sickert's wife, entitled *Arrangement in Violet and Pink*, and early works such as *Nocturne in Blue and Gold: Valparaiso Bay* and *Harmony in Grey: Chelsea in Ice* – remarking instead that 'The contributions of Mr Whistler, the President of the Society, will be naturally looked for, but they are this year less important than usual.' However, at least Stott's picture gave him the opportunity he had been looking for. It spelt the end of his relationship with Maud, and by the beginning of 1888, she had been ousted from her position as mistress and manager of the household. For a while she stayed with the Stotts in Oldham, occasionally visiting London, perhaps in the hope of a reconciliation that was not forthcoming.

In the summer of 1888, at a dinner at the Welcome Club in Earl's Court, and after some encouragement from his friends Louise Jopling and her new husband, George Rowe, together with the member of Parliament and publisher Henry Labouchere and his wife, James and Beatrice agreed to marry. Less than a week later, on Saturday 11 August, the Reverend Francis Byng, Chaplain to the House of Commons, officiated at their wedding at the parish church of St Mary Abbott's, Kensington. The handful of guests included most of the Philip family together with Labouchere, who gave the bride away, and Rowe who performed the duty of best man. According to the Pennells, throughout the short ceremony James, they had been told, seemed decidedly 'uneasy', looking 'from side to side'. It was not, however, the implications of entering into marriage which were unsettling him, but rather the unthinkable scenario of the spurned Maud turning up to vent her anger.[40] In fact, Maud only learned of the wedding through the papers. Despite a veil of secrecy imposed by James, the London press had quickly got wind of the event, and the day after, the *Sunday Times* gleefully reported: 'The Butterfly is captive at last. Sweet willing captivity no doubt, but still the airy freedom of bachelor days is gone.' After the ceremony the wedding party retired to James's new abode, ironically one of Godwin's last buildings, the Tower House in Tite Street, Chelsea. Here, amongst unpacked cases and unarranged furniture cluttering every available space, the newlyweds and their guests ate breakfast delivered from the Café Royal, and cut a tiered wedding cake which so appalled James he refused to sit anywhere near it. The couple set off on an extended honeymoon on the continent which lasted till early November.

In his absence James left the running of his day-to-day affairs to his illegitimate son, Charles Hanson. Now 18, Charles had re-entered his life. He had been brought up under the care of Joanna Hiffernan but, wanting

to study electrical engineering at King's College, London, he had arrived at his father's door seeking help, mostly of the financial kind. James obliged, and set him to work as his secretary.

During two weeks spent in Dieppe and Brittany James painted at least five small paintings on panel: *The Sea Shore, Dieppe, The Blue Sea, The Sea, Brittany, Violet and Blue: The Little Bathers, Perosquerie* and *The Butcher's Shop*. Then he and Beatrice travelled to the châteaux of the Loire, and the towns of Touraine, Bourges, Blois, Amboise, Loches, Bridore and Verneuil-sur-Indre. Carefully packed in their luggage were thirty-four ground copper plates which he etched along the way.[41] The etchings, which James described as his 'Renaissance lot', show his fascination with architectural detail. They were, as Lochnan has observed, 'a logical outgrowth of his enthusiasm for the early Italian Renaissance architecture of Venice'.[42] In etchings such as *Renaissance Window*, the structure of the design is his main concern: peripheral detail is of no interest; it was the selective 'arrangement' within the whole that concerned him. In the relaxed, happy atmosphere created by Beatrice, James perhaps for the first time in many years appeared to be enjoying his work and feeling confident in its quality and commercial viability, as evidenced by the note he sent to Charles Hanson in London to insert in the following week's *Pall Mall Gazette*:

> Mr Whistler, we hear, has in his journeying to France, not been idle – He brings back with him some fifty new etchings of the finest quality. Those who have seen them in Paris say that the elegances of the French Renaissance have never been so exquisitely rendered as in these fairy-like plates.[43]

A letter from his friend, the diplomat Rennell Rodd, was sent on to him from London. In it Rodd relayed his views on the award to James of a second-class medal for his recent contribution to the third international Kunst-Ausstellung in Munich. Rodd suggested that James decline the award; instead, he would seek to obtain for him the coveted Order of Maximilian. In the event – whether before or after this letter is unclear – James accepted the award, though not without expressing his feelings on the matter. To the secretary of the exhibition committee he wrote: 'Pray convey my sentiments of tempered and respectable joy to the gentlemen of the committee and my complete appreciation of the second-class compliment paid me.'[44]

His anger was totally forgotten shortly after he and Beatrice returned to London in early November. A letter had arrived from Munich in his absence conferring a much more coveted award. The letter was written by

the Secretary of the Royal Academy of the Fine Arts in Munich and simply stated that the Prince Regent of Bavaria had agreed to the Academy's proposal to nominate him as an Honorary Member.

James was thrilled with the award and threw himself back into work. One of the first projects he began was a portrait of one of Beatrice's younger sisters, Ethel. Although started with the best of intentions, the rather severe portrait, entitled *Mother of Pearl and Silver: The Andalusian*, began to drag, and after a few sittings was set aside and not completed until many years later. The initial sittings, however, helped to cement a strong and lasting friendship between the two, and Ethel, or 'Bunnie' as James called her, became a close confidante and organizer, besides being a convenient and willing model.

Indeed, James quickly became an integral part of the Birnie Philip family, which was a large one, even by Victorian standards – there were ten children. James positively thrived on their constant comings and goings. He revered Beatrice's mother, Frances, by then a widow for nearly thirteen years, and fussed over her endlessly. If she had any doubts as to her daughter's wisdom in marrying him, James quickly ensured they were dispelled. As for Beatrice's son Edward, or Teddy, now nearly 12, James took a fatherly interest in him and ensured that his artistic inclinations were catered for. But of all the Birnie Philip family, there was one he doted on – Frances's youngest child, Rosalind. Then only 15 years old, Rosalind adored him in return. During the years to come, she would play a key part in James's life and posthumous legacy.

With all his mistresses and lovers in the past, it had inevitably been James who held the power and retained control over the relationship. Not so with Beatrice. Perhaps having learnt a hard lesson from the raffish behaviour of her first husband, Beatrice, from the outset, laid down unofficial ground rules concerning his company and conduct. There was to be no more swanning off, without her permission, for an evening of wining and dining with his friends at the Beefsteak Club. Harder still, she gave her opinions on those friends. Most, it seems, she could cope with – and his immediate circle, including Sickert, posed no threat: they were educated and refined (at least in the company of Beatrice). But there were others from James's past with whom she could not bear him to be associated.

Chief amongst these were the Greaves. Whether on the grounds of snobbery, or perhaps because Beatrice felt threatened by the presence of 'Tinnie' Greaves, with whom James had almost certainly carried on an illicit affair for many years during the later 1870s, Beatrice was adamant that there be no more association between them. Although he had not

been in regular contact with the family for some time, James still saw them whenever the fancy took him; but this now stopped. Years after James's death, Walter Greaves, by then a Poor Brother at Charterhouse, succinctly summed up: 'one day he got married and vanished.'[45]

Throughout the latter part of 1888 and early 1889, Maud had remained with the Stotts in Oldham. On 3 January 1889, James, in the company of John Reid, a Scottish painter and pupil of G.P. Chalmers and William MacTaggart, was sitting in the smoking room of the Hogarth Club in Albemarle Street. Late in the evening, the peace was shattered by Stott. With a contrived illusion of offended innocence, James described the events which followed to the committee of the club:

> Gentlemen – I beg to express my deep sense of regret at the episode of last night, in the club drawing-room, when a newly elected member, Mr Stott of Oldham – entering the room about midnight, came up to me, and, without preface of any kind, addressed me in the following terms: – 'You are a liar and coward'!... I immediately rose and slapped Mr Stott's face – a spontaneous movement, and gentlemen, you must admit, a most inevitable consequence of such gross insult.
>
> I am grieved to add that the first slap was followed by a second one, and the incident closed by a kick administered upon a part of Mr Stott of Oldham's body that was finally turned towards me and that I leave to specify.
>
> I thereupon resumed my interrupted conversation with Mr Reid, and was not further disturbed by Mr Stott of Oldham.
>
> ... I earnestly beg, gentlemen, that some measures be taken to prevent the recurrence of such intolerable provocation and monstrous insult.[46]

Thoroughly pleased with the showdown with Stott, James quickly ensured that the confrontation was given a public airing in the press. It became a typical James story. Shortly afterwards, in a letter to Deborah Haden describing his 'latest scalp', he enclosed a cutting from the *Sporting & Dramatic News*, which contained such detailed information that one must suspect that James himself had supplied the story. Not content with that, he then sent his copy of the letter to the committee to the *Indépendant belge*[47] where it was duly printed on 10 January. He then wrote to Alfred Stevens in Paris, urging him to 'tell the story on the boulevards'. Likewise he wrote to Monet. Monet responded that while he had enjoyed the story of the 'désastre d'Oldham', it had not appeared in the press.[48]

Through all the controversy, Maud apparently remained silent and almost certainly did not encourage Stott's fury. Not long afterwards she

left Oldham for Paris, resuming her friendship with George Lucas, who was appalled at James's behaviour. Both men never spoke again. As for Maud, she later married a wealthy Parisian. As the years went by, taking the same stance as Joanna Hiffernan, she refused point blank to discuss the past. Even when her close friend George Lucas asked her for biographical information on behalf of someone else, Maud said: 'I cannot search back into the past for things that no longer concern me. I feel sure you will understand why.'

Stott, however, would not let the matter rest. He refused to apologize to the club for his behaviour, choosing instead to resign his membership. He then sent his own version of the event to the same newspapers that carried James's initial letter. The incident would have been dropped, through boredom more than anything else, had not another version appeared in the *Hawk* on 22 January 1889. Claiming that it had 'the right end of the stick', the *Hawk* chose to relate what all other reports had omitted – the reason for the assault – and simply noted: 'Whistler having at present no regard or interest in the fair young lady whose face has been seen so often in his pictures, Stott has bestowed his gracious patronage upon her . . .'

This was too near the knuckle for James. He was infuriated and embarrassed by the inaccurate implication that Stott was having an affair with Maud. A short time later he confronted the editor of the *Hawk*, Augustus Moore, brother of George Moore, at a theatre in Drury Lane. Much to the surprise of all around him, James lunged at him with his cane, yelling 'This is the way the Hawk strikes', while raining down blows on Moore's shoulders and head. According to one source, James then missed his footing and fell to the ground. Later rebuffing any suggestion that Moore was responsible for his ungraceful slip, James retorted, 'What difference does it make whether he knocked me down or whether I slipped. The fact is that he was publicly caned, and what happened afterwards could not offset the publicity and the nature of his chastisement.' The Moore incident brought to a close the delicate issue of Maud.

21

Tension within the Ranks

THERE IS A DICHOTOMY between James's personal and professional lives during the first six months of his marriage. On the one hand Beatrice provided domestic security and a personal happiness which he had never experienced before; on the other his professional life appeared to be in disarray. His resignation from the RBA meant that his power base in London had almost completely disintegrated. Now it seemed that his closest followers were betraying him too.

His relationship with Mortimer Menpes had never been completely smooth. For one thing James had always been suspicious, if not actually jealous, of Menpes's association with Seymour Haden through the Society of Painter-Etchers. This misdemeanour was tolerated, no doubt, because of Menpes's tremendous talent for printing. Other infractions too were ignored, and in a gesture of friendship he agreed to stand as godparent to Menpes's daughter, christened Dorothy Whistler Menpes. In 1887, however, Menpes committed an almost unpardonable act when he announced he was going to Japan. For James, the long-time admirer of the East, such a trip was unthinkable for a mere 'pupil'. If there was anyone qualified to pay homage to the art of Japan it was, James firmly believed, himself. After several discussions with Menpes on the subject, he was apparently placated and gave his 'pupil' his blessing, albeit with reservations.

His suspicion of Menpes's growing independence was confirmed when the latter returned to London early in 1888. At an exhibition of his Japanese work, held at Dowdeswells' in April, Menpes refused to sign himself as 'Pupil of Whistler'. The gesture infuriated James, and the

situation was not helped by the widespread and favourable reviews the exhibition received. From then on James ignored Menpes completely. Appalled by this vindictive behaviour, Menpes resigned from the RBA shortly after the exhibition.

Now completely outside the circle, Menpes would presumably have been forgotten had not an article appeared in the *Pall Mall Gazette* on 1 December 1888. Written by Sheridan Ford, a young American journalist working in London, it was entitled 'The Home of Taste' and was a serious, though not altogether humourless, interview with Menpes focusing on his house decoration skills. Unfortunately James did not see the humour, and immediately began formulating a particularly stinging riposte which duly appeared in the *World* several weeks later. It was just what he had been waiting for, an opportunity to begin hammering nails into Menpes's professional coffin.

> Nothing matters but the unimportant; so at the risk of advertising an Australian immigrant of Fulham – who, like the Kangaroo of his country, is born with a pocket and puts everything into it – and, in spite of much wise advice, we ought not to resist the joy of noticing how readily a hurried contemporary has fallen a prey to its superficial knowledge . . . How, by the way, so smart a paper should have printed its naff emotions of ecstasy before the false colours which the 'Kangaroo' has hoisted over his bush, defies all usual explanation, but clearly the jaunty reporter whose impudent familiarity, on a former memorable occasion, achieved my wondering admiration, must have been in stress of business replaced by a novice who had never breakfasted with you and me.[1]

In March 1889, James hammered in the last nail, a final and particularly vicious note to his former pupil, of which he sent a copy to the editor of *Truth*, who printed it:

> You will blow your brains out, of course. Pigott has shown you what to do under the circumstances, and you know your way to Spain. Goodbye![2] [Richard Pigott, the notorious forger of Parnell's letters, was exposed in February 1889 and shortly afterwards committed suicide.]

With that, for James, the name of Menpes became only a memory. To his sister-in-law, Helen, he referred to Menpes only as 'a treacherous rascal'.[3] To others who dared mention his name in James's presence, he feigned ignorance of his very existence.

Watching these events perhaps with a sense of foreboding was James's other 'pupil', Walter Sickert. Like Menpes, Sickert had his run-ins with the

'master' over the years, though there the similarity ends. From James's point of view, Sickert was always the more talented and the more valuable of the two: he not only painted but also wrote well, and often the appearance of a sympathetic article in a journal such as the *Saturday Review* was enough to placate an infuriated 'master'. Over the years, James had carefully nurtured Sickert, offering advice and occasionally scolding him when he felt that circumstances demanded. But by 1888 James's control of his pupil, unbeknown to him, was slipping.

The first clear signs of Sickert's quest for independence can be traced to 1887, when in his choice of subject-matter he moved decidedly away from James. Gone were the delicate little Whistlerian panels such as *The Laundry*, and in came the first of many paintings concerned solely with the theatre and music hall. Then, as if to declare his separation, Sickert exhibited independently at the Institute of Oil Painters during James's absence in 1888. Shocked, James demanded an explanation. Sickert's reply was reasoned and incisive:

> I am not crying to be carried. I do not mean to throw myself on your good nature but take my change and peddle my work where I can. In fact I have no other choice... Painting must be for me a profession and not a pastime.[4]

James's response has gone unrecorded. It was not Sickert's intention to drive a wedge between James and himself: rather, he felt a need to establish a change in the underlying ground rules between them. His continuing loyalty can be gauged from the fact that, keenly interested as he undoubtedly was in the inauguration of the New English Art Club, he initially held aloof from this new exhibiting body, preferring still to show under the auspices of James and the RBA.

Launched in April 1886, the New English Art Club was set up as an alternative, though not a rival, to the RBA. Its first exhibition, held at the Marlborough Galleries in New Bond Street, contained the work of some fifty-eight exhibitors and spanned almost the entire eclectic gamut of British art, from the naturalist ruralism of George Clausen to the social realism of Herkomer. There was, however, at least one common denominator uniting the seemingly disparate group – the art of France. At the outset James, then still president of the RBA, almost certainly viewed the fledgeling society with a mixture of disdain and jealousy, not least since it appeared to represent a challenge to his own hegemony at the RBA. Then, as his power at the RBA began to decline early in 1888, and perhaps in an effort to hedge his bets, he chose to exhibit with the NEAC along

with Sickert. By then the club had grown to include many of his unofficial followers and former members of the RBA such as Paul Maitland, Theodore Roussel and Philip Wilson Steer, and its members ranged geographically from St Ives to Glasgow. His participation was not exactly whole-hearted. He only allowed Sickert to show one of his paintings – one which in fact Sickert owned, *A White Note* painted in 1861 – along with a single etching, the *Grande Place, Brussels*.

If James's interest in the new group was somewhat muted, Sickert's enthusiasm was on the contrary passionate. With the rout of the Whistler faction at the RBA, the new club represented for him, as for many others, the only viable forum for his work in London. Shortly before James left London to honeymoon in France, Sickert wrote to his friend Jacques-Emile Blanche informing him that the NEAC 'will be the place I think for the young school of England'.[5] It was a telling remark. The 'young school' implied independence and seemed not to envisage James at its head.

Somewhat surprisingly perhaps, the internal squabbling of the NEAC aroused little notice from James; after the vicious and prolonged bickering of the RBA, he was probably wary of yet another public affray. Sickert, however, thrived on the secretive behaviour of the two opposing camps: the Newlyn School headed by George Clausen, with their emphasis on rustic naturalism, and those artists within James's orbit operating under the influence of French Impressionism. In early 1889 Sickert wrote to Blanche of the continuing power struggle, and of his own handling of the situation:

Our friends, i.e. the Impressionist nucleus of the NEAC, have all advised that my name must not this year appear much in the proposing or seconding of people as my work is said to be most unpopular with the dull but powerful section of the NEAC, the people whose touch is square and who all paint alike.[6]

Sickert's increasing preoccupation with the NEAC, and his quest for his own independence, did not signal the end of his friendship with James, though it marked a critical watershed. Another seven years passed before their relationship finally and irretrievably faltered. But after 1888, Sickert considered his apprenticeship with the 'master' completed. They continued to meet regularly; and for some time to come – mainly at the instance of Sickert – James's influence was sustained within the 'Impressionist nucleus' of the club.

This influence was never more keenly felt than when later in 1889 ten members of the 'nucleus' staged their own exhibition at the Goupil Gallery. Simply called the 'London Impressionists', it consisted of seventy

works by Sickert, Steer, Sidney Starr, Francis James, George Thompson, Bernhard Sickert, Fred Brown, Francis Bate, Roussel and Maitland. Walter Sickert wrote the preface to the catalogue, defining the aims of the group and the reasoning behind their use of 'Impressionism'. Reiterating the basic tenets of the 'art for art's sake' philosophy, and echoing the sentiments of James's recently republished 'Ten O'Clock' lecture, Sickert explained:

> Essentially and firstly it is not realism. It has no wish to record anything merely because it exists . . . It accepts, as the aim of the picture, what Edgar Allan Poe asserts to be the sole legitimate province of the poem – beauty. In its search through visible nature for the elements of this same beauty, it does not admit the narrow interpretation of the word 'Nature' which would stop short outside the four-mile radius. It is, on the contrary, strong in the belief that for those who live in the most wonderful and complex city in the world, the most fruitful course of study lies in the persistent effort to render the magic and the poetry which they daily see around them.[7]

The statement clearly reveals the heavy shadow of James's presence behind the group, but after the official NEAC exhibition earlier in the year, in which he exhibited a pastel, *Rose and Red*,[8] he no longer expressed any further interest in the club or, indeed, in any other collective exhibiting body in England. Although he probably still cherished the idea of his own society, with himself at its head, he was no longer interested in the petty politics of London exhibiting societies. Freed from the constraints of London, he set about recreating his own international reputation.

As though to underline this air of renewed confidence, in the spring of 1889 James was on the receiving end of two tributes, apparently arranged by fellow artists and friends in both Paris and London. Of the Paris banquet held on 28 April, little documentary evidence survives, although we know that there was at least one notable absentee, Claude Monet.[9] Presumably the Paris banquet followed roughly the same pattern as the event held in London a few days later on 1 May – just as the annual Royal Academy exhibition was due to open.

The circular sent out by the organizing committee stated that the objective of the 'complimentary Dinner' for James was 'in recognition of his influence upon Art, at Home and Abroad, and to congratulate him on the honour recently conferred upon him by the Royal Academy of Munich, Bavaria'.[10] The venue chosen was the fashionable restaurant, the Criterion, in Piccadilly. The committee included the affable Charles Keene and the ever-faithful Alfred Stevens and Albert Moore. The Royal

Academy was unofficially represented by several of their number, Associates and full Academicians alike, including J.E. Boehm, Alfred Gilbert and William Quiller Orchardson. George Clausen, now considered by Sickert an enemy within the NEAC, was a member of the committee, while interestingly Sickert himself was not, although invited to attend. The younger generation of admirers and followers on the committee included Percy Jacomb-Hood, Theodore Roussel, Charles Shannon, John Singer Sargent and Waldo Story.

Apart from the committee, over sixty chosen guests paid the one guinea charge to render homage to James. After dinner James rose to thank the assembled guests. In closing his short speech James uncharacteristically showed himself to have been moved by the occasion:

> It has before now been borne in upon me, that in my surroundings of antagonism, I may have wrapped myself, for protection, in a species of misunderstanding – as that other traveller drew closer about him the folds of his cloak the more bitterly the winds and the storm assailed him on his way. But, as with him, when the sun shone upon his shoulders, so I, in the warm glow of your friendship, throw from me all the former disguise, and, making no further attempt to hide my true feelings, disclose to you my deep emotion at such unwonted testimony of affection and faith.[11]

Shortly after the Criterion dinner Sickert organized a retrospective exhibition of James's work at the College of Working Men and Women in Queen's Square, just off Southampton Row in Bloomsbury. It was the only exhibition of James's work in London that year. Although no catalogue has been traced, it is known from the few extant press-cuttings that it included some recent shop-fronts, amongst them *Carlyle's Sweetstuff Shop*,[12] together with major portraits such as *Portrait of the Painter's Mother, Thomas Carlyle, Rosa Corder* and *Henry Irving*, together with a considerable body of work in other media such as pastels, watercolours and etchings.

Among the few visitors to the show were the American couple, Elizabeth and Joseph Pennell, who had recently taken a small house in North Street, near Westminster Abbey. Joseph Pennell, himself a talented artist, had been introduced to James several years before. Unfortunately they failed to hit it off, and James found Pennell somewhat presumptuous and overbearing. When Pennell suggested that James do some illustrations for the *Century Magazine*, James refused and instead offered the services of Menpes. Now settled in London and working as an art critic for the *Star* newspaper, Joseph Pennell, who had adored James's work since he had

first seen an exhibition of his etchings in the United States, set out to find a way in to the Whistler circle.

After viewing the retrospective, Pennell later recalled 'how indignant we were to find nobody there but one solitary man and the young lady at the desk, and how we urgently wrote in the *Star* that, if there were as many as half a dozen people who cared for good work, they should go at once to see this exhibition of "the man who has done more to influence artists than any other modern"'.[13] Many years on, Sickert excused the show's failure by claiming that it was merely a 'dress rehearsal' for the more important retrospective at the Goupil Gallery in 1892.[14] In an effort to appease James later that same year, Sickert suggested he might begin a 'catalogue déraisonné' of his etchings,[15] but it seems James quietly dissuaded him.

Luckily perhaps for Sickert, James appeared not to be greatly disturbed by the failure of the exhibition, at least in public. Sickert had written an article for the *Pall Mall Gazette*, in February 1889, heaping praise on James, which probably helped. In it he claimed that despite 'the sorry brood of callow art-products that would take refuge under the "citron wing" of the butterfly', there was only one true Impressionist in England, James. Such adulation ensured forgiveness for almost any offence.

There were other events which helped to deflect James's attention away from London. The first major showing of his painted work in his native country, staged at Wunderlich's in New York in March 1889, received a favourable response, and set the stage for future important sales in the United States. The show was organized by Edward G. Kennedy, a partner in the firm, and was the largest exhibition of James's work since the Venice etchings exhibition at the same gallery in 1883. Many of the works had been shown in Munich the previous year, and comprised some thirteen oils, including *The Falling Rocket*, along with a selection of pastels and watercolours. So enthusiastic was James about the exhibition, he seriously contemplated visiting New York for it.[16]

There were two other major exhibitions, one in Paris and the other in Amsterdam, to which he intended to submit in the hope of more medals and awards. By far the most important of these was the Exposition Universelle in Paris. In past international exhibitions James had always shown with the British. This time, however, he chose to exhibit in the American section, despite an invitation to join the British. His decision was made considerably easier now that he no longer played any part in the RBA, and could present his current show in New York as justification for his move.

Early in March, James duly despatched his submissions to be vetted by the American committee, headed by General Rush C. Hawkins. He

submitted two paintings – the early *Harmony in Flesh Colour and Green: The Balcony*, and the more recent *Arrangement in Black: La Dame au brodequin jaune – Portrait of Lady Archibald Campbell*, which he had exhibited the previous year in Munich, together with a collection of twenty-seven etchings. Believing the procedure to be a mere formality, James was staggered to receive a letter from the American committee on 3 April gravely informing him that his 'exhibits for the Exposition have not met with the jury's approval'.[17] As the letter explained, it was the quantity, not the quality, of his etchings that were the cause of the problem. James was furious, more at the tone of the letter than its actual contents. Almost immediately he left London to confront the General in Paris.

Recalling the event later in the year in a newspaper interview, James explained what happened when he arrived at the committee's headquarters:

> I was ushered into the presence of this gentleman, Hawkins, to whom I said: 'I am Mr Whistler, and I believe this note is from you. I have come to remove my etchings', but I did not mention that my work was to be transferred to the English Art Section.
>
> 'Ah!' said the gentleman – the officer – 'We are very sorry not to have had space enough for all your etchings, but we are glad to have seventeen and the portrait.'
>
> 'You are too kind,' I said, 'but really I will not trouble you.'
>
> Mr Hawkins was quite embarrassed, and urged me to reconsider my determination, but I withdrew every one of my etchings.[18]

In his fury James transferred his work to the British Section and into the company of Edward Burne-Jones, Leighton and several other artists associated with the Pre-Raphaelite Brotherhood. Such a move, in fact, gained him little except as a sop to his pride. Moreover his prints, from which he selected just eight to be shown, were in direct competition for medals with his old arch-rival, Seymour Haden.

Though invited, James and Beatrice chose not to attend the grand opening ceremony for the Exposition Universelle on 5 May, preferring instead to visit the spectacle later in the summer by which time the medals and honours would be public knowledge. In the interim, James was in correspondence with E.J. van Wisselingh, an art dealer from The Hague, and the painter and writer, Phillipe Zilcken, making preparations for the forthcoming Tentoonstelling van Kunstwerken van Levende Meesters to be held in The Hague. After some persuasion, he agreed to exhibit three paintings: *The Painter's Mother*, *The Fur Jacket* and a painting already sold by

van Wisselingh, *Arrangement in Yellow and Grey: Effie Deans*.[19] He did little work throughout the summer, but occasionally, when the fancy took him, printed some of the 'French Renaissance' etchings on his press in a little room on the top floor of Tower House.

Earlier in the spring, the young American writer Sheridan Ford, with whom James had become friendly despite his little indiscretion in printing the Menpes interview,[20] had put forward the idea of collecting and publishing the numerous letters James had written to the press over the years. Despite later assertions to the contrary by James, Ford's suggestion appealed to him immediately;[21] moreover the young American journalist seemed the ideal candidate for such a task.

During the early part of the summer James eagerly helped Ford to supplement the material he had already unearthed at the British Museum, and together they began to create a chronology of his letters. They continued the work throughout the summer despite numerous day-to-day distractions, of which the most important was the news beginning to filter through from Paris regarding awards at the Exposition Universelle.

On 21 July, James received a letter from Mallarmé in Paris. Pre-empting the publication of the official honours list, Mallarmé informed him that according to John Lewis Brown 'who had gained a 1st Class medal in painting', the jury had unanimously awarded James a similar honour.[22] Another first-class medal had gone to Edward Burne-Jones for his submission *King Cophetua and the Beggar Maid*. James's delight at his success with his portrait of Lady Archibald Campbell was tempered by not yet knowing how his etchings had done. Underlining the folly of his hasty departure from the American Section, Mallarmé claimed that had James stayed he would almost certainly have been awarded a *médaille d'honneur*.[23] Several days after Mallarmé's letter, Duret wrote to confirm what James already knew, informing him also that John Singer Sargent had received the *médaille d'honneur* in the American Section and that he, Duret, was exerting pressure in an attempt to get James 'a decoration', but his task was not made easier by James's presence in the British Section.[24]

Shortly afterwards James's worst fears were confirmed when Haden was given the highest award, the *Grand Prix*, for his etchings. It was yet another aching blow to his pride. Bitter at this failure, he wrote to Mallarmé lamenting the fact that although his etchings had been in Paris 'for years', they had always been ignored.[25] One member of the jury was his former friend Fantin-Latour: James would no longer have expected any firm support from that particular quarter.

News of the awards from the Exposition Universelle appeared to stop James dead in his tracks. He suddenly dismissed Ford from his task of

compiling the letters. According to the American-born portrait painter John McClure Hamilton, the abruptness of the dismissal distressed and angered Ford greatly. The letter written by James to Ford (and published several weeks later in the *St Stephen's Review*) gives little clue as to his reasoning:

> Let us have no wrong impressions. I thoroughly know that you are just the man to bring to completion the work in question, and how lucky I am in having interested you in it. Meanwhile without going further – for I fear that I have an inherent objection to being hurried about anything – do let me recognize slightly the time and the care you have taken to give the collection the shape it already has. I enclose, therefore, a cheque for ten guineas. I do not in this way pretend to value the pains you have been at, but in all fairness to each of us you must allow me to see that you are not so far absolutely the loser. I think, for many reasons, we would do well to post-pone the immediate consideration of the proposed publication for a while. At the moment I find myself anxiously interested in certain paintings, the production of which might appropriately be made anterior to more literature.[26]

James was to discover quickly that he had badly misjudged Ford. Far from accepting the derisory pay-off, he believed that James had given him the sole right to publish the letters, and decided to continue without his assistance. There was little James could do at that moment; not only was he about to begin a two-month holiday in Holland, but he was not quite sure what Ford's next move would be. Any development had to be left to his son, Charles Hanson, to handle, who once again was in charge of James's affairs while he was abroad.

James and Beatrice left London for Amsterdam shortly after mid-August. He departed armed with copper etching plates, several small wood panels and a sketchbook, intent on doing some work. He was, of course, also keen to see his three paintings which were on show in the city. The fact that he could begin a new series of etchings, after the disappointment of the Paris awards, speaks volumes for his determination to achieve the recognition he felt his work deserved. After some initial problems with the local inhabitants, when pails of filthy water were thrown over him as he etched some buildings from a boat on a canal, he began making perhaps some of the greatest etchings of his later career.

In etchings such as *The Little Street*, James as usual selected the most important features of the architectural detail. Focusing on this particular aspect, he refined the work into the essence of the image before him. Now,

more than ever, his work assumed an overtly two-dimensional feel and he stretched the medium to its limits by obliterating all but the essential details. Never before, or arguably later, had his work achieved such Symbolist qualities; through the merest stroke of the needle he had captured in total the image of the object before him. Evidently thrilled with what he had done so far, he quickly wrote to Marcus Huish of the Fine Art Society on 3 September:

> I find myself doing finer work than anything I have hitherto produced – and the subjects appeal to me most sympathetically – which is all-important. I make my first offer to yourselves, because of the recent entente cordiale which you have brought about . . . [My work is] combining a minuteness of detail – always referred to with sadness by the Critics – who hark back to the Thames etchings (forgetting that they wrote foolishly about those also when they first appeared!) – with greater freedom and more beauty of execution than even the Venice set, or the last Renaissance lot can pretend to.[27]

Despite his enthusiasm, the Fine Art Society, still fretting over the Venice etchings, preferred, it seems, to sit this particular offer out. It may have weighed with them also that they stood to make only half the profit James envisaged for himself. The etchings were also brought to the attention of Edward Kennedy in New York. Writing to him from Amsterdam in late September, Beatrice informed him that 'these plates will be amongst the finest he has done as they are very elaborate in character, and as they come from the country of the Knickerbockers they ought to be a great success in New York.'[28] Like the Fine Art Society in London, Kennedy was not prepared to make any definite commitment.

Aside from the etched work done in and around Amsterdam, James made several watercolour sketches, perhaps as preparatory studies to aid him with the etchings. One in particular, *House by a Canal, Amsterdam*,[29] which appears to relate to the etching *The Steps, Amsterdam*, incorporates charcoal, pastel and watercolour and is a good example of James's complementary use of the various media. Other work achieved during the visit included at least two small oil panels: *The Canal, Amsterdam*,[30] which shows roughly the same scene as the etching *Square House, Amsterdam*, and the barely finished *The Grey House*,[31] again related to an etching, *Jews' Quarter*. In both these works, it is the beautiful colouring which stands out, underlining perhaps James's occasional need to break away from the discipline and restrictions of black and white.

With some fourteen etchings completed, plus the two small oil panels

and several worked-up drawings, James and Beatrice left Amsterdam sometime in early October to visit Paris. By the time they arrived, over 25 million people from all over the world had visited the Exposition Universelle.[32] The city was still thronged with visitors and they would have had to queue to view the exhibitions. Almost certainly they met up with Mallarmé and friends such as Degas and Count Robert de Montesquiou, the eccentric poet and dandy whom James had met on a previous visit. Anxious to renew the friendship, Montesquiou had written to James earlier that year lamenting their lack of communication.[33]

An exhibition which they could not see, since it had only run from June to August, was the joint retrospective of Monet and Rodin at the Galérie Georges Petit. In Petit's large and sumptuous rooms, the choicest work of both artists had been displayed with the greatest care and attention. James would have heard all the details from Monet, whom he met during his stay.[34] Overshadowed as it was by the press coverage given to the 'official' exhibitions, the joint retrospective nevertheless proved to be a watershed for both the participants, in particular Monet. It helped to boost the value of his work as well as his status with collectors, and within weeks of the exhibition closing he had sold a painting for 9,000 francs, against the standard previous prices of around 1,200 to 2,000 francs. Such developments impressed James immensely. As he left Paris later in October, he did so with the idea of staging such a show for himself. Unfortunately for him other events and circumstances demanded his attention. A well-planned and executed 'retrospective' would have to wait.

22

The Gentle Art of Making Enemies

JAMES AND BEATRICE arrived back home in London to find a letter from the Burgemeester of Amsterdam informing him that he had been awarded a gold medal for his paintings and etchings at the recent exhibition.[1] Unfortunately for James, it was about the only piece of good news awaiting his return. Sheridan Ford's determination to publish James's letters appeared to have increased and by the end of November he had completed a manuscript which he intended to entitle *The Correspondence of James McNeill Whistler.* His next move was to find a printer willing to publish it. James was watching him every step of the way, ready to serve an injunction. In the meantime James decided to continue the work they had started together at Tower House, and by the beginning of December he and Beatrice were furiously at work compiling and editing the boxes of letters.

Living in Tite Street, despite its many advantages, presented two major problems. In the first place, Beatrice never really settled in Tower House because of its associations with her late husband, the architect E.W. Godwin, who had built it. Secondly, in the same street, a hundred yards or so further along, at no. 16, lived Oscar Wilde and his wife Constance. Beatrice had no argument with Constance (no one ever had) but she loathed and despised Oscar with a vehemence only equalled by James. Her reasons perhaps stemmed from Wilde's close association with her late husband, who had decorated Wilde's house for him in 1884. Both men had become close friends and Godwin had persisted in the friendship despite Beatrice's protests. The mere thought of accidentally bumping into Wilde again now was abhorrent to her.

Since moving into Tower House the year before, an uneasy peace had

held and there had been no embarrassing incidents between the couples. Both had kept their distance. In fact James had rarely seen Oscar since their last public controversy nearly three years before which succeeded the earlier affray of the 'Ten O'Clock' lecture. James affected horror when it became known that Oscar – along with the art critic Harry Quilter, the purchaser of the White House, whom James loathed arguably even more than he did Wilde – had been co-opted on to a new committee examining the possibilities of art reform outside the sphere of the Royal Academy. Characteristically James could not let such an incident pass without comment. Wilde's own aversion to Quilter was well known, so to link them together was a gross and calculated insult designed only to provoke reaction. The barbed attack duly appeared in the *World* in November 1886:

> Gentlemen, I am naturally interested in any effort made among Painters to prove that they are alive, but when I find, thrust in the van of your leaders, the body of my dead 'Arry, I know that putrefaction alone can result. When following 'Arry there comes an Oscar, you finish in farce, and bring upon yourselves the scorn and ridicule of your *confrères* in Europe.
>
> What has Oscar in common with Art? except that he dines at our tables and picks from our platters the plums for the puddings he peddles in the provinces. Oscar – the amiable, irresponsible, esurient Oscar – with no more sense of a picture than of the fit of a coat, has the courage of the opinions – of others! With 'Arry and Oscar you have avenged the Academy.[2]

Wilde was furious with James's letter and as Richard Ellmann, his biographer, has noted,[3] salvaged something with his succinct reply, which appeared a week later: 'This is very sad! With our James "vulgarity begins at home", and should be allowed to stay there.'[4]

Wilde's retort appeared to bring the matter to a close, though James later claimed that he privately answered Wilde's reply with the *bon mot*, '"A poor thing," Oscar – but, for once, I suppose, "your own"!' For the next two years both held their fire in public. James was preoccupied with other matters and when he did occasionally happen to see Oscar he behaved as condescendingly as ever. Although Wilde seemed to take the continued rebuffs in good humour, this outward appearance masked a transformation which was taking place in his own character. He was at this time busy with a major new work, *The Picture of Dorian Gray*, the only novel he would ever write. Ellmann observed: 'That Dorian Gray should kill a painter, who in the original draft (as Wilde told the translator Jean-Joseph Renaud) was clearly and libellously Whistler, makes the book more a record of Wilde's

personal feelings than might appear.'⁵ On Wilde's choice of story, Ellmann writes: 'Wilde had hit upon a myth of the vindictive image, an art that turns upon its original as son against father or man against God.' By producing such aesthetic inversion, Wilde was at last able metaphorically to put James in his place: the creator at last destroyed by his creation.

In January 1889, however, Wilde abandoned subterfuge and launched a scathing attack on James's sub-biblical style in the *Pall Mall Gazette*:

> Mr Whistler, for some reason or other, always adopted the phraseology of the minor prophets . . . The idea was clever enough at the beginning, but ultimately the manner became monotonous. The spirit of the Hebrews is excellent but their mode of writing is not to be imitated, and no amount of American jokes will give it that modernity which is essential to good literary style. Admirable as are Mr Whistler's fireworks on canvas, his fireworks in prose are abrupt, violent and exaggerated.⁶

James seems to have been unnerved, albeit momentarily, for he made no immediate public reply. Instead, he simmered, doubtless watching with a mixture of glee and bewilderment as Wilde took Swinburne to task nearly six months later when reviewing *Poems and Ballads* (Third Series) in the *Pall Mall Gazette*.⁷ The opportunity to strike a retaliatory blow presented itself not long after he and Beatrice had returned from Paris. Herbert Vivian, a young friend of both men, published the first chapter of his *Reminiscences of a Short Life* in the *Sun* on 17 November 1889. Vivian blatantly chose to ignore Wilde's plea for discretion and repeated all the old stories, reopening yet again the vexed issue of Wilde's plagiarism and pointing out, amongst other things, a recent example in Wilde's article 'The Decay of Lying' which had appeared in the periodical, the *Nineteenth Century*. James saw in this a golden opportunity to launch his own attack.

However, his preoccupation with Wilde was temporarily banished when, ten days after Vivian's disclosures, an official letter arrived from Paris. Sent by the Ministre de l'Instruction Publique et des Beaux-Arts it stated that the President of the Republic, in recognition of James's part in the success of the Exposition Universelle, had agreed to the proposal that he should be awarded the cross of 'Chevalier de l'Ordre National de la Légion d'Honneur'.⁸ James was overjoyed, even though he was not the only person to receive the award; Edward Burne-Jones and John Singer Sargent were also recipients. It was simply the most important award of his life and before long the congratulations began arriving at Tite Street. The first came from Mallarmé, followed by a delighted Monet who wrote at the foot of his letter, 'A vous d'amitiés, mon cher ami, et encore Bravo'.⁹ Shortly

afterwards Sargent wrote informing James, 'everyone is clamouring for you in Paris.'[10]

It was just the sort of news that brightened up a dreary winter in London, but thoughts of Ford and Wilde soon returned to obsess him. Just before the New Year, he sat down and composed one of the most vitriolic letters he had ever written. Only sheer hatred could explain why he chose to prolong such a mundane row with Wilde, after everyone else had been exhausted by its vacuity. On 2 January 1890, the following appeared in *Truth*:

Dear Truth, Among your ruthless exposures of the shams of today, nothing, I confess, have I enjoyed with keener relish than your late tilt at that arch-impostor and pest of the period – the all-pervading plagiarist!

I learn, by the way, that in America he may, under the 'Law of 48' . . . be criminally prosecuted, incarcerated, and made to pick oakum as he has hitherto picked brains – and pockets!

How is it that, in your list of culprits, you omitted that fattest of offenders – our own Oscar? . . . [In] Mr Herbert Vivian's Reminiscences . . . among other entertaining anecdotes, is told at length the story of Oscar simulating the becoming pride of author, upon a certain evening, in the Club of the Academy students [Wilde's lecture at the Royal Academy in 1883], and arrogating to himself the responsibility of the lecture, with which, at his earnest prayer, I had in good fellowship crammed him, that he might not add deplorable failure to foolish appearance, in his anomalous position as art expounder, before his clear-headed audience.

He went forth, on that occasion, as my St John – but, forgetting that humility should be his chief characteristic, and unable to withstand the unaccustomed respect with which his utterances were received, he not only trifled with my shoe, but bolted with the latchet!

Mr Vivian, in his book, tells us, further on, that lately, in an article . . . Mr Wilde has deliberately and incautiously incorporated, 'without a word of comment', a portion of the well-remembered letter in which, after admitting his rare appreciation and amazing memory, I acknowledge that 'Oscar has the courage of the opinions – of others!' . . . I send him in the following little note, which I fancy you may think à propos to publish . . .

'Oscar, you have been down that area again I see! I had forgotten you, and so allowed your hair to grow over the sore place. And now, while I looked the other way, you have stolen your own scalp! and potted it in more of your pudding.

Labby [Henry Labouchere] has pointed out that, for the detected

plagiarist, there is still one way to self-respect (besides hanging himself, of course), and that is for him boldly to declare, Je prends mon bien là où je le trouve. You, Oscar, can go further, and with fresh effrontery, that will bring you the envy of all criminal confrères, unblushingly boast, 'Moi, je prends son bien là où je le trouve!'[11]

Oscar, outraged, quickly replied in a reasoned, more cleverly written letter:

> I can hardly imagine that the public are in the very smallest degree interested in the shrill shrieks of 'Plagiarism' that proceed from time to time out of the lips of silly vanity or incompetent mediocrity . . . The definition of a disciple as one who has the courage of the opinions of his master is really too old even for Mr Whistler to be allowed to claim it, and as for borrowing Mr Whistler's ideas about art, the only thoroughly original ideas I have ever heard him express have had reference to his own superiority over painters greater than himself.[12]

This was Wilde's final rebuttal. He never mentioned James's name again in public. Murdered in *The Picture of Dorian Gray*, he no longer existed, nor was his memory of any importance. Wilde had other more profound problems and the coming decade would see public destruction on a scale that James could never have imagined. James, as always, had to have the last word on the matter and sent another letter to *Truth* a week or so later presenting witnesses to substantiate his allegations against Wilde. Wilde's answer was his silence.

Early in February 1890, after toying with the idea of moving to Paris and of Mallarmé even finding a house for them there, James and Beatrice moved to 21 Cheyne Walk, a short distance down the Embankment from Battersea Bridge. Their new house was on four floors, with a large garden at the rear, and wonderful views across the Thames.

About now Ford had taken his manuscript to the Leadenhall Press who, after setting the text, heard of James's opposition to the publication and quickly withdrew from the contract.[13] Ford then took the manuscript to Antwerp believing that there it would be out of James's reach. It was in Antwerp, at the suggestion of the printer, M. Kohler, that the somewhat dull and predictable title, *The Correspondence of James McNeill Whistler*, was altered to a more colourful form of words drawn from the introductory text: 'This collection . . . illustrates the gentle art of making enemies.' Almost immediately, James despatched his solicitor, Sir George Lewis, to Antwerp to seek an injunction. Realizing that the law was hot on his heels,

Ford took the manuscript to Ghent where he succeeded in having it type-set. From Ghent he took the printed pages to Paris, where several thousand copies were bound and published. The remainder were despatched to the New York publishers, Frederick Stokes and Brother. In both Ghent and Paris, Ford was interrupted by the arrival of Lewis. It was proving a hectic time for him and an increasingly expensive one for James.

As the chase developed, taking on comical proportions, it was not long before the press caught hold of the story. A telegram from James to his publisher William Heinemann, dated 30 April 1890, spoke of the booksellers, Hatchards in Piccadilly, selling 300 copies of the pirated edition. James was frantically engaged in completing the material for his own version. The Pennells recalled something of the activity which surrounded the young William Heinemann:

> [James] arrived at eleven, when the businessman had hardly got into the swing of the morning's work, and carried him off to the Savoy whether he would or no . . . there they could go over, discuss, change and arrange every little detail without interruption. Hours were spent often in the 'arranging' of a single Butterfly . . . Whistler was constantly at the Ballantyne Press . . . he chose the type, he spaced the text, he placed the Butterflies, each of which he designed especially to convey a special meaning. They danced, laughed, mocked, stung, defied, triumphed, drooped wings over the farthing damages, spread them to fly across the Channel . . . He designed the title-page, a design contrary to all established rules, but with the charm, the balance, the harmony, the touch of personality he gave to everything, and since copied and prostituted by foolish imitators who had no conception of its purpose.[14]

James vastly expanded Ford's title and the final form read: *The Gentle Art of Making Enemies: As pleasingly Exemplified in Many Instances, Wherein the Serious Ones of the Earth, Carefully exasperated, Have Been Prettily spurred on to Unseemliness and Indiscretion, While Overcome by an Undue Sense of Right.*

Ford's own dedication, which undoubtedly reflected his personal experience of the whole saga, read: 'To all good comrades who like a Fair Field and No Quarter These Pages are Peacefully Inscribed'. James retorted with this version: 'To the Rare Few, who Early in Life Have Rid Themselves of the Friendship of Many, These Pathetic Papers are Inscribed'.

The first edition of the book was simultaneously published in London and New York in mid-June. The 292 pages are essentially a carefully selected and edited view of James's contentious career. It provides glimpses

of adverse criticism directed towards his work; records personal quarrels conducted in public and artistic statements such as the 'Propositions' and the 'Ten O'Clock' lecture and – what James considered its most important component – reproduces evidence from the Ruskin libel trial of 1878. As the Pennells observed some years later: 'The book is really an artistic autobiography. Where Whistler gave the sub-title Auto-biographical to one section, he might have given it to the volume. He had a way, half-laughing, half-serious, of calling it his bible. "Well, you know, you have only to look and there it all is in the Bible".'[15]

The amount of time and energy James devoted to the publication underlines the importance he attached to it. This was no simple gathering of personal recollections and quarrels, it was an extension of his artistic persona, an arrangement in 'Black and White', carefully designed to complement his lifelong battle against ignorance and prejudice. In this respect *The Gentle Art of Making Enemies* was essentially an English book, aimed specifically at an English audience. James bothered to have it published in the United States on purely commercial grounds; and it was certainly never intended for a European audience, least of all a French one.[16]

Predictably, critical reaction to the book was mixed. The *Saturday Review* believed that James was 'acting like a clown', though the reviewer nevertheless acknowledged that beneath the façade lay 'the profound convictions of an artist'.[17] The *Pall Mall Gazette* followed a similar line, noting that amongst the multitude of personal, charming and humorous chaff, there was a 'bit of wheat'.[18] Among those friends he gave copies to, Mallarmé thought it 'enchanting',[19] and Théodore Duret wrote to say he had 'thoroughly enjoyed it'.[20] No verdict, however, is recorded from Degas who received a copy inscribed with the message, 'A Degas – charmant Enemy – meilleur ami'.[21]

The compiling and production of the book effectively put an end to any studio work for nearly six months. Years later Walter Sickert, lamenting these diversions, would write: 'for the collected quarrels the studio was needs let out for months at a time, to the benefit maybe of booksellers, but at an irreparable loss to art.'[22] James did find time, however, to arrange to send two paintings to the Paris Salon, his first submission since being made a Chevalier. His choice of work is revealing: *Nocturne in Blue and Gold: Valparaiso Bay*, recently bought at public auction by Alexander Ionides, and *Nocturne: Black and Gold – the Fire Wheel*, recently bought back by himself from Algernon Graves, the son and partner of Henry Graves who ran a print gallery on the Fulham Road and was the founder of the *Art Journal* and the *Illustrated London News*. Graves had held the painting for many years

as security against a loan. These two pictures, one nearly twenty-five years and the other at least eighteen years old, seem on the face of it an odd choice. In fact, it was, as always, a calculated gesture. As a Chevalier, his work was virtually guaranteed acceptance, and in all his years of submitting to the Salon he had never sent any of the Nocturnes.[23] Now, with his new status, he was safe to send the most controversial paintings of his career. According to Gustave Geffroy, writing in the *Revue d'aujourd'hui*, the paintings were well hung and well received by the critics and public alike.[24]

There was another distraction, which in retrospect would prove to be one of the most beneficial James ever had to endure. In March he made the acquaintance of a 34-year-old American collector, Charles Lang Freer. Possessing the physical fragility of an older man, and a short, carefully clipped Vandyke beard that indicated his fastidious nature, Freer had followed a path typical of many American success stories. Of French Huguenot stock, he had left school at 14 to begin his working life as a clerk in a general store in Kingston, New York, which occupied the same building as the offices of the New York, Kingston and Syracuse Railroad. There he quickly caught the attention of the railroad manager, Colonel Frank J. Hecker who, impressed by Freer's diligence and honesty, soon hired the young man. In 1876, Hecker took him to Detroit to become assistant treasurer of the recently formed Peninsular Car Works, and before long he had made Freer a partner. It was the first major rolling-stock factory in the whole of the Mid-West, and as the demand for freight rose, so did the profits of the company. By 1890 Freer was an extremely wealthy young man.

Freer seems to have started collecting art in earnest, specifically prints, in the mid-1880s. Prints not only appealed to his precise nature, but were easily accessible and generally inexpensive. Assisted by the New York art dealer, Frederick Keppel, he amassed a considerable collection which included works by Dürer and Rembrandt, and a selection of the European 'painter-etchers' then in vogue such as Félix Bracquemond.[25] At Keppel's gallery in Union Square, probably in 1887, he was introduced to another collector, a wealthy young lawyer called Howard Mansfield who, according to Keppel, possessed 'as good an eye for a print as anyone who comes here'. Mansfield had been collecting Whistler prints for some time, and after an evening displaying his collection to Freer, who had been sceptical about Whistler's talent, the latter became a convert. By the time Freer met James in March 1890, he had already purchased more than eighty etchings, and nine lithographs. A watercolour, *Grey and Silver: The Mersey*, had been bought at Wunderlich's in New York, in 1889. At their first meeting, James immediately warmed to the young American. His enthusiasm was

infectious, and his railroad background, reminiscent of James's own, seemed a good omen. After an evening of dinner and talk, they pledged to keep in contact. Unbeknown to James, he had just met his greatest and most generous collector.[26]

With *The Gentle Art of Making Enemies* out of the way by mid-June, James returned to painting with some vigour. His attention now focused on portraiture, and he almost certainly returned to one he had begun nearly two years before of his sister-in-law, Ethel Philip. Not long after, he received a commission from an American, Edward W. Hooper of Boston, to paint a portrait of his eldest daughter, Ellen. James, it seems, had made Hooper's acquaintance when the latter had bought a painting from him many years before entitled *Interior*.[27] Hooper's instructions to James were precise and to the point: he wanted James 'to make for me a "note" of my eldest daughter – a red haired girl about seventeen years old . . . [we] shall be in London only two weeks more, and my daughter is not very strong so that it will not be possible to have more than ten sittings of about an hour each.'[28] James, not normally amenable to command, jumped at the chance, and the next day sent a telegram to confirm the time and date of the first sitting.[29] Not only was it a timely opportunity to earn some badly needed money, particularly after the legal costs incurred over *The Gentle Art of Making Enemies*, but it offered him the chance to break into the lucrative portrait market again, especially for rich Americans.

Predictably the sittings took longer than planned. According to Ellen Hooper, she sat for James on about twenty occasions amounting to some sixty hours.[30] The sittings took place in James's south-facing studio at Cheyne Walk, always in the company of her father. James apparently talked little and 'gave the impression of intense concentration'.[31] The final result is one of his most unusual portraits. The model, wearing a dress made by a relative in Japan of Japanese linen, sits on a chair which the viewer cannot see, holding a Japanese fan in her hands. Despite the accessories, however, the portrait remains quintessentially Victorian. It is as though James, desperate to please, reverted to conventional methods. Completed towards the end of September, neither the sitter nor her father thought the portrait a good likeness. Nevertheless, they were obviously pleased with the result since a few weeks later James received a cheque from Boston for 100 guineas.[32]

Hot on the heels of the Hooper portrait, James began work on two other commissions in the autumn of 1890. The first, a portrait of Lilian Woaks, was almost certainly engineered by James's brother William, through his friendship with the sitter's father, E.G. Woaks, a Harley Street physician. Again, the sittings stretched from the suggested three to twenty-five, and it

was not until nearly a year later that the portrait was finally handed over to the owners. For reasons not altogether clear, James was never happy with the result and several years later when he spoke to Beatrice about works that should be touched up, or even destroyed, he included amongst them the 'little Woaks'.[33] Whatever his reservations, the portrait of Lilian Woaks is one of the most direct and beautiful of his later works.

Almost concurrently, he was engaged to paint Amy Brandon Thomas, the 6-month-old daughter of his friend, the playwright Brandon Thomas, author of *Charley's Aunt*. Amy was probably one of the youngest sitters James ever encountered, and the painting, now unfortunately lost and known only through photographs, recalls the delicacy he displayed many years before when drawing the little pencil portrait of his niece, Annie Haden, in 1848. According to one source, after the initial sitting the work was left unfinished, and when the baby was brought back to complete the portrait several months later, the little girl he had previously seen had completely changed. James apparently told her mother that he 'wanted the one he had before', and with that he dismissed them both![34]

James's preoccupation with portraits during this period also signalled a renewed interest in drawing – particularly the human figure. Beatrice undoubtedly played an important part in this; she was a talented artist in her own right, as drawings by her in the Rosalind Birnie Philip Collection, Glasgow University, show. Their mutual interest is clear in chalk drawings such as *A Woman Wearing a Chiton and Cap* by Beatrice, which closely resembles James's *A Woman Holding a Pot*, both it seems dating from the same period.[35]

Another renewed interest was lithography. The medium was, of course, no novelty to James: he was aware of its possibilities as early as his West Point days. During his early years in Paris, however, he shunned the medium despite the fact that friends such as Manet, encouraged by Cadart, were using it as early as 1862, and continued to do so for the rest of their careers.[36] Fantin-Latour had used the medium as early as 1863,[37] though it was not until the late 1870s that he began to adopt it in earnest.

Lithography is based on the chemical fact that grease and water do not mix. An image is drawn on to a prepared surface – usually limestone – with a greasy crayon or lithographic ink (tusche). After this the surface of the stone is treated to make the areas touched by the crayon receptive to the printer's ink, while areas left blank are kept moist, thus ensuring they repel the ink during printing. Up till the 1870s most, if not all, lithographic drawings had to be done directly on to the lithographic stone, but by that decade the technology required for transfer lithography had been sufficiently developed for widespread use. Now, the artist could make his

drawing on specially coated paper with a special ink or crayon and then transfer it to a lithographic stone, from which it would be printed as before. The effects of this new development were felt almost immediately. No special technical knowledge was required and, most important of all, the artist was no longer tied to the heavy stone throughout the whole process. Also, with the transfer method, the artist no longer had to make allowances for a reversed image. Now the image, while reversed when transferred from the paper to the stone, became after printing identical to the original drawing.

Alfred Robaut, one of the most important lithographers in France, encouraged Corot to work in the medium and the result was a set of a dozen transfer lithographs issued in 1873 entitled *Douze Croquis et dessins originaux*. Their publication marked the beginning of the lithography revival in France, which many of James's friends saw not so much as a development in printmaking, but primarily as 'a vehicle for the multiplication of drawings'.[38]

Although he was certainly aware of these new developments, James at first appeared to take little interest in them. It was not until he met the brilliant London lithographic printer, Thomas Way, in the summer of 1878, through an introduction made by Edward Godwin, that he seriously began to consider lithography as an artistic, and commercially feasible, alternative to etching.[39] Way and James hit it off immediately, and the former's enthusiasm for the medium, together with his technical brilliance, made him the ideal teacher. Within a year James had made about a dozen images which he was hoping to publish under the collective title *Art Notes*. The venture failed to materialize, primarily because the demand did not exist. Two, however, *The Toilet* and *The Broad Bridge*, appeared in the magazine *Piccadilly* owned by Swinburne's keeper, Theodore Watts-Dunton. Unfortunately the magazine folded shortly afterwards. James experimented under the watchful eye of Way, producing six lithotints, achieved by applying washes of diluted lithographic crayon over a lithograph, by pen or brush, to achieve an effect not dissimilar to watercolour wash. However, the lack of interest in *Art Notes* appeared to bring to an end this burst of enthusiasm for lithography.

In 1888, after a break of nearly ten years, he returned to the medium with a series of lithographs depicting London buildings mainly in and around Chelsea. This first series, numbering nine in all, are if anything simply an extension of his etching. Architectural aspects of shops, houses or churches are selected and then combined (usually) with some fleeting human interest. The work is dominated by light, spontaneous touches and economy of means. In these lithographs, as with all his later ones, James

used the transfer method, and again Thomas Way undertook the printing at his premises at 21 Wellington Road. In late 1890, Herbert Vivian, who caused such a stir with his *Reminiscences,* launched a satirical magazine called the *Whirlwind,* to which James contributed two lithographs, similar in style and subject to his 1888 work, entitled *The Tyresmith* and *Maunder's Fish Shop, Chelsea.*

James then abandoned architecture and turned to the human figure. Ethel Philip, his most consistent model, featured in two delicately drawn studies: a three-quarter portrait, sitting on a chair, called *The Winged Hat,* and a standing figure *Gants de suède,* which is related in pose to his most successful portrait of her, *Red and Black: The Fan,* started slightly later the following year. From these somewhat austere beginnings, James quickly moved to a subject that had absorbed his interest for most of his career – the depiction of the female nude. Lithography, soft and versatile, was ideal, on a par with pastel both in the nuances obtainable and in its handling. In comparison to his French contemporaries such as Degas, James's studies of the nude were always more delicate and subtle. In *The Purple Hat (A Note in Green and Violet)* the figure is clad only in transparent drapery which allows tantalizing glimpses of the shapely legs, breasts and groin. It is one of his most erotic images.

Throughout the remainder of 1890, James started and perhaps finished at least thirteen lithographs. All the subjects were nude women, and all involved drapery and pose. Concurrently, in pastel, he worked on female images drawn from literature and Greco-Roman mythology, as in the beautifully alluring figure of *Venus Astarte.*[40] The models he used were the Pettigrews: Harriet ('Hetty'), Rose and Lilian ('Lily'). These three beautiful sisters, from a family of thirteen children, had been brought to London by their mother to work as models. James seems to have known Rose from at least 1884, the year she posed for Millais' painting *An Idyll of 1745.* Later they would pose for a succession of artists – Poynter, Leighton, Hunt, Val Prinsep, Sickert, Steer, Sargent and Roussel. James certainly etched one of the Pettigrew children, though which one, and when, remains unclear.[41] Like so many others, James loved their irascible and down-to-earth temperament. They were splendid models: relaxed and reliable, and often more than a match for James. According to Rose, whose manuscript memoirs are now in Glasgow University Library, Hetty of them all was his equal when it came to a verbal contest:

> he admired her, and was very amused by her cleverly cruel sayings, even when it was against himself. He was an exceedingly mean man, paying his accounts as rarely as he dared, and cutting down as much as he could: he

hadn't paid Hetty for some time, so she waited until he was in the middle of an important painting of her and demanded her money and refused to pose again unless she had her money. We never, never posed under half a guinea a day, which was a big sum of money . . . So she handed him an account for the month. 'Oh! Hetty dear, that is too much,' Whistler said. Hetty looked at him with a little sneer and said, 'I'm so sorry, I'd quite forgotten you were one of the seven and sixpenny men.' Hetty said Whistler laughed until his white lock shook but from that day she got her half guinea.[42]

For nearly eighteen months the three Pettigrew girls became almost an integral part of the Whistler household. Rose, in particular, was a frequent visitor and she adored Beatrice. Nearly half a century later she recalled her with affection: 'The wife I really loved was the real one . . . I adored her and admired her very much; she was exceedingly pretty, a bit on the plump side, and much taller than Whistler; she adored her dear Jimmy. She sang beautifully, and gave me my first singing lesson.'[43]

Before 1890 was out, with the help of Thomas Way and his son Thomas junior, James began his first tentative experiments in colour lithography proper. The result was the aptly titled *Figure Study in Four Colours*. Printed in red, rose, bluish-green and black, only a few proofs were pulled. The laborious process, which involved using four lithographic stones, precise settings and tonal blending, was often exasperating. In all, James only ever completed seven colour lithographs, and as no proper edition was ever printed, they are extremely rare. Colour lithography was then in its infancy, and its supporters were trying to shake off adverse associations with the almost wholly commercially orientated chromolithography, a purely reproductive process without the inherently expressive possibilities of colour lithography. The ensuing debate proved bitter and prolonged, and divided the art world. As late as 1898, the Paris Salon still refused to accept any colour lithography in the print section.[44]

Of the artists who would make the most significant contribution in the medium, James followed closely behind Pierre Bonnard, who had made his first colour lithograph, *France Champagne*, in 1889 (it was not printed, however, until 1891); on the other hand James anticipated one of the most successful practitioners of all time, Henri de Toulouse-Lautrec. It is only when his work is set in this wider historical context that the full extent of James's achievement can be appreciated. Etching had absorbed him for over thirty-five years, during which time he had stretched the medium almost to its technical limit. Lithography now offered him the opportunity to start all over again. The challenge would occupy him over the next six years.

All this time James and Beatrice were leading a very busy social life. After the light of day had faded and the studio was shut up, the serious business of entertaining began. Their circle of friends, even by middle-class Victorian standards, was vast and covered virtually every sphere of professional life. For a quick trip to meet fellow artists in the past, James had often frequented the Hogarth Club or Solferino's restaurant in Rupert Street. Now, since his marriage, if he wanted to hear the latest gossip or generally talk shop, he tended to visit Manzoni's near Carlyle Square, or the Monaco restaurant or the Six Bells public house, both on the King's Road, not far from his house. He rarely walked anywhere. A four-wheel cab was hailed to take him to his destination and remained on station to take him home again.

Early in 1890, the studio of Stirling Lee, the sculptor, became the focal point for a group of artists. Whether James ever visited these unofficial soirees is not clear, but he certainly knew well many of those who attended, among them Theodore Roussel, Sickert and Fred Brown. In the autumn of 1890 twenty-two artists met at Lee's studio to discuss the possibility of a new local exhibiting society.[45] James was aware through the grapevine of plans for the new society and duly presented himself at the next meeting scheduled for 25 October. By all accounts, it was a lively gathering and at the end of the evening the emphasis had changed from the creation of an exhibiting society to the formation of a club. At one point during the boisterous discussion, an artist described as a 'Teutonic gentleman', and probably drunk, shouted from the floor that the group should rent a room at the Pier Hotel, which he unfortunately pronounced 'Bier'. At this point James rose and addressed the audience. 'Gentlemen,' he began, 'let us not start our club in a beer hotel – let us start our club clean.'[46]

This meeting marked the beginning of the history of the famous and often colourful Chelsea Arts Club. At the formal launch of the club in March 1891, James was elected chairman of the sub-committee concerned with house rules and membership. He carried out the duties with meticulous care and attention. For the next few years he regularly attended the club's premises, the ground floor and basement of James Christie's house at 181 King's Road. On 15 April, a month after its official inauguration, he even delivered a reprise of the 'Ten O'Clock' lecture to fifty-six members. In December, he introduced Monet. Writing later to thank James for his hospitality, Monet noted that he 'much enjoyed the club in Chelsea and appreciated the sympathy of the young artists'.[47]

23

A Question of Portraits

S IX WEEKS INTO the new year of 1891, James received a letter from Count Robert de Montesquiou asking him to undertake a portrait commission. Flattered by the invitation, he agreed immediately. Not only was it an opportunity to renew his acquaintanceship with this colourful Frenchman, but it would be his first major French commission since the Duret portrait of 1883. Montesquiou, like many of his French friends, fascinated James. As the model for Des Esseintes in Huysmans' *A Rebours* and for the Baron de Charlus in Proust's *A la Recherche du temps perdu*, Montesquiou was an infamous figure and noted habitué of fashionable Parisian society. Although a minor artist himself[1] and closely associated with many leading French artists, it was in his writing, particularly on Symbolist artists such as Gustave Moreau and Rodolphe Bresdin, that his real talent lay.

As James was pondering the logistics of the Montesquiou commission, he was also considering the implications of a letter he had received a month earlier from Edward Walton, one of the group of young artists known collectively as the Glasgow Boys, whom he had recently met. He asked James if the portrait of Thomas Carlyle was still for sale. If so, he and several other Scottish artists proposed to raise a subscription to buy it for the city of Glasgow.[2] That James should even consider such a proposition speaks volumes for the young men who were behind the idea. Like many others he had watched with growing interest this small but immensely talented group of painters, who included among their number James Guthrie, Joseph Crawhall, George Henry and John Lavery. Living outside the cultural sphere of London, these young painters looked to mainland Europe for their inspiration and found it in the *plein air* realism of painters

such as Millet, Frère, Bastien-Lepage, Maris and Israels. The attraction of James lay not only in his careful selection of detail, and the decorative aspects of his work; equally important was his attitude and the radical approach to art itself which set him apart from the rest. James was a rebel; the epitome of everything modern in art. As one writer has observed, these factors made him 'a demi-god in the eyes of the Boys'.³ The year before, at the international exhibition in Munich of 1890, the Glasgow Boys had shown some sixty paintings and drawings which were enthusiastically received by the critics. They had been showing at the New English Art Club since 1887 and had also held a successful exhibition of their work at the Grosvenor Gallery. Their collective force, their distinctly unEnglish art and outlook, ensured a sympathetic reaction from James.

His quick confirmation to Walton that the painting was now for sale also underlines a change in his own attitude. In 1884, when the painting had last been in Scotland, at the Royal Scottish Academy in Edinburgh in an exhibition of Scottish historical portraits, a petition had been raised to buy the painting for that city. When nearing its target of 500 guineas, James heard that amongst the subscribers were certain individuals who did not share his own views on art. Who exactly these people were cannot be ascertained, but James quickly telegraphed the organizers with his objection, and announced with characteristic glee that 'The price of the *Carlyle* has advanced to one thousand guineas. Dinna hear the bagpipes?'⁴ With that, the project was quickly abandoned. The Glasgow Boys, however, were a totally different proposition. He respected their work and, more to the point, warmed to their avowed admiration. The fact that the group had produced a full-page reproduction of the portrait in their magazine, the *Scottish Art Review* in August 1889, assuredly helped their case now. Moreover, they had chosen exactly the right moment to approach James. Bolstered by the awards he had received on mainland Europe, his attitude towards the 'English' was hardening, and would continue to do so for the rest of his life. As he would write to one dealer several years later, 'I will let things of mine go to Scotland – or to Ireland or America – I want no picture or drawings in England –'⁵ Privately, of course, he desperately wanted recognition in the country where he had lived most of his adult life, but in 1891 it still seemed a long way off. Scotland, however, was different. Not only did he lay claim to Scottish ancestry on his mother's side, through the McNeills of Barra, but he had now strengthened that link with his marriage to Beatrice. The sale of the *Carlyle* to Glasgow seemed the right and obvious choice.

The petition for the subscription was written by Walton. If James had entertained any doubts, this public statement would have dissolved them

immediately: 'the celebrated portrait of Thomas Carlyle by James McNeill Whistler [was] regarded by Carlyle as the most successful portrait of himself. Not only is the subject of this picture one that appeals strongly to all Scotchmen, but the masterly execution, the dignity, and the simplicity rank it among the noblest works of art of our time.'[6]

After quickly securing the painting from his creditor, the dealer Henry Graves, with a payment of £200 towards the balance of £435 owed, James wrote to Walton to discuss the price, subtly increasing it from the £1,000 asked at the International Exhibition of 1888, to 1,000 guineas.[7] On 27 February, Walton and Guthrie addressed the Art Gallery Committee of Glasgow Corporation, which agreed that an attempt to secure the painting within the 1,000 guinea limit should be made. James refused to budge on his price and the city corporation then agreed to pay it.

Despite James's seeming intransigence over the matter of price, the issue meant little to him. Of much greater significance was the fact that this was the first time one of his paintings had entered a public collection. As he explained to Charles Lang Freer two years before, 'When a picture is purchased by the Louvre or the National Gallery, we can come and see it on the walls, but when a painting is bought by a private gentleman, it is, so to speak, withdrawn from circulation, and public fame is missing from the story of the painter's reputation.'[8]

As the Glasgow dealings were coming to a close, Montesquiou arrived in London incognito, in typically eccentric fashion, to begin the sittings for his portrait. In all, he sat for James on some seventeen occasions throughout a four-week period.[9] Originally two portraits were begun, but only one, it appears, was continued: *Arrangement in Black and Gold*.[10] The format of the painting is roughly the same as the portrait of Duret and the earlier portrait of Frederick Leyland. But whereas both Duret and Leyland are firmly attached to the space that supports and envelops them, Montesquiou poses less easily in an ill-defined space, staring directly at the viewer in an almost challenging manner. While the exact chronology of the painting is far from certain and complete, one may assume that the seventeen sittings did not produce a great deal of progress before a viral type of flu caught by James early in May put paid to further work. By the time he had recovered, Montesquiou had vanished. For several weeks, while he slowly regained his strength, James took things easily. He worked on several lithographs and, when the mood caught his fancy and circumstances allowed, resumed work on the portrait of his sister-in-law, Ethel Philip.

Other preoccupations during the early summer included the forthcoming case against Sheridan Ford, scheduled to be heard in Antwerp

in the autumn. Fastidious to the point of distraction, James demanded many meetings with his long-suffering solicitor, George Lewis, to discuss the forthcoming 'battle' – which by now everyone else had forgotten. Of greater importance were his two submissions to the inaugural exhibition of the Société Nationale des Beaux-Arts, an alternative to the official Salon, which was to be held in May. For this James chose two works, *Crepuscule in Flesh Colour and Green: Valparaiso* and *Arrangement in Brown and Gold: Portrait of Miss Rosa Corder*. Both these paintings had been purchased by W. Graham Robertson in November 1890 at Christie's at the sale of the effects of the recently deceased Charles Augustus Howell. According to Robertson, he had been alerted to the sale by the actress Ellen Terry. 'Howell is *really* dead *this* time!' she wrote; 'Do go to Christie's and see what turns up."¹¹ Shortly afterwards James, on hearing the news that Robertson had bought the two paintings, wrote to him asking to see them 'hanging on your walls and . . . to know the collector who so far ventures to brave popular prejudice in this country'.¹² After looking at the paintings, James turned to Robertson:

> He [Howell] was really wonderful you know . . . You couldn't keep anything from him and you always did exactly as he told you. That picture [pointing to the *Rosa Corder*] is, I firmly believe, the only thing he ever paid for in his life: I was amazed when I got the cheque, and I only remembered some months afterwards that he had paid me out of my own money which I had lent to him the week before.¹³

Blithely ignoring any protests from the paintings' new owner, James immediately assumed responsibility for the well-being of Robertson's new pictures and undertook to supervise their revarnishing.¹⁴

With the two paintings safely despatched to Paris, James now set his sights on visiting the city. He was keen to continue with Montesquiou's portrait, and he was also anxious to work on some lithographic drawings in order to compile a set for publication. Above all, however, he was anxious to renew his friendship with Mallarmé and other friends, particularly after hearing of Oscar Wilde's visit earlier in the winter. The fact that Wilde had had, in James's eyes, the audacity to introduce himself to Mallarmé as a Symbolist poet, and had presented him with a copy of *The Picture of Dorian Gray*, was almost unbearable. The irony of Wilde's gesture in presenting one of James's closest friends with the story of his death was in all likelihood unsuspected by Mallarmé.

Wilde unnerved James. Mallarmé, true to his kindly disposition, played down the significance of Wilde's visit, but James had yet to be convinced.

He arrived in Paris on 11 June, for the first time since his marriage travelling alone. After booking into the Hôtel du Helder early in the morning, he sat down and wrote the first of many letters to his wife, packed full of gossip, atmosphere and opinions, love and devotion:

Chinkie – my own dear sweet Chinkie – I am talking to you Chinkie – at breakfast – by myself – I think I must get a little black book and talk to you on the leaves from time to time during the day as I go on – so that you will hear from me at different places ... When I arrived this morning I sent straight off to [Alfred] Stevens. But after my bath – yes I knew that bath would at last happen – and of course the coiffeur's – I came away from the coiffeurs completely wonderful! – after all this I found a note from poor old Stevens regretting that he could not breakfast with me...[15]

[Later in the day James continued his letter:] I could not resist walking through Durand-Ruel's – and there I saw again the horrible 'lampoon' of Chase's [a portrait of James by the American-born artist William Merritt Chase, now in the Metropolitan Museum, New York] – Shocking – I told them so – The place for the first time seems so full of people! The young son tells me that all Americans go there – I shall see what I shall say to him about my possible exhibition but I shall be careful – Oh! but Renoir! There is a little room full of Renoirs. You have no idea! – I *don't know* what has happened to the eyes of everybody – The things are simply *childish* and a Degas absolutely shameful!! – If you were with me the two Wams [James's reference to himself and Beatrice] would hold each others hands as they thought of the beautiful Rosie's and Hettie's [the Pettigrew sisters] in the little drawer in the sofa!! Take care of them Trixie – take the two drawers, just as they are, and carry them upstairs – don't let them be shaken, and cover them over with a little drapery and wait till I come back – We have no idea how precious they are! – I don't seem to be in any hurry to bother about Montesquiou – but doubtless I shall go out to him tomorrow or the day after – I shan't stay many days – but I shall try and get at Mallarmé ... Paris is lovely – !! – We must come here directly.[16]

Later that day James visited the Exposition Internationale des Beaux-Arts at the Champ de Mars. In his characteristically scathing fashion he promptly reported to Beatrice the full horror of what he saw:

Well you cannot imagine it. – Bad – so jolly bad! ... I don't believe that in London we would notice it so much, simply because there nothing is of *any* quality whatever – there everything is absolutely beneath notice and cannot

even expect your contempt . . . but here the painters you are forced to look at – and they seem to be gone stark raving mad after the Bad!! – The Impressionist analines (I can't even spell it) seem to have been spilled over all the palettes – Even the man [William Turner] Dannat, who, by the way is *right next* to the really *holy* Valparaiso has mauve and ultramarine running into the huge legs of his Spaniard – and, by the same token there is no B—— to be found anywhere [a likely reference to Berthe Morisot] – They must have got through with her – But beyond this, the *drawing* marvellous in its blatant badness! – The men seem to have thrown all tradition and discipline to the winds, in the crazy hope that something else will take its place – Sargent's *Boy* [*Portrait de jeune garçon*] that was supposed to be a masterpiece is *horrible!* – Boldini has some bad paintings and some hysterically *clever* pastels – but wildly out of drawing – My imitator Gandarini [Antonio de la Gandara], of course I fancy I see something in – but hope you wouldn't! – The Rosa Corder naturally is very austere and grand amongst these strange strugglings – but we have better – and Oh horrors it struck me suddenly that she looked short! I wonder . . .[17]

Such exaggerated descriptions were written solely for the benefit of Beatrice, to reassure and placate: to those concerned James would never have dared to express these opinions.

The following day, he met a very dejected and forlorn Stevens. For years, the old Belgian artist had felt frustrated by the system. Although he could be said to have done reasonably well for himself, he never lost an opportunity to bemoan his lot. James found Stevens eager to talk and they had a mutually enjoyable lunch full of gossip. It was no secret that Stevens admired James and was deeply impressed by his apparent, if misleading nonchalance. As they mulled over the past few years, the subject of exhibitions, particularly successful ones, was uppermost. The most recent had been Monet's exhibition at Durand-Ruel's in May, where he showed fifteen of his haystack paintings. The catalogue had been written by the Symbolist writer and critic Gustave Geffroy, and the show had been an enormous success. It was exactly the sort of breakthrough that James and Stevens aspired to.[18] They recalled the origins of Monet's new-found fame, in his joint exhibition with Rodin in 1889, and Stevens mooted the idea of himself and James staging a similar venture.

In the heat of the moment, James warmed to the plan, despite the fact – as he had earlier intimated to Beatrice – that he was keen to arrange his own show in Paris. But as Stevens enlarged on his ideas for them both, James was seduced. Later that day, barely able to contain his excitement, he wrote to Beatrice:

[Stevens] confided to me that the *one* thing left – the one great thing – & the *only* one would be a very very elegant little exhibition of Whistler and Stevens *alone*. More properly of course of Stevens and Whistler – Then came details – profound secrecy – very chic surroundings – Paris I insisted upon first, afterwards London Brussels, Munich or Berlin – Here at Petits – whom I am to see about it at once – I to arrange room – decoration etc. Stevens to see that we incur no expense – and share profits – Success to be stupendous! – The whole thing very choice – few works – say 25 apiece – but paintings in *perfect* condition – and then the Private Views ... He is greatly excited about it and guarantees or foresees all sorts of amazing things – In Brussels the King shall open the exhibition ... Then in Berlin I don't know what – and in London! fancy from our point of view what a shock! The accepted and the orthodox Stevens and the Black Pirate together! Neither admitting the society of others.

Don't you think it amazing? Well can't you see the pretty 'exposition' the Wams can bring together – with the Rosies and the Shells and the panels and the seapieces – We will really have to hold in our forces – I must hurry back to talk it all over. And now another thing Stevens is going with his daughter and in short what is left of his family to Honfleur – towards the end of July – and he assures me that it is the very most charming little garden of Brittany – sea, village and forest! and we must go together.[19]

The tone of Beatrice's reply from London did not, it seems, match the enthusiasm of her husband. His response was to play the matter down and continue to talk the potential up:

As to old Stevens, at least let him have the credit of his faith in my success, for I said nothing to him, notwithstanding the desire, about my intended exhibition – and it was his own proposition that we should have a show together – Do you know Chinkie I half believe it will all be for the best ... I saw Petit myself, and let him suppose that this idea originated from myself, as it was arranged I should do – He was capital about it and said that for us two he would do anything! and that we could make the conditions ourselves ... it shall be left as all things are to my dear Luck who can overrule them all.[20]

In between his dashing to and fro, James finally got down to work on Montesquiou's portrait. The sittings were sporadic, and Montesquiou was not to be relied on to turn up at the appointed hour. When he did manage to pose, James attacked the portrait with such ferocity and vigour that Montesquiou was left mentally and physically exhausted. Montesquiou

recounted the experience to Edmond and Jules Goncourt, who later recorded that

> For Whistler, the sketch is a positive onslaught on the canvas, one or two hours of fevered madness, from which the thing would emerge fully structured in its externals . . . and the sittings, long sittings where, most of the time, with his paintbrush held close to the canvas, the painter would not make the stroke he had at the tip of his brush, but would throw it aside and take another – and sometimes, in three hours, he would put only fifty or so strokes on to the canvas . . . each stroke, according to Whistler, lifting a veil from the glaze of the sketch. Oh! the sittings where it seemed to Montesquiou that Whistler was drawing his life from him with the fixity of his attention, was sucking something of individuality from him; and finally he felt so drained that he felt a sort of contraction of his whole being, and luckily one evening he had discovered a wine made with coca, which helped him recover from these terrible sittings![21]

It was a relief for James to be able to escape the city and visit Mallarmé at his country retreat outside Paris in a valley overlooking the Seine. Writing to Beatrice, James described the set-up:

> Mallarmé charming – a wonderful little cabin on the river where the little family eat soup . . . and dress in anything! Most hospitable and warm hearted they were and delighted to see me. – We drove over, Mallarmé and I, or rather he drove me in a tiny dog cart over to the great Château . . . Oh Chinkie you would have been enchanted – Of course we will go together over it all again – Simply beautiful of course – The lovely French architecture . . . and the rooms and halls and galleries in perfect condition – and the furniture from Louis XIII – XIV and XV to some of the most delightful sofas of the empire that you would have ever wanted to carry away.[22]

While there, James tactfully brought up the subject of Wilde, 'The Decadent Man' as he had now taken to describing him to Beatrice. Mallarmé, it seems, was not as dismissive of Wilde's appearance in Paris as James had expected although, as he reported to Beatrice, Mallarmé was 'greatly upset and said he would write at once and say that his own position in the matter is a disagreeable one – and that no more tardiness should be possible'.[23] Mallarmé, it seems, did not write to Wilde. The following day James returned briefly to Paris. After breakfasting with Montesquiou and 'endless talk', he went back to London, promising to return in September

to work on the portrait. Amongst the items in his suitcase was 'nearly three pounds worth of the most wonderful *transparent* lithographic paper such as old Way [his printer] never dreamed of!'[24]

While James's soul may have remained in Paris, his heart was certainly in London. The enforced break from Beatrice only reaffirmed his devotion to her, while at the same time it set an important precedent in their marriage. Given the correct and proper circumstances, he would be allowed to travel alone and work without her. For most of the remainder of the year James would spend more time away from Beatrice than with her.

On 21 July, James received a letter from the curator of the Walker Art Gallery in Liverpool inviting him to become a member of the executive selection committee for their forthcoming exhibition. Normally James would have been inclined to ignore such a request from a provincial gallery, but this was different. Not only did he know Liverpool well, but the Walker Gallery was generally considered to be the most important outside London. Its prestige and importance had been ensured by the chairman, Philip Rathbone, and the curator, Charles Dyall, who had launched an annual show based closely on the summer exhibition of the Royal Academy. James's associate, Percy Jacomb-Hood, recalls how it was organized:

> The chairman . . . always visited London with two or three of his Art com-mittee and the curator, a week or so before the artists were 'sending' to the Royal Academy. They then, as now, visited the studios and invited works of which they approved to be sent on, after the close of the summer exhibition in London, to their autumn Exhibition at Liverpool. These are collected by them, free of all cost and trouble to the artist, and packed, sent and hung in the Walker Gallery.[25]

While James had never sent to the exhibition, to serve on such an important committee was an honour he simply could not refuse; so with Beatrice's full approval, and forgoing the holiday in Honfleur with Stevens, he accepted the invitation. Arriving in Liverpool on 3 August, he found to his acute embarrassment that Arthur Melville, one of the Glasgow Boys, was also on the committee and also staying with Philip Rathbone. The embarrassment was caused by an incident which had taken place some time before concerning Sheridan Ford. However, he was soon able to report to Beatrice:

> I have just been talking to Melville - with whom all is straightened out – it had to be one thing or another – and it was absurd to stay all this while in

the same house on impossible relations – so we had it out – the Ford matter – to my complete satisfaction and that is all over – Now therefore he is restored to the usual amenities and we 'hang' peacefully together.[26]

The Liverpool experience, it must be said, brought out the most mischievous side of James's character: perhaps the irony of sleeping for a week in the same room that 'old Ruskin had when he stayed with the family'[27] played a part.

For the one room in the gallery of which James had complete charge, he chose works for which he felt a special affinity, supervising the decoration according to his own hard-and-fast beliefs. The *Liverpool Mercury* described the scene:

> On entering the small room No. 8 the spectator will find himself in a bijou gallery, which is one of the principal attractions of the exhibition, and has been personally arranged by Mr Whistler. The walls, carpet and potteries form a harmony of golden brown and green. The velarium or suspended curtain sheds a subdued light on the pictures, which cover a great variety of subjects, by some of our foremost men. In treatment some of them are what the uninitiated call slight and incomplete, but to the artist they will appeal as absolutely complete in essentials.[28]

Those pictures James did not care for were treated with disdain; the status of the artist concerned was simply no mitigation. Taking on more than his brief allowed, James decided to dedicate the largest room to members of the Royal Academy. Choosing the famed and eminently respected *Doctor* by Sir Luke Fildes for the place of honour, 'centre of line', he described the scene he had created to Beatrice:

> To begin with I made 'The Line' so low that the work of absurd impostors, in all its revolting details of ignorance, pretension and incapacity, may be leisurely examined with the utmost ease. In this way the absolute childishness of execution, the hopelessness of exploded technique, the poor doddering drawing, the ghastly colour, the total absence of all sense of 'picture', and the grotesque cheapness of the shocking befuddlement that takes its place, stand at last revealed to even the blind – but the British public may as well be told.[29]

Some years later a follower, Sidney Starr, explained James's arrangement more fully. After describing how Fildes's painting was set centre stage, Starr went on:

The picture showed a doctor watching a sick child. Around them he had grouped all the pictures he could find of dying people, convalescents, and the like, with a small still-life of medicine bottles which he was delighted to discover. Of course the hanging of this wall caused comment. 'But', as Whistler said, when with ill-concealed glee he related the story, 'I told them I wished to emphasize that particular school.'[30]

Despite the air of frivolity, there was a serious side to the proceedings. Out of etiquette, James initially decided against exhibiting his own work, but after some persuasion by Melville he decided to have *The Fur Jacket* sent up to Liverpool from the Goupil Gallery in London. As he himself reasoned, the season in London was more or less over by August, and the picture stood a better chance in Liverpool, where he hoped to sell it to the American Consul for £1,600. Despite both James's and Melville's optimism, the gamble failed. This was a blow as James desperately needed the money for the ever-mounting legal costs incurred by the Ford case. It was becoming crucial that he have a show which would earn some money, or at least create the basis for some future income. As time went on, the joint exhibition with Stevens looked less and less an option. Somehow and somewhere, he would have to find a gallery that would allow him to create the biggest and choicest show of his life. The format and content of such a venture would occupy him for the remainder of the summer.

As soon as he could, James left Liverpool for home. The experience had been fun, at least initially, but by the end of the week he was tired, restless and bored to death by the tedium of the proceedings. Back in Cheyne Walk, he resumed his normal day-to-day activities. After rising early, he saw to his correspondence and then fiddled around in the studio until lunch, which usually consisted of soup and bread, and was followed by a short siesta. On Mondays, some or all of the Pettigrew sisters arrived to sit for him, and he would work for hours on a delicate pastel.

Later in the summer an article sent to him from Paris cheered him up immensely. Written by the writer and art critic Gustave Geffroy, whom James had met through Théodore Duret a year or so before, it expressed the clearest perception yet of James's art within the Symbolist movement. Recalling his trip to England the previous autumn, Geffroy described in great detail the inherent mystery of the night as he sailed from Calais to Dover. Such images, 'eerie trails of brilliant dots, gold and silver dust, and creating, over and beyond reality, the trappings of a strange non-existent city', conjured up the art of James. Geffroy went on:

As the ferry made the final move towards the coast, to the sound of the paddles' last grinding, as the view broadened out and the light became brighter, I recalled so many lucid and dreamy transformations, so many expressive representations of things sunk in shadow and in silence, so many poems of fading light signed by the prestigious artist James McNeill Whistler... At the Salon in the Champ de Mars this year there is a Seascape [*Crepuscule in Flesh Colour and Green: Valparaiso*], a harbour in Valparaiso where the water and sky are in delicious accord, where light craft are celebrating long voyages and the sweet return to port... this Salon seascape, exhibited beside a portrait, leads me to Whistler's great portraits, which were confirmed by my first walk through London... unforgettable silhouettes loomed up in the middle of squares, at street corners, in the haloes of shop lights, under the smudged flames of the gas lights... A number of these figures live for ever on the canvases of Whistler, standing before dark backgrounds, in dense atmospheres... works of subtle psychology, such proud truthfulness, and such haughty strangeness.[31]

Geffroy's article was an important breakthrough for James. For the first time, his work was placed publicly within the Symbolist orbit. On a personal level he was enchanted by the piece, not least because it signified his seniority within the Parisian avant-garde. James had not forced his way into the Symbolist circle; his work had not changed. Mallarmé and Geffroy had perceived the link themselves and their praise put James firmly on a par with Monet and the other artists they championed. Oscar Wilde, despite his efforts, had yet to make this breakthrough.

Not since Duret's pioneering work some years before had James's name enjoyed so much currency in Paris. The time was now right for tapping possible sources of income. James determined not to let the opportunity pass by. A particular objective which he had been mulling over for some time, was the purchase of one of his major paintings by the French government. The idea that *The Painter's Mother* should be the candidate had been suggested some months before by the manager of the Goupil Gallery, David Croal Thomson, not long after the sale of the *Carlyle* to Glasgow. The campaign initiated by Monet in 1889 to raise a subscription to buy Manet's *Olympia* for the state, set the precedent. But such ventures ran the risk of failure and subsequent humiliation: it had taken nearly a year to raise the 20,000 francs required for the purchase of *Olympia* from Manet's widow. In his determination to avoid such a long-drawn-out affair, James set himself the task of ensuring that the French state itself would buy the painting from him.

This aspiration was on his mind as he prepared to go to Antwerp for his court case against Ford, before returning to Paris to work on Montesquiou's portrait. The late summer of 1891 was particularly hot, and his only finished work was an enchanting lithograph done in the open air and entitled *The Garden*. Such a scene must have been a regular occurrence during the heat of late August and September – friends sitting in the back garden of Cheyne Walk enjoying afternoon tea. The group included Walter Sickert and Sidney Starr, together with Mr and Mrs Brandon Thomas, Beatrice and her sister Ethel.

James travelled to Antwerp at the end of September without Beatrice who seems to have shared most people's view that the confrontation with Ford was a waste of precious time. After installing himself at the Hotel St Antonie, he wrote to Beatrice: 'The crossing was amazing – the old milk pond business – ah obi! not a ripple – Now Chinkie this must go on – and then we can be so delightfully at peace that wonderful works will come from our fingertips everyday.'[32]

The case against Ford was quickly won, and James was awarded 3,000 francs damages. Jubilant at the outcome, he attended a banquet in his honour given by his attorneys, Edmond Picard and Albert Maeterlinck, brother of the famous Symbolist poet and playwright, Maurice Maeterlinck. Within a day James was on his way back to Paris.

Meeting Mallarmé at a pavement café on the Boulevard des Capucines,[33] James asked whether it was possible that his mother's portrait might be considered by the Luxembourg. Later that evening James reported back to Beatrice: 'The Luxembourg is I really believe not that far off – for Proust is *no longer* the Ministre des Beaux Arts, but an intimate friend of Mallarmé holds that position – and the matter will be seen to at once!'[34]

James and Mallarmé visited the Goupil Gallery's Paris counterpart, Boussod et Valadon, and talked with the manager, Maurice Joyant, about the plan, and the idea that the painting should be exhibited at the gallery during the delicate discussions. Joyant agreed, and it was quickly arranged that the picture be shipped over from London. The next phase necessitated mustering public support. To this end, James approached Geffroy, who readily agreed to write an article in support of the purchase.

Meanwhile James became immersed in the fashionable Paris scene. He was a fellow dinner-guest, along with the decadent novelist and art critic Joris Karl Huysmans, champion of aestheticism and of James's art since 1883, at Madame Méry's, one of the most sought-after *salons* in Paris. The following day he met up with Stevens and broke the news that a joint exhibition would have to be postponed. Stevens' reaction was one of bitter disappointment.[35] Of his other artist friends he saw little. Monet was in

Giverny working on his poplar series, though James did meet Degas before the end of his stay.[36]

James did not appear at all enthusiastic to begin work again on the portrait of Montesquiou. Of greater importance to him at that moment was the progress of his lithography. The envisaged set of prints, *Songs on Stone*, which William Heinemann had pledged to publish, fulfilled two needs. On the one hand, it was to generate some badly needed income; while on the other it absorbed James's creative energy as he continued to experiment enthusiastically with the medium. He was working with the printer, Henry Belfont, at his studio on the rue Gaillon. As with the Ways in London, he was in awe of Belfont's skilled techniques, particularly his methods of transfer lithography. Keen to get the first set of prints to Heinemann in London, James spent most of his first few days in Paris working on some drawings. Explaining the technique to Beatrice, he wrote: 'I draw my sketch on paper, transfer it to the stone *myself*, bite it in and print it!! Well that is worth the journey ten times over, isn't it?'[37]

Eventually James met Montesquiou, and arrangements for more sittings were made. However, little was actually achieved. James began to realize that to stay in Paris much longer might prove embarrassing, since the campaign urging the official purchase of the portrait of his mother had now begun in earnest. Although he was in the thick of manoeuvres to secure the sale, he was anxious to distance himself from them publicly, so he returned to London to await the outcome.

24

A Most Successful Failure

N<small>O SOONER HAD</small> James arrived back in London in early November
1891, than Geffroy's article appeared in *Le Gaulois* on 4 November, an
emotional and impassioned plea for the state to acquire the picture of the
painter's mother. Its publication set in motion the prearranged plan of
action. Mallarmé approached his friend, Henri Roujon, the newly elected
Directeur des Beaux-Arts, to sound out the possibility.[1] Next Théodore
Duret, not knowing James's true feelings on the matter, suggested that a
public subscription should be raised. The answer to that was a definite no.
Still anxious that the painting should be bought, Duret then contacted
Roger Marx, a mutual friend of himself and James, and more importantly,
an influential figure in his capacity as Inspecteur Principal des Musées. The
arts bureaucracy was proving no obstacle, and the campaign now needed to
gain support in the all-important political arena. They quickly found a key
figure to help their cause, Georges Clemenceau, later to become the
country's prime minister. At his instigation the Minister of the Interior,
Léon Bourgeois, was persuaded to visit the gallery of Boussod et Valadon
and view the portrait for himself. His visit had the desired effect. A day
later, 20 November, the letter James had been waiting for so impatiently
finally arrived at Cheyne Walk. Writing with a hint of embarrassment,
Bourgeois explained that the only sum that could be offered was nominal,
though this was not any reflection on the painting.

Bearing in mind the precarious state of his finances, James was
unquestionably disappointed at the suggested price of 4,000 francs
(approximately £175). Had he waited for perhaps another year he could
have sold the picture for many times that amount to an American collector.

For him, however, the purchase by the French government was infinitely more important than any financial consideration. It was the most prestigious sale of his life. In comparison, even the Glasgow Corporation purchase of the *Carlyle* paled into insignificance. Then, he had been prepared to hold his ground over the price. But this was different. Not wishing to appear to respond with indecent haste, he bided his time for a few days before accepting the offer. His only precondition was that the painting went to the Luxembourg and was not consigned to some lesser gallery. His wish was granted, and the portrait was officially purchased by the French government on 27 November 1891. He wrote to Mallarmé, who had played such a central role in the proceedings: 'the honour of my picture being bought by the French government will show the recognition of my work in France in contrast to elsewhere and make up for past sufferings.'

As James was basking in his success and reading with glee the press reports that followed in its wake, his mind again focused on the urgent need for a major show of his work. As a dealer David Croal Thomson was aware of the commercial potential of such an exhibition. Moreover, it would enhance the reputation of the Goupil Gallery significantly, not only in London as against other dealers such as the Fine Art Society, but also in Paris against their two main rivals, Petit and Durand-Ruel. Compared with most of the London commercial galleries of the period, particularly those plush, over-decorated 'palaces' geared to the needs of Academicians and their aristocratic patrons, the Goupil was almost homelike. Divided into several rooms all of a modest size, it was intimate and inviting, and it was rare to find there the huge canvases which annually filled the Academy. Instead one saw small paintings arranged in the modest manner of a normal middle-class home. Dealers like Thomson had realized the potential of a new class of collectors which had entered the market from the mid-1870s. He along with others such as the Chenil and Carfax displayed, amongst the more traditional bread-and-butter paintings, an adventurous sprinkling of new 'modern' talent. In such an informal, welcoming setting, the prospective buyer was given a feeling of familiarity and direct accessibility. These dealers were crucial in creating a market for modern art, and they laid the foundations for a type of dealing which has changed very little in more than a century.

Such a gallery served James's purpose exactly. Throughout the latter part of November and the early part of December, he met Thomson frequently to discuss the proposed exhibition. He genuinely liked the dealer, and felt comfortable with him, and during their association over the past few years had come to trust his judgement. Moreover, he admired the adventurous

spirit with which he ran the Goupil Gallery. But even more importantly perhaps, Thomson – as well as being a moderately talented painter himself – was a writer by profession, and for some time had contributed to the influential magazine, the *Art Journal*. For his part, Thomson greatly admired James, particularly his swashbuckling manner when dealing with most aspects of 'officialdom'. He had been a little wary of him initially, and had made a special effort to carry out any dealings with him efficiently and with the minimum of fuss. He was liked by Beatrice, which was important. He never talked about money in her presence, and always treated her with great deference. Many years later, Thomson explained how he finally got James to agree on the format of the Goupil show, arguing that

> Your etchings are known to every collector, your pastels have been already exploited in Bond Street, while your works in lithography and watercolour will never command large enough markets to satisfy me and my gallery, therefore there only remain your pictures in oils ... let us now gather together your paintings and make a very big splash.[2]

Despite being his place of residence for most of his professional career, England was the only country of importance in Europe where James's work was still ignored by the establishment. Against the background of honours and awards from elsewhere, the time was right to launch a final bid for recognition. At the very least, he must have reasoned, such an event would perhaps shame the art establishment into making some official nod in his direction.

Shortly before Christmas 1891, James sent Thomson a list of the paintings he wanted to include in the show.[3] True to his stubborn nature in these matters, he proposed that the exhibition consist primarily of Nocturnes – the most criticized of all his work. These, he later declared, were to be supplemented by a small selection of etchings and lithographs, 'to group around the room'.[4] By the time Thomson had reasoned out his objections to this plan, in early January 1892, James had escaped to Paris to search out a studio and finish the portrait of Montesquiou. Again, for the moment, he travelled alone: Beatrice was to follow within the month. He had at last, it seems, persuaded her that Paris should be their home. Achieving such an agreement had been no mean feat. It must have been an extremely difficult decision for Beatrice to make. Not only did she feel uncomfortable in Paris, not speaking any French, but all her family and friends were in London.

James's decision to leave London at this critical juncture, with his forthcoming exhibition only weeks away, was quite out of character. But in

spite of the geographical distance he managed to keep almost total control of the forthcoming proceedings from his base at the Hôtel Foyot on the rue de Tournon. Only one concession, albeit a major one, was allowed to Thomson: he had finally succeeded in convincing James that to achieve their objective of a well-balanced and influential show they must include works besides the Nocturnes. For some weeks James fought against the idea, and as late as the end of February was still holding out:

> Portraits – Again I am not at all of the opinion that we do want any of them in this exhibition. Neither the Miss Alexander or the Corder – or any.
>
> Why not simply Nocturnes, – Seapieces and Chevalet painting – We are certainly not pretending to show a summed up collection of Whistler – It is a bad policy in my opinion to fire off such a lot of things at once.[5]

But Thomson's reasoning was sound. Until now, such general recognition as James had received had been for his portraiture; the Nocturnes and other works had been bought only by a small, though enlightened band of collectors. If, therefore, he wished to achieve wider acclaim in England, it was most likely to be for the portraits and for the spin-off of more commissions. With that important point conceded, the serious business of arranging the show could begin.

After some enquiries made on his behalf by Montesquiou, James hired a studio, which seemed the perfect place. Describing it to Beatrice, he wrote:

> Just fancy an enormous sort of mysterious palatial interior with parqueted floor, and windows going up to the roof as who should say with every effect dreamed of – from Rembrandt through to the daintiest of pastels! – all this and more within reach for 1100 francs – that is £44 a year! – of course we must have it.[6]

In the same letter it is clear that James was desperate that Beatrice should join him: 'When are you expected? I could get a little suite on the same floor, so the landlady says, for 12 francs a day . . . What do you think? But how long! – how long!' Beatrice, it seems, was not yet quite ready. She would arrive, but only in her own good time.

Left alone in London, she was quick to castigate him if she felt the situation demanded, especially when he seemed to be enjoying himself too much. Sometimes the news she sent from London was good: particularly so when it involved some income. One person who was beginning to supply the household with money was Charles Lang Freer, whom James had nicknamed 'The Detroit Freer'. Freer had been buying lithographs sent

to him by James; though so far spending only on a modest scale, he had already caught the Whistler bug. James could not yet guess at Freer's potential as a collector, and no reference is made to preferential treatment. Nevertheless, as the coming years would bear out, his decorum when dealing with him would eventually pay handsome dividends.

As their separation wore on, the tension between James and Beatrice increased. Perhaps the imminent prospect of moving to Paris was beginning to tell on her, and she would often take it out on him, as one of his replies indicates:

> How could you Trixie! Fancy hurling at the poor absent much betroubled mangler all this dreadful abuse across The Channel . . . How could you let the sun go down – when you know that unless everything in this world be changed he is always the same fondly devoted slave of his dear Luck. You know that away from you I am, whatever happens bored to death – and now of all times when I am wearied with entirely too much 'respectiveaux' – and enjoying nothing properly without you to the full . . . Are you sorry now? – Did I ever before let a day go without talking to you and sending you my love? And after all Chinkie you have not done so famously yourself – not that I wish to reproach you – for I am only too glad when the garçon brings me anything from you – even were it the sad scolding I got this morning.[7]

James, in fact, continued gaily with his hectic social round. Most of his spare time he spent in the company of Mallarmé and others of the circle. Sometimes he would meet up with his old friend Drouet, 'my little sculptor', and on one occasion he dined with the son of one of his earliest patrons, Ross Winans, the 'Baltimore mechanic' whom James was related to through the marriage of his half-brother, George. William Heinemann, his publisher, was also a visitor, anxious to see for himself the progress on the lithographs. After visiting Belfont's with James in the afternoon, he treated him to an evening at the Moulin Rouge. James found the famous theatre 'big and noisy and rowdy'[8] – at least that was how he described it to Beatrice. On another occasion a young girl turned up at the studio asking for work. Her name was Carmen, and James described her as 'A nice little Rosie . . . a tall bronze gold child – 13 – but long legs – Italian'.[9] James had no work for her at the moment, but she was destined to play an important role in his life in later years.

When work on the portrait was finally resumed, it was again sporadic. James found the necessity of arranging sittings to suit Montesquiou's social timetable infuriating: 'I am determined to go through with the whole

picture in one *perfect* final coating . . . Therefore I would only commence when I could be assured that we would be quite safe from further intrusion – Bon! That was agreed to – Thursday consequently went for nothing – a little tinkering at the hand.'[10]

Soon the painting became what he described as 'an eternal terror'.[11] Antonio de la Gandara stood in for Montesquiou and enabled James to 'put in the whole of the background and the tone of the figure'.[12] Later in the day, Montesquiou arrived. After some hectic hours of work, during which Gandara worked alongside him, also painting Montesquiou and almost certainly acting as a spur,[13] totally exhausted James was able to report to Beatrice that the picture looked 'superb'.[14] It was by no means finished, but at last there had been a breakthrough.

Late in January, James received notification that his previous award of Chevalier of the Legion d'honneur had been upgraded to the more prestigious Officier. He wrote to Beatrice:

> a knock at the door, and appears Mallarmé almost breathless with haste and excitement – poor fellow he got out of his bed to bring me the letter from Monsieur le Ministre and the Rosette!! The letter was on its way to London, when Roujon the Director of the Beaux Arts stopped it, sending it to Mallarmé . . . saying he had reserved for him the pleasure of being the first to bring the news 'au grand Whistler' . . . I can scarcely give you an idea of the importance of it here! They have no notion of it in England – or they pretend to ignore its full meaning or 'live it down' as usual – But here it is an enormous honour.[15]

Anxious that the news should be quickly announced in London, he urged Beatrice to get in touch with Charles Whibley, a young journalist and, conveniently, the current suitor of her sister, Ethel. 'Ask him if something might not be made out of the great worth and high esteem [in which] are held the honours which are being bestowed on the one for whom there was nothing but hostility, while this *last* struggle at the Burlington Bazaar place [the Royal Academy] shows how meretricious are the distinctions still withheld . . . and distributed among the foolish mediocrities by the Bourgeois who live in it . . .'[16]

A similar scathing line was taken when he wrote to his brother William enclosing a report of the award which had appeared in *Le Figaro*:

> after all these black and foolish years in London among the Pecksniffs and the Podsnaps with whom it is peopled, you can fancy the joyous change! – Amazing! Just think – To go and look at one's *own* picture hanging on the

walls of the Luxembourg! remembering how it was treated in England – to be met every where with deference and treated with respect and vast consideration – to be covered with distinction . . . and to know that all this is gall & bitterness and a tremendous slap in the face to the Academy and the rest! Really it is like a dream! a sort of fairy tale – well, well I think you know the Whistlers are bound to win.[17]

Such sentiments only served to reinforce James's appetite for his final showdown with the 'English' at the Goupil Gallery in London, and he was considerably fortified by the arrival of Beatrice, accompanied by her sister Ethel. All three took up residence at a small apartment on the rue de Tournon, from where James directed the most important exhibition of his life.

From the very beginning, he had been determined that the preparation of the exhibition should be kept secret. Its whole impact, he argued time and time again, would depend on the overall effect, which must be a surprise. He and Thomson would simply spring it on the great British public. Obsessed lest anyone should catch a notion of it, James continually warned Thomson to be on his guard. On one occasion he even went so far as to instruct the dealer to tell his framer/restorer Stephen Richards to be on the lookout for any journalists who might try to bluff their way into his Berners Street studio.[18]

Another crucial consideration was the timing. If, as Thomson explained, it were to be held in March, beginning either on the 12th or the 19th, it would coincide with 'the start of the London season, when the courts and parliament are in session'.[19] This could prove an important factor, Thomson argued, since 'the House of Commons will attend and perhaps be persuaded to buy a painting for the National Gallery'.[20] The alternative would be to open on 23 April, a week before the annual Royal Academy exhibition 'when the papers will be full of nominations'.[21] In the end James chose 19 March for the opening.

James's fastidiousness must at times have severely tested the normally placid and reasonable Thomson. When any new idea or development was communicated to Paris, James would send by return his considered, and usually contrary, opinion. The most contentious issues were to do with the design and content of the catalogue. Shortly after receiving the first paste-up, James returned it to Thomson, noting brusquely: 'The specimens you send will of course never do . . . Ask Houghton and Gunn to give you one of Mr Whistler's Invitation Cards to breakfast. That will give you the size and form of the card for the Private view – also the elegance, size and character of type – The *manner* of invitation of mine shall be quite different

from the usual thing.'[22] Interestingly, James seemed not to want to use his emblematic butterfly in the catalogue. But Thomson convinced him of the necessity and it finally appeared twice – on the cover prancing menacingly, and at the end in fleeting triumph.

Other constant worries were the availability of certain works and their condition. But by the first week in March the final format of the catalogue had been decided: it would follow the pattern set by the Venice Etchings catalogue of 1883, when each exhibit listed was followed by a derogatory press statement from the past concerning the work in question. This time, armed with the material collected for the publication of *The Gentle Art*, Ja(!)mes planned to make the quotations even more extensive. In its final, revised and amended version, the 31-page catalogue, bound in the customary brown paper covers, opens with the statement 'The Voice of A People'. The full text begins with a quotation from a speech by the Attorney-General at the Ruskin libel trial in 1878: 'I do not know when so much amusement has been afforded to the British public as by Mr Whistler's pictures.'

Some of the entries carry only one quotation, others three or four, while a painting such as the infamous *Falling Rocket* has seven, and the widely exhibited portrait of *Miss Cicely Alexander* fourteen. So up to date were his sources that one review, which had appeared in the *Glasgow Herald* on 3 March, caused the production of the catalogue to be halted so that it could be included. In the penultimate section entitled 'Résumé', which consists of seven carefully selected quotations, there are six damning statements from the English press, and then one of the many accolades he received from the French press when the portrait of his mother was being bought for the Luxembourg. In the last section, the 'Moral', his final sting is directed at the wanton hypocrisy of the English press. There he gleefully quoted the recent inaccuracies of the *Illustrated London News*: 'Modern *British*(!) art will now be represented in the National Gallery of the Luxembourg by one of the finest paintings due to the brush of an *English* (!) artist, namely, Mr Whistler's portrait of his mother.'

The final proof of the catalogue, unbeknown to James, was sent to the Goupil Gallery's solicitors: Thomson was not prepared to take any risks at this late stage and two small changes were then made, of which James, it seems, remained oblivious.[23] By the end of the week, some 2,800 invitations and 150 specially made press cards had been sent out, while at the same time dozens of posters announcing the exhibition were displayed throughout the West End, Chelsea and north London.

The question of which member of Parliament should be approached to persuade the government to make a purchase was secretly discussed.

SMALL COLLECTION

OF

NOCTURNES
MARINES & CHEVALET PIECES

BY

MR.. WHISTLER

THE GOUPIL GALLERIES

FOR

THREE WEEKS ONLY

Mᵉˢˢ BOUSSOD VALADON & Co
116 & 117 NEW BOND STREET

March 21 to April 9

Thomson suggested the obvious candidate – Cyril Flower (later Lord Battersea), who already owned a number of James's paintings. Other names mooted were Balfour and Gladstone himself. At the last moment a stroke of luck occurred. Glasgow Corporation, which had been exhibiting the portrait of Carlyle at the Victoria Exhibition in Regent Street, allowed the painting to be included after some persuasion on Thomson's part.

With this the show consisted of 44 oil paintings and an enlarged photograph of *The Painter's Mother*. There were 18 Nocturnes, 13 river/seascapes, 12 compositions which included figures, and a self-portrait which Thomson had to wrench from a reluctant James. Not one of the paintings was less than ten years old. The majority of them – the Nocturnes – came from the 1870s, along with several of the portraits; 16 came from the 1860s and 4 from the early 1880s. Most, if not all of the exhibits had been shown before, some on many occasions. Camille Pissarro for one thought the selection rather odd: 'It is so strange that he doesn't want to show his new canvases. Perhaps he hasn't any! For years now I have seen the same works again and again, even very early works! ... Why?'[24]

Two days before the show opened, James arrived in complete secrecy to oversee the hanging. In the larger of the two rooms used for the exhibition, he hung three of the major portraits – *Rosa Corder*, *Lady Archibald Campbell* and *The Fur Jacket*. Spaced between them were several of the smaller Nocturnes. Facing this wall was the large portrait of *Cicely Alexander*, flanked by two more Nocturnes, *Battersea Reach* and *Battersea Bridge*. The portrait of *Thomas Carlyle* occupied the third wall similarly flanked by Nocturnes, *Grey and Silver: Old Battersea Reach* owned by Madame Coronio, and *Blue and Gold: St Mark's, Venice* owned by Monsieur Gallimard.

In the other room were hung *Symphony in White, No. 3*, *Symphony in White, No. 1*, *Caprice in Purple and Gold – The Golden Screen* and *Harmony in Green and Rose – The Music Room*. Again, the rhythmic pattern was repeated and between these major works, evenly spaced and balanced, was hung the remainder of the exhibits. With his task completed, James quietly slipped away to await the arrival of Beatrice from Paris.

The exhibition opened in the morning of 19 March. During the first day, over 6,000 people filed into the gallery, amongst them 400 or so specially invited guests who received their free copy of the catalogue on production of their invitation. Neither James nor any member of his family attended the opening and years later Thomson explained why:

> he knew that many people would expect to see him and talk enthusiastic nonsense, and he rightly decided he was better to be away, and I was left

alone to receive the visitors ... Literally, crowds thronged the galleries all day, and it is quite impossible to describe the excitement produced. I do not know how it fared with the artist and his wife during the day, but about five o'clock in the evening Mr and Mrs Whistler came in, though they would not enter the exhibition – they remained in a curtained off portion of the gallery near the entrance. One or two of their most intimate friends were informed by me of the presence of the painter, and a smaller reception was held for a little while, but of course by that time the battle was over and won, and there were only congratulations to be rendered to the master.[25]

The following day James and Beatrice returned to Paris, but for the duration of the exhibition Thomson, on James's strict instructions, kept him fully informed of daily events. On 23 March, he wrote that the Duchess of Edinburgh, daughter-in-law of Queen Victoria, in the company of her own two daughters, had visited the show. According to Thomson, her parting remark to him was that 'they did not understand them one bit'.[26] At the same time Thomson informed James that Burne-Jones had spent some time in the gallery in the company of Walter Sickert and together they had carefully examined and discussed each exhibit. By the end of the first week, nearly 14,000 people had seen, or rather attempted to see, the exhibition; the small gallery was bursting at the seams all day, every day. In an effort to ease the pressure, they took the unprecedented step of extending the opening hours into the early evening.

A mixed review appeared in the *World*, one of his favourite periodicals, implying that, while the exhibition was 'important', nevertheless one missing element seemed to be James's old fighting spirit. In a letter to Thomson, James quickly rebutted any such suggestion: 'if I fight no more it is because the battle is won – the hatchet is buried, if you like, but "in the enemy's ribs" as I said – He has no more to do but to die – No further heed will be taken of his cries – The game is up – Rien ne va plus!'[27]

In the same letter, James raised the idea of a souvenir-type photograph album of the exhibition. Characteristically, Thomson was wary as to the legality of reproducing photographs of paintings which for the most part no longer belonged to the artist. James, however, was undeterred: 'My belief has always been that the copyright of any work of art *belongs always* to the artist, even after the sale of the work itself, until he sells it to the buyer with the *work* ... In this case photograph first and *fight* afterwards!'[28] His early optimism that the album might be completed before the end of the exhibition was misplaced, and nearly a year was to pass before the first albums were issued for general sale.[29]

In the meantime James was continually badgering Thomson for details of the day-to-day affairs of the show: who had visited; what had been said, and, of equal importance, who had not been to see it. In one letter in early April, he asked: '*Ruskin*. Did you send him by the way a book [catalogue]? You certainly ought to post him a season ticket at once! Anything droll to tell me about the others?'[30] John Ruskin, mentally ill and frail, did not attend.

As the show drew to its close in mid-April, it was clear that James's trust in Thomson had been fully justified. On 10 April, he expressed his thanks: 'I wish to express to you again, though in haste, how thoroughly pleased and highly satisfied I am with the manner of your management of this exhibition. Your letters have all been capital – and we shall keep them as a delightful souvenir of what has been such a perfect episode – in the general crusade against the Philistine! . . . The whole affair has been splendid!!!'[31]

The show had proved to be one of the most popular in London for many years, and set a record attendance for the Goupil which stood unbroken until 1911. (Ironically, the exhibition which broke the attendance record was the work of Walter Greaves, rediscovered by Thomson's successor at the Goupil, William Marchant.) On the final day, when Thomson shut the doors behind the last of the day's one thousand or so visitors – who had bought between them over 300 catalogues – the number of people who had viewed the exhibition had passed the 18,000 mark. It had been a remarkable achievement.

Critical reaction to the show was predictably mixed. Perhaps *The Times* best summed up the general feeling regarding the popular success of the exhibition: 'Mr Whistler is becoming the fashion, at least it is becoming the correct thing to do.' There were, of course, several laudatory articles, including one in the *Pall Mall Gazette* whose reviewer found the collection most 'distinguished' and noted that the time had long since passed in England when Whistler could be laughed at, for he 'is a serious and good artist'.[32] Many reviews, like the one which appeared in the *Echo*, took James to task for the flippant vindictiveness of the catalogue content. Vengeance is not justice, the reviewer contended, and while he admitted that James had more 'to forgive than most', nevertheless his method of tearing sentences from past reviews, 'like claptrap theatrical advertisements', was grossly unfair to critics who, like Frederick Wedmore, had done much over the years to state his case fairly to the public.[33]

The most significant review came from Walter Sickert, a lengthy one in the *Fortnightly Review* towards the end of the exhibition. In it Sickert expressed exasperation at the predictable reactions of the majority of English art critics:

A critic in the sixties or seventies spoke of the colour in *The Little White Girl* as generally grimy grey. Thirty years have really made little difference. Today the critic of the *Daily Chronicle* with *La Dame au brodequin jaune* staring him in the face, misses the collection at the Goupil . . . The *St James's Gazette* gravely fixes Whistler's best period – sixty to sixty-four. The art critic of *The Times* regrets that a man capable of painting the *Symphony in White, No. 3* should waste his time on comparatively unimportant titles like 'Nocturnes'. The *Daily News* writer mistakes a picture of a grey day for a Nocturne and speaks of conscientious labour as if it could only be manifested in the accumulation of detail. He is also apparently ignorant of the fact that the portrait of Mr Whistler's mother is unavailable for exhibition in London, not because it has been previously exhibited here, but because it hangs in the Luxembourg.

Why, Sickert argued, was his work hung in the Luxembourg and yet not represented in any national collection here? The work itself had not changed, though the public's perception of it obviously had. They flocked to see it, and collectors sought it out. What did the 'establishment' need to induce it to make some gesture of recognition? 'Let us, then, frankly face the facts,' he concluded: 'as a nation it has required these and a hundred purely commercial indications to convince us of truths which our eyes have not been sufficiently educated to perceive themselves.'

Sickert's pleas fell on deaf ears. The government was not persuaded to buy, nor for that matter was the Royal Academy induced to nominate James as a member. Despite the myth perpetuated by the Pennells and others over the following years, the Goupil show, while a popular success, was a professional failure. It did not achieve James's aim of official recognition. The 'establishment' was still not ready to forgive.

Even the immediate possibility of several portrait commissions was not, as has been held, a direct result of the show. One, from the Duke of Marlborough, which in the end failed to materialize, stemmed from a long-time acquaintanceship begun at the Beefsteak Club. The Duke was one of the very few people whom James had personally invited to the exhibition.[34] After the show had ended, the Duke wrote:

I am very glad to hear you are really coming to London for May. You will still find us in town [and we] will give you the time you require, especially the Duchess . . . [we] shall be home again at the end of August, and if you will come to us, and Mrs Whistler also, at Blenheim . . . we shall be alone then and we can all work like niggers. I will study 'The Gentle Art' . . . I have no doubt I shall have proved an apt pupil and a good sitter. Let

me know when you return. I will interview the estimable Thomson whom I much admire but greatly fear on account of his Scotch tenacity. You must stick to painting and give up writing letters about R.A's and A.R.A's.

Yours truly,
Marlborough[35]

James's reply to the Duke was uncharacteristically reflective and melancholic. He wondered how he had managed 'to stay so long in England'. Perhaps it was because 'I like "The Gentle Art of Making Enemies" . . . I enjoy the honours and my work being carried to the Louvre . . . I mean to stay in Paris and paint people. I leave London to the Herkomers, Holls and other H's [Haden].'[36]

The show left James physically and mentally exhausted and the idea of transferring it to Paris was now out of the question. The moment had passed, and moreover he was unsure how the Paris branch of Goupil's would deal with the organization; 'I felt it was hopeless as an undertaking,' he wrote to Thomson. There were now other things to consider, not least the second show of the Société Nationale des Beaux-Arts for which he had been elected a member of the jury. As an exhibitor, it was an event of great importance to him and he chose for it eight of the paintings which had been shown in London – though in the end he had to settle for six since Louis Huth, the owner of *Symphony in White, No. 3*, and Cyril Flower, the owner of *Caprice in Purple and Gold – The Golden Screen*, resolutely refused to co-operate any further.

On reflection, the Goupil show proved to be the final straw. The 'battle' in England had been lost. Feeling thoroughly fed up with British hypocrisy and indifference, James was convinced that henceforth he and Beatrice should make their base in Paris. Only personal tragedy was to bring him back.

Tragedy and Triumphs

25

Settling Down in Paris

A FTER THE OUTCOME of the Goupil show, Beatrice finally acquiesced in
James's desire to take up residence in Paris. She, like many other close
friends, now saw the uselessness of the situation in London. If James was
to sustain his trusted clientele, it would have to be in Paris, amongst friends
he admired and in an environment conducive to his work.

James had found a new studio at no. 86 rue Notre Dame des Champs.
Situated just north of the Boulevard du Montparnasse, the rue Notre Dame
des Champs contained more studios than any other street in Paris. James,
of course, knew the area well since it was here that Armstrong and the rest
of the 'English Gang' had had their studio many years before. The
Pennells, frequent visitors to Paris throughout the 1890s, described it in
some detail:

> The studio was a big bare room, the biggest studio Whistler ever had – a
> simple tone of rose on the walls; a lounge [sofa], a few chairs, a white-wood
> cabinet for the little drawings and prints and pastels; the blue screen with
> the river, the church, and the gold moon; two or three easels, nothing on
> them; rows and rows of canvases on the floor, all with their faces to the wall;
> in the further corner, a printing press – rather, a printing shop, with inks and
> papers on shelves; a little gallery above, a room or two opening off; a
> model's dressing-room under it; and in front, when you turned, the great
> studio window, with all Paris toward the Pantheon over the Luxembourg
> gardens. There was another little room, entrance-hall at the top of the stairs,
> and opposite, another, a sort of kitchen. On the front was a balcony with
> flowers.[1]

The famous restaurant at the end of the street, the Closerie des Lilas, was the setting for the *Vers et Prose* literary group which had Mallarmé at its head. Despite all its wonderful advantages, the studio did have one drawback. It was at the top of the building on the fourth floor. The concierge would cheerfully greet visitors searching for James's studio, 'You can't go any further than M. Vistlaire!'[2] As the years went by, the physical effort involved in climbing the seemingly interminable stairs was to become a significant matter.

The practical problems posed by the souvenir photographic album of the Goupil show continued to consume a great amount of his time. For most of the summer work on the portrait of Montesquiou went on as fitfully as before, and it was still unfinished by Christmas. Other commissions were sought, and via Thomson he received a request from Sir William Eden to paint his wife. In reply, James suggested that she should come to Paris and he would paint her head for 500 guineas.[3] Sir William thought the price excessive, although the commission was to go ahead. It was probably a bad omen.

Away from his professional concerns, James had other domestic problems to contend with. Since his marriage to Beatrice, his son Charles Hanson's role as secretary-cum-dogsbody had rapidly diminished: James's sister-in-law, Ethel, had taken on the duties of general organizer. In view of this James had agreed to support Charles through a course in electrical engineering at King's College, London. It was not a success and in June James lambasted the hapless Charles:

Enclosed I send a cheque for four pounds – I find from you ... what I feared – and that is your Kings College course was as usual a chance thrown *away* – You *couldn't* stand lower than at the bottom of the class, and so there you stood – You probably never went near the place – and again my goodwill was abused – If I had not insisted upon seeing the reports of the College you would have contented yourself with attempting to impress upon me by your own accounts ... If your conduct had been other, I don't know what I might have struggled to do for you. The cheque enclosed is for your *allowance* – out of the fifty guineas I promised you for the year – I have no means to help the 'Idle Apprentice' with 'tall hats' – he must wear a round one or a straw – and be thankful that the wind is tempered to a poor creature of so little ambition.[4]

It was only after Hanson's marriage to Sarah Ann Murray in 1896, which James initially disapproved of, that their relationship improved. From then on, they became more tolerant of each other; even friendly. It was

as though the marriage psychologically absolved James of further responsibility: freed from this obligation, he could at last get on a proper footing with Charles.

Although he should have felt safe in the knowledge that he could now protect his status among his Parisian friends from Oscar Wilde, who was building a steady following in Paris, James was still irked by Wilde's continuing success in London with the staging of his play *Lady Windermere's Fan*. Crowds flocked nightly to see it, and as Richard Ellmann has noted, the play 'made Wilde the most sought-after man in London'. When Wilde appeared unannounced in Paris in May, James was quick to move and within days had something derisory inserted into one of the Parisian newspapers, the *Revue bleue*.[5] As he gleefully reported back to Heinemann in London: 'Wilde has left Paris precipitately – utterly collapsed – saddened and demoralized – knowing that the gaff was blown, and it would be hopeless ever to try it on here again.'[6]

This was a characteristic 'overstatement', and the fuss James created at the merest mention of Wilde's name was extremely wearing for those around him, particularly Mallarmé. He resolutely refused to condemn Wilde, while at the same time attempting as best he could to allay James's fears. Perhaps as a recompense for the unnecessary stress he placed on Mallarmé, James tried to get William Heinemann to publish his *Postales*. This move would also have intimated to Wilde that the friendship between Mallarmé and James was unbending. 'Now don't you think it would be very *chic* in *you*,' he wrote to Heinemann, 'who are supposed to be always after the newest thing, to bring out this little gem in London? It would be the *fashion* – and now you see what I meant by Oscar's stealing it if only he could come upon it . . . so not a word . . . It would be a great success in Mayfair – where it would be the *fin de siècle* thing to have it on all tables. Not necessary to be a French publisher for you to put it there, anymore than it would be necessary for the people to be French scholars who *must* have it there.'[7]

For some time Mallarmé had been working on an anthology, or florilegium as he often referred to it, of his verse and prose. Originally he had intended to have his frontispiece portrait drawn by Marcellin Desboutin, another of his many artist friends. At the last moment James stepped in and offered his services. Mallarmé accepted and James fired off a number of drawings, none of which satisfied him. The final result was a synthesis of all these and unquestionably one of the finest portraits ever done of Mallarmé. The sittings had not been without incident. James had set Mallarmé posing in front of a burning stove and every time the poet tried to escape the searing heat, James frantically bade him return to his

position. The portrait completed, Mallarmé was left to nurse his scorched calves.[8] In spite of the discomfort, he was thoroughly pleased with the outcome: 'Ce portrait est une merveille, la seule chose qui ait été jamais faite d'après moi, et je m'y souris.'[9]

Although portraits, particularly those in oils, might have been his most lucrative source of income, the struggle with the portrait of Montesquiou meant James was in no hurry to commit himself to another. What seemed to preoccupy him more than anything during the early months in Paris was printmaking supplemented, when he felt the urge, by small pastel drawings of the human figure. After the previous summer's work in lithography for the intended publication *Songs on Stone*, he seems to have abandoned the medium, apart from Mallarmé's portrait, and to have returned to etching. Although he changed medium, he remained with the same subject-matter. It was as though he were searching for a pictorial solution and, unable to find it in one medium, resumed experimentation in another. The nude had occupied him intensely during his initial spell of lithography; he had also done many nude pastels. Now, in his new studio in Paris, he confronted the subject again in his etching.

The pictorial challenge posed by the human figure had been pursued by James for most of his professional life. As Lochnan has pointed out, the etchings of nude or partially clothed figures from this early Paris period, 1892–3, 'recall the Tanagra terracotta figurines which Whistler had found so appealing during the latter half of the 1860s'.[10] In etchings such as *Young Woman Standing*, it is the technical virtuosity of the revealing drapery which seems to be the real subject, and is certainly the lasting achievement. James had finally found a fresh solution to a problem which had beset the best part of his career.

The mid-summer was an enticement to work in the open air, and he embarked on some etched views of Paris. In the end there would be twenty-three, and their printing would occupy him on and off for nearly six years. Whether James intended them to be a 'set' is not clear. This initial burst of etching activity, which continued for just over a year, effectively brought to an end his work in that medium. These exquisite little Paris etchings are a fitting finale to his etching career.

James now used the streets of Paris as he had the streets and buildings of Chelsea, Venice and Amsterdam. Seven of these late etchings were of the beautiful gardens of the Palais du Luxembourg and nearby. His return to etching signalled a deepening interest in the effects of drawing. In plates such as the *Pantheon, Luxembourg Gardens*, the line has become more refined than ever before. Hatching and counter-hatching dominate the composition, creating an intensely atmospheric sense of light, shade and

depth. It was a natural development from his work in Amsterdam when the first signs of a growing concern with 'drawing' had become evident; as before, the scenes depicted are for the most part direct and frontal.

With some etchings completed by the end of summer, he set about printing them. Almost immediately he ran into difficulties. In Paris he could not find the good-quality old paper he required and he asked the young etcher, Frank Short, to find him some in London. Unfortunately, Short was only able to turn up one old book. This, together with the odd scraps James was able to locate himself, amounted to very little, and so the printing was abandoned.

Throughout the summer there were other things to keep him occupied and content. His six exhibits at the second Société Nationale des Beaux-Arts, the portrait of *Lady Meux* and five Nocturnes, were well received by the Paris press. In June he was awarded a gold medal at the sixth inter-national Kunst-Ausstellung in Munich for *The Fur Jacket*. There were other preoccupations too, like the sale of Frederick Leyland's famous house in Prince's Gate, London, where he had designed the Peacock Room, and the auction of Leyland's fabulous collection at Christie's. (Leyland had died some months before.) The sale received tremendous publicity and James was kept informed by several friends. Writing to Thomson in May, he voiced his concern about the fate of *La Princesse du Pays de la Porcelaine*. 'What are you going to do about the sale?' he wrote. 'I certainly think you ought to try and get the "Princesse" – It is a *beauty*! – and ought to be easy to place – In any case, even if you do not buy – you surely ought to see that the picture is properly competed for.'[11] Aside from the fate of the major paintings, James was also interested in a number of drawings which had been listed in the catalogue. As he explained to Thomas Way in London:

The drawings ... can only be very slight notes on brown paper left by accident at Speke Hall – or given carelessly to the children – with the exception perhaps of the pen and ink of the back view of a lady – this I fancy might be a sketch I did of Mrs Leyland – but you must be careful – for it was reproduced by photograph – and I don't remember whether I had the original drawing & this would be the facsimile – The late Mr Leyland *never* bought anything of mine of this kind at all.[12]

James asked another art dealer friend, Alexander Reid, to act on his behalf.[13] With Reid's help he managed to retrieve several small items from the sale but was not at all pleased when he learned that Reid had secured *La Princesse* for what James considered to be the derisory figure of 420 guineas. Several days later he fumed to Thomson, 'How could you let the splendid

picture go for such a ridiculous sum.'¹⁴ There was some comfort to be had from the fact that the house itself had failed to sell even though the bidding took the price up to the then enormous sum of £20,100. The Peacock Room for the time being remained intact.

James's reaction to the sale of Leyland's pictures is indicative of his obsession with any re-sale of his own work – an obsession which grew as the decade progressed. After Reid had bought *La Princesse*, James immediately offered advice on whom it should be sold to: the Potter Palmers in the United States, the price he had in mind being 2,000 guineas. Apart from dogmatically trying to ensure that paintings did not stray into the hands of the 'English', James's intentions were purely selfish in that he wanted to protect his own future market. It did not stop him from outrage at the latest profit made by one of his earlier patrons. Later in the summer, he wrote to the artist, Percy Jacomb-Hood: 'Since the exhibition in Bond Street, *six* of my paintings have been sold by "owners", "patrons" and what not! for eight or ten, in one case fourteen times the sum they themselves had paid – They *couldn't* resist it! and the pictures leave England – More to follow.'¹⁵

In the autumn with the help of a young follower, Sidney Starr, James managed to retrieve the infamous *Falling Rocket* from his creditors, Graves the print sellers, and sell it to a New York collector, Samuel Untermeyer, for 800 guineas. Having triumphantly informed Thomson of his successful ruse, he was annoyed by the brevity of the announcement Thomson placed in the *Pall Mall Gazette* concerning the sale; he wrote to the dealer:

> Instead of proclaiming boldly the fact that the famous picture which Mr Ruskin vilified as *a pot of paint flung in the face of the public* – for which the impostor charlatan & coxcomb painter had dared to ask 200 gs. has been sold 'without aid of the middleman' for eight hundred *guineas* (not pounds by the way as you have it) and that Professor Ruskin had *lived* to receive the commercial slap in the face, the only rebuff understood or appreciated in his country, instead I say, of making clear to the people that this thing has happened and the 'Pot of Paint' has become in value four pots (!) in spite of the Philistine's Priest and his apostles, – instead of all this, you have allowed a mere dull statement of sale to find its way into the papers . . . In short you have 'knocked the bottom out of the whole thing'.¹⁶

In practical terms the sale provided James with some timely financial security. A month or so before, the couple had finally found the house they had been searching for as a permanent base in Paris, 110 rue du Bac in the Latin Quarter. A tall narrow street that starts on the Left Bank opposite the

Louvre and winds its way south until it meets the Boulevard St Germain, the rue du Bac was full of small shops of every description. Convenient as it was for central Paris, it was a fifteen-minute carriage ride to James's studio at the rue Notre Dame. This small inconvenience was vastly outweighed by the fact that Beatrice loved the location and the house with its large garden; 'a real bit of the country in Paris', the Pennells recalled.[16] Describing the interior, they went on: 'Opposite the entrance, a big door opened into a spacious room, decorated in simple flat tones of blue, with white chairs and a couch, a grand piano, and a table which, like the blue matting-covered floor, was always littered with newspapers. Once in a while there was a single picture of his on the wall. For some time, the *Venus*, one of the *Projects*, hung or stood about.'[17]

Moving to and decorating the new house occupied James and Beatrice for the remainder of the year. Occasionally, he would escape the domestic arrangements to spend a few hours each day in the relative quiet of the studio, and it was almost certainly around this time that he began work on a small painting, *Nude Girl with a Bowl*.[18] The identity of the sitter remains unknown, but it may be presumed she was a professional. The painting seems to have evolved from the series of pastels he had been making and although obviously reworked, it retains a sense of fluidity in the handling. It was the first time for nearly twenty years that James had attempted such a composition, but he would return to the theme on several occasions.

He and Beatrice made a quick unannounced trip to London for the New Year of 1893, spending it in the company of Ethel and her fiancé, Charles Whibley – or 'Wobbles' as James had taken to calling him. When they returned to Paris a letter from Walter Greaves was waiting, informing James that Mrs Greaves had died. The sad note was their first communication for several years. His note to Walter, then living at Albert Lodge, Waltham Green, reflected his geniune sorrow: 'you may be sure that my greatest sympathy is with you all in your deep sorrow – Little can be written that is not better understood when grief like this comes upon you. Say only to your sisters and your brother all that is kind from me – and believe me Walter, Always Sincerely your friend.'[19]

If distanced geographically from London, James was always fully aware of what was happening. Thomson supplied a weekly package of art periodicals as well as relaying the latest gossip and news. Occasionally the news and information was lucrative. Such was the lead given by the young Irish painter, John Lavery, closely associated with the Glasgow Boys, when he suggested to a wealthy Edinburgh collector, John James Cowan, that James might be prepared to paint his portrait. With the introduction made in January, James wrote to Cowan suggesting that he should come to Paris

in May to begin the sittings. The prices, he was careful to note, were 600 guineas for a 'small full length' or 'a half length' or alternatively 400 guineas for 'a head'.[20]

Just as he was keen to keep up with everything that was happening in London, James – despite his protestations to the contrary – was also keen to ensure that his work was always available there. At various times throughout 1893 examples could be seen at three London venues: the Goupil, the Society of Portrait Painters, and at the newly inaugurated Grafton Galleries to which he had persuaded Lady Meux to loan her portrait, only just returned from Paris.

It was the exhibition at the Grafton Galleries that was to prove the most significant. This brought to the fore the debate which would increasingly dominate and polarize the British art scene for many years to come: the 'new art criticism' which supported the work of James, his French colleagues and his younger disciples, against the more conservative and didactic values of self-styled 'Philistines'. Viewed against the background of the modern French art which had been shown in London for nearly twenty years,[21] the Grafton show seemed tame enough. The new manager, F.G. Prange, simply wanted to open the gallery with an overview of modern painting, continental and British alike. James was chosen because Prange admired his work, and because he also recognized the commercial value of including him.

Typically, James was not altogether sure that it was right for him to show at this venue. He owed a loyalty to Thomson at the Goupil, and it was rumoured that his old adversary, Sheridan Ford, had some connection with the Grafton. Prange quickly assured him that there was no truth in this.[22] Then there was the question of the lighting. Again Prange insisted he would have it looked over and would discuss it with others, including the artist Charles Shannon.[23] Prange was proving an apt and capable manager. Like Thomson, he passed the test, and in the end not only did James exhibit the portrait of Lady Meux, but Beatrice exhibited a work under her pseudonym Miss Rix Birnie. As to the 'continental' painters represented, there were Eugène Carrière, Giovanni Segantini, Max Liebermann and Degas. It was Degas' painting *L'Absinthe*, sold by Alexander Reid to the collector Arthur Kay only weeks before, which fuelled the debate as never before. The wild-looking painter Marcellin Desboutin posed with an actress for this picture of a couple slumped in a café, which, as Bernard Denvir remarks, 'looks like a warning against the Demon Drink'.[24]

The immediate background to the controversy can be traced to an interview in the *Westminster Gazette* given some weeks before by the widely respected Scottish painter and President of the Royal Scottish Academy, Sir

George Reid. Reid had lambasted the adverse 'effects' of the 'impressionist movement' on young artists, particularly in Scotland, where he believed 'there was quite a school of them'. After reading several reports on the interview, James was keen to hear more and sought the help of Thomson: 'I want to see what the President really did say about me – and also what he said about *himself*! . . . Another thing – tell who is "D.S.M." with whom there is something of a correspondence going on about art criticism!'[25]

James's ignorance of the widely respected critic and writer Dugald Sutherland MacColl seems surprising, given that, not long after the Grafton show had opened, MacColl had written one of the longest and most considered articles on James's art which ever appeared in his lifetime in the English press. Furious at the treatment meted out to Degas' *L'Absinthe* by the *Westminster Gazette*, MacColl had come to its defence, attacking one 'Philistine' critic in particular, J.A. Spender, in an article that appeared in the *Spectator* entitled 'The Inexhaustible Picture'. Of Degas' picture he wrote:

> there is no false note of an imposed and blundering sentiment, but exactly as a man with a just eye and comprehending mind and power of speech could set up that scene for us in the fit words, whose mysterious relations of idea and sound should affect us as beauty, so does this master of character, of form, of colour, watch till the café table-tops and the mirror and the water-bottle and the drinks and the features yield up to him their mysterious affecting note.[26]

Spender's response was swift and considered. It appeared not on the pages normally allotted to art criticism, but as a leader on the front page of the *Westminster Gazette*.

> How strange, one thinks, that our old friend the 'Spectator', so moral and so reputable in all other relations of life, should lend itself to this threnody over a picture of 'two rather sodden people drinking in a café!' . . . For the 'new critics' are in possession of most of the weekly and several of the daily newspapers, and with one accord they tell us the same thing. These two sodden people are their ideal; it is for this that the world has been waiting; and if you refuse to hail it as a joy for ever, your affliction is incurable.[27]

MacColl, in his final article, argued that Old Masters and modern painters alike did not and do not address themselves to the popular understanding. He went on to say that people have to be educated into an appreciation of either: 'coerced by expert opinion into admiring, or

feigning to admire, the Old Master in the time of the Old Masters, just as the modern populace has been coerced by expert opinion into a grudging respect for Mr Whistler, and quite surely will come to believe that it admires Degas ...' James had been on the mind of others as well as MacColl throughout the debate, and his work had been mentioned on many occasions. In the wider context, the debate had been about the implications of 'Impressionism' as a whole, with *L'Absinthe* merely providing a convenient target for comment.

D.S. MacColl's article on James which appeared in the *Art Journal* in the midst of the controversy was initially motivated by two events: the first was the publication of the photographic album which had at last been released by the Goupil Gallery, and the second was the appearance of two articles on 'Design' written by Walter Crane in the January and February issues of the *Art Journal*. In these, Crane attempted to place James in the role of a 'designer', an idea which MacColl wished to refute.

For MacColl, who would later become a Keeper of the Tate Gallery, the chance to write a major article on James was opportune. As one of the least understood and certainly the most castigated artist in England for nearly thirty years, his art provided the perfect case-history for a practitioner of the 'new art criticism'. MacColl wished to demonstrate that 'modern art' was not something which had sprung from nowhere, gimmicky and historically transparent, but was deeply rooted in a long historical tradition. After dealing with Crane's assertions at some length, he then turned to link James's art with that of the great masters:

> Why did Velasquez in the full-length 'Philip' keep the modelling so flat, and use so great simplicity of tones, and why does Mr Whistler follow that procedure in the Miss Alexander? Surely because each wishes in that instance to play the piece more as a parti-coloured space than as an affair of planes and shadows ... It is in Velasquez that the old habit of mind, 'I have made this red, and that blue, and that yellow, so this must be green,' is broken with, and a tint, say of rose, taken as a theme, calls out a concert of ashy and black and silver notes, and greens only exist by opposition. To understand this lesson ... [is to] prove Mr Whistler the modern who has fallen heir to a great tradition in painting, and developed the inheritance.[28]

James revelled in the attention, finding the article 'really most delightful'. It certainly helped boost the sale of the photographic album: by the end of the year thirty-three signed copies and twenty-seven unsigned copies had been sold.[29]

Despite all the publicity, James was not tempted back to London in 1893.

But it was with some satisfaction that he could open so many newspapers and periodicals and find something about himself within. He had become the elder statesman of 'modern' British art – in exile; and a focal point for many visitors from across the Channel. This was particularly true during the summer months when writers, artists, dealers and critics descended on Paris to view the annual Salon. Among his many visitors in the summer of 1893 were Henry Harland, Henry James, Heinemann and Thomson. When the Pennells arrived they were accompanied by D.S. MacColl and also a young illustrator who had recently sprung to prominence in London, Aubrey Beardsley. Joseph Pennell had written an article about him for the first edition of the *Studio* magazine in which he had waxed lyrical about his phenomenal talent. As Beardsley later told a friend, 'I should blush to quote the article.'

Beardsley's first meeting with James took place after he and Pennell had been to the opera: they caught sight of him sitting with some friends in the Café de la Paix. After the friends had left, Pennell, anxious they should meet, immediately made the introduction. James surveyed the strange lank figure before him, impeccably dressed in 'an elegantly carried-out harmony of grey coat, grey waist coat, grey trousers, grey suede gloves, grey soft felt hat, and a grey tie knotted wide and loose in the French style'. Later, alone with James, Pennell asked him what he thought. Feigning horror, James replied: 'Why do you get mixed up with such things? look at him! – he's just like his drawings – he's all hairs and peacock plumes – hairs on his head – hairs on his finger ends – hairs in his ears – hairs on his toes. And what shoes he wears – hairs growing out of them!'

It was only some years later when they met again, this time in London, that James came to appreciate and acknowledge the true magnitude of Beardsley's talent. After being shown his magnificently elaborate and ambiguous illustrations for Alexander Pope's *The Rape of the Lock*, James became enraptured. As Pennell recalled, James slowly turned to Beardsley and said, 'Aubrey, I have made a very great mistake – you are a very great artist.' Beardsley at this point apparently burst into tears. James kept on repeating, 'I mean it – I mean it – I mean it.'[30]

While Pennell was in Paris in the summer of 1893, James decided to seek his assistance with the printing of the Paris etchings. He called at his hotel on the Quai des Grands Augustins, and was told that Pennell could be found working at Notre Dame. Having puffed his way up to one of the great towers where Pennell was working on his drawing, James put his request. Pennell, flattered at the invitation, immediately agreed. They began work the following day – not at the studio but at the rue du Bac. Like so many before before him, Joseph Pennell quickly found out that working as

James's assistant was no easy task. It required a cast-iron constitution, and a temperament to match. For four days they followed the ritual set by that first morning. A long breakfast, then James brought out the etchings very carefully, one by one, and together they sat and looked at them. Finally Pennell could stand it no longer. Either the printing must start, or he must return to his drawing. James quickly heeded the warning, and within minutes a cab had arrived to take them to the studio. As Pennell later recalled:

> We set to work at the press Belfont had put up for him. He peeled down to his undershirt with short sleeves, and I saw then, in his muscles, one reason why he was never tired. He put on his apron. The plates, only slightly heated, if heated at all, were inked and wiped, sometimes with his hand, at others with a rag, till nearly clean, though a good tone was left. He really painted the plate with his hand that day.[31]

This routine was followed for several more days. James would ink the plates, and Pennell would print them. Sometimes James was satisfied, on most occasions he was not. The main fault seemed to lie in the weakness of the image – the outline was just not strong enough. Again and again they tried to put it right. It was turning out to be a laborious, though fascinating task. Pennell watched in amazement as James tried various methods to rectify the problem:

> A number of plates had never been bitten, and one hot Sunday afternoon he brought them into the garden at the rue du Bac. A chair was placed under the trees, and on it a wash-basin, into which each plate was put. Instead of pouring the diluted acid all over the plate in the usual fashion drops were taken up from the bottle on a feather, and the plate practically printed with the acid . . . To me it was a revelation.[32]

For James it was a period of utter frustration, and soon the printing was abandoned. This episode marked the beginning of the close relationship between Joseph Pennell, his wife Elizabeth, and James. From now until the end of his life they would be part of James's court. So long as James remained in Paris, this friendship continued to blossom. In the years that followed, maintaining it in England was a different matter altogether.

While he was still struggling with the printing, James had begun a portrait of the Scottish collector, John James Cowan, who had arrived in Paris with his wife towards the end of May for sittings. Over a period of four weeks he sat to James on at least eighteen occasions, most of them lasting three

hours or more. To while away the time, Cowan's wife read aloud from *Treasure Island*. Whatever James may have thought of the intrusion, he said nothing at the time, though later he 'was inclined to blame the reading as a cause of his failure to complete the picture'.[33]

Much smaller than the Montesquiou portrait, the Cowan picture is unremarkable save for the time and effort James invested in it. Naïvely believing it to be completed – they had after all witnessed James signing it – Cowan and his wife returned to Scotland and later in the month he sent a cheque for 600 guineas. But by then James had scraped most of the portrait down, and the next time Cowan saw it, 'the signature had gone'.[34] Cowan had become yet another victim of James's inability to finish a portrait. Intermittently until 1900, he would arrive to sit patiently yet again for what James had humorously labelled 'The Grey Man'. In all there were over sixty sittings and the portrait remained with James until his death. It was presented to the National Gallery of Scotland in 1926 by James's executrix, his sister-in-law, Rosalind Birnie Philip, with the agreement of the long-suffering Cowan. Despite everything, Cowan became one of James's last substantial British collectors and by the time of the artist's death owned over a dozen of his oil paintings. It says a lot for Cowan's character that he could suffer such inconvenience and still greatly admire the man behind it.

Not long after the Cowans had left Paris, the New York dealer and long-time friend of James, Edward G. Kennedy, arrived from the United States to sit for a prearranged portrait.[35] It was not a commission but intended as a mark of respect and a token of thanks for all the work Kennedy had done for James over many years. Joseph Pennell witnessed at least some of the sittings which took place in the garden of the rue du Bac. James's treatment of his subjects had not softened over the years: 'He worked away all afternoon ... If Kennedy shifted – there were no rests – Whistler would scream, and he worked, on and on, and the sun went down ... a paint rag came out – and, with one fierce dash, it was all rubbed off. "Oh well", was all he said.'[36]

After a first version was 'put aside', James continued the sittings at the studio with temperatures in the nineties. Knowing James's reputation only too well Kennedy took the uncompleted canvas, still wet, away with him. He brought it back as promised the following summer, and of all James's late male portraits it is one of the most successful, now in the Metropolitan Museum of Art, New York. It follows the tradition set by Leyland's and Duret's, and latterly Montesquiou's portrait. Emerging from a dark space, Kennedy appears timeless and placeless. This is the antithesis of the laboured image of Cowan, who, dressed in his tweed jacket and breeks,

looks contrived and 'commissioned'. Kennedy, however, did not like the finished work and refused to allow it to be exhibited in his lifetime.[37]

Pennell, though he would never admit it, was fast becoming a studio assistant. In all likelihood, James considered him less a true friend than a useful acquaintance. If anything it was Elizabeth he warmed to. Well bred and well educated, with the style of an old-fashioned Southerner, she was thoughtful and diplomatic, whereas Joseph was prickly, opinionated and small-minded. Together, however, this eccentric couple, who devoted their entire life to art, were affable company given the right circumstances. As always, it was Beatrice who held the final card. She did not care for them much, but recognized their usefulness and so was prepared to put up with them. However, in years to come her distrust of them would filter down through the Birnie Philip family with dire consequences.

The summer of 1893 in Paris was notable for two things – the stifling heat, and the 'Sarah Brown Students' Revolution'. This was a series of student disturbances that claimed several lives and caused widespread damage around the Latin Quarter not far from James's house. The rioting continued for several days in early July and while it was at most an inconvenience, it distressed Beatrice who had become ill some days before. Her illness naturally concerned James, but with the help of a local doctor the symptoms appeared to pass. What they needed was a holiday, a break from the overpowering heat of the city, and within days they had departed in search of fresh air and subject-matter.

The place they chose was Brittany, and for nearly two months they roamed the area working and relaxing. Although James complained endlessly to his friends and family about the scorching and relentless heat which, he wrote to Thomson, may have 'enchanted' the tourists 'with the brazen sky and tin sea', but allowed 'nothing for the painter . . . at least not for this one', the vacation proved a fruitful break.[38] For the first time since his honeymoon, he returned to the freedom of painting seascapes – a wonderful relief from the pressures of portraiture. He painted six, possibly seven, pictures as fresh as anything he had achieved during his whole career. A year later, he could write confidently to Edward Kennedy in New York saying that two in particular, *Violet and Silver: A Deep Sea*[39] and *Dark Blue and Silver*,[40] were 'the finest things of the kind I have ever painted'.[41] In one extraordinary painting, *Seascape*,[42] which may have been done a little later, James came as close as he ever would to pure abstracted colour. Tiny in scale, measuring only some 11 × 14.4 cm, this beautiful panel consists of subtle, yet bold, strokes of light blue and white, tinged with the palest touch of purple. There is no recognizable motif, yet in it a moment is captured, a mood portrayed. During the holiday, James also completed a group of

watercolours. These were not in any sense preparatory drawings, but another way of achieving spontaneous images. Of these, two completed at Belle Isle, and one in particular *Blue and Silver*, recall the pictorial devices of the Japanese art he loved so well.

He carried with him sheets of lithographic transfer paper, but no etching plates. For the first time in many years he did no etched work during a working holiday; the problems with printing throughout the summer had put paid to that. What it seems he wanted more than ever before was to capture 'the moment'. He completed seven lithographs during the holiday, two of which were further experiments in colour, *Red House, Paimpol* and *The Yellow House, Lannion*. By now James had realized the intrinsic value of lithography as a vehicle for pure drawing, quite apart from its importance as a method of creating multiple images: he had a clear idea of its worth and stature as a fine art medium. This was a point he was keen to impress upon others, particularly art dealers. As he explained to Marcus Huish of the Fine Art Society: 'lithography reveals the artist in his true strength as a draughtsman and a colourist.'[43] With the advance of technology, the medium now lent itself favourably to commercial reproduction, a fact that was also not lost on him. A spate of new magazines had sprung up, foremost among them the *Studio* which, together with established specialist art periodicals such as the *Art Journal*, had also begun to use lithography as a method of illustration.

James and Beatrice returned to Paris in early September and he set about attempting to market the prints. He asked Thomas Way to act on his behalf in London,[44] and Way immediately began negotiating with Gleeson White, the editor of the *Studio*. It was to prove a lucrative and useful market. Not only did James earn £10 an image, which soon rose to nearer £20, but it helped immeasurably to popularize his work in the medium. The printed images were always carefully chosen, as was the magazine they were intended for. To avoid any possible confusion between the mass-produced prints and the limited editions, all carefully controlled by James, he was always keen for the magazine's stamp to be clearly seen on theirs, and for them to be printed not from the master stone which he used himself, but from a second stone specially prepared by Way.

Lithography kept him occupied for the remainder of the year as he experimented with different effects. One particular idea was using stumps of paper to wash a solution of liquid chalk over the image to create a rich tonal effect not dissimilar to an aquatint. Excited at his findings he wrote to Way in London, swearing him to secrecy: 'You are not to talk to everyone or anyone about this stump phase of the lithograph that I am developing! ... That is *mine* you know – and I don't want all the busy lot that you have

got about you, to get bedevilling with it before I have established the success and beauty of the thing.'[45]

Although James used his Paris printer Belfont to print for him on numerous occasions, the Ways in London still remained his preferred choice. Not only were they superb craftsmen, they understood him and were well used to his idiosyncratic methods and demands. When André Marty, the editor and publisher of *L'Estampe originale*, a periodical portfolio of original lithographs, asked James to contribute to his publication, he travelled to the Ways in London to select the work. Forewarning Thomas Way of Marty's arrival, James impressed on his printer the honour involved, and the need for an excellent printing of the chosen image, *The Draped Figure Seated*: 'As it shall be in the same box with the others, and as Puvis de Chavannes, Bracquemond, Fantin and the rest are who are going to be in it – I have been promised . . . let us be very swell among them!'[46]

Although James was thoroughly enjoying the new lease of creativity presented by the medium, there was another reason for this sudden preoccupation with his lithographic work. For the first time since his marriage five years before, he felt vulnerable and insecure. This was not a professional dilemma, but a personal crisis. The illness Beatrice had contracted earlier in the summer had returned sporadically throughout their holiday. Although neither had realized it, Beatrice was in the first stages of terminal cancer. If 1893 had proved a reflective, almost non-combative year, the new year about to begin would change all that. James, uncertain and threatened, would lash out at all around him.

26

Trials and Tribulations

As the new year 1894 opened, portraits again predominated. Montesquiou's – so long a thorn in James's side – at last appeared to be finished after more than a hundred sittings. Later in the spring it made its public debut at the annual showing of the Société Nationale. As the Montesquiou was being prepared to leave the studio another portrait was about to begin. Some time before, Sir William Eden, a keen and gifted amateur watercolourist himself, had been reluctant to pay the price of 500 guineas for a small portrait of his wife. The Baronet then asked the writer and critic, George Moore, to intervene and negotiate a lower fee.[1] In the mid-summer of the previous year, Moore apparently got James to accept the 'very liberal concessions' required by Eden, and it was agreed that he would produce a 'charming picture' for between £100 and £150.

On 9 January, Sybil Eden arrived in Paris in the company of her husband to begin the sittings at the studio in rue Notre Dame des Champs. They apparently went without a hitch and just over a month later, on St Valentine's Day, James, whilst still in possession of the painting, accepted from Eden an envelope containing the payment for the portrait. When the envelope was opened after Eden's departure, the cheque for 100 guineas inside infuriated James, though for what precise reason is difficult to fathom, since he had apparently been paid within the band previously agreed with Moore. He wrote at once to Sir William: 'I have your Valentine. You really are magnificent – and have scored all round. I can only hope that the little picture will prove slightly worthy of all of us, and I rely on Lady Eden's presence for one more sitting to let me add the few last touches we

373

know of. She has been so courageous and kind all along in doing her part. With best wishes for your journey.'²

The following day Eden, who was as prickly and as arrogant as James, confronted him at the studio demanding an explanation for 'the very rude letter'. James refused to be drawn, and furthermore refused Eden's offer to increase the price to 150 guineas. With the Edens departing the same day for an extended big-game shooting holiday in India, nothing more could be done until they returned in the autumn. Until then, James carried on as though nothing had happened and the small panel was exhibited at the Société Nationale as *Brun et or: Portrait de Lady E.*

James was very sensitive about the pricing of his work, both old and new. Only weeks before, he had lambasted Thomson for the way he was treating paintings by him owned by Gerald Potter, an early patron who was now keen to sell and take a profit: '*why* do you always drag about the pictures of Potters?? Why? Why? Why!!! It annoys me very much to think that works of that distinction should be hawked in this persistent way from one end of the land to the other.'³ When two of them were sold, Thomson again bore the brunt of his frustration:

> What was the full price paid for the *Little White Girl*? and what was the price paid for the *Nocturne, Cremorne Lights*? – I wish you would tell me this – Of course all this is of the greatest interest to me – I want to know what the shop-keeping 'art patrons', Potters and others, are making out of *my* labour, *my* brain, *my* name!! For that is real history – and the pose of Potter, Leathart, Ionides and the rest as Macenas [*sic*] and protectors of Art!! is in modern English, Rot! – and abomination.⁴

Thomson initially refused to name the buyer – a young artist whom James knew by name, Arthur Haythorne Studd – citing the interests of his clients as his excuse. Studd, an Englishman, bought *The Little White Girl* for £1,400 in late 1893, and *Nocturne: Blue and Silver* for £650, in early January 1894.⁵

Born in 1863, into a wealthy family later famed in the cricketing world,⁶ Studd was educated at Eton and Cambridge. Soon after graduating he enrolled at the Slade to study art, where he was taught by Legros, who shunned any mention of James's name. Another contemporary was William Rothenstein, who later described Studd as having 'preserved a delightfully child-like nature, an affectionate simplicity which endeared him to everyone, man, woman and child'.⁷ After the Slade, Studd crossed the Channel to Paris to study at the famed Académie Julian sometime in 1889. Setting himself up in a huge suite of rooms at the Hôtel de France, near the rue du Bac, he soon urged Rothenstein to join him. They both

seem to have avoided confronting James under any pretence, even though they were both, and in spite of Legros, clearly besotted by his work. During his student days Studd become a confirmed Francophile and travelled widely.

Studd appears not to have met James until after the purchases were made: it was, of course, a wonderful excuse to meet the master. Studd's purchases where certainly not made on a momentary whim, but based on his 'good eye' for a painting, and his desire to create a collection of modern paintings. Before the Whistlers he had already bought one of Monet's hay-stack paintings for £200, which complemented his other French paintings by Louis Picard and Puvis de Chavannes. There was an instant friendship, and Studd had no qualms in acknowledging what he considered to be his 'great artistic debt' to James, while the meeting also proved a tonic for James.[8] Well educated, humorous, and generous to the point of embarrassment, Studd soon became a constant and welcome visitor at the rue du Bac, along with Rothenstein. Beatrice too quickly came to adore him and before long the formal address of 'Mr Studd' had changed, in typical James fashion, to a nickname, 'Peter' – saintly and sound.

It was almost certainly through Studd that James was introduced to the work of artists such as Gauguin and Meyer de Haan, whom Studd had met during a visit to Le Pouldu, in Brittany, in 1890. For such artists, James had little time: frankly, he failed to see the beauty in their heavily patterned paintings. Studd, however, was the first person able to explain their motives to him. Indeed, at this time Studd's own work was an intriguing combination, veering from the firm, bold patterning of Gauguin to other small panels which could be mistaken for those of James himself. Occasionally, as though in compromise, his work took on elements of both, and he deployed the delicacy of James with the brilliant colouring of Gauguin. Both James and Beatrice genuinely admired Studd's work.[9]

Studd could see no conflict whatsoever between Gauguin and James. Indeed, several years later when he had gone to Tahiti with Gauguin, he urged James, 'cher maître', to join them there: 'there are amazing things to paint – women who walk like goddesses – splendidly proportioned youths sitting in the moonlight, crowned with garlands, where palms wave in the background like huge black plumes against the sky . . . We have had beautiful cloudy weather ever since my arrival a month ago and the day would be for you full of sea pieces and the night of nocturnes.'[10] James, however tempted, did not take up the offer. In the interim, Studd not only helped James begin to understand, if not always to admire, the younger continental generation, but he also provided a warm hand of friendship at a time when James perhaps needed it most.

If new friends such as Studd were proving a tonic, old friends, particularly English 'old friends', were soon to become a liability. One in particular, George du Maurier, had caught his attention again after many years of apparent indifference. While James may have followed Du Maurier's career as one of *Punch*'s most popular illustrators for over thirty years, they had rarely spoken since parting company back in the sixties. Du Maurier, marrying early, sought middle-class domesticity and security, while James, until his marriage over twenty years later, appeared to be stuck in perpetual studenthood. One aspect of Du Maurier's work over the years certainly did not help their friendship. From the early 1870s to the mid-1880s Du Maurier, through the pages of *Punch*, had poured humorous scorn on the Aesthetic Movement and the cult of Japan. Though never formally identified as his target, James was as assuredly in Du Maurier's sights as was Oscar Wilde; on several occasions Du Maurier poked fun at James's art generally, and specifically at his use of musical titles. James loathed such ridicule but, in fear of generating even more, declined to react in his customary manner. Suffering from recurring bouts of blindness, Du Maurier then turned his attention to writing novels. His second, *Trilby* – like his first, *Peter Ibbetson*, published in 1891 – was be sold to the American publication *Harper's Monthly Magazine* and serialized both in the United States and England. Unaware of the impending onslaught, James like many others probably enjoyed the first few instalments when they began to appear from January 1894. Its somewhat conventional *mise en scène* of three English art students studying in Paris seems simple enough. The plot, however, quickly thickens when the main character of the book, Trilby – a beautiful model – enters.

The novel became an almost overnight success. Although obviously drawing heavily on autobiographical recollections, the force and momentum of the narrative with its unexpected twists, together with the rich detail of student life in the Latin Quarter, immediately captivated the audience. In March, a new character entered the novel. His name was Joe Sibley, 'the idle apprentice'. Clearly based on James, the description of the new character was vicious, vindictive and calculated. Sibley was, according to the author, 'vain, witty, and a most exquisite and a most original artist'. He was also, Du Maurier wrote, 'genial, caressing, sympathetic, charming; the most irresistible friend in the world as long as his friendship lasted – but that was not forever!'[11] Warming to the task, Du Maurier continues:

He is now perched on such a topping pinnacle (of fame and notoriety combined) that people stare at him from two hemispheres at once; and so famous as a wit that when he jokes (and he is always joking) people laugh

first, and then ask what it was he was joking about . . . He was a monotheist, and had but one God, and was less tiresome in the expression of his worship. He is so still – and his god is still the same – no stodgy old master this divinity, but a modern of the moderns! For forty years the cosmopolite Joe has been singing his one god's praise in every tongue he knows and every country – and also his contempt for all rivals to this godhead – whether quite sincerely or not, who can say? Men's motives are so mixed! But so eloquently, so wittily, so prettily, that he almost persuades you to be a fellow-worshipper – *almost*, only! – for if he did *quite*, you (being a capitalist) would buy nothing but 'Sibleys' (which you don't). For Sibley was the god of Joe's worship, and none other! and you would hear of no other genius in the world.

Understandably James was furious. That Du Maurier chose not only to recall James as a student, but also to describe him now, amounted to nothing less than treachery. James's public response, in a letter to the *Pall Mall Gazette* in mid-May, was both bitter and to the point:

It would seem, notwithstanding my boastful declaration, that, after all, I had not, before leaving England, completely rid myself of that abomination – the 'friend'!

One solitary unheeded one – Mr George Dumaurier [*sic*] – still remained, hidden in Hampstead.

On that healthy Heath, he has been harbouring, for nearly half a life, every villainy of goodfellowship that could be perfected by the careless frequentation of our early intimacy and my unsuspecting camaraderie. Of this pent-up envy, malice and furtive intent, he never, at any moment during all this time allowed me, while affectionately grasping his honest Anglo-French fist, to detect the faintest indication.

Now that my back is turned, the old *marmite* of our *pot-au-feu* he fills with the picric acid of thirty years' spite, and, in an American Magazine, fires off his bomb of mendacious recollection and poisoned rancune.

The lie with which it is loaded, *à mon intention*, he proposes for my possible 'future biographer' – but I fancy it explodes, as is usual, in his own waistcoat, and he furnishes, in his present unseemly state, an excellent example of all those others who, like himself, have thought a foul friend a finer fellow than an open enemy.[12]

Besides sending a letter to the press, James also sent a letter to the Beefsteak Club setting out in the strongest possible terms the issue at stake: 'As good faith and good fellowship are your essentials it becomes plain that

Mr Du Maurier & I cannot both continue as members. Either I am a coward, or he is a liar – *That* is the issue.'[13]

In fact Du Maurier had resigned from the club sometime earlier, probably for other reasons. After James's letter was printed the *Pall Mall Gazette* then allowed Du Maurier to give his side of the story. Saying in his defence that he believed his book to be harmless and that James would take it with the same good humour that its author had intended, Du Maurier concluded:

> I am neither his friend nor his enemy. I am a great admirer of his genius and his wit, but I cannot say that I could call myself his friend, for thirty years past. We were intimate in the old days, but that is all. No, his whole letter is incomprehensible to me. Of course he has been embittered through life, by reason of his genius not being recognized at its full value and by the wide public, and it has certainly not. This circumstance, and possibly illness, may account for the leave he has taken of good manners. He talks of my pent-up envy and malice. I must ask you to believe that I am not such a beast as that. I have no occasion either for malice or envy, and, as I say, I should never have written even what I have had I imagined it would give Mr Whistler pain.[14]

Du Maurier's implied admission of his own misjudgement, while tantamount to an apology in all but name, was nevertheless disregarded by James, who refused to let the matter drop. Trying to enlist the help of other members of the cast of *Trilby*, he wrote to both Poynter and Stacy Marks. Poynter dismissed this attempt at enlistment out of hand. Besides, in truth, he cared little for James. Marks did, however, agree to side with James and went so far as to ask for Du Maurier's resignation from the Arts Club to which they both belonged. For some weeks the altercation continued. In the end, fearing a libel case against him and his publishers, Du Maurier agreed to change the character. But he stopped short of issuing a public apology as demanded by James's solicitor. The wrangle continued through the summer and into the autumn. Only when *Harper's* published a wholesome apology and a pledge that they would stop the European sale of the March number and delete the offending passages before the novel was released in book form, did the affair end.

The whole business had wounded James more than he was prepared to admit and revealed to him his vulnerability at the hands of those he could not control. Fearing the possibility of a hostile biography from someone with an axe to grind – and there were many – James shortly afterwards commenced work on his own memoirs. In the same querulous tone he had

used to rebuke Du Maurier in his letter to the *Pall Mall Gazette* he began by noting: 'Determined that no mendacious scamp shall tell foolish truths about me when centuries have gone by . . .'[15] He barely got further than the first two pages, and even then the evidence suggests that these were written over a two-year period. There was no apparent reason for the cessation, other than the fact that such a task proved beyond his capacities. For someone who often took a fortnight to write a single letter to the press, the thought of recreating his own life on the page must have been daunting. Besides, as long as Beatrice was alive, there was too much that had to be locked in the past. At this point it seems that James made the conscious decision that his 'Life' would never be written, by him or anyone else, with or without his consent. If he was to be remembered at all, it would be through his work, through detailed catalogues and not through biographical reconstruction. Later in the same year when Thomas Way Jnr, son of his loyal and long-suffering printer, suggested that he do a complete catalogue of the lithographs, he was met with wholehearted support. As Beatrice would write at the time, 'Jimmie will be delighted . . . and he will be very happy to help you with it.'[16]

While obsessed throughout the summer of 1894 with the row over *Trilby*, James and Beatrice continued to hold court for the numerous visitors who called at the rue du Bac. On cue, at the beginning of the summer the Pennells arrived on their by now annual pilgrimage to pay homage to the 'master'. One visitor particularly welcomed was William Rothenstein. Although James had taken to him almost immediately, and genuinely admired his work, it was not until the spring of 1894, when Rothenstein collaborated with the young Tom Way in an article on 'Artistic Lithography' for the *Studio* magazine, that the friendship was sealed. In it, Rothenstein singled out in glowing terms James's achievement in the medium.

In his autobiography, *Men and Memories*, Rothenstein gives one of the clearest glimpses of the intricacies of James's Parisian court. He loathed Pennell almost on sight; this was nothing new, of course: most people did. What is interesting was James's reaction. As Rothenstein later recalled, when Pennell in due course left the apartment, James turned to him and apologized, saying, 'Never mind, Parson [his nickname for Rothenstein]; you know, I always had a taste for bad company.'[17] In spite of Joseph's rather tiresome air of superiority to all but James, James had come to believe that both the Pennells were invaluable to him, ensuring his interests were well looked after in London. Only that spring Elizabeth had written an article for the *Art Journal*, entitled 'On the River', which Joseph illustrated. Much to James's delight she wrote glowingly of Old Battersea

Bridge evoking memories of both 'Whistler and Turner',[18] the sort of comparison for which James could forgive almost any indiscretion.

Although he had no quarrel with Sickert as such, it is clear that Pennell was out to undermine him in the eyes of the 'master' almost from the start. More than anybody in the circle, Pennell feared the multi-talented Sickert. But in James's absence in Paris Sickert was proving more anxious to establish his independent career and less inclined to continue to act as James's unofficial press agent in London. Certainly by 1894, Pennell was responsible for creating a distinct air of distrust between James and Sickert. Rothenstein was present during one of Sickert's visits to the rue du Bac, and later wrote, 'Whistler seemed to have some grievance against him, fancied or real, and Sickert was quiet and a little constrained.'[19]

Pennell, in his biography, sought to encourage the view that James's 'followers' were some sort of band of nonentities, drawn to him, unquestioning, like metal to a magnet. Rothenstein later attacked Pennell for this. For all his high-brow indifference, Rothenstein wrote, did not Pennell become 'one of the most sycophantic'?[20]

Throughout the summer and autumn of 1894 James created some of the most accomplished lithographs of his career. In one in particular, *La Belle Jardinière*, he drew Beatrice tending some flowers in the beautiful garden of the rue du Bac. It seemed he was desperate to create an image of normal and harmonious domesticity, when in fact, deep down, he knew that Beatrice's increasing and sustained bouts of illness were more serious than he dared to admit. The pattern was repeated on several occasions in images such as *The Duet*, in which Beatrice is seen playing the piano with her sister, Ethel. This haunting image is reminiscent of his early days at Sloane Street in London, in the company of his half-sister Deborah and his niece Annie. In another, entitled *La Robe rouge*, which was later published in the *Studio* in the same year, the image is of Beatrice, this time reclining somewhat wearily on a sofa. He was also working on a number of oil portraits of Ethel at this time.[21] Significantly, however, there are none of Beatrice: such a laborious undertaking was now beyond her physical capacities. There is evidence, too, that he began work on a self-portrait. The first for nearly a quarter of a century, this small painting, measuring only 26 × 20.5 cm,[22] shows James standing almost side-on, looking downwards towards the viewer. The fact that he should return to this form of introspection says much about his state of mind at this period.

The summer, however, did have some moments of wonderful pleasure. One of the most enjoyable was the marriage of Ethel to Charles Whibley. After a small church service the couple and their guests returned to the rue

du Bac for the reception in the garden. A photograph taken of the event shows James and his guests, happy and relaxed.

The warm reception given to the portrait of Montesquiou at the Société Nationale was another welcome diversion. As well as the French press, which generally agreed the success of the painting, the favourable reactions of most of the English press gave him a tremendous sense of satisfaction. One in particular, which appeared in the *Magazine of Art*, noted that the portrait 'is certainly one of the most remarkable . . . produced by him of late years'. Warming to his defence of James, the reviewer continued:

> Some unwise persons . . . have attempted to make mock of this singularly interesting performance, ignorant both of what Mr Whistler aims at in art, and more especially of what he here aims at in portraiture. M. de Montesquiou-Fezensac is the pontiff of aestheticism whom the Faubourg St Germain delights to honour, both the versifier-in-chief and the designer of 'unutterably precious' things in furniture and *vertu* to that exclusive section of Parisian society. The quintessential type of such a super-subtle personality as this is just such as this painter's art and his alone can adequately render, and he has rendered its main characteristics, physical and mental, in masterly fashion. All that can be said is that his execution has not all the mysterious refinements of former times, but more openly reveals its secrets to the beholder.

In the face of such praise, and despite the Eden débâcle which was yet to be resolved, James was keen to get back to portrait commissions. Throughout the remainder of 1894, he began at least three. Of these the first was probably *Rose et vert: L'iris – Portrait of Miss Kinsella*. Louise Kinsella was one of the three daughters of an American newspaper editor, Thomas Kinsella, in Paris to finish her education. How the commission originated is not altogether clear, but she certainly knew both Studd and Rothenstein and the latter made a drawing of her. The portrait was started in June and unlike the earlier portrait of Lady Eden, it was to be almost full-length. Within weeks of starting James was well pleased with its progress and wrote to Kennedy in New York that it 'promises superbly'.[23] Characteristically, after the initial burst of enthusiasm, the portrait began to drag and it, like Cowan's, remained unfinished at the time of James's death.

Soon after, James switched his attention to another portrait, which he began in the late summer. Arthur J. Eddy, a Chicago lawyer, had commissioned James the previous year. According to the Pennells, the sittings took only six weeks: 'Whistler liked his straightforward American frankness in saying that his portrait must be done by a certain date.'[24] James

noted later, 'Well, you know, he is the only man who ever did get a picture out of me on time, while I worked and he waited!'[25] Eddy's portrait, again a full-length, followed essentially the same format as Cowan's some eighteen months before. It did not have the 'lineage' of the Duret or the Montesquiou, nor did it measure up to the small-scale portrait of Kennedy. Like Cowan's it is a professional descriptive portrait. As Cowan was dressed like a country squire in breeches and jacket, about to venture forth on his rural pursuits, Eddy is the city professional personified. Armed with top hat and gloves, impeccably dressed in a suit and overcoat, he is about to begin a day's work at the office. In case the viewer may have missed the point, he also carries a legal brief to signify his calling. Portraits such as these were done only for the commission fee they generated and nothing more. They were, and remained, for the rest of James's life, lucrative respites. After watching the fortunes of people like John Singer Sargent, James can perhaps be forgiven if he strayed a little way down this path.

Not long after the Eddy portrait was completed, Sir William Eden and his wife returned from India. Almost immediately Eden demanded that the portrait he had paid for be handed over. James refused point blank to accede to his request. The portrait was not only his, he argued, but in addition he was not totally satisfied with the result; he therefore had the right to hold on to it until such time as he believed it fit to leave the studio. Such an argument held little sway with Eden: not only had he paid for the painting, he maintained, but the fact that it had been publicly exhibited must imply that the artist considered it 'finished'. Frustrated by James's refusal to release it, Eden instigated legal proceedings in Paris on 8 November, in an attempt to retrieve the painting. James's reply was totally in keeping: he simply returned the money. Eden, however, was loath to let the matter drop; he was not used to such treatment, never having had any trouble with artists before. Both Sickert[26] and Jacques-Emile Blanche had painted his wife already without any bother.[27]

Eden, however justified in his demand, could not have chosen a more inopportune moment to engage with James. Only days earlier, Beatrice's illness had taken a decisive turn for the worse. James sought the opinion of a noted Paris physician. His prognosis was devastating and for the first time James was made fully aware of her desperate state. She had cancer and she needed an operation as soon as possible. Almost in a blind panic, he wrote to his brother William in London, enclosing the fare for him to travel to Paris at once: 'The fact of it is I want you here on Monday morning – when at 9 o'clock some French doctors are coming – there is to be an operation performed – and Trixie must not know of your coming – though she will be glad to have you when you are here.'[28]

Dropping everything, William rushed to Paris. While he agreed with the diagnosis of cancer, he forbade the operation. Although the treatment of the disease in the late nineteenth century was varied and essentially ineffective, the standard procedure for a tumour was surgical, often through cauterization.[29] Though no expert on the subject, William appeared to distrust the French doctors, and began almost immediately to make other arrangements. It was certainly at his instigation that the services of an English nurse, a Miss Duncan, were enlisted to attend to Beatrice's needs, while he pondered the next course of action.[30]

Throughout most of November, James appeared numb as the awful events unfolded. Attitudes to cancer, one of the most dreaded diseases of the nineteenth century, appear strange to us today. It was viewed almost as a moral affliction, rarely mentioned and even more rarely admitted. There was one particular school of thought within the medical profession – almost universally accepted by the public at large – which held that the disease was sexually transmitted. It was certainly under such a cloud of guilt that James, unlike Beatrice, refused to accept the prognosis. Bitter, enraged, and at times almost demented at what fate had forced upon him, he spent the next eighteen months in a hopeless and forlorn search for something that simply did not exist: a cure for cancer. The year 1894 ended in a state of great distress and unhappiness.

27

The Sun Goes Out

WILLIAM WHISTLER STAYED for as long as he could at the rue du Bac. Although his medical expertise lay in the field of laryngology, his presence, at least initially, was comforting. True to his somewhat 'slow and sedate' manner[1] he did not mislead James into any false sense of security; rather he stressed the magnitude of the disease and its consequences. Such straightforwardness perturbed James greatly: it was not the sort of defeatist talk he wanted to hear from the one he had always accounted 'the great magician'.[2] On one of their many evenings together, perhaps as a diversion from the stark reality facing him, James began several lithographic drawings of William; the result was *The Doctor*. While James was not totally pleased with the results, Beatrice was, and unbeknown to him she sent them on to Way in London, who printed several proofs of one of them.[3] When they were returned from London several days later James's earlier reservations evaporated. 'This is really fine,' he wrote to his printer. 'I wish I had sent it to you when quite *fresh*. I like the proofs with the sharp bright black lines in the coat.'[4]

Feeling that he had done all he could, William returned to London probably in mid-November. After several weeks, James and Beatrice followed, closing up their beloved house in the rue du Bac and booking into Long's Hotel in New Bond Street. Almost immediately Walter Sickert put at James's disposal his studio at 13 Robert Street. James accepted Sickert's gesture gratefully; the last thing he needed at this stage was to sit idly waiting for something to happen.

Though he would never admit it, it probably felt good to be back amongst familiar surroundings. With Beatrice's close family network on

hand to see to her needs, James was soon getting out and about and visiting old friends and associates, which helped to take his mind off the unbearable. On several evenings he called at the Beefsteak Club, and on other occasions visited the Chelsea Arts Club where he was treated like a lost leader: he thrived on the attention bestowed upon him, particularly from the younger members. During the daytime he regularly made the trip to Wellington Street, to see young Thomas Way, and took a great interest in the catalogue of lithographs he was compiling. Other visits took him to the Pennells' renowned 'at homes' on Thursday evenings at their spacious flat in Buckingham Street, just off the Strand. Arriving, James customarily addressed the door with a 'memorable and unmistakable knock',[5] and no matter who was present, always assumed the role of chief guest and celebrity. During one of these evenings at the Pennells, in what must have been an uneasy truce, James made a lithographic drawing of Walter Sickert, sitting rather stiffly in a fireside chair, with the shadow of the flames of the fire leaping around him.

On one of these Thursday evenings he met Robert Barr. Canadian by birth, and a writer and journalist by profession, he volunteered his services to entertain James and visit him when required. Obviously genuine in his concern for James, Barr became for a while a close and trusted confidant,[6] and shortly after their meeting James suggested that he should sit for him. Barr quickly agreed, though it did not take long before he realized the implications of such an undertaking. Almost daily he was summoned to attend the studio and sit for hours on end. But despite the long hours, the picture has an air of spontaneity and a feeling of fluidity rare in James's late portraits, and must be seen as one of the most successful. It must have come as a relief when James switched his attention to Barr's daughter, Laura – although only tantalizing details of her portrait survive by way of written record: the portrait was lost, or perhaps stolen, shortly after completion.[7]

Throughout the late winter and early spring of 1895, James was engaged on several other portraits, some of which were commissions, including those of Mrs Beaumont, Mrs Walter Cave and Miss Marion Peck. But the pending Eden case was beginning to preoccupy him. Towards the end of February, he returned to Paris to defend his actions at the Civil Tribunal of the Seine. Before he left London he painted out the face of Lady Eden from the contested portrait and substituted for it that of another lady, an American, Mrs Herbert Dudley Hale; and for good measure, he added a vase of flowers. The lady in question accompanied James to the hearing, sat beside him throughout, and wore the same clothes as she had posed in.[8]

The evidence from the two parties was heard over several days. In

essence James's defence rested on the supposed fact that the agreement of sale between an artist and his patron is no ordinary agreement. The artist, he argued, had the right to hold on to the picture until he was satisfied that it was in fit condition to leave the studio. In this instance, conveniently forgetting that he had allowed the painting to be exhibited the previous spring, James maintained that it was not a satisfactory painting, hence his decision to withhold it. Eden's counsel, however, urged the contrary: Eden had commissioned the painting, paid for it and expected quite frankly to receive it.

Shortly after the submissions were heard, James returned to London to await the judgement. Characteristically, he could not resist writing a letter to the *Pall Mall Gazette* challenging Eden's claim that he was still in possession of the fee and the portrait:

> Pending the decision of the Court, we will not go much into this matter. Only permit me to correct a current error, suggesting that 'Mr Whistler has eclipsed himself in the "Gentle Art" by both keeping the noble Sportsman's Valentine, and declining to surrender the picture'.
>
> When the picture was demanded in return for the *Valentine*(!) I sent the cheque for the hundred, through my Solicitors, to this amazing Patron of Art – and wiped out the picture.
>
> The Baronet would not have back his money – as the busman would not take back his own bad shilling – he is going for bigger stakes – 10,000 francs!
>
> The cheque has been paid into Court – the picture has been entirely *repainted* – and the Portrait, which activated Sir William Eden's excellent 'confidence' tactics . . . doesn't exist! For the moment, voilà où nous en sommes. Pretty, isn't it!⁹

While James was warming to yet another senseless 'battle', Beatrice was fraught with worry about the outcome, not least because of the expense. After an interview given by Sir William Eden in the *New York Herald* on 2 March 1895, James responded in the *Pall Mall Gazette*, pointing out the meanness of both Eden and George Moore. Prompted by an onslaught of a relative of Eden's who condemned James's vulgarity in the whole matter, James sent a copy of his reply to George Moore himself. Moore's answer, published in the *Pall Mall Gazette*, was hard hitting:

> Dear Whistler, – I am reading a wonderful book *en route*, by J.K. Huysmans, and have no time to consider the senile little squalls which you address to the papers and are obliging enough to send to me. There is so much else in life to interest one. Yesterday I was touched by the spectacle of an elderly

eccentric hopping about on the edge of the pavement; his hat was in the gutter, and his clothes were covered with mud. The pity of the whole thing was that the poor chap fancied that every one was admiring him . . .

[As a postscript Moore noted:] If a man sent me a cheque for a MS., and I cashed the cheque, I should consider myself bound to deliver the MS., and if I decline to deliver the MS. I should consider that I was acting dishonourably. But, then, every one has his own code of honour.[10]

James believed that the only honourable way to answer such an insulting letter was to challenge Moore to a duel. He went so far as to recruit two 'seconds' to support him and represent his interests; but, despite several provocative letters aimed at him through the pages of the *Pall Mall Gazette*, Moore refused to be drawn. To add insult to injury, Moore explained that his decision not to enter into such a spectacle was in part due to the fact that 'Whistler was too old and near-sighted'.[11]

There was perhaps a deeper reason for James's drastic challenge to George Moore. Two years earlier Moore had published *Modern Painting* – a book, as the title implied, which addressed its subject from the standpoint of the 'new art criticism'. In the first chapter, which focused on James, Moore writes in an almost sycophantic manner. Beginning by claiming that the portrait of Cicely Alexander is 'the most beautiful in the world', even more 'delightful' than Velázquez's *Infantas*, Moore continues his barrage of adulation, going through the influences upon his work and the influence it in turn has had on others. While James may have blushed with embarrassment at such high-flown praise, his mood would have quickly changed on reading of Moore's belief that such magical moments in art were only made possible by character faults: a nervous tension and, even worse, a 'physical weakness'. To the former West Point officer cadet – an episode in his life to which James attached increasing importance as he grew older – such claims were wounding. The duel was a suitably martial riposte, when the moment came.

As the whole affair, which kept London, not to mention Parisian society absorbed, came to its tittering conclusion in the press, judgement in the Eden case was announced in Paris. James was ordered to hand over the portrait to Sir William and pay damages of 1,000 francs. James entered an appeal, as he was entitled to do, at the Cour de Cassation. More than two years later that court made its judgement, which allowed James to retain possession of the portrait so long as he did 'not make use of it, public or private'.[12] Still not content with that, James appealed again. In April 1900, some five years after the original case, he was given the judgement that he had wanted all along: full costs against Eden. In a case which should never

have been brought in the first place, his persistence finally paid off. But by then, as so often in the past, everyone one else had forgotten the matter.

Back in London in 1895 interest centred on the rumours concerning James's old adversary, Oscar Wilde, and Lord Alfred Douglas. On 3 April, the day that Wilde's libel action against Lord Alfred's father, the Marquess of Queensberry, opened in London – an action that would ultimately precipitate the later prosecutions against Wilde – James, now back with Beatrice at the rue du Bac, wrote to Thomson. No judgement was made of Wilde's alleged actions. Instead, he asked about the sale of Wilde's possessions which was taking place in London, noting: 'there is a little brown paper drawing that curiously enough I believe he bought at the sale of the White House when I was in Venice – one of the scrapings of the Studio as usual – but I dare say pretty – I think that Mrs Whistler would like to have it.'[13] With Wilde already purged from his life and replaced by Sir William Eden as a hate figure, there was no need to wallow in his misfortune. Against the background of his own anxieties it frankly mattered little.

Since the advent of the debate between the 'Philistines' and the 'new art critics', the art of Velázquez had become something of a touchstone and had taken on extra significance with the publication of R.A.M. Stevenson's book *Velasquez*, during 1895. Stevenson constructed a historically sophisticated aesthetic framework, primarily based on the art of Velázquez, to underpin and in many respects justify and explain the genealogy of modern art, particularly 'Impressionism'. The whole debate rekindled James's interest and during his stay in London he had several discussions with Stevenson himself during evenings at the Pennells. Stevenson's book came to represent a critical watershed in the literature of modern art in Britain. In more immediate terms, however, by rooting the basis of 'Impressionism' firmly within a long historical tradition, he helped both its popular and critical cause immeasurably.

One important aspect of Stevenson's eloquent argument was centred on the vexed issue of technique. Here, by stressing the dissimilarity between literature and the visual arts – a view in opposition to the prevalent Victorian notion – Stevenson was able to argue that looking at paintings and reading a book necessitated two different types of perception. Unlike literature, any of the visual arts, such as painting, expresses itself simultaneously; thus it is aspects such as form, light and space which make the immediate impression. For Stevenson, Velázquez was one of the first painters to appreciate this distinction and take advantage of its effects, particularly in his skill at rendering 'the mystery of enveloping air'.[14] These same effects, he argued, formed the basis of 'Impressionism'.

That such issues were on James's mind when he and Beatrice returned to Paris in April 1895, still fretting about the Eden case and preoccupied with Beatrice's health, is without question. Almost immediately he started a self-portrait. This time, unlike the almost jocular one of a year or so before, the portrait reveals the face of an old, even troubled man. Posing himself in the fashion of Velázquez's painting of Pablo de Valladolid, James marked his commitment to the idealization of Velázquez's art as never before. As if following the theories adumbrated by Stevenson, James appears, as it were, from nowhere. Surrounded by nothing but an empty space, he seems to pull the viewer towards the centre by means of his expressive hands, which reinforce the almost desperate undercurrent that permeates the painting. While the gesture of homage to Velázquez is clear, the portrait arguably falls also within the ethereal ethic of Symbolism. The pathos in *Brown and Gold*, as he later described it, is almost tangible.

Throughout the summer of 1895 little else was started at the studio in Paris. Some lithographs were attempted, but it was clear that James was preoccupied with other matters. Even the 'Salon' season did not give respite. One portrait was begun, of his favourite model Carmen, who had introduced herself to him as a girl some years before. Very much in the mould of the Pettigrew sisters, Carmen was a relaxed, even cheeky model. James felt unhurried in her company, and for hours on end he tinkered around with her portrait. By no means one of his most successful, it is nevertheless a sensitive portrait, if somewhat laboured. The sittings, however, cemented the friendship and Carmen, like the Pettigrew sisters before her, became an integral part of the Whistler household.

One thing that particularly irked him during the early summer was hearing the news that Seymour Haden had been awarded a knighthood for his services to the art of etching. Although the award was almost a foregone conclusion, its announcement still cut deep. Edward Kennedy wrote from New York in an attempt to make light of the announcement:

> Sir Wm. Agnew *Bart*! Poor Sir Seymour Kt!!! Alas, the futility of striving, when talent, genius, etc. etc. can only arrive at Knighthood, and Bill Agnew – picture dealer – is made a Baronet with a large B!!! Sigh not therefore, my dear friend, after such empty honours! Remain satisfied to be King of the brush and needle, for what would you do in the company of the Knight of the Shire and of the Baronet with a big, big B?[15]

The net result of Haden's honour was that James became even more concerned that his paintings should be kept as far away from English collections as humanly possible. Thomson made a bad misjudgement when

he approached Arthur Studd on behalf on an unspecified group of people who were anxious to buy *The Little White Girl* for the National Portrait Gallery. Furious at such a suggestion, James at once contacted Studd and begged that if the picture ever left his family, he would promise never to leave it to 'any gallery in *England* – The Louvre is good enough for me.'[16] Although Studd humoured James during his lifetime, he apparently felt no obligation to him after his death. Reputedly offered over a quarter of a million pounds by Charles Lang Freer for his three Whistler paintings, he declined the offer and instead bequeathed them to the National Gallery in London. In 1951, they were subsequently transferred to the Tate Gallery.

George McCulloch, a Scottish-born Australian millionaire, who already owned several paintings by James, bought the self-portrait, *Portrait of the Painter*, dating from the early seventies, from the Goupil for £700 where it had been since the 1892 retrospective. It was unsigned, and McCulloch requested Thomson to ask James to add his signature to it. At first he refused point blank. After some tactful diplomacy from Thomson he reluctantly acquiesced and added, not his signature, but the butterfly emblem. James wrote to Thomson: 'Be good enough to say to Mr McCulloch with my compliments that the picture is *signed* – as completely as one of his own cheques is signed when he has written his name on it – If, not content with that, he be ever asked *to print it* in the "bottom right hand corner," the nature of his own request to me may become clear to him.'[17]

Since the spring Beatrice had cherished the idea of a holiday near the sea. In one letter written to William's wife, Helen, Beatrice suggested that she join them on a holiday either on the Isle of Wight, or 'somewhere on the South Coast'.[18] The holiday never materialized, and by the end of the 'Paris season' Beatrice was no better, though short periods of remission continued to give James false hopes. In late August she and James closed up the rue du Bac and travelled to the seaside spa of Bagnoles on the northern French coast. Within days James had had his fill of the somewhat dull place: it was all rather 'triste', he informed his brother.[19] So from there, they quickly crossed the Channel and travelled to Lyme Regis in Dorset. Lyme, together with its therapeutic 'airs', also offered the visitor a vision of old world charm.

On arrival, James and Beatrice booked into the still extant Royal Lion Inn, situated on Broad Street. Writing to Thomson, James informed him: 'We are staying here for health at present, and I shall have some lovely little pictures of the nature of "The Little Sweet Shop" – only if anything finer in quality.'[20] Lyme Regis also provided new subject-matter for James's

lithographic crayon, and during his three-month stay in the town he produced some ten lithographs. Nearly all were centred on the blacksmith's shop owned by Samuel Edward Govier. Knowing that Thomson and the Goupil were not as interested in his printed work as the paintings, James was soon resuming contact with the Fine Art Society. Again, his motive was largely monetary, as he revealed in a moment of frankness to Marcus Huish:

> The truth is as I am sure you will have guessed, everything is difficult for me at this time . . . Much moving about has necessitated much leaving behind – in the way of work unfinished – & wherever I go I cannot help becoming entangled with new work – all of which has to be accomplished.
>
> An exhibition may be advisable at this moment – & I am urged to it on all sides – but the possible glory of a tolerable show of lithographs in the face of Burlington House & Goulding combined is not sufficient to tempt me. The chatter of papers & all that, I have but little thought for – No – this is the only excuse for my entertaining any propositions of a public kind. At this moment I ought to be far away – & not down here of all places in the world.[21]

The reference to Burlington House was an allusion to a planned exhibition of lithographs by British artists, organized by the printer Frederick Goulding, the President of the Royal Academy Frederic Leighton, and others, to be held at the Dunthorne Gallery that November.

When Beatrice travelled up to London in October, James's decision to remain behind in Lyme Regis to complete his work was undoubtedly influenced by his pressing lack of funds. It was during this separation, which lengthened to three months, that a regular exchange of letters between them again took place. Taking advantage of the three posts a day to London, James would often rush off a letter in the morning, sometimes another in the early afternoon, and both could be read by Beatrice in the evening. James's doubts and fears are clearly revealed. There was the constant worry about Beatrice, as well as his own private doubts as to the quality of his work. There is a tone of guilt throughout at his decision to remain behind. By doing so, however, he could remove himself from the harsh reality of his wife's disease and concentrate on creating some saleable work. James simply could not bear to witness her suffering; perhaps it recalled the anguish he endured watching his mother's slow decline. He feared death more than he would ever admit.

Whilst James accepted the absence of Beatrice, true to his character he found it impossible to be alone. Throughout most of his time in the town

he enjoyed the company of Arthur Studd, who had come over to visit him. Accompanying Studd was his French servant Auguste, and when Studd left Lyme Regis to attend to some business in London, he left Auguste behind to see to James's creature comforts.

His three-month stay in Lyme Regis allowed James to work in a more concentrated manner and produce a range of lithographs, drawings and paintings, though no etchings. Two portraits survive, out of a possible four which he started:[22] *Little Rosie of Lyme Regis* and *The Master Smith of Lyme Regis*, both uncommissioned. James was fascinated with the earthy wholesomeness of his sitters and in many ways the portraits recall his early days of realism. Rosie Rendall's father ran the greengrocer's shop in the town. James apparently met her in the street, and gently asked the little girl if he could paint her. Rosie, according to the tale, fled in horror, taking literally James's request and imagining that he intended to paint her from head to foot. The subsequent painting of Rosie posing in her clean school smock reveals an objectivity rarely seen in Victorian child portraiture and it remains one of the most successful of all his portraits of children.

Of the rest of the work completed in Lyme Regis, it is the theme of the blacksmith that is dominant. It was not a new one for James, being traceable to the early 1860s, and he continued with it when the opportunity presented itself until a few years before his death. Unlike his earlier work on the subject, such as the detailed and somewhat cluttered drypoint, *The Forge*, of 1861, the ten lithographs of Lyme Regis concerned with the blacksmith are notable for their economy, and with a few strokes of the crayon capture completely the essence of the scene. In almost all of James's drawings, the figure of Sam Govier, the master blacksmith, appears. His striking countenance must have appealed to James who asked him to sit for a portrait. The result was an intimate study of the master smith, on a scale far removed from commissioned works such as the portraits of Montesquiou or Cowan. As with his studies of children in Lyme Regis, James it seems was able to get close to his sitter, thus establishing an intimacy which his larger portraits arguably lacked. In *The Master Smith of Lyme Regis*, the head of Sam Govier emerges from a dark background, well modelled and three-dimensional. The dark setting, and the particular fall of the light, suggests that he was working in a dimly lit room, even possibly by candle-light. Interestingly, like a number of Old Master painters, James used a dark ground, and the red underpaint contributes to the richer colouring. More 'finished' than most of James's portraits, the highlights of white paint on the forehead and nose suggest some of the Old Masters he mentioned in his letters to Beatrice.

In many ways the painting is reminiscent of Velázquez, and in one

particular letter he related to Beatrice the story of how Velázquez was asked by the King of Spain to touch up his collection of paintings, and how 'they [the paintings] answered to the Master's call'.[23] Reviewing his own efforts, James wrote to Beatrice, that perhaps like Velázquez he could retouch his own works and they 'may be saved', presumably for posterity. He continued expanding on the idea:

> well again what I mean is that the trouble and agonies I have had – even with or especially with these present things – you can quite understand was owing to the *doubtful* beginnings of the old uncertainty – and that trouble – and loss of time – for time is taken by *Doubt* – I am to have no more! there *this* is what I mean – & *that* is the outcoming of the exile to which the grand Lady [Beatrice] condemned the wretched grinder [James] in order that he might become her Painter & be worthy of his office.[24]

In another letter James reverts again to the theme of time, writing: 'You see Chink [a pet name used between themselves] the one *great* truth that has impressed itself on me, is that time *is* an element in the making of pictures, & haste is their undoing!'[25]

James's almost confessional letters to Beatrice betray, for the first time since perhaps his student days with Fantin, the sheer frustration he encountered. Only someone as close as Beatrice would have been made privy to the vacillation James suffered in his work, as he veered between complete arrogance and crippling bouts of self-doubt and blind fear of failure. William Rothenstein was one of the few intimates who was sensitive enough to catch a glimpse of this double nature, which had become more pronounced in James since the move to Paris. During one visit to the studio at the rue du Bac, Rothenstein, together with other privileged guests, was shown several paintings, only to have James expatiate at almost embarrassing length on their beauty and worth. On another evening, not long after, as Rothenstein explained:

> He had been gay enough during dinner, but now he became very quiet and intent, as though he forgot me. Turning a canvas that faced the wall, he examined it carefully up and down, with the candle near it, and then did the like with the others, peering closely into each. There was something tragic, almost frightening, as he looked suddenly old, as he held the candle with trembling hands, and stared at this work, while our shapes threw restless, fantastic shadows, all around us. As I followed him silently down the stairs I realized that even Whistler must often have felt his heart heavy with the sense of failure.[26]

His son Charles was still plying him with tiresome demands. Asked for a loan so that Charles could register a patent, James obligingly sent him the £20 required, but not without rounding on his attitude: 'You have had what seems to you a very hard time, but your trials are nearly nothing – they only concern *yourself* – I suppose you never thought of it in this light! – What does it matter that you sometimes eat little.'[27] James needed all his resources to cope with his own situation.

In fact Beatrice still had some fight left in her, particularly when she felt her husband's integrity threatened. The Greaves brothers, Walter and Henry, had recently completed a series of mural decorations at Streatham Town Hall, across the Thames in south London. James first became aware of the project when he was sent a cutting from the *Star* by Thomson,[28] who seemed annoyed on James's behalf that the brothers had described themselves as 'Pupils of Whistler'. James's response was to assure Thomson that the Greaves brothers had in fact once been his 'pupils': 'They were more my students than anyone else has ever been – and full of talent – but for years and years I have seen nothing. So I don't know how they have turned out. All my good or bad influence they may have got rid of – but certainly I shall stand by them – for at least they seem to be *loyal*.'[29] But to satisfy all doubts James asked Beatrice to go and visit the town hall. He could hardly have envisaged the ferocity of her response:

> You have no idea how dreadful it all is!! terrible! . . . They have remembered anything and everything you ever did, even to the Japanese panels in your drawing room, your brown paper sketches, the balcony, Battersea Bridge, Irving as Philip, the patterns on your frames!! . . . There I can't go on – it was like a sort of hideous Whistlerian chaos, I felt quite mad and sick, I laughed out loud at last, I couldn't help it and turned round to find the man who showed us round was laughing too.
>
> It's frantic – my love, I could kill them, conceited, ignorant, miserable gutter born wretches.[30]

Despite Beatrice's almost manic report, James said little, and by doing so remained true to his former 'pupils'. It illustrated Beatrice's long-standing loathing of James's past in which the unfortunate Greaves brothers were always seen as central players. Beatrice noted that the murals had already begun to deteriorate and that they were unlikely to last more than ten years. Unfortunately, her observation was correct. Badly prepared for the damp environment of the building, the fruits of many years' labour by the brothers simply vanished.[31]

Such distractions only momentarily arrested James's attention. What

were guaranteed to lift his spirits were visits from his London dealers. The first to arrive was Thomson, keen to see the painted work with a view to an exhibition. Shortly after followed Ernest Brown of the Fine Art Society, who was tactfully steered away from any of the painted work and shown only the lithographs. James's anticipation over the sale of his work, particularly the portraits, certainly spurred him on. As he amusingly reported to Beatrice, in one of his numerous despatches:

> I sit right down – *never* looking at the picture at all beforehand – and off I go as if I had been wound up and set on the floor like one of those toys Peter [Studd] used to bring you in his walks about town with Bunnie or the Major! Yes the grinder with all his legs and arms going directly he was put down! You would be afraid to take him up for fear he would whiz! in the air!³²

Sadly, however, James's optimism about a show of his paintings was shortlived. Within weeks of seeing Thomson the advance of Beatrice's illness had totally absorbed him. Reluctantly, he informed Thomson that the show would have to be postponed. As before, he was loath to admit the truth, but almost certainly Thomson knew full well the reasons behind it:

> Since I have seen you, I have been unable to go on with anything like work – It is not necessary that I should dwell upon the cause which has made progress impossible – and indeed it is in the *strictest confidence* that I speak to you of the absorbing nature of my preoccupation at home.
>
> On the other hand I feel it necessary that you should at once make other arrangements for the month when we had hoped to hold our exhibition. – This I know now must be postponed – I can only promise that when things are better, and we can manage it with becoming perfection, *you* shall have it. –
>
> Meanwhile I am forced to remain here still instead of returning to Paris as I had depended upon doing.³³

Ernest Brown of the Fine Art Society was luckier than Thomson. With most of the lithographs completed by the time of his visit to Lyme Regis, the work had only to be printed up and this could be left in the capable hands of the Ways. In a letter written on 20 November, Beatrice confessed to James:

> Sweetheart, you will never stay away so long again somehow – I cannot tell you to come before the picture is finished. I have had another bad day – I thought my bad week well past but it looks as if it is on now – Oh Chink –

I do suffer. I never thought I should be like this. But you know I was too happy so I am given some aches to remind me that this world is not quite paradise.[34]

In early December James left Lyme Regis and returned to London, to see Beatrice and to attend to the business of the forthcoming lithographic show at the Fine Art Society. Returning to his wife after nearly three months must have been heartbreaking for him. The toll of her illness would have made a drastic change in her physical appearance. Indeed, several papers reported a marked decline in his own health, and suggested that because of it he was unable to withstand her suffering. These comments infuriated him, but such was the price of celebrity. When, later in the month, he returned briefly to Lyme Regis to do further work on one of the portraits, he revealed to his brother William the extent of his own fears and concerns:

> It is true I didn't get round to see you – but not only was I as usual run off my legs – but I was worried to death and could talk to no one – not even you – or to myself either, if it came to that –
>
> However brighter days are coming – but that scoundrel Champneys – and a man who takes away *hope* from the patient entrusted to him is a vile scoundrel – Champneys has been the curse of our lives.[35]

The letter ends abruptly, a portion evidently removed by a later editorial hand. Champneys was another doctor consulted, who again confirmed the disease as terminal. Still James remained convinced that a cure could be found. After hearing that there were doctors in the United States who might be able to help he made arrangements to travel for the necessary consultations. He wrote to his New York dealer Edward Kennedy insisting on the necessity of keeping the trip entirely secret: 'we are not well enough at present for any public meetings or mentions.'[36]

As Beatrice's agony grew, James relied on Kennedy to send her 'medicine' from the United States.[37] The globules Kennedy duly despatched undoubtedly contained morphine widely used as a palliative treatment for cancer. It would have been easily available to Beatrice in England, particularly with the professional aid of William. But instead James insisted on receiving it from the United States, perhaps in the belief that the American version contained other active ingredients. By this time Beatrice had become completely addicted.

In the end the planned trip to the United States was never undertaken because Beatrice was too weak; instead, James had recourse to a disciple of

his intended American surgeon working in London, Dr Coryn. Such medical resources cost money which James did not have and the burden of her illness became an increasing strain, the extent of which remained hidden from Beatrice. In a candid letter to Kennedy, James's despair is made abundantly clear:

> What shall I say when you know that sadness is still my part – The Lady of my life still suffers – and we wait and wait in the long weariness of hope –
>
> For the last two years – perhaps three – what has it been – and long it must so be –
>
> Home we have left – and studio – and work! – what is it – what can it be – Fitful – and terror-stricken – And all just as ease and success and even power & perhaps even knowledge seemed to be smiling upon us.
>
> Heaven help us – I don't know . . . Overwhelmed & entangled in engagements undertaken in full confidence –
>
> But what am I saying . . . Easily I could clean off the slate as one might say, if I could be rid of the terrible sense of responsibility that weighs upon me and could be again in security and calm at my canvas! – What I should like to do would be to send back two or three cheques to people and say 'now at my ease you shall have your pictures – free from all signs of fright and fatigue – and *then* you shall pay me again' – Good God! – When I do get out of this I will never allow anyone to advance a half-penny on work not finished – Well, well my dear friend – you must forget all this – and I need not say *burn this* pitiful evidence of weakness and depression. For I know you will – and this time once again not a soul shall know – not an eye shall see this miserable paper I have confided to you.[38]

By the time James had written this letter, in March 1896, his lithograph show, opened the previous December at the Fine Art Society, was over. Though a critical success, the show had not done as well as he had expected. The handsomely laid out catalogue listed some seventy lithographs, and was accompanied by a prefatory essay by Joseph Pennell – the first time James had asked someone else to fulfil such a task.

Perhaps in an effort to keep his mind on other matters, Beatrice suggested that he should purchase a new studio in London. As his relations with Sickert had turned cold, even frosty, and there was no prospect of leaving London in the foreseeable future, it seemed the time had now come to find a permanent studio of his own. As the search got under way, John Singer Sargent offered James the use of his studio on the Fulham Road which had previously been loaned to Paul Helleu. The offer was gratefully accepted. But by March, James had found what he was looking for at 8

Fitzroy Street. It was a large studio, some 40 feet long, 25 feet wide and 25 feet high, and comprised a small kitchen area, an entrance hall, lobby and a model's dressing-room. The furnishings, according to the artist John Wimbush who occupied the studio below, were sparse: there was a painting-table, an easel in the middle of the floor, a chair, a stove and a cabinet for etchings. In order that the light inside should be absolutely correct, James took great care with the colour tint on the walls which were washed with 'a grey-pink made of whitening and Venetian red with a touch of black in it'.[39] To add the finishing touch he had all the woodwork painted white. Combined, the whole effect 'gave a warm grey shadow to the flesh'.[40]

In the late winter James and Beatrice moved to the luxury of the Savoy Hotel, owned by his old friends the D'Oyly Cartes, which overlooked the River Thames. On several occasions as he sat with her, James did lithographic drawings of the river view from their window. One of the most successful was *Savoy Pigeons* which shows the view up-river with Charing Cross railway-bridge and in the far distance the faint outline of the Houses of Parliament and Big Ben. On another occasion he drew Beatrice lying on her day-bed. Entitled *Siesta*, it shows Beatrice's lethargic wasted state, her arm hanging listlessly from the covers which protect her from the cold. By this stage, her existence consisted of little more than a fitful drug-induced sleep.

In early spring there appears to have been a period of remission. James was overjoyed, feeling at last that a breakthrough had been made. Advised by her doctor to seek 'country' air, he took her to a furnished cottage situated on the high crest of Hampstead Heath. At Jude Cottage, which still exists today, James's hopes rose. Writing to his long-suffering patron, J.J. Cowan, James could hardly contain his misplaced optimism:

> For the last two years or more, my one thought has been her care – And so we have wandered from home and work – going from town to country, and from doctor to doctor – Living in hotels, and leaving behind us the beautiful place you know so well in Paris – and the studio in which we passed so many hours – In this pilgrimage for health all other plans have fallen to ground – all sense of time and ambition was lost – we were ill – and the sun had gone out of our sky! At last however there is hope – great hope – mounting to certainty and happiness – and the weariness of the past – and the months gone by will cost us nothing – and we will be well.[41]

In this new mood of optimism James discussed with Ernest Brown of the Fine Art Society the possibility of a set of lithographic portraits. Two

portraits were certainly begun during the winter: one of Herbert Pollitt, a Cambridge graduate and print collector to whom James was probably introduced by Arthur Studd; the other of a Scottish Kirk minister and part-time author, Samuel Crockett. Although both began as lithographs, it appears they soon developed into full-blown portraits in oil. Neither, however, survives. As Arthur Eddy humorously reported of Crockett, 'though extremely clever, [he] was not blessed with the fatal gift of beauty':[42]

> When the portrait was finished, the sitter did not seem satisfied with it. 'Don't you like it?' enquired Whistler. 'No; I can't say I do. But,' in self-justification, 'you must admit that it is a bad work of art.' 'Yes,' Whistler replied, 'but I think you must admit that you are a bad work of nature.'[43]

James's optimism soon evaporated when Beatrice had a relapse and became critically ill in late April. Even the arrival of Kennedy from the United States was of little comfort, at least initially. Finally, in the early hours of 10 May, Beatrice died, at the age of 38. The death certificate issued on the same day recorded the cause of death as 'carcinoma of cervix uteri, 18 months'. Distraught to the point of mental breakdown, James began a period of mourning the effects of which would last until his own death seven years later. Writing to Edward Kennedy at his hotel later that same morning of 10 May, he could barely convey his thoughts. The two lines he wrote seemed to say it all: 'The end has come OK! – My dear Lady has left us – and I am without further hope.'[44]

Sometime later, James revealed to his friend and patron, Charles Lang Freer, a more consoling moment when an exotic bird, which had been a gift from Freer to Beatrice, sang a song:

> And when she went – alone, because I was unfit to go too – the strange dainty creature stood uplifted on the topmost perch and sang and sang – as if it had never sung before! . . . Peal after peal until it became a marvel the tiny breast, torn by such a glorious voice, should live!
>
> And suddenly it was made known to me that in this mysterious magpie waif from beyond the temples of India the spirit of my beautiful lady had lingered on its way – and the song was *her* song of love, and courage, and command that the work in which she had taken part, should be complete – and so was her farewell.[45]

In the immediate aftermath of Beatrice's death James was inconsolable. Friends and family rallied round offering support and comfort, but only

Edward Kennedy was able to direct his attention away from his misery, suggesting they should holiday together in France. In early July they crossed the Channel to Le Havre where they stayed for a day or so before travelling on to Honfleur and finally to Trouville. During the short trip James managed to do little work. There were no lithographs; such work was now out of the question as it brought back painful memories of Beatrice who had been his greatest champion in the medium. Instead, he dabbled at perhaps two, possibly three paintings. The most significant of these was *Brown and Gold: The Curé's Little Class* which shows a lesson taking place inside the church of St Catherine at Honfleur. While such a subject was unusual for James it was totally in keeping with his troubled state of mind and thoughts of mortality. Indeed, during Beatrice's illness earlier in the spring he had drawn lithographs of the exteriors of two London churches, St Anne's in Soho, and St Giles-in-the-Fields: in his personal suffering he seems to have drawn solace from the experience. In Honfleur, however, he seems to have been less concerned with the structural aspects of the setting than with the spiritual ambience within. Pondering the future and reliving the past inside the church – James later confessed to Beatrice's sister Ethel – he was filled with the desire to become a Catholic and to light a candle for Beatrice's soul.[46] His Protestant faith, he believed, had let him down in his darkest hour.

In a private moment during his stay in France, he jotted down in his sketchbook the scale of his loss:

All incidents and accidents of travel bring with them now the deepest sadness. From habit and from old delight attention is drawn to the smallest and most trivial mark in the evenness of the route – the stopping of the train, the starting of the boat, the little preparation, whatever it may be – the ringing of the bell, the pushing of the gangway.

All these announcements of freshness, this calling of attention to the thing about to happen – the thing achieved – the departure, the arrival, these are moments of dear companionship – when the mere joy of being together suffices and invests the smallest hint of the occurrence with the coloured interest of the event that takes place for these two only, that in their happiness they may be shown.

So I still put out my hand to take the other that I may never again hold and again I know that I journey by myself. I have lost her by the way, and all haste and all eagerness are vain and nothing shall become of it.[47]

That Beatrice's death changed James profoundly is beyond doubt. Preoccupied before by his struggle with those he had grown to loathe, now,

perhaps for the first time in his life, he felt consumed by loneliness. As one acquaintance later noted, 'He now looked old for the first time, and after the dreaded blow had fallen was never the same man again.'[48]

28

L'Affaire Sickert

WALTER SICKERT HEARD the news of Beatrice's death while on a visit to Venice. With characteristic sincerity and sensitivity, he wrote to James to express his condolences:

> You must always remember now how you made her life, from the moment when you took it up, absolutely perfect. Your love has been as perfect a whole as your work, & that is the utmost that can be achieved. Nor has her exquisite comprehension of you, & companionship with you ceased now – never let yourself forget that her spirit at your side is now, & will always be, for sanity & gaiety, & work, & you must not fail her now either, in your hardest peril.[1]

While James was certainly touched by the note, the whole issue of Sickert had been rankling with him for some time. For nearly a year Sickert had kept himself out of James's way, and had communicated with him rarely. Sickert's own defence for this action was simple. Both were busy with their own lives and as James had come more and more to rely on Pennell, Sickert felt no compunction in withdrawing. The very fact that Pennell had written the catalogue introduction for James's lithograph exhibition was evidence enough of his new seniority within the ranks. Sickert was no sycophant and he had no intention of playing second fiddle to the likes of Pennell.

Sickert's absence in Venice was not wholly concerned with work. His wife Ellen had discovered that he was having an affair, and their marriage was inevitably under tremendous strain. The trip to Venice was an attempt

to heal the wounds. Sickert was horrified at the prospect of his infidelity being made public and a holiday away from the gossip of London seemed the right course to take. Unknown to Sickert, however, James was well aware of his marital problems through 'the ladies of the family' who, close friends of Ellen, kept him fully informed of developments.

Despite attempts at reconciliation, Sickert's marriage finally broke up several months after Beatrice's death, in September 1896. James was galled at his former pupil's behaviour. Not only did he like and admire Ellen, but her case seemed all the more poignant in the light of James's own tragedy. As he travelled to and fro between William Heinemann's flat in Whitehall Court where he was staying as a guest, and resorts along the north coast of France, the loss of Beatrice appeared not to have diminished one jot.

Not long after James's arrival back at Heinemann's flat at the beginning of October, Sickert too returned to London and within days was to make a serious miscalculation. As James informed the 'Major', Beatrice's sister Rosalind: 'My own news is that Walter Sickert has been in town for days – he has not presented himself to me – but has been parading Bond Street with Sir William Eden & George Moore!'² The two men being sworn enemies of James, the offence was unforgivable.

Sickert must have been tipped off about James's fury, for several days later he wrote and apologized for the misdemeanour, asking to remain friends. It was too late, and James quickly returned the card with a note, the contents of which must have cut Sickert to the quick:

> I fear I really dare not Walter! Though doubtless I shall miss you. Benedict Arnold [the infamous American War of Independence traitor] they say, was a pleasant desperate fellow and found our old friend of the 30 pieces irresistible! –
>
> I fancy you will have done it cheaper though poor chap! – yet be careful – Remember! and take nothing from the Baronet in an *envelope*. Adieu!³

William Rothenstein, so long a kindly and supportive friend, also felt James's wrath, in an incident not unconnected with Sickert. The New English Art Club invited Sir William Eden to submit some work to their forthcoming exhibition. Rothenstein was one of the committee members, along with Walter Sickert, Professor Fred Brown and Philip Wilson Steer. James therefore held Rothenstein responsible for Eden's invitation. Word of this inevitably reached Rothenstein, who responded by flatly denying any responsibility: 'I have nothing to do with the exhibition . . . I have heard you have been talking about me unfavourably.'⁴ Still not content, James planned what he would later describe as his 'raid' on the Chelsea Arts Club.

There he confronted Steer and several other members of the NEAC, told them what he thought and, as quickly as he had arrived, disappeared.[5] Sickert meanwhile had gone to ground and refused to be drawn, knowing full well the dangers should he react in the public domain.

Almost every evening a formal dinner was held by William Heinemann in his flat, to which were invited leading lights of London's literary and artistic milieu. James loved the cut and thrust of their topical debates and the gossip from around town. An evocative description of James comes from the Symbolist writer, Arthur Symons, present at one of these occasions:

> I never saw any one so feverishly alive as this little, old man, with his bright, withered cheeks, over which the skin was drawn tightly, his darting eyes, under their prickly bushes of eyebrow, his fantastically-creased black and white curls of hair, his bitter and subtle mouth, and, above all, his exquisite hands, never at rest. He had the most sensitive fingers I have ever seen, long, thin, bony, wrinkled, every finger alive to the tips, like the fingers of a mesmerist. He was proud of his hands, and they were never out of his sight; they travelled to his moustache, crawled over the table, grimaced in little gestures. If ever a painter had painter's hands it was Whistler.[6]

The luxury of life at the Heinemanns' was a million miles away from the plight of one particular artist for whom James had great respect, the water-colourist Charles Holloway. Four years younger than James, Holloway, at one point earlier in his career an associate of William Morris, had for years been quietly exhibiting watercolours, usually topographical, at the Royal Academy with limited success. James had known him from his earliest days in London when both Holloway and himself had occasionally attended the renowned painting school in Newman Street run by James Matthews Leigh. Holloway was a quiet reserved man and never fitted into James's social orbit. Over the years they had met occasionally, and now, some thirty years later, had renewed their friendship following a chance encounter in Fitzroy Street.

Throughout the period of Beatrice's final illness, James, it seems, was a frequent visitor to his friend's studio-flat, where Holloway must have proved an understanding friend. Not long after James had returned from his French holiday with Kennedy he heard that Holloway had been taken ill. Visiting him, James was shocked to see the squalid conditions that now engulfed his friend. Perhaps remembering Beatrice's suffering, he immediately set about providing a doctor, paying for food and employing a nurse to visit him daily. James, it seemed, needed to care for someone, if

only to distract him for a moment from his own prolonged grief and anger. Very likely it was James too who saw to it that a fund was discreetly set up for the ailing but immensely proud artist. During the late autumn and throughout the Christmas period, James visited him almost daily bringing with him newspapers and tobacco besides regaling him with the latest morsels of London gossip.

One of the people asked to contribute to the fund for Holloway was Walter Sickert. Sickert refused, for the simple reason that he was broke: 'I have nothing just now but my landlady's credit.'[7] Sickert's refusal to help Holloway was interpreted by James as yet another personal slight. All the while Sickert continued to avoid places where he might run into his former 'master', and said nothing publicly or privately to create a situation in which he might be called to account: it was the last thing he needed at this time. Just before Christmas, he visited a number of exhibitions in the West End, since his precarious financial situation meant that he had to earn some money from art criticism. The Fine Art Society was showing forty lithographs by Joseph Pennell. What perhaps irked Sickert most of all as he browsed through the catalogue was the fact that James had written the introduction, vindicating as it seemed Sickert's belief that it had been Pennell all along who had been poisoning James's mind against him. The drawings were good, Sickert would later write, but with his present feelings towards Pennell, there was no way, even for money, that he was going to write a favourable review.

As he continued viewing the show it dawned on Sickert that the pictures were not, in fact, what the labels claimed. They were transfer lithographs, not 'lithographs' in the traditional sense. That Sickert should have bothered with such a point which, by the late 1890s, was almost academic, served only to underline the fact that he was determined to cut Pennell down to size once and for all. Not only could Sickert expose Pennell as a fraud, but he could also work in a suitably laudatory passage on James and his brilliant work in the medium. Reasoning that James would not want to be associated with Pennell after such exposure, Sickert expected by this means to resume his position as trusted confidant.

For days Sickert honed and perfected his article. On Boxing Day 1896, a week after its delivery to the *Saturday Review*, it finally appeared. The first few sentences set its bitter and vitriolic tone:

It were unjust to hold Mr Pennell the draughtsman responsible for Mr Pennell the critic. Mr Pennell is a clever draughtsman and a shocking bad critic. Some years ago, however, Professor Herkomer published a book with illustrations which he described as etchings . . . Mr Pennell protested in

the papers that some of these illustrations were improperly described as etchings. He pointed out that, whereas an etching by So-and-So is worth so-and-so many guineas, a photo-zinc reproduction of a pen drawing by the same person is worth less in the market than so-and-so many pence. It is not a question of art, but of commercial morality . . . It appears to me that in entitling the collection of illustrations of scenes and places described in Washington Irving's *Alhambra* lithographs, Mr Pennell has been guilty of the same looseness of statement as he succeeded in bringing home to Professor Herkomer. If we are to keep our artistic diction pure – and it is, for every possible reason, artistic and commercial, well that we should do so, – a lithograph by Mr Pennell must be made to mean a drawing done on stone by Mr Pennell, and then printed. It does not mean a drawing done by Mr Pennell on transfer paper and then transferred by the lithographer on to stone, and then printed.

Sickert then called on historical precedents, and in particular the work of Daumier. The actions of Pennell, he declared, 'degraded' the medium and were done only for convenience. He concluded his essay with fulsome praise for James's pioneering work in the medium, and an appeal:

Mr Whistler is a genius. His slightest utterance is inspired. If it pleases him to touch for a moment any instrument, pure or debased, he conjures from it celestial harmonies. Mr Whistler's nothings are priceless. His smallest change is golden. But he must not help Mr Pennell to debase the currency.

Sickert had totally misjudged the situation. Joseph Pennell did not run for cover. He was livid with rage, and to compound his anger, his show at the Fine Art Society was a failure; 'a frost', he wrote to his wife's sister, Helen.[8] He quietly brooded over his response, then early in the new year consulted his solicitors, Lewis and Lewis, who had also acted for James on many occasions. They, in turn, wrote to the editor of the paper, the colourful Frank Harris, demanding an apology. The demand was rejected out of hand. Harris, like many others, had little time for Joseph Pennell, and felt it his duty to protect and defend his authors. Consequently, Pennell instructed his solicitors to issue a writ of libel against Harris as editor, and more importantly, Sickert as author.

From Pennell's point of view it was crucial to have James not only on his side, but taking an integral part in the action. For James it was one legal action he could have done without; it did not involve him directly and, more importantly, he had finished with lithography. Also he was now involved in a row with his printers, the loyal Ways, which would preoccupy

him for at least another year. He had, besides, rediscovered his appetite for work for the first time since Beatrice's death: he was not keen to take on Sickert in this fashion. So anxious was he to avoid involvement that he got Heinemann to arrange a meeting with Frank Harris in the forlorn hope that some out-of-court settlement could be reached.[9] Harris listened sympathetically but could offer nothing by way of compromise. The case was set to continue.

One particularly pleasing part of James's work was a little portrait of Charles Holloway which he had begun in the late autumn. As the sittings progressed in the new year, Holloway's already precarious health took a turn for the worse and throughout most of February, he was bedridden and in constant pain. Almost daily James visited him and looked after his material needs. On 7 March Holloway died in his sleep. For James it was yet another tragic blow. Unselfishly, he took it upon himself to organize, with Thomson's assistance, a retrospective of Holloway's work at the Goupil Gallery, which took place later in the year. In the interim, in an effort to ease the financial plight of Holloway's family, James helped sell some of the artist's work and generally managed the estate. In many ways the episode of nursing Holloway was therapeutic and went some way towards lifting the cloud of despondency and depression which had hung over him for nearly a year. The little portrait of Holloway, which he entitled *Rose and Brown: The Philosopher*,[10] and which had given him such tremendous pleasure, was exhibited in Paris at the Société Nationale des Beaux-Arts, and later that summer at the Society of Portrait Painters.

Other work in the studio was unpredictable and always uneven, in the aftermath of Beatrice's death. With no regular London model, now that the Pettigrew sisters had departed the scene, James would hail a cab and scour the streets for a suitable subject.[11] In this fashion he secured the services of a young red-headed girl called Lillie Pamington. Over the next year or so, he painted his little model on at least nine occasions and when not working in oils, tinkered around with watercolours and pastels. There appears to have been no method in his system: his efforts were intended to occupy his mind as much as anything else. The results are simply beautiful little 'notes', done for the pleasure they gave.

Just before the Sickert review and subsequent contretemps, James had plucked up the courage to return to Paris and his beloved apartment on the rue du Bac. One of the first people he chose to meet when he arrived was Mallarmé. Despite the pleasure the reunion gave him the trip, all in all, was full of sadness, particularly visiting the apartment alone. The only consolation must have been the feeling that despite his absence his reputation had in no way diminished: his name was still associated with

some of the most progressive artists and writers of the day. One measure of the esteem in which he was held is the opinion of the young author Marcel Proust. Although in 1896 not yet acquainted with James, Proust already held his work in high regard. Conversing with a young friend, he let it be known that if he could choose who should paint his portrait, there were only two in the history of art he could admit – James and Pisanello.[12]

Not long after his return James wrote a poignant letter to Mallarmé:

> I cross Paris and return to London to find myself alone and timid before my work (which may feel resentful at my having left it) and having to present a smiling and brave front to my enemies.
>
> And now I am always alone – alone as Edgar Poe must have been – you said you saw a certain resemblance. But in leaving you, I seemed to be saying Adieu to a second self! – alone in your Art as I am in mine – and in shaking your hand this evening, I felt the need to tell you how drawn I feel towards you – how touched I am by the closeness of spirit you showed me.[13]

As the date of the libel trial approached, Pennell had still not persuaded James to appear on his behalf. His reason was always the same, he was far 'too busy'. Pennell persisted, and, as he would later claim in the *Life*, finally snapped and stormed at his reluctant witness: 'The case is as much yours as mine, and you must come. Your reputation is involved. There will be an end to your lithography if we lose. You must fight.'[14]

James reluctantly agreed to help, but privately he was almost sick with worry. He confessed to the 'Major' (Rosalind) only days before the trial was to due to begin: 'I am too worn out and too distraught with work to write today – And here is the Pennells' trial in the midst of it all!!! Of course I am to be one of the principal witnesses – and everything has to be dropped – All through Walter Sickert's rubbish and mischief.'[15]

The case opened at the King's Bench Division of the High Court on 5 April. The presiding judge was Mr Justice Mathew and Pennell was represented by one of the most successful barristers of the day, Sir Edward Clarke, QC. Pennell was seeking £1,000 damages which, coincidentally or not, was exactly the amount James had claimed against John Ruskin nearly twenty years before.

Considering Pennell's formidable array of expert witnesses, who besides James included Sidney Colvin, the Keeper of Prints at the British Museum, E.F. Strange from the South Kensington Museum, and the sculptor Alfred Gilbert RA, who had started his career as a lithographer, the outcome had a feeling of inevitability about it. That Sickert did not offer even a

conditional apology is a measure perhaps of his detestation of Pennell. Sickert's own array of witnesses was a haphazard collection of friends and cronies. The testimony of George Moore for one was absolutely useless, even comical: when asked what he knew about lithography, he replied that he knew nothing, but he did know Degas! Mr Justice Mathew, according to James, thought that 'Degas' was some new lithographic method.[16] Sickert must have groaned inwardly as he sat and listened. Next was the artist, Charles Shannon, followed by Rothenstein. They too were of little help and seemed only to confirm that 'transfer' lithography was a commonly used practice amongst artists. The final straw came when it was pointed out to Frank Harris by Pennell's counsel that in the last Christmas Special of the *Saturday Review*, he had an illustrated supplement full of these so-called 'transfer' lithographs, which he had advertised inaccurately as 'lithographs'.

Despite his earlier reticence, James's mood seemed to change when he entered the courtroom on the second day of the proceedings to deliver his evidence. When Pennell's counsel asked James if he was angry with Sickert, he replied that he was not so much angry as disgusted 'that distinguished people like Mr Pennell and myself are attacked by an absolutely unknown authority, an insignificant and irresponsible person'.[17] Sickert's counsel then probed James's reply: 'Surely, if as you say, he is an insignificant and irresponsible person, he can do no harm?' James's reply was swift and damning: 'Even a fool can do harm, and if any harm is done to Mr Pennell, it is done to me. This is a question for all artists.'[18]

As James's cross-examination drew to a close, he began to say something unprompted. 'And now, my Lord,' he began, 'may I tell you why we are all here?' 'No,' replied the judge, who continued, 'we are all here because we cannot help it.'[19] Faced with that rebuff James stepped from the box. Whatever he was about to say, the chance had gone. Later, still puzzled, the Pennells asked him what it was. He simply shook his head; it no longer mattered.

After a brief deliberation, the verdict was awarded in Pennell's favour. Mr Justice Mathew dismissed the claim for £1,000, and instead set compensation at £50. Worse still, no costs were allowed. Seen in this light it had been a costly exercise, but for Pennell such expense was irrelevant. He had tasted Sickert's blood. James too, it appeared, also enjoyed the success and relayed the news of victory by telegram, and in suitably military jargon, to Rosalind in Paris: 'London, Headquarters, April 6th. Enemy Met and Destroyed. Guns and Quartermasters Department Ours. Sickert in Ambulance = Whistler General.'[20] The same evening he sat down and wrote to Deborah. After describing the courtroom events and several of the anecdotes from the proceedings, he concluded the letter: 'Well, well,

sis. I think you would have been pleased with your brother! And, mind all this will act upon other matters such as the Eden affair . . . Moore destroyed him for ever and for that matter Walter Sickert too.'[21]

Sickert was now thoroughly fed up with the petty politics of London. The impending public scandal of his divorce was also a heavy burden to bear. So long as James remained alive there was no place for him in London, and within months Sickert had left for France; more precisely, for Dieppe on the north coast. Until his death, James seemed to take a perverse delight in mocking Sickert at every opportunity and applauding and encouraging others to do the same. Sickert had become, in James's own words, 'the pupil who would sell the soul of his master'. In 1899, after hearing about him from Rosalind, who was staying in Dieppe, James gleefully replied: 'I am very pleased with your description "gazing upon . . . Walter in his miserable raffishness!"'[22]

The Pennells too considered their job well done and at every opportunity they derided Sickert to anyone who would listen. Throughout it all Sickert simply held his fire, reasoning, it seems, that his time would come. It did in 1903 when James died. After a respectful period, Sickert returned to London in the midst of the Pennells' research for the *Life*. Never daring to approach him directly either for the invaluable archival material he had in his possession, or for his personal memories, they asked their publisher William Heinemann to approach him instead. In the result they were given access to neither. When their book was finally published in 1908, Sickert inevitably became one of its fiercest critics.

Perhaps no one knew James better than Walter Sickert, and for many years after James's death he continued to question the real measure of James's lasting achievement. His mixed memories of happy times and bitter humiliation always, it seemed, coloured his view. Only towards the end of his own life in the late 1930s did he begin to soften his line. By then it was too late. Sickert had fulfilled James's worst fears and the long-term cost to the reputation of 'the master' was incalculable.

The Final Years

29

A Dream Realized: The International Society

THE NEXT CONTROVERSY to embroil James arose from an article and bibliography published in the Library Bulletin of the University of the State of New York. Entitled *A Guide to the Study of James Abbott McNeill Whistler*, the 14-page document was written by two authors, Walter Greenwood Forsyth and Joseph LeRoy Harrison. It was inaccurate, derogatory and altogether dismissive of both James and his work, yet the art dealer Frederick Keppel, for reasons best known to himself, sent copies to both Pennell and Ernest Brown of the Fine Art Society. When he was finally shown a copy, James was furious as much, it seems, with Keppel as with the two authors; according to one source, he told friends that 'he would kill Keppel if he could'.[1] Immediately he wrote to the State Library of New York and told them exactly what he thought of this 'grotesque slander of a distinguished and absent countryman'. Later he wrote to Keppel; he had known him for a good many years and his sense of betrayal was overwhelming: 'Had you sent to me *direct*, and to me *alone* the libellous little book, it would have been my pleasant duty to have thanked you for the kind courtesy – and to have recognized, in the warning given, the right impulse of an honourable man.'[2]

The letter, like so many before, marked the end of a friendship. But like Sickert, Keppel held his fire and only after James's death did he privately print a small booklet with an obvious pun: *The Gentle Art of Resenting Injuries: Being Some Unpublished Correspondence Addressed to the Author of 'The Gentle Art of Making Enemies'.*[3]

There was another silly argument looming which was to have more profound repercussions. Ever since the publication of Thomas Way's

413

catalogue of lithographs the previous year, James's relationship with his printers, father and son, had become distinctly hostile. The whole unseemly episode seems very much at odds with the deep friendship and mutual admiration which had existed between the parties for nigh on twenty years. James, initially, had taken exception to the frontispiece which Tom junior had designed for the book, apparently with James's agreement. But behind this lay a resentment at the growing secrecy surrounding lithographic reproduction, which had become more and more of a closed shop as the decade wore on. In the etching process, by contrast, the artist could buy himself a press and the necessary equipment and run off his own work. As early as 1893 James had asked for the lithographic chemical formulae so that he could set up his own printing operation in Paris. It was something the Ways would not allow. As Tom Way tactfully tried to explain, 'You ask us for a very difficult receipt! No less than a distillation of my father's experience resulting from his experiments during many years past.'[4]

It is conceivable that James might have accepted this with a sardonic smile had not Pennell's resentment been greater than his own. Not long after the Sickert trial, Pennell began what he would later describe as his *magnum opus, Lithography and Lithographers,*[5] which was intended to dispel the myths attached to the medium. Years later he described his feelings on the printer's monopoly: 'Finally some of us broke open the door of the lithographic shops and we found that the secret of lithography consisted mostly of stale beer and lemon juice, conservatism, and stupidity. It was with such secrets that the craft was surrounded. And it is in ways of this sort that most of the secrets of the arts are hidden.'[6] Perhaps Pennell also resented Way's catalogue of James's lithographs, a project he would in reality have liked to undertake himself. Moreover, the Ways' deep knowledge and understanding of James's work in the medium threatened the Pennells' position and their deep-rooted desire to create a monopoly over the artist.

After complaining about the frontispiece, James began contesting their bills, which he claimed were excessive. In an effort to allay bad feeling the Ways proposed that in order to defray costs they would simply keep any trial proofs they had in their possession. James was outraged, retorting, 'I don't see how my proofs printed from my drawings can be the property of anyone but myself.'[7] He then took his grievances one stage further by arriving at the Ways' house unannounced and demanding the return of his painting of Cremorne Gardens.[8] Thomas Way Jnr objected, rightly claiming that his father had bought it from James at the time of his bankruptcy, after the auctioneers 'had rejected it as unsaleable'.[9] This confrontation brought to an acrimonious end one of James's most

productive professional relationships. Nearly a year later, and after a barrage of solicitors' letters, James had returned to him all the lithographic stones.

James remained at Heinemann's flat at Whitehall Court, nursing his wounds. The past year alone had seen the death of Leighton, Millais, George du Maurier and Aubrey Beardsley. James could perhaps be forgiven for his half jocular belief that he would soon have not an 'enemy left in the world' – or perhaps the situation was closer to the one Beatrice had predicted: that if she died James would soon not have a friend in the world.

Apart from Heinemann and the Pennells, his circle of artist friends now consisted essentially of young men such as the Irishman John Lavery and his Scottish associates, together with a few older figures such as Sargent and Ralph Curtis. Although he could not stand Sargent's glossy work, and was undoubtedly jealous of his success, like most people he nevertheless thought highly of him as friend. Other people who would drop into Whitehall Court were the journalist W.E. Henley if he was in town, and Henry James. He had met Henry James in 1878, at the home of a mutual friend, Christina Rogerson, who was to have a much publicized affair with the politician Charles Dilke, another friend of James's. Initially, Henry James found little to admire in James's work and on one occasion criticized it adversely in a London periodical. But as their friendship developed over the years, so did his appreciation of his fellow countryman's art. Although never close, both men saw each other regularly and admired each other enormously. Another common factor linked them both: each despised Oscar Wilde, though for different reasons. For Henry James, Wilde was 'an unclean beast', and his hatred was sealed in 1895 when James's play *Guy Domville* was booed from the stage of the St James's Theatre and replaced by Wilde's immensely successful comedy *The Importance of Being Earnest*.

Another congenial acquaintance James was to make at this time was fellow American Mark Twain, then on an assignment in London. Prickly and outspoken like himself, Twain and he thoroughly enjoyed each other's company. Occasionally when the mood took him James would also travel by cab up to Highgate in north London to spend the evening with his old friend David Croal Thomson and his family at their Venetian Gothic house, Dartmouth Tower. Thomson's five children kept him entertained for hours on end. As always, he had quickly found a 'favourite', little Evelyn, and during the period of Beatrice's final illness, he drew a lithograph of her which totally captures her charm and innocence.

At the time of the Sickert trial, James was negotiating the lease of a first-floor gallery at no. 2 Hinde Street, just off Manchester Square. The idea of

marketing his own work was certainly not recent and in all probability originated with Beatrice some years before in an effort to ease his persistent anxieties about the sale of his work. What dealers like Thomson thought of the plan is not clear, but it was probably met with tactful disdain. It was certainly a bold move, though there was a long-established tradition of artists selling direct to their clients: potential clients would be invited to attend the artist's home or studio to view the work *in situ*. Usually the practice was confined to the period just prior to the opening of the Royal Academy Summer Exhibition when talk of the impending event began to dominate the newspapers. Probably, the most famous extension to this practice in England were the activities of J.M.W. Turner who, in 1804, enlarged his house in Harley Street to provide a gallery from which to market and sell his own work. Turner carried on this practice for most of the rest of his life and, in 1822, built a custom-made gallery where he successfully sold his prints and painted work. James, it seems, was now going to follow suit.

He announced his intention in the press. The gallery was to be called 'The Company of the Butterfly' and was to become henceforth the 'sole agency in London' to deal with his 'Etchings, Lithographs, Drawings, Pastels and Cabinet Pictures'. Giving the new company the sobriquet *Au Papillon Noir* (The Black Butterfly), he designed for it a logo consisting of the butterfly emblem set in a black and white rectangle. The black aspect of the motto and emblem, according to one source,[10] was meant to signify his continuing state of mourning.

After the initial euphoria of the opening, James engaged the services of a secretary-cum-manageress, Mrs Christine Anderson, to handle the day-to-day running of the gallery. The enterprise carried on, with increasing difficulty, until 1899, when Mrs Anderson resigned her post. Thereafter, the gallery was handed over to William Heinemann who used the space to show a collection of William Nicholson's coloured woodblock prints, before it was handed back to James. The burden of the lease, still in James's name, hung like a chain around his neck for several more years. While the Company of the Butterfly was never a great commercial success – the Pennells claimed it 'scarcely attracted a visitor'[11] – there was one practical spin-off realized largely through the efforts of Christine Anderson. Through her diligence his records, which he was never inclined to update or supplement, were essentially rewritten, ordered and filed.

For his painting James had returned to working from the model. Besides the services of Lillie Pamington, James also used the daughter of his housekeeper at Fitzroy Street, Lizzie Willis, who could always be relied upon when there were gaps between 'official' sittings. Reliability could not be said to be a virtue of her parents. By mid-summer 1897, their increasingly

drunken state had become a serious worry to James and he expressed his concern in a letter to the 'Major'.[12] Before he finally plucked up the courage to dismiss them, he had managed to get Lizzie to sit for three portraits. In all three – *Little Juniper Bud* (an obvious pun on the alcohol consumed by the family), *Little Lizzie Willis* and *The Little London Sparrow* – James seems to recapture the joy of his Lyme Regis portraits before the death of Beatrice. Although two of them are obviously unfinished, they all capture the essence of childhood innocence.

James was also working on at least one other portrait at the same time, his first portrait in oils of Rosalind, *The Jade Necklace*. In many ways it confirmed her new status as his protégée. Although she was only 23, the portrait, somewhat austere and forthright, conveys a sense of maturity. Over the next few years James painted her on at least two further occasions.[13]

Early in the summer James received a welcome financial boost when he was commissioned to paint the portrait of the wealthy American, George W. Vanderbilt.[14] The work began at Fitzroy Street as soon as Vanderbilt arrived in London. For eight weeks, on and off, James laboured hard, following closely the format of Eddy's portrait of several years before. The Vanderbilt portrait emanated the same type of worldly swagger though, at a thousand guineas, it cost considerably more. Predictably, after the initial burst of activity, work slowed to a halt.

Portraiture, which had preoccupied James for most of his creative life, always seemed to take on an added attraction when he was in London, and despite the frustrations he encountered, he remained almost doggedly persistent in his attempts to resolve the problems posed by the genre. In the 1890s he returned again to the figure, essaying portraits in almost every medium at his disposal. The reason traditionally given for James's seemingly never-ending quest was financial: a commissioned portrait, unlike a topographical scene, had a buyer from the start – the sitter. But this reasoning fails to account for the dozens of portraits of models that remained unfinished, unsold and mostly unsaleable. The real stimulus was not simply the marketability of portraits, but rather the status that success in this area afforded. As one recent writer has put it, 'The Portrait ruled the Academy and Sargent ruled the portrait. It was an uncontested fact.'[15] In 1897 Sargent claimed the prize which had so long eluded James, election as a full member of the Royal Academy. Of the young painters whom he knew personally, Steer, Rothenstein, Lavery, Charles Shannon and Robert Brough were all poised to challenge Sargent. A still younger generation, which included William Orpen, Ambrose McEvoy and Augustus John, waited impatiently for their turn. In such a competitive climate, with his

chance of fame and fortune at the Royal Academy long since gone, James had to pick up what he could by way of commissions. Artistically and personally the feeling of isolation, of being adrift in a sea of apparent indifference, was a terrible strain.

The festivities held to celebrate Queen Victoria's Diamond Jubilee were a welcome relief and James watched them with a mixture of incredulity and amazement. The festoons erected in Trafalgar Square particularly intrigued him: 'You see,' he told the Pennells, 'England expects every Englishman to be ridiculous.'[16] Joseph had James's sketch of the decorations printed, notations and all, in the paper to which he contributed art criticism, the *Daily Chronicle*. Unsurprisingly, certain patriotic readers were not amused.[17]

Vanderbilt and his wife invited James to be their guest aboard their yacht at the Queen's Royal Naval review being held on the south coast. The trip turned out to be a dismal failure. Not feeling particularly well, he was unable to enter into the spirit of the occasion. When the Vanderbilts and their other guests departed on a small boat to take high tea ashore, James remained on board. Later he penned a note to Deborah, in which a pathetic, almost child-like voice emerges:

You see they have taken me off to this naval display – and here on Sunday afternoon, glaring and dreary I am staring at Dover – which looks more depressingly 'English' than ever! . . . The review was well enough – but after all what is the use! – Then again the weather is, of all kinds, the one I have most in horror – clear and hard and sunny – and with it there is, about me, complete silence – for everyone has gone ashore and I am seated here completely steeped in the saddest thoughts I can muster for company.[18]

An altogether more successful trip occurred some weeks later when James travelled with the Pennells, together with Edward Kennedy, to Dieppe. Hardly had he arrived than 'the small paint-box was unpacked, and he was in the street hunting for a little shop front that he remembered'. At least two oils survive from this period, *The Priest's Lodging, Dieppe*[19] and *Harmony in Blue and Silver: Beaching the Boat, Etretat.*[20] Both are on small wood panels, primed in grey, which gives a dry matt appearance. Of the two, *Harmony in Blue and Silver* is particularly successful, beautifully tinted and evocative.

The trip proved a real tonic for James. His dress at this time, while less eccentric than it had been in earlier years, always made him stand out from the crowd. As the Pennells recorded: 'there was something in the length and cut of his overcoat, in the tilt of his flat-brimmed silk hat, or jaunty straw, over his eyes, that was peculiar to himself and that forced people to

look at him . . . his way of leaning on the arm of anybody who happened to be with him to walk the shortest distance, made him no less conspicuous.'[21]

Ever since he had been awarded the Légion d'honneur James was immensely proud of its rosette which he wore in his coat lapel almost daily. To his horror, when he arrived in Dieppe he discovered that he had left it behind in England. After much searching he finally found a shop that sold rosettes. The shop owner handed over the item with a long-suffering sigh, much to James's annoyance. 'All right, Monsieur,' he added, 'here is the rosette, but I have heard that story before.'[22]

James returned to France in September. Although the appeal hearing of the Eden case at the Cour de Cassation was the prime reason for the visit, he was determined to settle himself back in Paris. Before going there he made a short visit to Etretat where he had stayed some weeks earlier, and painted a small circular sketch portrait of a young French child, which he later entitled *Le Bébé français*. The looseness and fluidity of this painting of a dozing child, who has perhaps fallen asleep during the sitting, indicates a spontaneity rare in James's portraits. It also underlines two points: first, that freed from the pressures of commissioned work, he could work quickly and efficiently; secondly, throughout his career it was arguably children or young people who were consistently his most successful subjects. They were uncluttered intellectually, and did not give off a sense of impending critical expectation, so James always seemed at his freest in their company.

James moved on to Paris and his apartment at the rue du Bac. He felt at ease: London, despite the good friends he had there, represented failure, while Paris was the city of his greatest success. Earlier in the summer the three works which he exhibited at the Société Nationale des Beaux-Arts, which included the portrait of Charles Holloway, had been received with the customary respect. Ever since his move to Paris in 1892, James had made a special effort to resume old relationships. Those with Becquet, his old musician friend, and Drouet the sculptor, had proved the most enduring and on many occasions the trio would meet and relive old times. He would occasionally meet Degas also, but always felt somewhat insecure in his company, a feeling that was exaggerated after the split with Sickert, in whom Degas had taken an active interest. Even so, their work continued to show remarkable thematic and painterly similarities. As one writer has already observed:

In paintings such as *Chelsea Shops* and in the lithographs of Paris streets printed in 1894, there is the same delight in recording the charm of urban life, the same skill in finding decorative patterns within it, that informs

Bonnard's series 'Some Aspects of Paris Life' five years later and Degas' *Place de la Concorde* and similar scenes some twenty years earlier. In the same way, Whistler's late portraits and domestic interiors, small in scale, intimate in mood, and painted in a soft, slightly blurred manner that enhances their perfect stillness, are related both to contemporary works by the Nabis, particularly Vuillard, and to earlier pictures by Degas. Indeed, but for its lack of psychological penetration, the portrait of *Mrs Charles Whibley Reading*, painted in Whistler's Paris home in 1894, is remarkably like Degas' *Woman Pulling on Gloves* and similar pictures of the mid-1870s. At the end, then, the two artists, whose friendship and mutual esteem had never diminished through the years, turned partly toward each other again in their art.[23]

Of other artists, it was Monet whom James revered most. By the second half of the 1890s Monet's work was focused almost entirely on the atmospheric effects of the Seine as it passes through its final stages before emptying into the English Channel. At places such as Pourville-sur-mer, Varengeville and Dieppe, rising early in the morning, Monet sought to capture the essence of the day. Ironically, as James had lost interest in the Thames, so Monet's interest in the French equivalent had grown, and for over a year he experimented relentlessly with effects of light. In paintings such as *Morning on the Seine, near Giverny (Mist)*[24] Monet's work comes closest to James's earlier Nocturnes in their treatment of atmosphere and sense of time. Whether Monet was intentionally following James is not clear, but the fact that within two years he would apply the same experimentation to the River Thames in London seems to suggest that he was. Sadly, Monet's interest came over twenty years too late. By the nineties James had finished with the Thames.

Of all his Parisian friends it was still Mallarmé who provided the warmest friendship and the most sympathetic ear. Before the Eden case was due to be heard in November, he visited Mallarmé at his country retreat at Valvins. There life was completely unceremonious. If James wanted simply to wander around, he could. If he wanted to sit beside the log fire and talk to his host, or simply sit there in silence, so much the better. It was perhaps the only place where James could go and feel the pressures of his profession lift perceptibly the moment he alighted from the carriage. James asked for permission to paint Mallarmé's daughter, Geneviève. Both father and daughter were delighted and James began at once. Unusually for him, the painting was quickly completed. After taking it back to Paris to be framed, James wrote to Mallarmé, 'Il est déjà dans son cadre le petit tableau de la princesse en son boudoir rose et gris.'[25] It is a beautiful relaxed portrait, and shows yet again that given the correct circumstances, away

from commercial pressures, James could still produce remarkable results.

As the date for the Eden appeal drew near, Heinemann arrived from London to lend moral support. Like Mallarmé, he was one of the few people able to exert a calming influence on James. The judgement, delivered on 2 December, ruled in James's favour: he could keep the portrait, so long as he paid the Baronet 5 per cent interest on his initial commission payment. On top of that he was ordered to pay £40 damages with interest, and all the costs of the first trial, while the Baronet was to pay all the costs of the second. The result pleased him enormously not least because of the publicity it attracted from the French press. The case set an important legal precedent in that it established the right of the artist to his own work. Buoyed up by his success, James was loath to let the matter drop and would raise the subject at any convenient opportunity. He felt it was an important point of principle, especially as the recent judgement showed the law shifting towards his point of view, and he was determined to wring every ounce of victory from the Baronet.

James remained in Paris over Christmas and the New Year. For company he had the 'Major', and for short periods other members of the Philip family would arrive to brighten up the dreary season. Sometimes he would attend Madame Méry's *salons*. On one of these occasions James was introduced to Marcel Proust by a mutual acquaintance, Reynaldo Hahn. A recent convert to the works of Ruskin, Proust apparently dared to mention his name: James retorted that Ruskin knew nothing about painting. But as the evening wore on James apparently mellowed and Proust 'cajoled' him into admitting 'a few nice things' about the writer.[26] Unquestionably James had left his mark on the young author and at the end of the evening, when he inadvertently left his grey kid gloves behind, Proust claimed them as a souvenir.

As always the damp and cold of winter affected his health – this year worse than usual. From November onwards he contracted cold after cold, never seeming to shake them off. In such a condition any thought of work at his sixth-floor studio on rue Notre Dame des Champs was out of the question. Not being able to work made him irritable and unpleasant.

Towards the end of January, when there seemed to be some respite from illness, he heaved himself up the stairs to the studio and began work on a standing nude which he was to entitle *Purple and Gold: Phryne the Superb! – Builder of Temples*. The model was probably Carmen and in a letter to Heinemann, his joy at being able to return to work is almost palpable:

Indeed the beautiful condition of work is at last quite laughable – I don't know any other word for it! – I mean I sit in the studio and almost laugh at

the extraordinary progress I am making and the lovely things I am *inventing*! I now have in my studio a Phryne – a Danae – an Eve – an Odalisque – and a Bathsheba – that carried out [ought] to bring two or three thousand apiece – MacMonnies [an American sculptor friend] says he never has seen anything like the Phryne – which I am going to do large – after completing the little one – so I can see excellent business if I only hold on . . . All these 'inventions' are since *you* left me the other day![27]

All that remains from this over-enthusiastic catalogue is the smaller version of *Phryne* which was bought by Charles Lang Freer in 1900 for 600 guineas. The theme of the nude figure with a classical label had a long history in James's work. In this case the title may well have been suggested by someone in the Symbolist circle such as Mallarmé himself, or Francis Viele-Griffin who, according to James, had admired the work.[28]

While the winter of 1897–8 may have been frustrating for work, there were developments on other fronts. On 15 November 1897, the *Glasgow Evening News* gave a hint of what might be in store:

An important movement is on foot for a formation of a new Art Society, having for its president Mr Whistler, and for members the secessionists from the Royal Society of British Artists. Presumably they will be the artists of the R.S.B.A., who, according to Mr Whistler's amusingly impudent epigram, seceded from that body, leaving the 'British' behind. The new movement is receiving considerable financial support, and I expect will soon be fully launched forth upon the art world.

It was no accident that this notice appeared in a Scottish newspaper since the main driving force behind the idea came from within the ranks of the Glasgow Boys. The idea, however, originated elsewhere: it had been the brainchild of Francis Howard, the American stepson of an Irish newspaper proprietor and politician who had trained as a watercolour painter. Before long he had enlisted the help and support of Edward Arthur Walton, John Lavery and James Guthrie. By the late 1890s all three had left Glasgow to make their base in London. James had, of course, known their work for many years and was personally acquainted with them too. Indeed, it had been Walton who had been instrumental in persuading Glasgow Corporation to acquire James's portrait of Thomas Carlyle for the municipal collection. During the intervening years, while the Glasgow Boys' reputation steadily grew on the continent, critical acclaim there was not matched in London. Hence the appeal of an exhibiting body that would be international in scope.

The idea was highly attractive to James. Since leaving the RBA, he had always hankered to be part of a secessionist movement, having long borne a grudge against the governing committee of Les XX for refusing him membership in the 1880s. Now, when the only options open to him in London lay either with the commercial galleries or, somewhat ignominiously, through the Company of the Butterfly, such an organization was bound to attract him. Indeed, according to the Pennells, James and Walton had unsuccessfully tried sometime before to take a lease on the Grosvenor Gallery, and then the Grafton, for a similar purpose.[29]

Almost certainly by the time of the group's first recorded meeting on 23 December 1897, James was aware of their essential aims, although he did not attend. Those who did were Lavery, who took the chair, Walton and Howard. They were joined by Georg Sauter, a London-based German artist who had organized the English section for the Munich Secession exhibition held earlier in the year. The 'internationalism' of the new exhibiting body was apparent from the outset, and some thirty invitations were voted on to be sent out to European artists including Rodin, Fantin, Klimt, Besnard, Moreau and Carrière, while the countries canvassed included France, Holland, Germany, Austria, Belgium, Italy, Sweden, Norway and Switzerland. Inevitably during its early months the fledgeling society ran into trouble. Alfred Gilbert RA, who was asked to join the society presumably to add official weight to the proceedings, quickly took fright at the implications of his membership, 'lest he do anything to harm the Royal Academy'.[30] Walton apparently wrote to James in Paris suggesting that he write a 'strong letter' to the errant member.[31] James did not, knowing full well the position his old friend was in, and shortly afterwards Gilbert resigned.

At the fourth council meeting held on 16 February 1898, James was unanimously elected Chairman of the new society and almost from the outset he began to make his mark. His influence was strongest and most persuasive in the area of membership. After the problems with Gilbert, he emphatically ruled that membership of the new society was wholly incompatible with membership of any other body: members of the Royal Academy were therefore ineligible, as were members of the RBA and the NEAC. When John Lavery tentatively suggested membership for Walter Sickert the response was predictable. '"What," he said, making as though to take something from his breast pocket, "my Walter, whom I put down for a minute and who ran off. Oh no, not Walter."'[32] The same held true for Menpes and William Stott of Oldham. Other names which were closely scrutinized included Philip Wilson Steer, Henry Tonks, James's old adversary Alphonse Legros, and Hercules Brabazon. Instead, in an attempt

to surround himself with loyal soldiers, James quickly enlisted the names of Albert Ludovici, and later Joseph Pennell.

Despite his enthusiasm, James was to prove something of an absentee chairman, then president. Between his election in February 1898 and his death just over five years later, he attended meetings of the International, of which there were scores, only on a dozen or so occasions. Indeed, his first appearance at a meeting, the thirtieth held by the society, occurred over two years later, on 18 July 1899. He nevertheless fastidiously oversaw the workings of the society through voluminous correspondence with Vice-President Lavery, or trusted council members such as Walton or Ludovici. When a problem required immediate deliberation, it was usually left to Ludovici, who was in charge of the French section of the society, to travel to Paris to seek consultation. It was not an altogether easy situation and years later, the ever-loyal Lavery hinted at some of the logistical problems involved in such a set-up: 'He required the smallest details of its meetings to be reported to him at length, and rarely allowed time for this to be done adequately. He completely ignored the fact that almost daily letters were being sent reporting progress, and complained that he did not know what was going on.'[33]

On 30 March 1898, the society was incorporated as a limited company, the Exhibition of International Art Ltd, with a capital of £2,000 held in £5 shareholdings. Three weeks later, on 23 April, it was officially transformed into the International Society of Sculptors, Painters and Gravers. A rule book was drafted containing some forty 'rules' and was carefully and methodically edited by James.[34]

Only days after the official naming of the society, James gave his first interview as president to the *Pall Mall Gazette*.[35] Despite his absenteeism, James could still provide copy and this made him invaluable. The first exhibition was to coincide with the Royal Academy's show, so it was vital that the deadline was not missed. The major problem confronting the organizers was to find a suitable location for the event. The place chosen, incongruously perhaps, was Prince's Skating Rink in Knightsbridge. Owned by an Admiral Maxse, who had also become one of the International's commercial directors, the space was taken on at a charge of 8 guineas a day for rent and rates, plus an unknown percentage of the admission fee. It seemed a generous offer, since Maxse had undertaken to spend around £400 to convert the ice rink into a suitable space.

At James's prompting Ludovici visited the sculptor-friend of James in Paris, Frederick MacMonnies, to secure his pledge to show. He likewise approached Jacques-Emile Blanche and Albert Besnard. The one artist James was keenest to secure proved the most problematic – Puvis de

Chavannes. Non-committal initially, after some persuasive joint action from both James and Ludovici, he finally promised to send at least seven drawings and an oil, arranging this through his dealer, Durand-Ruel. Other French artists whom they managed to secure by various means included Bonnard, Vuillard and Maurice Denis.

James retained almost total control of the decoration and the positioning of the pictures. At his instigation the main hall was divided into three separate areas. All the walls were to be hung with canvas, painted French grey, while the lighting allowed by the glass roof was to be evenly diffused with white muslin, supplemented by a velarium of dark grey muslin underneath. James also designed the catalogue, together with the monogram for the society which consisted of its initials fancifully inter-woven.[36]

In all the exhibition consisted of the works of some 256 painters, sculptors and printers. Of these over 100 were from England, 41 from Scotland, 42 French, 20 German and 16 Americans. The remainder of the exhibitors were made up of artists from Belgium, Austria, Switzerland and Scandinavia. The whole notion of internationalism ran contrary to the inherent insularity of the British art establishment. In 1892, Frederic Leighton, President of the Royal Academy, had underlined this apparently official line when addressing the annual dinner of the Royal Academy. As the *Piccadilly* reported: 'The President . . . urbanist of men, spoke at the annual dinner with considerable and unexpected feeling against the "young painters with a French accent": but, as we have explained, the Royal Academy seems to have decided to accept Cornwall as part of the British empire, and to claim all that it provides as its own for the future.'[37] John Lavery wrote of the period: 'Up until our advent there was scarcely a modern foreign picture to be seen on exhibition in England except, per-haps, with dealers. It was considered unpatriotic to include foreign artists, and we had a hard struggle because few were really interested in art outside their own country.'[38]

Although most exhibitors' work at the International was hung two deep, significantly no thematic or nationalistic order was followed through the three large rooms. As to the 'arrangement' of his own work, James had his own ideas. Showing nine oils from various phases of his career – as well as three small etchings by Beatrice – he drew two different layouts for Ludovici's benefit to ensure his intentions were understood. 'Hang all my pictures *on* the line,' he wrote:

excepting the Holloway (Philosopher) just a tiny bit up to make the line pretty – and perhaps the Petite Souris, also slightly a matter for your eye –

And be sure to see to the proper tilting over – so that they can be well seen – Now mind *nothing* interferes with this your sailing orders – Hang nothing under any of my pictures. Remember the little etchings placed in the *last way* drawn.[39]

While James, as President, was given the place of honour, on the facing wall of the central hall, grouped around him were six works by Degas, work by Monet, Fantin, Hans Thoma, Aman-Jean and Besnard. In this room there was also work by Scottish artists such as Guthrie and Hornel, together with work by Franz Stuck, Toorop and Shannon. At both ends of the north gallery were works by Manet: *The Execution of the Emperor Maximilian* and *The Vagabond Musicians*. In the opinion of the *Saturday Review*'s art critic these two exhibits, together with James's work, were the highlight of the show.[40]

Shortly before the opening James arrived from Paris to oversee the final hanging. He was pleased with what he saw, and the Prince of Wales's refusal to open the exhibition was not allowed to dampen the enthusiasm. Press reaction to the show was generally encouraging. One of the most forthright defences of it and the goals of the society came from a predictable source, R.A.M. Stevenson. He compared it with the mundane offering annually supplied by the Royal Academy:

A mere handful of artists fix up a shed and organize a real exhibition, well-hung, well-lit, and neither overcrowded nor hampered by rules that impose a gilded uniformity upon the frame maker, while they leave the painter free to descend to any depth of silly trifling or commercial baseness. The International seems to be organized rather to satisfy artistic opinion than to tickle the fancy of the shilling paper or to outrun the illustrated papers in their scramble for the penny of the artless but business-minded multitude.[41]

Stevenson continued his article by listing what he believed to be the leaders of the modern movement – Manet, Whistler, Mathew Maris, Puvis de Chavannes, Degas, Monet and Rodin. While all these artists had been seen by the British public before, the significance of the International exhibition was that it introduced a scale and diversity under one roof never witnessed before in Britain. It was these very elements that distinguished James's involvement with the International from his earlier reign at the RBA. Then, the 'Whistlerian' emphasis had been all too obvious amongst his younger followers. Now, the sheer diversity of the show had the more enlightened critics in raptures.

Despite the enthusiastic press, the numbers of visitors nowhere

approached those going to the Royal Academy. Just over a week after it had opened, Ludovici reported to James that the exhibition had been attracting upwards of 160 visitors a day. When the idea of providing some form of entertainment together with refreshments was suggested to James, he exploded:

> Gentlemen – I gather from the papers that 'string bands', 'icecreams' together with buttery teas, and 'other' indecencies parade the Galleries 'of an afternoon'! . . . Why then should we turn the place into a penny gaff – or vie with the Hotel Cecil, or the circus at Olympia! Do we mean the people to see that the Body, in Burlington house, though less dull is certainly more dignified than any out of it?[42]

The executive council quickly took the hint. Despite Maxse's pleas, either that 'or ruin', the suggestion was quietly dropped.

On a personal level the International provided James with a badly needed diversion and a point of focus after his years of anger and frustration. In many ways it allowed a dream to be realized, and was a cause behind which he could throw his weight and aspirations. Although it would never fully live up to expectations, the International nevertheless marked an important watershed in British art. From that point on, the notion of artistic, aesthetic and cultural singularity appeared no longer to be an issue. The universality of art, the central tenet of James's 'Ten O'Clock' lecture, had become, in an ice rink in London, a demonstrated fact of cultural history.

30

A Most Reluctant Teacher

<hr>

AT THE TIME of the first exhibition of the International, James had almost entirely given up his printmaking activities and, as President of the fledgeling society, wanted first to be represented as a painter in oils. His legacy as a printmaker would follow later when, the next year, an entire wall was given over to a special collection of his etchings. Nonetheless, for the inaugural exhibition, James was insistent that the printmakers should be given 'as good a showing' as the painters and sculptors.[1] His ruling was heeded, and the show boasted over 300 prints, grouped around a special collection of twenty-six black and white drawings by the late Aubrey Beardsley.

Although by the late 1890s, James's interest in printmaking had all but ended, photography continued to intrigue him. From his earliest childhood, when he had watched in amazement the shimmering images of the 'magic lantern', to the technological advances he had witnessed through his lifetime, James's interest in the medium had never slackened. The care and attention he paid to the production of the Goupil Gallery album, and more generally to his own collection of photographs in the final decades of his life, indicated the depth of his interest and his awareness of photography's commercial potential. The International Society did not itself include the medium as one of its defining activities – an indication perhaps of the uncertain state in which the genre of photography found itself. The status of photography as an art form had been a vexed question for the last two decades, and the aesthetic issues raised by the debate brought it closer to the thinking of James than has traditionally been realized.

The apologists for 'artistic' or 'pictorial' photography relied heavily on

the ideologies prevalent in modern painting and printmaking with which James was closely associated. From these, the Naturalist or Impressionist circles of photography, the validity of the notion of the individual photographer's perception of nature came into currency. One of the leaders of this Naturalist movement in photography was P.H. Emerson, who in 1889 had published *Naturalistic Photography for Students of the Art*. It is no coincidence that the movement for Naturalistic photography had affinities with the school of Naturalistic painters who exhibited at the NEAC, and included George Clausen and H.H. La Thangue. In 1887 Francis Bate, secretary of the NEAC, had published *The Naturalistic School of Painting*, a book on which Emerson drew heavily when writing his own. Emerson constantly reiterated many of the ideas already posited and practised by James, noting for instance – à propos of exhibition hanging: 'Another great step in advance, introduced by Mr Whistler, has been the reform in hanging pictures; though he has not been allowed to carry out his plans thoroughly, yet he has managed his exhibitions much more artistically than any others in the country.'[2] He also advised the student to study the etchings of Rembrandt and James, in preference to other modern practitioners most of whose work could be regarded as examples of how not to etch. Criticizing the popular practice of reproductive etching, Emerson noted: 'One of the greatest evils commercialism has done to art is to ruin modern etching, by having pictures of the Old Masters copied slavishly by the etcher, and elaborated and worked up, so that one wearies of them.'[3]

Emerson's devotion to both James's theory and practice became even more apparent when in 1890 he published the black-bordered pamphlet *The Death of Naturalistic Photography*, renouncing his former stance. In the introduction, as Emerson attempted to explain his rather drastic change of heart, it was again to James that he looked: 'To you, then, who ask an explanation for my conduct, Art – as Whistler said – is not nature – is not necessarily the reproduction or translation of it – much, so very much, some of the very best – is not nature at all, nor even based upon it – vide Donatello and Hokusai.'[4] In essence Emerson was reiterating a basic tenet of the 'Ten O'Clock' lecture; nature only provides the vocabulary, not the complete story:

the artist is born to pick, and choose, and group with science, these elements, that the result may be beautiful . . . To say to the painter, that Nature is to be taken as she is, is to say to the player, that he might sit on the piano.

That Nature is always right, is an assertion, artistically, as untrue, as it is one whose truth is universally taken for granted.

For most, if not all Emerson's supporters, this volte-face came as a shock. It was the consequence, Emerson maintained, of a meeting he had had with 'a great artist' in Paris:[5] this has been taken by many to refer to James.[6] Emerson met James in August 1890 after sending him a portfolio of his photographs. Enchanted with the work, James wrote to the photographer immediately: 'I am delighted with the extraordinary photographs you sent me! They are full of the most charming effects – and certainly quite unlike anything else of the kind I ever saw – We are off abroad immediately – but I hope you will come and see us when we get back.'[7]

Emerson, according to an annotation made in 1922, did visit James. Later he described the visit to his friend, the sculptor Havard Thomas: 'He was delighted with the extraordinary photographs full of the most charming effects . . . he insists on my taking his portrait – I'll make a stunner of him too . . . It is very pleasing to get the great Jimmy's approval . . . Keep it private.'[8] There can be no doubt that James's aesthetic played a significant part in the formation of Emerson's own thinking on the matter of photography and its place in the wider scheme of the arts. In January 1892, the photographer again wrote to Thomas of James:

As to Whistler . . . the 'newness' of his theory on art is really his assertion that there is no *newness*. He holds pure and simple that the whole aim and subject of a picture is to seek a *decorative scheme or pattern* either of line or colour & he holds further that nature sometimes does the thing but *rarely* that is all.[9]

In spite of his theoretical position, Emerson continued unashamedly to publish his 'artistic' photographs in albums, printed in expensive, limited deluxe editions, with an accompanying narrative. Modelling this practice on the printmakers' portfolios of limited edition, rare prints, Emerson would then destroy the photographic plates. His album entitled *Marsh Leaves*, of which he gave James a copy, was printed in 1895. Both the photographs themselves and their titles – *Lilac and Green*, or *Study in Blue and Gold* – suggest that he was still heavily under James's influence. In Chapter XLIV, entitled 'A Nocturne', the comparison is blatant, and its accompanying text reinforces the point: 'After a burning day and lemon sunset, grey wreaths of mist began to rise and float over the dusky river, where the still reflections of the fairy-tale like trees slept under the bright

moonlight.' Apparently James's favourite image in the album was the plate that accompanied the above description, entitled *The Bridge*.[10]

From then to the end of his life James continued to watch the development of photography with keen interest. Although his relationship with Emerson was never close, the respect for each other's work was obvious. James was also in correspondence on several occasions in the 1890s with the great Scottish photographer, J. Craig Annan. In one letter, dated 26 May 1893, he came closest to expressing his own view of the nature of 'art' photography, when thanking Annan for some photographs he had sent him: 'these most curiously attractive photographs, I should say more simply pictures . . . certainly are pictures and very fine ones too.'[11]

In 1897, the *Practical Photographer* contained a fascinating article on 'The Influence of Painters on Photography: Whistler, Monet and Manet'. Written by E. Calland, it drew attention to the decorative aspects of James's art in relation to photography:

Mr Whistler's decorative and unusual composition, next to subtle tone relations, strikes one as having the most photographic interest. The photographer has to learn to see things decoratively arranged, and in his studio, if he have the feeling, he has such an arrangement in his hand. The eye needs education to appreciate a beautiful design in nature, more especially since colour has to be translated. That some photographers possess this quality in a high degree, Mr Craig Annan's 'Lombardy Pastorals' bear evidence; there are few amongst them that one would wish to alter in the slightest degree.[12]

Photography, as an artistic rather than a reproductive process, naturally aligned itself with the printmaking revival with which James himself was closely associated.[13] Although James did not live to see it, the founding of the London School of Photo-Engraving in 1906 meant the medium was at last assured of its place as an acknowledged branch of art.

By the late 1890s James's reputation as an artist had reached its peak. He was now a major celebrity and his slightest utterance was pounced on by the press. One thing that the formation of the International Society had impressed upon him was the magnitude of his popularity amongst the younger generation of painters. While they may not always have followed the style of his work, or even understood the implications of his aesthetics, they nevertheless looked to him as their champion, the fearless opponent of the establishment, scourge of the Royal Academy. This popularity was at

its strongest in Britain. While it did not always translate on the same scale to mainland Europe, James still continued to enjoy enormous fame there.

Shortly after the International Society exhibition had opened, James returned to Paris, perhaps with some trepidation. During the week before he left he had been shocked to find himself face to face with Oscar Wilde, now released from prison. Although he could only stare in amazement at the huge frame before him, the meeting brought back bad memories. Wilde, on the other hand, thought the chance encounter amusing. As he told his friend Robert Ross: 'Whistler and I met face to face the other night as I was entering Pousset's to dine with the Thaulows. How old and weird he looks! Like Meg Merrilies [the half-crazed gypsy in Walter Scott's novel, *Guy Mannering*].'[14] James need not have worried: within a few weeks Wilde had left the city and James was never to see him again.

Throughout the summer months James worked almost daily in his Paris studio, although the strain of climbing the stairs continued to take its toll and always left him feeling breathless and giddy. A steady procession of friends and acquaintances, dealers and collectors, were all eager to see him there or at his home in the rue du Bac. There were at least three portraits of Carmen Rossi, his Neapolitan model, in preparation: one started the previous year and two others begun during the late summer. It was doubtless during the many sittings for these that the idea of a teaching academy was first mooted between them.

Although little is known about Carmen Rossi, her later actions, including the appropriation of several paintings of James's, suggest that an appearance of innocence masked a more calculating, businesslike nature. By the early autumn precise plans for the academy's formation were well under way. It was to be managed by Carmen, whilst James and his friend the sculptor Frederick MacMonnies were to act as visiting 'Professors'. The premises chosen was a studio complex situated on the Passage Stanislas, a small street off the rue Notre Dame des Champs. It consisted of two storeys, with a garden and a courtyard which was quickly covered over with glass to extend the studio space as the student numbers rapidly increased. James was not to be the only 'celebrity' in the street; a few doors along at no. 11 was one of the most popular French painters of the day, Carolus Duran.

The idea of a teaching academy had appealed to James for many years. Indeed, the White House itself was built with special rooms to accommodate such plans: the bankruptcy, however, put an end to that. For most of his life James had always had 'pupils' around him and his writings and theories, such as those put forward in the 'Ten O'Clock', always give the impression that he saw himself in the role of teacher. Another reason

for its appeal was money. Well run, such academies had great financial potential, and despite the fact that there appeared to be one on almost every street in the Latin Quarter, Paris still seemed to afford room for such establishments.

Early in September 1898, James left Paris to visit London, staying with William Heinemann at Whitehall Court. There was no particular reason for the visit, other than that he felt ill and perhaps even lonely. He had advanced Carmen money to equip the academy and, more particularly, to see to its advertising. Heinemann had proved himself a loyal friend over the years and welcomed the opportunity to look after James, particularly when James felt himself 'a burden on the ladies of the family'. It was one thing to be nursed by a friend, but quite another to be smothered by the attentions of the entire Philip family. Heinemann's respect for James was unqualified. Early in 1899, when Heinemann married the Italian authoress, Magda Stuart Sindici, 'the most fair and dainty Donna', as James had taken to calling her,[15] it was James who was asked to undertake the duties of best man at their wedding in Porto D'Anzio.[16] Honoured by the invitation, James quickly agreed to perform the duties.

After several weeks James's illness seemed to get no better. Most of the time he stayed in bed, ate little, and suffered in silence. In reality, it was nothing more than the aches and pains of old age, but since the death of Beatrice over two years before, these episodes always seemed more acute and prolonged. In many ways, his care for her had sapped his own strength; for almost the entire duration of her illness, he had suffered no outward signs of ill-health.

James's illness was certainly not helped when he heard from Paris that his old friend Mallarmé had died. It was a crushing blow: Mallarmé had been a kindred spirit, a true friend and companion. For days James cried silently and alone – Mallarmé, that gentle, kindly soul, had always seemed to James somehow immortal. Now his death and James's own continuing ill-health markedly dampened James's enthusiasm for the new academy. Though still expressing an interest, he carried on more out of loyalty to Carmen than for any reasons of his own.

In late September he was annoyed to read of posters circulating in Paris and elsewhere announcing the new academy. Written by Carmen, the posters both in English and French read:

ANGLO AMERICAN SCHOOL
Whistler Academy
Painting, Sculpture and Drawing
Modele vivant all day

433

(Night Lessons also)
Professors:
Messrs Whistler and Mac-Monnis [*sic*]
For Inscriptions and all informations
Enquire at the Academy

James quickly attempted to rectify the matter. Composing a lengthy letter on the subject, circulated to all the influential papers, both English and French, James spelt out in detail his association with the 'Academy' and, perhaps more importantly, the role he had envisaged for himself:

An atelier is to be opened in the Passage Stanislas, and, in company with my friend, the distinguished sculptor, Mr MacMonnies, I have promised to attend its classes. The patronne has issued a document in which this new Arcadia is described as the Académie Whistler and further qualified as the Anglo-American School. I would like it to be understood that, having hitherto abstained from all plot of instruction, this is no sudden assertion in the Ville Lumière of my own. Nor could I be in any way responsible for the proposed mysterious irruption in Paris of whatever Anglo-American portends. 'American,' I take it, is synonymous with modesty, and 'Anglo,' in art, I am unable to grasp at all, otherwise than as suggestive of complete innocence and the blank of Burlington House. I propose only, then, to visit, as harmlessly as may be, in turn with Mr MacMonnies, the new academy, which has my best wishes, and, if no other good come of it, at least to rigorously carry out my promise of never appearing anywhere else.[17]

While James may have appeared a somewhat reluctant participant, when the news spread around Paris of its opening crowds of students flocked to it, despite the fact that on James's instructions Carmen was obliged to change its name from the advertised 'Whistler Academy' to the Academy Carmen. Of the countless reminiscences that describe the new academy, one in particular conveys James's attitude. It was written by the Irish painter Paul Henry:

Whistler's studio was soon crowded with enthusiasts. During my time there I did not see him there very often, I think he was too much of an artist to be a good teacher, he could not suffer fools gladly, or the dull and the incompetent . . . [He] went round the studio as quickly as he could, and you felt as the door closed behind him, he said with relief, 'Thank God that's over.'[18]

In spite of James's reluctance the academy left its mark on many of those who attended it. James's methods of tuition, on the rare occasions they were felt, were wholly conservative. The hours were strict, the men and women students were quickly segregated from one another and bad behaviour was frowned upon. Carmen found controlling the hordes of students well-nigh impossible. To instil the discipline that was lacking, James appointed a *massier* (a senior student, probably Paul Henry) for the men, and a *massière* for the women, Inez Bates. Together, they oversaw the day-to-day activities and discipline of the academy. Within months, so pleased was James with Inez Bates's performance and perhaps, more importantly, her loyalty to him, that he made her his legal 'apprentice'. The indenture,[19] an old-fashioned form of legal contract, impelled Miss Bates to serve James as an apprentice for five years, and forbade her, without her 'master's' consent, from selling to other painters or exhibiting without his permission during her apprenticeship. While the arrangement seems out of keeping with James's avowed belief in the independence of the artist, for the next three years Inez Bates was diligently to serve her 'master's' interests. But for her support and enthusiasm, it is doubtful if the academy would have seen a second year.

As part of James's brief was to give lectures, he resolved to take advantage of the latest technology: he had always been fascinated by new-fangled gadgets. One of the great attractions of William Heinemann's flat was its modern appliances, not least the telephone, which amused James for hours on end. Intent on using a microphone to amplify his voice at the academy, James was also keen that his utterances be recorded for posterity. As he explained to his fellow gadget enthusiast, William Heinemann:

> Now this is what I want! I want the *registering* part of the 'Gramophone'! The head office is in London . . . Don't you think you might go there and get it for me? – I suppose it attaches to the machine I have – But in any case, if it be altogether a separate movement, I want it! You see if I had it, I could put it in the Academie, and *everything* would be recorded – and by and bye you could bring out the 'Whistler Cows' in a wonderful book [presumably a humorous reference to someone else's earlier recording efforts] – and what an amazing thing that would be! Don't say *anything* about it – but do see about it – I shall try in Paris too – but I may not find it.[20]

Sadly, despite these exertions, the voice of Whistler was not to be recorded.

One of the most illuminating recollections of the academy comes from Anna Ostroumova-Lebedeva, a 28-year-old native of St Petersburg who enrolled not long after she arrived in the French capital, in early January

1899. In her extensive memoirs, published in the USSR in three volumes between 1935 and 1951, she reproduced from her diary and from letters written to her parents the feelings and thoughts she experienced as she entered the academy and began to absorb its teachings:

> The pupils are all American women, the men work separately upstairs. The American pupils received me with great curiosity but amiably and in a most affectionate way. This sometimes embarrasses me. When they pass my easel they sometimes pat me on the cheek, or kiss me on my hair or neck, and all this they do with great tenderness. Maybe it happens because I don't speak English and can't participate in their conversations.
>
> Whistler comes every Friday. In between his visits we are meant to prepare an 'étude'. On Friday there was a feeling of great excitement in the air from the morning onwards. Everyone was waiting for him to come and was listening for any sound behind the gates. He always came in a small black lacquer carriage. Dressed all in black with [the] Légion d'Honneur in his lapel. Black gloves on his hands. He was of medium height, lean but well proportioned. His large blue eyes were luminous. Crumpled face with traces of his former good looks and very pink cheeks through old age. Grey curls with one very white streak across his forehead. It was so strikingly white that on the first day I thought he had a streak of white paper in his hair.[21]

In a letter written to her parents on the evening of her first day at the academy, Anna gives a graphic account of its teaching methods:

> Today I started to work in Whistler's studio. Many things surprised me or even seemed quite funny to me: the complete lack of any freedom or independence and the absolute obedience to all rules insisted on by Whistler. To a completely absurd degree. The first thing was that one of the American pupils – the one in charge of the studio – took away my large palette and my colours and gave me instead a small one and told me to paint with the colours which were chosen by Whistler himself. To paint a nude with those colours seemed extremely difficult to me. To mix colours on the palette one had to use a special method invented by Whistler and if you try to do it your own way your neighbours grab hold of your hands because they watch you the whole time. I decided to submit completely and it is very interesting to me to be under instruction and to acquire a certain system although if it is not good I'll know after some time. Whistler is the greatest European painter and if my colleagues in the [St Petersburg] Academy know that I have become his pupil they'll go mad with envy.

Anna went on to describe in detail for her parents her first encounter with the 'master':

> He comes to the studio once a week . . . stays for four hours and it is said he is a very good teacher. To me he will speak French. I kiss you a thousand times and I'll never stop to thank you for allowing me to come here. One can learn a lot here.
>
> When I started on my first study of a nude for Whistler I painted it with large strokes. The heightening in white was done with thick blobs of paint and I wanted the whole thing to be so solid that it would look as if it was coming out of the frame. It was quite easy for me to finish it for Friday . . . To tell the truth I expected Whistler would be quite pleased with the results and even would be surprised to find it of such quality. But . . . what a blow! What a shock! When Whistler came near my étude he looked at it for a long time with bewilderment and then told me: 'But you can do nothing, you know nothing, I can't teach you! You don't know the ABC of painting. You can't draw, you have no knowledge whatsoever. Where have you had your training? Who was your teacher?' And when in a very crestfallen way I answered that I was a student of St Petersburg Academy and our famous painter Repin was my teacher he answered: 'I don't know this painter, I do not remember hearing about him.'
>
> He addressed his *massière* asking her to teach me as he can't do it himself as I know nothing (and this after 7 years in the Academy).
>
> After Whistler's departure the *massière* came up to me and asked me to come next door with her. There she repeated to me again that Whistler does not want to teach me himself and suggested that she should give some preparatory lessons. I was completely shattered. I listened to all this in silence and went home. It was the first time in my life that I was so cruelly battered. But in a strange way I liked it.

Inez Bates then took Anna through the rudiments of James's teaching. She was shown how to arrange the colours on the palette, 'In the centre of the upper edge – the whites – to the left – light ochre, sienna, natural earth, dark natural earth, cobalt, mineral blue; to the right of the whites – cinnabar, venetian red, indian red and black.' Next she was carefully instructed how to mix the colours:

> First of all I was expected to mix the predominant colour for the model and spread it in the middle of my palette. Underneath it I was to make a strip of black colour to correspond to the darkest possible shade in the model. Between the light tone of the body and the black colour one had to mix all

the intervening gradations of [the] same tone and each one had its separate brush.

On the left of the palette one had to put the gradations of the colour which were to be used in the background and each had to have a separate brush. One could only start to paint on the canvas when all the colóurs were prepared on the palette as if the model was already finished in your mind and you have only to collect together all the pieces. Or as if it was a sculpture which you have to model out of prepared parts.

Within a few weeks Anna, it seemed, had relearned the rudiments of painting. The next time James appeared, much to her relief, he approved of her performance and agreed to let her work under his personal supervision:

Today I am so happy! . . . Whistler came today and highly praised my work. He found that I had made enormous progress, that I showed a real understanding of his requirements, that my étude shows finesse intelligence and feeling and that if I continue in the same way I'll become *un vrai artiste*. Altogether he singles me out as a foreigner and a good pupil.

Through the weeks of early spring 1899, Anna's progress continued unabated. James's appearances at the academy, on the other hand, were becoming less frequent, much to the concern of Carmen. As his attendance dropped, so did the number of students. When this was pointed out by Carmen, James, albeit reluctantly, resumed his weekly visits.

By May, Anna felt she had learnt all she could at the Academy Carmen and made up her mind to travel to Italy with some other Russian friends. According to Anna her impending departure troubled James who pleaded with her to stay. He even offered to take her to the United States so that she could continue to develop her 'exceptional talent'. Anna refused the offer. After sitting for some time in silence, James finally said to her, 'Let it be then, if you can't go with me. But what a pity, what a pity. You have studied so little with me.' Greatly saddened, Anna then recorded her final thoughts:

He asked me to write to him and tell him what I was doing both in painting and engraving and promised me to give his advice. We said goodbye. I didn't go back into the studio. I would not have been able to work then. I went to the Luxembourg gardens and walked its alleys in a state of nervous excitement. I lived through our last conversation again and again although I at the time hadn't realized the importance of what I had rejected – the help of such a great master.

Later through unforgivable lightmindedness I never wrote to him. I never saw him again.

Although the academy grew throughout the summer of 1899, James's enthusiasm continued to wane. While his health was a major factor, it was the repetitive effort involved in teaching that kept him away. However, he insisted on knowing exactly what was happening and Inez Bates kept him voluminously supplied with the mundane details of day-to-day business. In an effort to control the numbers, the fees were increased dramatically in the autumn of 1899, with the desired effect.

The majority of the students who attended the academy were no more than gifted amateurs, young people from wealthy backgrounds fortunate enough to be allowed to visit the French capital by generous parents. One of the most talented women to attend the academy was Gwen John who was smuggled in by a friend to attend the afternoon classes.[22] Like her Russian counterpart, Anna Ostroumova-Lebedeva, Gwen John soon shone out from the ranks of the nonentities and James in turn afforded her the greatest respect. Augustus John, her illustrious brother, recalled that on one occasion when he met James, 'Mr Whistler with great politeness asked me to make Gwen his compliments. I ventured to inquire if he thought well of her progress, adding that I thought her drawings showed a feeling of character: "Character?" replied Whistler, "Character? What's that? It's tone that matters. Your sister has a fine sense of tone."'[23] On another occasion James invited the brother and sister to visit his studio at the rue Notre Dame des Champs: 'We found him engaged on an immense self-portrait. He had worked long on this canvas. The subject is hardly discernible. Presently a ghostly figure is seen to emerge. It must be about seven feet high. I am reminded of Balzac's *chef d'oeuvre inconnu*. The Master, lost in over-subtlety, paints into the dark.'[24]

Although the Academy Carmen continued a fitful existence until the spring of 1901, by the late summer of 1899 James had had his fill. The school, together with the business of the International Society, had made heavy inroads on his time, and more importantly, his health. Other interests exerted their claims. Long interested in his family genealogy, James had sought to establish a link which would locate his family among the first American settlers. Now in mid-summer 1899, writing to his brother William in London, he disclosed what he believed to be the clinching evidence:

While we are about this what do you say to the original *Ralph Whistler* gentleman who in 1609 held land in Virginia? (You remember I sent you the book

to look at) surely that settles the question of 'F.F.V.'! [First Family of Virginia] I shall certainly stick to this – Ralfe Whistler is in the list of those who held land in Virginia under the grant of Charles II, and is supposed to have gone over to take possession. Of course according to me did settle in Virginia and established the Whistler family F.F.V. How simple![25]

While such revelations pleased him immensely, they also came as a welcome distraction from other difficulties. Shortly after the letter was written, he made a start on the portrait commission of Mrs Vanderbilt, promised to her at the time James painted her husband; but after a few weeks he had had enough. He went to London in mid-July, accompanied by his 'pupil' Miss Bates. After a week or so he re-crossed the Channel to meet Mrs Philip and Rosalind for a planned holiday on the north coast of France where they rented a small house, the Pavillon Madeleine, at Pourville-sur-mer, about three miles west of Dieppe. While the trip was primarily to aid his wretched health, in such a beautiful location James could not fail to be inspired.

During his stay which, between visits to London, Dordrecht and Paris, stretched towards the end of October, James painted at least ten small seascapes, most of them done on wood panel. James, of course, had been fascinated by the effects of sea and shore for most of his career. In Trouville in the mid-sixties, it was the fluidity and economy of his paint stroke that had preoccupied him, together with the elimination of fussy detail. From then on, into the eighties, the seascapes evolved into almost abstracted views. Painted in broad sweeps of paint in almost monochromatic tones, and usually so thinly that the wood of the panel and the paint play a similar role, the objective was to capture the essence of the scene. In Pourville-sur-mer, James still felt challenged by the problems posed; he was still looking for pictorial answers. Before, he had concerned himself with ridding the scene of its superfluous baggage, but at Pourville-sur-mer he did a complete about-turn and became much more concerned with the image before him.

He portrays the crashing waves and he paints the moody clouds. Each painting recreates a different aspect of the day – morning, noon and evening. Viewed as a whole, James's work at Pourville-sur-mer appears to follow closely, though perhaps unwittingly, the work of his friend Claude Monet, and his 'series' paintings of the nineties. In both, time of day and atmospheric conditions appear to have been the governing consideration. James, of course, knew Monet's work intimately and respected it greatly. The admiration was mutual and on many occasions throughout their long association Monet had expressed his enthusiasm for James's work. By a

strange coincidence, as James was still painting on the north coast of France in September, Monet had arrived in London to begin his series of paintings of the Thames. Unquestionably inspired by James's earlier Nocturnes, the project would occupy him at regular intervals until*1904. From the same area of the Savoy Hotel where James had nursed Beatrice during her final illness, Monet would create some of the finest paintings of his career.

3 I

No Reprieve

<hr />

JAMES AND THE PHILIPS arrived back in London to the news that after months of diplomatic sparring the South African Boers had delivered their final ultimatum to the British government. The imminent threat of war was met by government officials in London with a mixture of 'derision, delight, dismay – and indifference'.[1] Like most, James had been watching the events in Transvaal during the past months with close interest. His old friend John O'Leary once again had sprung to public prominence, forming in Dublin the pro-Boer Irish Transvaal Committee. The issue breathed new life into the old warhorse O'Leary, and it came to serve as a similar tonic for James. Much to the chagrin of patriotic 'British' friends, James followed the ensuing war with obsessive delight.

James soon returned to Paris to spend the winter there. Although Rosalind and her mother continued in the apartment on the rue du Bac, James himself refused to stay there, claiming it was damp and bad for his health, and put up instead at the somewhat faded Hôtel Chatham. For someone who was not in receipt of a huge income, his style of life was expensive. Apart from the hotel bills in both London and Paris, he had the expenses of the rue du Bac, the rent of his Paris studio, together with the rent of his London studio at Fitzroy Street, not to mention the continuing rent of the gallery space for the Company of the Butterfly, in Hinde Street.

Throughout the winter of 1899/1900, James worked sporadically on a number of paintings, predominantly portraits, at his studio. As the winter wore on the occasions when he was well enough to make the journey to the studio, and then the long ascent to the sixth floor, became infrequent. More often than not ill-health confined him to his bedroom.

Just before Christmas 1899, the British army suffered its first major reverse in South Africa at the battle of Colenso. James was jubilant: as he received each newspaper he would carefully extract each battle report and neatly preserve it for the first unsuspecting 'Britisher' he met. Enchanted too with the weekly cartoons on the subject appearing in *Le Figaro*, drawn by one of the most popular cartoonists of the day, Caran d'Ache, he again carefully extracted these and sent them to the Pennells in London.

At the end of February 1900 James heard that his younger brother, William, had died in London. The news, though a shock, cannot have been a complete surprise, since over recent years William had taken to alcohol. Though aware of the problem, James probably never knew its full extent. As William's addiction grew, and he was able to work less, the family finances suffered. These shortfalls were tactfully ascribed to late payments by patients and James was always on hand to ensure that William's wife, Helen, suffered no undue embarrassment. Much to his credit James never lectured his brother, and as his illness worsened during the winter, he had visited him at Helen's request.

In the immediate aftermath of his brother's death, James seemed listless and restless. Unwell himself, he could do little work. Instead, he focused his attention on the forthcoming Exposition Universelle, due to open in April. After an initial contretemps with the American commissioner who unwisely requested James to meet him 'at 4.30 sharp' (James quickly pointed out that he had never been anywhere in his life 'at 4.30 sharp'), peace was quickly restored and James 'went' with the American section. For this major showcase James chose to show only portrait paintings: the picture of his sister-in-law Ethel Whibley, *Mother of Pearl and Silver: The Andalusian*, on which he had worked, incredible as it might seem, for nearly twelve years; together with the self-portrait in the style of his great hero, Velázquez, *Brown and Gold*. The US commissioners specifically requested *The Little White Girl*, which its owner, Arthur Studd, promptly agreed to lend. Although James asked the print collector Howard Mansfield to send from the United States the 'most magnificent proofs' of his etchings, they did not materialize: there was not time. Instead, he put together his own collection which, much to his delight, was awarded the *Grand Prix*.

James heard the news of his award, and the further award of the *Grand Prix* for his painting, after he had returned to London to stay with the Heinemanns at their new house in Norfolk Street, Mayfair. James could barely contain his joy at the news. Later that day, Heinemann gave a celebratory dinner during which he crowned James with laurel, or rather 'sprays from a plant in the dining room'.[3] More beneficial than any medicine, such an occasion worked wonders for his fragile health.

Throughout the early summer he worked a little when the fancy took him. There was one portrait at the Fitzroy Street studio he was particularly pleased with, *Rose and Gold: The Little Lady Sophie of Soho*, a portrait of Sophie Burkett, his landlady's daughter. Already bought by Freer nearly a year before, James continued to work on the painting 'giving it finer colour and tone'.[4]

The purchase by Freer of the portrait brought his total number of paintings by James to three. He had spent most of the 1890s adding to his collection of prints, the most substantial addition being the purchase in 1899 of Seymour Haden's collection of prints and drawings which Haden elected to sell because of his failing eyesight. It was not until 1900, after a shrewd business merger had made him 'independently wealthy', that Freer began to pursue and collect James's major works with fanatical single-mindedness. For the remaining years of James's life he and Freer worked closely together tracking down works and securing them for his collection. If the picture was right, the cost was usually no object. This practice continued for many years after James's death, up to the eve of the First World War. By then, Freer had methodically amassed the most extensive private collection of James's work anywhere in the world.[5]

When not toying with the occasional piece of work at the studio in Fitzroy Street, James involved himself with the Pennells and their projected catalogue of his work. The necessary photography being undertaken by William Gray was done at first in James's studio, but after a short time James could no longer bear the intrusion, and arranged for the work to be carried out in the studio below belonging to John Wimbush.

James was now living at Garlant's Hotel in the company of a secretary called Grimaldi. What exactly Grimaldi did, is not altogether clear, though he seemed to serve some purpose, if only as a companion and an organizer; he quickly faded out of James's life. Most evenings, if James felt well enough he dined with friends. Predictably, these evenings were dominated by news of the Boer War. Often his enthusiasm for explaining the Boer point of view was such that heated arguments erupted, voices rose and determined fists were banged on the table. So heated did the talk become on one occasion that the Pennells feared the 'kindling of a fatal war between himself and a good friend'.[6]

There may be some truth in the Pennells' observation that James believed the Boers' struggle had parallels with his own 'battle' with the British. He certainly also saw it through the eyes of his old friend O'Leary. As he explained on one occasion to Rosalind, whom he had taken to calling 'his dear little Boer boy', the British were now paying 'for the years of customary and continuous contempt [towards the Irish]'.[7] The same point

was made, though in a more dramatic fashion, earlier in the year, when he received a letter from Kennedy in New York in which the dealer made comments about the war. The comments did not please James and he scrawled across it, 'Ireland's Revenge'.[8]

Throughout the summer of 1900, Ireland was certainly on his mind. He asked Rosalind to find a house near the coast where they could stay. Within a week Rosalind had completed the necessary arrangements, and by the end of the first week in August she, together with her mother and a friend, Miss Frank, had departed for Ireland. James remained behind promising to join them after he had made a visit to Holland.

He was accompanied on this journey by a friend, an American artist Jerome Elwell, who had apparently suggested the trip while James was painting his portrait. They stayed at Domberg, a small fishing village near Middelburg. There was no repeat of the previous year's burst of work at Pourville-sur-mer, and instead James concentrated on several little water-colours and drawings. While there, according to the Pennells, he was delighted to fall into the company of a banker who talked, almost as much as he did, about the Boer War and assured him the Boers would be 'all right, the Dutch would see to that'.[9]

After spending two days resting in London, James sailed to Dublin on 20 August. Significantly, he did not go straight to the holiday house, 'Craigie', situated at Sutton some six miles north-east of the city where 'the spit of sand connects the Hill of Howth with the mainland', but instead chose to stay in the city itself at the Shelbourne Hotel. The decision was no passing fancy. James was there, away from the prying eyes of the family, to meet his lifelong friend O'Leary. It was almost certainly not their first meeting after years of separation, since O'Leary was a frequent visitor to London in the 1890s,[10] but it must have been the most emotional. Now the elder states-man of Irish nationalism, and still the scourge of the British press, O'Leary welcomed James to Ireland as a friend, and moreover a fellow countryman. After years of exploring and asserting his Irish background, James was finally in the land of his forefathers – although it seems he chose not to visit his ancestral home, Magherafelt, some 140 miles north of Dublin, where the family of Ralph Whistler once lived. This was to be the last time James was to meet O'Leary. As he walked away that night he took with him the secret of their friendship to his grave.

Late that evening, James sent a note to Rosalind at Craigie: 'Well, you better both come tomorrow and ask for me – say about 10 or half past. You can show me Dublin, which seems to me wonderful – I am so pleased with it already . . . If by chance I have wandered out you should wait for me . . . The place is full of people who sit about the Hall and are amusing!'[11]

Removed to Craigie, James thought the place splendid, though, according to John Butler Yeats, father of the poet W.B. Yeats, who met James during his stay in Ireland, James felt the view of the sea was far too distracting.[12] After acquiring some pins and brown paper, much to the amusement of the local inhabitants, he covered up the lower half of the windows around the house.

Although the trip to Ireland was a holiday, James could not resist the temptation to work. While there, he embarked on four, possibly five paintings. One of the most successful – later sold to an American collector, Richard Canfield, for £250 guineas – was *Grey and Gold: The Golden Bay, Ireland*.[13] A fluid, almost creamy painting, this little panel is one of the most evocative and sensitive James had painted in many years.

During the week of his stay James renewed his friendship with William Booth Pearsall, the dental surgeon who had organized his show at the Dublin Sketching Club in 1884. He also spent a day with Sir Walter Armstrong who took him on a private view of the National Gallery of which he was Director. According to Armstrong, two particular paintings caught James's attention: Hogarth's group portrait of George II and his family, which James declared was 'the most beautiful picture in the world', and a portrait of Armstrong by the young Irish painter, Walter Osborne, about which James declared, 'It has a *skin*, it has a skin!'[14] While James may have admired the prodigious talent of the Irish painter, he did not warm to his personality when they were introduced later that day.[15]

Back in London, James's health again took a turn for the worse and he was confined to bed at Garlant's Hotel. In between recurring bouts of illness that autumn he made several trips to Paris to attend to the business of the Academy Carmen. During one visit he began the long-promised portrait of William Heinemann's wife. Started characteristically in a flurry of enthusiasm, progress soon faltered. Although sittings were resumed on several occasions, the 'bella Mafia', as James jokingly referred to it, came to nothing and the painting, whatever remained of it, was lost.[16]

At the beginning of November, his health completely broke down. Weak and unable to work, worrying constantly about the state of his affairs and his unfinished work, he met the news of Oscar Wilde's death in Paris with no outward response: in James's eyes Wilde had died many years before. A cough which had developed some weeks earlier refused to clear and he found it difficult to breathe. The heavily polluted freezing fogs of London only agitated the condition, and after a visit to his doctor it was decreed that he should leave the town and seek recuperation in a warmer, cleaner climate.

James heeded the advice, and within days he had planned his escape

from London in the company of his brother-in-law, Ronald Murray Philip. Their destination was the south, Tangier, where they planned to stay and travel for several months. To ensure that James and his companion were well looked after on the voyage, an old friend from the Beefsteak Club, Sir Thomas Sutherland, chairman of the P & O shipping line, wrote to the captain of their ship. Several days later, with a dozen or so copper plates ground by Joseph Pennell wrapped carefully in his luggage, together with his drawing paper, pencils and pastels, he began the voyage.

Gibraltar he loathed at once: 'I refrain from expressing myself,' he wrote to friends in London.[17] Unfortunately, Tangier was little improvement. Apart from it being far too 'Eastern', the wind was bitterly cold. Within a few days they moved eastward along the North African coast to Algiers seeking warmth and sunshine. Again, there were only complaints; it poured with rain and the town seemed 'cheap, like the sort of stuff you see in the small booth in . . . the Avenue de l'Opéra'.[18] After a week or so, James and Ronald bolted, leaving behind the unpaid hotel bills, 'from which we have playfully sailed away'.[19] Some good was salvaged in Algiers; he completed several sepia drawings, and a sketchbook containing nearly eighteen pencil drawings, all depicting scenes from the daily life around him.[20] By now early January, James had had enough of North Africa and they sailed north to Marseilles where instead of warmth, they found 'two or three feet of snow'.

Despite the atrocious weather in Marseilles, James and Ronald stayed for nearly a fortnight at the Hôtel de la Canebière. While there, James saw a local doctor, who after a thorough examination gave him 'a clean bill of health'. On the doctor's advice, plans were made to leave for Corsica where the 'air' was more congenial. Predictably, the weather was again cold and wet. Nevertheless, after settling in to the Hotel Schweizerhof in Ajaccio James quickly informed Rosalind: 'This is a wonderful place! As I sit in the hotel garden, with oranges and large white roses on the trees all about, I make up my mind that we ought to have a villa . . . and just stay here!'[21] In a letter to William Heinemann, he urged his friend to come and join him, adding as an incentive that the menu was increasing as the guests were decreasing. Heinemann duly arrived, but inclement weather curtailed their outdoor activities, and much of the time was spent in a local café playing the game of dominoes which Heinemann had taught James. In typical style James invented his own form of cheating which he carried through with outstanding audacity.

One thing the holiday drove home to James was the need to relax, to rid himself of the pent-up anxiety that had begun to dominate his life. As he explained in a letter to Elizabeth Pennell:

At first, though I got through little, I never went out without a sketch-book or an etching plate. I was always meaning to work, always thinking I must. When the Curator [of a local museum] offered me the use of his studio. The first day I was there, he watched me but said nothing until the afternoon. Then – 'But, Mr Whistler, I have looked at you, I have been watching. You are all nerves, you do nothing. You try to, but you cannot settle down to it. What you need is rest – to do nothing – not to try to do anything. And all of a sudden, you know, it struck me that I had never rested, that I never had done nothing, that it was the one thing I needed! And I put myself down to doing nothing – amazing, you know. No more sketch-books – no more plates. I just sat in the sun and slept. I was cured. You know, Joseph must sit in the sun and sleep.[22]

The same point was reiterated to Rosalind in April: 'For *years* I have had no *play*! . . . for years I have made for myself my own treadmill and turned upon it in mad earnestness until I dared not stop! and the marvel is that I lived to be free in this other Island – and to learn, in my exile, that again, "Nothing Matters!"'[23]

Despite all this talk of relaxation, James completed at least three oil paintings while in Corsica, several drawings and, after a gap of nearly eight years, several etchings. Disaster nearly overtook the latter when the ground Joseph Pennell had prepared came off as James began to 'bite' the plates. It was not entirely Pennell's fault, as he had tried earlier to explain to James: he had not been given enough time to do the job properly. For James this was no excuse. Still fuming nearly three weeks later, he instructed Rosalind to inform Elizabeth Pennell that 'her husband's varnishing was simply *disastrous*, and all my etchings ruined. The plates were simply *burned* into a state of enamel, and the varnish flew away with the whole work!'[24] Despite his howls of protest, he managed to save at least four of the images, two of which were printed in his lifetime: *Bohemians, Corsica* and *Marchande de vin*, and two after his death: *The Sleeping Child, Ajaccio* and *The Flaming Forge, Ajaccio*.[25] However, as Lochnan has pointed out, these late etchings reveal no new direction; they were simply 'quiet postscripts to an illustrious career'.[26]

Although the extended trip did wonders for his health, James could still not escape the day-to-day running of his affairs. He wrote upwards of a hundred letters, together with cheques and numerous telegrams, and received more than seventy in reply. It was the Academy Carmen that remained his major preoccupation. By early 1901 Carmen had herself lost interest in the academy and become involved in a wine shop. Inez Bates carried on stoically running the only section of the school left open, the

Arrangement in Grey and Black: Portrait of the Painter's Mother, 1871, Musée d'Orsay, Paris.

The best known and most widely reproduced painting by Whistler. Begun as a full-length standing portrait of his mother, the posing quickly proved to be tiring. To ease her exhaustion Whistler then continued the portrait in her famous pose of side-on profile. A recently discovered photograph (see Plate 14), which may be related to the drypoint *Whistler's Mother* from the same period, opens up the possibility that Whistler might well have worked from the photograph when his mother Anna was too tired or unavailable to sit for him.

At the Piano, 1858–9, Taft Museum, Cincinnati, Ohio. Bequest of Mrs Louise Taft Semple.

Painted at 62 Sloane Street, London, the home of his brother-in-law, Francis Seymour Haden.
The painting shows Whistler's half-sister Deborah at the piano while her daughter Annie,
Whistler's niece, looks on.

Wapping on the Thames, 1860–4, National Gallery of Art, Washington DC, John Hay Whitney Bequest.

The painting caused Whistler great anguish. Originally begun as a narrative essay in pictorial
realism when Whistler was deeply influenced by the movement's leader, Gustave Courbet. Its hesitant
progress over several years belied his anxiety with the movement. In the end its design and anti-narrative
content set the basis for his future formal concerns. Included in the painting are Whistler's girlfriend, Joanna
Hiffernan, and Alphonse Legros (*centre*), an early artist friend from Paris who had come to live in London.

Symphony in White, No. 1: The White Girl,
1862, National Gallery of Art, Washington DC,
Harris Whittemore Collection.

One of Whistler's most beautiful portraits, it
was also one of the most controversial. Depicting
his Irish girlfriend, Joanna Hiffernan, Whistler was
accused of cashing in on the popularity of Wilkie
Collins's novel, *The Woman in White.* Whistler
fervently denied the charge, claiming the portrait was
simply a painting of a woman dressed in white.
Together with Manet's *Déjeuner sur l'herbe*, it was the
most discussed painting at the infamous Salon des
Refusés in 1863. The ephemeral nature of the portrait
together with its overriding formal concerns set the
agenda for his later work in portraiture.

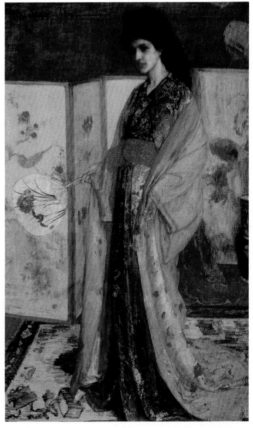

*Rose and Silver: The Princess from the Land of
Porcelain,* 1863–4, Freer Gallery of Art,
Washington DC.

This is one of the earliest paintings in which
Whistler begins to incorporate Oriental artefacts
into his designs. The model was Christine Spartali
who was considered one of the most beautiful
women of her generation. Whistler knew her
through his connections with the wealthy Greek
family, the Ionides. The painting was eventually
acquired by Frederick R. Leyland and hung in the
centre of the north wall in the Peacock Room at
49 Prince's Gate, London.

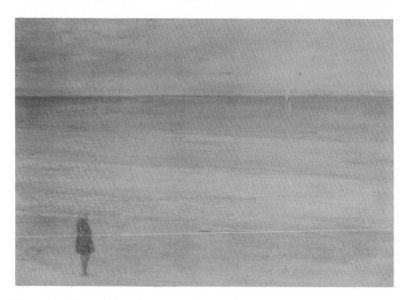

Harmony in Blue and Silver: Trouville, 1865, Isabella Stewart Gardner Museum, Boston.

This painting was completed in the autumn of 1865 shortly before Whistler departed for Valparaiso. The figure on the shore is Gustave Courbet who was also staying at Trouville. Although Courbet still considered Whistler a 'pupil', by this time Whistler had begun to move away from realism. In this respect this little panel takes on added significance. The figure of Courbet portrayed with his back to Whistler seems to symbolize the end of his association with realism.

Nocturne: Blue and Gold – Old Battersea Bridge, 1872–3, Tate Gallery, London.

From Whistler's break with Courbet's 'damned realism' he began to shape his own aesthetic objectives. Between 1866 and the early 1870s he honed and refined his desire to rid his art of any narrative content. Formal design took precedence over subject-matter. One result was the Nocturnes which, almost abstract, incorporated elements of Japanese spatial design. Given the prevalent Victorian desire for didactic paintings, crammed full of detail and incident, it is not surprising to find that in general the Nocturnes were met by critics and public alike with almost total incomprehension.

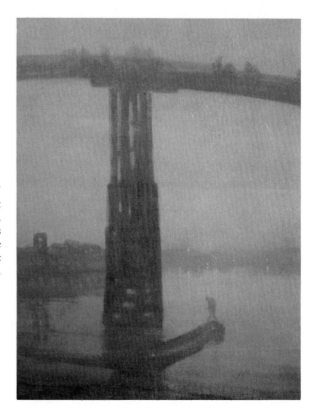

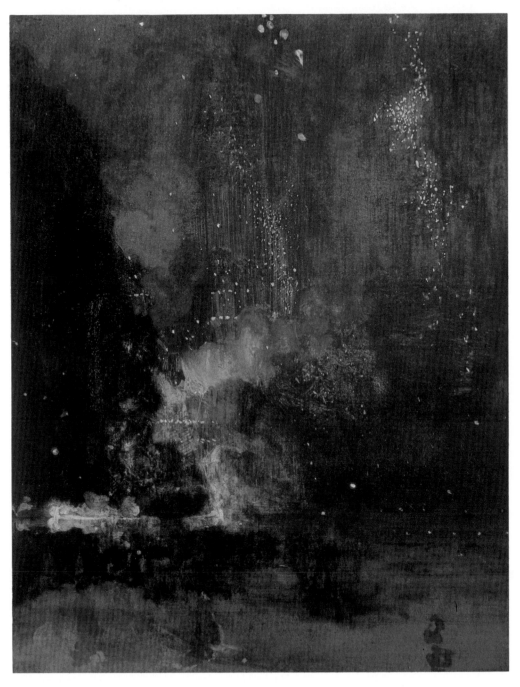

Nocturne in Black and Gold: The Falling Rocket, 1875, Detroit Institute of Art, Gift of Dexter M. Ferry Jnr.

This is probably the most notorious of all Whistler's paintings. Accused by John Ruskin, one of the most influential writers of the nineteenth century, of flinging a pot of paint in the public's face, Whistler sued the writer. Although Whistler eventually won the case when it came to trial in November 1878, he was awarded only one farthing's damages and no costs. The case bankrupted him.

Gold and Grey: The Sunny Shower – Dordrecht, watercolour, 1884, Hunterian Museum and Art Gallery, Glasgow University, Rosalind Birnie Philip Bequest.

Whistler's watercolours are perhaps the least known of all his work. He used the medium frequently as finished works in themselves and occasionally as preparatory tools for larger works in oils. As in his small seascape oil panels of the 1880s, the beauty of the watercolours lies in the economy of brushwork. Little, sparingly used flicks of colour simply create the suggestion of the subject.

Sunset: Red and Gold - Salute, pastel, 1880, Hunterian Museum and Art Gallery, Glasgow University, Rosalind Birnie Philip Bequest.

As with the watercolours Whistler's pastels are relatively unknown, yet some of his finest images were executed in this medium. During his stay in Venice after the Ruskin trial, Whistler completed a series of pastels whose quality remains unsurpassed. This image of the Santa Maria della Salute recalls the works of Turner and anticipates Monet's series of paintings of the River Thames later in the century. The nature of the medium itself allowed Whistler to use rich colours not normally associated with his oil paintings.

Arrangement in Black: Lady Meux, 1881–2, Honolulu Academy of Arts, Hawaii.

Whistler's portraiture is arguably the most complex aspect of his oeuvre and the most intriguing. By its very nature portraiture is the bread and butter of most artists' careers. Whilst Whistler relentlessly experimented with this aspect of his work most of his portraits were, for most of his adult life, of close friends and family. When he did get lucrative commissions he usually either failed satisfactorily to complete them, or nearly drove the sitter to distraction with interminable sittings – over seventy was not unusual. In some cases he simply refused to give the portrait over to the new owner as in the case of Lady Eden, while in others, such as Thomas Carlyle, he refused to sell, despite offers, for many years. Lady Meux represents one of Whistler's more successful portraits. Completed without too much anguish, it set the basis for a potentially lucrative market in fashionable portraiture. Predictably, Whistler did not continue in this vein. Unfortunately for Lady Meux Whistler recognized the success of the portrait and 'borrowed' it from her on many occasions for exhibitions all over Europe for the remainder of the century.

Arrangement in Flesh Colour and Black: Portrait of Théodore Duret, 1883–4, Metropolitan Museum of Art, New York.

The French critic and author Théodore Duret was one of Whistler's great champions in France. Not only did he consistently praise Whistler's work from the early 1880s onwards, but he was also instrumental in introducing him to the Symbolist poet Stéphane Mallarmé through their mutual friendship with Claude Monet. Whistler's portrait evokes the symbolism of Mallarmé, Duret appearing to emerge in a timeless, placeless space. Duret visited Whistler during his final illness in London in the early summer of 1903. Shocked at the sight of the artist painfully thin and unable to speak, Duret broke down and fled from the room. After Whistler's death in 1903, when many began to doubt the extent of his achievement, Duret never wavered in his support.

The Little Rose of Lyme Regis, 1895, Museum of Fine Arts, Boston.

This beautiful and sensitive portrait is of Rosie Randall, the 8-year-old daughter of G.J.Randall, Mayor and alderman of Lyme Regis. Rosie lived until 1958. Whistler visited Lyme Regis in 1895 in a desperate attempt to ease the ailing health of his wife, Beatrice, who was then suffering from terminal cancer. Although Whistler had painted, drawn and etched many young children during his career, the portrait of little Rosie Randall was certainly one of the most successful.

women's life class. By March, things had not improved and James's continuing absence led many of the remaining students to leave. At the beginning of April he sent a message to the students via Miss Bates, 'begging them to forget the narrow principles imposed upon them, which were too strong for milder mortals, and bade them goodbye'.[27] By return he received his final missive from Miss Bates on the subject, a telegram: 'Document read yesterday – assemblage large – sad stupefaction exists – all shall be as you wish.'[28] James forwarded the telegram to Rosalind, annotating it with the statement, 'Last act! Curtain! How do you like my play?'[29]

Another concern was the fate of the Company of the Butterfly, or rather the financial commitment to the lease. Fortunately for him, William Webb, James's solicitor, was able to find someone to take on the lease and at a stroke his worries evaporated. Still another was his uncompleted, commissioned work. The unfinished portrait of George Vanderbilt worried him endlessly. In mid-January, having received another letter from the millionaire expressing his concern, James wrote to his solicitor suggesting that perhaps he should send him back his money, £2,000. Vanderbilt's request was not unreasonable, particularly since James had accepted the final payment 'on completion' over eighteen months before, but on this occasion Vanderbilt got neither his money nor his portrait. For this he had to wait until after James's death.

For James, Freer was the ideal type of patron: a man of infinite patience (though sorely tested on several occasions), infinite finance, and equally important, an understanding friend. While they had not seen much of each other over the years James was always keen to send him the latest news. From Corsica, he wrote to Freer in early February. Although the note was primarily intended to secure Freer's permission to loan some of his work to an exhibition in Paris, he could not resist a humorous line: 'You will be amused to find me calmly writing from Bonaparte's Island! – Happily, you know that it is not my way to seek my effects in the glories of others! – Still "Napoleon and I" . . . Enfin!'[30]

The joviality of such utterances quickly turned again to depression. When Ronald had to leave the island, James stayed behind, ostensibly to finish some work. He wrote to Rosalind:

I staid on after Ronnie so that I might perhaps paint a head of a child or a lad that came, and in that way get myself into trim again before facing my old worries in the studio – well everything went against it! . . . It has rained for days since Ronnie's departure – and then inside it was impossible, for

when the boy came to sit, out dribbled the wet sun and drove me crazy with his foolish reflections![31]

James remained on the island for a further month, but the weather did not improve. In almost every photograph from the holiday, James is seen wearing his long, thick coat, topped with his wide-brimmed boater. This image of him wrapped against 'the cold', even on the hottest days, characterized his appearance for the rest of his life. At the end of April, he finally left the island for Marseilles and by 12 May, he was back at Garlant's Hotel. The five-month trip abroad certainly appeared to have worked wonders for his health, though it was only to be a short-term gain. This was his last fling at independent travel, and from then onwards his seriously failing health dictated that there should always be someone at his side.

So incensed was James at what he saw as British treachery in the Boer War peace talks that on the evening of his return to London, he nearly came to blows with his good friend Kennedy. Apparently, the only physical barrier to outright violence was the formidable presence of Elizabeth Pennell.[32] For the remainder of the summer James stayed in London, continuing to work at the Fizroy Street studio when his precarious health permitted. Evenings, as always, were sociable and entertaining, with the occasional visit to the Chelsea Arts Club. By the autumn James had finally made a decision that he had deferred for several years. He decided to close up the house on the rue du Bac, together with the studio on rue Notre Dame des Champs. After Beatrice's death he found it almost impossible to live at the rue du Bac, but it remained a difficult decision to make, since it symbolized after many years his break with the city he loved, Paris. But following a brief trip in October, the painful business was concluded.

The break with France seemed to refocus his attention on his affairs in London. With the proceeds from the sale of the rue du Bac, he purchased a house in Tite Street – no. 36 – for old Mrs Philip and Rosalind. In early November, he moved out of Garlant's Hotel, and booked himself into Tallant's Hotel in North Audley Street, Mayfair, which Elizabeth Pennell described as 'gloomy . . . but eminently correct'.[33]

As another winter enveloped London, James's health took a turn for the worse and he went to stay with the Philips in Tite Street. There, under the supervision of Rosalind, guests were rarely encouraged, except for particular friends deemed important by Rosalind, such as Freer, Edward Kennedy, if he were in town, or William Heinemann. The Pennells, the most dogged of his 'followers', were never allowed to set foot through the door. James could not bear such inhospitable tension and it was one of

the reasons he quickly regained his much needed, though increasingly limited, independence from the household.

On 5 December, together with Rosalind, he left London to spend the next two months in the mild clean air of Bath. Taking rooms in one of the big crescents, he did little of the work he hoped to achieve, and instead spent most of his time in antique shops hunting for 'old silver and things'.[34] In January he travelled back to London on several occasions, once to attend a meeting of the International Society, and again to visit an Old Master exhibition at the Royal Academy – on that occasion marvelling at the Kingston Lacy version of Velázquez's *Las Meninas* which was on show. Later he explained his thoughts to the Pennells: '[The exhibition] is full of things only Velasquez could have done, – the heads a little weak perhaps – but so much, or everything, that no one else could have painted like that. And up in a strange place they call the Diploma gallery I saw Spanish Phillip's copy of *Las Meninas* full of atmosphere really and dim understanding.'[35]

During his time in Bath, James was delighted to hear the news that he had been awarded the Gold Medal of Honor at the Pennsylvania Academy of the Fine Arts. Such awards he absolutely adored and, following on the heels of the other honours he had achieved the year before – gold medals in exhibitions in Buffalo and Dresden, and his election as an honorary member of the Académie des Beaux-Arts – it made him feel as important as he now assuredly was.

When he returned to London in the early spring of 1902, James took the lease on a house in Cheyne Walk, no. 74, which he moved into with Rosalind and Mrs Philip. A relatively new arts-and-crafts house, of peculiar design, it had been built by C.R. Ashbee on the site of a favourite old haunt and subject of James's, Maunder's fish shop. The Pennells carefully described their first impressions of the house:

> It was on a lower level than the street, reached by a descent of two or three steps from the entrance hall . . . Two flights of stairs went up to the drawing-room where, in glass-enclosed cases running round the room, he placed his beautiful blue and white china. Kitchen and dining-room were on this floor, but another flight of stairs led to the bedrooms under the eaves. Almost all the windows opening upon the river were placed so high and filled with such small panes that little could be seen from them of the beauty of the Thames and its shores so dear to Whistler. The street door was in beaten copper and the house was full of decorative touches . . .[36]

Despite the scenic disadvantages, the new house had one real advantage: a

large spacious studio at the rear. For the first time in many years, James no longer had to worry about getting to the studio, or climbing endless stairs. It was a real luxury.

Living full-time with the over-protective Philips was a cross James had to bear. The policy of guest censorship continued relentlessly, though after some weeks James had managed to soften their line. When their fussing became too much, he simply escaped into the studio for hours at a time. He now rarely ventured out alone, convinced he would catch some fatal bug. More and more of each day was spent, often fruitlessly, in the studio. The friends who came to see him, such as Walton and Lavery on International Society business, now rarely saw him dressed. He seemed always to be in his night clothes, topped with his heavy coat buttoned up to the neck. The prospect of one particular visitor in the spring, the sculptor Auguste Rodin, who was in London for a dinner which James could not attend, excited him greatly. But even that was to prove an anti-climax. Accompanied by the English sculptor John Tweed, Rodin arrived to be received warmly by James. The breakfast in the studio went well, so too did the conversation, but Rodin seemed totally uninterested in James's work. James could barely conceal his bitter disappointment when later describing the visit to the Pennells:

> It was all very charming. Rodin distinguished in every way – the breakfast very elegant – but – well, you know, you will understand. Before they came, naturally, I put my work out of sight, canvases up against the wall with their backs turned – nothing in evidence. And you know, never once, not even after breakfast, did Rodin ask to see anything, not that I wanted to show anything to Rodin, I needn't tell you – but in a man so distinguished, it seemed a want of – well, of what West Point would have demanded under the circumstances.[37]

There were, however, some brighter moments on the horizon. Throughout the winter months James had remained in frequent touch with his newest patron, Richard A. Canfield. A colourful character, the 45-year-old Canfield had made a good part of his fortune from a string of deluxe gambling houses in the United States. He was brought to James's attention in Corsica by a friend of the Winans family, W.D. Coggeshall. Canfield wanted James to do his portrait, and eventually, swayed by the beautiful photographs of Canfield's house and its interior which he saw at Coggeshall's, James wrote to Canfield:

> When I saw . . . photographs and reproductions of the rare furniture and

bronzes, with which you have surrounded yourself, I was especially pleased with the perfect relation between the objects themselves and the rooms in which they are placed – and to which they therefore seemed to have always belonged!

This absence of overcrowding – the refined feeling of fair space about the beautiful thing itself – like the large margin framing the sonnet – reveals immediately the subtle sense that marks the difference between the man, born to live with, and delight in, what he gathers around him, and the 'Collector' made to stack his place with bric-à-brac . . . I need not say what pleasure it will be to me to have work on such walls . . . and I gladly accept your proposition.[38]

In March, Canfield arrived in England to begin the sittings. After booking into Claridge's Hotel, he sent a note to James. The first meeting was a success and James was captivated by the gambler's charm, good manners and cultivated taste. In time-honoured fashion, James quickly found an appropriate nickname for Canfield whose smooth exterior hid the true nature of his shady business career: from then on he would be known as 'His Reverence'. The sittings for the portrait began almost immediately and continued through the spring into the early summer, until business matters unexpectedly called Canfield back to the United States. James's association with Canfield brought to an end his long friendship with Edward Kennedy who was horrified to learn of the new relationship. James was furious with Kennedy's warnings of the gambler's shady business dealings; angry words were exchanged and, according to Elizabeth Pennell, 'Kennedy could not forgive'.[39]

As Canfield departed, Charles Freer arrived in London to begin a summer vacation, liberally sprinkled with visits to private collectors, museums and anyone else who might have a treasure hidden away.[40] Freer also hoped that James would honour his long-standing promise of a portrait. The promise was duly kept and the portrait was quickly begun. After several weeks, the portrait, like so many before, was 'put aside'.

Despite the reassuring presence of the gentle and kindly Freer, James's mood had turned to anger and agitation during the early summer. Unknown to him when he secured the lease at Cheyne Walk, Ashbee was about to begin developing the vacant site next door. The dirt, dust, and continual banging and hammering irritated James intensely. He consulted his solicitor, but Ashbee had every right to redevelop the property and it simply could not be done in silence. To compound his misery at this time, after his paintings and other belongings had been shipped back from Paris, he discovered that many of them were missing. As stolen prints and other

small drawings began appearing in Paris shops, suspicion fell on Carmen. Unable to believe the truth, James made some lame overtures to her. Nothing happened. A private detective was employed to investigate her, and a firm of English lawyers in Paris were retained to handle the case in the French courts should sufficient evidence come to light. Again nothing came of it. Carmen was even enticed to London, where she was interrogated at length by James's solicitor, William Webb, but to no avail. In reality James was probably pleased that Carmen never admitted the theft; she had been like a daughter to him and evidence of betrayal would have been difficult to bear. But after James's death the missing paintings duly turned up in Carmen's possession: some were sold at auction at the Hôtel Drouot in Paris, others she kept and eventually sold to collectors like Freer. Whenever she was asked about their provenance she merely said that they had been given to her by James in lieu of various outstanding payments. Whatever the truth, the proceeds allowed her a good standard of living for the rest of her life.

To escape these anxieties James quickly jumped at the chance to go with Freer to The Hague in Holland. But no sooner had they arrived than James collapsed with what was probably a mild heart-attack. Freer quickly secured a local doctor and then wired Rosalind Philip and her sister Ethel, in London, to come immediately, which they did. For several days James hung on to life by a thread. Almost miraculously he began to revive and by the end of the week, he was sitting propped up in bed surrounded by family and friends. After hearing of his illness the Queen of the Netherlands provided the services of the court doctor. While such attentions were pleasing, privately the experience had terrified him. In a quiet moment with Freer, he dictated his will leaving everything he owned to Rosalind. To an article which appeared in the *Morning Post* and which had evidently been adapted from an obituary already prepared, he responded with characteristic glee:

> May I therefore acknowledge the tender glow of health induced by reading, as I sat here in the morning sun, the flattering attention paid me by your gentleman of ready wreath and quick biography!
>
> I cannot, as I look at my improving self with daily satisfaction, really believe it all – still it has helped to do me good! and it is with almost sorrow that I must beg you, perhaps, to put back into its pigeon-hole, for later on, this present summary, and replace it with something preparatory – which, doubtless, you have also ready.[41]

After several weeks recuperating in The Hague, James travelled to

Amsterdam with Elizabeth Pennell. While there, he asked her to accompany him to the Rijksmuseum to see his portrait of *Effie Deans* which had been bequeathed to the museum by the widow of its owner, Baron van Lynden. James was also keen to see the superb collection of Rembrandts. By mid-September he was back in London. The noise of the building work next door continued unabated and in an effort to lessen the acoustic torture he moved his bedroom from upstairs to a little room just off the studio. By early October he had found a new model, a young red-headed Irish girl called Dorothy Seton who bore an uncanny resemblance to Joanna Hiffernan. James obviously adored her, and remarked to Elizabeth Pennell that she reminded him of 'Hogarth's Shrimp Girl' in the National Gallery. Over the next six months he painted her at least twice. One of the paintings is now lost, but the remaining one, *Dorothy Seton – Daughter of Eve*,[42] though only a developed sketch, was a remarkable achievement for one so ill and frail. James told Joseph Pennell that he completed it in less than two hours.[43] During the winter James also made two lithographs of her – his last work in the medium.

Another London winter filled James with dread. Continually ill, there was now no question of him seeing out the season in a milder climate. Rarely now did he leave the confines of Cheyne Walk. He loved to see his old friends and was particularly enchanted when Arthur Studd arrived in London to call on him. Despite his ill-health his mind was as lively as ever and little escaped his attention. He was furious when he heard that a Mrs Arthur Bell had been commissioned to write a monograph on him and refused to help in any way whatsoever. In November, he was angered to read a report which appeared in the *Standard* implying that his painting, *Grenat et or: Le Petit Cardinal*, which was then on show at the Royal Society of Portrait Painters, had been shown around at exhibitions for years. He quickly gave vent to his anger in a long, rambling letter, which at times bordered on an almost incoherent attack on the author of the piece, his old enemy, Frederick Wedmore:

> The Little Cardinal is, in her absolute childhood and complete inexperience of these very sharp gentlemen, only yesterday returned from the Paris Salon, where, in brilliant company, she received her baptism. And this is the first Gallery in the Island in which she makes her appearance, and the busy and correct one has hitherto never set eyes on her! . . . this upright and unhesitating Master Podsnap – and surely Podsnap it is, with his convinced emphasis and angry innuendo . . . Podsnap General, Podsnap Financier, Podsnap Statesman we know, but it is my joy to have perceived our old friend in his last incarnation.[44]

It was the last letter James ever wrote to the press.

As illnesses lingered over Christmas and into 1903 there was little cheer at Cheyne Walk. Even an exhibition of his splendid collection of silver at the Fine Art Society could not entice him out of doors. When the news came that Montesquiou had sold his portrait to Canfield for 60,000 francs, he wrote to him, bitter and angry: 'Bravo Montesquiou! the portrait which you acquired as a poet, for a song, is resold . . . for ten times that song! Congratulations!'[45] On quieter days his time was taken up with tidying his studio, ordering his affairs and receiving guests. Heinemann was a frequent visitor, and on good days when he was feeling well enough James was taken, wrapped snugly in a blanket, for a drive in the former's motorcar. The machine, still a novelty in London, fascinated James, and he delighted in sitting up in the back seat waving regally to those they passed.

In January, Canfield arrived back in London to continue his sittings. The work was painfully slow, continually interrupted by James's ill-health. Towards the end of January his spirits were lifted momentarily when his old friend, the critic and author D.S. MacColl, arrived at Cheyne Walk with some wonderful news. The University of Glasgow proposed to confer on him an honorary degree of Doctor of Laws. In a moment of humour, he told MacColl he would have to think about it in another room. Gleefully he returned: of course, he would graciously accept the proposal. Unable to attend the ceremony in April, his degree was received on his behalf by his two principal sponsors, the newly elected President of the Royal Scottish Academy, Sir James Guthrie, and the Professor of English Literature at the University, Walter Raleigh. In his letter of thanks and appreciation to the University of Glasgow, James was quick to point out his own Scottish ancestry, noting that his mother was descended from Daniel MacNeill, chief of the clan, who had emigrated with some sixty clansmen from the Isle of Skye to North Carolina in 1746.

Throughout the spring of 1903, he spent most of his time in bed, coughing and always tired. There were, however, occasional moments of remission and visitors to Cheyne Walk were pleasantly surprised by his appearance. But by June, he had lapsed into a virtually comatose state, staring blankly at those allowed in to see him. Others, however, were not even afforded that privilege. His old 'pupil' Walter Greaves turned up, requesting to see 'the master'. After some consultation on the other side of the door, Greaves was curtly informed by 'the ladies of the house' that he was not known, and therefore his request would have to be refused. It was a pathetic moment, and one which James himself would never have permitted. Days later Edward Kennedy experienced a similar humiliation. After arriving at the house to make peace with James, he found that James

had been taken out. Instead, he asked to see Rosalind. She refused, though allowing in Kennedy's companion, the London print-dealer Robert Dunthorne. Her actions hurt Kennedy immensely.[46] Others more fortunate included Théodore Duret who arrived from Paris to see him on 9 July. Entering the cell-like room, he found James showing no signs of recognition and barely able to talk. Overcome with emotion, Duret quickly left. Several days later James's hands began to swell and when Elizabeth Pennell was eventually allowed in to see him, she reported that his face was sunken and 'his eyes as vague'.[47] A week later Duret summoned the strength to visit him again. James's condition was still shocking, although this time he 'wanted to talk' but had difficulty finding the words. There seemed no hope of recovery. Two days later, on the afternoon of Friday 17 July 1903, life finally left him for ever.

Because of the time of the death, news of it was not widely circulated until after the weekend. The Pennells did not hear of it until the following day.[48] Amidst the confusion of grief the details of the funeral were not announced until Tuesday 21 July, the day before it was due to take place. The service was to be held at the Chelsea Old Church at 11 a.m., and the interment at Chiswick cemetery an hour and a half later. Early on Wednesday morning, ahead of the scheduled hour, the local police at Chiswick erected barriers to protect the mourners from the expected crowds. It was a pointless exercise. Apart from close friends and family, few other people turned up. As the coffin was lifted from the carriage the pall-bearers fell into place – George Vanderbilt, Freer, the American-born painter Edwin Austin Abbey, Sir James Guthrie, John Lavery and Théodore Duret. Significantly, there was not an Englishman amongst them. Other mourners included members of the family, Heinemann and his wife, Studd, his solicitor William Webb, David Croal Thomson, several members of the Royal Academy including Sir Lawrence Alma-Tadema and Sir Alfred East. Luke Ionides, one of his oldest friends, was there, as was Mortimer Menpes, long since cast in the role of 'enemy', though gracious enough to attend and pay his respects. Walter Sickert did not attend, though his ex-wife Ellen did. Charles Hanson was there together with his wife, Sarah. James's old adversary, his brother-in-law Sir Francis Haden, now ill and almost blind, did not attend. Deborah did, along with the children. The International Society was well represented and a wreath of golden laurel leaves from the members was placed upon the dark purple pall which covered the coffin. On a blustery, showery summer afternoon, his mortal remains were lowered into the grave to rest eternally beside his beloved Beatrice.

32

Retrospect

F OR THE FIRST DECADE or so after his death, it seemed almost as though Whistler's life was being played all over again; this time, however, in reverse. From the almost universal acclamation which followed his death, when hardly a newspaper or periodical in Europe and the United States failed to mourn his passing, the tone, particularly in England, changed dramatically as the decade wore on. In many respects this reflected the shifting focus amongst the more progressive British art critics. As the perception of art itself began fundamentally to change, so too did its values, and equally important the language used to express its meaning. By the latter half of the first decade of the new century, Whistler's art literally begged reinterpretation.

One thing that his death confirmed was Whistler's celebrity, personally and commercially. He remained an editor's dream, especially now that the threat of retaliation was no longer an issue. In commercial terms, after his death prices for his work rose markedly, with Freer almost single-handedly determining the market. In February 1904, he bought the Peacock Room from the London dealers Obach for £6,400. In December the same year, the Wickham Flower collection of prints and paintings was sold at auction at Christie's in London. Of all the lots in the sale it was the Whistler prints and the two little oil panels that caused the most interest. Reporting the sale of the thirty-five etchings which made £1,181 4s 6d, the *Daily News* commented: 'Never before have etchings by Whistler realized anything like so much under the hammer. The level of prices was, roughly, about twice as high as that reached a year ago, and by collectors of the old-fashioned type even at that level was regarded as perilous.' On the final day of the

Flower sale, the two oil panels painted in St Ives in 1884 fetched 540 guineas and 360 guineas respectively. Again the press could only look on in amazement. Noting the fact that 'open-air studies' by Lord Leighton 'were sold for an average of slightly over ten guineas each', the *Globe* continued: 'But the appraisement of the Whistler's must have astonished many people who do not know how high is the valuation put upon his best performances, and it was possibly not expected by anyone but a few of his admirers.' Whistler prices continued to rise steadily until the advent of the First World War.

Alongside the commercial sale of Whistler's work, the three huge memorial exhibitions in Boston, Paris and London during 1904 and 1905 meant that there was hardly an area of his life and art which did not come under the critical microscope. But it was not only his work which kept his name to the fore: even in death the personal controversies continued unabated. Within weeks of his death a split had occurred between different factions of the Whistler entourage. Ranged on one side was the executrix, Rosalind Birnie Philip, who had inherited the entire estate and powers of disposition – interestingly, Charles Hanson, James's illegitimate son, was left nothing. In full support of Rosalind was Charles Lang Freer. On the other side stood the Pennells, together with the publisher William Heinemann. In many ways the acrimonious split was predictable. Not only had Rosalind inherited from her sister Beatrice a grave mistrust of James's associates, and in particular the Pennells, but she also assumed an almost paranoid desire to protect James from anything she felt remotely detrimental to his reputation. Rosalind's suspicions of the Pennells were quickly confirmed when barely a month after Whistler's death the *Athenaeum* reported that the Pennells were shortly to begin an 'authorized' biography.

From that moment onwards the Pennells, and Heinemann by association, were effectively ostracized from the 'Syndicate', as Freer had come humorously to label the family group. Rosalind also began to edit James's papers in an effort to protect his reputation, systematically censoring and destroying any material which she considered unsuitable.[1] In doing this Rosalind may well have been following instructions left to her by James, since he had been doing the same sort of thing himself for several years. John Lavery actually witnessed James incinerating his work; when the startled Lavery asked why, Whistler apparently responded, 'To destroy is to exist, you know.'

Freer's role in the posthumous legacy is intriguing. Almost certainly he remained unaware of the extent of Rosalind's censorship, although sharing with her a deep antipathy to the Pennells. That Rosalind felt close to him is

certain, and it may well have been the case that she felt a certain romantic attachment towards him. Freer, however, never reciprocated such feelings. A homosexual, he was careful to hide his sexual inclinations from the prejudices of the age, and Rosalind remained unaware of them. Nevertheless, as a trusted confidant and friend, he guided her for many years. His support was well rewarded and over the following decade, often with Rosalind's help, he acquired some of the finest Whistlers in his collection.

In immediate terms the split between Rosalind and the Pennells had one very serious implication. She refused to have anything to do with the International Society, with which Joseph Pennell was closely associated, and its planned memorial exhibition of its late president's work had to be arranged against a background of petty obstructionism. Despite the efforts of the ever-diplomatic John Lavery, Rosalind, bolstered by Freer, refused to have anything to do with the Society. Instead, at his instigation she allowed an 'official' memorial exhibition to be organized under the auspices of the Copley Society of Boston, in the United States, and supported a similar exhibition in Paris at the Ecole des Beaux-Arts. There were other important exhibitions, however, which she could not control. These included the show of Mortimer Menpes's collection of James's etchings and lithographs held at Obach's in London, in 1903; an exhibition in Rome at the Villa di San Vitale, in 1904 (the first time James's work had been shown in Italy); an exhibition of some fifty works at the Royal Scottish Academy of which James had been an honorary member; and a large collection of some 400 etchings and drypoints held at the Grolier Club, in New York. While all these exhibitions kept his work firmly in the public eye, ironically it was the huge International Society memorial show, containing nearly 880 works and representing every medium, which provided the evidence on which James's posthumous critical reputation would rest for many decades to come in England.

Placed between the memorial exhibition of the popular Academician, George Frederick Watts, at the Royal Academy, and the largest exhibition of Impressionist paintings ever held in London at the Grafton Gallery (the show contained some 315 exhibits and included 54 by Monet, 19 by Manet, 30 by Degas, and 10 by Cézanne), the exhibition was treated with the respect it deserved and Whistler's achievement was duly noted and acclaimed. There were, however, several significant and discernible shifts of opinion which, in retrospect, sounded a warning that Whistler's critical standing, at least in England, was about to crumble. In the course of two articles written in the *Saturday Review*, D.S. MacColl's attitude, from one of whole-hearted support, took on an altogether more questioning tone. The

art of Whistler, according to MacColl, was the art of an era which had drawn to its natural close; the 'battles . . . had been fought and ended years ago'.[2] MacColl, in effect, was stating openly what many others believed in secret. Whistler sat uneasily against the backdrop of the new century. His work, refined and dignified, now looked old and dated. Nevertheless, MacColl conceded, his contribution was immense, if sometimes inconsistent:

> Whistler's paintings introduced something that was inventive and novel in Western Art, and he narrowed his ground to the expression of the peculiar part of his vision. To praise this procedure as 'personal' is to raise a false issue . . . when the artist brings something new into the world the novelty is never justified as significance and beauty; that is, as no one man's property, but as part of common stock retrieved . . . A coxcomb of the most offensive order is a man who prides himself on personal tricks that have no value, and thinks that to be original is necessarily to be great. There are lesser degrees of coxcombry . . . That Whistler often played the part of the coxcomb is evident enough. That weakness came out abundantly in his life, and it was the pitfall of his art, which at times ceased to be anything but 'personal'. There are drawings which seem to exist more for the sake of the signature than for the sake of the drawing.[3]

On the same day as MacColl's final article appeared, so did another, which in retrospect was to become one of the most important long-term assessments of James's work in England. It came not from the pen of a seasoned commentator, but instead from a young critic, himself a gifted painter, who had trained under a Whistler follower, Francis Bate. His name was Roger Fry. Although it is for his formalist writings about modern art that Fry is remembered today, he was at this time essentially an orthodox critic whose artistic passions were firmly rooted in the Old Masters. During a spell with the magazine, the *Pilot*, between 1899 and 1905, he did dabble with the 'moderns', but his writing continued to reveal the mind of a traditionalist. Through Bate Fry was well aware of the intricacies of James's work, as is evident in the glowing obituary he wrote for the *Athenaeum* in July 1903, in which he made an impassioned protest against what he believed to be the 'monstrous injustice' that Whistler's work was not represented in any official collection.

Within the space of two years Fry's attitude, like MacColl's, underwent a fundamental shift of emphasis, as seen in two essays in the *Quarterly Review*. After reiterating MacColl's earlier expressed belief that Whistler, Watts, together with the Impressionists, 'symbolized the close of a period in

modern art', Fry wrote that 'Whistler lacked humanity'. Because of this he became 'a negative Mephistophelian figure . . . The fire burned within him; but he spoke only ephemeral criticisms in the press; he never painted the satires that he conceived; for the root of all his quarrel with life lay in the one really deep emotion he possessed – the love of pure beauty.'

For Fry, it was from this somewhat limited aesthetic that James's work ultimately derived, and under close scrutiny, ultimately failed:

> The world laughed; the terrible irony of the situation lay in the fact that, on the main issue, a stupidly emotional world was right and the prophet wrong. For beauty cannot exist by itself; cut off from life and human realities it withers. It must send its roots down into other layers of human consciousness and be fed from imaginatively apprehended truth, as in religious art, or from human sympathy, as in dramatic art, or from the sense of human needs and fears in the face of nature, as in all great landscape art. But Whistler, like Oscar Wilde – who in some ways is a similar product of the same moment of modern life – wanted beauty to be self-contained and self-sufficing . . . What comes out for us most at the present time is the isolation of Whistler. People were fond of calling him an impressionist, and so, in a sense, he was, in that he tried to confine himself to the visual impression, to exclude from his work the associated ideas of objects. But the gulf which separates him from men like Degas, Monet and Renoir, is immense. They nod recognition to Watts behind Whistler's back, for they are all interested in life, ironically, scientifically, or lyrically, as their temperaments incline . . . But Whistler stands alone untouched by the imitations of life, protesting that beauty exists apart, that the work of man's hands is fairer than all that nature can show. He is a monument to the power of the artist's creed in the narrowest interpretations, and to the unbending rectitude of the artistic conscience, a lonely, scarcely a loveable, but surely an heroic figure.[4]

Fry's pontifications, as his own importance grew, became a benchmark for later criticism of James's work. But in spite of the limitations he perceived in James's achievement, Fry continued to rate highly certain aspects of his work, particularly the formal qualities he found in the portraits. During his spell as adviser to the Metropolitan Museum of Art in New York, it was he who instigated the purchase of the portrait of Duret in 1909.

Despite their best intentions, the publication of the Pennells' biography in 1908 appeared only to underline and uphold the sense of James's isolation and the somewhat negative and naïve view of the 'lone genius'. It

was a point not lost on Walter Sickert. Now back in London after his self-imposed exile in France, Sickert realized Whistler's worst fears and became 'the pupil who would sell the soul of his master'. He savaged not only Whistler but, predictably, the Pennells as well. In an article which appeared in the *Fortnightly Review*, after letting rip on the Pennells, Sickert focused on what he saw as the major problem, and the fundamental fault, of the book:

> It was Whistler's incessant preoccupation to present himself as having sprung completely armed from nowhere. And it certainly was a flaw in his philosophy that he did not understand that it is no shame to be born. In matters of trade it is doubtless necessary to defend the originality and the copyright of your trademark with vigilance. But pretensions of that kind are useless and confusing to the serious study of art.[5]

Sickert continued to undermine Whistler's reputation for another two decades. Only towards the end of his life did the rhetoric soften, and a sense of forgiveness prevail.

On the international front, the attack continued with the publication of Julius Meier-Graefe's influential work, *Modern Art. Being a Contribution to a New System of Aesthetics*, which was translated into English in 1908. Meier-Graefe found the art of Whistler a major problem, since it failed to fit easily within his thesis, though by the same token he acknowledged that it could not be ignored. In the end, unable to categorize him, Meier-Graefe sub-divided his analysis of Whistler into four parts, within a chapter barely thirty pages long: there was Whistler the Englishman, Whistler the Frenchman, Whistler the Japanese and Whistler the Spaniard. For all this, Meier-Graefe conceded that Whistler had 'a perfectly English core' and in fact was little more than 'an unfrocked Pre-Raphaelite'.[6]

A spirited and sympathetic account from James's French friend and champion, Théodore Duret, in 1904, later translated into English, failed to stop the rout.[7] By the end of the decade Whistler's critical decline was almost complete. He seemed too refined and almost contrived when set against the bold and colourful work of artists such as Van Gogh, Denis and Gauguin, or the analytical incisiveness of Cézanne and his heirs. His work appeared neither to rest easily within the modern movement, nor to most did it appear to have contributed substantially to the movement's genesis. To underline this, Whistler was excluded from the important exhibition, 'Manet and the Post-Impressionists', which was staged in London in the late autumn of 1910 by Roger Fry, unquestionably under the influence of Meier-Graefe's polemic.

In spite of the years of critical pounding, the shadow of Whistler resolutely refused to dissolve. Even modernist critics such as Clive Bell, who disagreed fundamentally with Whistler's notion of 'beauty' in art, were still compelled to acknowledge a tremendous debt. In 1914, Bell in his influential book *Art*, which became the bible of the modern movement in England, would state:

> He is a lonely artist, standing up and hitting below the belt for art. To the critics, painters, and substantial men of his age he was hateful because he was an artist; and because he knew that their idols were humbugs he was disquieting . . . He is said to have been ill-mannered and caddish. He was; but in these respects he was by no means a match for his most reputable enemies. And ill-mannered, ill-tempered, and almost alone, he was defending art, while they were flattering all that was vilest in Victorianism.[8]

Bell, like Fry and Sickert before him, had put his finger on the major difficulty with Whistler, one which has beset writers and historians ever since. Not aligned with any group or 'ism', he was hard to place, and even more difficult to evaluate. Whistler, although happily existing in and around 'groups', would never allow himself to follow the pack, though on occasion he was sorely tempted. Certainly during his earlier years he craved admission to the hallowed ranks of the Royal Academy. The whole issue of his self-inflicted isolation is most clearly seen in the context of the first Impressionist exhibition of 1874. He must have been tempted to exhibit alongside his peers in Paris, but instead he organized his own exhibition in London. It was as much to do with his personality as with any overriding aesthetic intention; he was simply too much of an individualist.

The Pennells endeavoured to set Whistler up on a pedestal as the all-conquering American outsider, but as Sickert rightly implied, this was a nonsense and a sham. Whistler's artistic roots were no more American than those of his French and English contemporaries, nor any more original. In a radically changing industrial world all looked to the past to find answers for the present. Then, like many of the young radicals of his day, the stark and frank aspects of realism initially appealed to him, as did the writings of Baudelaire. Like Manet, Degas and Monet, Whistler gradually created his own language to express his vision of the modern world. Unlike the others, however, he also created a persona to go with it.

In France, in the midst of a very active cultural milieu suffused with a robust sense of radicalism, Whistler could avoid notoriety. The same was true in other mainland European countries where there was a substantial secessionist groundswell. In the United States, his nationality seemed for

the most part to defuse his notoriety, and he was sold to the public as a significant American artist and was quietly tolerated. In England there was simply no avant-garde to speak of, so Whistler stood out as a lone rebel. The battle he waged against the establishment for nearly thirty years was no mere whim. Rather, it reflected his deeply held belief in the blatant hypocrisy of the ruling élite in British art. The Victorian notion that the purpose of art was to express and convey a moral message to the masses he held to be nonsense. Most knew it, but few dared to contradict it. Whistler did, and found himself ostracized for doing so.

Whistler was never accorded the quintessential Victorian epithet of 'earnestness' or 'seriousness', yet in retrospect it can be seen that his work created the bridgehead between the old order and the new. Instead, he became and sadly remained, from the establishment's point of view, a quirky, lonely and eccentric figure. Art history, like many of its other historical relatives, finds a certain academic comfort in neat packages and pigeon-holes. Movements, groups, slide easily along and into each other, demonstrating the questionable historiographical notion of 'development' and 'progress'. Anything which falls outside this methodological or ideological convenience is, at best, lamely acknowledged, and then quickly passed over. Whistler is a prime example of the process. Based in no apparent 'group', he was destined for the sidelines. This view fails to accept the reality of individual achievement, seen not as 'springing from nowhere' as the Pennells claimed, but rather from within the creative framework of a given period of history.

While several artists of the nineteenth century contributed to the reshaping of the centuries-old visual language, there are few who spread their influence as wide as Whistler. In almost every genre of art, and in virtually every aspect of its production – its techniques, display and commercial marketing – his contribution was profound and lasting. In related fields such as photography and typography the same holds true. In less easily quantifiable aspects such as those of the public perception of art, Whistler's role was certainly pivotal. In a period which saw the creation of the modern consumer society, when the fabric of patronage was radically changing, Whistler was as instrumental as anyone in setting up new linkages between the artist and the society which art purportedly served. He played a significant role in breaking the mould. No longer could critics pontificate, or the establishment officiate, and rest easily with their actions. Whistler demanded that the artist have a central determining role in the destiny of the cultural artefact he was responsible for creating.

The impact of his work, particularly his etching and his painting, was widespread and lasting. In this respect, as in many others, he was an artist's

artist. As one of the greatest etchers of his age he spawned a multitude of followers. It is difficult to imagine an etcher anywhere who is not familiar with his work, or unaffected by it. In England some of the most influential etchers this century, such as Frank Short, D.Y. Cameron and James McBey, took his work as their starting point. On mainland Europe his influence was far-reaching and no less profound. It can be seen, for example, in the work of James Ensor and Theo van Rysselberghe in Belgium, Gustave Leheûtre and Camille Pissarro in France and T. François Simon in Czechoslovakia. In the United States, there are numerous etcher-artists who followed his lead, of whom John Marin, Frank Duveneck and Otto Bacher are perhaps the best known.

In painting, Whistler's influence was perhaps more pervasive, and its implications more lasting and profound than even his graphic work. Comparative 'influence' is a notion problematic at the best of times. In terms of straightforward borrowings of certain aspects of his work, he has had scores of followers across the world. In the more complex, and infinitely more interesting issue, of influence defined as a similarity of aesthetic intent, the results confirm his modernity. The earlier twentieth-century critical belief that Whistler played no part in the genesis of modernism is simply untenable.

Tempting as it is to exaggerate the claims made on his behalf, nevertheless many of the greatest names in modern art this century shared and still share the same aesthetic sensibilities as Whistler. His fundamental belief in formal considerations over narrative content was arguably one of the defining characteristics of the modern movement. The limited tonal range of the Nocturnes, the muted palette of many of his seascapes, the ethereal nature of the portraits, even the anti-narrative titles he imposed on his paintings anticipated the work of many of the greatest innovators of this century. One immediately thinks of the work of Henri Matisse in the first decade of the twentieth century and the titles he chose, such as *Harmony in Red* (1908). Whistler was a starting point for the young Pablo Picasso – who likewise openly admitted his debt – as he was for certain members of the first generation of abstract painters in Britain such as Wyndham Lewis. And one can scarcely contemplate the abstracted colour field of American artists such as Mark Rothko without recourse to the abstracted tonal work of Whistler.

While the painterly refinements of Whistler's art did not always arrest their attention for long, these heirs and successors carried with them for the rest of their lives his attitude, as he himself defined and practised it, to the role of the artist in modern society. Whistler's life provides a window through which we catch a glimpse of one of the most exciting periods of art

and social history. The aesthetic and professional issues that concerned him over a century ago remain as tantalizing and as pertinent today. Together with his French contemporaries, he set up the agenda for change; the artists of the twentieth century are still working their way through it.

Notes

D URING THE PERIOD of research the extensive Whistler Bequest at the University of Glasgow underwent a new cataloguing system. Some of the references given here are in the old style: Glasgow University Library (GUL), Birnie Philip Bequest (BP) followed by item reference. The new system is simply prefixed by GUL, a letter and then the reference number. For those wishing to explore further a particular reference a concordance of old and new references is available for consultation at the library. The place of publication in other bibliographical references is London unless otherwise indicated. Works listed in the Select Bibliography are cited, after the first entry, only by short title.

Chapter 1: Childhood

1 Nigel Thorp and Kate Donnelly, *Whistlers and Further Family*, exhibition catalogue, Glasgow University Library, Special Collections, 1980.

2 Ibid.

3 Margaret MacDonald, *Whistler's Mother's Cookbook*, Elek, 1979, p. 11.

4 Ms. GUL.

5 Miscellaneous Whistler Correspondence, Box 37, Pennell Collection, Library of Congress, Washington DC (hereafter PC/LC).

6 The drawing is illustrated in Albert Parry, *Whistler's Father*, New York, 1939, facing page 137.

7 Glasgow University Library, Birnie Philip Bequest, hereafter GUL, BP, Res.155.

8 His mother Anna makes constant reference to this in her 'Russian Journal'. Manuscript, New York Public Library (hereafter NYPL).

9 Ms. Anna Whistler's Diary, Gift of Mrs Henry Draper, NYPL.

10 Ibid.

11 Ibid.

12 Ibid.

13 Information contained in a letter from the Imperial Academy, St Petersburg, to the Pennells. Ms. PC/LC.

14 Ms. NYPL, entry dated 2 May 1846.

15 Ms. Anna Whistler's Diary, December 1846, NYPL.

16 Ms. Anna Whistler's Diary, 27 February 1847, NYPL.

17 Ms. NYPL.

18 GUL, W.353.

19 GUL, W.654.

20 Ibid.

21 Ibid.

22 Ms. GUL.

23 Ms. NYPL.

24 Katharine A. Lochnan, *The Etchings of James McNeill Whistler*, Yale University Press, New Haven and London, 1984, p. 4.

25 E.R. and J. Pennell, *The Whistler Journal*, Philadelphia, 1921, p. 182 (hereafter *Journal*).

26 Ibid.

Chapter 2: Formative Years

1 This episode is told in Milo M. Quaite, *Lake Michigan*, 1947, pp. 111–21, fn. 4.

2 St Petersburg Sketchbooks, Hunterian Museum and Art Gallery, Glasgow University.

3 Anna Whistler's Diary, Library of Congress; dated 10 July 1848.

4 GUL, W.656, dated 9 August 1848.

5 GUL, BP II, Res.1/12.

6 GUL, BP II, Res.1/14.

7 Ibid.

8 This painting, located by Ronald Anderson, is in a private collection in Worcestershire, England.

9 Ms. GUL.

10 GUL, BP II, Res.1/43.

11 Ms. GUL, dated 18 February 1849.

12 GUL, BP II, Res.1/43.

13 Lochnan, *Etchings*, pp. 7–8.

14 *Discourses*, XI, p. 199; see also Lochnan's discussion on this point: op. cit., p. 8.

15 GUL, BP II, Res.1/52, dated 17 March 1849.

16 See Freer Gallery of Art, Occasional Papers, Vol. I, No. 4, p. 3.

17 Letter to Joseph Harrison, dated 25 June 1849, Ms. LC. For an excellent pioneering discussion of Whistler and photography see Nigel Thorp, 'Studies in Black and White:

Whistler's Photographs in Glasgow University Library', in Ruth Fine (ed.), *James McNeill Whistler: A Reexamination*, Studies in the History of Art, Vol. 19, National Gallery of Art, Washington DC, 1987, pp. 85–100.

18 Noted by Emma Palmer in A.J. Bloor, 'Whistler's Boyhood', *The Critic*, September 1903.

19 Ibid.

20 Now in PC/LC.

21 Bloor, op. cit., p. 250.

22 Anna Whistler's Diary, LC, dated 6 February 1850.

23 The Pennells in *The Life of James McNeill Whistler* (hereafter *Life*) suggest the existence of twenty-two black and white drawings and a watercolour.

24 Charles Dickens, *American Notes*, 1842; reprinted Macmillan, 1903.

25 For Swift's role at West Point see Jeffrey Simpson, *Officers and Gentlemen: Historic West Point in Photographs*, New York, 1982, p. 22.

26 Confirmed in Joseph Gardner Swift, *Memoirs*, privately printed, 1890, pp. 267–8.

27 Noted in Douglas Southall Freeman, *Robert E. Lee*, Scribner, New York, 1934, Vol. 1, p. 334.

28 Ms. GUL, dated September 1851.

29 Ms. West Point Military Academy Library, dated 28 September 1852, No. 288–9.

30 For this point see Lochnan, op. cit., p. 11.

31 Ms. West Point Military Academy Library, dated 26 May 1853.

32 Quoted in Thomas Wilson, 'Whistler at West Point', *Book Buyer*, 2 September 1898.

33 For an excellent background to this, see John Sandberg, 'Whistler's Early Work in America, 1834–1855', *Art Quarterly*, Vol. XXIX, 1966.

34 The reminiscences appeared in *Century Magazine*, Vol. LXXV, April 1908, pp. 928–32.

35 This episode is mentioned in a letter from Anna to her friend, Mrs Mann. GUL, W.426, dated 18 November 1853.

36 PC/LC, Box 32, dated 12 December 1853.

37 Ms. West Point Military Academy Library, dated 8 July 1854.

Chapter 3: Wanderings

1 *Life*, Vol. I, p. 40.

2 Ibid., p. 41.

3 Noted in Thomas Winans's journal, 16 November 1854, Maryland Historical Society, Baltimore.

4 See *Map of the Western Hemisphere, c.* 1849–1851. Pen and ink drawing, Metropolitan Museum of Modern Art, New York.

5 John Ross Key, *Century Magazine*, Vol. LXXV, April 1908, pp. 928–32.

6 *Life*, pp. 43–4.

7 Key, op. cit.

8 The dismembered plate is known as *The Seven Fragments from the Coast Survey Plate*. Winans Scrapbook, Collection: Metropolitan Museum of Modern Art, New York.

9 GUL, W.447, 13 February 1854.

10 Now lost.

11 Private collection, USA.

12 Prints and Photographs Division, Library of Congress.

13 Lochnan, *Etchings*, p. 17.

14 GUL, BP II, Res.1/128 and W.459.

Chapter 4: Arrival

1 L.M. Lamont (ed.), *Thomas Armstrong, C.B. – A Memoir 1852–1911*, Secker, 1912, p. 172.

2 See Marcus Bourke, *John O'Leary: A Study in Irish Separatism*, Tralee, 1967.

3 John O'Leary, *Recollections of Fenians and Fenianism*, 2 vols., 1896, Vol. I, p. 67.

4 9 June 1855.

5 For an excellent background to the Expositions Universelles of 1855 and 1867, see Patricia Mainardi, *Art and Politics in the Second Empire*, Yale University Press, 1987.

6 Quoted in Paula Gillett, *The Victorian Painter's World*, Rutgers University Press, 1990, p. 3.

7 Hippolyte Taine, *Lectures on Art*, trans. J. Durand, New York, 1889, p. 218.

8 See Albert Boime, 'The Second Empire's Official Realism', in Gabriel P. Weisberg (ed.), *The European Realist Tradition*, Indiana University Press, 1982, pp. 40–51.

9 An exception was made in 1853 because of the forthcoming Exposition Universelle.

10 Boime, op. cit., p. 41.

11 Pierre Borel, *Lettres de Gustave Courbet à Alfred Bruyas*, Geneva, 1951, pp. 78–9.

12 Ibid., p. 32.

13 *Life*, Vol. I, p. 49.

14 Bourke, op. cit., p. 33.

15 Student Entry Cards: GUL, BP II, 36/33, 36/35.

16 The claim is made in Stanley Weintraub, *Whistler: A Biography*, 1974, p. 38.

17 Lamont (ed.), op. cit., p. 127.

18 GUL, BP II, Res.1/24; letter from Anna to James.

19 Freer Gallery of Art, Washington.

20 Private collection, New York.

21 Freer Gallery of Art, Washington.

22 Letter from Charles Gleyre to Director-General, June 1856. Ms. Archives du Louvre.

23 GUL, BP II, 36/35.

24 For an excellent account of Charles Gleyre's teaching, see *The Instruction of Charles Gleyre and the Evolution of Painting in the Nineteenth Century*, exhibition catalogue, Winterthur Kunstmuseum, Zurich, 1974.

25 Claude Monet in an interview in *Le Temps*, 27 November 1900.

26 *Gleyre*, exh. cat., op. cit.

27 This association is confirmed in a letter written later in 1864: Ms. Fenian Briefs 1865–1869, O'Leary Letters, No. 10, State Papers Office, Dublin.

28 Lamont (ed.), op. cit., pp. 183–4.

29 Ibid., pp. 191–2.

30 Noted in Leonee Ormond, *George du Maurier*, 1969, p. 53.

31 *Life*, Vol. I, pp. 51–2.

32 Quoted in MacDonald, *Whistler's Mother's Cookbook*, p. 24.

33 James mentions this fact in a letter dated 11 July 1855: GUL, BP II, Res.1/134.

34 Louvre: Autorisations Données à des Copistes: Ecoles Françaises et Flamandes 1851–1871, Archives du Louvre, LL22.

35 Lamont (ed.), op. cit., p. 146.

36 'Untitled', Collection: British Museum.

37 See 'Paris Salon de 1857', in H.W. Handson (ed.), *Catalogue of the Paris Salon 1673–1881*, 60 vols., Garland Publishing, 1977, p. 318.

Chapter 5: First Steps

1 *Correspondance générale de Eugène Delacroix*, A.J. Joubin, Paris, 1937, Vol. III, p. 396.

2 Gabriel P. Weisberg (ed.), *The European Realist Tradition*, pp. 31–124.

3 Fould's speech is reproduced in J.C. Sloane, *French Painting Between Past and Present: Artists, Critics and Traditions from 1848 to 1870*, Princeton University Press, 1951.

4 'Notes sur l'art: Réalisme', 10 July 1856.

5 *L'Artiste*, 1857, II, p. 34.

6 *La Presse*, 4 August 1857.

7 Jules Castagnary, 'Philosophie du Salon de 1857', *Salons 1857–70*, Bibliothèque Charpentier, Paris, 1892, p. 47.

8 Freer Gallery of Art.

9 Théodore Duret, *Whistler*, trans. Frank Rutter, 1917, p. 20.

10 Lamont (ed.), *Armstrong*, pp. 177–9.

11 Confirmed in an entry in Miss Emily Chapman's diary, PC/LC, cont. 280, dated 11 September 1857.

12 Nigel Thorp, 'Studies in Black and White: Whistler's Photographs in Glasgow University Library', in Ruth Fine (ed.), *James McNeill Whistler*, p. 88.

13 On this important point see Lochnan's excellent discussion, *Etchings*, pp. 24–5.

14 *Journal*, pp. 88–9.

15 'Le Papillon et le Vieux Boeuf' in Theodore Reff, *From Realism to Symbolism*, exhibition catalogue, Columbia University, 1971, p. 28.

16 One of these rare impressions is in the Avery Collection, NYPL.

17 Freer Gallery of Art.

18 From notes written by Swift, Ms. NYPL.

19 Archives du Louvre, LL22.

20 *Life*, Vol. I, p. 57.

21 Undated letter, 1858. Ms. PC/LC.

22 Undated letter, 1858. Ms. GUL, BP II, Res.1955, H1.

23 Pencil drawing, Freer Gallery of Art.

24 Lilian M.C. Randall (ed.), *The Diary of George A. Lucas: An American Art Agent in Paris, 1857–1909*, Princeton University Press, 1979. Entry dated 28 September 1858.

25 *Life*, Vol. I, p. 72.

26 Several authors and compilers such as Lochnan, op. cit., p. 48, and Richard Dorment in *From Realism to Symbolism: Whistler and His World*, 1971, p. 75, posit the date of the first encounter with Fantin as 7 October. However, the fact that Whistler's passport was stamped in Liège on the same day makes this date impossible.

27 *Life*, Vol. I, p. 68.

28 E.R. Pennell, *Whistler the Friend*, 1930, p. 43.

29 Cuisin Album, Louvre, Cabinet des dessins; dated 15 November 1855.

30 This was Fantin's first entry in his journal.

31 George Heard Hamilton, *Manet and His Critics*, New York, 1969, p. 20.

32 GUL, BP II, AM/1962; dated 5 December 1858.

33 This claim was later recounted in a letter to the *New York Tribune*, published on 16 August 1880. Original Ms. GUL, BP II, 6A/40.

34 Ibid.

Chapter 6: Between London and Paris

1 Letter dated 5 December 1858; Ms. PC/LC.

2 See Minutes of the Etching Club, Tuesday 17 November 1858, Archives of the Victoria and Albert Museum, London.

3 See Charles Baudelaire, *Oeuvres Complètes*, Vol. II, Paris, 1976, pp. 123, 609 and 1386.

4 Collection of Ralfe Whistler, England.

5 Taft Museum, Cincinatti, Ohio. Gift of Louise Taft Semple.

6 See Andrew Mclaren Young, Margaret MacDonald, Robin Spencer with the assistance of Hamish Miles, *The Paintings of James McNeill Whistler*, 2 vols., Yale University Press, 1980, catalogue entry no. 24.

7 GUL, Rev.H/2.

8 Letter dated 22 September 1906; Ms. PC/LC.

9 Osbert Sitwell (ed.), *A Free House! or the Artist as Craftsman: Being the Writings of Walter Richard Sickert*, London, 1941, p. 11.

10 Bernhard Sickert, *Whistler*, London, 1908, p. 66.

11 GUL, Rev.H/2; dated January 1859.

12 Private collection.

13 Collection: Musée du Louvre.

14 *Life*, Vol. I, p. 74.

15 Lochnan, *Etchings*, p. 67.

16 For an excellent discussion of the teaching and influence of Boisbaudran see 'Lecoq Boisbaudran and Memory Drawing: A Teaching Course between Idealism and

Naturalism', in Gabriel P. Weisberg (ed.), *The European Realist Tradition*, pp. 242–90.

17 Hamilton, *Manet and His Critics*, pp. 22–3.

18 *Gustave Courbet*, exhibition catalogue, Arts Council of Great Britain, 1978, pp. 33–4.

19 Letter from Fantin to Charles Deschamps. Transcribed in GUL, Letterbook(LB)/25.

20 *Life*, Vol. I, p. 69.

21 *Journal*, p. 40.

22 Present whereabouts unknown.

23 Addison Gallery of American Art, Phillips Academy, Andover, Massachusetts.

24 *Japonisme: Japanese Influence on French Art*, exhibition catalogue,1975, p. 30.

25 Confirmed in a letter from James to Luke Ionides: GUL, BP II, I/2, dated 15 August 1895.

26 Lamont (ed.), *Armstrong*, p. 151.

27 GUL, BP II, L/25, dated 16 June 1859.

28 Léonce Bénédite, 'Artistes Contemporains: Whistler', *Gazette des Beaux-Arts*, XXXIII, 1905.

29 Lochnan, op. cit., p. 73.

30 Jonathan Mayne (ed./trans.), *Charles Baudelaire: Art in Paris 1845–1862*, 1965, p. 164.

31 Courbet, exh. cat., op. cit., p. 92.

32 Charles Baudelaire, 'Salon de 1859: Le Public moderne et la photographie', *Variétés critiques*, Vol. II, Paris, 1924, pp. 121–4.

33 Mayne, op. cit., p. 197.

34 Ibid., p. 162.

35 Quoted in Douglas Druick and Michael Hoog, *Fantin-Latour*, exhibition catalogue, The National Gallery of Canada, Ottawa, 1981, p. 68.

36 Ibid.

37 Marion Spielmann, *Millais and His Works*, 1898, p. 74.

38 Lochnan, op. cit., p. 90.

39 Druick and Hoog, op. cit., p. 68.

40 Ibid., p. 78.

41 Mayne, op. cit., pp. 200–1.

42 Ibid.

43 Asa Briggs, *Victorian Cities*, 1975, p. 314.

44 Lochnan, op. cit., p. 90.

45 Ibid., p. 100.

46 Collection of the Denver Art Museum, Edward and Tullah Hanley Memorial Gift for the People of Denver and the Area.

47 Lochnan, op. cit., p. 102.

48 Private collection, London.

49 GUL, BP II, L/26, dated 5 August 1859.

50 Courbet, exh. cat., op. cit., p. 34.

51 Cabinet des dessins, Musée du Louvre, Paris.

Chapter 7: A Little Public Recognition

1 *Life*, Vol. I, p. 82.

2 Bourke, *John O'Leary*, p. 43.

3 Lochnan, *Etchings*, p. 107.

4 The painting was accepted two years later.

5 See F.G. Stephens, *James Clarke Hook R.A.*, 1888, p. 32.

6 19 May 1860.

7 Quoted in *Life*, Vol. I, p. 83.

8 William Michael Rossetti, *Some Reminiscences*, 1906, Vol. I, p. 68.

9 Confirmed in a letter written by James to O'Leary: Ms. *Irish People* Papers, Fenian Briefs 1865–9, State Papers Office, Dublin.

10 *Journal*, pp. 78–9.

11 Luke Ionides, 'Memories: Whistler in the Latin Quarter', *Transatlantic Review*, January 1924, pp. 40–1.

12 Daphne du Maurier (ed.), *The Young George du Maurier: A Selection of His Letters 1860–1867*, London, 1951, p. 16.

13 Ionides, op. cit.

14 Minutes of the Junior Etching Club, entry dated 2 May 1860, Archives of the Victoria and Albert Museum, London.

15 Daphne du Maurier, op. cit., p. 4.

16 Lamont (ed.), *Armstrong*, p. 203.

17 Private collection, New York.

18 Quoted in *Life*, Vol. I, p. 77.

19 Quoted in *Life*, Vol. I, p. 85.

20 McLaren Young *et al.*, *Paintings*, cat. no. 35, p. 15.

21 Lochnan, op. cit., p. 119.

22 Daphne du Maurier, op. cit., p. 16.

23 Ms. PC/LC.

24 For a detailed study of *Wapping* see Robin Spencer, 'Wapping 1860–1864', *Gazette des Beaux-Arts*, No. 1356, Vol. 100, October 1982, pp. 131–41.

25 James also appeared several weeks later on 27 October 1860 as the letter 'Q' in a *Punch* alphabet.

26 Freer Gallery of Art.

27 *Life*, Vol. I, p. 89.

28 Ibid.

29 Ormond, *George du Maurier*, p. 100.

30 GUL, BP II, Res.12/20, dated 15 March 1892.

31 Daphne du Maurier, op. cit., p. 26. An X-ray examination confirms Du Maurier's story. See McLaren Young *et al.*, op. cit., cat. no. 34, p. 13.

32 *Life*, Vol. I, p. 90.

33 The story is retold in Luke Ionides, *Memories*, Paris, 1925, p. 10.

34 *Life*, Vol. I, p. 86.

35 The etching inscribed to Frith is in a private collection, England.

36 2 May 1861.

37 *Gustave Courbet*, exhibition catalogue, Arts Council of Great Britain, 1978, p. 35.

38 Hamilton, *Manet and His Critics*, p. 25.

39 Ibid., p. 28.

40 Noted in a letter to James from his mother: GUL, BP II, 1/147, dated 3 August 1861.

Chapter 8: *The White Girl*

1 See Paul B. Crabo, 'Proudhon, Courbet and the Antwerp Congress of 1861', *Art History*, Vol. 14, No. 1, March 1991, pp. 67–91.

2 George Riat, *Gustave Courbet, peintre*, Paris, 1906, pp. 191–201.

3 Lochnan, *Etchings*, p. 143.

4 Wadsworth Athenaeum, Hartford, Connecticut.

5 Daphne du Maurier, *George du Maurier*, pp. 104–5.

6 Hilary Taylor, *James McNeill Whistler*, 1978, pp. 19–20.

7 National Gallery of Art, Washington.

8 *Athenaeum*, 28 June 1862.

9 Confirmed in a ballot held in 1884 by the *Pall Mall Gazette*. See *The Sphere History of Literature in the English Language*, Vol. 6, 'The Victorians', Arthur Pollard (ed.), p. 227.

10 *Athenaeum*, op. cit.

11 Wilkie Collins, *The Woman in White*, Penguin Books, Harmondsworth, 1974, Introduction by Julian Symonds, p. 11.

12 Ibid.

13 *The Pre-Raphaelites*, exhibition catalogue, Tate Gallery, 1984, p. 199.

14 Taylor, op. cit., p. 28.

15 Ibid.

16 Collection: The Tate Gallery, London.

17 Collection: The Tate Gallery, London.

18 No. 890.

19 Daphne du Maurier, op. cit., p. 105.

20 Private collection, USA.

21 Virginia Surtees (ed.), *The Diaries of George Price Boyce*, Norwich, 1980, p. 25.

22 *The Pre-Raphaelites*, exh. cat., op. cit., p. 174.

23 McLaren Young *et al.*, *Paintings*, cat. no. 38, pp. 17–21.

24 Roger Bonniot, *Gustave Courbet en Saintonge*, Paris, 1973, p. 18.

25 *Gustave Courbet*, exhibition catalogue, Arts Council of Great Britain, 1978, p. 36.

26 Daphne du Maurier, op. cit., p. 104.

27 Theodore Reff, *Degas: The Artist's Mind*, Harvard University Press, 1987, p. 27.

28 Lilian M.C. Randall (ed.), *The Diary of George A. Lucas: An American Agent in Paris, 1857–1909*, Princeton University Press, 1979, pp. 130–2.

29 John A. Mahey, 'The Letters of James McNeill Whistler to George A. Lucas', *Art Bulletin*, No. 49, September 1967, p. 284.

30 Letter from James to Edwin Edwards dated 7 April 1862: Ms. Fitwilliam Museum, Cambridge.

31 This is confirmed in a letter from James to O'Leary: Ms. State Papers Office, Dublin.

32 Bourke, *John O'Leary*, pp. 47–8.

33 Ms. GUL.

34 Letter quoted in Paul G. Marks, 'James McNeill Whistler's Family Secret: An Arrangement in White and Black', *Southern Quarterly*, pp. 67–75.

35 Ibid., p. 70.

36 Ibid., p. 71.

37 John O'Leary, *Recollections of Fenians and Fenianism*, 2 vols., 1896, Vol. 1, p. 196.

38 Bourke, op. cit., p. 45.

39 Harper Pennington, 'Reminiscences of Whistler': Ms. PC/LC; quoted in McLaren Young *et al.*, op. cit., p. 18.

40 Druick and Hoog, *Fantin-Latour*, p. 113.

41 *Life*, Vol. I, p. 99.

42 Ms. Fitzwilliam Museum, Cambridge.

43 Lochnan, op. cit., p. 138.

44 Daphne du Maurier, op. cit., p. 105.

45 Information contained in a 26-page hand-written exhibition list drawn up by the Pennells in 1906: Ms. PC/LC, Box 346.

46 Letter dated 26 June 1862. Ms. Wadsworth Athenaeum, Hartford, Connecticut.

47 *Athenaeum*, 28 June 1862.

48 5 July 1862.

49 19 July 1862.

50 Surtees (ed.), *George Price Boyce*, p. 35.

51 Max Beerbohm, *Rossetti and His Circle*, with an introduction by N. John Hall, Yale University Press, 1987, p. 24.

52 Ibid.

53 Leonee Ormond, *George du Maurier*, p. 126.

54 Forest Reid, *Illustrators of the 1860s*, Dover Books, 1975, p. 59.

55 Derek Stanford (ed.), *Pre-Raphaelite Writing: An Anthology*, Everyman, 1984, p. 15.

56 John Dixon Hunt, *The Wider Sea: The Life of John Ruskin*, 1982, p. 130.

57 Ibid., p. 213.

58 *Liverpool Echo*, 11 June 1858.

59 *Pre-Raphaelite Papers*, Tate Gallery Publications, 1984, pp. 136–7.

60 Ibid., p. 131.

61 Jonathan Mayne, *Charles Baudelaire: The Painter of Modern Life and Other Essays*, Phaidon, 1964, Introduction, p. xvi.

62 *Pre-Raphaelite Papers*, op. cit., pp. 141–3.

63 Museum of Fine Art, Boston.

64 They were certainly at the address by 6 August 1862 when Boyce confirms it in his diary.

65 Weintraub, *Whistler,* p. 71.

66 14 November 1903.

67 There is only one known impression which is in the Avery Collection, NYPL.

68 Confirmed in a letter from James to Lucas dated 23 December 1862: GUL, BP II, L/50.

69 In a letter written to Lucas in June, James noted, 'indeed this autumn we shall probably return to Paris': Ms. Wadsworth Athenaeum, Hartford, Connecticut.

Chapter 9: The Salon des Refusés

1 GUL, BP II, L/28, dated 10 November 1862.

2 Ms. PC/LC.

3 *L'Eau-forte au dix-neuvième siècle: La Société des Aquafortistes 1862–1867*, 2 vols., Paris, 1972, p. 94.

4 Jonathan Mayne (ed./trans.), *Charles Baudelaire: Art in Paris 1845–1862*, 1965, p. 220.

5 PC/LC, mfm. 772–4, September 1862.

6 GUL, BP II, L/27, October 1862.

7 Druick and Hoog, *Fantin-Latour*, p. 139.

8 Ibid.

9 *Boulevard*, 14 September 1862.

10 Robin Spencer, 'Whistler, Manet and the Tradition of the Avant-Garde', in Ruth Fine (ed.), *James McNeill Whistler*, p. 52, fn. 17.

11 Ibid.

12 Druick and Hoog, op. cit., p. 149.

13 Ibid., p. 152.

14 PC/LC, mfm. 775–6.

15 Ibid.

16 Ibid.

17 Duret, *Whistler*, trans. Frank Rutter, p. 28.

18 Hill-Stead Museum, Farmington, Connecticut.

19 Ms. PC/LC.

20 John A. Mahey, 'The Letters of James McNeill Whistler to George A. Lucas', *Art Bulletin*, no. 49, September 1967, p. 250.

21 The chosen etching was *Fulham*. It appeared in the portfolio as *Vue de la Tamise*.

22 10 February 1863, p. 192.

23 Daphne du Maurier, *George du Maurier*, p. 197.

24 Collection of Sir Brinsley Ford, CBE, FSA: Lochnan, *Etchings*, p. 151.

25 The Tate Gallery, London.

26 *The Pre-Raphaelites*, exhibition catalogue, Tate Gallery, 1984, p. 200.

27 Collection of Her Majesty Queen Elizabeth, The Queen Mother.

28 Daphne du Maurier, op. cit., p. 216.

29 PC/LC, Anderson Rose Papers, dated 24 February 1864.

30 *Japonisme: Japanese Influence on French Art 1854–1910*, exhibition catalogue, Cleveland Museum of Art, 1975, p. 11.

31 GUL, BP II, L/30, dated 7 February 1863.

32 Druick and Hoog, op. cit., p. 116.

33 The etching is entitled *Battersea Reach*. On the first-state impressions Haden inscribed 'Old Chelsea, Seymour Haden, 1863, Out of Whistler's Window'.

34 There are at least two letters in PC/LC that imply that James owed her money and was finding it difficult to repay her.

35 PC/LC, letter dated 16 March 1863.

36 According to John Butler Yeats, father of the poet W.B. Yeats, J.T. Nettleship once told him Whistler did indeed have a calming effect on Swinburne. See Joseph Hone (ed.), *J.B. Yeats: Letters to His Son W.B. Yeats and Others*, 1950, p. 104.

37 *The Letters of A.C. Swinburne*, New York & London, 1919, p. 204.

38 Léonce Bénédite, 'Whistler', *Gazette des Beaux-Arts*, June 1905.

39 'Le Salon des Refusés', *L'Artiste*, 1 August 1863.

40 Léonce Bénédite, op. cit.

41 26 May 1863.

42 Druick and Hoog, op. cit., pp. 141–2.

43 Philippe Burty, 'Salon des 1863: La Gravure et la Lithographie', *Gazette des Beaux-Arts*, 15, No. 2, 1863, p. 153.

44 Ormond, *George du Maurier*, p. 134.

45 Daphne du Maurier, op. cit., p. 150.

46 10 May 1863.

47 *Courrier artistique*, 15 May 1863.

48 Emile Zola, *L'Oeuvre*, Paris, 1886.

49 Druick and Hoog, op. cit., p. 176.

50 GUL, BP II, L/33, dated 15 May 1863.

51 PC/LC, mfm. 850–2.

52 Hamilton, *Manet and His Critics*, p. 44.

53 Ibid., p. 49.

54 PC/LC, May 1863.

55 Ms. Fenian Briefs, State Papers Office, Dublin.

56 Corcoran Gallery of Art, Washington.

57 Art Institute of Chicago.

58 It was eventually acquired by another member of the Greek community in London, Madame Coronio, in 1887. Before that it was exhibited at the Royal Academy in 1867, no. 243.

59 Ms. Fenian Briefs, State Papers Office, Dublin.

Chapter 10: **Domestic Upheavals and Professional Uncertainties**

1 Robin Spencer, 'Whistler's Subject-Matter: Wapping 1860–1864', *Gazette des Beaux-Arts*, No. 1365, Vol. 100, October 1982, pp. 131–41.

2 Jonathan Mayne (ed./trans.), *Charles Baudelaire: Art in Paris 1845–1862*, pp. 41–69.

3 Ibid., p. 46.

4 Musée d'Orsay, Paris.

5 The letter is now lost. Druick and Hoog, *Fantin-Latour*, p. 173.

6 PC/LC, mfm. 797–802, dated 3 February 1864.

7 Daphne du Maurier, *George du Maurier*, p. 173.

8 *Life*, Vol. I, p. 115.

9 For an excellent description of Chelsea inns in this period see Reginald Blunt, *Red Anchor Pieces*, London, 1928, pp. 40–54.

10 Philadelphia Museum of Art.

11 Freer Gallery of Art, Washington. A smaller study is in the collection of Worcester Art Museum, Massachusetts.

12 Leonee Ormond, *George du Maurier*, p. 155.

13 Lamont (ed.), *Armstrong*, p. 196.

14 *Life*, Vol. I, p. 123.

15 PC/LC, letter dated 5 January 1864.

16 Ibid.

17 Lamont (ed.), op. cit., pp. 218–19.

18 PC/LC.

19 Daphne du Maurier, op. cit., p. 227.

20 *Life*, Vol. I, p. 105.

21 Katharine A. Lochnan, 'The Thames from Its Source to the Sea: An Unpublished Portfolio by Whistler and Haden', in Ruth Fine (ed.), *James McNeill Whistler*, pp. 29–45.

22 GUL, W.516.

23 Ibid.

24 Ibid.

25 Archives du Louvre, Salon 1864.

26 Ms. PC/LC: the first part of this letter is missing. The date of 3 February 1864 is noted on page five.

27 There is an oil sketch and a watercolour in the Rosalind Birnie Philip Bequest, Hunterian Museum and Art Gallery, Glasgow University.

28 PC/LC, mfm. 803–5, dated 19 February 1864.

29 Hamilton, *Manet and His Critics*, p. 52.

30 Ibid., p. 55.

Chapter 11: 'A Most Inexplicable Adventure'

1 Detroit Institute of Art.
2 Tom Pocock, *Chelsea Reach: The Brutal Friendship of Whistler and Walter Greaves*, 1970, p. 64.
3 See, for example, Weintraub, *Whistler*, p. 117.
4 Quoted in McLaren Young *et al.*, *Paintings*, p. 29.
5 W. Graham Robertson, *Time Was*, 1931, pp. 57–8.
6 Alfred Lys Baldry, *Albert Moore: His Life and Work*, 1894, p. 7.
7 Weintraub, op. cit., p. 127.
8 PC/LC, mfm. 833–5, dated 10 August 1865.
9 *The Artist's Studio*, Hugh Lane Municipal Gallery, Dublin; and *Whistler in His Studio*, Art Institute of Chicago.
10 Barber Institute of Fine Arts, University of Birmingham.
11 W.M. Rossetti (ed.), *Rossetti Papers, 1862–1870*, 2 vols., London, 1903, p. 228.
12 PC/LC, mfm. 833–5.
13 At least two preparatory drawings exist which indicate that during the initial stages at least, James intended to depict both models seated on the sofa. One pencil and chalk drawing is in the collection of the Munson-Williams-Proctor Institute, Utica, New York, while the other is in the collection of the Hunterian Museum and Art Gallery, Glasgow University.
14 PC/LC, dated 23 October 1864.
15 PC/LC, Miss Chapman's diary, entry dated 12 September 1865.
16 Ibid.
17 Christopher Newall and Judy Egerton, *George Price Boyce*, exhibition catalogue, Tate Gallery, London, 1987, p. 53.
18 The Tate Gallery, London.
19 Isabella Stewart Gardiner Museum, Boston.
20 There are at least four known versions of this painting. By general agreement the painting in the collection of the National Museum in Stockholm is the original version.
21 *Gustave Courbet*, exhibition catalogue, Arts Council of Great Britain, 1978, p. 164.
22 Ms. McAlpine Collection. Quoted in McLaren Young *et al.*, op. cit., p. 38.
23 GUL, W.521, letter dated 22 January 1866.
24 *Journal*, p. 42.
25 PC/LC, Anderson Rose Papers, dated 2 February 1866.
26 PC/LC, Anderson Rose Papers.
27 PC/LC, LC3/2135.
28 GUL, BP II, NE9.
29 Anson Vriel Hancock, *A History of Chile*, Chicago, 1893, p. 246.
30 *Journal*, p. 43.
31 Donald Holden, *Whistler: Landscapes and Seascapes*, 1969, p. 30.
32 Letter to William Boxall dated 24 December 1867: quoted in M.J.H. Liveridge, 'The

Artist as Adversary: The Burlington Arts Club Affair', in *Whistler*, exhibition catalogue, Tokyo, September 1987, p. 38.

33 *Journal*, p. 43.

34 *Courbet*, exh. cat., op. cit., p. 165.

35 *Life*, Vol. I, p. 136.

36 M.J.H. Liveridge in *Whistler*, exh. cat., op. cit., p. 39.

37 Ibid.

Chapter 12: Search for an Aesthetic

1 From G.C. Williamson, *Murray Marks and His Friends*, London, 1919, p. 93. This is also quoted in *Life*, Vol. I, p. 142. There is a variation on this limerick which goes:

> There is a young artist, called Whistler,
> Who in every respect is a bristler;
> A tube of white lead
> Or a punch on the head
> Come equally handy to Whistler.

2 V. Surtees (ed.), *The Diaries of George Price Boyce*, Norwich, 1980, p. 45. Recorded on 17 November 1866.

3 Ibid. Although Boyce throws no censorious light on Whistler's escapades, when Whistler repeated the story to W.M. Rossetti at a later date, Rossetti remarked: 'I must say, Whistler, that your conduct was scandalous.' *Life*, Vol. I, p. 142.

4 In a letter from Fantin-Latour to Whistler, dated 12 February 1867, he writes of the painting being seen by himself, [Alfred] Stevens, and Tissot. T. Reff in *Degas: The Artist's Mind*, 1987, fig. 11, reproduces the drawing by Degas which has slight variations in Whistler's right-hand figure, suggesting that the figure was later altered.

5 W.M. Rossetti (ed.), *Rossetti Papers, 1862–1870*, 1903, p. 229, entry for Sunday 31 March 1867.

6 Whistler does mention Jo in a letter to his friend George Lucas, in the winter of 1869, when he sends her greetings. Copy of letter postmarked 3 May 1869, Whistler to Lucas, in PC/LC, cont. 13, p. 39.

7 Whistler's movements can be ascertained by the postmarked letters he sent to his friend George Lucas in Paris. In one letter bearing the postmark 23 March 1867, from Dieppe, Whistler asks Lucas to bring some things he left behind in Paris. In another letter, postmarked 6 April 1867, from no. 2 Lindsey Row, London, Whistler discusses his pictures on display at the Exposition Universelle.

8 From Patricia Mainardi, *Art and Politics of the Second Empire*, 1987, p. 135.

9 *Twilight at Sea* is now known as *Crepuscule in Flesh Colour and Green: Valparaiso*.

10 For a translation of this letter, written in August 1867, see R. Spencer, *Whistler: A Retrospective*, New York, 1989, pp. 82–4.

11 *Journal*, p. 83.

12 From R. Spencer, op. cit., p. 84. The original letter was first published by Léonce Bénédite in the *Gazette des Beaux-Arts*, September 1905, Vol. 34.

13 Mainardi, op. cit., p. 152.

14 In 1857 Whistler had copied Ingres' *Roger Rescuing Angélique*. Whistler's copy is now in the Hunterian Gallery, Glasgow.

15 R. Spencer, op. cit., pp. 82–4.

16 From John A. Mahey, 'The Letters of James McNeill Whistler to George A. Lucas', *Art Bulletin*, no. 49, September 1967, p. 251: Whistler to G. Lucas, postmarked 5 November 1867.

17 Ibid.

18 Ibid., p. 252: Whistler to Lucas, early December 1867.

19 *Life*, Vol. I, p. 148.

20 Whistler to Fantin-Latour, letter postmarked 30 September 1868, PC/LC. Translation from D. Sutton, *Nocturne*, 1963, p. 64.

21 A. Swinburne, 'Some Pictures of 1868', *Essays and Studies*, 1874, p. 360.

22 See *Life*, Vol. I, p. 304, on Whistler's fondness for Poe's tales.

23 See Malcolm Salamon, *The Great Painter-Etchers from Rembrandt to Whistler*, 1914, p. 39: 'Then he went on to talk of Poe's scientific analysis of his own poem "The Raven", which, Whistler said, was to him one of the most fascinating things in literature. For in this he found, consciously applied to the composition of his poem, his own principle of focussing the pictorial interest, and then deliberately building up to it with careful selection of essential detail, so the complete work of art should be determined from the first.'

24 Swinburne, op. cit., p. 360.

25 E. Warner and G. Hough (eds.), *Strangeness and Beauty: An Anthology of Aesthetic Criticism, 1840–1910*, Vol. I, Cambridge, 1983, p. 237, extract from A. C. Swinburne, 'Blake'.

26 A.L. Baldry, *Albert Moore, His Life and Works*, 1894, pp. 73–8. Baldry outlines Moore's elaborate system of working up to a painting in a series of sketches, gradually moving towards the painted canvas.

27 *Life*, Vol. I, p. 148.

28 C. Brinton, *Walter Greaves (Pupil of Whistler)*, New York, 1912, pp. 13–14.

29 Anna Whistler to F. Leyland, PC/LC, cont. 34A, copy of letter dated 11 March. The letter can be placed in the year 1869, as she mentions in her letter the 'new' Royal Academy, which moved to new quarters in Burlington House that year.

30 GUL, W.1071, copy of undated letter Whistler to Winans.

31 The letters are in GUL, BP II, M/97,8. See R. Spencer, op. cit., pp. 85–6.

Chapter 13: The Butterfly Emerges

1 See John Rewald, *The History of Impressionism*, 1980, ch. VII, pp. 239–70.

2 Ibid., p. 261. Pissarro wrote to T. Duret of his losses in June 1871, 'I've lost everything there [house in Louveciennes]. About forty pictures are left to me out of fifteen hundred.'

3 Robert L. Herbert, *Impressionism: Art, Leisure, and Parisian Society*, 1988, p. 13.

4 Rewald, op. cit., pp. 265–6. Zola's article originally appeared in *Le Corsaire*, 3 December 1872.

5 See Paul Tucker, 'The First Impressionist Exhibition in Context', in C. Moffett (ed.), *The New Painting: Impressionism, 1874–1886*, exhibition catalogue, National Gallery of Washington, 1986, pp. 93–117.

6 For further information on this subject see the Arts Council exhibition catalogue, *The Impressionists in London*, London, 1973.

7 See Lochnan, *Etchings*, pp. 168–81. Whistler had sold the etchings to Alexander Ionides in 1868–9. Ionides passed the plates on to the publishing house of Ellis and Green who published the set in May 1871.

8 Ibid., p. 170. 'A Whistler for Whistler', *Punch*, 17 June 1871, p. 245.

9 McLaren Young *et al.*, *Paintings*, p. 62. The original letter was written on 3 November 1871 and is in PC/LC, cont. no. 34.

10 Originally in the *Fortnightly Review*, June 1888. Reprinted, in part, in Whistler's *Gentle Art of Making Enemies*, Dover, 1967, p. 252. Swinburne's comment related to Whistler's insistence that his portraits were simply 'arrangements' independent of all other sentiments, such as 'devotion, pity, love, patriotism and the like' (Whistler in letter to *World*, 22 May 1878).

11 Anna McNeill Whistler to Kate Palmer, 3 November 1871, PC/LC. Quoted from McLaren Young *et al.*, op. cit., cat. no. 103.

12 McLaren Young *et al.*, op. cit., listed as nos. 103, 104.

13 Ibid., p. 64. *The Times*, 14 November 1871.

14 See copy of letter Whistler to Walter Greaves, no date, from Speke Hall, nr Liverpool. PC/LC, cont. 9, pp. 645–6.

15 Ibid.

16 Whistler to Walter Greaves, undated copy of a letter, from Speke Hall. PC/LC, cont. 9, p. 643.

17 Ibid.

18 Ibid.

19 *Athenaeum*, 21 October 1882, 'The Private Collections of England', gives a description of this painting. An undated letter exists from Whistler to Leyland concerning the purchase of a Velázquez. PC/LC, cont. 4, pp. 3191–3.

20 In Glasgow University Library, now a Whistler Study Centre, there is a set of photographs of Old Master painters owned by Whistler. Included in this set are nine black and white photographs of works by Velázquez. For further on this see Nigel

Thorp, 'Studies in Black and White: Whistler's Photographs in Glasgow University Library', in Ruth Fine (ed.), *James McNeill Whistler*, pp. 67–82.

21 See Lochnan, op. cit., pp. 156–67.

22 See O. Bomand (ed.), *The Diary of W.M. Rossetti, 1870–73*, Oxford, 1977, pp. 165–6, for Rossetti's entry: 'Wednesday 21 February 1872 . . . Dined at Chelsea with Brown, Leyland, and the two Whistler's [James and William] . . . Whistler, it seems, has proposed to Miss Lizzie Dawson, a sister of Mrs Leyland, and his suit is believed to be prosperous: she is only about 20 years of age.' This engagement was later broken.

23 M. MacDonald, 'Whistler: The Painting of the "Mother"', *Gazette des Beaux-Arts*, February 1975, no. LXXXV, p. 84.

24 *Life*, Vol. I, p. 117. Huth owned Whistler's painting for a brief time in 1865.

25 The paintings owned by the Huth family included *Queen Isabel*, a *Philip IV*, now attributed to Mazo, and *Count Duke de Olivares*, now School of Velázquez.

26 T. Honeyman, *Whistler: Arrangement in Grey and Black*, exhibition catalogue, Glasgow Art Gallery, 1951, p. 14: undated letter from Carlyle's niece, Mary Carlyle Aitken, to Whistler.

27 This photograph of Max Beerbohm is by Filson Young (1916) and can be seen at the National Portrait Gallery, London.

28 This unfinished portrait is now at the Tate Gallery, London.

29 McLaren Young *et al.*, op. cit., p. 78.

30 James would have known the painting *Portrait of the Infanta Maria Margarita* in the Louvre, which was then attributed to Velázquez. He also owned a large photograph of Velázquez's *Las Meninas*, now in Glasgow University Library, Special Collections.

31 *Life*, Vol. I, pp. 173–4.

32 Frank Harris, *Contemporary Portraits*, 1915, pp. 69–70.

33 PC/LC, cont. 2, Whistler to Leyland. Although the letter is undated it can be assigned to the winter of 1872 when Whistler first exhibited under the title of Nocturnes at the Dudley Gallery. In the same letter to Leyland, Whistler mentions a 'Nocturne, in Blue and Silver', which is listed in the Dudley Gallery 1872 winter catalogue as no. 237.

34 That Whistler regarded himself as the 'inventor' of moonlights is not uncharacteristic of his temperament. In an undated letter to his pupil Walter Greaves, Whistler wrote of this originality: 'Now look suppose you were to see any other fellow doing my moonlights – how vexed you would be – You see I *invented* them – never in the history of art have they been done –' PC/LC, cont. 9, pp. 639–40.

35 T.R. Way, *Memories of J.M. Whistler*, 1912, p. 68.

36 Furthermore, in Whistler's 'one-skin' surface he followed a more traditional method of blending the paint with little impastoed paintwork, thus moving away from the Impressionists' use of thickly applied pigments.

37 This tendency can be discovered in Baudelaire's essay, 'The Painter of Modern Life', in various Salon reviews and in his poetry, including *Les Fleurs du mal*.

38 J.M. Whistler, *Mr Whistler's 'Ten O'Clock'*, given in 1885, first published in 1888,

p. 15. The similarity between Whistler's description of the city and Baudelaire's earlier description of Paris as viewed through the work of the etcher Meryon, is striking. In his review, 'The Salon of 1859', Baudelaire wrote the following: 'I have rarely seen the natural solemnity of an immense city more poetically reproduced. Those majestic accumulations of stone; those spires "whose fingers point to heaven," those obelisks of industry, spewing forth their conglomerations of smoke against the firmament . . .' From Lochnan, op. cit., p. 78.

39 Jonathan Mayne (ed./trans.), *The Painter of Modern Life and Other Essays*, 1964, p. 9.

40 Listed in McLaren Young *et al.*, op. cit., as nos. 98 and 122 respectively.

41 From Robin Spencer, 'Whistler, Manet, and the Tradition of the Avant-Garde', in Ruth Fine (ed.), *James McNeill Whistler*, p. 63. Letter from Scholderer to Fantin-Latour, 17 Greek Street, Soho, London, dated 26 November 1872, from Brame and Lorenceau collection, translation by Spencer.

42 Fantin-Latour's *Self-Portrait* painted in 1867 is now in Manchester City Art Gallery.

43 From John A. Mahey, 'The Letters of James McNeill Whistler to George A. Lucas', *Art Bulletin*, no. 49, September 1967, pp. 252–3. Letter from Whistler to Lucas, postmarked 18 January 1873. This letter is very reminiscent of *The Times* (14 November 1871) review of Whistler's work at the Dudley Gallery, suggesting that he had influenced the writer with his evolving theories.

44 Edmund Duranty, 'La Nouvelle Peinture', from C.S. Moffett (ed.), *The New Painting: Impressionism*, Geneva, 1986, p. 42.

45 Mahey, op. cit., Whistler to Lucas.

46 Fantin-Latour to O. Scholderer, 23 January 1873, trans. from R. Spencer, 'Whistler, Manet, and the Tradition of the Avant-Garde', op. cit., p. 63.

47 Fantin-Latour to O. Scholderer, 10 March 1873, Paris to London, ibid., p. 63.

48 See Druick and Hoog, *Fantin-Latour*, p. 203, on the artist's re-evaluation of the traditions of art.

49 Ibid., Fantin-Latour to Scholderer, letter dated 22 June 1873. Brame and Lorenceau, Spencer translation.

50 See John House, *Monet: Nature into Art*, 1986, p. 79.

51 Reproduced in *The Impressionists in London*, Arts Council of Great Britain, 1974, p. 14. From Wynford Dewhurst, *Impressionist Painting*, 1904, p. 32.

52 At the winter exhibition of the Royal Society of British Artists Monet exhibited four works, entitled *Coast of Belle Isle, Bretagne, Meadow of Limetz, Village of Bennecourt* and *Cliff near Dieppe*.

53 *Athenaeum*, 22 November 1873, p. 666. Whistler was referring to a review written on 8 November 1873, p. 601.

54 Surtees (ed.), *George Price Boyce*, p. 58. Boyce's diary entry is for 11 November 1873. The *Athenaeum* in an earlier review of 1 November 1873, p. 567, wrote: 'We are sorry to hear that Mr Whistler is seriously ill.'

55 PC/LC, letter from Mary Cassatt to Joseph Pennell: 'Long ago M. Degas told me he had

once written a very urgent letter to Whistler asking him to join a group of painters who were intending to exhibit together, the same group afterwards nicknamed "impressionists" but Whistler never replied to his letter.'

56 Druick and Hoog, op. cit., p. 217. Fantin to Scholderer, 20 May 1874.

Chapter 14: The Artistic Seventies

1 For more on this exhibition see Robin Spencer, 'Whistler's First One-Man Exhibition Reconstructed', *The Documented Image: Visions in Art History*, Syracuse, 1987, pp. 27–49. Considerable expense went into the exhibition including the lease of the gallery at £315 per year, paid in four instalments.

2 O. Doughty and J. R. Wahl, *Letters of D.G. Rossetti*, 1967, no. 1490. Rossetti's comment on Leyland's frills and buckles referred to the attire he chose to wear for the Whistler portrait.

3 *Life*, Vol. I, p. 179.

4 Sidney Colvin, 'Exhibition of Mr Whistler's Pictures', *Academy*, 13 June 1874, pp. 672–3.

5 Ibid., p. 673.

6 GUL, p/c: Henry Blackburn, 'A "Symphony" in Pall Mall', *Pictorial World*, 13 June 1874.

7 Anon., 'Mr Whistler's Paintings and Drawings', *Art Journal*, June 1874, p. 230.

8 GUL, p/c: *Hour*, 9 June 1874.

9 *Hour*, 10 June 1874, reprinted by Whistler in *The Gentle Art of Making Enemies*, 1892, pp. 47–8.

10 By the 1860s the average price for a small portrait photograph was one shilling. In London alone, by 1861, over 200 photographic studios existed. From A. Scharf, *Art and Photography*, 1968, pp. 20–1.

11 E.A. McCauley, *A.A.E. Disdéri and the Carte de Visite Portrait Photograph*, New Haven, 1985, p. 220, discusses photography's effect on portrait-painting in France, a phenomenon which Whistler picked up and tried to appropriate in England: 'On the contrary, photography reinforced artists' tendencies to flaunt their touch and their paintings' removal from reality while it bankrupted the mere artisans who made their livings by handpainting small likenesses on ivory, porcelain, or canvas.'

12 Whistler, *World*, 22 May 1878, reproduced in *The Gentle Art of Making Enemies*, Dover, 1967, p. 128.

13 Oscar Wilde, *The Picture of Dorian Gray*, from *The Works of Oscar Wilde*, Collins, 1931, pp. 15–16. Originally published in *Lippincott's Magazine*, 20 June 1890; published as book in April 1891.

14 See Robin Spencer, 'Whistler's First One-Man Exhibition Reconstructed', op. cit., for more information on the ensuing costs of renting the gallery, pp. 41–4.

15 Walter Sickert, 'With Wisest Sorrow' (from *Daily Telegraph*, 25 April 1925), in Sitwell (ed.), *The Writings of Walter Sickert*, p. 37.

16 Ibid., pp. 37–8. Sickert wrote further: 'That Whistler judged himself only too justly is proved by the fact that perhaps thirty per cent, and I am putting it pretty high, of the

perpendicular six-footers were allowed to remain in existence. I cannot remember how many of these I helped him to cut into ribbons on their stretchers.'

17 See the Pennells' account of Whistler's teaching at the Academy Carmen, *Life*, Vol. II, p. 231.

18 From A.J. Eddy, *Recollections and Impressions of J.A. McNeill Whistler*, 1903, p. 233.

19 Ibid., p. 236.

20 Richard Ellmann, *Oscar Wilde*, 1987, p. 261.

21 McLaren Young *et al.*, *Paintings*, p. 56.

22 Eddy, op. cit., p. 214.

23 *Life*, Vol. I, p. 113.

24 Ellen Terry, *Memoirs,* ed. E. Craig and C. St John, 1933, p. 217.

25 *Life*, Vol. I, p. 186.

26 See Margaret MacDonald, 'Maud Franklin', in Ruth Fine (ed.), *James McNeill Whistler,* pp. 13–26, for a history of her relationship with Whistler.

27 Ibid., p. 24. Maud exhibited with Whistler at the Society of British Artists from the winter show of 1884/5 to 1887/8.

28 There are several letters from Whistler to Frances Leyland which express his fondness for her: PC/LC, cont. 2. There were also rumours spread by Rossetti that she and Whistler were about to elope. *Journal,* p. 104.

29 *Life*, Vol. I, p. 191.

30 L. Jopling, *Twenty Years of My Life, 1867–1887,* 1925, p. 228.

31 *Journal,* p. 105.

32 A. Symons, *A Study of Oscar Wilde*, 1930, p. 63.

33 Anon., 'A Chat with Mr Whistler', *Studio*, 1894, Vol. 4, p. 117.

34 Max Beerbohm, 'Whistler's Writing', *Metropolitan Magazine*, September 1904, p. 732, writes further: 'Like himself, necessarily, his style was cosmopolitan and eccentric. It comprised Cockneyisms and Boweryisms and Parisian *argot*, with constant reminiscences of the authorized version of the Old Testament, and with chips off Molière, and with shreds and tags of what-not snatched from a hundred and one queer corners. It was in fact an Autolycine style.'

35 Jopling, op. cit., p. 71.

36 Godwin Diaries, V & A Archives, AAD 19/3. Entry for Sunday 22 July 1877.

37 *Life*, Vol. I, p. 138.

38 Ibid., Vol. I, pp. 187–8.

39 MacDonald, *Whistler's Mother's Cookbook*, p. 41.

40 Ibid., pp. 36–7.

41 *Life*, Vol. I, p. 192.

42 In PC/LC, cont. 27, in the Anderson-Rose papers, there are various unpaid accounts, including several 1876 bills from the wine merchant S. Ladenburg and Co., which list Whistler's choice of wines.

43 *Life*, Vol. I, p. 204.

44 GUL, H.342: Charles Hanson memoirs, 'Out of My Memory', p. 1.

45 GUL, Whistler 246/1.

46 See *Pall Mall Gazette*, 15 February 1877.

47 GUL, BP II, 23/13.

48 Ibid.

49 GUL, BP II, 23/14–16, draft letter Whistler to Leyland, dated 31 October 1876.

50 GUL, L.117 (BP II, 23/24), Whistler to Mrs Leyland [July 1877].

51 PC/LC, cont. 2, undated letter from Whistler to Frances Leyland.

52 PC/LC, cont. 2, Whistler to Frances Leyland [1875].

53 While Whistler could be speaking of his portrait of Frances Leyland, there is also a possibility that he is speaking of his work entitled *Three Girls*.

54 *Journal*, p. 101.

55 Ibid., p. 105. The fact that the Leylands were having marital problems is evident; they separated in 1879. Rossetti wrote to his mother on 17 August 1879: 'I saw Leyland and it seems Mrs, after getting £2,000 a year out of him besides £3,500 down for house and equipage, has gone into cheap lodgings in Liverpool and is saving all her money! She keeps no carriage and makes no show of any kind.' Doughty and Wahl (eds.), op. cit., no. 2087.

56 The three satirical paintings of Leyland are listed in McLaren Young *et al.*, *Paintings*, as no. 208 *The Gold Scab*, no. 209 *The Loves of Lobsters* and no. 210 *Mount Ararat*.

57 A.L. Baldry, *Hubert von Herkomer*, 1904, p. 102.

58 See V & A Archives, AAD 19/3, E.W. Godwin Diary, entry for 2 November 1877: 'introd. Whistler to Mr Fildes went over new home also Burges.' Burges's 'Tower House' was next door to Fildes.

59 Library of Congress, Rare Books, case 2, Dowdeswell.

60 See Robin Spencer, *The Aesthetic Movement*, 1972.

61 *Journal*, p. 105.

62 John Hollingshead, *The Grasshopper*, 1877, p. 27.

63 Ibid., Act III, pp. 38–9.

64 See T. Reff, *Degas: The Artist's Mind*, 1987, p. 36.

Chapter 15: *Whistler v. Ruskin*

1 G.H. Boughton, 'Reminiscences of Whistler: A Few of the Various Whistlers I Have Known', *Studio*, Vol. 30, 1904, pp. 212, 215.

2 John Ruskin, *Fors Clavigera*, July 1877, 'Letter 79'.

3 Boughton, op. cit., p. 212.

4 For a full account of the trial see Linda Merrill, *A Pot of Paint: Aesthetics on Trial in Whistler v. Ruskin*, Smithsonian Institute, Washington and New York, 1992.

5 Georgina Burne-Jones, *Memorials of Edward Burne-Jones*, Vol. II, 1909, p. 86.

6 Merrill, op. cit., p. 54, citing letter from Ruskin, 16 July 1877.

7 Merrill, op. cit., pp. 95–8, discusses the validity of this argument.

8 During this period Whistler was receiving a number of writs, including one from his builder B.E. Nightingale, dated 17 September 1878, for £655 13s 6d: PC/LC, no. 4, 'Bankruptcy Act'.

9 Glasgow University Library, *Whistlers and Further Family*, 1980, p. 4. Anna's birthdate was 27 September 1804.

10 GUL, Whistler, extracts copied from the diary of Alan Cole, 16 October 1878.

11 PC/LC, cont. 4, Whistler to Rose, received 20 November 1878.

12 PC/LC, cont. 4, Whistler to Rose, letter dated 21 November 1878.

13 PC/LC, cont. 4, W.M. Rossetti to Anderson Rose, letter dated 22 November 1878. Rossetti had written of the painting in 'The Dudley Gallery', *Academy*, VIII, 30 October 1875, p. 462.

14 Merrill, op. cit., pp. 106–10.

15 PC/LC, cont. 27, pp. 29–30. Burne-Jones's lengthy written account has been copied by Ruskin's solicitors on to the brief, pp. 29–37.

16 No permanent record of the trial was kept. However, Merrill, op. cit., pp. 133–97, reconstructs the trial from existing newspaper accounts. For the purposes of this chapter we have relied on Merrill's excellent reconstruction.

17 Cremorne Pleasure Gardens were first opened in 1846. According to Warwick Wroth, *Cremorne and the Later London Gardens*, 1907, p. 11, petitions against the licensing of the premises on the grounds of its immoral character were registered on an annual basis by the Chelsea Vestry. In October 1877, the owner was advised by his counsel to withdraw his application for renewal of the licence and the Gardens were closed. On its respectability Wroth writes: 'It was not, for one thing, a place that ladies (in the strict sense of the word) were in the habit of visiting, unless, perhaps, (as Mr Sala puts it) "in disguise and on the sly", or, at any rate, under the safe conduct of a husband or brother. Ladies [prostitutes] of some sort were, no doubt, considerably in evidence there, though we are not to think of Cremorne as so entirely given over to "drink, dancing and devilry" as its sterner critics declared.'

18 From R. Spencer, *Whistler: A Retrospective*, 1989, p. 133.

19 E.T. Cook and A. Wedderburn (eds.), *Works of John Ruskin*, Vol. 29, p. xxv, Ruskin to H.G. Liddell, 28 November 1878.

20 PC/LC, cont. 4, Whistler to Rose, 7 January 1879.

21 See Lochnan, *Etchings*, pp. 176–81.

22 See M. MacDonald, 'Maud Franklin', in Ruth Fine (ed.), *James McNeill Whistler*, p. 23.

23 See John A. Mahey, 'The Letters of James McNeill Whistler to George Lucas', *Art Bulletin*, no. 49, September 1967, pp. 253–4. These letters can be dated by the postmarks to 1, 7 and 11 January 1879.

24 MacDonald, op. cit., p. 26, fn. 37.

25 Mahey, op. cit., p. 254.

26 Merrill, op. cit., p. 285.

Chapter 16: A Venetian Exile

1 Note that Sargent did not arrive until September 1880, when Whistler had moved to rooms at the Casa Jankovitz.

2 GUL, W.680, undated letter.

3 GUL, H.20, dated New Year's day.

4 See end of Chapter 12, 'Search for an Aesthetic', letter from Whistler to Thomas Winans, GUL, W.1071.

5 *Life*, Vol. I, p. 273, letter from Ralph Curtis to the Pennells. Henry James devotes an essay to the subject of her soirées in *Italian Hours*. Ralph Curtis was an American artist whose family moved to Venice and leased, then bought, the Palazzo Barbaro.

6 GUL, H.20, letter to Deborah Haden, dated New Year's day.

7 L.V. Fildes, *Luke Fildes, R.A., A Victorian Painter*, 1968, p. 64.

8 GUL, W.681, to Helen Whistler, after Christmas. To some extent, despite his exile in Venice, Whistler was still newsworthy, with the *World*, a society weekly, occasionally featuring a humorous item on the artist. The *World* was in existence from 1874 to 1922 and was under the editorship of Edmund Yates (known as Atlas) from 1874 to 1894. Whistler was featured in the Christmas number, dated 24 December 1879, by Weeder, 'Ididdlia', which included a humorous illustration and account of Whistler in Venice. The story and illustration appear to allude to Whistler's relationship with a certain lady, possibly Mrs Leyland. Frances Leyland was by this point estranged from her husband and living separately in a flat in St James's Street, London.

9 Ibid.

10 GUL, LB 3/8.

11 Fildes, op. cit., p. 66.

12 Ibid., pp. 65–6. According to the artist William Graham, Whistler began a portrait of a colonel's son in his studio. When painting the portrait Whistler kept Graham and the boy entertained by the naming of his brushes, Charlotte, Jane, Luisa, Josephine, Sophia and Susan. This portrait is untraced. (McLaren Young *et al.*, *Paintings*, cat. no. 211.)

13 Fildes, op. cit., p. 64.

14 Ibid., p. 23.

15 GUL, H.55.

16 It is likely that any correspondence between Jo and Whistler was later destroyed by Whistler's executrix Rosalind Birnie Philip, who saw it as her task to edit and preserve his reputation.

17 Freer Collection, folder no. 176.

18 GUL, Whistler LB 3/8, dated to January 1880.

19 M. Menpes, *Whistler as I Knew Him*, 1904, p. 22.

20 GUL, Whistler LB 12/39, postmarked Venice 26 January 1880.

21 Otto Bacher, *With Whistler in Venice*, New York, 1908, p. 97.

22 Ibid., pp. 75–7.

23 Ibid., pp. 201–4.

24 See Margaret MacDonald in her forthcoming Yale publication of the catalogued watercolours and pastels of Whistler for examples of his work of Venice in this medium. Also D.P. Curry, *James McNeill Whistler at the Freer Gallery of Art*, Washington, 1984, p. 176, plate 91.

25 Bacher, op. cit., p. 238.

26 Whistler used Florian's as his postal address whilst in Venice.

27 *Life*, Vol. I, pp. 273–4.

28 Bacher, op. cit., p. 262.

29 *Life*, Vol. I, p. 273.

30 GUL, BP 13/10, autograph copy, October 1880.

31 GUL, W.56.

32 *Life*, Vol. I, p. 289.

Chapter 17: A Triumphant Return

1 For an account of Whistler's printing methods see Lochnan, *Etchings*, pp. 181–218.

2 D. Habron, *Godwin*, 1949, pp. 144–5.

3 Anon. (H. Quilter), *Spectator*, 11 December 1880, p. 1587.

4 Lochnan, op. cit., p. 216.

5 GUL, Rev.1955 W/60, Whistler to Mrs W. Whistler, October 1881.

6 McLaren Young *et al.*, *Paintings*, cat. no. 227.

7 Ellen Terry, *Memoirs*, ed. E. Craig and C. St John, 1933, p. 231.

8 Arthur Symons, *A Study of Oscar Wilde*, 1930, pp. 63–4.

9 Frank Harris, 'Oscar Wilde', *Contemporary Portraits*, 1915, p. 103.

10 Ibid.

11 Ibid., p. 67.

12 Freer letters no. 177, postmarked 25 March 1881.

13 GUL, W.80, Way to Whistler, 2 February 1881.

14 Anon. (T.R. Way), 'Venice Pastels and Etchings', *Art Journal*, 1881, p. 93.

15 E.W. Godwin, *British Architect*, 25 February 1881, p. 99.

16 *Journal*, p. 252.

17 R. Ellmann, *Oscar Wilde*, 1987, p. 126, undated letter.

18 GUL, W.694, Whistler to Mrs W. Whistler, undated letter.

19 See Lochnan, op. cit., pp. 216–18.

20 Lochnan, op. cit., fn. 24, mentions that close friends saw Whistler's battles with T.R. Way, and Sir William Eden, after the death of his wife Beatrice, as ways of alleviating his grief. If true, this pattern can be seen emerging with his mother's death in 1881.

21 Ibid., p. 218.

22 See F.E. Wissman, 'Realists among the Impressionists', *The New Painting: Impressionism 1874–1886*, Switzerland, 1986, p. 337.

23 J.E. Blanche, *A Propos de peintres de David à Degas*, Paris, 1919, p. 54.

24 Theodore Reff, *Degas: The Artist's Mind*, New York, 1976, p. 18, roughly dates the letter to the 1880s. Original draft of undated letter in GUL, BP II, D/6.

25 Reff, op. cit., p. 18. Original quote from William Rothenstein, *Men and Memories*, 1931, Vol. I, p. 101.

26 It has already been suggested that Whistler was invited to the first Impressionist exhibition. He was possibly also invited to the second show held in 1876, as a letter from Otto Scholderer to Fantin-Latour, dated 17 January 1875, indicates. See Robin Spencer, 'Whistler, Manet, and the Tradition of the Avant-Garde', in Ruth Fine (ed.), *James McNeill Whistler*, p. 63, fn. 54.

27 Théodore Duret, 'James Whistler', *Gazette des Beaux-Arts*, no. 23, April 1881, p. 368. Translation from Robin Spencer, *Whistler: A Retrospective*, p. 182.

28 *Life*, Vol. I, p. 300. Diary entry dated 26 May 1881.

29 Duret, *Whistler*, trans. F. Rutter, p. 66.

30 McLaren Young *et al.*, op. cit., cat. no. 229.

31 Mrs Julian Hawthorne, 'Mr Whistler's Portraits', *Harper's Bazaar*, 15 October 1881. Reproduced in Robin Spencer, *Whistler: A Retrospective*, pp. 178–80.

32 Mrs Julian Hawthorne, 'A Champion of Art', *Independent*, 2 November 1899, pp. 2957–8. Reproduced in McLaren Young *et al.*, op. cit., p. 129.

33 Duret, *Whistler*, p. 66.

34 Lady Archibald Campbell, *Rainbow Music*, July 1886, pp. 1–2, 4, 12–15.

35 Duret, *Whistler*, p. 66.

36 McLaren Young *et al.*, op. cit., cat. no. 242. Quoted from W.G. Robertson, letter of 9 February 1937.

37 Stanley Olson, *John Singer Sargent*, 1989, pp. 103–5.

38 See ibid., for a further discussion of the subject.

39 Max Beerbohm did a caricature of such a sight, entitled *31 Tite Street*, reproduced in Olson, op. cit., plate XXII.

40 The opera had been running successfully since April, when it first appeared in London at the Opéra Comique.

41 Ellmann, op. cit., p. 129.

42 Ibid., p. 130.

43 Rennell Rodd, *Rose Leaf and Apple Tree*, Philadelphia, 1882, pp. 12–13.

44 R. Hart-Davis (ed.), *The Letters of Oscar Wilde*, 1962, pp. 110–11. Wilde to Mrs Bernard Beere, letter dated 17 April 1882, Kansas City, Missouri.

45 Ibid., p. 121.

46 Lois Marie Fink, *American Art at the Nineteenth-Century Paris Salons*, Washington DC, 1990, p. 116.

47 Ibid., p. 120.

48 Reff, op. cit., p. 16. Original letter dated 2 May 1882.

49 Henry James, 'London Pictures of 1882', *Atlantic Monthly*, August 1882, in Henry James, *The Painter's Eye*, 1956, p. 208.

50 T. Duret, 'Expositions de la Royal Academy et de la Grosvenor Gallery', *Gazette des Beaux-Arts*, Vol. 25, May 1882, pp. 617–20.

51 Pierpont Morgan Library, Whistler to Waldo Story, 1 February 1883.

52 PC/LC, cont. 2, letter 3.

53 Anon., 'Art Gossip', *Lady's Pictorial*, 24 February 1883.

54 Wendy Baron, *Sickert*, 1973, p. 8.

55 Ibid.

56 Mortimer Menpes, *Whistler as I Knew Him*, 1904, p. 23.

57 Ibid., p. 100.

58 Ellmann, op. cit., p. 127, undated letter.

59 Camille Pissarro, *Letters to His Son Lucien*, Santa Barbara, 1981, p. 9, letter dated 29 March 1883.

60 Duret, *Whistler*, pp. 68–9.

61 See Manet, *Portrait of Théodore Duret*, 1868, Musée du Petit Palais, Paris. For further discussion of this subject see Robin Spencer, 'Whistler, Manet and the Tradition of the Avant-Garde', in Ruth Fine (ed.), *James McNeill Whistler*, pp. 47–64.

62 See J. Rewald, *The History of Impressionism*, New York, 1973, pp. 240–1.

63 See K. Flint, *Impressionists in England: The Critical Reception*, 1984, p. 6, who mentions that the catalogue for the exhibition included extracts from Duret's preface to a recent catalogue of Renoir's work. The catalogue for the Dowdeswell exhibition is reproduced in ibid., pp. 55–6.

64 Ibid., p. 7.

65 Ibid., p. 6.

66 Ibid., p. 61, from unsigned review, *Artist*, 1 May 1883, IV, 138.

67 Ellmann, op. cit., p. 225.

68 Ibid., p. 152.

69 M. Menpes, *World Pictures*, London, 1902, pp. 6–8.

70 Menpes, *Whistler as I Knew Him*, p. 20.

71 Ibid., p. 140.

72 Sitwell (ed.), *A Free House: The Writings of Walter Sickert*, pp. 18–19. Originally from the *Fortnightly Review*, December 1908, 'The New Life of Whistler'.

73 A. Ludovici, *An Artist's Life in London and Paris*, 1926, pp. 73–4.

74 Menpes, *Whistler as I Knew Him*, p. 138.

75 See Kenneth McConkey, 'The Bouguereau of the Naturalists: Bastien-Lepage and British Art', *Art History*, Vol. 1, No. 3, 1978, pp. 371–82.

76 GUL, W.698. Whistler to Helen Whistler (Nellie) from St Ives, letter dated December 1883. In the same letter Whistler asks if she might know of someone interested in having their portrait painted, as portraiture was one of the more lucrative ventures for artists.

77 Ibid.

78 J.M. Whistler, *Mr Whistler's 'Ten O'Clock'*, 1888, p. 14. This notion of nature being improved upon by the artist relates to Baudelaire's celebration of the artificial. Furthermore, the 'dandy' as presented by Baudelaire had an inborn abhorrence for the countryside, preferring the city as a visual spectacle.

79 GUL, LB9/16, undated letter from Whistler to his dealer at the Fine Art Society, E. Brown. Whistler again refers to the novelty of his work in LB9/17, and asks Brown to his studio, in LB9/15.

80 E.W. Godwin, 'To Art Students', *British Architect*, Vol. 22, 11 July 1884, letter no. 9, p. 13.

81 Anon., 'Flesh Colour and Grey', *Queen*, 31 May 1884. From GUL, p/c: Vol. 7, p. 5.

82 J.M. Whistler, *'Notes' – 'Harmonies' – 'Nocturnes'*, London, Dowdeswells' Gallery, May 1884, p. 1. Also reprinted in *The Gentle Art of Making Enemies*, Dover, 1967, p. 115.

83 This notion that a high degree of finish in a painting, resulting from many hours of necessary work, was a moral virtue, was a view Ruskin reiterated in his writing. See Ruskin, *Modern Painters*, Vol. II, New York, 1880, p. 2.

84 Whistler, *'Notes'*, p. 1.

85 *Artist*, 1884, p. 200. GUL, p/c: Vol. 7, p. 11.

86 *Court and Society Review*, 20 April 1887, p. 378.

87 Library of Congress, Rare Books, case no. 1, Whistler to Dowdeswell, 27 July.

Chapter 18: Performance Art

1 Dublin Sketching Club Minute Ledger, 1880–6, dated Monday 8 November 1884. The Dublin Sketching Club archival material is today in the possession of the club's secretary in Dublin.

2 When the Pennells were writing the *Life* they contacted Lawless in Dublin. He responded generously to their requests for information and supplied them with a photograph of all the 'followers' grouped with Whistler. A little statuette which appears in the photograph was claimed by Lawless to have been the work of Whistler. This claim, however, has never been substantiated.

3 PC/LC, 2/1186–7.

4 Dublin Sketching Club Minute Ledger, 1880–6.

5 *Irish Times*, 1 December 1884.

6 *Dublin Daily Express*, 1 December 1884.

7 *Irish Times*, 3 December 1884.

8 PC/LC, 2/1192–3.

9 *Dublin Evening Mail*, 3 December 1884.

10 *Irish Times*, 4 December 1884.

11 PC/LC, 2/1190–1.

12 Dublin Sketching Club Minute Ledger, 1880–6.

13 PC/LC, 2/1190–1.

14 PC/LC, 2/1193.

15 There was to be one final twist in Dublin. On 19 January 1885, some three weeks after the Whistler exhibition had ended, John O'Leary returned to Ireland a free man after nearly fourteen years in exile in Paris. The same evening he made a highly emotional speech to a packed audience of Young Irelanders at the Rotunda, in Dublin. Ironically, it was around the same date that Whistler had tentatively agreed his own lecture in Dublin. One wonders if this was another reason for Whistler to choose not to lecture in Dublin, so as not to detract from O'Leary's return.

16 GUL, BP II, 9/16, letter dated 8 January 1885, Helen D'Oyly Carte to Archibald Forbes.

17 GUL, W.767, note in Charles Hanson's handwriting.

18 GUL, BP II, 32/29.

19 PC/LC, Whistler to Waldo Story, undated letter.

20 *World*, February 1885: GUL, BP, p/c.

21 See GUL, W.766 *et al.*

22 G.P. Jacomb-Hood, *With Brush and Pencil*, 1925, p. 45.

23 All of the above information from GUL, P.625, 'Seating Plan'.

24 *Age*, 22 February 1885.

25 James McNeill Whistler, *Mr Whistler's 'Ten O'Clock'*, 1888, pp. 7–8.

26 Ibid., p. 9.

27 Ibid., p. 20.

28 Confirmed in letter from Colvin to Whistler, 21 February 1885: GUL, BP II, 32/34.

29 GUL, BP II, 32/8, Boehm to Whistler.

30 GUL, BP II, 32/15, Alan Cole to Whistler.

31 GUL, M.304, Menpes to Whistler.

32 GUL, Whistler p/c: *Daily Telegraph*, 21 February 1885.

33 H. Taylor, *Whistler*, 1978, p. 121.

34 *Pall Mall Gazette*, 21 February 1885.

35 Ibid.

36 *World*, 25 February 1885. James took offence at being grouped with Wilde's choice of painters. Both the American artist, Benjamin West PRA (1738–1820), best known for his *Death of General Wolfe*, and the French artist, Paul Delaroche (1797–1856), known for his *The Execution of Lady Jane Grey*, had belonged to the outdated genre of history painting.

Chapter 19: Vive le Président

1 GUL, BP II, 2/305, Coutts to Whistler, 18 April 1884.

2 *Times*, 3 December 1884, quoted from A. Ludovici, 'The Whistlerian Dynasty at Suffolk Street', *Art Journal*, 1906, p. 194.

3 GUL, R.162, J. Burr, 'Brief History of the Society', 1 May 1883.

4 A. Ludovici, *An Artist's Life in London and Paris, 1870–1925*, 1926, pp. 73–4.

5 Ludovici, *Art Journal*, 1906, p. 194.

6 Menpes, *Whistler as I Knew Him*, 1904, pp. 110–11.

7 Ibid., p. 15.

8 Frank Rutter, 'Impressionism', *Art in My Time*, 1933, p. 57. Lucien Pissarro wrote of the difference between English and French Impressionism in a letter to his father in 1891: 'They [English Impressionists] discussed the issue like Englishmen who don't know the first thing about Impressionism, young people who paint flat and have black on their palettes.' Camille Pissarro, *Letters to His Son Lucien*, 1981, p. 202.

9 Menpes, op. cit., p. 20.

10 Ibid., pp. 24–5.

11 *Pall Mall Gazette*, 8 December 1885. GUL, p/c: Vol. 8.

12 G.P. Jacomb-Hood, *With Brush and Pencil*, 1925, pp. 32–3.

13 *Pall Mall Gazette*, 11 June 1888. Those who resigned with Whistler were: Waldo Story, C. Keene, A. Stevens, N. Maclean, M.P. Lindner, E.G. Giradot, M. Ludby, A. Hill, W.S. Llewellyn, C. Symons, C. Wyllie, A.F. Grace, J.D. Watson, A. Ludovici, P. MacNab, G.P. Jacomb-Hood, C. Thornley, J.J. Shannon, W. Patten, A. Hunt, T. Roussel, S. Starr, F.E. James, W.A. Rixon. Mortimer Menpes, anticipating the conflict, resigned prior to Whistler, which caused the latter to remark that Menpes was no better than the rat who deserts the sinking ship.

14 Ronald Pisano, *William Merritt Chase*, New York, 1982, p. 36.

15 McLaren Young *et al.*, *Paintings*, cat. no. 157.

16 Ibid.

17 Anon., 'Art. The Society of British Artists', *Spectator*, 26 December 1885: GUL, Whistler, p/c.

18 In 1873 (the year preceding the first Impressionist exhibition), Whistler showed some Nocturnes and portraits at Durand-Ruel's Gallery in both London and Paris. Later in 1887 Whistler exhibited over fifty works at George Petit's Gallery, which included works by Monet and Pissarro.

19 GUL, D.139, letter from Helen Lenoir (secretary to D'Oyly Carte) to Whistler, dated 20 December 1886.

20 SBA Minute Book 13. Minutes of meeting for 19 November 1886 record that Wyke Bayliss proposed that the picture of Lady Colin Campbell be removed. The proposal was lost. The portrait was left unfinished and was either destroyed by Whistler or lost.

21 *Saturday Review*, 12 May 1888. GUL, p/c: Vol. 3, p. 129.

22 Menpes, op. cit., p. 106.

23 Ludovici, 'The Whistlerian Dynasty at Suffolk Street', *Art Journal*, 1906, p. 238.

24 Ludovici, *An Artist's Life*, op. cit., p. 73.

25 Ibid., p. 78.

26 PC/LC, Whistler to Waldo Story (sculptor), letter can be dated to May 1884.

27 M. Salaman, 'Hail President Whistler', *Court and Society Review*, 10 June 1886, pp. 520–1. That Salaman was partisan to Whistler's views is indicated by a number of reviews he wrote, not only for the above paper, but also for the *Manchester Courier*. In a letter to Whistler from Salaman dated 2 January 1889, he confesses that his opinions on art cost

him his job on the latter paper, concluding that 'The editors are not educated enough to allow of Whistler critics – but I shall perservere': GUL, S.8.

28 This account is repeated several times, in *Art Journal*, op. cit., p. 237, and in Sidney Starr, 'Personal Recollections of Whistler', *Atlantic Monthly*, Vol. 101, April 1908, p. 533.

29 In Whistler's correspondence with Sir Henry Hulbert, a number of letters suggest this possibility of knighthood, with Hulbert addressing Whistler affectionately as 'Sir James': GUL, H.302–32.

30 See John House, *Monet: Nature into Art*, 1986, p. 222.

31 R.A.M. Stevenson, *Saturday Review*, 3 December 1887, p. 760, reprinted in Kate Flint, *Impressionists in England*, 1984, p. 87.

32 GUL, R.210: printed agenda drawn up and presented to the RBA meeting of 1 November 1887.

33 *Pall Mall Gazette*, 7 November 1887, Vol. XLVI, No. 7064, p. 8.

34 GUL, P.21: draft letter dated 7 November.

35 Ludovici, *An Artist's Life*, p. 79.

36 Ibid., p. 87.

37 G.P. Jacomb-Hood, *With Brush and Pencil*, p. 35.

38 Menpes, op. cit., p. 105.

39 A. Ludovici, 'The Whistlerian Dynasty', *Art Journal*, 1906, pp. 238–9.

40 Anon., 'An Interview with an Ex-President', *Pall Mall Gazette*, 11 June 1888, reproduced in *The Gentle Art of Making Enemies*, Dover, 1967, p. 208.

41 GUL, W.826, draft for *Who's Who*, early 1901.

Chapter 20: The Butterfly Chained

1 GUL, P.47.

2 John Rewald (ed.), *Lettres de Camille Pissarro à son fils Lucien*, 1943, p. 146.

3 Walter Sickert was one of the two British artists suggested by James; the other was most likely Philip Wilson Steer. See GUL, S.133.

4 GUL, S.133.

5 GUL, BP II, 11/99.

6 GUL, R.107.

7 Ms. Harvard University.

8 GUL, BP II, 11/135.

9 The date of Monet's arrival in London is not clear, but he was certainly there by 22 December when he signed his nomination form for the Beefsteak Club. Ms. Property of the Beefsteak Club, London.

10 GUL, BP II, S.102, dated 22 February 1888.

11 For Monet's dealings with Durand-Ruel, see L. Venturi, 'Memories de Paul Durand-Ruel', in *Les Archives de l'Impressionisme*, Paris and New York, 1939, Vol. 1, pp. 307–14, and p. 325.

12 GUL, BP II, M.359.

13 For example, see Stéphane Mallarmé, 'The Impressionists and Edouard Manet', *Art Monthly Review*, London, 1876, p. 121.

14 See Carl Barbier (ed.), *Correspondance Mallarmé–Whistler: Histoire de la grande amitié de leur dernières années*, Paris, 1964: letter dated 14 March 1888.

15 GUL, BP II, 32/53, dated 22 March 1888.

16 Ms. Collection Mondor, dated 18 March 1888.

17 GUL, M.112.

18 GUL, M.113.

19 Ms. Collection Mondor, dated 7 May 1888.

20 GUL, BP II, 11/90, dated 12 May 1888.

21 GUL, T.79.

22 The visit is confirmed in a letter from Morisot to Mallarmé, dated 21 May 1888. Ms. Collection Mme E. Rouart.

23 Noted in D. Rouart (ed.), *The Correspondence of Berthe Morisot*, 1957, p. 138.

24 *Gil Blas*, 9 June 1888.

25 *Mercure de France*, 1931, pp. 209–10.

26 GUL, M.116, dated 28 June 1888.

27 Walter Theodore Watts reputedly changed his name to Theodore Watts-Dunton when Whistler sent him a telegram which read 'Theodore Whats Dunton?' Noted in Rupert Hart-Davis (ed.), *The Letters of Oscar Wilde*, New York, 1962, p. 192, note 3.

28 GUL, S.274.

29 *Life*, Vol. I, p. 45.

30 Ms. Collection Mondor, dated 30 June 1888.

31 GUL, W.639, dated 20 November 1895.

32 Both Maud Franklin and Beatrice exhibited regularly at the RBA. Like Beatrice, Maud also used a pseudonym. In Maud's case the name was 'Clifton Lin'. See Margaret MacDonald, 'Maud Franklin', in Ruth Fine (ed.), *James McNeill Whistler*, p. 24, note 40.

33 Hunterian Museum and Art Gallery, University of Glasgow. Rosalind Birnie Philip Bequest.

34 Dudley Harbron, *The Conscious Stone: The Life of E.W. Godwin*, 1949, p. 175.

35 PC/LC, dated October 1886.

36 Harbron, op. cit., p. 235.

37 Oldham Art Gallery, England.

38 Quoted in MacDonald, op. cit., p. 24.

39 Ibid.

40 *Journal*, pp. 165–7.

41 For an excellent discussion of James's etched work during the honeymoon period see Lochnan, *Etchings*, pp. 244–55.

42 Ibid., p. 245.

43 PC/LC, Charles Hanson note, undated.

44 GUL, BP II, g/26, dated September 1888.

45 Tom Pocock, *Chelsea Reach: The Brutal Friendship of Whistler and Walter Greaves*, 1970, p. 125.

46 GUL, BP II, 31/1.

47 GUL, Whistler p/c: Vol. 16, p. 64.

48 GUL, M.362, undated.

Chapter 21: Tension within the Ranks

1 From Whistler's own version as it appeared in *The Gentle Art of Making Enemies*, 1890, pp. 230–2. The original letter appeared in the *World* on 26 December 1888.

2 *Truth*, 28 March 1889.

3 Ms. PC/LC.

4 Quoted in Wendy Baron, *Sickert*, 1973, p. 22. Original letter GUL.

5 Ibid., p. 22.

6 Ibid., p. 23.

7 Ibid.

8 From information contained in a hand-written Whistler exhibition list compiled by the Pennells, *c.* 1906. Ms. PC/LC.

9 Monet apologized for his absence to James by letter on 28 April 1888: GUL, M.363.

10 GUL, BP II, S/95, 9b.

11 Report of dinner in *Sunday Times*, 5 May 1888. Reprinted in *The Gentle Art of Making Enemies*, 1890, pp. 285–7.

12 GUL, p/c: Vol. 10, p. 93.

13 *Life*, Vol. II, p. 93.

14 O. Sitwell (ed.), *The Writings of Walter Sickert*, p. 8.

15 Ibid.

16 The proposed trip to the United States was referred to in an interview which Whistler gave to Sheridan Ford and which appeared in the *Citizen*, a New York newspaper, on 2 December 1888. GUL, p/c: Vol. 10, p. 54.

17 GUL, P.48.

18 *New York Herald* (Paris edition), 3 October 1889.

19 The painting is now in the Rijksmuseum, Amsterdam.

20 Ford was one of those invited to the 'Complimentary Dinner' at the Criterion.

21 Whistler later incorrectly claimed to his solicitor Sir George Lewis, 'It [the book] is in any case my property – the letters – *and the idea of publication*' (underlined as in the original): GUL, BP II, 15/17.

22 GUL, M.120.

23 Ibid.

24 GUL, D.191, dated 23 July 1889.

25 GUL, M.121, dated 29 July 1889.

26 The original letter to Ford is dated by Evelyn Grantham as 18 August 1889: see 'The Gentle Art of Making Enemies', *More Books: The Bulletin of the Boston Public Library*, Vol. 20, No. 6, June 1945, pp. 278–80.

27 PC/LC, dated 3 September 1889.

28 GUL, BP II, 37/11, dated 29 September 1889.

29 Hunterian Museum and Art Gallery, Glasgow University, Rosalind Birnie Philip Bequest.

30 Hunterian Museum and Art Gallery, Glasgow University, Rosalind Birnie Philip Bequest.

31 Freer Art Gallery, Washington.

32 By the time the Exposition closed at the end of October 1889, the official attendance figure was given as 32,350,000.

33 GUL, M.381, dated 10 February 1889.

34 Confirmed in a letter from Monet to Whistler: GUL, M.364, dated 1 December 1889.

Chapter 22: The Gentle Art of Making Enemies

1 GUL, BP II, A.159, dated 8 October 1889.

2 *World*, 17 November 1886.

3 Richard Ellmann, *Oscar Wilde*, 1987, p. 258.

4 *World*, 24 November 1886.

5 Ellmann, op. cit., p. 261.

6 Ellmann, who does not identify the publication, dates the article as 26 January 1889: ibid., p. 271.

7 *Pall Mall Gazette*, 27 June 1889.

8 GUL, BP II, X.64, dated 27 November 1889.

9 GUL, M.364, dated 1 December 1889.

10 GUL, S.27.

11 *Truth*, 2 January 1890.

12 Reprinted in Rupert Hart-Davis (ed.), *The Letters of Oscar Wilde*, New York, 1962, pp. 253–4.

13 Leadenhall Press gave their version of the episode in the *Pall Mall Gazette*, 27 March 1890.

14 *Life*, Vol. II, pp. 106–7.

15 Ibid., p. 107.

16 A German translation did appear after Whistler's death in 1909. It was never translated into French.

17 *Saturday Review*, 16 June 1890.

18 *Pall Mall Gazette*, 18 June 1890.

19 Ms. Collection Mondor, dated 28 June 1890.

20 Ms. GUL, undated.

21 Information contained in a letter from Whistler to Mallarmé: GUL, M.144, dated 19 June 1890.

22 Walter Sickert, 'The New Life of Whistler', *Fortnightly Review*, December 1908.

23 Whistler had, of course, sent Nocturnes to commercial galleries in Paris such as Durand-Ruel.

24 Gustave Geffroy, 'Le Salon des Champs-Elysées', *Revue d'aujord'hui*, 1 May 1890, pp. 294–5.

25 Indicative of Freer's fastidious approach to print collecting is the fact that he once owned four different states of the same etching by Félix Bracquemond: see David Park Curry, 'Charles Lang Freer and American Art', *Apollo*, Vol. 1, No. CXVIII, August 1983, p. 172.

26 For the most recent insight into the Whistler–Freer relationship, see Thomas Lawton and Linda Merrill, *Freer: A Legacy of Art*, Freer Gallery of Art in association with Harry N. Abrams, Washington, 1993.

27 Hooper had the painting in his possession as early as 1879.

28 Ms. collection of Mrs J.B. Swan, USA.

29 Ibid., noted in McLaren Young *et al.*, *Paintings*, cat. no. 391, p. 173.

30 The story of this portrait is told by J.B. Armstrong in 'Portrait of a Lady: A Recollection of Whistler', *Art Journal*, Vol. XXV, No. 3, Spring 1966, pp. 250–1.

31 Ibid., p. 250.

32 Price confirmed in GUL, H.7.

33 GUL, BP II, Res.12/34, dated 19 November 1894.

34 Recounted in Clifford H. Dalton, 'A Farmhouse Converted for Comfort', *Country Life*, Vol. CXXVII, July 1960, pp. 438–9.

35 Margaret MacDonald, *Whistler's Pastels*, exhibition catalogue, Hunterian Museum and Art Gallery, Glasgow University, 1984, p. 44.

36 For an excellent overview of lithography in this period, see Frances Carey and Anthony Griffiths, *French Lithographs 1860–1900*, exhibition catalogue, British Museum, 1978.

37 Druick and Hoog, *Fantin-Latour*, p. 14.

38 See Sue Walsh Reed and Barbara Stern Shapiro, *Edgar Degas: The Painter as Printmaker*, New York Graphic Society, 1984, pp. xxxiv–xxxv.

39 Way's first commission for James was to print the leaflet describing Frederick Leyland's 'Peacock Room'.

40 Freer Gallery of Art, Washington.

41 Walter Sickert etched Rosie Pettigrew in 1884. In all probability Whistler etched *Baby Pettigrew*, which bears a close resemblance to Sickert's etching, at the same time.

42 Rose Pettigrew's Memoirs: Ms. GUL, MacColl Papers, p. 64.

43 Ibid.

44 See A. Mellerio, *La Lithographie originale en couleurs*, Paris, 1898, pp. 4–5.

45 For the background to the formation of the Chelsea Arts Club, see Tom Cross, *Artists and Bohemians: 100 Years with the Chelsea Arts Club*, 1992.

46 Ibid., p. 9.

47 GUL, M.368, dated 3 January 1892.

Chapter 23: A Question of Portraits

1 See Philippe Jullian and Alan Bowness, *French Symbolist Painters*, Arts Council of Great Britain exhibition catalogue, 1972, p. 77.

2 GUL, AM. 1974, W.74–5.

3 Roger Billcliffe, *The Glasgow Boys: The Glasgow School of Painting 1875–1895*, John Murray, 1985, p. 31.

4 Ibid., p. 290.

5 Letter to the art dealer, Ernest Brown: GUL, AM. 1969, i/21, dated September 1895.

6 Quoted in T.J. Honeyman, *Whistler: Arrangement in Grey and Black*, Glasgow Art Gallery, exhibition catalogue, 1951.

7 Billcliffe, op. cit., p. 290.

8 Ms. Freer Gallery Archives, Washington: letter dated 25 April 1888.

9 Quoted in Robert Ricatte (ed.), Edmond and Jules de Goncourt, *Journal: Mémoires de la vie littéraire*, Monaco, 1956, Vol. XVIII, pp. 52–3.

10 Frick Collection, New York.

11 W. Graham Robertson, *Time Was*, p. 188.

12 Ibid.

13 Ibid., p. 190.

14 See Kerrison Preston (ed.), *Letters of W. Graham Robertson*, 1953, pp. 95 and 368.

15 GUL, W.584.

16 Ibid.

17 Ibid.

18 For the most recent background to the Monet exhibition, see Paul Hayes Tucker, *Monet in the '90s: The Series Paintings*, Museum of Fine Arts, Boston, 1989, p. 84.

19 GUL, W.585.

20 Ibid.

21 Ricatte (ed.), *Journal*, op. cit., p. 53.

22 GUL, W.586.

23 Ibid.

24 GUL, W.587.

25 G.P. Jacomb-Hood, *With Brush and Pencil*, 1925, p. 37.

26 GUL, W.582.

27 Noted in letter fragment: GUL, W.590.

28 *Liverpool Mercury*, 29 August 1891.

29 GUL, W.589.

30 Sidney Starr, 'Personal Recollections', *Atlantic Monthly*, Vol. 101, April 1908.

31 Gustave Geffroy, 'The Salon of 1891', *La Justice*, 1 July 1891.

32 GUL, W.593.

33 GUL, W.594.

34 Ibid.

35 James wrote to Beatrice, '[Stevens] is very depressed': GUL, W.595.

36 Ibid.

37 Ibid.

Chapter 24: **A Most Successful Failure**

1 Confirmed in a letter from James to Mallarmé, dated 7 November 1891; and letter from Mallarmé to James, dated 9 November 1891: GUL, AM. 1969, M.24 and GUL, M.175.

2 *Life*, Vol. II, p. 120.

3 GUL, T.25, dated 21 December 1891.

4 PC/LC, dated 26 February 1892.

5 PC/LC, dated 19 February 1892.

6 GUL, W.596.

7 GUL, W.598, January 1892.

8 GUL, W.599.

9 GUL, W.601.

10 GUL, W.599.

11 GUL, BP II, Res.12/18.

12 Ibid.

13 Gandara's portrait of Montesquiou is now in the collection of the Chateau d'Azay-le-Ferron (Indre et Loire).

14 GUL, BP II, Res.12/18.

15 GUL, W.604.

16 Ibid.

17 GUL, Rev.1955, W/30.

18 PC/LC.

19 PC/LC, T.35, dated 27 February 1892.

20 Ibid.

21 Ibid.

22 PC/LC, T.27, dated 27 March 1892.

23 PC/LC, letter from Routh, Stacy and Castle (solicitors), to Thomson, dated 15 March 1892.

24 In John Rewald (ed.), *Camille Pissarro: Letters to His Son Lucien*, New York, 1981, p. 242.

25 *Life*, Vol. II, p. 121.

26 PC/LC, T.51.

27 PC/LC, dated 1 April 1892.

28 PC/LC, dated 5 April 1892.

29 For an excellent summation of the Goupil Album, see Nigel Thorp, 'Studies in Black and White: Whistler's Photographs in Glasgow University Library', in Ruth Fine (ed.), *James McNeill Whistler*, pp. 85–100.

30 PC/LC, April 1892.

31 PC/LC, dated 10 April 1892.

32 *Pall Mall Gazette*, 19 March 1892.

33 'The Vengeance of Mr Whistler', *Echo*, 22 March 1892.

34 PC/LC, dated 26 February 1892.

35 PC/LC, dated 19 March 1892.

36 GUL, B.36.

Chapter 25: Settling Down in Paris

1 *Life*, Vol. II, pp. 137–8.

2 Ibid.

3 PC/LC, dated 25 May 1892.

4 PC/LC, dated 19 June 1892.

5 Information contained in a letter to William Heinemann: PC/LC, dated 2 May 1892.

6 Ibid.

7 PC/LC, undated, but before September 1892.

8 Recounted by Henri Régnier, 'Nos rencontres', *Mercure de France*, 1931, pp. 213–14.

9 Barbier (ed.), *Correspondance: Mallarmé–Whistler*, p. 188.

10 Lochnan, *Etchings*, pp. 257–8.

11 PC/LC, dated 19 May 1892.

12 GUL, Letterbook 5, p. 13, dated 27 May 1892.

13 Information in letter from Beatrice to Reid in GUL, Letterbook 4, p. 82.

14 PC/LC, dated 31 May 1892.

15 PC/LC, undated.

16 *Life*, Vol. II, p. 139.

17 Ibid., p. 138.

18 Hunterian Museum and Art Gallery, Glasgow University.

19 PC/LC, undated.

20 GUL, AM. 1970, C/6, dated 15 February 1893.

21 The first exhibition of 'modern' French art took place in London in 1873.

22 Ms. Freer Gallery Archives, No. 229, dated 31 May 1893.

23 GUL, P.672, dated 27 May 1893.

24 Bernard Denvir (ed.), *The Impressionists at First Hand*, Thames and Hudson, 1987, p. 75.

25 PC/LC, dated 18 March 1893.

26 *Spectator*, 25 February 1893.

27 *Westminster Gazette*, 'A Philistine's Remonstrance', 9 March 1893.

28 D.S. MacColl, 'Mr Whistler's Paintings in Oil', *Art Journal*, March 1893.

29 Nigel Thorp, 'Studies in Black and White: Whistler's Photographs in Glasgow University Library', in Ruth Fine (ed.), *James McNeill Whistler*, p. 94.

30 *Life*, Vol. II, p. 140.

31 Ibid., pp. 142–3.

32 Ibid.

33 Quoted in McLaren Young *et al.*, *Paintings*, cat. no. 402, p. 179.

34 Ibid.

35 GUL, K.1, and GUL, BP II, 37/169.

36 *Life*, Vol. II, p. 146.

37 McLaren Young *et al.*, op. cit., cat. no. 404, p. 181.

38 PC/LC, August 1893.

39 Art Institute of Chicago.

40 Hill-Stead Museum, Farmington, Connecticut.

41 Ms. Edward Kennedy Papers, New York Public Library (NYPL), 146, 50.

42 Private collection, USA.

43 GUL, BP II, c/36.

44 PC/LC, dated 12 September 1893.

45 GUL, BP II, Res.18e/21, dated 3 October 1893.

46 GUL, BP II, Res.18e/29, dated 12 November 1893.

Chapter 26: Trials and Tribulations

1 Arthur Eddy, *Recollections and Impressions of James A. McNeill Whistler*, Philadelphia and London, 1903, pp. 266–9.

2 James McNeill Whistler, *Eden Versus Whistler: The Baronet and the Butterfly*, New York, 1899, p. 10.

3 PC/LC, dated 15 November 1893.

4 PC/LC, dated 23 January 1894.

5 Confirmed in a letter from Studd to Whistler: GUL, S.51, dated 27 January 1894.

6 See Alfred Thornton, *Diary of an Art Student of the Nineties*, 1938, p. 5.

7 William Rothenstein, *Men and Memories*, 1931, p. 37.

8 GUL, S.53.

9 GUL, Letterbook 4, dated 25 April 1894.

10 GUL, S.52, dated 22 June 1897.

11 From the original serialization: *Harper's Monthly Magazine*, LXXXVIII, March 1894, pp. 577–8.

12 *Pall Mall Gazette*, 15 May 1894.

13 GUL, draft letter to the Beefsteak Club dated 7 May 1894.

14 Ormond, *Georges du Maurier*, pp. 468–9.

15 Ms. GUL.

16 GUL, Letterbook 5, p. 89, undated.

17 Rothenstein, op. cit., p. 123.

18 *Art Journal*, April 1894, p. 99.

19 Rothenstein, op. cit., p. 123.

20 Ibid., p. 267.

21 McLaren Young *et al.*, *Paintings*, cat. nos. 418–19.

22 Fogg Art Museum, Harvard University.

23 Kennedy Papers, NYPL, I/50.

24 *Life*, Vol. II, p. 156.

25 Ibid.

26 Baron, op. cit., cat. no. 63, p. 308.

27 The portrait was shown at the Société Nationale in 1894 and mentioned in the *Magazine of Art*, April 1894.

28 GUL, W.1004, postmarked 15 November 1894.

29 See Herbert Snow MD, *A Treatise, Practical and Theoretic, on Cancers and the Cancer-Process*, 1893, p. 206.

30 GUL, Letterbook 5, p. 113.

Chapter 27: The Sun Goes Out

1 Thomas Way, *Memories of James McNeill Whistler*, 1912, p. 60.

2 Ibid.

3 GUL, BP II, Res.18e/70.

4 GUL, BP II, Res.18e/71.

5 In Elizabeth Pennell, *Nights: Rome, Venice in the Aesthetic Eighties: London, Paris in the Fighting Nineties*, 1916, p. 216.

6 *Academy*, 10 October 1903, p. 390.

7 McLaren Young *et al.*, *Paintings*, cat. no. 429, pp. 190–1.

8 GUL, BP II, Res.12/22, dated 4 March 1895.

9 *Pall Mall Gazette*, 1 March 1895.

10 *Pall Mall Gazette*, 12 March 1895.

11 *Daily Chronicle*, 'A Picture and a Challenge: The Strange Story of Mr Whistler and Mr Moore', 29 March 1895.

12 McLaren Young *et al.*, op. cit., cat. no. 408, p. 182.

13 PC/LC.

14 R.A.M. Stevenson, *The Art of Velasquez*, 1895, p. 44.

15 GUL, BP II, 37/81, dated 12 July 1895.

16 PC/LC, dated 11 July 1895.

17 Ibid.

18 GUL, W.611, April 1895.

19 GUL, W.1007, postmarked 29 August 1895.

20 PC/LC, 1810–11.

21 GUL, Letterbook 3, p. 23, postmarked 27 October 1895.

22 McLaren Young *et al.*, op. cit., cat. nos. 445 and 446.

23 GUL, W.637, postmarked 19 November 1895.

24 Ibid.

25 GUL, W.630.

26 William Rothenstein, *Men and Memories*, Vol. II, p. 109.

27 PC/LC, dated 27 November 1895.

28 GUL, T.170, dated 22 October 1895.

29 PC/LC, dated 24 October 1895.

30 GUL, W.622, postmarked 26 October 1895.

31 Pocock, *Chelsea Reach*, pp. 126–30.

32 GUL, W.638, postmarked 30 November 1895.

33 PC/LC.

34 GUL, W.639, dated 20 November 1895.

35 GUL, W.1249.

36 Edward Kennedy Papers, NYPL, II, 72.

37 See GUL, W.1249.

38 Edward Kennedy Papers, NYPL, II, 75, dated 14 March 1896.

39 Edward Ertz, 'Some Interesting Studio Methods of the Great Painter', in *Drawing*, No. 20, Vol. 4, December 1916, pp. 42–3.

40 Ibid., p. 42.

41 GUL, C.213, postmarked 4 April 1896.

42 Eddy, *Recollections and Impressions*, p. 239.

43 Ibid.

44 Edward Kennedy Papers, NYPL, II, 85.

45 Freer Gallery Archives, dated 24 March 1897.

46 GUL, postmarked July 1896.

47 GUL, W.308.

48 Robertson, *Time Was*, p. 298.

Chapter 28: L'Affaire Sickert

1 GUL, S.87.

2 GUL, BP II, Res.19/17.

3 GUL, S.66.

4 Rothenstein Papers, Harvard University.

5 GUL, BP II, Res.19/76.

6 Arthur Symons, *Studies in Seven Arts*, 1906, p. 124.

7 Ms. Islington Public Libraries.

8 Elizabeth Pennell, *The Life and Letters of Joseph Pennell*, 2 vols., 1930, Vol. 1, pp. 308–9.

9 *Life*, Vol. II, p. 187.

10 Private collection, France.

11 Edith Shaw, with an introduction by Margaret McDonald, 'Four Years with Whistler', *Apollo*, March 1968, p. 200.

12 George Painter, *Marcel Proust*, 2 vols., 1959 and 1965, Vol. 1, p. 207.

13 Quoted in Barbier (ed.), *Correspondance: Mallarmé–Whistler*, p. 257.

14 *Life*, Vol. II, p. 188.

15 GUL, P.344, dated 31 March 1897.

16 This exchange is recounted in GUL, H.33.

17 Recalled in *Life*, Vol. II, p. 189.

18 Ibid.

19 Ibid.

20 GUL, P.345.

21 GUL, H.33.

22 GUL, P.389, dated 18 August 1899.

Chapter 29: A Dream Realized: The International Society

1 Weintraub, *Whistler*, p. 423.

2 Ibid.

3 New York, 1904.

4 GUL, W.97, dated 17 October 1893.

5 Joseph Pennell and Elizabeth Robins, *Lithography and Lithographers*, New York, 1898.

6 Elizabeth and Joseph Pennell, *The Graphic Arts: Modern and Modern Methods*, Art Institute of Chicago, 1920, pp. 24–5.

7 Quoted in Susan Hobbs, *Lithographs of James McNeill Whistler: From the Collection of Steven Louis Block*, Smithsonian Institution, 1982, p. 32.

8 Metropolitan Museum of Art, New York.

9 McLaren Young *et al.*, *Paintings*, cat. no. 164, p. 94.

10 Ms. GUL. Note by the print-dealer Harold Wright.

11 *Life*, Vol. II, p. 200.

12 GUL, BP II, Res.19/103.

13 McLaren Young *et al.*, op. cit., cat. nos. 478–80.

14 GUL, V.1, dated 18 May 1897.

15 Stanley Olson, *John Singer Sargent: His Portrait*, New York, 1986, p. 205.

16 *Life*, Vol. II, p. 194.

17 Ibid.

18 PC/LC.

19 Hunterian Museum and Art Gallery, Glasgow University.

20 Fogg Art Museum, Harvard University.

21 *Life*, Vol. II, p. 195.

22 Ibid.

23 Reff, *Degas*, pp. 34–5.

24 The Art Institute of Chicago.

25 McLaren Young *et al.*, op. cit., cat. no. 485, p. 210.

26 George Painter, *Marcel Proust*, 2 vols., 1959 and 1965, Vol. 1, p. 219.

27 Quoted in McLaren Young *et al.*, op. cit., cat. no. 490, pp. 211–12.

28 Noted in a letter to Freer, dated 28 July 1902; Freer Gallery Archives.

29 *Life*, Vol. II, p. 216.

30 Philip Athill, 'The International Society of Sculptors, Painters and Gravers', *Burlington Magazine*, 1986, pp. 21–9.

31 Ibid.

32 John Lavery, *The Life of a Painter*, Boston, 1940, p. 108, note 7.

33 Ibid., p. 110.

34 The copy of the International Society's Rule Book as annotated by Whistler is in PC/LC, Box 34.

35 GUL, p/c: Vol. 17, p. 21, dated 26 April 1898.

36 The working drawings are in PC/LC.

37 NEAC, p/c: Vol. 1892, p. 436, Tate Gallery Archives.

38 Lavery, op. cit., pp. 111–12.

39 PC/LC.

40 21 May 1898.

41 *Pall Mall Gazette*, Vol. LXVI, 16 May 1898, pp. 1–2.

42 Ms. GUL, undated.

Chapter 30: A Most Reluctant Teacher

1 Philip Athill, 'The International Society of Sculptors, Painters and Gravers', *Burlington Magazine*, 1986, p. 26.

2 P.H. Emerson, *Naturalistic Photography for the Students of Art*, 1889, p. 78. Here Emerson is referring to James's reforms at the RBA.

3 Ibid., p. 81.

4 P.H. Emerson, *The Death of Naturalistic Photography*, 1890.

5 Ibid., p. 7.

6 See R. Wood, *P.H. Emerson*, 1974, p. 27.

7 Ms. Emerson Family Papers, dated 1 August 1890. Emerson later annotated the letter 'A letter from the great Whistler'.

8 Quoted by Fiona Pearson in 'The Correspondence between P.H. Emerson and J. Havard Thomas', in M. Weaver (ed.), *British Photography in the Nineteenth Century*, Cambridge University Press, 1989, p. 199.

9 Ibid., p. 201.

10 In a letter to the painter James Charles dated 17 July 1890, Emerson wrote in reference to *The Bridge*, 'Whistler liked this.' Ms. Emerson Papers, private collection.

11 Ms. Archives of T. & R. Annan & Sons, Glasgow.

12 Vol. VIII, p. 105.

13 For further on this subject see Nigel Thorp, 'Studies in Black and White: Whistler's Photographs in Glasgow University Library', in Ruth Fine (ed.), *James McNeill Whistler*, pp. 85–100. Also discussed in Anne Koval, *Responses to J.M. Whistler's Theory and Practice: The Followers in Britain*, University of London, PhD thesis (forthcoming), chapter on 'Artistic Reproduction – Photography'.

14 Hart-Davis (ed.), *Letters of Oscar Wilde*, p. 731, letter dated 1898.

15 PC/LC, undated.

16 Confirmed in document: PC/LC.

17 As quoted in *Life*, Vol. II, p. 228.

18 Paul Henry, *An Irish Portrait*, 1950, pp. 18–19.

19 GUL, dated 20 July 1899 and witnessed by William Webb.

20 PC/LC, Box 10, p. 920.

21 Translation by Larissa Haskell.

22 *Gwen John*, exhibition catalogue, Anthony d'Offay Gallery, 1982, p. 5.

23 Augustus John, *Chiaroscuro*, 1952, p. 66.

24 Ibid., p. 67.

25 GUL, W.1019, postmarked June 1899.

Chapter 31: No Reprieve

1 Thomas Pakenham, *The Boer War*, Abacus, 1992, p. 109.

2 *Life*, Vol. II, p. 251.

3 *Journal*, p. 53.

4 McLaren Young *et al.*, *Paintings.*, cat. no. 504, pp. 215–16.

5 See David Park Curry, *James McNeill Whistler at the Freer Gallery of Art*, 1984, Chapter 1, pp. 11–34.

6 *Life*, Vol. II, p. 254.

7 GUL, P.414, dated 7 April 1900.

8 GUL, BP II, 37/1311, dated 27 February 1900.

9 *Life*, Vol. II, p. 258.

10 On one occasion in the 1890s O'Leary was a dinner guest at the same function as William Rothenstein: see *Men and Memories*, Vol. 1, p. 201.

11 GUL, G.417.

12 Noted in exhibition catalogue, *Oils, Watercolours, Pastels and Drawings by James McNeill Whistler*, Introduction by John Butler Yeats, Knoedler Galleries, New York, April 1914.

13 GUL, Ledger a, p. 108.

14 Quoted in *Life*, Vol. II, p. 259.

15 PC/LC, letter from Booth Pearsall to Joseph Pennell, dated 7 October 1907.

16 PC/LC.

17 Margaret MacDonald, 'Whistler's Last Years: Spring 1901 – Algiers and Corsica', *Gazette des Beaux-Arts*, June 1969, Vol. LXXIII, pp. 323–42.

18 Ibid., p. 324.

19 Ibid.

20 All the drawings are now in the Hunterian Museum and Art Gallery, Glasgow University.

21 GUL, BP II, Res.19/16.

22 *Life*, Vol. II, pp. 266–7.

23 MacDonald, op. cit., p. 338.

24 Ibid.

25 These etchings were printed by Nathaniel Sparks in 1931 and limited to 27 impressions of each image.

26 Lochnan, *Etchings*, p. 272.

27 MacDonald, op. cit., p. 329.

28 GUL, BP II, Res.19/32.

29 GUL, AM. 13/3.

30 MacDonald, op. cit., p. 331.

31 Ibid., p. 327.

32 *Journal*, p. 209.

33 Ibid., p. 219.

34 *Life*, Vol. II, p. 269.

35 Ibid., p. 270.

36 Ibid., p. 277.

37 Ibid., p. 278.

38 GUL, Letterbook 4, p. 149.

39 *Journal*, p. 271.

40 Park Curry, op. cit., p. 27.

41 *Morning Post*, 6 August 1902.

42 Hunterian Museum and Art Gallery, Glasgow University.

43 *Life*, Vol. II, p. 291.

44 *Standard*, 'Une Dernière Incarnation', 21 November 1902.

45 GUL, M.46.

46 *Journal*, p. 293.

47 Ibid., p. 291.

48 Confirmed in Elizabeth Pennell's pocket diary: PC/LC.

Chapter 32: Retrospect

1 That Rosalind Birnie Philip carried on this task for many years after Whistler's death is confirmed by a letter written by a neighbour, a copy of which is in the collection of Ralfe Whistler.

2 *Saturday Review*, 25 February 1905.

3 *Saturday Review*, 4 March 1905.

4 Roger Fry, 'Watts and Whistler', *Quarterly Review*, Vol. 202, April 1905, pp. 607–23.

5 Walter Sickert, 'The *New* Life of Whistler', *Fortnightly Review*, December 1908.

6 Julius Meier-Graefe, *Modern Art: Being a Contribution to a New System of Aesthetics*, 2 vols., translated by F. Simmonds and G. W. Chrystal, 1908.

7 T. Duret, *Histoire de J.McN. Whistler et de son oeuvre*, Paris, 1904, translated by Frank Rutter, 1917.

8 Clive Bell, *Art*, Grey Arrow edition, 1961, pp. 170–1.

Select Bibliography

THE LITERATURE RELATING to James McNeill Whistler is vast, and the authors can only acknowledge the most frequently cited sources. For more information readers are referred to Robert H. Getscher and Paul G. Marks, *James McNeill Whistler and John Singer Sargent: Two Annotated Bibliographies*, Garland Publishing Inc., New York and London, 1986. In the following list, the place of publication is London unless otherwise indicated.

Manuscript Sources

Rosalind Birnie Philip Bequest, Special Collections, University of Glasgow. [GUL]

Pennell Collection, Manuscript Division, Library of Congress, Washington DC. [PC/LC]

Related Papers concerning Whistler, Print Division, Library of Congress, Washington DC.

Edward Kennedy Papers, and other related material, New York Public Library, New York.

Manuscript Department of the British Library, London.

Manuscript Department of the British Museum, London.

The Public Record Office, London.

State Papers Office, Dublin.

Freer Gallery Archives, Freer Gallery of Art, Washington DC.

Les XX archive, Musées Royaux des Beaux-Arts de Belgique, Archive de l'art contemporain, Albert Vanderlinden Collection.

Minutes of the Dublin Sketching Club, 1883–1886, in the possession of the club secretary, Dublin.

Minutes and Accounts of the Etching Club, 1838–1885. 6 vols., Victoria and Albert Museum Library, London.

Minutes of the International Society of Sculptors, Painters and Gravers, 1903–1906. Tate Gallery Archives, London.

Minutes of the Junior Etching Club, 1857–1864. Victoria and Albert Museum Library, London.

Minutes, Accounts and Agendas of the Royal Society of British Artists, in the possession of the society, London.

Selected Monographs, Published Articles, Exhibition Catalogues and Works of Standard Reference

Anderson, Ronald, 'Whistler: An Irish Rebel and Ireland – Implications of an Undocumented Friendship', *Apollo*, cxxiii, April 1986, pp. 254–8.

——, 'Whistler in Dublin, 1884', *Irish Arts Review*, Autumn 1987.

Bacher, Otto, *With Whistler in Venice*, Century, New York, 1908.

Cheney, Liana de Girolami and Marks, Paul G. (eds.), *The Whistler Papers*, Lowell, Mass., 1986.

Curry, David Park, *James McNeill Whistler at the Freer Gallery of Art*, W.W. Norton, London and New York, in association with the Smithsonian Institution, 1984.

Donnelly, Kate, and Thorp, Nigel, *Whistlers and Further Family*, exhibition catalogue, Glasgow University Library, 1980.

Dufwa, Jacques, *Winds from the East: A Study in the Art of Manet, Degas, Monet and Whistler 1856–86*, Stockholm and Atlantic Highlands, 1981.

Duret, Théodore, *Whistler*, trans. Frank Rutter, 1917, originally published as *Histoire de J.McN. Whistler et de son oeuvre*, H. Floury, Paris, 1904.

Fine, Ruth E. (ed.), *James McNeill Whistler: A Reexamination*, Studies in the History of Art, Vol. 19, Washington DC, 1987.

Fleming, Gordon, *The Young Whistler, 1834–1866*, 1978.

Getscher, Robert H., 'Whistler and Venice', Case Western Reserve University, USA, 1970, PhD thesis.

——, *The Stamp of Whistler*, exhibition catalogue, Allen Memorial Art Museum, Oberlin, 1977.

——, *James Abbott McNeill Whistler: Pastels*, John Murray, 1991.

Grieve, Alastair, 'Whistler and the Pre-Raphaelites', *Art Quarterly*, 34 (1971), pp. 219–23.

Hobbs, Susan, *Lithographs of James McNeill Whistler, From the Collection of Steven Louis Block*, Smithsonian Institution Traveling Exhibition Service, Washington DC, 1982.

Holden, Donald, *Whistler Landscapes and Seascapes*, New York, 1969.

Kennedy, Edward G., *The Etched Work of Whistler, Illustrated by Reproductions in Collotype of the Different States of the Plates*, New York, 1910 (new edition, Alan Wofsy Fine Arts, San Francisco, 1978).

Laver, James, *Whistler*, 1930.

Levy, Mervyn, *Whistler's Lithographs: A Catalogue Raisonné*, 1975.

Lochnan, Katharine A., *The Etchings of James McNeill Whistler*, Yale University Press in association with the Art Gallery of Ontario, 1984.

——, *Whistler and His Circle*, exhibition catalogue, Art Gallery of Ontario, 1986.

MacDonald, Margaret, 'Whistler's Last Years: Spring 1901 – Algiers and Corsica', *Gazette des Beaux-Arts*, 6, 73, (May 1969), pp. 323–42.

——, 'Whistler: The Painting of the Mother', *Gazette des Beaux-Arts*, Per. 6, 85, No. 1273 (1975), pp. 73–88.

——, *Whistler, the Graphic Work: Amsterdam, Liverpool, London, Venice*, exhibition catalogue, Thos. Agnew & Son, 1976.

——, *Whistler Pastels*, exhibition catalogue, Hunterian Museum and Art Gallery, University of Glasgow, 1984.

Menpes, Mortimer, *Whistler as I Knew Him*, 1904.

Newall, Christopher and Egerton, Judy, *George Price Boyce*, exhibition catalogue, Tate Gallery, 1987.

Parry, Albert, *Whistler's Father*, New York, 1939.

Pennell, Elizabeth Robins, *Whistler the Friend*, Philadelphia, 1930.

Pennell, Elizabeth Robins and Joseph, *The Life of James McNeill Whistler*, 2 vols., London and Philadelphia, 1908.

——, *The Whistler Journal*, Philadelphia, 1921.

Pressly, Nancy D., 'Whistler in America: An Album of Early Drawings', *Metropolitan Museum Journal*, 5, (1972), pp. 125–54.

Rutter, Frank, *James McNeill Whistler: An Estimate and a Biography*, 1911.

Sandberg, John, 'Japonisme and Whistler', *Burlington Magazine*, 106, No. 740, (1964), pp. 500–7.

——, 'Whistler's Early Work in America, 1834–1855', *Art Quarterly*, 29, (1966), pp. 46–59.

Sickert, Bernhard, *Whistler*, 1908.

Spencer, Robin, *The Aesthetic Movement*, Studio Vista, 1972.

——, 'Whistler and Japan: Work in Progress', in *Japonisme: An International Symposium*, Society for the Study of Japonisme, Kodancha, Tokyo, 1981, pp. 57–80.

——, *Whistler: A Retrospective*, New York, 1989.

——, *Whistler*, Studio Editions, 1990.

Staley, Allen (ed.), *From Realism to Symbolism: Whistler and his World*, exhibition catalogue, Columbia University, New York, 1971.

Surtees, Virginia (ed.), *The Diaries of George Price Boyce*, Norwich, 1980.

Sutton, Denys, *James McNeill Whistler: Paintings, Etchings, Pastels and Watercolours*, 1966.

——, *The Art of James McNeill Whistler*, London, 1963.

Sweet, Frederick A., *James McNeill Whistler*, exhibition catalogue, Art Institute of Chicago, 1968.

Tate Gallery, *The Pre-Raphaelites*, exhibition catalogue, 1984, in association with Penguin Books.

Taylor, Hilary, *James McNeill Whistler*, 1978.

Walker, John, *James McNeill Whistler*, New York, 1987.

Way, T.R., *Mr Whistler's Lithographs: The Catalogue*, 2nd edition, 1905.

Way, T.R. and Dennis, G.R., *The Art of James McNeill Whistler: An Appreciation*, 1903.

Weintraub, Stanley, *Whistler: A Biography*, New York, 1974.

Whistler, James McNeill, *The Gentle Art of Making Enemies*, 1890, and subsequent editions.

Young, Andrew McLaren, MacDonald, Margaret, Spencer, Robin, with the assistance of Hamish Miles, *The Paintings of James McNeill Whistler*, 2 vols., Yale University Press, New Haven and London, 1980.

General Works

Barbier, Carl P. (ed.), *Correspondance: Mallarmé–Whistler*, Paris, 1964.

Baron, Wendy, *Sickert*, 1973.

Bell, Clive, *Art*, 1914.

——, *Old Friends, Personal Recollections*, 1956.

Billcliffe, Roger, *The Glasgow Boys: The Glasgow School of Painting 1875–1895*, John Murray in association with Britoil, 1985.

Blanche, Jacques-Emile, *Portraits of a Lifetime: The Late Victorian Era; The Edwardian Pageant, 1870–1914*, trans. and ed. Walter Clement, 1937.

Clark, T.J., *The Painting of Modern Life: Paris in the Art of Manet and His Followers*, New York, 1985.

Cross, Tom, *Artists and Bohemians: 100 Years with the Chelsea Arts Club*, 1992.

Druick, Douglas, and Hoog, Michael, *Fantin-Latour*, exhibition catalogue, National Gallery of Canada, Ottawa, 1982.

Du Maurier, Daphne, *The Young George du Maurier: A Selection of his Letters, 1860–1867*, 1951.

Eddy, Arthur J., *Recollections and Impressions of James McNeill Whistler*, Philadelphia and London, 1903.

Ellmann, Richard, *Oscar Wilde*, 1987.

Farr, Denis, *English Art 1870–1940*, Oxford, 1978.

Flint, Kate (ed.), *Impressionists in England: The Critical Reception*, 1984.

Floyd, Phillis Anne, *Japonisme in Context: Documentation, Criticism, Aesthetic Reactions*, 3 vols., UMI Research Press, Ann Arbor, 1986.

Fry, Roger, *Vision and Design*, 1921.

Gimpel, René, *Diary of an Art Dealer*, introduction by Sir Herbert Read, 1986.

Hamilton, George Heard, *Manet and His Critics*, New York, 1969.

Hart-Davis, Rupert (ed.), *The Letters of Oscar Wilde*, New York, 1962.

Hartrick, A.S., *A Painter's Pilgrimage through Fifty Years*, Cambridge, 1939.

House, John, and Stevens, MaryAnne (eds.), *Post-Impressionism: Cross-Currents in European Paintings*, exhibition catalogue, Royal Academy of Arts, 1979–1980.

L.M. Lamont (ed.), *Thomas Armstrong, CB: A Memoir, 1852–1911*, Secker, 1912.

Lang, C.Y. (ed.), *Algernon C. Swinburne: Letters, Vol. 1, 1854–69; Vol. 2, 1869–1875*, 1959.

Lavery, J., *The Life of a Painter*, 1940.

Ludovici, A., *An Artist's Life in London and Paris*, 1926.

Maas, Jeremy, *The Victorian Art World in Photographs*, New York, 1984.

Mayne, J. (ed.), *Charles Baudelaire: The Painter of Modern Life and Other Essays*, Phaidon Press, 1964.

——, *Charles Baudelaire: Art in Paris 1845–1862: Salons and Other Exhibitions*, London and New York, 1965.

McConkey, Kenneth, *British Impressionism*, Oxford, 1989.

Milner, John, *The Studios of Paris: The Capital of Art in the Late Nineteenth Century*, Yale University Press, New Haven and London, 1988.

Moore, George, *Confessions of a Young Man*, 1888.

Nochlin, Linda, *Realism*, Penguin Books, Harmondsworth, 1971.

Select Bibliography

Olson, Stanley, *John Singer Sargent: His Portrait*, New York, 1986.

Ormond, Leonee, *George du Maurier*, 1969.

Pissarro, Camille, *Letters to His Son Lucien*, ed. John Rewald, 1980.

Pocock, Tom, *Chelsea Reach: The Brutal Friendship of Whistler and Walter Greaves*, 1970.

Reff, Theodore, *Degas: The Artist's Mind*, Harvard University Press, 1976.

Rewald, John, *The History of Impressionism*, revised and enlarged edition, New York, 1973.

Robertson, W. Graham, *Time Was*, 1931.

Rothenstein, William, *Men and Memories: A History of the Arts, 1872–1922; Being the Recollections of William Rothenstein*, 2 vols., New York, 1938.

——, *Men and Memories: Recollections, 1872–1938, of William Rothenstein*, ed. Mary Lago, 1978.

Sitwell, Osbert (ed.), *A Free House! or the Artist as Craftsman: Being the Writings of Walter Richard Sickert*, 1941.

Thornton, Alfred, *Fifty Years of the New English Art Club, 1886–1935*, 1935.

——, *The Diary of an Art Student of the Nineties*, 1938.

Tucker, Paul Hayes, *Monet in the '90s: The Series Paintings*, Museum of Fine Arts, Boston, in association with Yale University Press, New Haven and London, 1989.

Weisberg, Gabriel P., *The European Realist Tradition: French Painting and Drawing, 1830–1900*, Cleveland, Ohio, 1980.

Index

NOTE: Art works by JMW appear directly under title; works by others appear under the artist's or author's name.